2009

P9-DJV-041

ARTIST'S &
GRAPHIC DESIGNER'S
MARKET®

From the Editors of Writer's Digest Books

WRITER'S DIGEST BOOKS
CINCINNATI, OH

If you are an editor, art director, creative director or gallery director and would like to be considered for a listing in the next edition of *Artist's & Graphic Designer's Market*, send your request for a questionnaire to *Artist's & Graphic Designer's Market*—QR, 4700 East Galbraith Road, Cincinnati, Ohio 45236, or e-mail artdesign@fwpubs.com.

Editorial Director, Writer's Digest Books: Jane Friedman
Managing Editor, Writer's Digest Market Books: Alice Pope

Artist's & Graphic Designer's Market Web page: www.artists-market.com
Writer's Market Web site: www.writersmarket.com
Writer's Digest Web site: www.writersdigest.com
F+W Media Bookstore: http://fwmedia.com

Distributed in Canada by Fraser Direct
100 Armstrong Ave.
Georgetown, ON, Canada L7G 5S4
Tel: (905) 877-4411

Distributed in the U.K. and Europe by David & Charles
Brunel House, Newton Abbot, Devon, TQ12 4PU, England
Tel: (+44) 1626 323200, Fax: (+44) 1626 323319
E-mail: postmaster@davidandcharles.co.uk

Distributed in Australia by Capricorn Link
P.O. Box 704, Windsor, NSW 2756, Australia
Tel: (02) 4577-3555

Distributed in New Zealand by David Bateman Ltd.
P.O. Box 100-242, N.S.M.C., Auckland 1330, New Zealand
Tel: (09) 415-7664, Fax: (09) 415-8892

Distributed in South Africa by Real Books
P.O. Box 1040, Auckland Park 2006, Johannesburg, South Africa
Tel: (011) 837-0643, Fax: (011) 837-0645
E-mail: realbook@global.co.za

ISSN: 1075-0894
ISBN-13: 978-1-58297-545-0
ISBN-10: 1-58297-545-0

Cover design by Claudean Wheeler
Interior design by Clare Finney
Production coordinated by Greg Nock

F•W PUBLICATIONS, INC.

Attention Booksellers: This is an annual directory of F+W Media, Inc. Return deadline for this edition is December 31, 2009.

Contents

BUSINESS BASICS

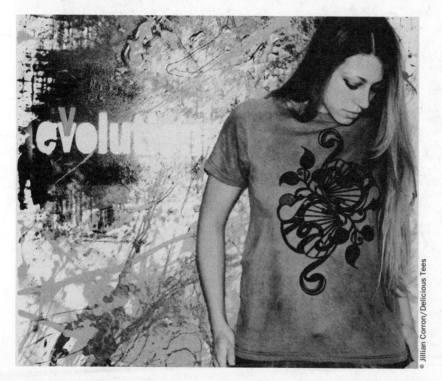

© Jillian Corron/Delicious Tees

ARTICLES & INTERVIEWS

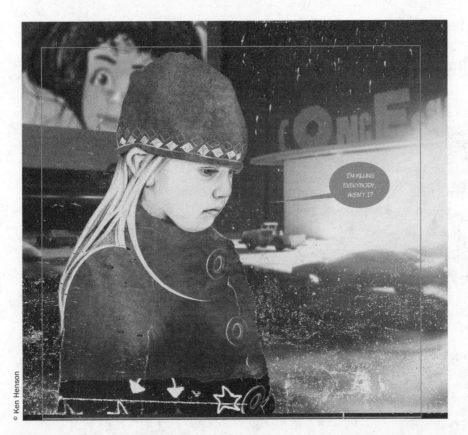

© Ken Henson

MARKETS

© Leslie Bistrowitz

RESOURCES

INDEXES

From the Editor

I don't have to tell you that these days there are myriad ways to get your art out into the world. While the traditional method of popping postcard samples in the mail several times a year is still a great way to get your work in front of art directors, now it's acceptable to e-mail your samples. (For more on this topic see The Etiquette of E-mail Promotions on page 27.)

And beyond the usual markets such as galleries, magazines, and stock art firms, artists can sell their work at art fairs (see our Art Fairs section on page 468 and Secrets for Successful Outdoor Shows on page 39), on online sites like etsy.com and eBay, and through many markets you may not have considered. (See Unconventional Markets for Illustrators on page 34 if you're curious.)

There are many working artists out there creating and selling work in non-traditional ways. Jullian Corron (page 56) designs and sells T-shirts through her own Web site. Ken Henson (pages 49) illustrates amazing graphic novels. Leslie Bistrowitz (page 43) has a successful career creating storyboards.

For these artists, success didn't happen overnight. They developed their skills, and discovered their niches. They marketed their work, and found the right buyers over time. "Patience and commitment," says Ken Henson, "are key to both the process of making the work and getting it out there."

Jullian Corron's business is still building. She's got a day job and works on her own projects evenings and weekends. "I essentially work from the moment I wake up to the moment I go to sleep, but what artist doesn't?" she says. "I feel like I am at a creative peak in my life and I want to absorb every last drop. I don't mind putting in the hours now to be able to enjoy the rewards later."

Whatever path you choose as an artist, whether you're just starting or more established, the *2009 Artist's & Graphic Designer's Market* is here to guide you with our articles, interviews and up-to-date market listings for everything from magazines and book publishers to syndicates and record labels, so one day you can share the same sentiment as Leslie Bistorwitz: "I love my job," she says. "A bad day at the drawing table is still better than a great day at any other job."

Alice Pope
Managing Editor
Writer's Digest Market Books
artdesign@fwpubs.com

2009 Reader Survey:
Tell us about yourself!

1. How often do you purchase *Artist's & Graphic Designer's Market?*

○ every year
○ every other year
○ This is my first edition

2. Describe yourself and your artwork—and how you use *AGDM.*

3. What do you like best about *AGDM*?

4. Would you like to see an online version of *AGDM*?

○ Yes
○ No

Name: _____
Address: _____
City: _____ State: _____ Zip: _____
E-mail: _____
Web site: _____

Fax to Artist's & Graphic Designer's Market at (513) 531-2686; mail to Artist's & Graphic Designer's Market, 4700 East Galbraith Road, Cincinnati, OH 45236; or e-mail artdesign@fwpubs.com.

How to Use This Book

If you're picking up this book for the first time, you might not know quite how to start using it. Your first impulse might be to flip through and quickly make a mailing list, submitting to everyone with hopes that *someone* might like your work. Resist that urge.

First you have to narrow down the names in this book to those who need your particular art style. That's what this book is all about. We provide the names and addresses of art buyers along with plenty of marketing tips. You provide the hard work, creativity and patience necessary to hang in there until work starts coming your way.

Listings: the heart of this book

The book is divided into market sections, from galleries to art fairs. (See the Table of Contents for complete list.) Each section begins with an introduction containing information and advice to help you break into that specific market.

Listings are the meat of this book. In a nutshell, listings are names, addresses and contact information for places that buy or commission artwork, along with a description of the type of art they need and their submission preferences.

Articles and interviews

Throughout this book you will find helpful articles and interviews with working artists and experts from the art world. These articles give you a richer understanding of the marketplace by sharing the featured artists' personal experiences and insights. Their stories, and the lessons you can learn from other artists' feats and follies, give you an important edge over competition.

HOW *AGDM* WORKS

Following the instructions in the listings, we suggest you send samples of your work (not originals) to a dozen (or more) targeted markets. The more companies you send to, the greater your chances of a positive response. Establish a system to keep track of who you submit your work to and send follow-up mailings to your target markets at least twice a year.

How to read listings

The first thing you'll notice about many of the listings in this book is the group of symbols that appears before the name of each company. (You'll find a quick-reference key to the symbols on the front and back inside covers of the book.) Here's what each symbol stands for:

Business Basics

N̶ Market new to this edition

❖ Canadian market

⊕ International market

⚑ Market perfers to work with local artists/designers

Each listing contains a description of the artwork and/or services the company prefers. The information often reveals how much freelance artwork is used, whether computer skills are needed, and which software programs are preferred.

In some sections, additional subheads help you identify potential markets. Magazine listings specify needs for cartoons and illustrations. Galleries specify media and style.

Editorial comments, denoted by bullets (•), give you extra information about markets, such as company awards, mergers and insight into a company's staff or procedures.

It might take a while to get accustomed to the layout and language in the listings. In the beginning, you will encounter some terms and symbols that might be unfamiliar to you. Refer to the Glossary on page 529 to help you with terms you don't understand.

Working with listings

1. Read the entire listing to decide whether to submit your samples. Do *not* use this book simply as a mailing list of names and addresses. Reading listings carefully helps you narrow your mailing list and submit appropriate material.

2. Read the description of the company or gallery in the first paragraph of the listing. Then jump to the **Needs** or **Media** heading to find out what type of artwork is preferred. Is it the type of artwork you create? This is the first step to narrowing your target market. You should send your samples only to places that need the kind of work you create.

3. Send appropriate submissions. It seems like common sense to research what kind of samples a listing wants before sending off just any artwork you have on hand. But believe it or not, some artists skip this step. Many art directors have pulled their listings from *AGDM* because they've received too many inappropriate submissions. Look under the **First Contact & Terms** heading to find out how to contact the market and what to send. Some companies and publishers are very picky about what kinds of samples they like to see; others are more flexible.

What's an inappropriate submission? I'll give you an example. Suppose you want to be a children's book illustrator. Don't send samples of your cute animal art to *Business Law Today* magazine—they would rather see law-related subjects. Use the Niche Marketing Index on page 546 to find listings that accept children's illustrations. You'd be surprised how many illustrators waste their postage sending the wrong samples. And boy, does that alienate art directors. Make sure all your mailings are *appropriate* ones.

4. Consider your competition. Under the **Needs** heading, compare the number of freelancers who contact the company with the number they actually work with. You'll have a better chance with listings that use a lot of artwork or work with many artists.

5. Look for what they pay. In most sections, you can find this information under **First Contact & Terms**. Book Publishers list pay rates under headings pertaining to the type of work they assign, such as **Text Illustration** or **Book Design**.

At first, try not to be too picky about how much a listing pays. After you have a couple of assignments under your belt, you might decide to only send samples to medium- or high-paying markets.

6. Be sure to read the Tips. This is where art directors describe their pet peeves and give clues for how to impress them. Artists say the information within the **Tips** helps them get a feel for what a company might be like to work for.

These steps are just the beginning. As you become accustomed to reading listings, you

Frequently Asked Questions

1 **How do companies get listed in the book?** No company pays to be included—all listings are free. Every company has to fill out a detailed questionnaire about their art needs. All questionnaires are screened to make sure the companies meet our requirements. Each year we contact every company in the book and ask them to update their information.

2 **Why aren't other companies I know about listed in this book?** We may have sent these companies a questionnaire, but they never returned it. Or if they did return a questionnaire, we may have decided not to include them based on our requirements. If you know of a market you'd like to see in the book, send an e-mail request to artdesign@fwpubs.com.

3 **I sent some samples to a company that stated they were open to reviewing the type of work I do, but I have not heard from them yet, and they have not returned my materials. What should I do?** At the time we contacted the company, they were open to receiving such submissions. However, things can change. It's a good idea to contact any company listed in this book to check on their policy before sending them anything. Perhaps they have not had time to review your submission yet. If the listing states that they respond to queries in one month, and more than a month has passed, you can send a brief e-mail to the company to inquire about the status of your submission. Some companies receive a large volume of submissions, so you must be patient. Never send originals when you are querying—always send copies. If for any reason your samples are never returned, you will not have lost forever the opportunity to sell an important image. It is a good idea to include a SASE (self-addressed, stamped envelope) with your submissions, even if the listing does not specifically request that you do so. This may facilitate getting your work back.

4 **A company says they want to publish my artwork, but first they will need a fee from me. Is this a standard business practice?** No, it is not a standard business practice. You should never have to pay to have your art reviewed or accepted for publication. If you suspect that a company may not be reputable, do some research before you submit anything or pay their fees. The exception to this rule is art fairs. Most art fairs have an application fee, and sometimes there is a fee for renting booth space. Some galleries may also require a fee for renting space to exhibit your work (see page 63 for more information).

will think of more ways to mine this book for your potential clients. Some of our readers tell us they peruse listings to find the speed at which a magazine pays its freelancers. In publishing, it's often a long wait until an edition or book is actually published, but if you are paid "on acceptance," you'll get a check soon after you complete the assignment and it is approved by the art director.

When looking for galleries, savvy artists often check to see how many square feet of space are available and what hours the gallery is open. These details all factor in when narrowing down your search for target markets.

Business Basics

Pay attention to copyright information

It's also important to consider what **rights** companies buy. It is preferable to work with companies that buy first or one-time rights. If you see a listing that buys "all rights," be aware you may be giving up the right to sell that particular artwork in the future. See Copyright Basics on page 18 for more information.

Look for specialties and niche markets

Read listings closely. Most describe their specialties, clients and products within the first paragraph. If you hope to design restaurant menus, for example, target agencies that have restaurants for clients. If you prefer illustrating people, you might target ad agencies whose clients are hospitals or financial institutions. If you like to draw cars, look for agencies with clients in the automotive industry, and so on. Many book publishers specialize, too. Look for a publisher who specializes in children's books if that's the type of work you'd like to do. The Niche Marketing Index on page 546 lists possible opportunities for specialization.

Read listings for ideas

You'd be surprised how many artists found new niches they hadn't thought of by browsing the listings. One greeting card artist read about a company that produces mugs. Inspiration struck. Now this artist has added mugs to her repertoire, along with paper plates, figurines and rubber stamps—all because she browsed the listings for ideas!

Sending out samples

Once you narrow down some target markets, the next step is sending them samples of your work. As you create your samples and submission packets, be aware that your package or postcard has to look professional. It must be up to the standards art directors and gallery dealers expect. There are examples throughout this book of some great samples sent out by other artists. Make sure your samples rise to that standard of professionalism.

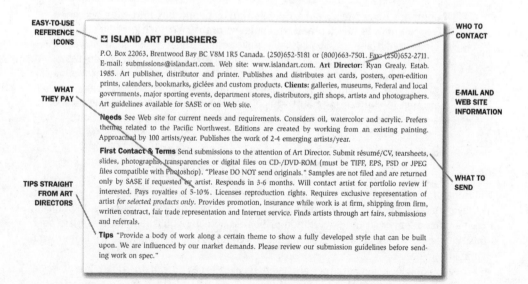

EASY-TO-USE
REFERENCE
ICONS

WHAT
THEY PAY

TIPS STRAIGHT
FROM ART
DIRECTORS

WHO TO
CONTACT

E-MAIL AND
WEB SITE
INFORMATION

WHAT TO
SEND

▣ ISLAND ART PUBLISHERS

P.O. Box 22063, Brentwood Bay BC V8M 1R5 Canada. (250)652-5181 or (800)663-7501. Fax: (250)652-2711. E-mail: submissions@islandart.com. Web site: www.islandart.com. **Art Director:** Ryan Grealy. Estab. 1985. Art publisher, distributor and printer. Publishes and distributes art cards, posters, open-edition prints, calenders, bookmarks, giclées and custom products. **Clients:** galleries, museums, Federal and local governments, major sporting events, department stores, distributors, gift shops, artists and photographers. Art guidelines available for SASE or on Web site.

Needs See Web site for current needs and requirements. Considers oil, watercolor and acrylic. Prefers themes related to the Pacific Northwest. Editions are created by working from an existing painting. Approached by 100 artists/year. Publishes the work of 2-4 emerging artists/year.

First Contact & Terms Send submissions to the attention of Art Director. Submit résumé/CV, tearsheets, slides, photographs, transparencies or digital files on CD-/DVD-ROM (must be TIFF, EPS, PSD or JPEG files compatible with Photoshop). "Please DO NOT send originals." Samples are not filed and are returned only by SASE if requested by artist. Responds in 3-6 months. Will contact artist for portfolio review if interested. Pays royalties of 5-10%. Licenses reproduction rights. Requires exclusive representation of artist *for selected products only.* Provides promotion, insurance while work is at firm, shipping from firm, written contract, fair trade representation and Internet service. Finds artists through art fairs, submissions and referrals.

Tips "Provide a body of work along a certain theme to show a fully developed style that can be built upon. We are influenced by our market demands. Please review our submission guidelines before sending work on spec."

See you next year

Use this book for one year. Highlight listings, make notes in the margins, fill it with Post-it notes. In November of 2009, our next edition—the *2010 Artist's & Graphic Designer's Market*—starts arriving in bookstores. By then, we'll have collected hundreds of new listings and changes in contact information. It is a career investment to buy the new edition every year. (And it's deductible! See page 13 for information on tax deductions.)

Join a professional organization

Artists who have the most success using this book are those who take the time to read the articles to learn about the bigger picture. In our interviews and Insider Reports, you'll learn what has worked for other artists and what kind of work impresses art directors and gallery dealers.

You'll find out how joining professional organizations such as the Graphic Artists Guild (www.gag.org) or the Society of Illustrators (www.societyillustrators.org) can jump start your career. You'll find out the importance of reading trade magazines such as *HOW* (www.howdesign.com), *PRINT* (www.printmag.com) and *Greetings etc.* (www.greetingsmagazine.com) to learn more about the industries you hope to approach. You'll learn about trade shows, art reps, shipping, billing, working with vendors, networking, self-promotion and hundreds of other details it would take years to find out about on your own. Perhaps most importantly, you'll read about how successful artists overcame rejection through persistence.

Hang in there!

Being professional doesn't happen overnight. It's a gradual process. It may take two or three years to gain enough information and experience to be a true professional in your field. So if you really want to be a professional artist, hang in there. Before long, you'll feel that heady feeling that comes from selling your work or seeing your illustrations on greeting cards or in magazines. If you really want it and you're willing to work for it, it *will* happen.

Complaint Procedure

Important

If you feel you have not been treated fairly by a company listed in *Artist's & Graphic Designer's Market*, we advise you to take the following steps:

- First, try to contact the company. Sometimes one e-mail or letter can quickly clear up the matter.

- Document all your correspondence with the company. If you write to us with a complaint, provide the details of your submission, the date of your first contact with the company, and the nature of your subsequent correspondence.

- We will enter your complaint into our files.

- The number and severity of complaints will be considered in our decision whether to delete the listing from the next edition.

- We reserve the right to not list any company for any reason.

How to Stay on Track and Get Paid

As you launch your artistic career, be aware that you are actually starting a small business. It is crucial that you keep track of the details, or your business will not last very long. The most important rule of all is to find a system to keep your business organized and stick with it.

YOUR DAILY RECORD-KEEPING SYSTEM

Every artist needs to keep a daily record of art-making and marketing activities. Before you do anything else, visit an office supply store and pick out the items listed below (or your own variations of these items). Keep it simple so you can remember your system and use it on automatic pilot whenever you make a business transaction.

What you'll need:

- A packet of colorful file folders or a basic Personal Information Manager on your computer or Palm Pilot.
- A notebook or legal pads to serve as a log or journal to keep track of your daily art-making and art marketing activities.
- A small pocket notebook to keep in your car to track mileage and gas expenses.

How to start your system

- Designate a permanent location in your studio or home office for two file folders and your notebook.
- Label one red file folder "Expenses."
- Label one green file folder "Income."
- Write in your daily log book each and every day.

Every time you purchase anything for your business, such as envelopes or art supplies, place the receipt in your red Expenses folder. When you receive payment for an assignment or painting, photocopy the check or place the receipt in your green Income folder.

Keep track of assignments

Whether you're an illustrator or fine artist, you should devise a system for keeping track of assignments and artworks. Most illustrators assign a job number to each assignment they receive and create a file folder for each job. Some arrange these folders by client name; others keep them in numerical order. The important thing is to keep all correspondence for each assignment in a spot where you can easily find it.

Pricing illustration and design

One of the hardest things to master is what to charge for your work. It's difficult to make blanket statements on this topic. Every slice of the market is somewhat different. Nevertheless, there is one recurring pattern: Hourly rates are generally only paid to designers working in house on a client's equipment. Freelance illustrators working out of their own studios are almost always paid a flat fee or an advance against royalties.

If you don't know what to charge, begin by devising an hourly rate, taking into consider-

Pricing Your Fine Art

Tips

There are no hard-and-fast rules for pricing your fine artwork. Most artists and galleries base prices on market value—what the buying public is currently paying for similar work. Learn the market value by visiting galleries and checking prices of works similar to yours. When you're starting out, don't compare your prices to established artists but to emerging talent in your region. Consider these factors when determining price:

- **Medium.** Oils and acrylics cost more than watercolors by the same artist. Price paintings higher than drawings.

- **Expense of materials.** Charge more for work done on expensive paper than for work of a similar size on a lesser grade paper.

- **Size.** Though a large work isn't necessarily better than a small one, as a rule of thumb you can charge more for the larger work.

- **Scarcity.** Charge more for one-of-a-kind works like paintings and drawings, than for limited editions such as lithographs and woodcuts.

- **Status of artist.** Established artists can charge more than lesser-known artists.

- **Status of gallery.** Prestigious galleries can charge higher prices.

- **Region.** Works usually sell for more in larger cities like New York and Chicago.

- **Gallery commission.** The gallery will charge from 30 to 50 percent commission. Your cut must cover the cost of materials, studio space, taxes and perhaps shipping and insurance, and enough extra to make a profit. If materials for a painting cost $25, matting and framing cost $37, and you spent five hours working on it, make sure you get at least the cost of material and labor back before the gallery takes its share. Once you set your price, stick to the same price structure wherever you show your work. A $500 painting by you should cost $500 whether it is bought in a gallery or directly from you. To do otherwise is not fair to the gallery and devalues your work.

As you establish a reputation, begin to raise your prices—but do so cautiously. Each time you graduate to a new price level, it will be that much harder to revert to former prices.

ation the cost of materials and overhead as well as what you think your time is worth. If you're a designer, determine what the average salary would be for a full-time employee doing the same job. Then estimate how many hours the job will take and quote a flat fee based on these calculations.

There is a distinct difference between giving the client a job estimate and a job quote. An estimate is a ballpark figure of what the job will cost but is subject to change. A quote is a set fee which, once agreed upon, is pretty much carved in stone. Make sure the client under-stands which you are negotiating. Estimates are often used as a preliminary step in itemizing costs for a combination of design services such as concepting, typesetting and printing. Flat quotes are generally used by illustrators, as there are fewer factors involved in arriving at fees.

For recommended fees for different services, refer to the *Graphic Artists Guild's Handbook of Pricing & Ethical Guidelines* (www.gag.org). Many artists' organizations have standard pay rates listed on their Web sites.

As you set fees, certain stipulations call for higher rates. Consider these bargaining points:

- **Usage (rights).** The more rights purchased, the more you can charge. For example, if the client asks for a "buyout" (to buy all rights), you can charge more, because by relinquishing all rights to future use of your work, you will be losing out on resale potential.
- **Turnaround time.** If you are asked to turn the job around quickly, charge more.
- **Budget.** Don't be afraid to ask about a project's budget before offering a quote. You won't want to charge $500 for a print ad illustration if the ad agency has a budget of $40,000 for that ad. If the budget is that big, ask for higher payment.
- **Reputation.** The more well known you are, the more you can charge. As you become established, periodically raise your rates (in small steps) and see what happens.

What goes in a contract?

Contracts are simply business tools used to make sure everyone agrees on the terms of a project. Ask for one any time you enter into a business agreement. Be sure to arrange for the specifics in writing or provide your own. A letter stating the terms of agreement signed by both parties can serve as an informal contract. Several excellent books, such as *Legal Guide for the Visual Artist* and *Business and Legal Forms for Illustrators*, both by Tad Crawford (Allworth Press), contain negotiation checklists and tear-out forms, and provide sample contracts you can copy. The sample contracts in these books cover practically any situation you might encounter.

The items specified in your contract will vary according to the market you're dealing with and the complexity of the project. Nevertheless, here are some basic points you'll want to cover:

Commercial contracts
- **A description of the service(s) you're providing.**
- **Deadlines for finished work.**
- **Rights sold.**
- **Your fee.** Hourly rate, flat fee or royalty.
- **Kill fee.** Compensatory payment received by you if the project is cancelled.
- **Changes fees.** Penalty fees to be paid by the client for last-minute changes.
- **Advances.** Any funds paid to you before you begin working on the project.
- **Payment schedule.** When and how often you will be paid for the assignment.
- **Statement regarding return of original art.** Unless you're doing work for hire, your artwork should always be returned to you.

Gallery contracts
- **Terms of acquisition or representation.** Will the work be handled on consignment? What is the gallery's commission?
- **Nature of the show(s).** Will the work be exhibited in group or solo shows or both?
- **Timeframes.** If a work is sold, when will you be paid? At what point will the gallery return unsold works to you? When will the contract cease to be in effect?
- **Promotion.** Who will coordinate and pay for promotion? What does promotion entail? Who pays for printing and mailing of invitations? If costs are shared, what is the breakdown?
- **Insurance.** Will the gallery insure the work while it is being exhibited and/or while it is being shipped to or from the gallery?
- **Shipping.** Who will pay for shipping costs to and from the gallery?
- **Geographic restrictions.** If you sign with this gallery, will you relinquish the rights to show your work elsewhere in a specified area? If so, what are the boundaries of this area?

How to send invoices

If you're a designer or illustrator, you will be responsible for sending invoices for your services. Clients generally will not issue checks without them, so mail or fax an invoice as soon as you've completed the assignment. Illustrators are generally paid in full either upon receipt of illustration or on publication. Most graphic designers arrange to be paid in thirds, billing the first third before starting the project, the second after the client approves the initial roughs, and the third upon completion of the project.

Standard invoice forms allow you to itemize your services. The more you spell out the charges, the easier it will be for your clients to understand what they're paying for. Most freelancers charge extra for changes made after approval of the initial layout. Keep a separate form for change orders and attach it to your invoice.

If you're an illustrator, your invoice can be much simpler, as you'll generally be charging a flat fee. It's helpful, in determining your quoted fee, to itemize charges according to time, materials and expenses. (The client need not see this itemization; it is for your own purposes.)

Most businesses require your social security number or tax ID number before they can cut a check, so include this information in your bill. Be sure to put a due date on each invoice; include the phrase "payable within 30 days" (or other preferred time frame) directly on your invoice. Most freelancers ask for payment within 10-30 days.

Sample invoices are featured in *Business and Legal Forms for Illustrators* and *Business and Legal Forms for Graphic Designers*, both by Tad Crawford (Allworth Press).

If you're working with a gallery, you will not need to send invoices. The gallery should send you a check each time one of your pieces is sold (generally within 30 days). To ensure that you are paid in a timely manner, call the gallery periodically to touch base. Let the director or business manager know that you are keeping an eye on your work. When selling work independently of a gallery, give receipts to buyers and keep copies for your records.

Take advantage of tax deductions

You have the right to deduct legitimate business expenses from your taxable income. Art supplies, studio rent, printing costs and other business expenses are deductible against your gross art-related income. It is imperative to seek the help of an accountant or tax preparation service in filing your return. In the event your deductions exceed profits, the loss will lower your taxable income from other sources.

To guard against taxpayers fraudulently claiming hobby expenses as business losses, the IRS requires taxpayers to demonstrate a "profit motive." As a general rule, you must show

Can I Deduct My Home Studio?

Important

If you freelance fulltime from your home and devote a separate area to your business, you may qualify for a home office deduction. If eligible, you can deduct a percentage of your rent or mortgage as well as utilities and expenses like office supplies and business-related telephone calls.

The IRS does not allow deductions if the space is used for purposes other than business. A studio or office in your home must meet three criteria:

- The space must be used exclusively for your business.

- The space must be used regularly as a place of business.

- The space must be your principle place of business.

The IRS might question a home office deduction if you are employed full time elsewhere and freelance from home. If you do claim a home office, the area must be clearly divided from your living area. A desk in your bedroom will not qualify. To figure out the percentage of your home used for business, divide the total square footage of your home by the total square footage of your office. This will give you a percentage to work with when figuring deductions. If the home office is 10% of the square footage of your home, deduct 10% of expenses such as rent, heat and air conditioning.

The total home office deduction cannot exceed the gross income you derive from its business use. You cannot take a net business loss resulting from a home office deduction. Your business must be profitable three out of five years; otherwise, you will be classified as a hobbyist and will not be entitled to this deduction.

Consult a tax advisor before attempting to take this deduction, as its interpretations frequently change.

For additional information, refer to IRS Publication 587, Business Use of Your Home, which can be downloaded at www.irs.gov or ordered by calling (800)829-3676.

a profit for three out of five years to retain a business status. If you are audited, the burden of proof will be on you to validate your work as a business and not a hobby.

The nine criteria the IRS uses to distinguish a business from a hobby are:

- the manner in which you conduct your business
- expertise
- amount of time and effort put into your work
- expectation of future profits
- success in similar ventures
- history of profit and losses
- amount of occasional profits
- financial status
- element of personal pleasure or recreation

If the IRS rules that you paint for pure enjoyment rather than profit, they will consider you a hobbyist. Complete and accurate records will demonstrate to the IRS that you take your business seriously.

Even if you are a "hobbyist," you can deduct expenses such as supplies on a Schedule A, but you can only take art-related deductions equal to art-related income. If you sold two $500 paintings, you can deduct expenses such as art supplies, art books and seminars only up to $1,000. Itemize deductions only if your total itemized deductions exceed your standard deduction. You will not be allowed to deduct a loss from other sources of income.

Figuring deductions

To deduct business expenses, you or your accountant will fill out a 1040 tax form (not 1040EZ) and prepare a Schedule C, which is a separate form used to calculate profit or loss from your business. The income (or loss) from Schedule C is then reported on the 1040 form. In regard to business expenses, the standard deduction does not come into play as it would for a hobbyist. The total of your business expenses need not exceed the standard deduction.

There is a shorter form called Schedule C-EZ for self-employed people in service industries. It can be applicable to illustrators and designers who have receipts of $25,000 or less and deductible expenses of $2,000 or less. Check with your accountant to see if you qualify.

Deductible expenses include advertising costs, brochures, business cards, professional group dues, subscriptions to trade journals and arts magazines, legal and professional services, leased office equipment, office supplies, business travel expenses, etc. Your accountant can give you a list of all 100-percent and 50-percent deductible expenses. Don't forget to deduct the cost of this book!

As a self-employed "sole proprieter," there is no employer regularly taking tax out of your paycheck. Your accountant will help you put money away to meet your tax obligations and may advise you to estimate your tax and file quarterly returns.

Your accountant also will be knowledgeable about another annual tax called the Social Security Self-Employment tax. You must pay this tax if your net freelance income is $400 or more.

The fees of tax professionals are relatively low, and they are deductible. To find a good accountant, ask colleagues for recommendations, look for advertisements in trade publications, or ask your local Small Business Association.

Whenever possible, retain your independent contractor status

Some clients automatically classify freelancers as employees and require them to file Form W-4. If you are placed on employee status, you may be entitled to certain benefits, but a portion of your earnings will be withheld by the client until the end of the tax year and you could forfeit certain deductions. In short, you may end up taking home less than you would if you were classified as an independent contractor.

The IRS uses a list of 20 factors to determine whether a person should be classified as an independent contractor or an employee. This list can be found in IRS Publication 937. Note, however, that your client will be the first to decide how you'll be classified.

Report all income to Uncle Sam

Don't be tempted to sell artwork without reporting it on your income tax. You may think this saves money, but it can do real damage to your career and credibility—even if you are never audited by the IRS. Unless you report your income, the IRS will not categorize you as a professional, and you won't be able to deduct expenses. And don't think you won't get caught if you neglect to report income. If you bill any client in excess of $600, the IRS requires the client to provide you with a Form 1099 at the end of the year. Your client must send one

Business Basics

Important

Most IRS offices have walk-in centers open year-round and offer over 90 free IRS publications to help taxpayers. Some helpful booklets include Publication 334—Tax Guide for Small Business, and Publication 505—Tax Withholding and Estimated Tax. Order by phone at (800)829-3676, or download from the official IRS Web site: www.irs.gov.

If you don't have access to the Internet, the booklet that comes with your tax return forms contains addresses of regional Forms Distribution Centers you can write to for information.

The U.S. Small Business Administration offers seminars and publications to help you launch your business. Check out their extensive Web site at www.sba.gov.

Arts organizations hold many workshops covering business management, often including detailed tax information. Inquire at your local arts council, arts organization or university to see if a workshop is scheduled.

The Service Corp of Retired Executives (SCORE) offers free business counseling via e-mail at their Web site: www.score.org.

copy to the IRS and a copy to you to attach to your income tax return. Likewise, if you pay a freelancer over $600, you must issue a 1099 form. This procedure is one way the IRS cuts down on unreported income.

Register with the state sales tax department

Most states require a two to seven percent sales tax on artwork you sell directly from your studio or at art fairs, or on work created for a client. You must register with the state sales tax department, which will issue you a sales permit or a resale number and send you appropriate forms and instructions for collecting the tax. Getting a sales permit usually involves filling out a form and paying a small fee. Reporting sales tax is a relatively simple procedure. Record all sales taxes on invoices and in your sales journal. Every three months, total the taxes collected and send it to the state sales tax department.

In most states, if you sell to a customer outside of your sales tax area, you do not have to collect sales tax. However, this may not hold true for your state. You may also need a business license or permit. Call your state tax office to find out what is required.

Save money on art supplies

As long as you have the above sales permit number, you can buy art supplies without paying sales tax. You will probably have to fill out a tax-exempt form with your permit number at the sales desk where you buy materials. The reason you do not have to pay sales tax on art supplies is that sales tax is only charged on the final product. However, you must then add the cost of materials into the cost of your finished painting or the final artwork for your client. Keep all receipts in case of a tax audit. If the state discovers that you have not collected sales tax, you will be liable for tax and penalties.

If you sell all your work through galleries, they will charge sales tax, but you still need a sales permit number to get a tax exemption on supplies.

Some states claim ''creativity'' is a non-taxable service, while others view it as a product

and therefore taxable. Be certain you understand the sales tax laws to avoid being held liable for uncollected money at tax time. Contact your state auditor for sales tax information.

Save money on postage

When you send out postcard samples or invitations to openings, you can save big bucks by mailing in bulk. Fine artists should send submissions via first class mail for quicker service and better handling. Package flat work between heavy cardboard or foam core, or roll it in a cardboard tube. Include your business card or a label with your name and address on the outside of the packaging material in case the outer wrapper becomes separated from the inner packing in transit.

Protect larger works—particularly those that are matted or framed—with a strong outer surface, such as laminated cardboard, masonite or light plywood. Wrap the work in polyfoam, heavy cloth or bubble wrap, and cushion it against the outer container with spacers to keep it from moving. Whenever possible, ship work before it is glassed. If the glass breaks en route, it may destroy your original image. If shipping large framed work, contact a museum in your area for more suggestions on packaging.

The U.S. Postal Service will not automatically insure your work, but you can purchase up to $600 worth of coverage. Artworks exceeding this value should be sent by registered mail. Certified packages travel a little slower but are easier to track.

Consider special services offered by the post office, such as Priority Mail, Express Mail Next Day Service and Special Delivery. For overnight delivery, check to see which air freight services are available in your area. Federal Express automatically insures packages for $100 and will ship art valued up to $500. Their 24-hour computer tracking system enables you to locate your package at any time.

The United Parcel Service automatically insures work for $100, but you can purchase additional insurance for work valued as high as $25,000 for items shipped by air (there is no limit for items sent on the ground). UPS cannot guarantee arrival dates but will track lost packages. It also offers Two-Day Blue Label Air Service within the U.S. and Next Day Service in specific zip code zones.

Before sending any original work, make sure you have a copy (photocopy, slide or transparency) in your files. Always make a quick address check by phone before putting your package in the mail.

Send us your business tips

If you've used a business strategy we haven't covered, please write to *Artist's & Graphic Designer's Market*, 4700 East Galbraith Road, Cincinnati OH 45236, or e-mail us at artdesign@ fwpubs.com. We may feature you and your work in a future edition.

Copyright Basics

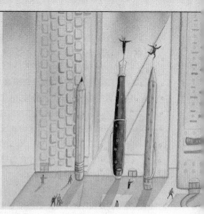

As creator of your artwork, you have certain inherent rights over your work and can control how each one of your works is used, until you sell your rights to someone else. The legal term for these rights is called **copyright**. Technically, any original artwork you produce is automatically copyrighted as soon as you put it in tangible form.

To be automatically copyrighted, your artwork must fall within these guidelines:

- **It must be your *original* creation.** It cannot be a *copy* of somebody else's work.
- **It must be "pictorial, graphic, or sculptural."** Utilitarian objects, such as lamps or toasters, are not covered, although you can copyright an illustration featured on a lamp or toaster.
- **It must be fixed in "any tangible medium, now known or later developed."** Your work, or at least a representation of a planned work, must be created in or on a medium you can see or touch, such as paper, canvas, clay, a sketch pad or even a Web site. It can't just be an idea in your head. An idea cannot be copyrighted.

Copyright lasts for your lifetime plus seventy years

Copyright is *exclusive*. When you create a work, the rights automatically belong to you and nobody else but you until those rights are sold to someone else.

Works of art created on or after January 1978 are protected for your lifetime plus 70 years.

The artist's bundle of rights

One of the most important things you need to know about copyright is that it is not just a *singular* right. It is a *bundle* of rights you enjoy as creator of your artwork:

- **Reproduction right.** You have the right to make copies of the original work.
- **Modification right.** You have the right to create derivative works based on the original work.
- **Distribution rights.** You have the right to sell, rent or lease copies of your work.
- **Public performance right.** You have the right to play, recite or otherwise perform a work. (This right is more applicable to written or musical art forms than to visual art.)
- **Public display right.** You have the right to display your work in a public place.

This bundle of rights can be divided up in a number of ways, so that you can sell all or part of any of those exclusive rights to one or more parties. The system of selling parts of your copyright bundle is sometimes referred to as **divisible copyright**. Just as a land owner can divide up his property and sell it to many different people, the artist can divide up his rights to an artwork and sell portions of those rights to different buyers.

Divisible copyright: Divide and conquer

Why is divisible copyright so important? Because dividing up your bundle and selling parts of it to different buyers will help you get the most payment for each of your artworks. For any one of your artworks, you can sell your entire bundle of rights at one time (not advisable!) or divide each bundle pertaining to that work into smaller portions and make more money as a result. You can grant one party the right to use your work on a greeting card and sell another party the right to print that same work on T-shirts.

Clients tend to use legal jargon to specify the rights they want to buy. The terms below are commonly used in contracts to indicate portions of your bundle of rights. Some terms are vague or general, such as "all rights;" others are more specific, such as "first North American rights." Make sure you know what each term means before signing a contract.

Divisible copyright terms

- **One-time rights.** Your client buys the right to use or publish your artwork or illustration on a one-time basis. One fee is paid for one use. Most magazine and bookcover assignments fall under this category.
- **First rights.** This is almost the same as one-time rights, except that the buyer is also paying for the privilege of being the first to use your image. He may use it only once unless the other rights are negotiated.

 Sometimes first rights can be further broken down geographically. The buyer might ask to buy **first North American rights**, meaning he would have the right to be the first to publish the work in North America.
- **Exclusive rights.** This guarantees the buyer's exclusive right to use the artwork in his particular market or for a particular product. Exclusive rights are frequently negotiated by greeting card and gift companies. One company might purchase the exclusive right to use your work as a greeting card, leaving you free to sell the exclusive rights to produce the image on a mug to another company.
- **Promotional rights.** These rights allow a publisher to use an artwork for promotion of a publication in which the artwork appears. For example, if *The New Yorker* bought promotional rights to your cartoon, they could also use it in a direct mail promotion.
- **Electronic rights.** These rights allow a buyer to place your work on electronic media such as Web sites. Often these rights are requested with print rights.
- **Work for hire.** Under the Copyright Act of 1976, section 101, a "work for hire" is defined as "(1) a work prepared by an employee within the scope of his or her employment; or (2) a work specially ordered or commissioned for use as a contribution to a collective work, as part of a motion picture or other audiovisual work . . . if the parties expressly agree in a written instrument signed by them that the work shall be considered a work made for hire." When the agreement is "work for hire," you surrender all rights to the image and can never resell that particular image again. If you agree to the terms, make sure the money you receive makes it well worth the arrangement.
- **All rights.** Again, be aware that this phrase means you will relinquish your entire copyright to a specific artwork. Before agreeing to the terms, make sure this is an arrangement you can live with. At the very least, arrange for the contract to expire after a specified date. Terms for all rights—including time period for usage and compensation—should be confirmed in a written agreement with the client.

Since, legally, your artwork is your property, when you create an illustration for a magazine you are, in effect, temporarily "leasing" your work to the client for publication. Chances are you'll never hear an art director ask to lease or license your illustration, and he may not

even realize he is leasing, not buying, your work. But most art directors know that once the magazine is published, the art director has no further claims to your work and the rights revert back to you. If the art director wants to use your work a second or third time, he must ask permission and negotiate with you to determine any additional fees you want to charge. You are free to take that same artwork and sell it to another buyer.

However, if the art director buys "all rights," you cannot legally offer that same image to another client. If you agree to create the artwork as "work for hire," you relinquish your rights entirely.

What licensing agents know

The practice of leasing parts or groups of an artist's bundle of rights is often referred to as **"licensing,"** because (legally) the artist is granting someone a "license" to use his work for a limited time for a specific reason. As licensing agents have come to realize, it is the exclusivity of the rights and the ability to divide and sell them that make them valuable. Knowing exactly what rights you own, which you can sell, and in what combinations, will help you negotiate with your clients.

Don't sell conflicting rights to different clients

You also have to make sure the rights you sell to one client don't conflict with any of the rights sold to other clients. For example, you can't sell the exclusive right to use your image on greeting cards to two separate greeting card companies. You *can* sell the exclusive greeting card rights to one card company and the exclusive rights to use your artwork on mugs to a separate gift company. You should always get such agreements in writing and let both companies know your work will appear on other products.

When to use the Copyright © and credit lines

A copyright notice consists of the word "Copyright" or its symbol ©, the year the work was created or first published, and the full name of the copyright owner. It should be placed where it can easily be seen, on the front or back of an illustration or artwork. It's also common to print your copyright notice on slide mounts or onto labels on the back of photographs.

Under today's laws, placing the copyright symbol on your work isn't absolutely necessary to claim copyright infringement and take a plagiarist to court if he steals your work. If you browse through magazines, you will often see the illustrator's name in small print near the illustration, *without* the Copyright ©. This is common practice in the magazine industry. Even though the © is not printed, the illustrator still owns the copyright unless the magazine purchased all rights to the work. Just make sure the art director gives you a credit line near the illustration.

Usually you will not see the artist's name or credit line next to advertisements for products. Advertising agencies often purchase all rights to the work for a specified time. They usually pay the artist generously for this privilege and spell out the terms clearly in the artist's contract.

How to register a copyright

To register your work with the U.S. Copyright Office, call the Copyright Form Hotline at (202) 707-9100 and ask for package 115 and circulars 40 and 40A. Cartoonists should ask for package 111 and circular 44. You can also write to the Copyright Office, Library of Congress, 101 Independence Ave. SE, Washington DC 20559, Attn: Information Publications, Section LM0455.

Whether you call or write, they will send you a package containing Form VA (for visual artists). You can also download forms from the Copyright Office Web site at www.copyright.gov.

You can register an entire collection of your work rather than one work at a time. That way you will only have to pay one fee for an unlimited number of works. For example, if you have created a hundred works between 2006 and 2008, you can send a copyright form to register "the collected works of Jane Smith, 2006-2008." But you will have to send either slides or photocopies of each of those works.

Why register?

It seems like a lot of time and trouble to send in the paperwork to register copyrights for all your artworks. It may not be necessary or worth it to you to register every artwork you create. After all, a work is copyrighted the moment it's created anyway, right?

The benefits of registering are basically to give you additional clout in case an infringement occurs and you decide to take the offender to court. Without a copyright registration, it probably wouldn't be economically feasible to file suit, because you'd be entitled to only your damages and the infringer's profits, which might not equal the cost of litigating the case. If the works are registered with the U.S. Copyright Office, it will be easier to prove your case and get reimbursed for your court costs.

Likewise, the big advantage of using the Copyright © also comes when and if you ever have to take an infringer to court. Since the Copyright © is the most clear warning to potential plagiarizers, it is easier to collect damages if the © is in plain sight.

Register with the U.S. Copyright Office those works you fear are likely to be plagiarized before or shortly after they have been exhibited or published. That way, if anyone uses your work without permission, you can take action.

Deal swiftly with plagiarists

If you suspect your work has been plagiarized and you have not already registered it with the Copyright Office, register it immediately. You have to wait until it is registered before you can take legal action against the infringer.

Before taking the matter to court, however, your first course of action might be a well-phrased letter from your lawyer telling the offender to "cease and desist" using your work,

Copyright Resources

Important

The U.S. Copyright Web site (www.copyright.gov), the official site of the U.S. Copyright Office, is very helpful and will answer just about any question you can think of. Information is also available by phone at (202) 707-3000. Another great site, called The Copyright Website, is located at http://benedict.com.

A few great books on the subject are *Legal Guide for the Visual Artist* by Tad Crawford (Allworth Press); *The Rights of Authors, Artists, and other Creative People* by Kenneth P. Norwick and Jerry Simon Chasen (Southern Illinois University Press); *Electronic Highway Robbery: An Artist's Guide to Copyrights in the Digital Era* by Mary E. Carter (Peachpit Press); and *The Business of Being an Artist* by Daniel Grant (Allworth Press).

because you have a registered copyright. Such a warning (especially if printed on your law-yer's letterhead) is often enough to get the offender to stop using your work.

Don't sell your rights too cheaply

Recently a controversy has been raging about whether or not artists should sell the rights to their works to stock illustration agencies. Many illustrators strongly believe selling rights to stock agencies hurts the illustration profession. They say artists who deal with stock agencies, especially those who sell royalty-free art, are giving up the rights to their work too cheaply.

Another pressing copyright concern is the issue of electronic rights. As technology makes it easier to download images, it is more important than ever for artists to protect their work against infringement.

Log on to www.theispot.com and discuss copyright issues with your fellow artists. Join organizations that crusade for artists' rights, such as the Graphic Artists Guild (www.gag.org) or The American Institute of Graphic Arts (www.aiga.org). Volunteer Lawyers for the Arts (www.vlany.org) is a national network of lawyers who volunteer free legal services to artists who can't afford legal advice. A quick search of the Web will help you locate a branch in your state. Most branches offer workshops and consultations.

Promoting Your Work

So you're ready to launch your freelance art or gallery career. How do you let people know about your talent? One way is by introducing yourself to them by sending promotional samples. Samples are your most important sales tool, so put a lot of thought into what you send. Your ultimate success depends largely on the impression they make.

We divided this article into three sections, so whether you're a fine artist, illustrator or designer, check the appropriate heading for guidelines. Read individual listings and section introductions thoroughly for more specific instructions.

As you read the listings, you'll see the term SASE, short for self-addressed, stamped envelope. Enclose a SASE with your submissions if you want your material returned. If you send postcards or tearsheets, no return envelope is necessary. Many art directors want only nonreturnable samples, because they are too busy to return materials, even with SASEs. So read listings carefully and save stamps.

ILLUSTRATORS AND CARTOONISTS

You will have several choices when submitting to magazines, book publishers and other illustration and cartoon markets. Many freelancers send a cover letter and one or two samples in initial mailings. Others prefer a simple postcard showing their illustrations. Here are a few of your options:

Postcard. Choose one (or more) of your illustrations or cartoons that represent your style, then have the image(s) printed on postcards. Have your name, address, phone number, e-mail and Web site printed on the front of the postcard or in the return address corner. Somewhere on the card should be printed the word "Illustrator" or "Cartoonist." If you use one or two colors, you can keep the cost below $200. Art directors like postcards because they are easy to file or tack on a bulletin board. If the art director likes what she sees, she can always call you for more samples.

Promotional sheet. If you want to show more of your work, you can opt for an $8\frac{1}{2} \times 11$ color or black and white photocopy of your work. No matter what size sample you send, never fold the page. It is more professional to send flat sheets, in a 9×12 envelope, along with a typed query letter, preferably on your own professional stationery.

Tearsheets. After you complete assignments, acquire copies of any printed pages on which your illustrations appear. Tearsheets impress art directors because they are proof that you are experienced and have met deadlines on previous projects.

Photographs. Some illustrators have been successful sending photographs, but printed or photocopied samples are preferred by most art directors. It is not practical or effective to send slides.

Query or cover letter. A query letter is a nice way to introduce yourself to an art director for the first time. One or two paragraphs stating your desire and availability for freelance work is all you need. Include your phone number and e-mail address.

E-mail submissions. E-mail is another great way to introduce your work to potential clients. When sending e-mails, provide a link to your Web site or JPEGs of your best work.

DESIGNERS AND COMPUTER ARTISTS

Plan and create your submission package as if it were a paying assignment from a client. Your submission piece should show your skill as a designer. Include one or both of the following:

Cover letter. This is your opportunity to show you can design a beautiful, simple logo or letterhead for your own business card, stationery and envelopes. Have these all-important pieces printed on excellent-quality bond paper. Then write a simple cover letter stating your experience and skills.

Sample. Your sample can be a copy of an assignment you've completed for another client, or a clever self-promotional piece. Design a great piece to show off your capabilities. For ideas and inspiration, browse through *Designers' Self-Promotion: How Designers and Design Companies Attract Attention to Themselves*, edited by Roger Walton (HBI).

Stand out from the crowd

You may have only a few seconds to grab art directors' attention as they make their way through the "slush pile" (an industry term for unsolicited submissions). Make yourself stand out in simple, effective ways:

Tie in your cover letter with your sample. When sending an initial mailing to a potential client, include a cover letter of introduction with your sample. Type it on a great-looking letterhead of your own design. Make your sample tie in with your cover letter by repeating a design element from your sample onto your letterhead. List some of your past clients within your letter.

Send artful invoices. After you complete assignments, a well-designed invoice (with one of your illustrations or designs strategically placed on it, of course) will make you look professional and help art directors remember you—and hopefully, think of you for another assignment.

Print and Mail Through the USPS

Tip

If you're looking for a convenient, timesaving and versatile service for printing and mailing promotional postcards, consider the U.S. Postal Service. USPS offers a postcard service through their Web site (www.usps.com). You can have promotional postcards printed on 4×6 or 6×9 glossy cardstock and buy as many or as little as you need.

One drawback of going through the USPS is that you can't order a certain amount of postcards to keep on hand—cards must be addressed through the Web site and are mailed out for you automatically. But you can essentially create a personal database and simply click on an address and mail a promo card whenever needed. You can upload different images to the site and create postcards that are geared to specific companies. (When you visit the site, click on "Send Cards, Letters & Flyers" in the Mailing Tools box.)

Follow up with seasonal promotions. Many illustrators regularly send out holiday-themed promo cards. Holiday promotions build relationships while reminding past and potential clients of your services. It's a good idea to get out your calendar at the beginning of each year and plan some special promos for the year's holidays.

Are portfolios necessary?

You do not need to send a portfolio when you first contact a market. But after buyers see your samples they may want to see more, so have a portfolio ready to show.

Many successful illustrators started their careers by making appointments to show their portfolios. But it is often enough for art directors to see your samples.

Some markets in this book have drop-off policies, accepting portfolios one or two days a week. You will not be present for the review and can pick up the work a few days later, after they've had a chance to look at it. Since things can get lost, include only duplicates that can be insured at a reasonable cost. Only show originals when you can be present for the review. Label your portfolio with your name, address and phone number.

Portfolio pointers

The overall appearance of your portfolio affects your professional presentation. It need not be made of high-grade leather to leave a good impression. Neatness and careful organization are essential whether you're using a three-ring binder or a leather case. The most popular portfolios are simulated leather with puncture-proof sides that allow the inclusion of loose samples. Choose a size that can be handled easily. Avoid the large, "student-size" books, which are too big to fit easily on an art director's desk. Most artists choose 11×14 or 18×24. If you're a fine artist and your work is too large for a portfolio, bring slides of your work and a few small samples.

- **Don't include everything you've done in your portfolio.** Select only your best work, and choose pieces relevant to the company you are approaching. If you're showing your book to an ad agency, for example, don't include greeting card illustrations.
- **Show progressives.** In reviewing portfolios, art directors look for consistency of style and skill. They sometimes like to see work in different stages (roughs, comps and finished pieces) to examine the progression of ideas and how you handle certain problems.
- **Your work should speak for itself.** It's best to keep explanations to a minimum and be available for questions if asked. Prepare for the review by taking along notes on each piece. If the buyer asks a question, take the opportunity to talk a little bit about the piece in question. Mention the budget, time frame and any problems you faced and solved. If you're a fine artist, talk about how the piece fits into the evolution of a concept and how it relates to other pieces you've shown.
- **Leave a business card.** Don't ever walk out of a portfolio review without leaving the buyer a sample to remember you by. A few weeks after your review, follow up by sending a small promo postcard or other sample as a reminder.

GUIDELINES FOR FINE ARTISTS

Send a 9×12 envelope containing whatever materials galleries request in their submission guidelines. Usually that means a query letter, slides and résumé, but check each listing for specifics. Some galleries like to see more. Here's an overview of the various components you can include:

- **Slides.** Send 8-12 slides of similar work in a plastic slide sleeve (available at art supply stores). To protect slides from being damaged, insert slide sheets between two pieces

of cardboard. Ideally, slides should be taken by a professional photographer, but if you must take your own slides, refer to *The Quick & Easy Guide to Photographing Your Artwork* by Roger Saddington (North Light Books) or *Photographing Your Artwork* by Russell Hart and Nan Star (Amherst Media). Label each slide with your name, the title of the work, media and dimensions of the work, and an arrow indicating the top of the slide. Include a list of titles and suggested prices gallery directors can refer to as they review slides. Make sure the list is in the same order as the slides. Type your name, address, phone number, e-mail and Web site at the top of the list. Don't send a variety of unrelated work. Send work that shows one style or direction.

- **Query letter or cover letter.** Type one or two paragraphs expressing your interest in showing at the gallery, and include a date and time when you will follow up.
- **Résumé or bio.** Your résumé should concentrate on your art-related experience. List any shows your work has been included in, with dates. A bio is a paragraph describing where you were born, your education, the work you do and where you have shown in the past.
- **Artist's statement.** Some galleries require a short statement about your work and the themes you're exploring. Your statement should show you have a sense of vision. It should also explain what you hope to convey in your work.
- **Portfolios.** Gallery directors sometimes ask to see your portfolio, but they can usually judge from your slides whether your work would be appropriate for their galleries. Never visit a gallery to show your portfolio without first setting up an appointment.
- **SASE.** If you need material returned to you, don't forget to include a SASE.

The Etiquette of E-mail Promotions

by Robert Pizzo

Are you looking for cheap "enhancement" meds in your inbox? Maybe a phony degree from a prestigious college? How about a can't-miss scheme to collect millions from the government of Nigeria? I didn't think so.

If you're anything like me, you find this common e-mail spam a daily annoyance. It's something we dismiss out of hand like the latest Britney news while we sort out the more important correspondence. As artists with something to promote to art buyers, we never want to end up in that irritating category. But what are the rules governing e-mail promotions? What's the etiquette here? I'm reasonably sure Amy Vanderbilt never wrote a book on the subject so I think we have to tread carefully lest we wind up annoying the very people we want to work with.

Why am I taking a crack at what the proper manners are regarding e-mail promos—a guy who still doesn't know (or care) what side of his dinner plate the fork should reside on? Well, I've been dabbling in what is relatively new territory for all of us with success. I've learned a few lessons along the way. And other artists ask me about my e-mail promos quite frequently.

I had always been pretty good about promoting my illustration work at regular intervals throughout the year, but sometime ago, I was faced with the reality that some of the traditional methods were yielding diminishing returns. Ads in the big directories were still costing big money but it seemed like art directors were recruiting mostly from their computers. Plus, in this instant electronic age, it felt like a lifetime waiting up to a year for a directory to be published. By the time it came out, the pieces I had chosen to represent my current work weren't even my favorites anymore.

I started making what I call "Instant Custom Promos." These were simple 8.5 × 11 directory style pages, cleanly designed, with my name, phone number, e-mail and Web site, along with space for 3 to 5 images. They were "Instant" because I could drag and drop any one of thousands of my digital images into the promo at any time and "custom" because I could tailor them to specific prospects or clients. If I saw a great looking magazine about finance I could grab a few financial themed illustrations and drop them into the promo, print out one

ROBERT PIZZO is an award-winning illustrator. He has worked with hundreds of top ad agencies, design firms, publications, and corporations all over the nation. His clients have included Citibank, Verizon, Coca-Cola, Mastercard, *Newsweek* and *The Wall Street Journal*. See his work at www.robertpizzo.com because he's "fast, friendly, and reliable without a speck of that flaky-artist stuff." He lives and works from his home studio in the Connecticut countryside.

copy on a nice glossy stock and mail it off to the art director. I even live across the road from our town's post office, so it couldn't be easier. Or could it?

What if instead of printing and mailing I simply fired the promo off to an art director's e-mail address? Easy—but would that be OK? And what if I sent it out to a few art directors,

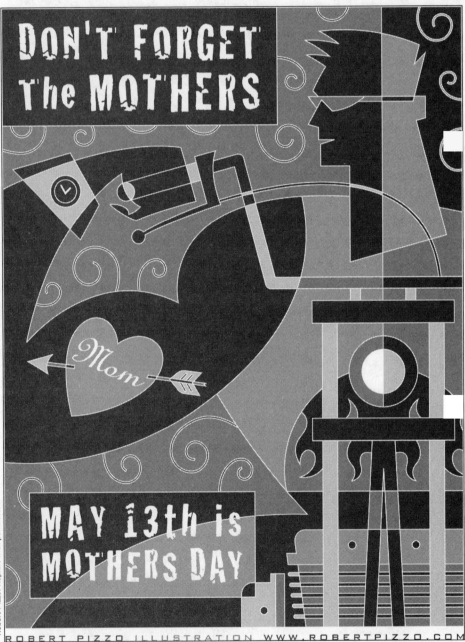

ROBERT PIZZO ILLUSTRATION WWW.ROBERTPIZZO.COM

When creating a Mothers Day-themed promo, Robert Pizzo didn't go with the usual sweet, sentimental imagery. "Out of all the Mother's Day concepts I could think of," he says, "the one that said it best visually was a tattoo."

or a few dozen, or a few hundred? Did that make me a dreaded spammer? Technology made it simple to mass broadcast via e-mail but was it polite to?

I'll never forget a Pre-E-mail Era day way back in the late 1980s. I was in the offices of *Business Week* magazine frantically working on a sketch that would soon have to be approved by editors on the spot while the art director ran to take care of some business in another room. This was right around the time that consumer fax machines were first becoming available to the public. (I would soon get mine own down on the lower east side of Manhattan for the "bargain" price of $1,000 and be able to fax ideas in instead of commuting to the magazine to personally deliver sketches—an amazing breakthrough.) As I was penciling, the art director stormed back into the office looking really ticked off. I asked her what was wrong. She replied, "I am trying to send a letter out but the line is tied up by some illustrator faxing us his unsolicited 30-page portfolio."

Ouch. I didn't want to ever be that guy.

E-mailing current clients

For my first foray into e-mailers, I assembled a custom promo that was generic enough for anyone and sent it to a handful of good steady clients. Since these were all people I had a long, great history with, there was no spam factor to worry about. I took my Illustrator document and "saved a copy" as a PDF—which made for a really small file size, around 100k. A JPEG or GIF would've been fine for screen viewing, but I was gambling that some people might actually want to print the piece so I wanted better quality if that was the case. In the subject line I simply put "Pizzo Promo" and I attached the PDF with a short list of instructions:

Instructions for "Pizzo Promo":

1. Click tiny attachment to view
2. Print
3. Staple to forehead

Finally, I made sure to include my Web site link in the signature.

The reaction I got was pretty good. Most people sent back a simple reply like, "Nice piece" or made some other positive comment. Some said, "It's now hanging above my desk." I immediately learned a little etiquette when one art director said he loved the promo but asked to be blind copied in the future so that others wouldn't see his e-mail address. A few started longer conversations that volleyed back and forth for a couple of days and then even led to assignments.

Naturally, the whole point of the promotion is to get some work, but there's more to it than that. In a business that can be very isolating for an individual toiling away in a remote home studio, e-mail promos are a great way to keep in touch with the good clients you've worked with over the years. It's just a way of strolling down the virtual hallway, gently tapping on their virtual office window and holding up a little virtual example of what you're working on—a "Hey, look at this!" Otherwise, clients tend to only see the art that you're working on for them. "But don't they see all the new pieces you regularly post to your Web site to keep it right up to date?" you ask. Um . . . well, I'm sure they've been meaning to.

These days a lot of people like Roger J. Greiner, art director at Shostak Studios in New York City, prefer getting e-mail to regular mail. "If I like the style I see in the e-mail promo, I will click on the link in the e-mail, and go to the artists' Web site, and at that point, if I really like what I see, I will bookmark their site in the appropriate folder," he says.

I've found that events on the calendar such as "Spring Ahead" or "Fall Behind" are a good excuse to whip up a timely promo. This way they feel fresh and current, like little public service announcements. Mary Zisk, design director of *Strategic Finance* magazine & IMA

Marketing in New Jersey told me: "I like your promos because they celebrate a season and have something clever to say."

So the e-mail verdict for good regular clients is: no problem. I believe this holds true for anyone who's ever given you an assignment more than once. Generally speaking, if they keep coming back to you, it's reasonable to assume they like your work and chances are they'll eagerly look at the promos you send them, even if they're not particularly fans of e-mail promos.

That said, even with good steady clients I wouldn't push it. The art directors I talked to seemed to agree that, like the cable bill, once a month is enough. Roger Greiner adds, "Once a week/fortnight (is) really annoying!!!"

Jane Firor, principal of Jane Firor & Associates, a Washington, D.C. firm specializing in strategic and creative services for magazines, had some unique insight regarding e-mail vs. snail mail. "I prefer the e-mail, perhaps because they come from some of my very favorites, plus a B list and new folks come in every so often. I print the images and stick them on my wall. When the one piece of white tape gives out, they fall down and make room for others. Super selects get two pieces of white tape and stay up longer. Sometimes I print them out and put them in a plastic holder in our co-op's elevator; if they are winners they stay until I replace them and if they are losers they get turned upside down or backwards usually within 12 hours. I don't know what to think about the ones that disappear," she says. Talk about letting the marketplace decide!

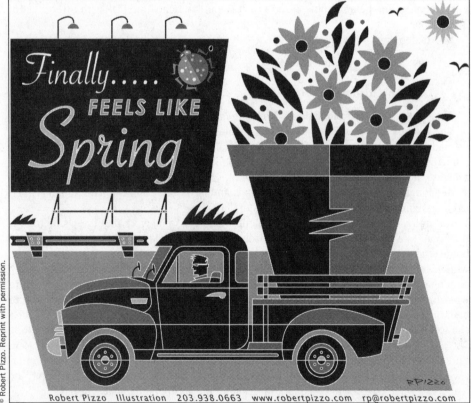

Robert Pizzo Illustration 203.938.0663 www.robertpizzo.com rp@robertpizzo.com

Robert Pizzo created this Ready Set Shop! promo to mail out during the holiday season. "I wanted to do some sort of Christmas theme but sending it out too close to the holiday was bad timing," he says. "The shopping angle allowed me to e-mail this at the beginning of December."

E-mailing potential clients

Now, when it comes to people you'd like to work with, the etiquette shifts a bit. What's the rule for prospects?

I cringe when I think of how, when I first started out, I tried cold calling.

The conversation usually went something like this:

> *Me: Hi, this is (I'm withholding my own name to protect my dignity. No fair peeking at my credit.)*
> *Art director: Uh, yeah. Who can I transfer you to?*
> *Me: Um, I was wondering if you had any assignments for me?*
> *Art director: (click)*
> *Me: Hello? . . . hello? . . . I'm gonna take that as a "no."*

There's no way I'm going down that path again with e-mail, so I came up with a very simple strategy. If there is only one rule to follow this would be it: Be extremely discriminating when collecting e-mails addresses in the first place. Yes, you heard me.

Strict adherence to this guideline will save you embarrassment while ensuring that the target of your promotions can forgo that restraining order on you. All of the art directors I spoke with said it was OK to approach them for the first time via e-mail but you have to be careful not to pester. Remember, these are busy professionals who are subject to a daily bombardment of Inbox inundation. Mary Zisk summed it up: "To be fair, if an illustrator is being too persistent, I ask to be taken off their list."

When it comes to people I'd like to work for, I'll start by checking their Web sites. If I see

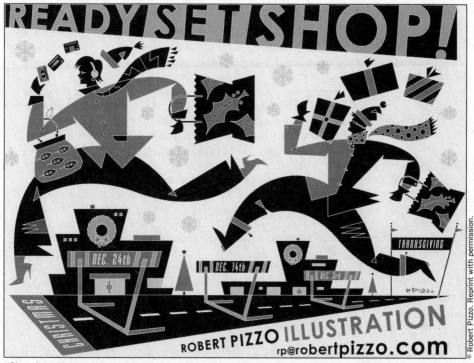

"Since it had been such a cold winter and *very* cold spring, I took advantage of a sudden warm spell to make this timely," says Robert Pizzo of his promo Finally Spring. "I sketched it up and rendered it in half a day. The next morning I e-mailed it out. The weather went right back to being un-Spring-like." (It's this promo, by the way, that got him this article assignment.)

Articles & Interviews

An AD on E-Mail Promos

Michael Aubrecht, associate art director at *Selling Power* magazine in Fredericksburg, Va., talks about his preferences and offers advice for e-mail promotion.

Do you get many e-mail art promos?
Yes, we receive e-mail promotions here at the magazine on a fairly regular basis. At least every day or so they arrive, along with the usual printed samples and postcards. Most are sent from representatives and the more simple and visual they are, the better. I don't have a lot of time to browse through pages of e-mail and the quicker that I can access a portfolio link, the more likely I am to commission someone. It is far too easy to end up in our "spam filter."

Are you getting more e-mail promos now than through regular mail?
Over the last few years, digital promotions have increased. Here at the magazine, our art department has been together in its entirety for close to 10 years. We are a close-knit group and already know our likes and dislikes. We tend to be very loyal to people that consistently produce great work. Those individuals will get the first call. This presents a challenge to "newbies" and their e-mail promos have to stand out in order to get noticed.

Which do you prefer? And do you save them or print them?
The printed materials tend to be filed in our library for future reference, while some e-mail links are added to the "favorites" in our browser. Most are deleted. I don't necessarily have a preference, although I dislike getting the same e-mails over and over. Printed promos often appear to be a waste of money, as we get three separate samples of the same thing. One copy is all we save. E-mails cost nothing.

Do you mind getting approached this way from artists you don't know and have never worked with?
Not at all. We sit at computers everyday, all day, so the technology for receiving digital promos is fine. What I absolutely despise is receiving an e-mail promotion, followed by a follow-up e-mail promotion, followed by a phone call, and voice mail. This always seems to happen on a final proof day. Do that, and I will *never* call you back. Unfortunately, there have been some really good artists that have turned us off by overkill.

Any thoughts on what you like about e-mail promos?
I love the fact that I can easily access the individual's Web site and contact information. I also like the fact that I can refer him/her to a specific piece over the phone. It helps when I can point out a particular style or palette that I like. It makes communicating so much easier and it also saves a tremendous amount of time.

Any thoughts on what you dislike about e-mail promos?
Working in print as I do, it is virtually impossible to reproduce that medium in an electronic format. Regardless of the resolution, monitor, or format of the e-mail promo, it can never be a physical piece that you can 'visualize' as being printed in the magazine. The Internet is a wonderful tool, but it does not translate into the printed page.

Any technical preferences to JPEGs, GIFs, or PDFs?
I like PDFs as that format translates well on both a Mac and PC. In our shop, the art

department uses PCs while the production deptartment has both Macs and PCs. I'm fairly computer savvy, but I dislike having to convert formats, or go to another office to view or share a file. Also, a PDF's color-quality tends to be richer than a JPG or GIF.

As far as frequency, how often would be comfortable?

Once a month (per person) works for me. We sometimes work up to a month in advance on designing the magazine, so I don't look to commission people all the time. If it's good, I'll remember it.

How often would be annoying?

Anything more than that. Think of it this way . . . even if everyone who reps someone sends me a monthly e-mail promotion, they are obviously staggered and that still translates into a daily event. My e-mail box is already filled with client and project information relative to what I'm working on. These e-mail promos are essentially junk mail that clutters it all up. And just like at home, only the really good junk mail gets saved.

that they've listed e-mail addresses along with their names then I'm guessing they'd have to know that someone might get in touch with them via e-mail. That's the reason I've got my e-mail address on my site. Still, the prime directive is always in effect: Never Intentionally Annoy.

I'll very carefully approach an art director I've never worked with this way: First off, for initial contacts, I only send to one at a time so I'm literally never spamming. In the subject line I'll write something like "Got Illos?" to at least let them know this is not junk mail about increasing their, um . . . girth. Then I'll introduce myself as a freelance illustrator in two sentences or less and invite them to see my work by clicking a Web site link or an attached PDF. The PDF will be a one-page custom promo or a mini PDF portfolio (about 20 pages in one document) but in either case the file size will be small, under 1MB. Many art directors echo Jane Firor's wish that things are kept simple. "I don't like it when the attachments open to something huge or something tiny and I have to fiddle with the image," she says.

I hate to break it to you, but after that initial introduction, it's in the hands of the universe. If art directors contact you to say they love your work and would like to use you in the future, that's great. Drop their e-mails into your address book and e-mail them a promo every once in a while. But if they don't contact you to say they'd love to hear from you again, it is of my opinion that you walk away—electronically anyway. Without permission it's (Soup Nazi voice:) No e-mail for you! Back to snail mail for that prospect, my friend.

Have I put forth The Gospel of E-mail Etiquette? Probably not. But I hope that by sharing what I've learned as I've refined the process of e-mail self promotion, I can help you to, via e-mail, successfully reach out to—and never annoy—art directors who are potential clients. If you have any ideas don't hesitate to let me know, especially if you're an art director who'd like to see what it's like to get a few of my promos now and then. I sincerely hope they'll be worthy of two pieces of white tape.

Articles & Interviews

Unconventional Markets for Illustrators

by Holly DeWolf

Creativity involves breaking out of established patterns in order to look at things in a different way," says Edward de Bono. As an illustrator today—if your goal is landing steady assignments that lead to a successful career doing rewarding work—you need to be innovative and creative and look for unconventional markets rather than gravitating to the obvious ones.

While it is great to work for designers and publishers, there are some hidden opportunities that may interest you, and your creative business will benefit from these opportunities. Taking the concept of marketability up a notch will help you grow a successful illustration business. Using any and all experiences and interests to help expand your business will be an asset, and exploring all the markets that can use your illustrations will save you from dry spells in any one of them.

You can get ideas by looking at what other illustrators are doing that is unique. Illustrator Gary Baseman (www.garybaseman.com) has a line of collector vinyl toys. He also creates paintings and sells posters, lunchboxes and T-shirts on his Web site. Keri Smith (www.kerismith.com) describes herself as an illustrator, author and guerilla artist. She has a collection of books that focus on creativity such as *Living Out Loud* and *Wreck This Journal.* Claudine Hellmuth (www.collageartist.com) creates custom artwork that combines photos, paint, paper and pen into fun collages. She also does workshops, has been published, and she has been on *The Martha Stewart Show* as well as *I Want That.*

Another great example is Tony Dusko's (http://tonydusko.com) efforts with creative problem solving through animation. He creates animations for his fifth grade students as a way to teach. It all started with the challenge to get his students ready for lunch. A talking grilled cheese sandwich did the trick. He since created many animations such as "Homework Hero," "Some Facts About Owls," and "How to Take Care of a Pet." His efforts were rewarded for an animation called "What Is a Friend?" which received Best of Festival at the Mobifest Toronto Film Festival in 2007. Dusko saw a need and filled it with a little bit of silliness, funny characters, and a whole lot of creativity. (His animation work is showcased on his site www.notebookbabies.com.)

HOLLY DeWOLF is a hands-on illustrator who loves to create "handmade experiences" in paint. With an eye for detail, whimsy and color, her style works well for children's publishing, greeting cards, packaging, magazines, advertising, corporate, and editorial markets. Outside of illustration, she is an artist, writer and teacher with an upcoming book on the business side of illustration due out in 2009 from HOW Books. She is an avid blogger and lives in picturesque Nova Scotia with her husband and two equally creative daughters.

Being open to possibilities might require getting the right and left sides of your brain mingling so you can make your business creative. It's taking what you're passionate about and combining that with your business skills, which may not travel the traditional route. We all love to get paid for innovation and problem solving and that's possible by looking at what you can offer to various markets, your community or by coming up with your own projects.

As you progress in you career and pursue various markets, your promotional materials should cater to the different markets that interest you. Make your promotions memorable and unique and remember that one promotion will not suit all. If you are targeting a greeting card company, don't send the promotion you did for a skateboard company. They have different needs—address them.

As an illustrator, you need to be realistic about your ability to get work. Clients are not necessarily going to come to you. Instead you need to hustle and look all around to see where our work will be needed. Make research a habit by looking at magazines and books, making cold calls, and searching the Web. Success is never an accident, no matter how easy it appears to be for others—and success as an illustrator doesn't happen overnight.

Remember to focus on what is important to you (not what is important to another illustrator) and don't bother with projects that do not hold your interest. If that means being an illustrator and author, then do that. If you've wanted to have a show with paintings you have been shelving, then make it a goal in the future to get them out there.

Here's a huge tip that will keep you moving forward: Avoid the comparison habit. When looking at other illustrators' work, look at what they are doing and their client list. Draw inspiration from them and enjoy their creations. But keep the focus on yourself and what you need to do. Comparing yourself to other illustrators could make you lose momentum. It could make your creativity come to a screeching halt.

GENERATING INCOME STREAMS

We all could use more income. Who couldn't? Earning more has many benefits, allowing the flexibility to pursue your favorite pastimes, travel, education and most likely an overall better quality of life. By treating your illustration career as an enjoyable task instead of a job, it no longer feels like work. An illustration career, in essence, is living the creative life. Making a good living at it makes it all the sweeter.

There are obvious businesses that need your creative expertise and then there are hidden gems that you may not be focusing on. It's easy to get busy with daily routines and focus on what you always do. But looking around every corner for more publicity is a good career move—consider it a side project. Recognize a need for your work and fill it. The results of this could be more income, variety, creativity, and fans.

Variety is the spice of the creative life. If you don't add some variety from time to time, you could stagnate and get bored by the usual routines. It is hard to feel creative when you are frustrated by projects that do not inspire you. We all want to have work that is exciting instead of taking on any old assignment that comes our way. It's important to nurture your creative spirit daily and a good way to do that is by adding new ideas, concepts and possible new projects to tickle your big innovative brain. Taking on the unusual makes getting through the tedious tasks much easier.

Variety also helps you find a diverse group of admirers of your work, which can in turn create more work for you. Your admirers will be on the lookout for what you are creating by Googling you, reading your blog, and linking to your Web site. They will buy your work, prints and other goodies. They will spread your name around. You could get spotlighted on various sites on the Internet. They could become your very own creative community. What does all of this have to do with unconventional markets? It becomes another avenue to promote yourself to people who would like nothing better than to see you succeed. Your fans

will, in essence, promote you. This is also known as the 80:20 Rule—80% of your business will comes from 20% of your clients and buyers. So you can take a good look at your business, identify where the money is coming from, and focus on that.

UNCONVENTIONAL MARKETS

Being in business as an illustrator means living the experimental life. Targeting unconventional markets is a way of giving future clients what they don't know they need. And, on the flip side, you are creating work for clients that you didn't know needed you.

As you explore alternate markets for your work, however, don't expect that potential clients will immediately understand the business of illustration. A little explanation could go along way. Talking about your illustration career with those who do not understand what illustration is all about is a great way to educate a possible client who may actually benefit from your services.

Here are a few markets for your illustration that you may have not considered.

- **Art galleries.** Many illustrators consider themselves artists as well. There are many benefits from showing in galleries, such as the opportunity to break away a bit from the usual styles of work you do. (See the Galleries section of this book for information about approaching galleries with your illustration.)
- **Unique stationery.** How about play-date invitations for stay-at-home moms or dads? Unique party invitations? Calling cards? These are just a few examples of simple stationery ideas that can be designed with style. These stationery items can be sold at art shops, galleries and gift shops and can be hand done or professionally printed. This could lead to a side business. These items could also sell on your Web site.
- **Postage stamps.** Illustrating stamps would definitely get your work seen. It will be seen all over the world! Visit Stamps.com and Zazzle.com for information on creating custom stamp designs.
- **Selling prints.** There are many online print companies such as ThumbtackPress.com that showcases unique illustrated prints. You can also sell them on your own Web site. (Also see the Posters & Prints section of this book.)
- **T-shirts.** Creating work for T-shirts for online companies like threadless.com could attract attention to you and your work. You can also sell them through your own Web site. (See the interview with Jillian Corron on page 56 for more information about T-shirt design.)
- **Licensing your work.** You can work with a licensing company or an agent and lending your work to things like wallpaper, toys, giftware, games, children's clothing, snowboards, skateboards, fabric, household goods . . . the list goes on. In many cases, illustrators are paid in the royalties or a flat fee. Not a bad gig if you can get it.
- **Architecture firms.** If you like the technical side of illustration, architects may be able to use you for concepts—showing a building, living space or home addition from a different perspective.
- **Interior decorators.** Your work could be used in a children's space or an office that needs unique work. You may be able to sell paintings, prints or paint images or text right on the walls.
- **Universities and colleges.** Institutions of higher education need posters, billboards, banners, brochure illustrations, and Web site illustrations on an ongoing basis.
- **Dance clubs.** Clubs may need posters, postcards or stickers to showcase their unique style, deejays, and groups they are promoting.

- **Pet portraiture.** People take their pets very seriously and many are willing to pay for something a little different than the usual photograph. Pet portraiture could be a great option if you are fond of furry friends.
- **Charities.** If there's a cause you believe in and support, you may be able to contribute work for brochures or auctions, or offer images for their Web site. While this work may often be *pro bono* work, there are rewards. You help an organization that's close to your heart, create new work to include in your portfolio—and may even get noticed by a like-minded art buyer.
- **Calls for submissions.** Always be on the lookout for magazines, book publishers, illustrator showcases, and galleries looking for illustrators to show work. Look for legitimate ones listed on sites such as illustrationmundo.com, drawn.ca and thelittlechimpsociety.com.
- **Web site designers.** Designers can always use colorful banners, moving flash illustrations, link buttons, and little spot illustrations that add visual punch to any Web site. Take note of Web site designers as you surf and contact those whose work you admire to inquire about their needs.
- **Coffee shops.** Many caffeine-fueled businesses like to have creative signs, stationery, and art on the walls. After all, they are not only selling a great cuppa joe but also a great atmosphere.
- **Handmade items.** Online shops such as Etsy.com can help you sell great collectables like prints, T-shirts, toys and other items you love to create.
- **Get published.** Writing and illustrating children's books, writing about a technique, and writing about illustration not only establishes you as an illustrator but it can also open up many doors. (See the Book Publishers section of this book as well as the current edition of *Children's Writer's & Illustrator's Market*.)
- **Teaching.** If you like mentoring, try taking it to the classroom. There are many art institutions that really should teach illustration and don't. Could you create an illustration department at a local art school? Too many illustrators are training themselves but could use classes on creative business. There is a huge need for this and it's worth exploring.
- **Propose an idea.** If you see a business or industry that you feel could use illustrations, throw it out there. You never know what might happen by opening up a business owner's mind to another more visual way of doing things. It could lead to a job or steady gig.
- **Small business.** Many small businesses need promotional stationery such as mailers, business cards and letterhead. They may need a business icon that you could illustrate.
- **Become an illustration advocate.** If you love illustration and want to see it the industry improve, then write about it, talk about it, and blog about it. The industry needs more people promoting it. And doing so will not only get you attention, it will establish you as an expert in your field because as you let people know what you're passionate about. Illustration is important. Spread the word.

When approaching markets for your work, don't be indirect—be straightforward. Talk about what you can do and ask for what you want. You may be very surprised what could happen. In the past year, I got a book deal and designed a class on the business side of creativity. How did this happen? I decided what I wanted to do it then asked for what I wanted. I was determined and prepared. I laid it all out and it worked.

I now see opportunities for myself outside of illustration. The funny thing is that if someone had of told me six years ago that I would be doing all of this today, I would have thought they were crazy. I now apply exploration as part of my career by being open to all possibilities. That is a huge part of what being a successful illustrator is all about.

There is an expression that says a finished person is a boring person. I say never feel finished. Always be on the look out for new challenges. Illustration careers evolve through many actions and strategies. Sometimes a few mistakes can happen along the way—look at them as a part of the process to reach your goals. Visualizing your ideal professional career will help you achieve it. It is possible.

Be sure to cover all your bases. Always be ready to talk about what you do and practice what you want to say—practice will make you better at expressing yourself. You'll be able to rise to the challenge when you're put on the spot. Remember, you just never know whom you will bump into. Chance meetings could lead to more business. Have business cards with you at all times. Your contact information coupled with the ability to describe your work makes a complete and impressive package to potential clients.

As illustrators, we all want to achieve success based on abilities, talent, and effort. We want to get paid for our time and expertise. Constantly being aware of the economic value of your work will help you create the career you want and make the illustration industry stronger. Then you're in business!

Secrets for Successful Outdoor Shows

by Norman E. Thomas

A ndy Warhol once said: "Making money is art and working is art and good business is the best art." Some may differ with this statement, but the fact remains that an artist who consistently sells work and hones his skill is really doing something right.

As a visual artist working with glass and mixed media for the past 38 years, I have spent most of my time creating, exhibiting and selling my art in a number of venues, including outdoor shows. Through the years, I've been surprised by the lack business skills possessed by many artists selling their work at these shows. Imagination will not get you noticed. Art does not sell itself. You must self promote and display your art brilliantly. And you must do some homework.

Before you decide to offer your work at outdoor shows, you must become a good "art detective." Visit the best outdoor shows and venues in your areas. Follow these guidelines as you peruse the booths and observe the vendors—taking notes is highly recommended.

- Ask yourself if you really want to show at the venue, and why.
- Be an art patron at these events. Purchase something within your budget. How were you received? How was the service?
- Study the festival layout and pick the top 10 booths for originality, effectiveness, craftsmanship, and traffic flow. Could these displays handle inclement weather? Are they portable and easy to assemble and dismantle?
- Study the art shown. Ask yourself if your art is good enough for the venue. Or is it above the caliber of the art shown?
- Study the artists in action. How do they present themselves to the public? How is their demeanor? Is their packaging service easy and seamless?
- What kind of portfolio information is available to the public? Collect some sample promo pieces from the best and most outstanding artists.
- Which artists do the most business? Why do you think their work sells so well?

APPLYING TO SHOWS

These days it's fairly easy to keep on top of all the shows and festivals with the click of a mouse. (For a sampling, see the Art Fairs section of this book.) Many shows allow artists to

NORMAN E. THOMAS holds a BA in Jewelry/Metalsmithing and an MA in Glass from California State University, Fullerton. He has been creating glass art and mixed media for 38 years and currently teaches at Clark College in Vancouver, WA and Portland Community College in Portland, OR. His art has been exhibited at the Clinton White House and is currently in an art collection of First Lady Laura Bush. Since 1971 he has produced more than 14,000 art works. His current art can be seen at Guardino Gallery and Fireborne Gallery, both in Portland.

apply online. On the surface, applying for shows online seems like an easy way to become rich doing what you do as an artist. You simply submit your files in seconds and wait for the letters of acceptance to come pouring in.

But there's more to it—it takes quite a bit of thought and detective work when you exhibit your art. You need to know each festival's ground rules. Show directors have protocol and procedures and ultimately the purchasers have their own rules too.

When submitting, always include only your best work—show directors expect this from you. Considering having a third party photograph your work or, better yet, take a photography class at your local college and learn to do it yourself. And be sure to fill out applications completely.

For most shows, applications are screened by jurors who review three to five slides of your work. Whatever you exhibit, it is very important to keep the art in a series or family of works; if you show vessels, show vessels in the same genre. The same applies to painting, glass, and ceramics. Your body of work should look compelling. Use some color psychology when setting up your slides. If your art contains a variety of colors, show the first slide in blue tones, then green, black, yellow, and finish your slide show with a piece in red. This is a powerful color and the jurors may only remember your last piece. Think of your application portfolio as an open book with only five pages of images to woo your audience (in about 30 seconds).

Artwork may be rejected by jurors for a number of reasons. It may contain inappropriate subject material; show too many styles, sizes, disciplines or genre; be commercial, imported, or plagiarized; or use the wrong background in the slide or photo.

RUNNING THE SHOW

Thirty-two years ago, I did my first big wholesale show at Fort Mason in San Francisco with the American Craft Council. My idea of a display was bringing out my furniture with a couple of spider-webbed pool lights. I had no idea about wholesale and retail, but I learned by meeting with professional artists and panelists. Paul Revere, a jeweler from San Francisco, had done the show before and had obviously done his homework. His presentation was outstanding. His jewelry was more beautiful than Tiffany. Revere had a persona and his manner was very diplomatic. His salesmanship was totally convincing. This was the gold standard to follow.

We generally glance at an advertisement in a magazine for a few seconds, but the ad agency's job is to keep us there as long as possible. The longer we are attracted to an advertisement, the greater the chance we will remember the product and then paint a mental picture of that product or service—which will hopefully generate sales.

Your display should look like a successful ad in a magazine. The artwork has to be great, the lighting perfect, and the pedestals clean and proportional to the art. The display materials (the walls and the canopy) should be clean and fresh; the display appropriate to the scale and dimensions of the 2-D art; and the booth/presentation needs to be ready for most weather conditions.

What more can you do? You must really look at your art and determine which pieces work as stand-alone or need to be grouped as a family. Think scale, color, dimensions and texture. With all this in mind, create stories about your art that viewers will remember.

You may feel compelled to exhibit everything you have to offer at a show, thinking it will give you the best chance to catch the eyes of the patrons and will make you seem like a very productive artist. But a film director doesn't include everything he shoots in a movie—he leaves it up to the editor to cut the film, picking the best and most effective scenes. Often less is more, and this certainly applies to your art exhibition. Showing too many disciplines at a show can confuse potential patrons—be sure to edit.

If you lack confidence to personally sell your work, hire a skilled sales person to help man your booth—someone who can tell the world how great your work is.

It may also help to take a class in networking if one is offered at your local college or community center. Networking is a learned skill and an art form in itself. It's all about romancing your public, making it all about them.

MAKE IT IRRESISTIBLE

Art is to be experienced—owned, held, seen, felt, touched, and cherished. Art also may increase in value. Artists can create the need to own their art by breaking down the objections and resistance potential patrons may have. And there are many. From my 38 years of selling art, here are some basic objection solutions to marketing art at outdoor shows/festivals— ways to make art browsers art buyers.

- **Location, location, location.** Show your art where it should be shown. If you make Western art, keep it out of New York City—show it in Montana. Take a road trip to your closest big city, study the shows there, and take notes. What art is being shown and where is it being purchased? Refer to the Art Fairs section of this book to find show dates and locations.
- **Display is key.** When you are out and about taking notes, observe what kind of display/ presentation each artist is using. Is it heavy and cumbersome, or creative and uniquely constructed? Lightweight displays will ease the burden of schlepping display components from show to show. A unit-bodied display that creates walls and partitions incorporating fold down shelving that can be easily carried in and out of a vehicle is helpful. I have used a light dome canopy with pro-panels and cardboard interlocking pedestals for a number of years and the display has withstood winds of 40 miles per hour with no problems.
- **Price appropriately.** Keep your prices in line with the galleries you show with. This keeps everyone on the same page, especially if your galleries come by the show and want to order wholesale. Offer your prospects a discount for three or more works—10 percent is appropriate. And remember to charge sales tax on each purchase if applicable.
- **Lectures/workshops.** Offer to give your prospects a small lecture and slide presentation at some point after the show ends. This makes you more familiar with their group/ club. Familiarity forms connection, which leads to good business for you.
- **Be flexible.** Offer your prospects the chance to design their own art. Follow their lead. When the deal is done and they are ready to pay for your art, stop talking! Many deals have gone astray by too much confusion and misguided focus.
- **Payment flexibility.** Accept all credit cards. The east coast uses American Express more often than the west. Accept it anyway wherever you are. Offer customers a layaway plan for more expensive art—90 days is usually appropriate. You could also offer a rent-to-buy option—no longer than a six-month contract should be in place for this transaction and the selling price should be at least in the hundreds or thousands of dollars to make it worth your while.
- **Service with a smile.** Be willing to ship you art anywhere and by the shipping method preferred by the customer. I use FedEx and charge the customer about 6-10% of the total value of the art sold. If they need quicker service or a professional fine art shipping service then charge them accordingly. Reevaluate your packaging material and keep it clean, simple, and direct. Pretend you are Neiman Marcus and offer your customers the same service.

SOMETHING TO REMEMBER YOU BY

As a professional touch, you should offer some take-away material to buyers or potential buyers, from basic bio information to take-away portfolio packets. I recommend offering a business card and a short bio sheet about your work to interested non-buyers and having three types of take-away portfolios for paying customers depending on the amounts of their purchases. Here are some suggestions:

Plan A Packet—up to $100 of art sold
- Business card (optional picture of your art on the card)
- Artist's statement
- Artist's biography
- Announcement of any current or upcoming shows

Plan B Packet: $100-500 of art sold
- Business card
- Artist's statement
- Artist's biography
- Announcement of any current or upcoming shows
- Gallery résumé
- Photo of yourself working on your art
- An 8×10 picture of a special piece of your art

Plan C Packet: $500 or more of art sold
- Business card
- Artist's statement
- Artist's biography
- Announcement of any current or upcoming shows
- Gallery résumé
- Photo of yourself working on your art
- Three 8×10 photos of your art in a presentation sleeve
- Newspaper or magazine article about your art
- An invitation to any fundraiser you maybe doing for charity

KEEP THEM COMING BACK

Having a successful show every time, either at Cherry Creek in Denver or on Main Street in your hometown, depends upon the many moving parts of the exhibition process. These parts need to be in place for you to attract, captivate and create not only satisfied clients but also loyal customers. Loyal customers give you commissions, follow your career, and display your work for others to see and experience. Your loyal patrons will help you sell your art!

Remember all the times you went to a store, bought something you liked, enjoyed it, were satisfied, but never purchased something there again? We all do this from time to time and then never think about it twice. But a loyal customer loves to go to their favorite place of business; purchases something again and again; and forgives if occasionally the service is not quite up to par.

Artists, musicians and creative people who have enduring brand names carefully developed their art and persona over a long period of time. Think of Madonna, Warhol, and George Clooney to name a few—we hardly have to think about who they are and what they have contributed. Their brand names are as enduring as Starbucks, FedEx, and Disney.

How do you as an outdoor festival artist begin to obtain the status of these people? You will probably never be able to achieve their level of fame or wealth. A great track record takes time. You must spend thousands of hours and years honing your artistic skills. You must improve and expand your creative horizon by not making common mistakes. You must learn to handle your customers and prospects confidently and successfully. Then you'll achieve your own level of fame and wealth.

Leslie Bistrowitz

From Concept to Storyboarding—
Giving Visual Form to Ideas

by Poppy Evans

I f you've ever wondered how a television commercial gets from initial concept to final form, an important phase of its development is storyboarding. Storyboard illustration involves producing rough pencil or marker sketches of the sequence of events as they take place in the script. A similar rendering process is used in producing comp illustration, or rough sketches of concepts for events and product layouts. Both serve as a means of communicating an idea to a client as well as the production team when the concept is approved.

Illustrator Leslie Bistrowitz has spent the past 20 years as a freelance illustrator doing storyboarding and other types of concept illustration under the studio name of Bistrodraw Illustration. She estimates that storyboarding and comp illustration comprises about 75% of her Boston-based business, while the remainder is finished illustration. "I've carved out a niche in storyboards where I'm known by a group of people who come to me on a regular basis," she says. With nationally-known clients such as Ocean Spray, Ruby Tuesday and the National Park Services, and awards from Communication Arts, Bistrowitz has established herself as one of the best and most venerable artists working in this field.

Her career in storyboarding evolved out of working in an ad agency where she headed up the illustration department. "When I interviewed with the creative director at the firm, I remember him saying as he looked at my portfolio, 'You can draw like a son-of-a-bitch,' " Bistrowitz says. "When I got that job, I realized I was good at this."

In addition to drawing well and doing it quickly, Bistrowitz also has a vivid imagination and an instinct for knowing what will appeal to and grab the attention of an audience. These capabilities, and a love for being involved on the ground level of an idea's development, led her to get involved in freelancing as a storyboard artist and establishing her firm in 1986.

Although the computer has increasingly become a means of producing finished illustration, the hand-rendered look of marker and pencil illustration hasn't changed much since the days when Bistrowitz started her firm. In fact, storyboarding and concept illustration is a field that continues to grow as design firms and ad agencies increasingly turn to it as a way of presenting concepts for events and other promotional venues. A loose rendering style sends a message to clients that the concept is fresh and literally on the drawing board for discussion and revision. And as the need for other types of commercial illustration has waxed

POPPY EVANS is the former Managing Editor for *HOW* magazine who currently serves as a freelance designer and writer for the design industry while teaching at the Art Academy of Cincinnati. She has written hundreds of articles and 14 books including her latest titles, *Exploring the Elements of Design* and *Exploring Publication Design*. She lives in Park Hills, KY.

and waned over the years, storyboarding and comp illustration has remained a consistently viable field for artists with a knack for realistic drawing and an ability to work from their imagination.

Here Bistrowitz discusses what it's like to work as a storyboard and concept illustrator and what it takes to make it in this field.

How would you describe working as a concept illustrator?

As an illustrator, I'm like a studio musician. If you look at rock-and-roll recordings, there's the star and then there are the people who play in the session. They never have their own album, but everyone wants to have them play on their album.

How many hours do you put in during a typical week?

Two to a hundred—being a freelance illustrator is definitely not a nine-to-five job. When I work, I put in lots of hours. There are times when I spend 12 hours straight just drawing. Other times I'll be in my robe at 10:30 a.m., talking to someone on the phone. Sometimes I get so many calls on a Friday afternoon I feel like a weekend illustrator.

What is your process for creating a storyboard?

Usually a client will e-mail me a script and then we will talk about it over the phone. First I'll call and discuss with them how many frames they want, and get a rough idea of what they'd like each one to show. Many times I'll discuss the specs for the person they want in the spot, whether they're white, light brown, dark brown, etc. I work with a lot of ethnic agencies. Once we've figured that out, I'll do pencil thumbnails of all of the frames, scan them and e-mail them to the client. Then they will okay it or they'll suggest revisions. When it comes to doing the marker renderings, I start in pencil then I do some line work in ink and then I do the marker rendering. It's definitely a quicker way to work and I enjoy that.

Do you always work directly from a script?

If it's the first time I've worked with the client, they often give me thumbnails to work from. I don't look at a thumbnail sketch and draw the most obvious design. When I develop each sketch, I try to add dynamism by creating interesting compositions and considering point of view.

Why do you work in pencil or marker? I know that they're quick, but are there other advantages to working with these media?

As soon as a client sees something rendered on the computer, it looks so finished they're likely to say, "Okay you're too married to this idea. We can't change anything." They have this perception, when it's drawn by hand, that it's still in the conceptual stages and it's open to change, and that the concept came from the people they are working with, they didn't swipe it from somewhere.

Have storyboard artists always worked in marker?

Before they invented markers, in the golden age of advertising, people used pastel for comps. That was considered to be another really spontaneous medium.

What do you do when you are presented with tight deadlines?

If we have enough time, I like to give people pencil sketches. Even though I feel as though I can read minds, I like to be sure we're working on the same page. But, there are times when I have worked with a client enough and we have a good working relationship, they'll say, "Go to finish. We need it by tomorrow morning."

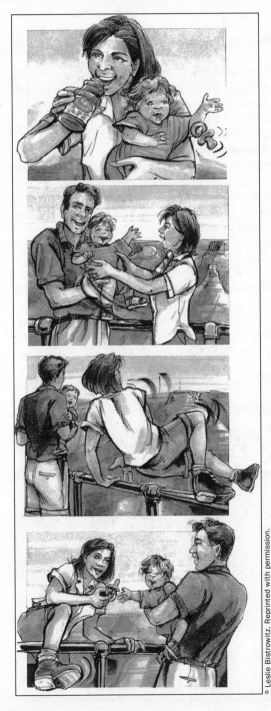

© Leslie Bistrowitz. Reprinted with permission.

In this storyboard depicting a concept for an Ocean Spray commercial, Leslie Bistrowitz needed to show the incredible energizing powers of cranberry juice blends for women. The loose marker rendering reinforces the fact that the idea is in workable format—nothing is final while it's in this phase.

Some times they'll want sketches so quickly I don't have time to go to marker. I'll do a pencil sketch and then bump up the contrast in Photoshop, and I end up with beautiful line work. I think that none of the immediacy of marker comes close to a good pencil drawing. If color isn't an issue, that works just as well.

When you get a script for a commercial spot, how do you determine how many panels you need to render?

It depends on the client, the budget, the schedule and his or her level of apprehension about the idea. Sometimes someone who is worried about their concept will tell me that I need to stretch it out to 12 panels. It doesn't always need to happen that way. Sometimes too much information gets in the way of communicating an idea.

Can you give an example of how an idea can be simplified?

I recently worked with some brand managers on an event illustration. They told me they wanted me to depict a huge tent in the parking lot of a retailer, with a car in front, and inside the tent they would be giving out tire gauges. I had to ask them, "What's more important, an overview of the event or the corporate signage on the front of the tent, or the tire gauges they're giving out?" Very often you'll have to help people simplify. And that happens in all types of comp and storyboard rendering. You want to emphasize the things that are most important to the concept and play down the things that are going to distract people from the message.

How much time do you usually have for a project?

I usually try to spend an hour on each frame. If they say, "Give me 40 frames and we have to have them in two days," I say, "Sorry." I used to be able to do that, but when I first started, the accepted style was much looser. Now it's more realistic. Now they want to be able to recognize details such as the ages of the people you are depicting.

© Leslie Bistrowitz. Reprinted with permission.

An event rendering for Wyeth Pharmaceuticals, in which the agency proposed a theme of "Mother's Healthy Home," as a means of showcasing family-friendly health exhibits for the Latino market. Bistrowitz created type for the signage in her illustration by scanning her marker rendering and composing the type on the computer.

How close does the final commercial or product shot come to your rendering?

Sometimes it's so close it's amazing. I've had the experience where I'll see a commercial and say, "I just saw my spot!" Or a photo shoot will be really close to the comp layout I did.

What do you think it takes to become successful in this field?

You need to have strong realistic drawing skills and the ability to work without reference from a huge visual library in your head. Sometimes there isn't time to Google an image and work from that as a reference. You have to be able to think in your mind about the salient features of a subject and somehow represent that in visual form. You also need to read the minds of your clients and get in touch with what they want.

An understanding of design and composition also helps. My college education included a strong design foundation. We had to take graphic design, three-D design, and of course, I loved the conceptualizing of advertising design. With that background to draw upon, I find I can add a lot more meaningful content and feasibility to a project in the planning stages.

Can you give an example or be more specific about what that involves?

I could compare it to being a director of a script or an actor. You're considering the character and saying to yourself, "What's motivating this character? What's their personality like?" Even though it's just a 30-second spot, that kind of information matters.

I was recently drawing a storyboard that depicted a little old lady in a station wagon dropping off things at a food pantry. I loved the idea of her being independent. One of the close-up shots was supposed to be of her hands on the steering wheel. I changed it to her hand shifting gears, because even though she's in her eighties, she's still getting around. I had this vision of her driving an old four-speed Volvo station wagon. That was a situation where I needed to combine imagination with what the client originally thought they wanted.

How does that help in marketing a product or a concept to the consumer?

When you do a storyboard, you're selling a concept to a client, and it's going to cost them a lot to produce the commercial. It's still sales and you want to lure viewers. When I draw my characters, I want to know who they are, so the consumer can relate to them. I want them to empathize with, say, the bride who's a little miffed that her husband doesn't have a good insurance policy. Otherwise, the commercial isn't going to produce results. My storyboard characters are like actors—if I do a good job, you either love them or hate them.

What would a newcomer seeking storyboard work need in their portfolio to be convincing in this area of illustration?

At least half of your portfolio should be marker samples. Don't do an existing commercial spot—agencies will recognize it. Do your own spot, or something that's proposed, like a documentary as a sequence of drawings. That's a fabulous way to show what you can do. When I taught a class on storyboarding, I had my students watch the Olympics and draw a motion sequence of an athlete in action. You could also include marker comps of a magazine layout or an event, such as a community recycling day or a store opening with tents. It's also good to include a marker rendering that's a product illustration. Even if it's a TV commercial, clients always want a shot of their product. And, whatever you put in your portfolio, be sure it isn't something you've seen somewhere else.

How would you go about getting work in this area?

A Web site is important. I get work from all over the country through my Web site Bistrodraw. com. It's also important to have a mailer, such as a self promotion piece or postcard to lure people to your Web site.

Cold call ad agencies or design firms and ask to speak to their art buyers or creative director. Or call and get their names and then contact them.

Is there any other advice that you can give to newcomers to the field?
Sometimes people who are just breaking into the field will have an unusual style of drawing people, like a Marvel comics look or one that resembles Japanese animé. That doesn't always work for storyboard illustration. If you can't give up a unique style of drawing, then story-boarding's not for you.

You've been doing this now for more than 20 years. Do you ever suffer from burn out or consider expanding into other areas of illustration?
I love my work. A bad day at the drawing table is still better than a great day at any other job. I'm lucky enough that my avocation is my vocation, but I also work freelance, so around the corner, I know I can always run away and cook on a schooner for a week.

Ken Henson

For a Graphic Novelist,
Self Expression Gets Published

© Ken Henson

by Poppy Evans

Artists who are interested in illustration and have the desire to tell a story might consider getting involved in graphic novels. The artistic sensibility of graphic novel imagery allows artists more flexibility in their exploration of expressive media and technique as well as a chance to create their own story line. And with mainstream publishers such as Random House and HarperCollins creating imprints to publish graphic novels in the past couple of years, this publishing venue is experiencing a resurgence in popularity.

Ken Henson is one of many artist/illustrators who is discovering that writing and illustrating graphic novels works well as both a creative outlet and a potential means of income. A fine artist with an MFA in painting, Henson has also been involved in creating underground comics, an experience that helped him get his feet wet in publishing his work and furthered his interest in producing a graphic novel.

Henson just recently finished his first graphic novel, tentatively titled *Splendid-Lite*. He feels that his background as a painter has adapted nicely to the fine arts sensibility of graphic novels. "*Splendid-Lite* grew out of a body of paintings, expanding into a more complex narrative," says Henson.

Splendid-Lite spans over 80 pages and has been a year in the making, but the creative satisfaction Henson more than gained from the experienced sustained him through this extensive undertaking. "The thing I value most about art, and this experience, is the self-actualization that results from dredging my unconscious for subject matter and content," he says.

The graphic novel also gave Henson a chance to experiment with a wide range of media, including (but not limited to) pen and ink, pastel, watercolor and acrylic paint. Images were further enhanced, pieced together and intermeshed on the computer. He describes how this experience has expanded his abilities as an artist: "Because the graphic novel format has helped diversify my range of activities as a painter, it allowed me to create images that are very foreign to my experience as an art-maker. I feel as though I have directed a more elaborate experience for both me and my audience, creating a more complete and believable universe."

Henson's transition from a fine artist to graphic novelist can serve as a guide for artists who have thought about exploring this publishing venue.

POPPY EVANS is the former Managing Editor for *HOW* magazine who currently serves as a freelance designer and writer for the design industry while teaching at the Art Academy of Cincinnati. She has written hundreds of articles and 14 books including her latest titles, Exploring *the Elements of Design* and *Exploring Publication Design*. She lives in Park Hills, Kentucky.

Coming up with a cover design for *Splendid-Lite* involved creating typography for the title. Ken Henson rendered the cover with a mix of pencil, pastel and watercolor. The image was then scanned and further enhanced in the computer.

As a fine artist and painter, what first got you interested in producing comics and graphic novels?

Creating narrative through a sequence of images is really an outgrowth of my painting. I was doing multi-panel paintings such as triptychs or series of four to five painted panels, as well as grids which were held together loosely by a narrative. My work caught the eye of Anthony Bannon, who wrote an article about a juried show I was in and, at the time, was the director of the International Museum of Photography and Film in Rochester, N.Y. I found it interesting that someone with a background in film would be responsive to my work, so I started reading books on film theory. That got me even more interested in doing narratives. I thought I would try doing children's books and I went so far as to make a dummy that I presented to a few publishers. But I had a desire to tell a more elaborate story with adult themes, and that's how I began working in the comic format.

What type of comics were you making?

At the beginning, I was doing strips that tended to be several pages long. I developed some characters and used them in various stories. The main character's name was Horace. These strips were focused on surreal, strange, and humorous elements, and I was focused on exploring a range of storytelling strategies. This was a fun time, as I was collaborating with my friends Mark O'Neill and Matt Wright on these.

Where were these published?

They were published in comic anthologies by Fanatic Press, Alternacomics, Young American Comics and a few others. The work I was doing in these strips was for smaller companies that print dominantly in black and white because it's less expensive. Out of that you get an aesthetic that's typical of what came out of the underground comics revolution in the '60s and '70s, such as *Zap Comix* and even up to Spiegelman's *Maus*. They're subversive and sub-cultural. People in that community really love black and white. It signifies a durability of spirit.

Did you look at what was going on in the underground comics world and then adapt your work to fit what you saw happening in that market?

No. I was really self-driven in what I was doing. I had been doing these strips for about a year and a half and I hit a point where I decided to look for publication. I said to myself, 'I feel like I'm in a vacuum.' I decided to go out and look for people who wanted to publish the kind of things I do.

How did you find a publisher?

I read comics as a kid but then I didn't read them in college. Then I had to backtrack and explore what had been going on and dig a little deeper than what I already knew. It's a hidden world that you don't really know much about unless you're involved in it. I went to bookstores and also comic stores. Even so, those venues portray a very small scope of what goes on in the comic world, largely because comic shops dominantly rely on one distributor and the distributor decides what they want to carry and that depends on the market preferences. A lot of the smaller companies and underground distributors publish books that are harder to obtain. Some of them are only available online.

Once I had some idea of what was out there, I found that there were certain places online that I could go to find potential publishers. Digitalwebbing.com, conceptart.org, and gfxartists.com all have forums sections where you'll find communities of artists who are networking with one another. You'll also find job postings there and calls for submission. I found my first few publishers through Digital Webbing.

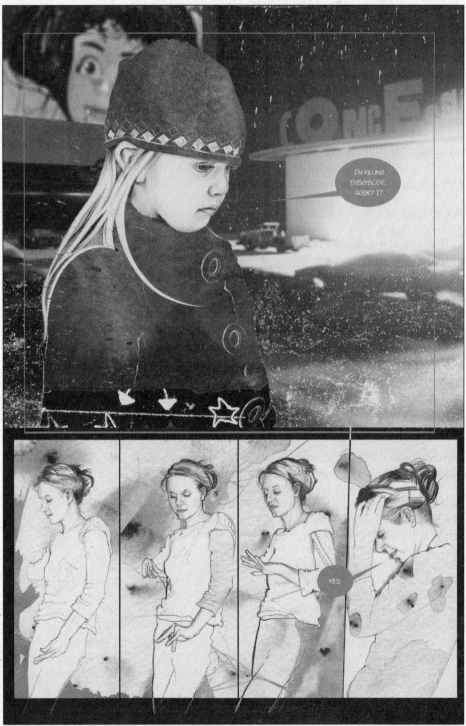

In creating illustrations for *Splendid-Lite*, Ken Henson experimented with techniques that took him beyond conventional ways of working. In this instance, he created a mini set depicting a drive-in theater for the background, photographed it and used the computer to combine it with images he rendered in traditional media.

Once you identified some potential publishers, how did you query and submit your work?

I used free online blog accounts with Livejournal and used Photobucket, a free image-hosting provider to post the story online, then I'd just e-mail a link to the editor I was submitting to.

How did you go from producing underground comics to becoming a graphic novelist?

There were a few things that fueled that decision. While I was involved in doing underground comics, I attended comics conventions to get a better idea of where I could market my work. I was showing art samples to editors at one of these conventions and they responded better to my paintings than to my traditional comic work. They'd say things like "Why don't you do some sequential work in this painting style?" I remember initially thinking: "It would take forever to paint a comic book." But after living with the idea for a while, it made a lot of sense to me. I had been painting and making mixed media work for years, so why not bring that experience to making a book?

Can you talk more about how the comics conventions may have spurred you on?

I actually invested in a table at a convention called S.P.A.C.E. (Small Press Alternative Comic Expo) in Columbus, Ohio. You set up a table and show your goods. You put out anything that you want: comics to sell, art prints, any other kind of ancillary merchandise that you can sell to promote what you're doing. I saw a great range of activities and met a number of people who were making their own graphic novels and selling them. I was really blown away by the range of work. It was clear that the level of creator control in comics creates endless opportunities.

Did you find that other graphic novelists were blurring the lines between print and fine art?

Yes. One such artist is David Mack, who lives in my area and is the internationally known creator of the ongoing series *Kabuki*, a very artful, mixed media story. I've worked with David to give cartooning workshops for teenagers at the local public library. He's very open about his process and inspires an attitude of risk-taking and experimental art strategies. It's this kind of exposure coupled with a desire to bring my painting into my comics that encouraged me to pursue a fine art graphic novel approach.

I was also inspired by a number of artists I was researching. I was really amazed by Bill Sienkiewicz' *Stray Toasters*, which shows such an amazing range of storytelling and art strategies. Scott Hampton's *The Upturned Stone*, and Neil Gaiman's and Dave McKean's *Violent Cases*, and various works by Jon Muth, Kent Williams, and Paul Johnson all played a role in my inspiration.

Do you see long-term opportunity in creating graphic novels?

We're at a really interesting time. There's currently a boom of renewed interest in our culture for graphic novels. Simultaneously, we're coming out of a period that has been considered by the comics industry as a bit of a crash in the market. It really flourished in the '80s and then by the late '90s it started to wither up as a consequence of video games and the Internet. We're at a point in time when it's difficult to determine exactly where the market will go. A lot of people are exploring the possibility of making graphic novels available online. Another factor to consider is that some filmmakers are having graphic novel adaptations of their movies made. A recent example is Aronofsky's *The Fountain*, painted by Kent Williams. You'll also see video game companies creating graphic novels based on their video games.

Articles & Interviews

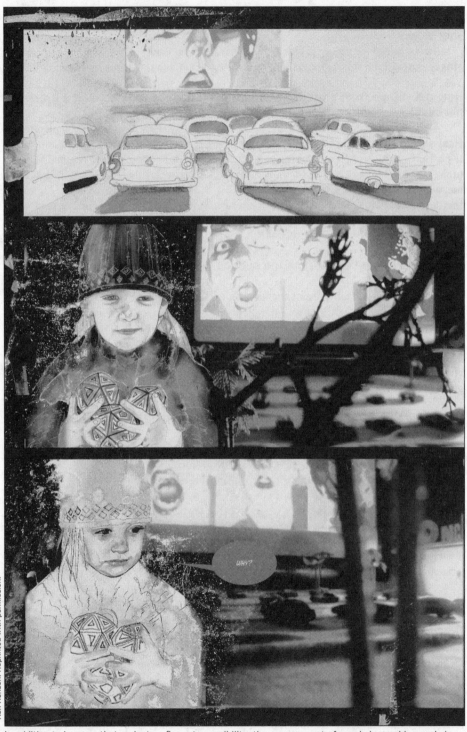

In addition to imagery that projects a fine arts sensibility, the arrangement of panels in graphic novels is more fluid and organic as evidenced in these panels from Ken Henson's *Spendid-Lite*. His graphic novel is 80 pages long and took the artist about a year to create.

All of those industries start to piggy back on one another—a movie will come out based on a video game. You get this constellation of media based on one concept.

Has there also been an increase in artists wanting to create graphic novels?

Yes. There's such a large talent pool and an increase in the artfulness of the work—people willing to hand-paint every panel. There are so many people out there who are trying to do their own graphic novels that only the very best are going to be taken into the field.

How profitable is the graphic novel market?

It's hit or miss. Royalty arrangements vary, depending on the publisher. With any creative project there's always the hope that it will be embraced, and it's nice when your project is lucrative. I've always had the attitude that you make the thing that you want to make and then look for a market. This is what nourishes the spirit. *Splendid-Lite*, which is 80 pages, took more than a year of intense studio time to make. It's hard to predict how successful it will be in the market, but as an art experience, it has been the most fulfilling project I've ever worked on. I'm starting on my second creator-driven graphic novel, and I can't see myself turning away from this for some time.

What advice do you have for others wanting to do graphic novels?

Patience and commitment are key to both the process of making the work and getting it out there. In addition to the online forums, conventions are a great hub of activity. It's a resource for staying informed about the market, networking, finding work and getting published.

Most importantly, as with all art, I think it's important to remember that the more personal you make your work, the more universal it will be. Follow your heart, stay positive, and good luck!

Jillian Corron

Selling Wearable Art with
Delicious Designs

by Alice Pope

"You're probably going to see me the word 'love' a lot in this interview," says T-shirt designer Jillian Corron. Love, she says, is the motivation behind her company Delicious Tees—and she seems to have a genuine love for the creative business she's fashioned for herself.

Corron spreads her vision through aesthetically fresh T-shirt designs that promote a message of love and unity rooted from the female experience. Her first collection of 10 tees seamlessly incorporate design and text in earthy yet empowering designs—that really look great on."

The company started as a cluster of ideas in my head," she says. She gathered and kept track of her ideas over the course of a several years. As she slowly brainstormed, she simultaneously became interested—and educated—in apparel design. "And things just progressed from there. I began creating artwork and then married my thoughts with the designs. I love seeing my artwork on a T-shirt because it adds an organic quality to the design and the message comes alive."

Here Corron talks about her philosophy, what it took to start her business, her experience in the apparel industry, and the supportive online creative community. For more information about Corron and Delicious Tees, visit her Web site, shopdelicioustees.com, and her blog, My Delicious Life at delicioustees.blogspot.com.

When was Delicious Tees up and running? What did it take to get your business going?

Delicious Tees is one year old. My first task was to register all of my artwork with the Library of Congress. Then I registered my business name with the State of Ohio. I also applied for a Transient Vendor's License so I could sell my tees at festivals and shows. The company was started with a $2,500 investment, which allowed me to purchase my blanks, print my tees, put up a Web site and take care of a few other costs. Looking back now, I would have doubled my initial investment because there are always business expenses that creep up unexpectedly.

How did you go about educating yourself on things like choosing shirts, printing designs on tees, merchandizing, etc.? What other things did you have to learn before launching Delicious Tees?

Much of my education with screen printing, embellishment design, marketing and sourcing came through with my 9-to-5 job. My main duty is to create original apparel collections, as well as facilitate designs for companies like Express, Victoria's Secret, The Limited, and

Tween Brands. There are a variety of jobs within the apparel/accessory design genre in Columbus, Oh. Much of that is attributed to companies like The Limited being headquartered here. I think I lucked out because I get to work with these brands from a distance. My hours are consistently set to 40 hours a week and the atmosphere is incredibly laid back and supportive. The past few years have taught me a lot about sourcing garments domestically as well as overseas. I learned how to take a design from conception to production. I also learned more about demographics, target audiences and the importance of merchandising.

How did you pick the name Delicious Tees? Why did you choose to solely offer woman's T-shirts?

I really like pairing the words "Delicious" and "Perspective" because they speak of something so palpable that you can taste it. This is how I view life and so it seemed like the obvious choice with the naming of my company. So, I used "Delicious" in the name and I kept "perspective" in the tag line. I carry woman's tees exclusively because I know how to design for a woman, plus the whole message behind Delicious Tees is female unity. With that said, I am totally open to the idea of designing a men's line or a children's line. However, at this point, I am sticking to what I know, perfecting that recipe, and then I will branch out.

Your first Delicious Tees offering was a group of 10 tees, approaching the shirts as a wearable art collection. How often do you offer new designs?

I am getting ready to launch my second series, which is actually a set of six designs, rather than ten. I try to follow industry standards, which seem to require seasonal collections. However, I am producing wearable art with a message, not just your basic graphic tee. The process is much more cerebral and emotional and I don't want to rush it. I guess my compromise is to produce two collections a year, a Spring/Summer collection and a Fall/Winter collection.

Have you designed shirts for other companies' lines as well as for your Delicious Tees online store?

As I mentioned prior, my 9-to-5 job gives me extensive brand variety and keeps me in the loop with trend forecasting, which I can apply to Delicious Tees. I have also donated a few designs to Rise Up Clothing (riseupclothing.com), an apparel line created by Rise Up International. Rise Up is a cooperative of artists, idealists and social entrepreneurs, who are

<div style="writing-mode: vertical">Articles & Interviews</div>

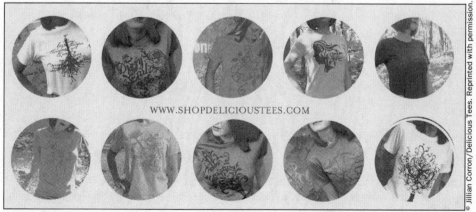

WWW.SHOPDELICIOUSTEES.COM

© Jillian Corron/Delicious Tees. Reprinted with permission.

These 10 T-shirts are the first collection created by Jillian Corron for her line Delicious Tees. Corron incorporates type with into nature-inspired designs that "celebrate all women who seek understanding and truth." Her messages, she says, "remind us to feel solidarity and peace, rather than shame and separation." Her second collection will feature six new tee designs.

using art, anti-poverty campaigns, humanitarian projects, and grass roots organizing to help fight the exploitation of children. I have become friends with the founder, Jesse Roberts. Delicious Tees is all about spreading the love and I feel positive about any collaboration centered around service and humanitarian projects. I have learned that donating time is just as valuable as donating money.

Are your shirts available on sites other than your own? If so, how did these opportunities come about?

My tees are also available on soul-flower.com. I believe Soul Flower came across my tees through a random online search. Soul Flower is one customer that I offer wholesale pricing to. They carry tee #4: Resonate, as well as tee #10: Wisdom Tree. We have established a great working relationship and I have received reorders as well as interest in my second series. I am looking for more wholesale opportunities, especially with retailers and specialty boutiques throughout the United States. I am working on getting into some trade shows, where I will be face to face with buyers.

The design for Delicious Tees #6: Instrument surrounds the text "An instrument of peace and love" with symmetrical organic swirling designs and flowers, at once feminine and powerful. The design is offered on a gray tee at shopdelicioustees.com.

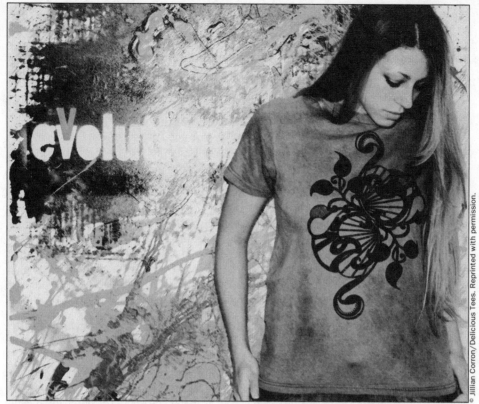

Jillian Corron's Web site showcases her T-shirt designs by picturing women wearing Delicious Tees—like tee #3: Duality. Corron uses her friends as models, shoots her own photos, and color corrects in PhotoShop before posting on her Web site. ''I like to have creative control of all aspects of the company,'' she says.

You offer a very positive approach to your tee business with your ''spread the love'' motto. How does this motto impact your work?

Love motivates me and my work is a reflection of that. The message seems to create this buzz of good energy between me and my customers. Word of mouth seems to be my best marketing tool so I am very appreciative to all who support Delicious Tees. The more positivity I put out there, the more I get back. I am inspired by the women who buy my tees and feel honored to offer them new collections and an intimate shopping experience. I have established relationships with woman all over the world . . . and to think it all started with a T-shirt. I can't help but feel blessed.

You have a 9-to-5 job and work on your own business in evenings and weekends. You must have some long days—how do you stay motivated? What is your ultimate goal for Delicious Tees?

Yes, the hours are long. I essentially work from the moment I wake up to the moment I go to sleep, but what artist doesn't? I take many breaks throughout the day. I get outside, I watch TV from time to time. It's all about balance. If I start to feel stressed out, which happens about once a month, then I know something is off balance and I work on fixing it. I feel like I am at a creative peak in my life and I want to absorb every last drop. I don't mind putting in the hours now to be able to enjoy the rewards later. My immediate goal is for Delicious Tees to reach its highest potential. I would like to go international and be

able to travel all over the world spreading the message. From there, Delicious Tees will evolve into whatever it's destined to be.

Your designs are more than just T-shirt decorations, incorporating type and expressing things like the duality of fear and love. How do you choose themes for your designs? Which have been the most popular?

The themes come from familiar places like life experiences, nature, and human connection. Tee #4: Resonate has been my best seller so far. I think it is the most striking image and the underlying text seems to draw a lot of attention as well. The tee reads: "The collective momentum of all things beautiful guided her to remember what resonates within."

You encourage your customers "to support others who are out there doing what they love." Do you find there's a community spirit among independent designers and artists online?

Absolutely, there is. I think that a T-shirt is a light-hearted, inexpensive form of expression. Most people don't just have one. It's quite the opposite. Usually, you find people with collections so large that they lose count. The industry is full of artists and entrepreneurs just like me who have something to say. I feel like I have come in contact with a lot of good people spreading positive energy and creating wearable art. Plus, everyone seems to be doing it more for the love of art in motion, than for money. It's a great community to be a part of.

I saw reviews of your tees on tshirtwatch.com and shirtsnob.com. Are there other sites that review T-shirts? What impact do these reviews have on your business?

The reviews are helpful. They broaden my audience, increase sales and work as a great marketing resource. There are many people who dedicate a lot of time to collecting and writing about T-shirts. The only hitch, I would say, is that if you aren't constantly producing new designs, then there is no point for these sites to review the same merchandise again and again. I have learned that people want to see fresh, new ideas at a fast pace. It is what it is. We have all been programmed to expect seasonal collections.

Who models your T-shirts for your Web site? Do you shoot the photos yourself or do you hire a photographer? Any tips for making merchandise appealing online? Do you think it's important to show a shirt on a model?

I use friends as models . . . they let me pay them in T-shirts so it works out for both parties. I shoot my own photographs, color correct and alter in PhotoShop. I like to have creative control of all aspects of the company. Sure, it can be exhausting at times, but my creative vision is very clear and I want to nurture it with the right energy. I think that branding is very important and will help assist with marketing appeal. You have to know your brand and who you are selling to in order to become familiar. My tees, for example, talk about nature and feature many nature-oriented designs. So, it makes sense for me to shoot my models in natural settings. It would seem silly to have my models against a sterile background. I am also selling the idea of a flowing, poetic connection to humanity, which comes to life when you see the T-shirt on a model. With successful recognizable brands, you rarely see merchandise on flat, formless surfaces. This formula is easy to apply to Delicious Tees.

What's your advice to creatives who want to start a business selling their work? What have you learned in your first year of Delicious Tees that might be helpful?

First off, I would say it's very important to have focus and clarity. If the idea is there but the focus is not, then a great concept can get lost in the details. Who am I selling to? is another

great question to ask yourself. Where is my audience? Will most of my sales be Web based or will I be selling mostly in a retail setting? For me, the answer was both. I sell from my Web store as well as specialty boutiques.

In my first year of business, I have learned to make clear and methodical decisions. I have a tendency to get overly excited about things and make quick decisions vs. smart decisions. As a business owner, I want to always accommodate my customers but sometimes you can't offer instant gratification. For instance, many customers have asked me about customizing their designs on different tee colors. Though I want to offer this, it isn't a business expense I can take on right now. It isn't always easy saying no to a customer, but I make note of every suggestion and I have a plan in action, which will get me there one day. I just have to be patient. For anyone getting started, I would suggest being open to outside influence but remember that this is your business and you know it best. So, remember to stay true to your vision and take it one day at a time.

Galleries

Most artists dream of seeing their work in a gallery. It's the equivalent of "making it" in the art world. That dream can be closer than you realize. The majority of galleries are actually quite approachable and open to new artists. Though there will always be a few austere establishments manned by snooty clerks, most are friendly places where people come to browse and chat with the gallery staff.

So don't let galleries intimidate you. The majority of gallery curators will be happy to take a look at your work if you make an appointment or mail your slides to them. If they feel your artwork doesn't fit their gallery, most will steer you toward a more appropriate one.

A few guidelines

- **Never walk into a gallery without an appointment,** expecting to show your work to the director. When we ask gallery directors about their pet peeves, they always mention the talented newcomer walking into the gallery with paintings in hand. Send a polished package of about eight to 12 neatly labeled, mounted duplicate slides of your work in plastic slide sheets. (Refer to the listings for more specific information on each gallery's preferred submission method.) Do not send original slides, as you will need them to reproduce later. Send a SASE, but realize your packet may not be returned.
- **Seek out galleries that show the type of work you create.** Most galleries have a specific "slant" or mission. A gallery that shows only abstract works will not be interested in your realistic portraits.
- **Visit as many galleries as you can.** Browse for a while and see what type of work they sell. Do you like the work? Is it similar to yours in quality and style? What about the staff? Are they friendly and professional? Do they seem to know about the artists the gallery represents? Do they have convenient hours? If you're interested in a gallery outside your city and you can't manage a personal visit before you submit, read the listing carefully to make sure you understand what type of work is shown there. Check out the gallery's Web site to get a feel for what the space is like, or ask a friend or relative who lives in that city to check out the gallery for you.
- **Attend openings.** You'll have a chance to network and observe how the best galleries promote their artists. Sign each gallery's guest book or ask to be placed on galleries' mailing lists. That's also a good way to make sure the gallery sends out professional mailings to prospective collectors.

Showing in multiple galleries

Most successful artists show in several galleries. Once you've achieved representation on a local level, you might be ready to broaden your scope by querying galleries in other cities.

Types of Galleries

As you search for the perfect gallery, it's important to understand the different types of spaces and how they operate. The route you choose depends on your needs, the type of work you do, your long-term goals and the audience you're trying to reach.

Retail or commercial galleries. The goal of the retail gallery is to sell and promote the work of artists while turning a profit. Retail galleries take a commission of 40 to 50 percent of all sales.

Co-op galleries. Co-ops exist to sell and promote artists' work, but they are run by artists. Members exhibit their own work in exchange for a fee, which covers the gallery's overhead. Some co-ops also take a small commission of 20 to 30 percent to cover expenses. Members share the responsibilities of gallery-sitting, sales, housekeeping and maintenance.

Rental galleries. The rental gallery makes its profit primarily through renting space to artists and therefore may not take a commission on sales (or will take only a very small commission). Some rental spaces provide publicity for artists, while others do not. Showing in this type of gallery is risky. Rental galleries are sometimes thought of as "vanity galleries" and, consequently, do not have the credibility other galleries enjoy.

Nonprofit galleries. Nonprofit spaces will provide you with an opportunity to sell your work and gain publicity but will not market your work aggressively, because their goals are not necessarily sales-oriented. Nonprofits generally take a small commission of 20 to 30 percent.

Museums. Though major museums primarily show work by established artists, many small museums are open to emerging artists.

Art consultancies. Consultants act as liasions between fine artists and buyers. Most take a commission on sales (as would a gallery). Some maintain small gallery spaces and show work to clients by appointment.

You may decide to be a "regional" artist and concentrate on galleries in surrounding states. Some artists like to have East Coast and West Coast representation.

If you plan to sell work from your studio, or from a Web site or other galleries, be up front with each gallery that shows your work. Negotiate commission arrangements that will be fair to you and all involved.

Pricing your fine art

A common question of beginning artists is "What do I charge for my paintings?" There are no hard and fast rules. The better known you become, the more collectors will pay for your work. Though you should never underprice your work, you must take into consideration what people are willing to pay. Also keep in mind that you must charge the same amount for a painting sold in a gallery as you would for work sold from your studio.

Juried shows, competitions and other outlets

It may take months, maybe years, before you find a gallery to represent you. But don't worry; there are plenty of other venues in which to show your work. Get involved with your local

art community. Attend openings and read the arts section of your local paper. You'll see there are hundreds of opportunities.

Enter group shows and competitions every chance you get. Go to the art department of your local library and check out the bulletin board, then ask the librarian to direct you to magazines that list "calls to artists" and other opportunities to exhibit your work. Subscribe to the Art Deadlines List, available in hard copy or online (www.artdeadlineslist.com). Join a co-op gallery and show your work in a space run by artists for artists.

Another opportunity to show your work is through local restaurants and retail shops that exhibit the work of local artists. Ask the managers how you can get your art on their walls. Become an active member in an arts group. It's important to get to know your fellow artists. And since art groups often mount exhibitions of their members' work, you'll have a way to show your work until you find a gallery to represent you.

Helpful Resources

For More Info

Look for lists of galleries and information about dealing with galleries in the following publications:

- *Art Calendar* (www.artcalendar.com)

- *Art in America* (www.artinamericamagazine.com; each August issue is an annual Guide to Museums, Galleries and Artists)

- *Art New England* (www.artnewengland.com; East Coast)

- *ART PAPERS* (www.artpapers.org)

- *The Artist's Magazine* (www.artistsmagazine.com)

- *ARTnews* (www.artnews.com)

- *Artweek* (www.artweek.com; West Coast)

Galleries

A.R.C. GALLERY/EDUCATIONAL FOUNDATION

832 W. Superior St., #204, Chicago, IL 60622. (312)733-2787. E-mail: arcgallery@yahoo.com. Web site: www.arcgallery.org. **President:** Patricia Otto. Nonprofit gallery. Estab. 1973. Exhibits emerging, mid-career and established artists. 21 members review work for solo and group shows on an ongoing basis. Visit Web site for prospectus. Exhibited artists include Miriam Schapiro. Average display time: 1 month. Located in the West Town Neighborhood; 1,600 sq. ft. Clientele: 80% private collectors, 20% corporate collectors. Overall price range: $50-40,000; most work sold at $200-4,000.

Media Considers all media. Most frequently exhibits painting, sculpture (installation) and photography.

Style Exhibits all styles and genres. Prefers postmodern and contemporary work.

Terms There is a rental fee for space. Rental fee covers 1 month. No commission taken on sales. Gallery provides promotion; artist pays shipping costs. Prefers framed artwork.

Submissions See Web site (www.arcgallery.org/invitationals.html) for info or send e-mail query. Reviews are ongoing. Call for deadlines. Slides or digital images are accepted.

ACA GALLERIES

529 W. 20th St., 5th Floor, New York NY 10011. (212)206-8080. Fax: (212)206-8498. E-mail: info@acagalleries.com. Web site: www.acagalleries.com. **Vice President:** Dorian Bergen. For-profit gallery. Estab. 1932. Exhibits mid-career and established artists. Approached by 200 artists/year; represents 35 artists/year. Exhibited artists include Faith Ringgold (painting, drawing, soft sculpture) and Jon Schueler (painting). Sponsors 8 exhibits/year. Average display time: 6-7 weeks. Open Tuesday through Saturday, 10:30-6. Closed last 2 weeks of August. Clients include local community, tourists, upscale. 25% of sales are to corporate collectors. Overall price range: $1,000-1,000,000.

Media Considers all media except photography. Most frequently exhibits acrylic, ceramics, collage, drawing, fiber, mixed media, oil, paper, pastel, pen & ink, sculpture, watercolor.

Style Considers all styles, all genres. Most frequently exhibits color field, expressionism, impressionism, postmodernism, surrealism.

Terms Artwork is accepted on consignment (10-50% commission). Retail price set by both artist and gallery. Gallery provides insurance, promotion, contract. Accepted work should be framed. Requires exclusive representation locally.

Submissions Send query letter with bio, artist's statement, résumé, brochure, photocopies, photographs, slides, reviews and SASE. Mail portfolio for review. Returns material with SASE. Responds to queries in 1-2 months. We handle established, mid-career artists that have had solo museum exhibitions and have major books or catalogues written about them that are not self-published.

ACADEMY GALLERY

8949 Wilshire Blvd., Beverly Hills CA 90211. (310)247-3000. Fax: (310)247-3610. E-mail: gallery@oscars.org. Web site: www.oscars.org. **Contact:** Ellen Harrington. Nonprofit gallery. Estab. 1992. Exhibitions focus on all aspects of the film industry and the filmmaking process. Sponsors 3-5 exhibitions/year. Average display time: 3 months. Open all year; Tuesday-Friday, 10-5; weekends, 12-6. Gallery begins in building's Grand Lobby and continues on the 4th floor. Total square footage is approx. 8,000. Clients include students, senior citizens, film aficionados and tourists.

Submissions Call or write to arrange a personal interview to show portfolio of photographs, slides and transparencies. Must be film process or history related.

ADDISON/RIPLEY FINE ART

1670 Wisconsin Ave. NW, Washington DC 20007. (202)338-5180. Fax: (202)338-2341. E-mail: romyaddisonrip@aol.com. Web site: www.addisonripleyfineart.com. **Assistant Director:** Romy Silverstein. For-profit gallery and art consultancy. Estab. 1981. Approached by 100 artists/year. Represents 25 emerging, mid-career and established artists. Sponsors 13 exhibits/year. Average display time: 6 weeks. Open all year; Tuesday-Saturday, 11-6. Closed end of summer. Clients include local community, tourists and upscale. 20% of sales are to corporate collectors. Overall price range: $500-80,000; most work sold at $2,500-5,000.
Media Considers acrylic, ceramics, collage, drawing, fiber, glass, installation, mixed media, oil, paper, pastel, sculpture and watercolor. Most frequently exhibits oil and acrylic. Types of prints include etchings, linocuts, lithographs, mezzotints, photography and woodcuts.
Style Considers all styles and genres. Most frequently exhibits painterly abstraction, color field and expressionism.
Terms Retail price set by the gallery and the artist. Gallery provides insurance, promotion and contract. Accepted work should be framed, mounted and matted. No restrictions regarding art or artists.
Submissions Mail portfolio for review. Send query letter with artist's statement, bio, photocopies, résumé and SASE. Returns material with SASE. Responds in 1 month. Finds artists through word of mouth, submissions, and referrals by other artists.
Tips "Submit organized, professional-looking materials."

AGORA GALLERY

530 W. 25th St., New York NY 10001. (212)226-4151, ext. 206. Fax: (212)966-4380. E-mail: Angela@Agora-Gallery.com. Web site: www.Agora-Gallery.com. **Director:** Angela Di Bello. For-profit gallery. Estab. 1984. Approached by 1,500 artists/year. Exhibits 100 emerging, mid-career and established artists. Sponsors 10 exhibits/year. Average display time: 3 weeks. Open all year; Tuesday-Saturday, 11-6. Closed national holidays. Located in Soho between Prince and Spring; landmark building with 2,000 sq. ft. of exhibition space; exclusive gallery block. Clients include upscale. 10% of sales are to corporate collectors. Overall price range: $550-10,000; most work sold at $3,500-6,500.
Media Considers acrylic, collage, digital, drawing, mixed media, oil, pastel, photography, sculpture, watercolor.
Style Considers all styles.
Terms There is a representation fee. There is a 35% commission to the gallery; 65% to the artist. Retail price set by the gallery and the artist. Gallery provides insurance and promotion.
Submissions Guidelines available on Web site (www.agora-gallery.com/artistinfo/GalleryRepresentation.aspx). Send 5-15 slides or photographs with cover letter, artist's statement, bio and SASE; include Portfolio Submission form from Web site, or submit all materials through online link. Responds in 3 weeks. Files bio, slides/photos and artist statement. Finds artists through word of mouth, submissions, portfolio reviews, art exhibits, Internet and referrals by other artists.
Tips "Follow instructions!"

ALASKA STATE MUSEUM

395 Whittier St., Juneau AK 99801-1718. (907)465-2901. Fax: (907)465-2976. E-mail: bruce_kato @eed.state.ak.us. Web site: www.museums.state.ak.us/asmhome.html. **Chief Curator:** Bruce Kato. Museum. Estab. 1900. Approached by 40 artists/year; exhibits 4 emerging, mid-career and established artists. Sponsors 10 exhibits/year. Average display time: 6-10 weeks. Downtown location—3 galleries exhibiting temporary exhibitions.

Media Considers all media. Most frequently exhibits painting, photography and mixed media. Considers engravings, etchings, linocuts, lithographs, mezzotints, serigraphs and woodcuts.

Style Considers all styles.

Submissions Finds Alaskan artists through submissions and portfolio reviews every two years. Register for e-mail notification at: http://list.state.ak.us/guest/RemoteListSummary/Museum_E xhibits_Events_Calendar.

THE ALBUQUERQUE MUSEUM OF ART & HISTORY

2000 Mountain Rd. NW, Albuquerque NM 87104. (505)243-7255. E-mail: dfairfield@cabq.gov. Web site: www.cabq.gov/museum. **Curator of Art:** Douglas Fairfield. Nonprofit museum. Estab. 1967. Sponsors 7-10 exhibits/year. Average display time: 3-4 months. Open Tuesday-Sunday, 9-5. Closed Mondays and city holidays. Located in Old Town, west of downtown.

Style Mission is to collect, promote, and showcase art and artifacts from Albuquerque, the state of New Mexico, and the Southwest. Sponsors mainly group shows and work from the permanent collection.

Submissions Artists may send portfolio for exhibition consideration: slides, photos, disk, artist statement, résumé, SASE.

ALEX GALLERY

2106 R St. NW, Washington DC 20008. (202)667-2599. E-mail: Alexartint@aol.com. Web site: www.alexgalleries.com. **Contact:** Victor Gaetan. Retail gallery and art consultancy. Estab. 1986. Represents 20 emerging and mid-career artists. Exhibited artists include Willem de Looper, Gunter Grass and Olivier Debre. Sponsors 8 shows/year. Average display time: 1 month. Open all year. Located in the heart of a "gallery" neighborhood; "two floors of beautiful turn-of-the-century townhouse; a lot of exhibit space." Clientele: diverse; international and local. 50% private collectors; 50% corporate collectors. Overall price range: $1,500-60,000.

Media Considers oil, acrylic, watercolor, pastel, mixed media, collage, sculpture, photography, original handpulled prints, lithographs, linocuts and etchings. Most frequently exhibits painting, sculpture and works on paper.

Style Exhibits expressionism, abstraction, color field, impressionism and realism; all genres. Prefers abstract and figurative work.

Terms Accepts artwork on consignment. Retail price set by gallery and artist. Gallery provides insurance, promotion and contract; shipping costs are shared.

Submissions Send query letter with résumé, slides, bio, SASE and artist's statement. Write for appointment to show portfolio, which should include slides and transparencies. Responds in 2 months.

CHARLES ALLIS ART MUSEUM

1801 N. Prospect Ave., Milwaukee WI 53202. (414)278-8295. Fax: (414)278-0335. E-mail: shaber stroh@cavtmuseums.org. Web site: www.cavtmuseums.org. **Manager of Exhibitions & Collec-**

tions: Sarah Haberstroh. Museum. Estab. 1947. Approached by 20 artists/year. Represents 6 emerging, mid-career and established artists that have lived or studied in Wisconsin. Exhibited artists include Anne Miotke (watercolor); Evelyn Patricia Terry (pastel, acrylic, multi-media). Sponsors 6-8 exhibits/year. Average display time: 2 months. Open all year; Wednesday-Sunday, 1-5. Located in an urban area, historical home, 3 galleries. Clients include local community, students and tourists. 10% of sales are to corporate collectors. Overall price range: $200-6,000; most work sold at $300.

Media Considers acrylic, collage, drawing, installation, mixed media, oil, pastel, pen & ink, sculpture, watercolor and photography. Print types include engravings, etchings, linocuts, lithographs, serigraphs and woodcuts. Most frequently exhibits acrylic, oil and watercolor.

Style Considers all styles and genres. Most frequently exhibits realism, impressionism and minimalism.

Terms Artwork is accepted on consignment. Artwork can be purchased during run of an exhibition. There is a 30% commission. Retail price set by the artist. Museum provides insurance, promotion and contract. Accepted work should be framed. Does not require exclusive representation locally. Accepts only artists from or with a connection to Wisconsin.

Submissions Send query letter with artist's statement, bio, business card, résumé, reviews, SASE and slides. Material is returned if the artist is not chosen for exhibition. Responds to queries in 1 year. Finds artists through art exhibits, referrals by other artists, submissions and word of mouth.

Tips "All materials should be typed. Slides should be labeled and accompanied by a complete checklist."

ALVA GALLERY

54 State St., New London CT 06320. (860)437-8664. Fax: (860)437-8665. E-mail: Alva@Alvagallery.com. Web site: www.alvagallery.com. For-profit gallery. Estab. 1999. Approached by 50 artists/year. Represents 30 emerging, mid-career and established artists. Exhibited artists include Maureen McCabe (assemblage), Sol LeWitt (gouaches) and Judith Cotton (paintings). Average display time: 6 weeks. Open all year; Tuesday-Saturday, 11-5. Closed between Christmas and New Year and last 2 weeks of August. Clients include local community, tourists and upscale. 5% of sales are to corporate collectors. Overall price range: $250-10,000; most work sold at $1,500.

Media Considers acrylic, collage, drawing, fiber, glass, mixed media, oil, paper, pastel, pen & ink, sculpture and watercolor. Most frequently exhibits oil, photography and mixed media. Considers all types of prints.

Style Considers all styles and genres.

Terms Artwork is accepted on consignment, and there is a 50% commission. Retail price set by the artist. Gallery provides insurance and promotion. Does not require exclusive representation locally.

Submissions Mail portfolio for review. Responds in 2 months. Finds artists through word of mouth, portfolio reviews and referrals by other artists.

THE AMERICAN ART COMPANY

1126 Broadway Plaza, Tacoma WA 98402. (253)272-4327. E-mail: craig@americanartco.com. Web site: www.americanartco.com. **Director:** Craig Radford. Retail gallery. Estab. 1889. Represents/exhibits 150 emerging, mid-career and established artists/year. Exhibited artists include

Art Hansen, Michael Ferguson, Danielle Desplan, Doug Granum, Oleg Koulikov, Yoko Hara and Warren Pope. Sponsors 10 shows/year. Open all year; Tuesday-Friday, 10-5:30; Saturday, 10-5. Located downtown; 3,500 sq. ft. 60% of space for special exhibitions; 40% of space for gallery artists. Clientele: local community. 90% private collectors, 10% corporate collectors. Overall price range: $500-15,000; most work sold at $1,800.

Media Considers oil, fiber, acrylic, sculpture, glass, watercolor, mixed media, quilt art, pastel, collage, woodcuts, wood engravings, linocuts, engravings, mezzotints, etchings, lithographs, serigraphs, contemporary baskets, contemporary sculptural wood. Most frequently exhibits contemporary wood sculpture and original paintings.

Style Exhibits all styles. Genres include landscapes, Chinese and Japanese.

Terms Artwork is accepted on consignment (50% commission) or bought outright for 50% of retail price; net 30 days. Retail price set by the gallery and the artist. Gallery provides insurance and promotion; shipping costs are shared. Prefers artwork unframed.

Submissions Send query letter with résumé, slides, bio and SASE. Write for appointment to show portfolio of slides. Responds in 3 weeks. Finds artists through word of mouth, referrals by other artists, visiting art fairs and exhibitions, submissions.

AMERICAN PRINT ALLIANCE

302 Larkspur Turn, Peachtree City GA 30269-2210. E-mail: director@printalliance.org. Web site: www.printalliance.org. **Director:** Carol Pulin. Nonprofit arts organization with online gallery and exhibitions, travelling exhibitions, and journal publication; Print Bin: a place on Web site that is like the unframed, shrink-wrapped prints in a bricks-and-mortar gallery's "print bin." Estab. 1992. Approached by hundreds of artists/year; represents dozens of artists/year. "We only exhibit original prints, artists' books and paperworks." Usually sponsors 2 travelling exhibits/year—all prints, paperworks and artists' books. Most exhibits travel for 2 years. Hours depend on the host gallery/museum/arts center. "We travel exhibits throughout the U.S. and occasionally to Canada." Overall price range for Print Bin: $150-3,200; most work sold at $300-500.

Media Considers and exhibits original prints, paperworks, artists' books. Also all original prints including any combination of printmaking techniques; no reproductions/posters.

Style Considers all styles, genres and subjects; the decisions are made on quality of work.

Terms Individual subscription: $30-37. Print Bin is free with subscription. "Subscribers have free entry to juried travelling exhibitions but must pay for framing and shipping to and from our office." Gallery provides promotion.

Submissions Subscribe to journal, *Contemporary Impressions* (www.printalliance.org/alliance/al_subform.html). Send one slide and signed permission form (www.printalliance.org/gallery/printbin_info.html). Returns slide if requested with SASE. Usually does not respond to queries from non-subscribers. Files slides and permission forms. Finds artists through submissions to the gallery or Print Bin, and especially portfolio reviews at printmakers conferences. "Unfortunately, we don't have the staff for individual portfolio reviews, though we may—and often do—request additional images after seeing one work, often for journal articles. Generally about 100 images are reproduced per year in the journal."

Tips "See the Standard Forms area of our Web site (www.printalliance.org/library/li_forms.html) for correct labels on slides and much, much more about professional presentation."

AMERICAN SOCIETY OF ARTISTS, INC.

P.O. Box 1326, Palatine IL 60078. (847)991-4748 or (312)751-2500. E-mail: asoa@webtv.net. Web site: www.americansocietyofartists.org. **Membership Chair :** Helen Del Valle.

Terms Members and nonmembers may exhibit. "Our members range from internationally known artists to unknown artists—quality of work is the important factor." Accepted work should be framed, mounted or matted.

Submissions To jury on line (only at asoaartists@aol.com) submit four images of your work-resume/show listing helpful or send SASE and 4 slides/photographs that represent your work; request membership information and application. Responds in 2 weeks. Accepted members may participate in lecture and demonstration service. Member publication: *ASA Artisan*.

ANDERSON-SOULE GALLERY

325 Pleasant St., Concord NH 03301. E-mail: art@anderson-soulegallery.com. Web site: www.anderson-soulegallery.com. **Director:** Trish Soule. For-profit gallery, rental gallery, art consultancy. Estab. 2002. Exhibits the work of emerging, mid-career and established artists. Approached by 15 artists/year; represents or exhibits 20+ artists. Average display time: 6 weeks. Open Tuesday-Saturday, 10-4. Clients include local community, tourists, upscale. Overall price range: $100-8,000; most work sold at $1,000.

Media Considers acrylic, ceramics, collage, drawing, glass, mixed media, oil, pastel, sculpture, watercolor. Most frequently exhibits oil, mixed media, sculpture. Considers all types of prints.

Style Exhibits color field, expressionism, pattern painting and painterly abstraction. Genres include figurative, florals and landscapes.

Terms Artwork is accepted on consignment (50% commission). Retail price set by gallery and artist. Gallery provides insurance, promotion, contract. Accepted work should be framed, mounted, matted. Requires exclusive representation locally. Accepts only artists from Northeastern U.S.

Submissions Mail portfolio for review. Send query letter with artist's statement, bio, résumé, photocopies, CD for PC, SASE. Returns material with SASE. Responds to queries within 4 weeks, only if interested. Finds artists through portfolio reviews, referrals by other artists.

Tips "Provide *all* requested materials."

Ⓝ ARKANSAS STATE UNIVERSITY FINE ARTS CENTER GALLERY

P.O. Drawer 1920, State University AR 72467. (870)972-3050. E-mail: csteele@astate.edu. Web site: http://finearts.astate.edu/art/art.html. **Chair, Department of Art:** Curtis Steele. University—Art Department Gallery. Estab. 1968. Represents/exhibits 3-4 emerging, mid-career and established artists/year. Sponsors 3-4 shows/year. Average display time 1 month. Open fall, winter and spring; Monday-Friday, 10-4. Located on university campus; 1,600 sq. ft.; 60% of time devoted to special exhibitions; 40% to faculty and student work. Clientele: students/community.

Media Considers all media. Considers all types of prints. Most frequently exhibits painting, sculpture and photography.

Style Exhibits conceptualism, photorealism, neo-expressionism, minimalism, hard-edge geometric abstraction, painterly abstraction, postmodern works, realism, impressionism and pop. "No preference except quality and creativity."

Terms Exhibition space only; artist responsible for sales. Retail price set by the artist. Gallery provides insurance, promotion and contract; shipping costs are shared. Prefers artwork framed.

Submissions Send query letter with résumé, CD/DVD and SASE. Portfolio should be submitted on CD/DVD only. Responds only if interested within 2 months. Files résumé. Finds artists through call for artists published in regional and national art journals.

Tips "Show us 20 slides of your best work. Don't overload us with lots of collateral materials (reprints of reviews, articles, etc.). Make your vita as clear as possible."

ARNOLD ART

210 Thames, Newport RI 02840. (401)847-2273. E-mail: info@arnoldart.com. Web site: www.ar noldart.com. **President:** William Rommel. Retail gallery. Estab. 1870. Represents 40 emerging, mid-career and established artists. Exhibited artists include John Mecray, Willard Bond. Sponsors 4 exhibits/year. Average display time: 1 month. Open Monday-Saturday, 9:30-5:30; Sunday, 12-5. Clientele: local community, students, tourists and Newport collectors. 1% of sales are to corporate clients. Overall price range: $100-35,000; most work sold at $600.

Media Considers oil, acrylic, watercolor, pastel, pen & ink, drawings, mixed media. Most frequently exhibits oil and watercolor.

Style Genres include marine sailing, classic yachts, America's cup, yachting/sailing.

Terms Accepts work on consignment (40% commission). Retail price set by artist. Exclusive area representation not required. Gallery provides promotion.

Submissions Send e-mail. Call or e-mail for appointment to show portfolio of originals. Returns materials with SASE.

Tips To make your submissions professional you must "Frame them well."

ART ENCOUNTER

5720 S. Arville St., Suit 114, Las Vegas NV 89118. (702)227-0220. Fax: (702)227-3353. E-mail: sharon@artencounter.com. Web site: www.artencounter.com. **Director of Artist Relations:** Sharon Darcy. Gallery Director: Rod Maly. Retail gallery. Estab. 1992. Represents 100 emerging and established artists/year. Exhibited artists include Jennifer Main, Jan Harrison and Vance Larson. Sponsors 4 shows/year. Open all year; Tuesday-Friday, 10-6; Saturday and Monday, 12-5. Located near the famous Las Vegas strip; 13,000 sq. ft. Clients include upscale tourists, locals, designers and casino purchasing agents. 95% of sales are to private collectors, 5% corporate collectors. Overall price range: $200-20,000; most work sold at $500-2,500.

Media Considers all media and all types of prints. Most frequently exhibits watercolor, oil, acrylic, and sculpture.

Style Exhibits all styles and genres.

Terms Rental fee for space; covers 6 months. Retail price set by the gallery and artist. Gallery provides promotion and contract; artist pays for shipping. Prefers artwork framed.

Submissions E-mail JPEGs or mail photographs and SASE. Appointments will be scheduled according to selection of juried artists. Responds within 2 weeks, only if interested. Files artist bios and résumés. Finds artists by advertising in *The Artist's Magazine* and *American Artist*, art shows and word of mouth.

Tips "Poor visuals, attempted walk-in without appointment, and no SASE are common mistakes."

THE ART EXCHANGE

17 East Brickel Street., Columbus OH 43215. (614)464-4611. Fax: (614)464-4619. E-mail: kristin @theartexchangeltd.com. Web site: www.theartexchangeltd.com. **Principal:** Kristin Meyer. Art consultancy. Estab. 1978. Represents 150+ emerging, mid-career and established artists/year. Exhibited artists include LaVon Van Williams, Frank Hunter, Mary Beam and Carl Krabill. Open all year; Monday-Friday, 9-5. Located downtown in the historic Short North Arts Distirct neighborhood; 2,000 sq. ft. 100% of space for gallery artists. Clientele: corporate leaders; 20% private collectors; 80% corporate collectors. "We work directly with interior designers and architects." Overall price range: $150-8,000; most work sold at $1,000-4,000.

Media Considers oil, acrylic, watercolor, pastel, mixed media, collage, sculpture, ceramics, fiber, glass, photography and all types of prints. Most frequently exhibits oil, acrylic, watercolor.

Style Exhibits painterly abstraction, urban landscapes, impressionism, realism, folk art. Genres include florals and landscapes. Prefers impressionism, painterly abstraction, urban landscapes, realism.

Terms Accepts work on consignment. Retail price set by the gallery and the artist.

Submissions Send query letter or e-mail with résumé and CD, slides or photographs. Write for appointment to show portfolio. Responds in 2 weeks. Files CD, slides or photos and artist information. Finds artists through word of mouth, referrals by other artists, visiting art fairs and exhibitions, submissions.

Tips "Our focus is to provide high-quality artwork and consulting services to the corporate, design and architectural communities. Our works are represented in corporate offices, healthcare facilities, hotels, restaurants and private collections throughout the country."

[N] ART GUILD OF BURLINGTON/THE ARTS FOR LIVING CENTER

620 Washington, Burlington IA 52601-5145. Fax: (319)754-4731. E-mail: arts4living@aol.com. Web site: www.artguildofburlington.org. **Executive Director:** Ann Distelhorst. Nonprofit gallery. Estab. 1974. Exhibits the work of mid-career and established artists. May consider emerging artists. Sponsors 10 shows/year. Average display time 3 weeks. Open all year; Tuesday-Saturday, 12-6,. Located in Heritage Hill Historic District, near downtown; 2,500 sq. ft.; In former 1868 German Methodist church. 35% of space for special exhibitions. Overall price range $25-1,000; most work sold at $75-500.

Media Considers all visual media. Most frequently exhibits two-dimensional work.

Style Exhibits all styles.

Terms Accepts work on consignment (25% commission). Retail price set by artist. Gallery provides insurance, promotion and contract; artist pays for shipping. Prefers artwork framed.

Submissions Send query letter with résumé, slides, bio, brochure, photographs, SASE and reviews.

ART SOURCE L.A., INC.

2801 Ocean Park Blvd., #7, Santa Monica CA 90405. (310)452-4411. Fax: (310)452-0300. E-mail: info@artsourcela.com. Web site: www.artsourcela.com. **Artist Liason:** Patty Levert. Estab. 1980. Submission guidelines available on Web site.

• See additional listing in the Artists' Reps section.

Media Considers fine art in all media, including works on paper/canvas, sculpture, giclée and a broad array of accessories handmade by American artists. Considers all types of prints.

Terms Artwork is accepted on consignment (50% commission). No geographic restrictions.

Submissions "Send minimum of 20 slides or photographs (laser copies are not acceptable) clearly labeled with your name, title and date of work, size and medium. Catalogs and brochures of your work are welcome. Also include a résumé, price list and SASE. We will not respond without a return envelope." Also accepts e-mail submissions. Responds in 6-8 weeks. Finds artists through art fairs/exhibitions, submissions, referrals by other artists, portfolio reviews and word of mouth.

Tips "Be professional when submitting visuals. Remember, first impressions can be critical! Submit a body of work that is consistent and of the highest quality. Work should be in excellent condition and already photographed for your records. Framing does not enhance presentation to the client."

ART WITHOUT WALLS, INC.

P.O. Box 341, Sayville NY 11782. Phone/fax: (631)567-9418. E-mail: artwithoutwalls@webtv.n et. **Executive Director:** Sharon Lippman. Nonprofit gallery. Estab. 1985. Approached by 300 artists/year. Represents 100 emerging, mid-career and established artists. Sponsors 10 exhibits/ year. Average display time: 1 month. Open daily, 9-5. Closed December 22-January 5 and Easter week. Overall price range: $1,000-25,000; most work sold at $3,000-5,000.

Media Considers all media and all types of prints. Most frequently exhibits painting, sculpture and drawing.

Style Considers all styles and genres. Most frequently exhibits impressionism, expressionism, postmodernism.

Terms Artwork is accepted on consignment (20% commission). Retail price set by the artist. Gallery provides promotion and contract. Accepted work should be framed, mounted and matted.

Submissions Mail portfolio for review. Send query letter with artist's statement, brochure, photographs, résumé, reviews, SASE and slides. Returns material with SASE. Responds in 1 month. Files artist résumé, slides, photos and artist's statement. Finds artists through submissions, portfolio reviews and art exhibits.

Tips "Work should be properly framed with name, year, medium, title and size."

ART-AGENT.COM

Web site: www.art-agent.com. Commission-free, electronic broker of fine art; online gallery. "There are no commissions, no signup fees, no service charges, and no subscriptions to pay. The only thing that is required is a free community account at our sister site, WetCanvas.com. If you are a visual artist and are interested in selling your works via Art-Agent.com, please visit www.wetcanvas.com for more information on creating your account and getting started marketing and selling your art through our network."

ART@NET INTERNATIONAL GALLERY

E-mail: artnetg@yahoo.com. Web site: www.designbg.com. **Director:** Yavor Shopov. For-profit Internet gallery. Estab. 1998. Approached by 150 artists/year. Represents 20 emerging, mid-career and established artists. Exhibited artists include Nicolas Roerich (paintings) and Yavor Shopov (photography). Sponsors 15 exhibits/year. Average display time: permanent. Open all year; Monday-Sunday, 24 hours. "Internet galleries like ours have a number of unbelievable advantages over physical galleries and work far more efficiently, so they are expanding extremely rapidly and taking over many markets held by conventional galleries for many years. Our gallery exists only online, giving us a number of advantages both for our clients and artists. Our expenses are reduced to the absolute minimum, so we charge our artists lowest commission in the branch (only 10%) and offer to our clients lowest prices for the same quality of work. Unlike physical galleries, we have over 100 million potential Internet clients worldwide and are able to sell in over 150 countries without need to support offices or representatives everywhere. We mount cohesive shows of our artists, which are unlimited in size and may be permanent. Each artist has individual 'exhibition space' divided to separate thematic exhibitions along with bio and statement. We are just hosted in the Internet space, otherwise our organization is the same as of a traditional gallery." Clients include collectors and business offices worldwide; 30% corporate collectors. Overall price range: $150-50,000.

Media Considers ceramics, crafts, drawing, oil, pastel, pen & ink, sculpture and watercolor. Most frequently exhibits photos, oil and drawing. Considers all types of prints.

Style Considers expressionism, geometric abstraction, impressionism and surrealism. Most frequently exhibits impressionism, expressionism and surrealism. Also considers Americana, figurative work, florals, landscapes and wildlife.

Terms Artwork is accepted on consignment, and there is a 10% commission and a rental fee for space of $1/image per month or $5/image per year (first 6 images are displayed free of rental fee). Retail price set by the gallery or the artist. Gallery provides promotion. Accepted work should be matted. Does not require exclusive representation locally. "Every exhibited image will contain your name and copyright as watermark and cannot be printed or illegally used, sold or distributed anywhere."

Submissions E-mail portfolio for review. E-mail attached scans of 900×1200 pixels (300 dpi for prints or 900 dpi for 36mm slides) as JPEG files for IBM computers. "We accept only computer scans; no slides, please." E-mail artist's statement, bio, résumé, and scans of the work. Cannot return material. Responds in 6 weeks. Finds artists through submissions, portfolio reviews, art exhibits, art fairs, and referrals by other artists.

Tips "E-mail us or send a disk or CD with a tightly edited selection of less than 20 scans of your best work. All work must be very appealing and interesting, and must force any person to look over it again and again. Main usage of all works exhibited in our gallery is for limited edition (photos) or original (paintings) wall decoration of offices and homes. Photos must have the quality of paintings. We like to see strong artistic sense of mood, composition, light and color, and strong graphic impact or expression of emotions. We exhibit only artistically perfect work in which value will last for decades. We would like to see any quality work facing these requirements on any media, subject or style. No distractive subjects. For us only quality of work is important, so new artists are welcome. Before you send us your work, ask yourself, 'Who and why will someone buy this work? Is it appropriate and good enough for this purpose?' During the exhibition, all photos must be available in signed limited edition museum quality 8×10 or larger matted prints."

ⓝ ARTEMIS, INC.

4715 Crescent St., Bethesda MD 20816. (301)229-2058. Fax: (301)229-2186. E-mail: sjtropper@aol.com. **Owner:** Sandra Tropper. Retail and wholesale dealership and art consultancy. Represents more than 100 emerging and mid-career artists. Does not sponsor specific shows. Clientele 40% private collectors, 60% corporate clients. Overall price range $100-10,000; most artwork sold at $1,000-3,000.

Media Considers oil, acrylic, watercolor, mixed media, collage, works on paper, sculpture, ceramic, craft, fiber, glass, installations, woodcuts, engravings, mezzotints, etchings, lithographs, pochoir, serigraphs and offset reproductions. Most frequently exhibits prints, contemporary canvases and paper/collage.

Style Exhibits impressionism, expressionism, realism, minimalism, color field, painterly abstraction, conceptualism and imagism. Genres include landscapes, florals and figurative work. "My goal is to bring together clients (buyers) with artwork they appreciate and can afford. For this reason I am interested in working with many, many artists." Interested in seeing works with a "finished" quality.

Terms Accepts work on consignment (50% commission). Retail price set by dealer and artist. Exclusive area representation not required. Gallery provides insurance and contract; shipping costs are shared. Prefers unframed artwork.

Submissions Send query letter with résumé, slides, photographs, CD and SASE. Write to sched-

ule an appointment to show a portfolio, which should include originals, slides, transparencies and photographs. Indicate net and retail prices. Responds only if interested within 1 month. Files slides, photos, résumé and promo material. All material is returned if not accepted or under consideration.

Tips "Many artists have overestimated the value of their work. Look at your competition's prices."

ARTISIMO UNLIMITED

(formerly Artisimo Artspace), P.O. Box 28044, Scottsdale AZ 85255. (480)949-0433. Fax: (480)214-5776. E-mail: artisimo@artisimogallery.com. Web site: www.artisimogallery.com. **Owner:** Julia Ohman. For-profit gallery. Estab. 1991. Approached by 30 artists/year. Represents 20 emerging, mid-career and established artists. Exhibited artists include Carolyn Gareis (mixed media) and Phyllis Brooks (acrylic). Sponsors 3 exhibits/year. Average display time: 5 weeks. Clients include local community, upscale, designers, corporations, restaurants. Overall price range: $200-4,000; most work sold at $2,500.

Media Considers all media and all types of prints.

Style Exhibits geometric abstraction and painterly abstraction. Genres include figurative work, florals, landscapes and abstract.

Terms "Available art is displayed on the Artisimo Web site. Artisimo will bring desired art to the client's home or business. If art is accepted, it will be placed on the Web site." There is a 50% commission upon sale of art. Retail price set by the artist. Gallery provides insurance and promotion.

Submissions Send query e-mail with artist's statement, bio, photographs, résumé or link to Web site. Responds in 3 weeks. Files photographs and bios. Finds artists through submissions, portfolio reviews, art fairs and exhibits, word of mouth and referrals by other artists.

ARTISTS LAIR

2766 Janitell Rd. S., Colorado Springs CO 80906. (719)576-5247. Fax: (719)579-9070. E-mail: PagiArtistsLair@aol.com. Web site: www.artistslair.net. **Gallery Consultant:** Ernie Ferguson. For-profit gallery. Estab. 2006. Exhibits emerging, mid-career and established artists. Average display time: 2-4 weeks. Open Tuesday, Thursday and Friday, 10:30-5; Wednesday, 12:30-7:30; Saturday, 12-5. Closed Sunday, Monday and some holidays. Located in an emerging retail area; 3,000 sq. ft. Clients include local community, students, tourists. 25% of sales are to corporate collectors. Overall price range: $60-3,000; most work sold at $400-800.

Media Considers all media and all types of prints.

Style Exhibits all styles and genres.

Terms Artwork is accepted on consignment (35% commission). Retail price set by artist. Gallery provides promotion and contract. Accepted work should be framed, mounted, matted.

Submissions Send query letter with artist's statement, bio, brochure, business card, résumé, photocopies, photographs, slides, reviews, SASE. E-mail query letter with JPEG samples or link to Web site. Call or write to arrange a personal interview to show portfolio of photographs, slides, transparencies. Mail portfolio for review. Returns material with SASE. Responds in 3 weeks. Keeps CDs on file. Finds artists through submissions, portfolio reviews, art fairs and exhibits, word of mouth and referrals by other artists. "We also have a call for entries."

ARTISTS' COOPERATIVE GALLERY

405 S. 11th St., Omaha NE 68102. (402)342-9617. Web site: www.artistsco-opgallery.com. Estab. 1974. Sponsors 11 exhibits/year. Average display time: 1 month. Gallery sponsors all-member exhibits and outreach exhibits; individual artists sponsor their own small group exhibits throughout the year. Overall price range: $100-500.

Media Considers oil, acrylic, watercolor, pastel, drawings, mixed media, collage, paper, sculpture, ceramic, fiber, glass, photography, woodcuts, serigraphs. Most frequently exhibits sculpture, acrylic, oil and ceramic.

Style Exhibits all styles and genres.

Terms Charges no commission. Reviews transparencies. Accepted work should be framed work only. "Artist must be willing to work 13 days per year at the gallery. We are a member-owned-and-operated cooperative. Artist must also serve on one committee."

Submissions Send query letter with résumé, SASE. Responds in 2 months.

Tips "Write for membership application. Membership committee screens applicants August 1-15 each year. Responds by September 1. New membership year begins October 1. Members must pay annual fee of $325. Our community outreach exhibits include local high school photographers and art from local elementary schools."

THE ARTS COMPANY

215 Fifth Ave., Nashville TN 37219. (615)254-2040. Fax: (615)254-9289. E-mail: art@theartscompany.com. Web site: www.theartscompany.com. **Owner:** Anne Brown. Art consultancy, for-profit gallery. Estab. 1996. Over 6,000 sq. ft. of gallery space on 2 floors. Overall price range: $10-35,000; most work sold at $300-3,000.

Media Considers all media. Most frequently exhibits painting, photography and sculpture.

Style Exhibits all styles and genres. Frequently exhibits contemporary outsider art.

Terms Artwork is accepted on consignment. Gallery provides insurance and contract. Accepted work should be framed. Requires exclusive representation locally.

Submissions "We prefer an initial info packet via e-mail." Send query letter with artist's statement, bio, brochure, business card, photocopies, résumé, reviews, SASE, CD. Returns material with SASE. Finds artists through word of mouth, art fairs/exhibits, submissions, referrals by other artists.

Tips "Provide professional images on a CD along with a professional bio, résumé."

⚜ ARTS ON DOUGLAS

123 Douglas St., New Smyrna Beach FL 32168. (386)428-1133. Fax: (386)328-5008. E-mail: mail@artsondouglas.net. Web site: www.artsondouglas.net. **Gallery Director:** Meghan Martin. For-profit gallery. Estab. 1996. Represents 56 professional Florida artists and exhibits 12 established artists/year. Average display time: 1 month. Open all year; Tuesday-Friday, 11-6; Saturday, 10-2. 5,000 sq. ft. of exhibition space. Clients include local community, tourists and upscale. Overall price range varies.

Media Considers all media except installation.

Style Considers all styles and genres.

Terms Artwork is accepted on consignment (50% commission). Retail price set by the artist. Gallery provides insurance and promotion. Accepted work should be framed. Requires exclusive representation locally. Accepts only professional artists from Florida.

Submissions Returns material with SASE. Files slides, bio and résumé. Artists may want to call gallery prior to sending submission package—not always accepting new artists.

Tips "We want current bodies of work—please send slides of what you're presently working on."

ARTWORKS GALLERY

811 Race St., Cincinnati OH 45202. (513)333-0388. Fax: (513)333-0799. E-mail: allen@artworksc incinnati.com. Web site: www.ArtWorksCincinnati.com. **Coordinator:** Allen Cochran. Alternative space; cooperative, nonprofit, rental gallery. Estab. 2003. Exhibits emerging, mid-career and established artists. Approached by 75-100 artists/year; represents or exhibits 50-75 artists. Exhibited artists include Brian Joiner (painting), Tiffany Owenby (sculpture, doll art), Pam Kravetz (fiber) and Frank Herrmann (painting). Sponsors 11-12 exhibits/year. Average display time: 4 weeks or 1½ months. Open Monday-Friday, 9-5; also by appointment. "Generally we are closed during the month of January." Located in downtown Cincinnati; 1,500 sq. ft.; available for event rentals and small private parties. Clients include local community, students, tourists, upscale. 20% of sales are to corporate collectors. Overall price range: $200-15,000; most work sold at $500-1,200.

Media Considers all media. Most frequently exhibits painting, drawing and small sculpture. Considers all types of prints.

Style Considers all styles and genres. Most frequently exhibits abstract, realistic and figurative work.

Terms Artwork is accepted on consignment (30% commission). Retail price set by both artist and gallery. Gallery provides promotion and contract. Accepted work should be "finished and exhibition ready. We have the right to jury the works coming into the space."

Submissions Call or mail portfolio for review. Send query letter with résumé, artist's statement, slides or digital images via CD or e-mail. Cannot return material; "We hold on to materials for future exhibition opportunities. We have many opportunities beyond just exhibiting in our gallery." Responds to queries in 3-4 weeks. Finds artists through submissions, art fairs/exhibits, portfolio reviews, art competitions, referrals by other artists, word of mouth.

Tips "ArtWorks is looking for strong artists who are not only talented in terms of their ability to make and create, but who also can professionally present themselves and show a genuine interest in the exhibition of their artwork. In regards to this, ArtWorks is looking for concise statements that the artists themselves have written about their own work, as well as résumés of exhibitions to help back up their written statements. We do ask that communication is top on the list. Artists and interested parties should continue to communicate with us beyond exhibitions and further down the line just to let us know what they're up to or how they've grown."

☷ ARTWORKS GALLERY, INC.

233 Pearl St., Hartford CT 06103. (860)247-3522. E-mail: artworks.gallery@snet.net. Web site: www.artworksgallery.org. **Executive Director:** Francesca Verblen. Cooperative nonprofit gallery. Estab. 1976. Exhibits emerging, mid-career and established artists. Sponsors 12 shows/year. Average display time: 1 month. Open Wednesday-Friday, 11-5; Saturday, 12:30-3:30; also by appointment. Located in downtown Hartford; 1,300 sq. ft.; large, first floor, store front. 20% of space for special exhibitions; 80% of space for gallery artists. Clientele: 80% private collectors; 20% corporate collectors. Overall price range: $200-5,000; most work sold at $200-1,000.

Media Considers all media and all types of prints. Most frequently exhibits paintings, photography and sculpture. No crafts or jewelry.

Style Exhibits all styles and genres, especially contemporary.

Terms Co-op membership fee plus a donation of time. Payment by installments acceptable. There is a 30% commission. Retail price set by artist. Gallery provides insurance, promotion and contract. Artist pays for shipping costs. All artists considered for membership. Accepts artist nationally for juried shows.

Submissions For membership, e-mail query letter with resume, slides or cd's, and bio to francesca.artworks@snet.net, and mail to gallery, $25 application fee. Membership Committee will contact artist for interview. Responds in 1 month. Finds artists through submissions, visiting exhibitions, various art publications and sourcebooks, art collectors' referrals, but mostly through word of mouth and 1 juried show/year.

ALAN AVERY ART COMPANY

(formerly Trinity Gallery), 315 E. Paces Ferry Rd., Atlanta GA 30305. (404)237-0370. Fax: (404)240-0092. E-mail: info@alanaveryartcompany.com. Web site: www.alanaveryartcompany.com. **President:** Alan Avery. Retail gallery and corporate sales consultants. Estab. 1983. Represents/exhibits 67 mid-career and established artists and old masters/year. Exhibited artists include Roy Lichtenstein, Jim Dine, Robert Rauschenberg, Andy Warhol, Larry Gray, Ray Donley, Robert Marx, Lynn Davison and Russell Whiting. Sponsors 6-8 shows/year. Average display time: 6 weeks. Open all year; Tuesday-Friday, 10-6; Saturday, 11-5 and by appointment. Located mid-city; 6,700 sq. ft.; 25-year-old converted restaurant. 50-60% of space for special exhibitions; 40-50% of space for gallery artists. Clientele: upscale, local, regional, national and international. 70% private collectors, 30% corporate collectors. Overall price range: $2,500-100,000; most work sold at $2,500-5,000.

Media Considers all media and all types of prints. Most frequently exhibits painting, sculpture and work on paper.

Style Exhibits expressionism, conceptualism, color field, painterly abstraction, postmodern works, realism, impressionism and imagism. Genres include landscapes, Americana and figurative work. Prefers realism, abstract and figurative.

Terms Artwork is accepted on consignment (negotiable commission). Retail price set by gallery. Gallery pays promotion and contract. Shipping costs are shared. Prefers framed artwork.

Submissions Send query letter with résumé, at least 20 slides, bio, prices, medium, sizes and SASE. Reviews every 6 weeks. Finds artists through submissions, word of mouth and referrals by other artists.

Tips "Be as complete and proffessional as apossile in presentation. We provide sumittal process sheets listing all items needed for review. Following this sheets important."

SARAH BAIN GALLERY

411 W. Broadway, Suite C, Anaheim CA 92805. (714)758-0545. E-mail: sarahbain@aol.com. Web site: www.sarahbaingallery.com. For-profit gallery. Exhibits emerging and mid-career artists. Approached by 200 artists/year; represents or exhibits 24 artists. Sponsors 12 total exhibits/year. Average display time: 1 month. Clients include local community, students, tourists and upscale. Overall price range: $700-15,000; most work sold at $4,000.

Media Considers acrylic, drawing, mixed media, oil. Most frequently exhibits drawing, mixed media, paintings in representational or figurative style.

Style Exhibits representational or figurative.

Terms Artwork is accepted on consignment. Retail price set by the gallery. Gallery provides

promotion. Accepted work should be framed and mounted. Prefers only representational or figurative art.

Submissions Mail portfolio for review. Send query letter with slides. Returns material with SASE. Responds to queries in 1 month.

Tips "Show a consistent, comprehensive body of work as if it were its own show ready to be hung."

BARUCCI GALLERY

8101 Maryland Ave., St. Louis MO 63105. (314)727-2020. E-mail: baruccigallery@dellmail.com. Web site: www.baruccigallery.com. **Owner/Director:** Shirley Taxman Schwartz. Retail gallery and art consultancy specializing in hand-blown glass by national juried artists. Estab. 1977. Represents 40 artists. Interested in emerging and established artists. Sponsors 3-4 solo and 4 group shows/year. Average display time: 6 weeks. Located in an "affluent, young area;" corner location featuring 3 large display windows. 70% private collectors, 30% corporate clients. Overall price range: $100-10,000; most work sold at $1,000.

Media Considers oil, acrylic, watercolor, pastel, collage and works on paper. Most frequently exhibits watercolor, oil, acrylic and hand-blown glass.

Style Exhibits painterly abstraction and impressionism. Currently seeking contemporary works; abstracts in acrylic and fiber; some limited edition serigraphs.

Terms Accepts work on consignment (50% commission). Retail price set by gallery or artist. Sometimes offers payment by installment. Gallery provides contract.

Submissions Send query letter with résumé, slides and SASE. Portfolio review requested if interested in artist's work. Slides, bios and brochures are filed.

Tips "More clients are requesting discounts or longer pay periods."

SETH JASON BEITLER FINE ARTS

250 NW 23rd St., Suite 202, Miami FL 33127. (305)438-0218. Fax: (800)952-7026. E-mail: info@s ethjason.com. Web site: www.sethjason.com. **Owner:** Seth Beitler. For-profit gallery, art consultancy. Estab. 1997. Approached by 300 artists/year. Represents 40 mid-career, established artists. Exhibited artists include Florimond Dufoor, oil paintings; Terje Lundaas, glass sculpture. Sponsors 5 exhibits/year. Average display time: 2-3 months. Clients include local community and upscale. 5-10% of sales are to corporate collectors. Overall price range: $2,000-300,000; most work sold at $5,000.

Media Considers acrylic, glass, mixed media, sculpture, drawing, oil. Most frequently exhibits sculpture, painting, photography. Considers etchings, linocuts, lithographs.

Style Exhibits color field, geometric abstraction and painterly abstraction. Most frequently exhibits geometric sculpture, abstract painting, photography. Genres include figurative work and landscapes.

Terms Artwork is accepted on consignment (50% commission). Retail price set by the gallery. Gallery provides insurance, promotion and contract. Accepted work should be mounted.

Submissions Write to arrange personal interview to show portfolio of photographs, slides, transparencies. Send query letter with artist's statement, bio, photographs, résumé, SASE. Returns material with SASE. Responds to queries in 2 months. Files photos, slides, transparencies. Finds artists through art fairs, portfolio reviews, referrals by other artists and word of mouth.

Tips Send "easy to see photographs. E-mail submissions for quicker response."

MARY BELL GALLERIES

311 West Superior St. , Chicago IL 60610. (312)642-0202. Fax: (312)642-6672. Web site: www.marybell.com. **President:** Mary Bell. Retail gallery. Estab. 1975. Represents mid-career artists. Interested in seeing the work of emerging artists. Exhibited artists include Mark Dickson. Sponsors 4 shows/year. Average display time: 6 weeks. Open all year. Located downtown in gallery district; 5,000 sq. ft. 25% of space for special exhibitions. Clientele: corporations, designers and individuals. 50% private collectors, 50% corporate collectors. Overall price range: $500-15,000.

Media Considers oil, acrylic, pastel, mixed media, collage, paper, sculpture, ceramic, fiber, glass, original handpulled prints, offset reproductions, woodcuts, engravings, lithographs, pochoir, posters, wood engravings, mezzotints, serigraphs, linocuts and etchings. Most frequently exhibits canvas, unique paper and sculpture.

Style Exhibits expressionism, painterly abstraction, impressionism, realism and photorealism. Genres include landscapes and florals. Prefers abstract, realistic and impressionistic styles. Does not want ''figurative or bizarre work.''

Terms Accepts artwork on consignment (50% commission). Retail price set by gallery and artist. Offers customer discounts and payment by installments. Gallery provides insurance and contract; shipping costs are shared. Prefers artwork unframed.

Submissions Send query letter with slides and SASE. Portfolio review requested if interested in artist's work. Portfolio should include slides or photos.

CECELIA COKER BELL GALLERY

All mail to Larry Merriman, Coker College, 300 East College Ave., Hartsville, SC 29550. (843)383-8156. E-mail: lmerriman@pascal.coker.edu. Web site: http://www.coker.edu/art/gallery.html for prospectus. **Director:** Larry Merriman. ''A campus-located teaching gallery that exhibits a variety of media and styles to expose students and the community to the breadth of possibility for expression in art. Exhibits include regional, national and international artists with an emphasis on quality and originality. Shows include work from emerging, mid, and late career artists.'' Sponsors 5 solo shows/year, with a 4-week run for each show.

Media Considers all media including installation and graphic design. Most frequently exhibits painting, photograpy, sculpture/installation and mixed media.

Style Considers all styles. Not interested in conservative/commercial art.

Terms Retail price set by artist (sales are not common). Exclusive area representation not required. Gallery provides insurance, promotion and contract; shipping costs are shared.

Submissions Send résumé, 10 slides (or JPEGs on CD), and SASE by October 27. Visits by artists are welcome; however, the exhibition committee will review and select all shows from the slides and JPEGs submitted by the artists.

BELL STUDIO

3428 N. Southport Ave., Chicago IL 60657. Web site: www.bellstudio.net. **Director:** Paul Therieau. For-profit gallery. Estab. 2001. Approached by 60 artists/year; represents or exhibits 10 artists. Sponsors 10 exhibits/year. Average display time: 6 weeks. Open all year; Monday-Friday, 12-7; weekends, 12-5. Located in brick storefront with high traffic; 750 sq. ft. of exhibition space. Overall price range: $150-3,500; most work sold at $600.

Media Considers acrylic, collage, drawing, mixed media, oil, paper, pastel, pen & ink and watercolor. Considers all types of prints except posters. Most frequently exhibits watercolor, oils and photography.

Style Exhibits minimalism, postermodernism and painterly abstraction. Genres include figurative work and landscapes.

Terms Artwork is accepted on consignment (50% commission). Retail price set by the gallery. Gallery provides insurance, promotion and contract. Accepted work should be framed. Requires exclusive representation locally.

Submissions Write to arrange a personal interview to show portfolio; include bio and résumé. Responds to queries within 3 months, only if interested. Finds artists through referrals by other artists, submissions, word of mouth.

Tips "Type submission letter and include your show history, résumé and a SASE."

BENNETT GALLERIES

5308 Kingston Pike, Knoxville TN 37919. (865)584-6791. Fax: (865)588-6130. Web site: www.bennettgalleries.com. **Director:** Marga Hayes. Owner: Rick Bennett. Retail gallery. Represents emerging and established artists. Exhibited artists include Richard Jolley, Carl Sublett, Scott Duce, Andrew Saftel and Tommie Rush, Akira Blount, Scott Hill, Marga Hayes Ingram, John Boatright, Grace Ann Warn, Timothy Berry, Cheryl Warrick, Dion Zwirne. Sponsors 10 shows/ year. Average display time: 1 month. Open all year; Monday-Thursday, 10-6; Friday-Saturday, 10-5:30. Located in West Knoxville. Clientele: 80% private collectors, 20% corporate collectors. Overall price range: $200-20,000; most work sold at $2,000-8,000.

Media Considers oil, acrylic, watercolor, pastel, drawing, mixed media, works on paper, sculpture, ceramic, craft, photography, glass, original handpulled prints. Most frequently exhibits painting, ceramic/clay, wood, glass and sculpture.

Style Exhibits contemporary works in abstraction, figurative, narrative, realism, contemporary landscape and still life.

Terms Accepts artwork on consignment (50% commission). Retail price set by the gallery and the artist. Sometimes offers customer discounts and payment by installments. Gallery provides insurance on works at the gallery, promotion and contract. Prefers artwork framed. Shipping to gallery to be paid by the artist.

Submissions Send query letter with résumé, no more than 10 slides, bio, photographs, SASE and reviews. Finds artists through agents, visiting exhibitions, word of mouth, various art publications, sourcebooks, submissions/self-promotions and referrals.

SYBIL BERG CONTEMPORARY ART

444 E. 82nd St., Suite 6T, New York NY 10028. E-mail: mgyerman@verizon.net. Web site: www.sybilbergca.com. **Curator:** Marcia G. Yerman. Estab. 2004. "Sybil Berg Contemporary Art is a consultancy that focuses on the work of women artists. We file JPEGs of artwork by women for projects, lectures and exhibits."

Media Considers all media.

Submissions E-mail JPEGs to be kept on file.

MONA BERMAN FINE ARTS

78 Lyon St., New Haven CT 06511. (203)562-4720. Fax: (203)787-6855. E-mail: info@monabermanfinearts.com. Web site: www.monabermanfinearts.com. **Director:** Mona Berman. Art consultant. Estab. 1979. Represents 100 emerging and mid-career artists. Exhibited artists include Tom Hricko, David Dunlop, Pierre Dardignac and S. Wind-Greenbaum. Sponsors 1 show/year. Open all year by appointment. Located near downtown; 1,400 sq. ft. Clientele: 25% private collectors,

75% corporate collectors. Overall price range: $400-20,000; most artwork sold at $500-7,000.

Media Considers all media except installation. Shows very little sculpture. Considers all limited edition prints except posters and photolithography. Also considers limited and carefully selected, well-priced, high-quality digital media. Most frequently exhibits works on paper, painting, relief and ethnographic arts.

Style Exhibits most styles. Prefers abstract, landscape and transitional. Little figurative, little still life.

Terms Accepts work on consignment (50% commission; net 30 days). Retail price is set by gallery and artist. Retail prices must be consistent regardless of venue. Customer discounts and payment by installment are available. Gallery provides insurance; artist pays for shipping. Prefers artwork unframed.

Submissions Accepts digital submissions by e-mail and links to Web sites- please include retail prices with all inquiries; or send query letter, résumé, CD, bio, SASE, reviews and "retail price list." Portfolios are reviewed only after images have been reviewed. Responds in 1 month. Include e-mail address for faster response. CDs and supporting material returned only if SASE is included. Finds artists through word of mouth, art publications and sourcebooks, submissions and self-promotions and other professionals' recommendations.

Tips "We will not carry artists who do not maintain consistent retail pricing. We are not a gallery, although we do a few exhibits; so please do not submit if you are looking for an exhibition venue. We are primarily art consultants. We continue to be busy selling high-quality art and related services to the corporate, architectural, design and private sectors. A follow-up e-mail is preferable to a phone call."

BERTONI GALLERY

1392 Kings Hwy., Sugar Loaf NY 10981. (845)469-0993. Fax: (845)469-6808. E-mail: bertoni@op tonline.net. Web site: www.bertonigallery.com. **Owner:** Rachel Bertoni. For-profit gallery, rental gallery, art consultancy. Estab. 2000. Exhibits emerging, mid-career and established artists. Approached by 15 artists/year; represents 5 artists/year. Exhibited artists include Mae Bertoni (watercolor) and Mike Jarosko (oil). Sponsors 5 exhibits/year. Average display time: 2 months. Open Thursday-Sunday, 11-6. Clients include local community, tourists. 10% of sales are to corporate collectors. Overall price range: $100-1,500; most work sold at $400.

Media Considers all media. Most frequently exhibits watercolor, oil, mixed media. Considers all types of prints

Style Exhibits all styles and genres.

Making Contact & Terms Artwork is accepted on consignment (40% commission); or artwork is bought outright for 50% of retail price. There is a rental fee for space; rental fee covers 2 months. Retail price set by the artist. Accepted work should be framed, mounted, matted.

Submissions Send query letter with artist's statement, résumé and photographs. Returns material with SASE. Responds to queries in 2 weeks. Finds artists through word of mouth and referrals by other artists.

Tips "Submit materials in a neat manner with SASE for easy return."

TOM BINDER FINE ARTS

825 Wilshire Blvd. #708, Santa Monica CA 90401. (310)822-1080. Fax: (310)822-1580. E-mail: info@artman.net. Web site: www.artman.net. **Owner:** Tom Binder. For-profit gallery. Exhibits established artists. Also has a location in Marina Del Rey. Clients include local community, tourists and upscale. Overall price range: $200-2,000.

● See additional listing in the Posters & Prints section.

Media Considers all media; types of prints include etchings, lithographs, posters and serigraphs.

Style Considers all styles and genres.

Making Contact & Terms Artwork is accepted on consignment or bought outright. Retail price set by the gallery. Gallery provides insurance. Accepted work should be mounted.

Submissions Write to arrange a personal interview to show portfolio. Returns material with SASE. Responds in 2 weeks.

☷ BLUE SPIRAL 1

38 Biltmore Ave., Asheville NC 28801. (828)251-0202. Fax: (828)251-0884. E-mail: info@bluespi ral1.com. Web site: www.bluespiral1.com. **Director:** John Cram. Retail gallery. Estab. 1991. Represents emerging, mid-career and established artists living in the Southeast. Over 100 exhibited artists including Julyan Davis, John Nickerson, Suzanne Stryk, Greg Decker and Will Henry Stephens. Sponsors 15-20 shows/year. Average display time: 6-8 weeks. Open all year; Monday-Saturday, 10-6; Sunday, 12-5 (May-October). Located downtown; 15,000 sq. ft.; historic building. 50% of space for special exhibitions; 50% of space for gallery artists. Clientele "across the range;" 90% private collectors, 10% corporate collectors. Overall price range: less than $100-50,000; most work sold at $100-2,500.

Media Considers all media. Most frequently exhibits painting, clay, sculpture and glass.

Style Exhibits all styles, all genres.

Terms Accepts work on consignment (50% commission). Retail price set by the artist. Gallery provides insurance, promotion and contract; artist pays shipping costs to and from gallery. Prefers framed artwork.

Submissions Accepts only artists from Southeast. Send query letter with résumé, slides, prices, statement and SASE. Responds in 3 months. Files slides, name and address. Finds artists through word of mouth, referrals and travel.

Tips "Work must be technically well executed and properly presented."

BOCA RATON MUSEUM OF ART

501 Plaza Real, Boca Raton FL 33432. (561)392-2500. Fax: (561)391-6410. E-mail: info@bocamu seum.org. Web site: www.bocamuseum.org. **Executive Director:** George S. Bolge. Museum. Estab. 1950. Represents established artists. 5,500 members. Exhibits change every 2-3 months. Open all year; Tuesday, Thursday and Friday, 10-5; Wednesday, 10-9; Saturday and Sunday, 12-5. Located one mile east of I-95 in Mizner Park; 44,000 sq. ft.; national and international temporary exhibitions and impressive second-floor permanent collection. Three galleries—one shows permanent collection, two are for changing exhibitions. 66% of space for special exhibitions.

Media Considers all media. Exhibits modern masters including Braque, Degas, Demuth, Glackens, Klee, Matisse, Picasso and Seurat; 19th and 20th century photographers; Pre-Columbian and African art; contemporary sculpture.

Submissions "Contact executive director in writing."

Tips "Photographs of work of art should be professionally done if possible. Before approaching museums, an artist should be well-represented in solo exhibitions and museum collections. Their acceptance into a particular museum collection, however, still depends on how well their work fits into that collection's narrative and how well it fits with the goals and collecting policies of that museum."

⊠ BOODY FINE ARTS, INC.; PUBLIC ART & PRACTICE, LLC

10706 Trenton Ave., St. Louis MO 63132. (314)423-2255. Fax: (314)423-9977. E-mail: BFA@Boo dyFineArts.com; PAP@PublicArtAndPractice.com. Web site: www.boodyfinearts.com; www.p ublicartandpractice.com. **Owners:** Steven and Diane Boody. Retail gallery and art consultancy. "Clientele is nationwide. Staff travels on a continual basis to develop collections." Estab. 1978. Represents 200 mid-career and established artists. Clientele: 20% private collectors, 30% public and 50% corporate clients. Overall price range: $1,000-$3,000,000.

Media Considers oil, acrylic, watercolor, pastel, drawings, mixed media, collage, sculpture, ceramic, fiber, metalworking, glass, works on handmade paper, neon and original hand pulled prints, stainless steel, bronze, aluminum, corten, stone, etc.

Style Exhibits color field, painterly abstraction, minimalism, impressionism and photorealism. Prefers non-objective, figurative work and landscapes.

Terms Accepts work on consignment. Retail price is set by artist and staff. Customer discounts and payment by installments available. Gallery provides promotion and contract; shipping costs are shared.

Submissions Send query letter, resume and slides. "Accepts e-mail introductions with referrals or invitations to Web sites; no attachments. Write to schedule an appointment or to send attachments to show a portfolio, which should include originals, slides and transparencies. All material is filed. Finds artists by visiting exhibitions, word of mouth, submissions, Internet and art collectors' referrals.

Tips "I very seldom work with an artist until they have been out of college for about ten years."

⊞ BRACKNELL GALLERY; MANSION SPACES

South Hill Park Arts Centre, Berkshire RG12 7PA United Kingdom. E-mail: outi.remes@southhill park.org.uk. Web site: www.southhillpark.org.uk. **Visual Arts & Exhibitions Officer:** Dr. Outi Remes. Alternative space/nonprofit gallery. Estab. 1991. Approached by at least 50 artists/ year; exhibits several shows of emerging, mid-career and established artists. "Very many artists approach us for the Mansion Spaces; all applications are looked at." Exhibited artists include Billy Childish (painting), Paul Russell (photography) and Matt Sherratt (ceramic). Average display time: 2 months. Open all year; call or check Web site for hours. Located "within a large arts centre that includes theatre, cinema, studios, workshops and a restaurant; one large room and one smaller with high ceilings, plus more exhibiting spaces around the centre." Clients include local community and students.

Media Considers all media. Most frequently exhibits painting, sculpture, live art, installations, group shows, video-digital works, craftwork (ceramics, glasswork, jewelry). Considers all types of prints.

Style Considers all styles and genres.

Terms Artwork is accepted on consignment, and there is a 20% commission. Retail price set by the artist. Gallery provides insurance, promotion and contract.

Submissions Send query letter with artist's statement, bio and photographs. Returns material with SAE. Responds to queries only if interested. Files all material "unless return of slides/ photos is requested." Finds artists through invitations, art exhibits, referrals by other artists, submissions and word of mouth.

Tips "We have a great number of applications for exhibitions in the Mansion Spaces. Make yours stand out! Exhibitions at the Bracknell Gallery are planned 2-3 years in advance."

RENA BRANSTEN GALLERY

77 Geary St., San Francisco CA 94108. (415)982-3292. Fax: (415)982-1807. E-mail: leigh@renabr anstengallery.com. Web site: www.renabranstengallery.com. **Director:** Leigh Markopoulos. For-profit gallery. Estab. 1974. Exhibits emerging, mid-career and established artists. Approached by 200 artists/year. Exhibits 12-15 artists/year. Average display time: 4-5 weeks. Open Tuesday-Friday, 10:30-5:30; Saturday, 11-5; usually closed the last week of August and the first week of September.

Media Considers all media except craft and fiber. Considers all types of prints.

Style Considers all styles of contemporary art.

Term Retail price set by the gallery and the artist.

Submissions Send JPEGs or Web site link via e-mail. Mailed submissions must include SASE if return of materials is required. Files cover letter from artist. Finds artists through art fairs and exhibits, portfolio reviews, referrals by curators and other artists, studio visits and word of mouth.

BRENAU UNIVERSITY GALLERIES

500 Washington St. SE, Gainesville GA 30501. (770)534-6263. Fax: (770)538-4599. E-mail: galler y@lib.brenau.edu. Web site: www.brenau.edu. **Gallery Director:** Tonya Cribb. Nonprofit gallery. Estab. 1980s. Exhibits emerging, mid-career and established artists. Sponsors 7-9 shows/year. Average display time: 6-8 weeks. Open all year; Tuesday-Friday, 10-4; Sunday, 2-5 during exhibit dates. "Please call for summer hours." Located near downtown; 3,958 sq. ft., 3 galleries—the main one in a renovated 1914 neoclassic building, another in an adjacent renovated Victorian building dating from the 1890s, the third in the center for performing arts. 100% of space for special exhibitions. Clientele: tourists, upscale, local community, students. "Although sales do occur as a result of our exhibits, we do not currently take any percentage, except in our invitational exhibitions. Our purpose is primarily educational."

Media Considers all media.

Style Exhibits wide range of styles. "We intentionally try to plan a balanced variety of media and styles."

Terms Retail price set by the artist. Gallery provides insurance and promotion; shipping costs are shared, depending on funding for exhibits. Prefers artwork framed. "Artwork must be framed or otherwise ready to exhibit."

Submissions Send query letter with résumé, 10-20 slides, photographs and bio. Write for appointment to show portfolio of slides and transparencies. Responds within months if possible. Artist should call to follow up. Files one or two slides or photos with a short résumé or bio if interested. Remaining material returned. Finds artists through referrals, direct viewing of work and inquiries.

Tips "Be persistent, keep working, be organized and patient. Take good slides and develop a body of work. Galleries are limited by a variety of constraints—time, budgets, location, taste—and rejection does not mean your work may not be good; it may not 'fit' for other reasons at the time of your inquiry."

BREW HOUSE SPACE 101

2100 Mary St., Pittsburgh PA 15203. (412)381-7767. Fax: (412)390-1977. E-mail: thebrewhouse @gmail.com. Web site: www.brew-house.org. Alternative space; cooperative, nonprofit, rental gallery. Estab. 1993. Average display time: 1 month. Open Wednesday and Thursday, 6-9; Satur-

day, 12-6. Located in Pittsburgh's historic south side; 1,360 sq. ft. with 23-ft.-high ceilings.

Media Considers all media and all types of prints. Most frequently exhibits sculpture, painting and installation.

Style Considers all styles and genres.

Terms Artwork is accepted through juried selection. Gallery provides insurance, promotion, contract. Accepted work should be framed.

Submissions Mail portfolio for review. Responds in 3 months. Finds artists through submissions.

BROOKFIELD CRAFT CENTER

P.O. Box 122, 286 Whisconier Rd., Brookfield CT 06804-0122. E-mail: info@brookfieldcraftcente r.org. Web site: www.brookfieldcraftcenter.org. **Contact:** Gallery Director. Nonprofit gallery. Estab. 1954. Exhibits emerging, mid-career and established craft artists. Approached by 100 artists/year; represents 400+ craft artists.

Media Considers ceramics, craft, drawing, glass, mixed media and paper. Most frequently exhibits clay, glass, metal, wood

Style Exhibits originally curated group shows of art in craft media.Considers all genres.

Terms Artwork is accepted on consignment (40% commission) or bought outright for 50% of retail price; net 30 days. Retail price of the art set by the artist. Gallery provides insurance, promotion and contract. Accepted work should be framed.

Submissions Call or E-mail to arrange personal interview to show portfolio of photographs and slides. Send query letter with brochure. Returns material with SASE. Responds to queries in 2 weeks to 1 month. Finds artists through art fairs/exhibits, portfolio reviews, referrals by other artists, submissions and word of mouth.

BROOKLYN BOTANIC GARDEN—STEINHARDT CONSERVATORY GALLERY

1000 Washington Ave., Brooklyn NY 11225. (718)623-7200. Fax: (718)622-7839. E-mail: emilyca rson@bbg.org. Web site: www.bbg.org. **Public Programs Associate:** Emily Carson. Nonprofit botanic garden gallery. Estab. 1988. Represents emerging, mid-career and established artists. 20,000 members. Sponsors 10-12 shows/year. Average display time: 4-6 weeks. Open all year; Tuesday-Sunday, 10-4. Located near Prospect Park and Brooklyn Museum; 1,200 sq. ft.; part of a botanic garden, gallery adjacent to the tropical, desert and temperate houses. Clients include BBG members, tourists, collectors. 100% of sales are to private collectors. Overall price range: $75-7,500; most work sold at $75-500.

Media Considers all media and all types of prints. Most frequently exhibits watercolor, oil and photography.

Style Exhibits all styles. Genres include landscapes, florals and wildlife.

Terms Accepts work on consignment (20% commission). Retail price set by the artist. Gallery provides insurance, promotion and contract; artist pays shipping costs to and from gallery. Artwork must be framed or ready to display unless otherwise arranged. Artists hang and remove their own shows.

Submissions Work must reflect the natural world. Send query letter with résumé, slides, bio, brochure, photographs, SASE, business card and reviews for review.

Tips ''Artists' groups contact me by submitting résumé and slides of artists in their group. We favor seasonal art which echoes the natural events going on in the garden. Large format, colorful works show best in our multi-use space.''

BRUNNER GALLERY

215 N. Columbia St., Covington LA 70433. (985)893-0444. Fax: (985)893-4332. E-mail: submissio ns@brunnergallery.com. Web site: www.brunnergallery.com. **Owner/Director:** Susan Brunner. For-profit gallery. Estab. 1997. Approached by 400 artists/year. Exhibits 45 emerging, mid-career and established artists. Sponsors 10-12 exhibits/year. Average display time: 1 month. Open all year; Tuesday-Saturday, 10-5; weekends, 10-5. Closed major holidays. Located 45 minutes from metropolitan New Orleans, one hour from capital of Baton Rouge and Gulf Coast; 2,500 sq. ft. Building designed by Rick Brunner, artist and sculptor, and Susan Brunner, designer. Clients include local community, tourists, upscale and professionals. 20% of sales are to corporate collectors. Overall price range: $200-10,000; most work sold at $1,500-3,000.

Media Considers all media. Types of prints include etchings and monoprints.

Style Considers all styles and genres. Most frequently exhibits abstraction, expressionism and conceptualism.

Terms Artwork is accepted on consignment (50% commission) or bought outright for 90-100% of retail price (net 30 days). Retail price set by the gallery and the artist. Gallery provides insurance, promotion and contract. Accepted work should be framed. Requires exclusive representation locally.

Submissions Preliminary review: E-mail artist's statement, bio, résumé, 3 JPEG files (no larger than 72 dpi) or URL. Submissions are reviewed quarterly. Will contact for portfolio review if interested. (See Web site for additional information regarding "secondary review" guidelines.) Finds artists through word of mouth, submissions, portfolio reviews, art fairs/exhibits, and referrals by other artists.

Tips "In order for us to offer representation to an artist, it is necessary for us to consider whether the artist will be a good fit for the private and corporate collectors who make up our client base. We request that each image include not only the title, dimensions and medium, but also the retail price range."

BUNNELL STREET GALLERY

106 W. Bunnell, Suite A, Homer AK 99603. (907)235-2662. Fax: (907)235-9427. E-mail: bunnell @xyz.net. Web site: www.bunnellstreetgallery.org. **Director:** Asia Freeman. Nonprofit gallery. Estab. 1990. Approached by 50 artists/year. Represents 35 emerging, mid-career and established artists. Sponsors 12 exhibits/year. Average display time: 1 month. Open Monday-Saturday, 10-6; Sunday, 12-4 (summer only). Closed January. Located on corner of Main and Bunnell Streets, Old Town, Homer; 30×25 exhibition space; good lighting, hardwood floors. Clients include local community and tourists. 10% of sales are to corporate collectors. Overall price range: $50-2,500; most work sold at $500.

Media Considers all media. Most frequently exhibits painting, ceramics and installation. No prints; originals only.

Style Considers all styles and genres. Most frequently exhibits painterly abstraction, impressionism, conceptualism.

Terms Artwork is accepted on consignment (35% commission). A donation of time is requested. Gallery provides insurance, promotion and contract. Accepted work should be framed. Does not require exclusive representation locally.

Submissions Call or write to arrange a personal interview to show portfolio of slides or mail portfolio for review. Returns material with SASE. Responds in 1 month. Finds artists through word of mouth, submissions, art exhibits and referrals by other artists.

CADEAUX DU MONDE

26 Mary St., Newport RI 02835. (401)848-0550. Fax: (401)849-3225. E-mail: info@cadeauxdumo nde.com. Web site: www.cadeauxdumonde.com. **Owners:** Jane Dyer and Katie Dyer. Retail gallery. Estab. 1987. Represents emerging, mid-career and established artists. Exhibited artists include John Lyimo and A.K. Paulin. Sponsors 7 changing shows and 1 ongoing show/year. Average display time: 3-4 weeks. Open all year; daily, 10-6 and by appointment. Located in "the Anna Pell House (circa 1840), recently restored with many original details intact including Chiswick tiles on the fireplace and an outstanding back stairway 'Galerie Escalier' (the servant's staircase), which has rotating exhibitions from June to December;" historic, commercial district; 1,300 sq. ft. 15% of space for special exhibitions; 85% of space for gallery artists. Clients include tourists, upscale, local community and students. 95% of sales are to private collectors, 5% corporate collectors. Overall price range: $20-5,000; most work sold at $100-300.

Media Considers all media suitable for display in a stairway setting for special exhibitions. No prints.

Style Exhibits folk art. "Style is unimportant; quality of work is deciding factor. We look for unusual, offbeat and eclectic."

Terms Accepts work on consignment (30% commission). Retail price set by the artist. Gallery provides insurance. Artist pays shipping costs and promotional costs of opening. Prefers framed artwork.

Submissions Send query letter with résumé, 10 slides, bio, photographs and business card. Call for appointment to show portfolio of photographs or slides. Responds within 2 weeks, only if interested. Finds artists through submissions, word of mouth, referrals by other artists, visiting art fairs and exhibitions.

Tips Artists who want gallery representation should "present themselves professionally; treat their art and the showing of it like a small business; arrive on time and be prepared; and meet deadlines promptly."

THE CANTON MUSEUM OF ART

1001 Market Ave. N., Canton OH 44702. (330)453-7666. Fax: (330)453-1034. E-mail: al@cantonart. org. Web site: www.cantonart.org. **Executive Director:** M. Joseph Albacete. Nonprofit gallery. Estab. 1935. Represents emerging, mid-career and established artists. "Although primarily dedi-cated to large-format touring and original exhibitions, the CMA occasionally sponsors solo shows by local and original artists, and one group show every 2 years featuring its own 'Artists League.'" Average display time: 6 weeks. Overall price range: $50-3,000; few sales above $300-500.

Media Considers all media. Most frequently exhibits oil, watercolor and photography.

Style Considers all styles. Most frequently exhibits painterly abstraction, post-modernism and realism.

Terms "While every effort is made to publicize and promote works, we cannot guarantee sales, although from time to time sales are made, at which time a 25% charge is applied." One of the most common mistakes in presenting portfolios is "sending too many materials. Send only a few slides or photos, a brief bio and a SASE."

Tips There seems to be "a move back to realism, conservatism and support of regional artists."

🏛 CAPITOL ARTS ALLIANCE GALLERIES

416 E. Main St., Bowling Green KY 42101-2241. (270)782-2787. E-mail: gallery@capitolarts.com. Web site: www.capitolarts.com. **Gallery Director:** Lynn Robertson. Nonprofit gallery. Ap-

proached by 30-40 artists/year. Represents 16-20 emerging, mid-career and established artists. Sponsors 10 exhibits/year. Average display time: 3-4 weeks. Open daily,. 9-5 Closed Christmas-New Year's Day. Clients include local community and tourists.

Media Considers all media except crafts; all types of prints except posters.

Style Considers all styles.

Terms Artwork is accepted on consignment (30% commision). Retail price set by the artist. Gallery provides promotion and contract. Accepted work should be framed, wired and ready to hang. Accepts only artists within a 100-mile radius.

Submissions Contact Capitol Arts to be added to Call to Artists List. Finds artists through submissions and word of mouth.

CARNEGIE ARTS CENTER

204 W. Fourth St., Alliance NE 69301-3332. Phone/Fax: (308)762-4571. E-mail: carnegieartscent er@bbc.net. Web site: www.carnegieartscenter.com. **Director:** Peggy Weber. Visual art gallery. Estab. 1993. Represents 300 emerging, mid-career and established artists/year. 350 members. Exhibited artists include Liz Enyeart (functional pottery) and Silas Kern (handblown glass). Sponsors 12 shows/year. Average display time: 6 weeks. Open all year; Tuesday-Saturday, 10-4; Sunday, 1-4. Located downtown; 2,346 sq. ft.; renovated Carnegie library built in 1911. Clients include tourists, upscale, local community and students. 90% of sales are to private collectors; 10% corporate collectors. Overall price range: $10-2,000; most work sold at $10-300.

Media Considers all media and all types of prints. Most frequently exhibits pottery, blown glass, 2D, acrylics, bronze sculpture, watercolor, oil and silver jewelry.

Style Exhibits all styles and genres. Most frequently exhibits realism, modern realism, geometric, abstraction.

Terms Accepts work on consignment (35% commission). Retail price set by the artist. Gallery provides promotion. Shipping costs negotiated. Prefers framed artwork.

Submissions Accepts only quality work. Send query. Write for appointment to show portfolio of photographs, slides or transparencies. Responds within 1 month, only if interested. Files résumé and contracts. Finds artists through submissions, word of mouth, referrals by other artists, visiting art fairs and exhibitions.

Tips ''Presentations must be clean, 'new' quality—that is, ready to meet the public. Two-dimensional artwork must be nicely framed with wire attached for hanging. Unframed prints need protective wrapping in place.''

JOAN CAWLEY GALLERY, LTD.

7135 E. Main St., Scottsdale AZ 85251. (602)947-3548. Fax: (602)947-7255. E-mail: karinc@jcglt d.com. Web site: www.jcgltd.com. **President:** Kevin P. Cawley. Director: Karin Cawley. Retail gallery and print publisher. Estab. 1974. Represents 20 emerging, mid-career and established artists/year. Exhibited artists include Carol Grigg, Adin Shade. Sponsors 5-10 shows/year. Average display time: 2-3 weeks. Open all year; Monday-Saturday, 10-5; Thursday, 7-9. Located in art district, center of Scottsdale; 2,730 sq. ft. (about 2,000 for exhibiting); high ceilings, glass frontage and interesting areas divided by walls. 50% of space for special exhibitions; 75% of space for gallery artists. Clientele: tourists, locals. 90% private collectors. Overall price range: $100-12,000; most work sold at $3,500-5,000.

• Joan Cawley also runs an art licensing company: Joan Cawley Licensing, 1410 W. 14th St., Suite 101, Tempe AZ 85281. (800)835-0075.

Media Considers all media except fabric or cast paper; all graphics. Most frequently exhibits acrylic on canvas, watercolor, pastels and chine colle.

Style Exhibits expressionism, painterly abstraction, impressionism. Exhibits all genres. Prefers Southwestern and contemporary landscapes, figurative, wildlife.

Terms Accepts work on consignment (50% commission.) Gallery provides promotion and contract; shipping costs are shared. Prefers artwork framed.

Submissions Prefers artists from west of Mississippi. Send query letter with bio and at least 12 slides or photos. Call or write for appointment to show portfolio of photographs, slides or transparencies. Responds as soon as possible.

Tips "We are a contemporary gallery in the midst of traditional Western galleries. We are interested in seeing new work always." Advises artists approaching galleries to "check out the direction the gallery is going regarding subject matter and media. Also always make an appointment to meet with the gallery personnel. We always ask for a minimum of five to six paintings on hand. If the artist sells for the gallery, we want more, but a beginning is about six paintings."

CEDARHURST CENTER FOR THE ARTS

Richview Rd., Mt. Vernon IL 62864. (618)242-1236. Fax: (618)242-9530. E-mail: mitchellmuseu m@cedarhurst.org. Web site: www.cedarhurst.org. **Director of Visual Arts:** Amy Roadarmel. Museum. Estab. 1973. Exhibits emerging, mid-career and established artists. Average display time: 6 weeks. Open all year; Tuesday through Saturday, 10-5; Sunday, 1-5; closed Mondays and federal holidays.

Submissions Call or send query letter with artist's statement, bio, resume, SASE and slides.

CENTRAL MICHIGAN UNIVERSITY ART GALLERY

Wightman 132, Art Department, Mt. Pleasant MI 48859. (989)774-3800. Fax: (989)774-2278. E-mail: keefe1ca@cmich.edu. Web site: www.uag.cmich.edu. **Director:** Cynthia Ann Keefe. Nonprofit gallery. Estab. 1970. Approached by 250 artists/year. Represents 40 emerging, mid-career and established artists. Exhibited artists include Ken Fandell, Jan Estep, Sang-Ah-Choi, Amy Yoes, Scott Anderson, Richard Shaw. Sponsors 7 exhibits/year. Average display time: 1 month. Open all year; Monday, Tuesday, Thursday and Friday, 10-5; Wednesday, 12-8; Saturday, 12-5. Clients include local community, students and tourists. Overall price range: $200-5,000.

Media Considers all media and all types of prints. Most frequently exhibits sculpture, painting and photography.

Style Considers all styles.

Terms Buyers are referred to the artist. Gallery provides insurance, promotion and contract. Accepted work should be framed. Does not require exclusive representation locally.

Submissions Write to arrange a personal interview to show portfolio of slides. Mail portfolio for review. Send query letter with artist's statement, bio, résumé, reviews, SASE and slides. Returns material with SASE. Responds within 2 months, only if interested. Files résumé, reviews, photocopies and brochure. Finds artists through word of mouth, submissions, portfolio reviews, art exhibits, and referrals by other artists.

THE CHAIT GALLERIES DOWNTOWN

218 E. Washington St., Iowa City IA 52240. (319)338-4442. Fax: (319)338-3380. E-mail: info@the galleriesdowntown.com. Web site: www.thegalleriesdowntown.com. **Director:** Benjamin Chait.

For-profit gallery. Estab. 2003. Approached by 300 artists/year. Represents 50 emerging, mid-career and established artists. Exhibited artists include Benjamin Chait (giclee), Corrine Smith (painting), John Coyne (cast metal sculpture), Mary Merkel-Hess (fiber sculpture) and Ulfert Wilke (ink on paper). Sponsors 12 exhibits/year. Average display time: 90 days. Open all year; Monday-Friday, 11-6; Saturday, 11-5; Sunday by chance or appointment. Located in a downtown building restored to its original look (circa 1882), with 14-ft. molded ceiling and original 9-ft. front door. Professional museum lighting and scamozzi-capped columns complete the elegant gallery. Clients include local community, students, tourists, upscale. Overall price range: $50-10,000; most work sold at $500-1,000.

Media/Style Considers all media, all types of prints, all styles and all genres. Most frequently exhibits painting, sculpture and ceramic.

Terms Artwork is accepted on consignment, and there is a 50% commission. Retail price set by the gallery and the artist. Gallery provides insurance, promotion and contract. Accepted work should be framed. Requires exclusive representation locally.

Submissions Call; mail portfolio for review. Returns material with SASE. Responds to queries in 2 weeks. Finds artists through art fairs, exhibits, portfolio reviews and referrals by other artists.

CHAPELLIER FINE ART

128 Cabernet Dr., Chapel Hill NC 27516. (919)656-5258. E-mail: chapellier@earthlink.net. Web site: www.artnet.com/gallery/91721/chapellier-fine-art.html. **Director:** Shirley C. Lally. Retail gallery. Estab. 1916. Represents 3 established artists/year. Exhibited artists include Mary Louise Boehm, Elsie Dinsmore Popkin. Sponsors 3-4 shows/year. Average display time: 6-8 weeks. Open all year; Monday-Saturday by appointment. 1,000 sq. ft. 75% of space for special exhibitions; 25% of space for gallery artists. Clientele: upscale. 90% private collectors, 10% corporate collectors. Overall price range: $500-90,000; most work sold at $3,000-10,000.

Media Considers oil, acrylic, watercolor, pastel, pen & ink, drawing, mixed media, paper, sculpture (limited to small pieces) and all types of prints. Most frequently exhibits oil, watercolor, pastel.

Style Exhibits impressionism and realism. Exhibits all genres. Prefers realism and impressionism. Inventory is primarily 19th and early 20th century American art.

Terms Accepts work on consignment (50% commission). Retail price set by the gallery. Gallery provides insurance, promotion and contract; shipping costs are shared. Prefers artwork framed.

Submissions Accepts only artists from America. Send query letter with résumé, slides, bio or photographs, price list and description of works offered, exhibition record. Write for appointment to show portfolio of photographs, transparencies or slides. Responds in 1 month. Files material only if interested. Finds artists through word of mouth, visiting art fairs and exhibitions.

Tips "Gallery owner and artist must be compatible and agree on terms of representation."

CHAPMAN FRIEDMAN GALLERY

624 W. Main St., Louisville KY 40202. E-mail: friedman@imagesol.com. Web site: www.chapmanfriedmangallery.com; www.imagesol.com. **Owner:** Julius Friedman. For-profit gallery. Estab. 1992. Approached by 100 or more artists/year. Represents or exhibits 25 artists. Sponsors 7 exhibits/year. Average display time: 1 month. Open Wednesday-Saturday, 10-5. Closed during August. Located downtown; approximately 3,500 sq. ft. with 15-ft. ceilings and white walls. Clients include local community and tourists. 5% of sales are to corporate collectors. Overall price range: $75-10,000; most work sold at more than $1,000.

Media Considers all media except craft. Types of prints include engravings, etchings, lithographs, posters, serigraphs and woodcuts. Most frequently exhibits painting, ceramics and photography.

Style Exhibits color field, geometric abstraction, primitivism realism, painterly abstraction. Most frequently exhibits abstract, primitive and color field.

Terms Artwork is accepted on consignment (50% commission). Retail price set by the artist. Gallery provides insurance, promotion and contract. Accepted work should be framed. Requires exclusive representation locally.

Submissions Send query letter with artist's statement, bio, brochure, photographs, résumé, slides and SASE. Returns material with SASE. Responds to queries in 1 month. Finds artists through portfolio reviews and referrals by other artists.

CINCINNATI ART MUSEUM

953 Eden Park Dr., Cincinnati OH 45202. (513)639-2995. Fax: (513)639-2888. E-mail: information@cincyart.org. Web site: www.cincinnatiartmuseum.org. **Deputy Director:** Anita J. Ellis. Estab. 1881. Exhibits 6-10 emerging, mid-career and established artists/year. Sponsors 20 exhibits/year. Average display time: 3 months. Open all year; Tuesday-Sunday, 11-5 (Wednesday open until 9). Closed Mondays, Thanksgiving, Christmas, New Year's Day and Fourth of July. General art museum with a collection spanning 6,000 years of world art. Over 100,000 objects in the collection with exhibitions on view annually. Clients include local community, students, tourists and upscale.

Media Considers all media and all types of prints. Most frequently exhibits paper, mixed media and oil.

Style Considers all styles and genres.

Submissions Send query letter with artist's statement, photographs, reviews, SASE and slides.

CLAMPART

531 W. 25th Street, New York NY 10001. (646)230-0020. E-mail: info@clampart.com. Web site: www.clampart.com. **Director:** Brian Paul Clamp. For-profit gallery. Estab. 2000. Approached by 1200 artists/year. Represents 15 emerging, mid-career and established artists. Exhibited artists include Arthur Tress (photography), and John Dugdale (photography). Sponsors 6-8 exhibits/year. Average display time: 5 weeks. Open Tuesday-Saturday from 11 to 6; closed last two weeks of August. Located on the ground floor on Main Street in Chelsea. Small exhibition space. Clients include local community, tourists and upscale. 5% of sales are to corporate collectors. Overall price range: $300-50,000; most work sold at $2,000.

Media Considers acrylic, collage, drawing, mixed media, oil, paper, pastel, pen & ink and watercolor. Considers all types of prints. Most frequently exhibits photo, oil and paper.

Style Exhibits conceptualism, geometric abstraction, minimalism and postmodernism. Considers genres including figurative work, florals, landscapes and portraits. Most frequently exhibits postmodernism, conceptualism and minimalism.

Terms Artwork is accepted on consignment (50% commission). Retail price set by the gallery. Gallery provides insurance, promotion and contract. Accepted work should be framed, mounted and matted. Does not require exclusive representation locally.

Submissions E-mail query letter with artist's statement, bio and JPEGs. Cannot return material. Responds to queries in 2 weeks. Finds artists through portfolio reviews, referrals by other artists and submissions.

Tips "Include a bio and well-written artist statement. Do not submit work to a gallery that does not handle the general kind of work you produce."

CLAY CENTER'S AVAMPATO DISCOVERY MUSEUM

One Clay Square, 300 Leon Sullivan Way, Charleston WV 25301. (304)561-3570. Fax: (304)561-3598. E-mail: info@theclaycenter.org. Web site: www.theclaycenter.org. **Curator:** Ric Ambrose. Museum gallery. Estab. 1974. Represents emerging, mid-career and established artists. Sponsors 6 shows/year. Average display time: 2-3 months. Open all year; contact for hours. Located inside the Clay Center for the Arts & Sciences—West Virginia.

Media Considers oil, acrylic, watercolor, pastel, pen & ink, drawings, mixed media, collage, works on paper, sculpture, installations, photography and prints.

Style Considers all styles and genres.

Terms Retail price set by artist. Gallery pays shipping costs. Prefers framed artwork.

Submissions Send query letter with bio, résumé, brochure, slides, photographs, reviews and SASE. Write for appointment to show portfolio of slides. Responds within 2 weeks, only if interested. Files everything or returns in SASE.

THE CLAY PLACE

1 Walnut St., Suite #2, Carnegie PA 15106 . (412)-276-3260. Fax: (412)276-3250. E-mail: clayplac e1@aol.com. Web site: www.clayplace.com. **Director:** Elvira Peake. Retail gallery. Estab. 1973. Represents 50 emerging, mid-career and established artists. Exhibited artists include Jack Troy and Kirk Mangus. Sponsors 7 shows/year. Open all year. Located in small shopping area; 1,200 sq. ft. 50% of space for special exhibitions. Overall price range: $10-2,000; most work sold at $40-100.

Media Considers ceramic, sculpture, glass and pottery. Most frequently exhibits clay, glass and enamel.

Terms Accepts artwork on consignment (50% commission) or buys outright for 50% of retail price (net 30 days). Retail price set by artist. Sometimes offers customer discounts and payment by installments. Gallery provides insurance, promotion and shipping costs from gallery. We also sell books, tools, equipment and supplies.

Submissions Prefers only clay, some glass and enamel. Send query letter with résumé, slides, photographs, bio and SASE. Write for appointment to show portfolio. Portfolio should include actual work rather than slides. Responds in 1 month. Does not reply when busy. Files résumé. Does not return slides. Finds artists through visiting exhibitions and art collectors' referrals.

Tips "Functional pottery sells well. Emphasis on form, surface decoration. Some clay artists have lowered quality in order to lower prices. Clientele look for quality, not price."

⊞ COAST GALLERIES

P.O. Box 223519, Carmel CA 93922. (831)625-8688. Fax: (831)625-8699. E-mail: gary@coastgall eries.com. Web site: www.coastgalleries.com. **Owner:** Gary Koeppel. Retail galleries. Estab. 1958. Represents 300 emerging, mid-career and established artists. Sponsors 3-4 shows/year. Open daily, all year. Locations in Big Sur and Carmel, California; Hana, Hawaii (Maui). No two Coast Galleries are alike. Each gallery was designed specifically for its location and clientele. The Hawaii gallery features Hawaiiana; the Big Sur gallery is constructed of redwood water tanks and is the one of the largest galleries of American Crafts in the United States." Square footage of each location varies from 1,500 to 3,000 sq. ft. 100% of space for special exhibitions.

Clientele: 90% private collectors, 10% corporate collectors. Overall price range: $25-60,000; most work sold at $400-4,000.

Media Considers all media; engravings, lithographs, posters, etchings, wood engravings and serigraphs. Most frequently exhibits bronze sculpture, limited edition prints, watercolor and oil on canvas.

Style Exhibits impressionism and realism. Genres include landscape, marine, abstract and wild-life.

Terms Accepts fine art and master crafts on consignment (commission varies), or buys master crafts outright (net 30 days). Retail price set by gallery. Gallery provides insurance, promotion and contract; artist pays for shipping. Requires framed artwork.

Submissions Accepts only artists from Hawaii for Hana gallery; coastal and wildlife imagery for California galleries; California painting for Carmel gallery and American crafts for Big Sur gallery. Send query letter with résumé, slides, bio, brochure, photographs, business card and reviews; SASE mandatory if materials are to be returned. Write or e-mail info@coastgalleries.com for appointment. Owner responds to all inquiries.

COLEMAN FINE ART

79 Church St., Charleston SC 29401. (843)853-7000. Fax: (843)722-2552. E-mail: info@colemanfi neart.com. Web site: www.colemanfineart.com. **Gallery Director:** Katherine Wright. Retail gallery; gilding, frame making and restoration. Estab. 1974. Represents 8 emerging, mid-career and established artists/year. Exhibited artists include John Cosby, Marc Hanson, Glenna Hartmann, Joe Paquet, Jan Pawlowski, Don Stone, George Strickland, Mary Whyte. Hosts 2 shows/year. Average display time: 1 month. Open all year; Monday, 10-4; Tuesday-Saturday, 10-6, and by appointment. ''Both a fine art gallery and restoration studio, Coleman Fine Art has been representing regional and national artists for over 30 years. Located on the corner of Church and Tradd streets, the gallery reinvigorates one of the country's oldest art studios.'' Clientele: tourists, upscale and locals. 95-98% private collectors, 2-5% corporate collectors. Overall price range: $1,000-50,000; most work sold at $3,000-8,000.

Media Considers oil, watercolor, pastel, pen & ink, drawing, mixed media, sculpture. Most frequently exhibits watercolor, oil and sculpture.

Style Exhibits expressionism, impressionism, photorealism and realism. Genres include portraits, landscapes, still lifes and figurative work. Prefers figurative work/expressionism, realism and impressionism.

Terms Accepts work on consignment (45% commission); net 30 days. Retail price set by the gallery and the artist. Gallery provides promotion and contract. Shipping costs are shared. Prefers artwork framed.

Submissions Send query letter with brochure, 20 slides/digital CD of most recent work, reviews, bio and SASE. Write for appointment to show portfolio of photographs, slides and transparencies. Responds within 1 month, only if interested. Files slides. Finds artists through submissions.

Tips ''Do not approach gallery without an appointment.''

THE COLONIAL ART GALLERY & CO.

1336 NW First St., Oklahoma City OK 73106. (405)232-5233. Fax: (405)232-6607. E-mail: info@c olonialart.com. Web site: www.colonialart.com. **Owner:** Willard Johnson. Estab. 1919.

● See listing in the Posters & Prints section.

N F COLOR CONNECTION GALLERY

2050 Utica Square, Tulsa OK 74114. (918)742-0515. E-mail: info@colorconnectiongallery.com. Web site: www.colorconnectiongallery.com. Retail and cooperative gallery. Estab. 1991. Represents 11 established artists. Sponsors 12 shows/year. Average display time 1 month. Open all year; Tuesday-Saturday, 10-5:30. Located in midtown. Clientele: upscale, local community. 85% private collectors, 15% corporate collectors. Overall price range $100-5,000; most work sold at $250-1,500.

Media Considers oil, acrylic, watercolor, pastel, pen & ink, drawing, mixed media, collage, paper, sculpture, ceramics, glass, linocuts and etchings. Most frequently exhibits watermedia.

Style Exhibits expressionism, neo-expressionism, painterly abstraction, impressionism and realism. Genres include florals, portraits, southwestern, landscapes and Americana. Prefers impressionism, painterly abstraction and realism.

Terms Seeking 3-D work, no membership fee or work time, 50% commission. Retail price set by the artist. Gallery provides promotion and contract.

Submissions Accepts regional artists. Send query letter with résumé, slides and bio. Call for appointment to show portfolio of photographs, slides and sample of 3-D work. Does not reply. Artist should contact in person. Finds artists through word of mouth, referrals by other artists, visiting art fairs and exhibitions and artist's submissions.

F CONTEMPORARY ART WORKSHOP

542 W. Grant Place, Chicago IL 60614. (773)472-4004. Fax: (773)472-4505. E-mail: info@contemporaryartworkshop.org. Web site: www.contemporaryartworkshop.org. **Director:** Lynn Kearney. Nonprofit gallery. Estab. 1949. Average display time: 1 month. Gallery open Tuesday-Friday, 12:30-5:30; Saturday, 12-5. Closed holidays. "The CAW is located in Chicago's Lincoln Park neighborhood. It is housed in a converted dairy that was built in the 1800s." Includes over 21 artists' studios as well as 2 galleries that show (exclusively) emerging Chicago-area artists.

Media Considers oil, acrylic, mixed media, works on paper, sculpture, installations and original handpulled prints. Most frequently exhibits paintings, sculpture, works on paper and fine art furniture.

Style "Any high-quality work" is considered.

Terms Accepts work on consignment (30% commission). Retail price set by gallery or artist. Gallery provides insurance and promotion. Accepts artists from Chicago area only.

Submissions Send query letter with artist's statement, bio, résumé, reviews, samples (slides, photos or JPEGs on CD), SASE. Responds in 2 months. Finds artists through word of mouth, submissions, art exhibits, referrals by other artists.

CONTEMPORARY ARTS COLLECTIVE

231 W. Charleston Blvd., Suite 110, Las Vegas NV 89102. (702)382-3886. Fax: (702)598-3886. E-mail: info@lasvegascac.org. Web site: www.lasvegascac.org. **Contact:** Natalia Ortiz. Nonprofit gallery. Estab. 1989. Sponsors more than 9 exhibits/year. Average display time: 1 month. Gallery open Tuesday-Saturday, 12-4. Closed Thanksgiving, Christmas, New Year's Day. 1,200 sq. ft. Clients include tourists, local community and students. 75% of sales are to private collectors, 25% corporate collectors. Overall price range: $200-4,000. Most work sold at $400.

Media Considers all media and all types of prints. Most frequently exhibits painting, photography and mixed media.

Style Exhibits conceptualism, group shows of contemporary fine art. Genres include all contemporary art/all media.

Terms Artwork is accepted through annual call for proposals of self-curated group shows; there is a 30% requested donation. Gallery provides insurance, promotion, contract.

ⓝ CONTRACT ART INTERNATIONAL, INC.

P.O. Box 629, Old Lyme CT 06371-0629. (860)434-9799. Fax: (860)434-6240. E-mail: info@contr actartinternational.com. Web site: www.contractartinternational.com. **President:** K. Mac Thames. In business approximately 38 years. "We contract artwork for hospitality, blue-chip, and specialized businesses." Collaborates with emerging, mid-career and established artists. Assigns site-specific commissions to artists based on project design needs, theme and client preferences. Studio is open all year to corporate art directors, architects, designers, and faculty directors. 1,600 sq. ft. studio. Clientele 98% commercial. Overall price range $500-500,000.
Media Places all types of art mediums.
Terms Pays for design by the project, negotiable; 50% up front. Rights purchased vary according to project.
Submissions Send letter of introduction with résumé, slides, bio, brochure, photographs, DVD/ video and SASE. If local, write for appointment to present portfolio; otherwise, mail appropriate materials, which should include slides and photographs. "Show us a good range of your talent. Also, we recommend you keep us updated if you've changed styles or media." Responds in 1 week. Files all samples and information in registry library.
Tips "We exist mainly to art direct commissioned artwork for specific projects."

ⓘ COOS ART MUSEUM

235 Anderson Ave., Coos Bay OR 97420. (541)267-3901. E-mail: info@coosart.org. Web site: www.coosart.org. Not-for-profit corporation; 3rd-oldest art museum in Oregon. Estab. 1950. Mounts 4 juried group exhibitions/year of 85-150 artists; 20 curated single/solo exhibits/year of established artists; and 6 exhibits/year from the Permanent Collection. 5 galleries allow for multiple exhibits mounted simultaneously, averaging 6 openings/year. Average display time: 6-9 weeks. Open Tuesday-Friday, 10-4; Saturday, 1-4. Closed Sunday, Monday and all major holidays. Free admission during evening of 2nd Thursday (Art Walk), 5-8. Clients include local community, students, tourists and upscale.
Media For curated exhibition, considers all media including print, engraving, litho, serigraph. Posters and giclées not considered. Most frequently exhibits paintings (oil, acrylic, watercolor, pastel), sculpture (glass, metal, ceramic), drawings, etchings and prints.
Style Considers all styles and genres. Most frequently exhibits primitivism, realism, postmodernism and expressionism.
Terms No gallery floor sales. All inquiries are referred directly to the artist. Retail price set by the artist. Museum provides insurance, promotion and contract. Accepted work should be framed, mounted and matted. Accepts only artists from Oregon or Western United States.
Submissions Send query letter with artist's statement, bio, résumé, SASE, slides or digital files on CD or links to Web address. Responds to queries in 6 months. Never send 'only copies' of slides, résumés or portfolios. Exhibition committee reviews 2 times/year—schedule exhibits 2 years in advance. Files proposals. Finds artists through portfolio reviews and submissions.
Tips "Have complete files electronically on a Web site or CD. Have a written positioning statement and proposal of show as well as letter(s) of recommendation from a producer/curator/ gallery of a previous curated exhibit. Do not expect us to produce or create exhibition. You should have all costs figured ahead of time and submit only when you have work completed and ready. We do not develop artists. You must be professional."

CORBETT GALLERY

Box 339, 459 Electric Ave. B, Bigfork MT 59911. (406)837-2400. E-mail: corbett@digisys.net. Web site: www.corbettgallery.com. **Director:** Jean Moore. Retail gallery. Estab. 1993. Represents 20 mid-career and established artists. Exhibited artists include Cynthia Fisher. Sponsors 2 shows/year. Average display time: 3 weeks. Open all year; Sunday-Friday, 10-7 summer, 10-5 winter. Located downtown; 2,800 sq. ft. Clients include tourists and upscale. 90% of sales are to private collectors. Overall price range: $250-10,000; most work sold at $2,400.

Media Considers all media; types of prints include engravings, lithographs, serigraphs and etchings. Most frequently exhibits oil, watercolor, acrylic and pastels.

Style Exhibits photorealism. Genres include western, wildlife, southwestern and landscapes. Prefers wildlife, landscape and western.

Terms Accepts work on consignment (40% commission). Retail price set by the artist. Gallery provides insurance, promotion and contract. Shipping costs are shared. Prefers artwork framed.

Submissions Send query letter with slides, brochure and SASE. Call for appointment to show portfolio of photographs or slides. Responds in 1 week. Files brochures and bios. Finds artists through art exhibitions and referrals.

Tips "Don't show us only the best work, then send mediocre paintings that do not equal the same standard."

CORPORATE ART SOURCE

2960-F Zelda Rd., Montgomery AL 36106. (334)271-3772. E-mail: casjb@mindspring.com. Web site: casgallery.com. For-profit gallery, art consultancy. Estab. 1985. Exhibits mid-career and established artists. Approached by 40 artists/year; exhibits 50 artists/year. Exhibited artists include George Taylor and Lawrence Mathis. Open Monday-Friday, 10-5:30; closed weekends. Located in an upscale shopping center; small gallery walls, but walls are filled; 50-85 pieces on display. Clients include corporate clients. Overall price range: $200-40,000; most work sold at $1,000.

Media Considers all media and all types of prints. Most frequently exhibits paintings, glass and watercolor.

Style Considers all styles and genres. Most frequently exhibits painterly abstraction, impressionism and realism.

Terms Artwork is accepted on consignment (50% commission). Retail price set by artist.

Submissions Call, e-mail, or write to arrange a personal interview to show portfolio of photographs, slides, transparencies or CD, résumé and reviews. Returns material with SASE.

Tips "Have good photos of work, as well as Web sites with enough work to get a feel for the overall depth and quality."

CUESTA COLLEGE ART GALLERY

P.O. Box 8106, San Luis Obispo CA 93403-8106. (805)546-3202. Fax: (805)546-3904. E-mail: tanderso@cuesta.edu. Web site: academic.cuesta.cc.ca.us/finearts/gallery.htm. **Director:** Tim Anderson. Nonprofit gallery. Estab. 1965. Exhibits the work of emerging, mid-career and established artists. Exhibited artists include Italo Scanga and JoAnn Callis. Sponsors 8 shows/year. Average display time: 4½ weeks. Open all year. Space is 1,300 sq. ft.; 100% of space for special exhibitions. Overall price range: $250-5,000; most work sold at $400-1,200.

Media Considers all media and all types of prints. Most frequently exhibits painting, sculpture and photography.

Style Exhibits all styles, mostly contemporary.

Terms Accepts work on consignment (20% commission). Retail price set by artist. Customer payment by installment available. Gallery provides insurance, promotion and contract; shipping costs are shared. Prefers artwork framed.

Submissions Send query letter with artist statement, slides, bio, brochure, SASE and reviews. Call for appointment to show portfolio. Responds in 6 months. Finds artists mostly by reputation and referrals, sometimes through slides.

Tips "We have a medium budget, thus cannot pay for extensive installations or shipping. Present your work legibly and simply. Include reviews and/or a coherent statement about the work. Don't be too slick or too sloppy."

▧ DALES GALLERY

Fisgard St., Victoria BC V8W 1R3 Canada. (250)383-1552. E-mail: dalesgallery@shaw.ca. Web site: www.dalesgallery.ca. **Contact:** Alison Trembath: Art Gallery and framing studio. Estab. 1976. Approached by 50 artists/year, Sponsors 10 exhibits/year. Average display time: 4 weeks. Open all year; Monday-Friday 10-5; Saturday, 11-4. Gallery situated in Chinatown (Old Town); approximately 650 sq. ft. of space-warm and inviting with brick wall and large white display wall. Clients include local community, students, tourists and upscale. Overall price range: $100-4000; most work sold at $800.

Media Considers all media including photography. Most frequently exhibits oils, photography and sculpture.

Style Exhibits both solo and group artists.

Terms Accepts work on consignment (40% commission) Retail price set by both gallery and artist. Accepted work should be framed by professional picture framers. Does not require exclusive representation locally.

Submissions Please email images and Portfolio should include, contact number and prices. Responds within 2 months, only if interested. Finds artists through word of mouth, art exhibits, submissions, art fairs, portfolio reviews and referral by other artists.

THE DALLAS CENTER FOR CONTEMPORARY ART

2801 Swiss Ave., Dallas TX 75204. (214)821-2522. Fax: (214)821-9103. E-mail: info@thecontemporary.net. Web site: www.thecontemporary.net. **Director:** Joan Davidow. Nonprofit gallery. Estab. 1981. Sponsors 10 exhibits/year. Average display time: 6-8 weeks. Gallery open Tuesday-Saturday, 10-5.

Media Considers all media.

Style Exhibits all styles and genres.

Terms Charges no commission. "Because we are nonprofit, we do not sell artwork. If someone is interested in buying art in the gallery, they get in touch with the artist. The transaction is between the artist and the buyer."

Submissions Reviews slides/CDs. Send material by mail for consideration; include SASE. Responds October 1 annually.

Tips "We offer a lot of information on grants, commissions and exhibitions available to Texas artists. We are gaining members as a result of our in-house resource center and non-lending library. Our Business of Art seminar series provides information on marketing artwork, presentation, museum collection, tax/legal issues and other related business issues. Memberships available starting at $50. See our Web site for info and membership levels."

DALLAS MUSEUM OF ART

1717 N. Harwood St., Dallas TX 75201. (214)922-1200. Fax: (214)922-1350. Web site: www.dalla smuseumofart.org. Museum. Estab. 1903. Exhibits emerging, mid-career and established artists. Average display time: 3 months. Open Tuesday-Sunday, 11-5; open until 9 on Thursday. Closed Monday, Thanksgiving, Christmas and New Year's Day. Clients include local community, students, tourists and upscale.

Media Exhibits all media and all types of prints.

Style Exhibits all styles and genres.

Submissions Does not accept unsolicited submissions.

MARY H. DANA WOMEN ARTISTS SERIES

Douglass Library, Rutgers, 8 Chapel Dr., New Brunswick NJ 08901. E-mail: olin@rci.rutgers.edu. Web site: www.libraries.rutgers.edu/rul/exhibits/dana_womens.shtml. **Curator:** Dr. Ferris Olin. Alternative space for juried exhibitions of works by women artists. Estab. 1971. Sponsors 4 shows/year. Average display time: 5-6 weeks. Located on college campus in urban area. Clients include students, faculty and community.

Media Considers all media.

Style Exhibits all styles and genres.

Terms Retail price by the artist. Gallery provides insurance and promotion; arranges transportation.

Submissions Does not accept unsolicited submissions. Write or e-mail with request to be added to mailing list.

HAL DAVID FINE ART

P.O. Box 411213, St. Louis MO 63141. (314)409-7884. E-mail: mscharf@sbcglobal.net. Web site: www.maxrscharf.com. **Director:** Max Scharf. For-profit gallery. Estab. 1991. Exhibits established artists. Approached by 30 artists/year; represents 3 artists/year. Exhibited artists include Max R. Scharf (acrylic on canvas) and Sandy Kaplan (terra cotta sculpture). Sponsors 3 exhibits/year. Average display time: 2 months. Open all year. Clients include upscale. 30% sales are to corporate collectors. Overall price range: $2,000-30,000; most work sold at $10,000.

Style Exhibits expressionism, impressionism, painterly abstraction. Most frequently exhibits impressionism and expressionism.

Making Contact & Terms Artwork is accepted on consignment (50% commission). Retail price set by the artist. Accepted work should be framed. Does not require exclusive representation locally.

Submissions Returns material with SASE. Responds to queries in 3 weeks. Finds artists through referrals by other artists.

Tips "Have a good Web site to look at."

⊠ DISTRICT OF COLUMBIA ARTS CENTER (DCAC)

2438 18th St. NW, Washington DC 20009. (202)462-7833. Fax: (202)328-7099. E-mail: info@dcar tscenter.org. Web site: www.dcartscenter.org. **Executive Director:** B. Stanley. Nonprofit gallery and performance space. Estab. 1989. Exhibits emerging and mid-career artists. Sponsors 7-8 shows/year. Average display time 1-2 months. Open Wednesday-Sunday, 2-7; Friday-Saturday, 2-10; and by appointment. Located "in Adams Morgan, a downtown neighborhood; 132 running exhibition feet in exhibition space and a 52-seat theater." Clientele: all types. Overall price range $200-10,000; most work sold at $600-1,400.

Media Considers all media including fine and plastic art. "No crafts." Most frequently exhibits painting, sculpture and photography.

Style Exhibits all styles. Prefers "innovative, mature and challenging styles."

Terms Accepts artwork on consignment (30% commission). Artwork only represented while on exhibit. Retail price set by the gallery and artist. Offers payment by installments. Gallery provides promotion and contract; artist pays for shipping. Prefers artwork framed.

Submissions Send query letter with résumé, slides, bio and SASE. Portfolio review not required. Responds in 4 months. More details are available on Web site.

Tips "We strongly suggest the artist be familiar with the gallery's exhibitions and the kind of work we show strong, challenging pieces that demonstrate technical expertise and exceptional vision. Include SASE if requesting reply and return of slides!"

DOLPHIN GALLERIES

230 Hana Highway, Suite 12, Kahalui HI 96732. (800)669-5051, ext. 207. Fax: (808)873-0820. E-mail: ChristianAdams@DolphinGalleries.com. Web site: www.dolphingalleries.com. **Director of Sales:** Christian Adams. For-profit galleries. Estab. 1976. Exhibits emerging, mid-career and established artists. Exhibited artists include Alexandra Nechita, Pino and Thomas Pradzynski. Sponsors numerous exhibitions/year, "running at all times through 9 separate fine art or fine jewelry galleries." Average display time "varies from one-night events to a 30-day run." Open 7 days/week, 9 a.m. to 10 p.m. Located in upscale, high-traffic tourist locations throughout Hawaii. On Oahu, Dolphin has galleries at the Hilton Hawaiian Village. On Big Island they have galleries located at the Kings Shops at Waikoloa. Clients include local community and upscale tourists. Overall price range: $100-100,000; most work sold at $1,000-5,000.

- The above address is for Dolphin Galleries' corporate offices. Dolphin Galleries has 8 locations throughout the Hawaiian islands.

Media Considers all media. Most frequently exhibits oil and acrylic paintings and limited edition works of art. Considers all types of prints.

Style Most frequently exhibits impressionism, figurative and abstract art. Considers American landscapes, portraits and florals.

Terms Artwork is accepted on consignment with negotiated commission, promotion and contract. Retail price set by the gallery. Gallery provides insurance, promotion and contract. Accepted work should be framed, mounted and matted. Requires exclusive representation locally.

Submissions E-mail submissions to ChristianAdams@DolphinGalleries.com. Finds artists mainly through referrals by other artists, art exhibits, submissions, portfolio reviews and word of mouth.

⚡ THE DONOVAN GALLERY

3895 Main Rd., Tiverton Four Corners RI 02878. (401)624-4000. E-mail: kd@donovangallery.com. Web site: www.donovangallery.com. **Owner:** Kris Donovan. Retail gallery. Estab. 1993. Represents 50 emerging, mid-career and established artists/year. Average display time: 1 month. Open all year; Monday-Saturday, 10-5; Sunday, 12-5; shorter winter hours. Located in a rural shopping area; 1750s historical home; 2,000 sq. ft.. 100% of space for gallery artists. Clientele: tourists, upscale, local community and students. 90% private collectors, 10% corporate collectors. Overall price range: $100-6,500; most work sold at $250-800.

Media Considers oil, acrylic, watercolor, pastel, mixed media, collage, paper, ceramics, some craft, fiber and glass; and limited edition prints. Most frequently exhibits watercolors, oils and pastels.

Style Exhibits conceptualism, impressionism, photorealism and realism. Exhibits all genres. Prefers realism, impressionism and representational.

Terms Accepts work on consignment (45% commission). Retail price set by the artist. Gallery provides limited insurance, promotion and contract; artist pays for shipping. Prefers artwork framed.

Submissions Accepts only artists from New England. Send query letter with résumé, 6 slides, bio, brochure, photographs, SASE, business card, reviews and artist's statement. Call or write for appointment to show portfolio of photographs or slides or transparencies. Responds in 1 week. Files material for possible future exhibition. Finds artists through networking and submissions.

Tips "Do not appear without an appointment. Be professional, make appointments by telephone, be prepared with résumé, slides and (in my case) some originals to show. Don't give up. Join local art associations and take advantage of show opportunities there."

DOT FIFTYONE GALLERY

51 NW 36 St., Miami FL 33127. Phone/fax: (305)573-3754. E-mail: dot@dotfiftyone.com. Web site: www.dotfiftyone.com. **Directors:** Isaac Perelman and Alfredo Guzman. For-profit gallery. Estab. 2004. Approached by 40+ artists/year. Represents or exhibits 10 artists. Sponsors 9 exhibits/year. Average display time: 40 days. Open Monday-Friday, 12-7; Saturdays and private viewings available by appointment. Located in the Wynwood Art District; approximately 7,000 sq. ft.; 2 floors. Overall price range: $600-30,000; most work sold at $6,000.

Media Considers all media, serigraphs and woodcuts; most frequently exhibits acrylic, installation, mixed media and oil.

Style Exhibits color field, conceptualism, expression, geometric abstraction, minimalism. Exhibits all genres including figurative work.

Terms Artwork is accepted on consignment (50% commission). Retail price set by the gallery and the artist. Gallery provides promotion and contract. Requires exclusive representation locally.

Submissions E-mail link to Web site. Write to arrange a personal interview to show portfolio. Mail portfolio for review. Finds artists through art fairs, portfolio reviews, referrals by other artists.

Tips "Have a good presentation. Contact the gallery first by e-mail. Never try to show work during an opening, and never show up at the gallery without an appointment."

N DUCKTRAP BAY TRADING COMPANY

37 Bayview St., Camden ME 04843. (207)236-9568. Fax: (207)236-0950. E-mail: info@ducktrapb ay.com. Web site: www.ducktrapbay.com. **Owners:** Tim and Joyce Lawrence. Retail gallery. Estab. 1983. Represents 200 emerging, mid-career and established artists/year. Exhibited artists include Sandy Scott, Stefane Bougie, Yvonne Davis, Beki Killorin, Jim O'Reilly and Gary Eigenberger. Open all year; Monday-Saturday, 9-5, Sunday, 11-4. Located downtown waterfront; 2 floors 3,000 sq. ft. 100% of space for gallery artists. Clientele: tourists, upscale. 70% private collectors, 30% corporate collectors. Overall price range $250-120,000; most work sold at $250-2,500.

Media Considers watercolors, oil, acrylic, pastel, pen & ink, drawing, paper, sculpture, bronze and carvings. Types of prints include lithographs. Most frequently exhibits woodcarvings, watercolor, acrylic and bronze.

Style Exhibits realism. Genres include nautical, wildlife and landscapes. Prefers marine and wildlife.

Terms Accepts work on consignment (40% commission) or buys outright for 50% of the retail price (net 30 days). Retail price set by the artist. Gallery provides insurance and minimal promotion; artist pays for shipping. Prefers artwork framed.

Submissions Send query letter with 10-20 slides or photographs. Call or write for appointment to show portfolio of photographs. Files all material. Finds artists through word of mouth, referrals by other artists and submissions.

Tips "Find the right gallery and location for your subject matter. Have at least eight to ten pieces or carvings or three to four bronzes."

DURHAM ART GUILD

120 Morris St., Durham NC 27701-3242. (919)560-2713. E-mail: artguild1@yahoo.com. Web site: www.durhamartguild.org. **Gallery Director:** Jennifer Collins. Nonprofit gallery. Estab. 1948. Represents/exhibits 500 emerging, mid-career and established artists/year. Sponsors more than 20 shows/year, including an annual juried art exhibit. Average display time: 6 weeks. Open all year; Monday-Saturday, 9-9; Sunday, 1-6. Free and open to the public. Located in center of downtown Durham in the Arts Council Building; 3,600 sq. ft.; large, open, movable walls. 100% of space for special exhibitions. Clientele: general public; 80% private collectors, 20% corporate collectors. Overall price range: $100-14,000; most work sold at $200-1,200.

Media Considers all media. Most frequently exhibits painting, sculpture and photography.

Style Exhibits all styles, all genres.

Terms Artwork is accepted on consignment (30-40% commission). Retail price set by the artist. Gallery provides insurance and promotion. Artist installs show. Prefers artwork framed.

Submissions Artists must be 18 years or older. Send query letter with résumé, slides and SASE. "We accept slides for review by February 1 for consideration of a solo exhibit or special projects group show." Finds artists through word of mouth, referral by other artists, call for slides.

Tips "Before submitting slides for consideration, be familiar with the exhibition space to make sure it can accommodate any special needs your work may require."

N EAST END ARTS COUNCIL

133 E. Main St., Riverhead NY 11901. (631)727-0900. Fax: (631)727-0966. E-mail: gallery@eastendarts.org. Web site: www.eastendarts.org. **Gallery Director:** Jane Kirkwood. Nonprofit gallery. Estab. 1971. Exhibits the juried work of artists of all media. Presents 7 shows annually most of which are juried group exhibitions. Exhibits include approximately 300 artists/year, ranging from emerging to mid-career exhibitors of all ages. Average display time 4-5 weeks. Prefers regional artists. Clientele small business and private collectors. Overall price range $100-7,500; most work sold at $100-500.

Media Considers all media including sculptures and installations. Considers matted but not framed giclees and serigraphs for gift shop but not shows.

Style Exhibits contemporary, abstract, naive, non-representational, photorealism, realism, post-pop works, projected installations and assemblages. "Being an organization relying strongly on community support, we aim to serve the artistic needs of our constituency and also expose them to current innovative trends within the art world. Therefore, there is not a particular genre bias, we are open to all art media."

Terms Accepts work on consignment (30% commission). Retail price for art sold through our juried exhibits is set by the artist. Exclusive area representation not required.

Submissions Work is dropped off at gallery for open calls, no slides are accepted.

Tips "Visit, become a member ($50/year individual) and you'll be sent all the mailings that inform you of shows, lectures, workshops, grants and more! All work must be framed with clean mats and glass/plexi and wired for hanging. Artwork with clean gallery edge (no staples) is also accepted. Presentation of artwork is considered when selecting work for shows."

PAUL EDELSTEIN STUDIO AND GALLERY

540 Hawthorne St, Memphis TN 38112. (901)496-8122 fax: (901)276-1493. E-mail: henrygrove@ yahoo.com. Web site: www.askart.com. **Director/Owner:** Paul R. Edelstein. Estab. 1985. "Shows are presented continually throughout the year." Overall price range: $300-10,000; most work sold at $1,000.

Media Considers all media and all types of prints. Most frequently exhibits oil, watercolor and prints.

Style Exhibits hard-edge geometric abstraction, color field, painterly abstraction, minimalism, postmodern works, feminist/political works, primitivism, photorealism, expressionism and neo-expressionism. Genres include florals, landscapes, Americana and figurative. Most frequently exhibits primitivism, painterly abstraction and expressionism.

Terms Charges 50% commission. Accepted work should be framed or unframed, mounted or unmounted, matted or unmatted work. There are no size limitations.

Submissions Send query letter with résumé, 20 slides, bio, brochure, photographs, SASE and business card. Cannot return material. Responds in 3 months. Finds artists mostly through word of mouth, *Art in America*, and also through publications like *Artist's & Graphic Designer's Market*.

Tips "Most artists do not present enough slides or their biographies are incomplete. Professional artists need to be more organized when presenting their work."

EMEDIALOFT.ORG

55 Bethune St., A-269, New York NY 10014-2035. E-mail: abc@emedialoft.org. Web site: www.e MediaLoft.org. **Co-Director:** Barbara Rosenthal. Alternative space. Estab. 1982. Exhibits mid-career artists. Sponsors 4 exhibits/year. Average display time: 3 months. Open by appointment. Located in the West Village of New York City. Overall price range: $5-50,000; most work sold at $500-2,000.

Media Considers installation, mixed media, oil, watercolor. Most frequently exhibits performance videos, artists' books, photography. Considers Xerox, offset, digital prints ("if used creatively").

Style Exhibits conceptualism, primitivism realism, surrealism. Genres include Americana, figurative work, landscapes.

Making Contact & Terms Artwork is accepted on consignment (50% commission). Accepts work from artists over age 30.

Submissions E-mail 250 words and 5 JPEGs (72 dpi max, 300 px on longest side). Or send query letter with "anything you like, but no SASE—sorry, we can't return anything. We may keep you on file, but please do not telephone." Responds to queries only if interested.

Tips "Create art from your subconscious, even if it ooks like something recognizable; don't illustrate ideas. No political art. Be sincere and probably misunderstood. Be hard to categorize. Show me art that nobody 'gets,' but please, nothing 'psychadelic.' Intrigue me: Show me something I really haven't seen in anything like your way before. Don't start your cover letter with 'my name is . . .' Take a hard look at the artists' pages on our Web site before you send anything."

N JAY ETKIN GALLERY

409 S. Main St., Memphis TN 38103. (901)543-0035. E-mail: etkinart@hotmail.com. Web site: www.jayetkingallery.com. **Owner**: Jay S. Etkin. Retail gallery. Estab. 1989. Represents/exhibits over 30 emerging, mid-career and established artists/year. Exhibited artists include Annabelle Meacham, Jeff Scott and Pamela Cobb. Sponsors 10 shows/year. Average display time 1 month. Open all year; Tuesday-Saturday, 11-5. Located in downtown Memphis; 8,000 sq. ft.; gallery features public viewing of works in progress. 30% of space for special exhibitions; 50% of space for gallery artists. Clientele: young upscale, corporate. 80% private collectors, 20% corporate collectors. Overall price range $200-12,000; most work sold at $1,000-3,000.

Media Considers all media except craft, papermaking. Also considers kinetic sculpture and conceptual work. "We do very little with print work." Most frequently exhibits oil on paper canvas, mixed media and sculpture.

Style Exhibits expressionism, conceptualism, neo-expressionism, painterly abstraction, post-modern works, realism, surrealism. Genres include landscapes and figurative work. Prefers figurative expressionism, abstraction, landscape.

Terms Artwork is accepted on consignment (50% commission). Retail price set by the gallery and the artist. Gallery provides promotion. Artist pays for shipping or costs are shared at times. Submissions Accepts artists generally from mid-south. Prefers only original works. Looking for long-term committed artists. Send query letter with CD's or photographs, bio and SASE. Write for appointment to show portfolio of photographs or digital samples. Responds only if interested within 1 month. Files bio/slides if interesting work. Finds artists through referrals, visiting area art schools and studios, occasional drop-ins.

Tips "Be patient. The market in Memphis for quality contemporary art is only starting to develop. We choose artists whose work shows technical know-how and who have ideas about future development in their work. Make sure work shows good craftsmanship and good ideas before approaching gallery. Learn how to talk about your work."

FAR WEST GALLERY

2817 Montana Ave., Billings MT 59101. (406)245-2334. Fax: (406)245-0935. E-mail: farwest@18 0com.net. Web site: www.farwestgallery.com. **Manager:** Sondra Daly. Retail gallery. Estab. 1994. Represents emerging, mid-career and established artists. Exhibited artists include Joe Beeler, Dave Powell, Kevin Red Star and Stan Natchez. Sponsors 4 shows/year. Average display time: 6-12 months. Open all year; 9-6. Located in downtown historic district in a building built in 1910. Clientele: tourists. Overall price range: $1-9,500; most work sold at $300-700.

Media Considers all media and all types of prints. Most frequently exhibits Native American beadwork, oil and craft/handbuilt furniture.

Style Exhibits all styles. Genres include western and Americana. Prefers Native American beadwork, western bits, spurs, memorabilia, oil, watercolor and pen & ink.

Terms Buys outright for 50% of retail price. Retail price set by the gallery and the artist. Gallery provides insurance and promotion.

FARMINGTON VALLEY ARTS CENTER'S FISHER GALLERY

25 Arts Center Lane, Avon CT 06001. (860)678-1867. Fax: (860)674-1877. E-mail: info@fvac.net. Web site: www.fvac.net. **Executive Director:** Marty Rotblatt. Nonprofit gallery. Estab. 1972. Exhibits the work of 100 emerging, mid-career and established artists. Open all year; Wednesday-Saturday, 11-5; Sunday, 12-5; extended hours November-December. Located in Avon Park North

just off Route 44; 600 sq. ft.; "in a beautiful 19th-century brownstone factory building once used for manufacturing." Clientele: upscale contemporary craft buyers. Overall price range: $35-500; most work sold at $50-100.

Media Considers "primarily crafts," also some mixed media, works on paper, ceramic, fiber, glass and small prints. Most frequently exhibits jewelry, ceramics and fiber.

Style Exhibits contemporary, handmade craft.

Terms Accepts artwork on consignment (50% commission). Retail price set by the artist. Gallery provides promotion and contract; shipping costs are shared. Requires artwork framed where applicable.

Submissions Send query letter with résumé, bio, slides, photographs, SASE. Responds only if interested. Files a slide or photo, résumé and brochure.

FINE ARTS CENTER GALLERIES—UNIVERSITY OF RHODE ISLAND

105 Upper College Rd., Kingston RI 02881-0820. (401)874-2775. Fax: (401)874-2007. E-mail: jtolnick@uri.edu. Web site: www.uri.edu/artgalleries. **Director**: Judith Tolnick Champa. Non-profit galleries. Estab. 1968. Generates 15-20 exhibits/year. Average display time: 1-3 months. There are 3 exhibition spaces: The Main and Photography Galleries, open Tuesday-Friday, 12-4 and weekends, 1-4; The Corridor Gallery, open daily, 9-9. Audience includes University community, and visitors NE and NY and nationally. Exhibitions are curated from a national palette and regularly reviewed in the local press. Unsolicited proposals (slides or CD with SASE are reviewed as needed).

Media Considers all types of contemporary art.Non-profit, academically affiliated.

Submissions Mail portfolio for review. Returns material with SASE.

THE FLYING PIG LLC

N6975 State Hwy. 42, Algoma WI 54201. (920)487-9902. Fax: (920)487-9904. E-mail: theflyingpig@charterinternet.com. Web site: www.theflyingpig.biz. **Owner/Member**: Susan Connor. For-profit gallery. Estab. 2002. Exhibits approximately 150 artists. Open daily, 9-6 (May 1st-October 31st); Thursday-Sunday, 10-5 (winter). Clients include local community, tourists and upscale. Overall price range: $5-3,000; most work sold at $300.

Media Considers all media.

Style Exhibits impressionism, minimalism, painterly abstraction and primitivism realism. Most frequently exhibits primitivism realism, impressionism and minimalism. Genres include outsider and visionary.

Terms Artwork is accepted on consignment (40% commission) or bought outright for 50% of retail price, net 15 days. Retail price set by the artist. Gallery provides insurance, promotion and contract. Accepted work should be framed. Does not require exclusive representation locally.

Submissions Send query letter with artist's statement, bio and photographs. Returns material with SASE. Responds to queries in 3 weeks. Files artist's statement, bio and photographs if interested. Finds artist's through art fairs and exhibitions, referrals by other artsts, submissions, word of mouth and Online.

FOCAL POINT GALLERY

321 City Island Ave., City Island NY 10464. (718)885-1403. Fax: (718)885-1451. E-mail: RonTerner@aol.com. Web site: www.FocalPointGallery.com. **Contact**: Ron Terner. Retail gallery and alternative space. Estab. 1974. Interested in emerging and mid-career artists. Exhibited artists

Galleries

include Marguerite Chadwick-Juner (watercolor). Sponsors 2 solo and 6 group shows/year. Average display time: 3-4 weeks. Open Tuesday-Sunday, 12-7 with additional evening hours; Friday and Saturday, 7:30-9. Clients include locals and tourists. Overall price range: $175-750; most work sold at $300-500.

Media Considers all media. Most frequently exhibits photography, watercolor, oil. Also considers etchings, giclée, color prints, silver prints.

Style Exhibits all styles. Most frequently exhibits painterly abstraction, conceptualism, expressionism. Genres include figurative work, florals, landscapes, portraits. Open to any use of photography.

Terms Accepts work on consignment (40% commission). Exclusive area representation required. Customer discounts and payment by installment are available. Gallery provides promotion. Prefers artwork framed.

Submissions "Please call for submission information. Do not include résumés. The work should stand by itself. Slides should be of high quality."

Tips "Care about your work."

⟨N⟩ FOSTER/WHITE GALLERY

220 Third Avenue South, Suite 100, Seattle WA 98104. (206)622-2833. Fax: (206)622-7606. E-mail: seattle@fosterwhite.com. Web site: www.fosterwhite.com. **Owner/Director:** Phen Huang. Retail gallery. Estab. 1973. Represents 60 emerging, mid-career and established artists. Interested in seeing the work of local emerging artists. Exhibited artists include Mark Tobey, George Tsutakawa, Morris Graves, and William Morris. Average display time 1 month. Open all year; Tuesday-Saturday, 10am-6pm; closed Sunday. Located historic Pioneer Square; 7,500 sq. ft. Clientele private, corporate and public collectors. Overall price range $300-35,000; most work sold at $2,000-8,000.

● Gallery has additional spaces at Ranier Square, 1331 Fifth Ave., Seattle WA 98101, (206)583-0100. Fax: (206)583-7188.

Media Considers oil, acrylic, watercolor, pastel, pen & ink, drawing, mixed media, collage, paper, sculpture, ceramics, craft, fiber, glass and installation. Most frequently exhibits glass sculpture, works on paper and canvas and ceramic and metal sculptures.

Style Contemporary Northwest art. Prefers contemporary Northwest abstract, contemporary glass sculpture.

Terms Gallery provides insurance, promotion and contract.

Submissions E-mail submissions are prefered. Responds in 2 months.

FOUNDRY GALLERY

1314 18th St. NW, 1st Floor, Washington DC 20036. (202)463-0203. E-mail: president@foundrygallery.org. Web site: www.foundry_gallery.org. **President:** Steve Nordinger. Cooperative gallery and alternative space. Estab. 1971. Interested in emerging artists. Sponsors 10-20 solo and 2-3 group shows/year. Average display time: 1 month. Open Wednesday-Sunday, 12-6. Clientele: 80% private collectors; 20% corporate clients. Overall price range: $200-2,500; most work sold at $100-1,000.

Media Considers oil, acrylic, watercolor, pastel, pen & ink, drawings, mixed media, collage, paper, sculpture, ceramic, fiber, glass, installation, photography, woodcuts, engravings, mezzotints, etchings, pochoir and serigraphs. Most frequently exhibits painting, sculpture, paper and photography.

Style Exhibits "serious artists in all mediums and styles." Prefers nonobjective, expressionism and neo-geometric. "Founded to encourage and promote Washington area artists and to foster friendship with artists and arts groups outside the Washington area. The Foundry Gallery is known in the Washington area for its promotion of contemporary works of art."

Terms Co-op membership fee plus donation of time required; 30% commission. Retail price set by artist. Offers customer discounts and payment by installments. Exclusive area representation not required. Gallery provides insurance, promotion, contract and Web site presence.

Submissions See Web site for membership application. Send query letter with 10 PDF images or slides. Local artists drop off 6 pieces of actual work. Portfolio reviews every third Wednesday of the month. Finds artists through submissions.

Tips "Have a coherent body of work, a minimum of 10 actual, finished works. Show your very best, strongest work. Build your résumé by submitting your artwork at juried shows. Visit gallery to ascertain whether the work fits in."

N FOXHALL GALLERY

3301 New Mexico Ave. NW, Washington DC 20016. (202)966-7144. Fax: (202)363-2345. E-mail: foxhallgallery@foxhallgallery.com. Web site: www.foxhallgallery.com. **Director:** Jerry Eisley. Retail gallery. Represents emerging and established artists. Sponsors 6 solo and 6 group shows/year. Average display time 3 months. Overall price range $500-20,000; most artwork sold at $1,500-6,000.

Media Considers oil, acrylic, watercolor, pastel, sculpture, mixed media, collage and original handpulled prints (small editions).

Style Exhibits contemporary, abstract, impressionistic, figurative, photorealistic and realistic works and landscapes.

Terms Accepts work on consignment (50% commission). Retail price set by gallery and artist. Customer discounts and payment by installment are available. Exclusive area representation required. Gallery provides insurance.

Submissions Send résumé, brochure, slides, photographs and SASE. Call or write for appointment to show portfolio. Finds artists through agents, by visiting exhibitions, word of mouth, various art publications and sourcebooks, artists' submissions, self promotions and art collectors' referrals.

Tips To show in a gallery artists must have "a complete body of work—at least 30 pieces, participation in a juried show and commitment to their art as a profession."

THE FRASER GALLERY

7700 Wisconsin Ave., Suite E, Bethesda MD 20814. (301)718-9651. E-mail: info@thefrasergallery.com. Web site: www.thefrasergallery.com. **Director:** Catriona Fraser. For-profit gallery. Estab. 1996. Approached by 500 artists/year; represents 25 artists and sells the work of an additional 75 artists. Average display time: 1 month. Open Tuesday-Saturday, 11:30-6. Closed Sunday and Monday except by appointment. Overall price range: $200-20,000; most work sold at under $5,000.

Media Considers acrylic, drawing, mixed media, oil, paper, pastel, pen & ink, sculpture and watercolor. Most frequently exhibits oil, photography and drawing. Types of prints include engravings, etchings, linocuts, mezzotints and woodcuts.

Style Most frequently exhibits contemporary realism. Genres include figurative work and surrealism.

Terms Artwork is accepted on consignment (50% commission). Gallery provides insurance, promotion, contract. Accepted work should be framed, matted to full conservation standards. Requires exclusive representation locally.

Submissions Send query letter with bio, reviews, slides or CD-ROM, SASE. Responds in 1 month. Finds artists through submissions, portfolio reviews, art fairs/exhibits.

Tips "Research the background of the gallery, and apply to galleries that show your style of work. All work should be framed or matted to full museum standards."

N FRESNO ART MUSEUM

2233 N. First St., Fresno CA 93703. (559)441-4221. Fax: (559)441-4227. E-mail: info@fresnoartm useum.org. Web site: www.fresnoartmuseum.org. **Executive Director:** Eva Torres. Curator: Jacquelin Pilar. Estab. 1948. Exhibitions change approximately every 4 times a year. Open Tuesday-Sunday, 11-5; and until 8 on Thursdays. Accredited by AAM.

Media Considers acrylic, ceramics, collage, drawing, glass, installation, mixed media, oil, paper, pastel, pen & ink, sculpture and watercolor. Most frequently exhibits painting, sculpture and prints. Types of prints include engravings, etchings, linocuts, lithographs, serigraphs, woodcuts and fine books.

Style Exhibits contemporary and modernist art.

Making Contact & Terms Museum does not take commission. Retail price set by the artist. Gallery provides insurance.

Submissions Write to arrange a personal interview to show portfolio of transparencies and slides or mail portfolio for review. Send query letter with bio, résumé and slides. Files letters and bio/ résumé. Finds artists through portfolio reviews and art exhibits. Be sure to include " Artist's & Graphic Designers Market" on correspondence.

⊕ GALERÍA VÉRTICE

Lerdo de Tejada #2418 Col. Laffayette, C.P. 44140, Guadalajara, Jalisco, México. E-mail: grjsls@ mail.udg.mx. Web site: www.verticegaleria.com. **Director:** Luis Garca Jasso. Estab. 1988. Approached by 20 artists/year; exhibits 12 emerging, mid-career and established artists/year. Sponsors 10 exhibitions/year. Average display time: 20 days. Open all year. Clients include local community, students and tourists. Overall price range: $5,000-100,000.

Media Considers all media except installation. Considers all types of prints.

Style Considers all styles. Most frequently exhibits abstraction, new-figurativism and realism. Considers all genres.

Terms Artwork is accepted on consignment (40% commission). Retail price set by the gallery. Gallery provides insurance, promotion and contract. Accepted work should be framed. Requires exclusive representation locally.

Submissions Mail portfolio for review or send artist's statement, bio, brochure, photocopies, photographs and résumé. Responds to queries in 3 weeks. Finds artists through art fairs, art exhibits and portfolio reviews.

N ⊕ GALERIAS PRINARDI

Gallerias Prinardi-Hotel Normandi Ave. Muñoz Rivera #499, esquina Rosales San Juan, Puerto Rico 00901-2219. (787)763-5727. Fax: (787)763-0643. E-mail: prinardi@prinardi.com. Web site: www.prinardi.com. **Contact:** Judith Nieves, director. Administrator: Sheyla M. Albandoz and Victor R. Garcia. Art consultancy and for-profit gallery. Approached by many artists/year; repre-

sents with exclusivity 10 artists and exhibits many emerging, mid-career and established artists' works. Exhibited artists include Rafael Tufiño, Domingo Izquierdo and Carlos Santiago (oil painting). Sponsors 8-10 exhibits/year. Average display time 1 month. Open all year; Monday-Friday, 1pm-6pm; Saturday, 11am-4pm. Or by appointment. Closed Sunday. Clients include upscale. 50% of sales are to corporate collectors. Overall price range $3,000-25,000; most work sold at $8,000. "We also have serigraphs from $500-$3,500 and other works of art at different prices."

Media Considers oil, acrylic, ceramics, drawing, glass, installation, mixed media, paper, pastel, pen & ink, sculpture and watercolor. Considers most media. Most frequently exhibits oil, sculpture and works of art on paper. Considers all types of prints, especially limited editions.

Style Exhibits color field, expressionism, imagism, minimalism, neo-expressionism, postmodernism, painterly abstraction and some traditional works of art.

Terms Artwork is accepted on consignment and there is a 40% or 50% commission, or artwork is bought outright for 100% of retail price; net 30 days. Retail price set by the gallery and the artist. Gallery provides promotion and contract. Sometimes requires exclusive representation locally. Accepts only fine artists.

Submissions Mail portfolio for review or send query letter with artist's statement, bio, brochure, business card, photocopies, photographs, résumé, reviews and e-mail letter with digital photos. Cannot return material. Responds to queries in 1 month. If interested, files artist's statement, bio, brochure, photographs, résumé and reviews. Finds artist's through portfolio reviews, referrals by other artists and submissions.

Tips "Present an artist's portfolio which should include biography, artist's statement, curriculum and photos or slides of his/her work of art."

GALERIE ARTSOURCE

401 N. Brand Blvd., Glendale CA 91203. (818)244-0066. E-mail: artsource_online@yahoo.com. **Managing Director:** Ripsime Marashian. For-profit gallery. Estab. 1997. Exhibits mostly established artists. Sponsors 4 exhibits/year. Average display time: 3 months. Located in downtown Glendale, on the 9th floor of a historical building; 1,500-sq.-ft. showroom with 3,000-sq.-ft. patio offering a spectacular view of the city skyline and surrounding mountains. Clients include established and beginning collectors. 80% of sales are to private collectors; 20% to corporate clients. Overall price range: $500-60,000; most work sold at $3,500-35,000.

• See also listing for ArtSource International Inc. in the Posters & Prints section.

Media Considers all media. Most frequently exhibits oils, watercolors, pastel, mixed media, handblown glass and sculpture.

Style Exhibits all styles, all genres.

Terms Accepts artwork on consignment (50% commission). Retail price set by gallery and artist. Gallery provides insurance, promotion and contract; artist pays shipping costs to and from gallery.

Submissions Send query letter with résumé, slides and SASE. Accepts e-mail introductions with referrals or invitations to Web sites; no attachments. Portfolio review requested if interested in artist's work.

Tips "Art must be outstanding, professional quality."

GALERIE BONHEUR

10046 Conway Rd., St. Louis MO 63124. (314)993-9851. Fax: (314)993-9260. E-mail: gbonheur@ aol.com. Web site: www.galeriebonheur.com. **Owner:** Laurie Griesedieck Carmody. Private re-

tail and wholesale gallery. Focus is on international folk art. Estab. 1980. Represents 60 emerging, mid-career and established artists/year. Exhibited artists include Milton Bond and Justin McCarthy. Sponsors 6 shows/year. Average display time: 1 year. Open all year; by appointment. Located in Ladue (a suburb of St. Louis); 3,000 sq. ft.; art is displayed all over very large private home. 75% of sales to private collectors. Overall price range: $25-25,000; most work sold at $50-1,000.

Media Considers oil, acrylic, watercolor, pastel, pen & ink, drawing, mixed media, collage, paper, sculpture, ceramics and craft. Most frequently exhibits oil, acrylic and metal sculpture.

Style Exhibits expressionism, primitivism, impressionism, folk art, self-taught, outsider art. Genres include landscapes, florals, Americana and figurative work. Prefers genre scenes and figurative.

Terms Accepts work on consignment (50% commission). Retail price set by the gallery and the artist. Gallery provides promotion; artist pays shipping costs to and from gallery. Prefers artwork framed.

Submissions Prefers only self-taught artists. Send query letter with bio, photographs and business card. Write for appointment to show portfolio of photographs. Responds within 6 weeks, only if interested. Finds artists through agents, visiting exhibitions, word of mouth, art publications, sourcebooks and submissions.

Tips "Be true to your inspirations. Create from the heart and soul. Don't be influenced by what others are doing; do art that you believe in and love and are proud to say is an expression of yourself. Don't copy; don't get too sophisticated or you will lose your individuality!"

ROBERT GALITZ FINE ART & ACCENT ART

166 Hilltop Court, Sleepy Hollow IL 60118. (847)426-8842. Fax: (847)426-8846. E-mail: robert@g alitzfineart.com. Web site: www.galitzfineart.com. **Owner:** Robert Galitz. Wholesale representation to the trade. Makes portfolio presentations to corporations. Estab. 1986. Represents 40 emerging, mid-career and established artists. Exhibited artists include Marko Spalatin and Jack Willis. Open by appointment.

● See additional listings in the Posters & Prints and Artists' Reps sections.

Media Considers oil, acrylic, watercolor, mixed media, collage, ceramic, fiber, original hand-pulled prints, engravings, lithographs, pochoir, wood engravings, mezzotints, serigraphs and etchings. "Interested in original works on paper."

Style Exhibits expressionism, painterly abstraction, surrealism, minimalism, impressionism and hard-edge geometric abstraction. Interested in all genres. Prefers landscapes and abstracts.

Terms Accepts artwork on consignment (variable commission), or artwork is bought outright (25% of retail price, net 30 days). Retail price set by artist. Customer discounts and payment by installment are available. Gallery provides promotion and shipping costs from gallery. Prefers unframed artwork only.

Submissions Send query letter with SASE and submission of art. Will request portfolio review if interested.

Tips "Do your thing and seek representation—don't drop the ball! Keep going—don't give up!"

GALLERY 110 COLLECTIVE

110 S. Washington St., Seattle WA 98104. E-mail: director@gallery110.com. Web site: www.gall ery110.com. **Director:** Sarah Dillon. Estab. 2002. Represents 30 artists. "Our exhibits change monthly and consist two solo shows or group/thematic exhibits. We also display intimate solo

shows in our Loft Space.'' Open Wednesday-Saturday, 12-5; hosts receptions every First Thursday of the month, 6-8 pm. Located in the historic gallery district of Pioneer Square. Overall price range: $125-3,000; most work sold at $500-800.

Media Considers all media.

Style Exhibits all styles and genres.

Terms Artwork is accepted on consignment (50% commission); or artwork is bought outright for 50% commission (net 60 days). Gallery provides insurance, promotion, contract (nonexclusive).

Submissions Please follow directions on the Submission page of our Web site.

Tips ''We want to know that the artist has researched us. We want to see art I've never seen before that shows the artist is aware of both contemporary art and art history.''

GALLERY 1988: LOS ANGELES

7020 Melrose Ave., Los Angeles CA 90038. (323)937-7088. E-mail: gallery1988@aol.com. Web site: www.gallery1988.com. For-profit gallery. Estab. 2004. Exhibits emerging artists. Approached by 300 artists/year; represents or exhibits 100 artists. Sponsors 15 exhibits/year. Average display time: 3 weeks. Open Tuesday-Sunday, 11-6. Closed Monday and national holidays. Located in the heart of Hollywood; 1,250 sq. ft. with 20-ft.-high walls. Clients include local community, students, upscale. Overall price range: $75-15,000; most work sold at $750.

- Second location: 1173 Sutter St., San Francisco CA 94109. E-mail: gallery1988sf@gmail.com. Open Tuesday-Saturday, 12-7. Closed Sunday and Monday.

Media Considers acrylic, drawing, oil, paper, pen & ink. Most frequently exhibits acrylic, oil, pen & ink. Types of prints include limited edition giclées.

Style Exhibits surrealism and illustrative work. Prefers character-based works.

Making Contact & Terms Artwork is accepted on consignment. Retail price set by both the artist and gallery. Gallery provides insurance, promotion, contract. Accepted work should be framed.

Submissions Accepts e-mail submissions only. Send query e-mail (subject line: ''submission'') with link to Web site or 3-4 JPEG samples. Keeps Web site addresses on file. Cannot return material. Responds to queries within 4 weeks, only if interested. Finds artists through art exhibits, submissions, referrals by other artists, word of mouth.

Tips ''Keep your e-mail professional and include prices. Stay away from trying to be funny, which you'd be surprised to know happens a *lot*. We are most interested in the art.''

GALLERY 400

College of Architecture and the Arts, University of Illinois at Chicago, 400 S. Peoria St. (MC 034), Chicago IL 60607. (312)996-6114. Fax: (312)355-3444. E-mail: uicgallery400@gmail.com. Web site: http://gallery400.aa.uic.edu. **Director:** Lorelei Stewart. Nonprofit gallery. Estab. 1983. Approached by 500 artists/year; exhibits 80 artists. Sponsors 8 exhibits/year. Average display time: 4-6 weeks. Open Tuesday-Friday, 10-6; Saturday, 12-6. Clients include local community, students, tourists and upscale.

Media Considers drawing, installation, painting, photography, design, architecture, mixed media and sculpture.

Style Exhibits conceptualism, minimalism and postmodernism. Most frequently exhibits contemporary conceptually based artwork.

Terms Gallery provides insurance and promotion.

Submissions Check info section of web site for guidelines. Responds in 5 months. Finds artists through word of mouth, art exhibits, referrals by other artists.

Tips "Check our Web site for guidelines for proposing an exhibition and follow those proposal guidelines. Please do not e-mail, as we do not respond to e-mails."

⚝ GALLERY 54, INC.

54 Upham, Mobile AL 36607. (251)473-7995. E-mail: gallery54art1@aol.com. **Owner:** Leila Hollowell. Retail gallery. Estab. 1992. Represents 35 established artists/year. May be interested in seeing the work of emerging artists in the future. Exhibited artists inlcude Charles Smith and Lee Hoffman. Sponsors 5 shows/year. Average display time: 1 month. Open all year; Tuesday-Saturday, 11-4:30. Located in midtown, about 560 sq. ft. Clientele: local; 70% private collectors, 30% corporate collectors. Overall price range: $20-6,000; most work sold at $200-1,500.

Media Considers oil, acrylic, watercolor, pastel, pen & ink, drawing, mixed media, collage, sculpture, ceramics, glass, photography, woodcuts, serigraphs and etchings. Most frequently exhibits acrylic/abstract, watercolor and pottery.

Style Exhibits expressionism, painterly abstraction, impressionism and realism. Prefers realism, abstract and impressionism.

Terms Accepts work on consignment (40% commission) or buys outright for 50% of retail price (net 30 days). Retail price set by the artist. Gallery provides contract. Artist pays shipping costs. Prefers framed artwork.

Submissions Southern artists preferred (mostly Mobile area). "It's easier to work with artist's work on consignment." Send query letter with slides and photographs. Write for appointment to show portfolio of photographs and slides. Responds in 2 weeks. Files information on artist. Finds artists through art fairs, referrals by other artists and information in mail.

Tips "Don't show up with work without calling and making an appointment."

ℕ GALLERY@49

322 W. 49th St., New York NY 10019. (212)581-0867. Fax: (212)664-1534. E-mail: info@gallery49.com. Web site: www.gallery49.com. **Contact:** Monica or Coca Rotaru.
● Gallery is now closed. Works can still be purchased by contacting us directly.

THE GALLERY AT 910

910 Santa Fe Dr., Denver CO 80204. (303)815-1779. Fax: (303)333-2820. E-mail: info@thegalleryat910.com. Web site: www.thegalleryat910.com. **Curator:** Michele Renée Ledoux. Alternative space; for-profit gallery; nonprofit gallery; rental gallery; community educational outreach. Estab. 2007. Exhibits emerging, mid-career and established artists. Sponsors 6 exhibits/year in main gallery; 6/year in community; 2/year in sculpture garden. Average display time: 2 months in gallery/community; 6 months in sculpture garden. Open Tuesday-Friday, 12-6; Saturday, 10-2; Monday by appointment. "Gallery hours may vary. Hours as listed unless otherwise posted. Please check Web site." Located in Denver's Art District on Santa Fe at Nine10Arts, Denver's only green-built creative artist community; 1,300 sq. ft.; 105 linear ft.; additional 76 linear ft. of movable walls. Clients include local community, students, tourists, upscale.

Media Considers all media, including performance art. Considers all types of prints except posters.

Style Considers all styles and genres.

Making Contact & Terms Artwork is accepted on consignment (35% commission); or there is a rental fee for space. Retail price set by the artist. Gallery provides insurance, promotion, contract.

Submissions See Web site or contact for guidelines. Responds to queries "as soon as possible." Cannot return material. Keeps all submitted materials on file if interested. Finds artists through submissions, art fairs/exhibits, portfolio reviews, art competitions, referrals by other artists, word of mouth.

Tips "Adhere to submission guidelines. Visit Web site prior to submitting to ensure work fits gallery's mission."

GALLERY BERGELLI

483 Magnolia Ave., Larkspur CA 94939. (415)945-9454. Fax: (415)945-0311. E-mail: gallery@bergelli.com. Web site: www.gallerybergelli.com. **Owner:** Robin Critelli. For-profit gallery. Estab. 2000. Approached by 200 artists/year; exhibits 15 emerging artists/year. Exhibited artists include Jeff Faust and James Leonard (acrylic painting). Sponsors 8-9 exhibits/year. Average display time: 6 weeks. Open daily, 10-4. "We're located in affluent Marin County, just across the Golden Gate Bridge from San Francisco. The Gallery is in the center of town, on the main street of Larkspur, a charming village known for its many fine restaurants. It is spacious and open with 2,500 square feet of exhibition space with large window across the front of the building. Moveable hanging walls (see the home page of our Web site) give us great flexibility to customize the space to best show the current exhibition." Clients include local community, upscale in the Marin County & Bay Area. Overall price range is $2,000-26,000; most work sold at $4,000-10,000. Also publishes Jeff Faust through Bergelli Limited. Seeking other artists for publishing: www.bergellilimited.com.

Media Considers acrylic, collage, mixed media, oil, pastel, sculpture. Most frequently exhibits acrylic, oil and sculpture.

Style Exhibits geometric abstraction, imagism, new-expressionism, painterly abstraction, postmodernism, surrealism. Most frequently exhibits painterly abstraction, imagism and neo-expressionism.

Terms Artwork is accepted on consignment (50% commission). Retail price set by the artist with gallery input. Gallery provides insurance and promotion. Accepted work should be matted, stretched, unframed and ready to hang. Requires exclusive representation locally. Artwork evidencing geographic and cultural differences is viewed favorably.

Submissions E-mail portfolio for review or send query letter with artist's statement, bio, and low resolution jpegs. Returns material with SASE. Responds to queries in 1 month. Files material not valuable to the artist (returns slides) that displays artist's work. Finds artists through art exhibits, portfolio reviews, referrals by other artists, submissions and word of mouth.

Tips "Your submission should be about the artwork, the technique, the artist's accomplishments, and perhaps the artist's source of creativity. Many artist's statements are about the emotions of the artist, which is irrelevant when selling paintings."

GALLERY M

2830 E. Third Ave., Denver CO 80206. (303)331-8400. Fax: (303)331-8522. E-mail: newartists@gallerym.com. Web site: www.gallerym.com. **Contact:** Managing Partner. For-profit gallery. Estab. 1996. Average display time: 6-12 weeks. Overall price range: $1,000-75,000.

Media Considers acrylic, collage, drawing, glass, installation, mixed media, oil, paper, pastel, pen & ink, watercolor, engravings, etchings, linocuts, lithographs, mezzotints, serigraphs, woodcuts, photography and sculpture.

Style Exhibits color field, expressionism, geometric abstraction, neo-expressionism, postmodernism, primitivism, realism and surrealism. Considers all genres.

Terms Retail price set by the gallery and the artist. Gallery provides insurance and promotion. Requires exclusive local and regional representation.

Submissions "Artists interested in showing at the gallery should visit the Artist Submissions section of our Web site (under Site Resources). The gallery provides additional services for both collectors and artists, including our quarterly newsletter, *The Art Quarterly*."

☒ GALLERY NAGA

67 Newbury St., Boston MA 02116. (617)267-9060. Fax: (617)267-9040. E-mail: mail@gallerynaga.com. Web site: www.gallerynaga.com. **Director:** Arthur Dion. Retail gallery. Estab. 1977. Represents 30 emerging, mid-career and established artists. Sponsors 9 shows/year. Average display time: 1 month. Open Tuesday-Saturday, 10-5:30. Closed during August. Located on "the primary street for Boston galleries;" housed in a 1,500-sq.-ft historic neo-gothic church. Clientele: 90% private collectors, 10% corporate collectors. Overall price range: $500-60,000; most work sold at $2,000-10,000.

Media Considers oil, acrylic, mixed media, photography, studio furniture. Most frequently exhibits painting and furniture.

Style Exhibits expressionism, painterly abstraction, postmodern works and realism. Genres include landscapes, portraits and figurative work. Prefers expressionism, painterly abstraction and realism.

Terms Accepts work on consignment (50% commission). Retail price set by gallery and artist. Gallery provides insurance and promotion; artist pays for shipping. Prefers artwork framed.

Submissions "Not seeking submissions of new work at this time." See Web site for updates.

Tips "We focus on Boston and New England artists. We exhibit the most significant studio furniture makers in the country. Become familiar with any gallery to see if your work is appropriate before you make contact."

THE FANNY GARVER GALLERY

230 State St., Madison WI 53703. (608)256-6755. E-mail: art@fannygarvergallery.com. Web site: www.fannygarvergallery.com. **President:** Jack Garver. Retail Gallery. Estab. 1972. Represents 100 emerging, mid-career and established artists/year. Exhibited artists include Lee Weiss, Jaline Pol. Sponsors 11 shows/year. Average display time: 1 month. Open all year; Monday-Thursday, 10-6; Friday, 10-8; Saturday, 10-6; Sunday, 12-4 (closed Sundays Jan-April). Located downtown; 3,000 sq. ft.; older refurbished building in unique downtown setting. 33% of space for special exhibitions; 95% of space for gallery artists. Clientele: private collectors, gift-givers, tourists. 40% private collectors, 10% corporate collectors. Overall price range: $100-10,000; most work sold at $100-1,000.

Media Considers oil, pen & ink, paper, fiber, acrylic, drawing, sculpture, glass, watercolor, mixed media, ceramics, pastel, collage, craft, woodcuts, wood engravings, linocuts, engravings, mezzotints, etchings, lithographs and serigraphs. Most frequently exhibits watercolor, oil and glass.

Style Exhibits all styles. Prefers landscapes, still lifes and abstraction.

Terms Accepts work on consignment (50% commission) or buys outright for 50% of retail price (net 30 days). Retail price set by gallery. Gallery provides promotion and contract, artist pays shipping costs both ways. Prefers artwork framed.

Submissions Send query letter with résumé, 8 slides, bio, brochure, photographs and SASE. Write for appointment to show portfolio, which should include originals, photographs and slides.

Responds within 1 month, only if interested. Files announcements and brochures.

Tips ''Don't take it personally if your work is not accepted in a gallery. Not all work is suitable for all venues.''

GERING & LÓPEZ GALLERY

730 Fifth Ave., New York NY 10019. (646)336-7183. Fax: (646)336-7185. E-mail: info@geringlop ez.com. Web site: www.geringlopez.com. **Partner:** Sandra Gering. For-profit gallery. Estab. 2006. Exhibits emerging, mid-career and established artists. Open Tuesday-Saturday, 10-6 (June 22 through Labor Day: Tuesday-Friday, 10-6; Saturday and Monday by appointment). Located in the historic Crown Building.

- This is a new gallery created through the partnership of Sandra Gering (formerly of Sandra Gering Gallery, New York) and Javier López (formerly of Galería Javier López, Madrid).

Media Considers mixed media, oil, sculpture and digital. Most frequently exhibits computer-based work, electric (light) sculpture and video/DVD.

Style Exhibits geometric abstraction. Most frequently exhibits cutting edge.

Terms Artwork is accepted on consignment.

Submissions Send e-mail query with link to Web site and JPEGs. Cannot return material. Responds within 6 months, only if interested. Finds artists through word of mouth, art fairs/exhibits, and referrals by other artists.

HALLWALLS CONTEMPORARY ARTS CENTER

341 Delaware Ave., Buffalo NY 14202. (716)854-1694. Fax: (716)854-1696. E-mail: john@hallwa lls.org. Web site: www.hallwalls.org. **Visual Arts Curator:** John Massier. Nonprofit multimedia organization. Estab. 1974. Sponsors 10 exhibits/year. Average display time: 6 weeks.

Media Considers all media.

Style Exhibits all styles and genres. ''Contemporary cutting edge work which challenges traditional cultural and aesthetic boundaries.''

Terms Retail price set by artist. ''Sales are not our focus. If a work does sell, we suggest a donation of 15% of the purchase price.'' Gallery provides insurance.

Submissions Send material by mail for consideration. Work may be kept on file for additional review for 1 year.

THE HARWOOD MUSEUM OF ART

238 Ledoux St., Taos NM 87571-6004. (505)758-9826. Fax: (505)758-1475. E-mail: harwood@un m.edu. Web site: www.harwoodmuseum.org. **Curator:** Margaret Bullock. Estab. 1923. Approached by 100 artists/year; represents or exhibits more than 200 artists. Sponsors 10 exhibits/year. Average display time: 3 months. Open Tuesday-Saturday, 10-5; Sunday, 12-5. Consists of 7 galleries, 2 of changing exhibitions. Clients include local community, students and tourists. 1% of sales are to corporate collectors. Overall price range: $1,000-5,000; most work sold at $2,000.

Media Considers all media and all types of prints.

Style Considers all styles and genres.

Terms Artwork is accepted on consignment (40% commission). Gallery provides insurance, contract. Accepted work should be framed, mounted, matted. ''The museum exhibits work by Taos, New Mexico, artists as well as major artists from outside our region.''

Submissions Mail portfolio for review. Send query letter with artist's statement, bio, brochure,

résumé, reviews, SASE, slides. Responds in 3 months. Finds artists through word of mouth, submissions, art exhibits, referrals by other artists.

Tips "The gift shop accepts some art on consignment, but the museum itself does not."

Ⓝ JANE HASLEM GALLERY

2025 Hillyer St. NW, Washington DC 20009-1005. (202)232-4644. Fax: (202)387-0679. E-mail: haslem@artline.com. Web site: www.JaneHaslemGallery.com. For-profit gallery. Estab. 1960. Approached by hundreds of artists/year; exhibits 75-100 emerging, mid-career and established artists/year. Exhibited artists include Garry Trudeau (cartoonist), Mark Adams (paintings, prints, tapestry), Nancy McIntyre (prints). Sponsors 6 exhibits/year. Average display time 7 weeks. Open by appointment. Located at DuPont Circle across from Phillips Museum; 2 floors of 1886 building; 3,000 square feet. Clients include local community, students, upscale and collectors worldwide. 5% of sales are to corporate collectors. Overall price range is $30-30,000; most work sold at $500-2,000.

Media Considers acrylic, collage, drawing, mixed media, oil, paper, pastel, pen & ink, watercolor. Most frequently exhibits prints and works on paper. Considers engravings, etchings, linocuts, lithographs, mezzotints, serigraphs, woodcuts and digital images.

Style Exhibits expressionism, geometric abstraction, neo-expressionism, pattern painting, painterly abstraction, postmodernism, surrealism. Most frequently exhibits abstraction, realism and geometric. Genres include figurative work, florals and landscapes.

Terms Artwork is accepted on consignment and there is a 50% commission. Retail price set by the artist and the gallery. Gallery provides promotion and contract. Accepts only artists from the US. Prefers only prints, works on paper and paintings.

Submissions Artists should contact via e-mail. Returns material with SASE. Responds to queries only if interested in 3 months. Finds artists through art fairs and exhibits, referrals by other artists and word of mouth.

Tips "100% of our sales are Internet generated. We prefer all submissions initially by e-mail."

Ⓘ WILLIAM HAVU GALLERY

1040 Cherokee St., Denver CO 80204 (303)893-2360. Fax: (303)893-2813. E-mail: bhavu@mho.n et. Web site: www.williamhavugallery.com. **Owner:** Bill Havu. Gallery Administrator: Nick Ryan. For-profit gallery. Estab. 1998. Exhibits 50 emerging, mid-career and established artists. Exhibited artists include Emilio Lobato (painter and printmaker) and Amy Metier (painter). Sponsors 7-8 exhibits/year. Average display time: 6-8 weeks. Open all year; Tuesday-Friday, 10-6; Saturday, 11-5. Closed Sundays, Christmas and New Year's Day. Located in the Golden Triangle Arts District of downtown Denver; the only gallery in Denver designed as a gallery; 3,000 sq. ft., 18-ft.-high ceilings, 2 floors of exhibition space; sculpture garden. Clients include local community, students, tourists, upscale, interior designers and art consultants. Overall price range: $250-18,000; most work sold at $1,000-4,000.

Media Considers acrylic, ceramics, collage, drawing, mixed media, oil, paper, pastel, pen & ink, sculpture and watercolor. Most frequently exhibits painting, prints. Considers etchings, linocuts, lithographs, mezzotints, woodcuts, monotypes, monoprints and silkscreens.

Style Exhibits expressionism, geometric abstraction, impressionism, minimalism, postmodernism, surrealism and painterly abstraction. Most frequently exhibits painterly abstraction and expressionism.

Terms Artwork is accepted on consignment (50% commission). Retail price set by the gallery

and the artist. Gallery provides insurance, promotion and contract. Accepted work should be framed. Primarily accepts only artists from Rocky Mountain/Southwestern region.

Submissions Mail portfolio for review. Send query letter with artist's statement, bio, brochure, résumé, SASE and slides. Returns material with SASE. Files slides and résumé, if interested in the artist. Responds within 1 month, only if interested. Finds artists through word of mouth, submissions and referrals by other artists.

Tips "Always mail a portfolio packet. We do not accept walk-ins or phone calls to review work. Explore our Web site or visit gallery to make sure work would fit with the gallery's objective. Archival-quality materials play a major role in selling fine art to collectors. We only frame work with archival-quality materials and feel its inclusion in work can 'make' the sale."

ꆈ HEAVEN BLUE ROSE CONTEMPORARY GALLERY, LLC

934 Canton St, Roswell GA 30075 (770-642-7380). E-mail: info@heavenbluerose.com. Web site: www.heavenbluerose.com. **Contact**: Director Catherine Moore. Estab. 1991. Showing fresh, original contemporary art of established and emerging artists from Metropolitan Atlanta. Exhibited artists include owner Catherine Moore (interpretive water color, mixed media on paper and canvas), Ron Pircio ("famous" pear paintings in oil and pastel), Leslie Cohen (unique figurative executions in oil on wood, handmade paper and beeswax) and Faith Tatum (vibrant life scapes in acrylic and oil). Average exhibit run is 6 weeks. Open all year; Tuesday-Saturday 11:00 - 5:30; Sunday 1:00-4:00; closed Monday. "Located in the Historic Art and Cultural District of Roswell GA. One-of-a-kind, carefully selected 2 and 3 dimensional works tastefully placed in a two-level gallery, creating inviting spaces with fantastic energy! Artfully curated for each exhibit. Exemplary reputation both from artists and buyers." 10% of sales from corporate collectors. Overall price range $200 - $7000; most work average $1100.

Media Considers contemporary acrylic, collage, drawing, fiber, glass, mixed media, oil, paper, pastel, sculpture, watercolor, photography, wood.

Style Exhibits color field, nontraditional works of conceptualism, expressionism, geometric abstraction, minimalism, neo-expressionism, surrealism and painterly abstraction. Considers all genres.

Terms Artwork is accepted based on submission guidelines. 50% commission. Gallery provides contract. Work must be properly finished/framed, ready to hang. 25 mile radius non-compete clause.

Submissions Call for guidelines or view online. Artists also selected by invitation through referrals.

Tips "Properly framed /finished art is crucial. Consistency of work, available inventory, quality and integrity of artist and work are imperative."

MARIA HENLE STUDIO

55 Company St., Christiansted, St. Croix VI 00820. E-mail: mariahenle@earthlink.net. Web site: www.mariahenlestudio.com. **Owner:** Maria Henle. For-profit gallery. Estab. 1993. Exhibits mid-career and established artists. Approached by 4 artists/year; represents or exhibits 7 artists. Sponsors 4 exhibits/year. Average display time: 1 month. Open Monday-Friday, 11-5; weekends, 11-3. Closed part of September/October. Located in an 18th-century loft space in historical Danish West Indian town; 750 sq. ft. Clients include local community, tourists, upscale. 10% of sales are to corporate collectors. Overall price range: $600-6,000; most work sold at $600.

Media Considers all media. Most frequently exhibits painting, photography, printmaking. Types of prints include etchings, mezzotints.

Style Considers all styles. Most frequently exhibits realism, primitive realism, impressionism. Genres include figurative work, landscapes, Caribbean.

Making Contact & Terms Artwork is accepted on consignment (40% commission). Retail price set by the artist. Gallery provides promotion. Accepted work should be matted. Requires exclusive representation locally.

Submissions Call or send query letter with artist's statement, bio, brochure. Returns material with SASE. Responds in 4 weeks. Files promo cards, brochures, catalogues. Finds artists through art exhibits, referrals by other artists, submissions.

Tips "Present good slides or photos neatly presented with a clear, concise bio."

THE HENRY ART GALLERY

15th Ave. NE and NE 41st St., Seattle WA 98195-1410. (206)543-2280. Fax: (206)685-3123. E-mail: info@henryart.org. Web site: www.henryart.org. **Curatorial Associate**: Misa Jeffereis. Contemporary Art Museum. Estab. 1927. Exhibits emerging, mid-career, and established artists. Presents 18 exhibitions/year. Open Tuesday-Sunday, 11-5; Thursday, 11-8. Located "on the western edge of the University of Washington campus. Parking is often available in the underground Central Parking garage at NE 41st St. On Sundays, free parking is usually available. The Henry Art Gallery can be reached by over twenty bus routes. Call Metro at (206)553-3000 (http://transit.metroke.gov) or Community Transit at (425)778-2785 for additional information." Clients include local community, students, and tourists.

Media Considers all media. Most frequently exhibits photography, video, and installation work. Exhibits all types of prints.

Style Exhibits contemporary art.

Terms Does not require exclusive representation locally.

Submissions Send query letter with artist statement, résumé, SASE, 10-15 images. Returns material with SASE. Responds to queries quarterly. Finds artists through art exhibitions, exhibition announcements, individualized research, periodicals, portfolio reviews, referrals by other artists, submissions, and word of mouth.

MARTHA HENRY INC. FINE ART

400 E. 57th St., Suite 7L, New York NY 10022. (212)308-2759. Fax: (212)754-4419. E-mail: info@marthahenry.com. Web site: www.marthahenry.com or www.artnet.com/marthahenry.html. **President:** Martha Henry. Estab. 1987. Art consultancy. Exhibits emerging, mid-career and established artists, specializing in art by African Americans. Approached by over 200 artists/year; exhibits over 12 artists/year. Exhibited artists include Jan Muller (oil paintings), Mr. Imagination (sculpture), JAMA (acrylic paintings) and Bob Thompson (oil paintings). Sponsors 6 exhibits/year. Average display time: 4 days to 6 weeks. Open all year; by appointment only. Located in a private gallery in an apartment building. 5% of sales are to corporate collectors. Overall price range: $5,000-200,000; most work sold under $50,000.

Terms Accepts all artists, with emphasis on African-American artists.

Submissions Mail portfolio for review or send query letter with artist's statement, bio, photocopies, photographs, slides and SASE. Returns material with SASE. Responds in 3 months. Files slides, bio or postcard. Finds artists through art fairs and exhibits, portfolio reviews, referrals by other artists, submissions, word of mouth and press.

HERA EDUCATIONAL FOUNDATION AND ART GALLERY

327 Main St., P.O. Box 336, Wakefield RI 02880. (401)789-1488. E-mail: info@heragallery.org. Web site: www.heragallery.org. **Director:** Chelsea Heffner. Cooperative gallery. Estab. 1974. Sponsors 9-10 shows/year. Average display time: 6 weeks. Open Wednesday-Friday, 1-5; Saturday, 10-4. Closed during January. Sponsors openings; provides refreshments and entertainment or lectures, demonstrations and symposia for some exhibits. Overall price range: $100-10,000.

Media Considers all media and original handpulled prints.

Style Exhibits installations, conceptual art, expressionism, neo-expressionism, painterly abstraction, surrealism, conceptualism, postmodern works, realism and photorealism, basically all styles. "We are interested in innovative, conceptually strong, contemporary works that employ a wide range of styles, materials and techniques." Prefers "a culturally diverse range of subject matter which explores contemporary social and artistic issues important to us all."

Terms Co-op membership. Gallery charges 25% commission. Retail price set by artist. Sometimes offers customer discount and payment by installments. Gallery provides promotion; artist pays for shipping and shares expenses such as printing and postage for announcements. Works must fit inside a $6'6'' \times 2'6''$ door.

Submissions Inquire about membership and shows. Responds in 6 weeks. Membership guidelines and application available on Web site or mailed on request. Finds artists through word of mouth, advertising in art publications, and referrals from members.

Tips "Hera exhibits a culturally diverse range of visual and emerging artists. Please follow the application procedure listed in the Membership Guidelines. Applications are welcome at any time of the year."

GERTRUDE HERBERT INSTITUTE OF ART

506 Telfair St., Augusta GA 30901-2310. (706)722-5495. Fax: (706)722-3670. E-mail: ghia@ghia. org. Web site: www.ghia.org. **Executive Director:** Kim Overstreet. Nonprofit gallery. Estab. 1937. Exhibits 40 emerging, mid-career and established artists in 5 solo/group shows annually. Exhibited artists include Andrew Crawford, sculpture; Roger Shimomura, prints. Sponsors 5 exhibits/year. Average display time: 6-8 weeks. Open Tuesday-Friday, 10-5; Saturdays by advance appointment only; closed first week in August, December 20-31. Located in historic 1818 Ware's Folly mansion. Clients include local community, tourists and upscale. Approx. 5% of sales are to corporate collectors. Overall price range: $100-5,000; most work sold at $500.

Media Considers all media except craft. Considers all types of prints.

Style Exhibits all styles.

Terms Artwork is accepted on consignment (35% commission). Retail price set by the artist. Gallery provides insurance and promotion. Accepted works on paper must be framed and under Plexiglass. Does not require exclusive representation locally.

Submissions Send query letter with artist statement, bio, brochure, résumé, reviews, SASE, slides or CD of current work. Returns material with SASE. Responds to queries quarterly after expeditions review committee meets. Finds artists through art exhibits, referrals by other artists and submissions.

THE HIGH MUSEUM OF ART

1280 Peachtree St. NE, Atlanta GA 30309. (404)733-4444. Fax: (404)733-4529. E-mail: highmuseum@woodruffcenter.org. Web site: www.high.org. Museum. Estab. 1905. Exhibits emerging, mid-career and established artists. Has over 11,000 works of art in its permanent collection. The

museum has an extensive anthology of 19th and 20th century American art; significant holdings of European paintings and decorative art; a growing collection of African-American art; and burgeoning collections of modern and contemporary art, photography and African art. Open Tuesday, Wednesday, Friday, Saturday, 10-5; Thursday, 10-8; Sunday, 12-5; closed Mondays and national holidays. Located in Midtown Atlanta. The Museum's building, designed by noted architect Richard Meier, opened to worldwide acclaim in 1983 and has received many design awards, including 1991 citation from the American Institute of Architects as one of the "ten best works of American architecture of the 1980s." Meier's 135,000-sq.-ft. facility tripled the Museum's space, enabling the institution to mount more comprehensive displays of its collections. In 2003, to celebrate the twentieth anniversary of the Richard Meier-designed building, the High unveiled enhancements to its galleries and interior, and a new, chronological installation of its permanent collection. Three new buildings, designed by Italian architect Renzo Piano, more than double the Museum's size to 312,000 sq. ft. This allows the High to display more of its growing collection, increase educational and exhibition programs, and offer new visitor amenities to address the needs of larger and more diverse audiences. The expansion strengthens the High's role as the premier art museum in the Southeast and allows the Museum to better serve its growing audiences in Atlanta and from around the world. Clients include local community, students, tourists and upscale.

Media Considers all media and prints.

Style Considers all styles and genres.

Terms Retail price is set by the gallery and the artist. Gallery provides insurance, promotion and contract.

Submissions Call, e-mail or write to arrange a personal interview to show portfolio of slides, artist's statement, bio, résumé and reviews. Returns materials with SASE.

Ⓝ EDWARD HOPPER HOUSE ART CENTER

82 North Broadway, Nyack NY 10960. (845)358-0774. E-mail: edwardhopper.house@verizon.net. Web site: www.hopperhouse.org. **Director:** Carole Perry. Nonprofit gallery, historic house. Estab. 1971. Approached by 200 artists/year. Exhibits 100 emerging, mid-career and established artists. Sponsors 9 exhibits/year. Average display time 5 weeks. Open all year; Thursday-Sunday from 1-5. The house was built in 1858. There are four gallery rooms on the first floor. Clients include local community, students, tourists, upscale. Overall price range $100-12,000; most work sold at $750.

Media Considers all media and all types of prints except posters. Most frequently exhibits watercolor, photography, oil.

Style Considers all styles and genres. Most frequently exhibits realism, abstraction, expressionism.

Terms Artwork is accepted on consignment and there is a 35% commission. Retail price set by the artist. Gallery provides insurance, promotion and contract. Accepted work should be framed, mounted and matted. Does not require exclusive representation locally.

Submissions Call or check web site for submission guidelines. Send query letter with artist's statement, bio, brochure, business card, photocopies, photographs, résumé, reviews, SASE and slides. Returns material with SASE. Files all materials unless return specified and paid. Finds artists through art fairs, art exhibits, portfolio reviews, referrals by other artists, submissions and word of mouth.

Tips "When shooting slides, don't have your artwork at an angle and don't have a chair or hands in the frame. Make sure the slides look professional and are an accurate representation of your work."

ICEBOX QUALITY FRAMING & GALLERY

1500 Jackson St. NE, Suite 443, Minneapolis MN 55413. (612)788-1790. Fax: (612)788-6947. E-mail: icebox@bitstream.net. Web site: www.iceboxminnesota.com. **Owner:** Howard M. Christopherson. Exhibition, promotion and sales gallery. Estab. 1988. Represents photographers and fine artists in all media, predominantly photography. "A sole proprietorship gallery, Icebox sponsors installations and exhibits in the gallery's 2,200-sq.-ft. space in the Minneapolis Arts District." Overall price range: $200-2,500; most work sold at $200-800.

Media Considers mostly photography, with the door open for other fine art with some size and content limitations.

Style Exhibits photos of multicultural, environmental, landscapes/scenics, rural, adventure, travel and fine art photographs from artists with serious, thought-provoking work. Interested in alternative process, documentary, erotic, historical/vintage.

Terms Charges 50% commission.

Submissions "Send letter of interest telling why and what you would like to exhibit at Icebox. Include only materials that can be kept at the gallery and updated as needed. Check Web site for more details about entry and gallery history."

Tips "Be more interested in the quality and meaning of your artwork than in a way to make money. Unique thought provoking artwork of high quality is more likely suited." Not interested in wall decor art.

⊞ ILLINOIS STATE MUSEUM CHICAGO GALLERY

100 W. Randolph, Suite 2-100, Chicago IL 60601. (312)814-5322. Fax: (312)814-3471. E-mail: jstevens@museum.state.il.us. Web site: www.museum.state.il.us. **Assistant Administrator:** Jane Stevens. Museum. Estab. 1985. Exhibits emerging, mid-career and established artists. Sponsors 2-3 shows/year. Average display time: 5 months. Open all year. Located "in the Chicago loop, in the James R. Thompson Center designed by Helmut Jahn." 100% of space for special exhibitions.

Media All media considered, including installations.

Style Exhibits all styles and genres, including contemporary and historical work.

Terms "We exhibit work but do not handle sales." Gallery provides insurance and promotion; artist pays for shipping. Prefers artwork framed.

Submissions Accepts only artists from Illinois. Send résumé, 10 high-quality slides or CD, bio and SASE.

⊞ INDIAN UPRISING GALLERY™

25 S. Tracy Ave., Bozeman MT 59715. (406)586-5831. Fax: (406)582-9848. E-mail: info@indianu prisinggallery.com. Web site: www.indianuprisinggallery.com. **Owner:** Iris Model. Retail gallery "dedicated exclusively to Native American art featuring the unique beauty and spirit of the Plains Indians." Estab. 1993. Represents 50 emerging, mid-career and established artists/year. Exhibited artists include Sam English, Bruce Contway, Rance Hood, Frank Shortey and Gale Running Wolf. Open all year, Tuesday-Friday; 10:30-5:30.

Media Considers all media. Most frequently exhibits fine, contemporary and traditional tribal.

Style Exhibits all styles and genres.

Terms Accepts work on consignment (20% commission) or buys outright for 50% of retail price (net 30 days). Retail price set by the gallery. Gallery provides insurance, promotion and contract; shipping costs are shared. Prefers framed artwork.

Submissions Accepts only Native American artists from northern U.S. Send résumé, slides, bio and artist's statement. Write for appointment to show portfolio of photographs. Responds in 2 weeks. Finds artists through visiting museums and art shows for Indian art.

⊞ INDIANAPOLIS ART CENTER

820 E. 67th St., Indianapolis IN 46220. (317)255-2464. Fax: (317)254-0486. E-mail: exhibs@indpl sartcenter.org. Web site: www.indplsartcenter.org. **Director of Exhibitions:** David Kwasigroh. Estab. 1934. Nonprofit art center. Prefers emerging artists. Sponsors 10-15 exhibits/year. Average display time: 8 weeks. Overall price range: $50-5,000; most work sold at $500.

Media Considers all media and all types of original prints. Most frequently exhibits painting, sculpture installations and fine crafts.

Style Exhibits all styles. ''In general, we do not exhibit genre works. We do maintain a referral list, though.'' Prefers postmodern works, installation works, conceptualism, large-scale outdoor projects.

Terms Charges 35% commission. One-person show: $300 honorarium; 2-person show: $200 honorarium; 3-person show: $100 honorarium; plus $0.32/mile travel stipend (one way). Accepted work should be framed (or other finished-presentation formatted). Prefers artists who live within 250 miles of Indianapolis.

Submissions Send minimum of 20 digital images with résumé, reviews, artist's statement and SASE between July 1 and December 31.

Tips ''Research galleries thoroughly; get on their mailing lists, and visit them in person at least twice before sending materials. Find out the 'power structure' of the targeted galleries and use it to your advantage. Most artists need to gain experience exhibiting in smaller or nonprofit spaces before approaching a traditional gallery. Work needs to be of consistent, dependable quality. Have slides done by a professional if possible. Stick with one style—no scattershot approaches. Have a concrete proposal with installation sketches (if it's never been built). We book two years in advance—plan accordingly. Do not call. Put me on your mailing list one year before sending application so I can be familiar with your work and record. Ask to be put on my mailing list so you know the gallery's general approach. It works!''

⊠ THE JAMESON ART GROUP

305 Commercial St., Portland ME 04101. (207)772-5522. Fax: (207)774-7648. E-mail: info@jame songallery.com. **Gallery Director:** W. Weston Lafountain. Retail gallery, custom framing, restoration, appraisals, consultation. Estab. 1992. Jameson Gallery represents mid-career and established artists. Exhibited artists include William Manning, Jason Berger, Charles DuBack, Brita Holmquist, Denis Boudreau, Nathaniel Larrabee, Jon A. Marshall; the estates of Lynne Drexler, Marilyn Powers, Edward Christiana, William & Emily Muir. Mounts 6 - 9 shows/year. Average display time 3-4 weeks. Open all year; Monday-Saturday, 10-6. Located on the waterfront in the heart of the shopping district; 3,000 sq.ft.of space. The Jameson Estate Collection deals in late 19th and early 20th century paintings. Jameson Modern deals in mid to late 20th century Abstract Expressionism and American Modernism. Clientele consists of local community, tourists, upscale. Overall price range most work sold at $1,500-100,000.

Media Most frequently exhibited: oil, watercolor, photographs and sculpture.

Terms TBD. Retail price set by the gallery. Gallery provides insurance, promotion and contract; artist pays shipping costs. Prefers artwork unframed, but will judge on a case by case basis. Artist may buy framing contract with gallery.

Submissions Send CV and artist's statement, a sampling of images on a PC-compatible CD and SASE if you would like the materials returned.

STELLA JONES GALLERY

201 St. Charles Ave., New Orleans LA 70170. (504)568-9050. Fax: (504)568-0840. E-mail: jones6 941@aol.com. Web site: www.stellajones.com. **Contact:** Stella Jones. For-profit gallery. Estab. 1996. Approached by 40 artists/year. Represents 121 emerging, mid-career and established artists. Exhibited artists include Elizabeth Catlett (prints and sculpture), Richard Mayhew (paintings). Sponsors 7 exhibits/year. Average display time: 6-8 weeks. Open all year; Monday-Friday, 11-6; Saturday, 12-5. Located in downtown New Orleans, one block from French Quarter. Clients include local community, tourists and upscale. 10% of sales are to corporate collectors. Overall price range: $500-150,000; most work sold at $1,000-5,000.

Media Considers all media. Most frequently exhibits oil and acrylic. Considers all types of prints except posters.

Style Considers all styles. Most frequently exhibits postmodernism and geometric abstraction. Exhibits all genres.

Terms Artwork is accepted on consignment (50% commission). Retail price set by the artist. Gallery provides insurance, promotion and contract. Accepted work should be framed. Requires exclusive representation locally.

Submissions To show portfolio of photographs, slides and transparencies, mail for review. Send query letter with artist's statement, bio, brochure, business card, photocopies, photographs, résumé, reviews, SASE and slides. Returns material with SASE. Responds in 1 month. Finds artists through word of mouth, submissions, portfolio reviews, art exhibits, and referrals by other artists.

Tips "Send organized, good visuals."

ℕ KAVANAUGH ART GALLERY

131 Fifth St., W. Des Moines IA 50265. (515)279-8682. Fax: (515)279-7609. E-mail: kagallery@ao l.com. Web site: www.kavanaughgallery.com. **Director:** Carole Kavanaugh. Retail gallery. Estab. 1990. Represents 100 mid-career and established artists/year. May be interested in seeing the work of emerging artists in the future. Exhibited artists include Kati Roberts, Don Hatfield, Dana Brown, Gregory Steele, August Holland, Ming Feng and Larry Guterson. Sponsors 3-4 shows/year. Averge display time 3 months. Open all year; Monday-Saturday, 10-5. Located in Valley Junction shopping area; 10,000 sq. ft. 70% private collectors, 30% corporate collectors. Overall price range $300-20,000; most work sold at $800-3,000.

Media Considers all media and all types of prints. Most frequently exhibits oil, acrylic and pastel.

Style Exhibits color field, impressionism, realism, florals, portraits, western, wildlife, southwestern, landscapes, Americana and figurative work. Prefers landscapes, florals and western.

Terms Accepts work on consignment (50% commission). Retail price set by the artist. Gallery provides insurance, promotion and contract. Shipping costs are shared. Prefers artwork unframed.

Submissions Send query letter with resume, bio and photographs. Portfolio should include

photographs. Responds in 3 weeks. Files bio and photos. Finds artists through word of mouth, referrals by other artists, visiting art fairs and exhibitions, artist's submissions.

Tips "Get a realistic understanding of the gallery/artist relationship by visiting with directors. Be professional and persistent."

N KIRSTEN GALLERY, INC.

5320 Roosevelt Way NE, Seattle WA 98105. (206)522-2011. E-mail: r2thetop@hotmail.com. Web site: www.kirstengallery.com. **President:** R. Kirsten. Retail gallery. Estab. 1974. Represents 60 emerging, mid-career and established artists. Exhibited artists include Birdsall and Daiensai. Sponsors 4 shows/year. Average display time 1 month. Open all year. Open Monday-Sunday, 11-5. 3,500 sq. ft.; outdoor sculpture garden. 40% of space for special exhibitions; 60% of space for gallery artists. 90% private collectors, 10% corporate collectors. Overall price range $75-15,000; most work sold at $75-2,000.

Media Considers oil, acrylic, watercolor, mixed media, sculpture, glass and offset reproductions. Most frequently exhibits oil, watercolor and glass.

Style Exhibits surrealism, photorealism and realism. Genres include landscapes, florals, Americana. Prefers realism.

Terms Accepts work on consignment (50% commission). Retail price set by artist. Offers payment by installments. Gallery provides promotion; artist pays shipping costs. "No insurance; artist responsible for own work."

Submissions Send query letter with résumé, slides and bio. Write for appointment to show portfolio of photographs and/or slides. Responds in 2 weeks. Files bio and résumé. Finds artists through visiting exhibitions and word of mouth.

Tips "Keep prices down. Be prepared to pay shipping costs both ways. Work is not insured (send at your own risk). Send the best work—not just what you did not sell in your hometown. Do not show up without an appointment."

⊕ ✠ MARIA ELENA KRAVETZ ART GALLERY

San Jerónimo 448, 5000 Córdoba Argentina. E-mail: mek@mariaelenakravetzgallery.com. Web site: www.mariaelenakravetzgallery.com. **Director:** Maria Elena Kravetz. For-profit gallery. Estab. 1998. Approached by 30 artists/year; exhibits 16 emerging and mid-career artists/year. Exhibited artists include Sol Halabi (paintings) and Paulina Ortiz (fiber art). Average display time: 25 days. Open Monday-Friday, 4:30pm-8:30pm; Saturday, by appointment. Closed Sunday. Closed January and February. Located in the main downtown of Cordoba city; 170 square meters, 50 spotlights and white walls. Clients include local community and tourists. Overall price range: $500-10,000; most work sold at $1,500-5,000.

Media Considers all media. Most frequently exhibits glass sculpture and mixed media. Considers etchings, linocuts, lithographs and woodcuts.

Style Considers all styles. Most frequently exhibits new-expressionism and painterly abstraction. Considers all genres.

Terms Artwork is accepted on consignment (30% commission). Retail price set by the artist. Requires exclusive representation locally. Prefers only artists from South America and emphasizes sculptors.

Submissions Mail portfolio for review. Cannot return material. Responds to queries in 1 month. Finds artists through art fairs and exhibits, portfolio reviews, referrals by other artists, submissions and word of mouth.

Tips Artists "must indicate a Web page to make the first review of their works, then give an e-mail address to contact them if we are interested in their work."

MARGEAUX KURTIE MODERN ART

39 Yerba Buena, P.O. Box 39, Cerrillos NM 87010. (505)473-2250. E-mail: mkma@att.net. Web site: www.mkmamadrid.com. **Director:** Jill Alikas St. Thomas. Art consultancy. Estab. 1996. Approached by 200 artists/year. Represents 13 emerging, mid-career and established artists. Exhibited artists include Thomas St. Thomas (mixed media painting and sculpture) and Gary Groves (color infrared film photography). Sponsors 8 exhibits/year. Average display time: 5 weeks. Located in a historic adobe home, 18 miles southeast of Santa Fe; 5,000 sq. ft. Clients include local community, students and tourists. 5% of sales are to corporate collectors. Overall price range: $500-15,000; most work sold at $2,800.
Media Considers acrylic, glass, mixed media, paper, sculpture. Most frequently exhibits acrylic on canvas, oil on canvas, photography.
Style Exhibits conceptualism, pattern painting. Most frequently exhibits narrative/whimsical, pattern painting, illussionistic. Genres include figurative work, florals.
Terms Artwork is accepted on consignment (50% commission). Retail price set by the gallery. Gallery provides insurance. Accepted work should be framed, mounted or matted. Requires exclusive representation locally.
Submissions Criteria for review process listed on Web site. Send query letter with artist's statement, bio, résumé, reviews, SASE, slides, $25 review fee (check payable to gallery). Returns material with SASE. Responds to queries in 1 month. Finds artists through art fairs/exhibits, portfolio reviews, referrals by other artists, submissions, word of mouth.
Tips "Label all slides: medium, size, title and retail price. Send only works that are available."

LAKE GEORGE ARTS PROJECT / COURTHOUSE GALLERY

1 Amherst St., Lake George NY 12845. (518)668-2616. E-mail: mail@lakegeorgearts.org. Web site: www.lakegeorgearts.org. **Gallery Director:** Laura Von Rosk. Alternative space; nonprofit gallery. Estab. 1986. Exhibits emerging, mid-career and established artists. Approached by 200 artists/year; exhibits 8-15 artists/year. Average display time: 5 weeks. Open Tuesday-Friday, 12-5; Saturday, 12-4.
Media "We show work in any media."
Style Considers all styles.
Making Contact & Terms Artwork is accepted on consignment (25% commission). Retail price set by the artist. Gallery provides insurance, promotion, contract.
Submissions Annual deadline for open call is January 31. Send artist's statement, résumé, 10-12 images (slides or CD), image script and SASE. Guidelines available on Web site. Returns material with SASE. Finds artists through art exhibits, portfolio reviews, referrals by other artists, submissions, word of mouth.
Tips Do not send e-mail submissions or links to Web sites. Do not send original art. Review guidelines on Web site.

ⓝ LATINO ARTS, INC.

1028 S. Ninth, Milwaukee WI 53204. (414)384-3100. Fax: (414)649-2849. E-mail: info@latinoart sinc.org. Web site: www.latinoartsinc.org. **Visual Artist Specialist:** Zulay Oszkay. Nonprofit gallery. Represents emerging, mid-career and established artists. Sponsors up to 5 individual

and group exhibitions/year. Average display time 2 months. Open all year; Monday-Friday, 9-8. Located in the near southeast side of Milwaukee; 1,200 sq. ft.; one-time church. Clientele: the general Hispanic community. Overall price range $100-2,000.

Media Considers all media, all types of prints. Most frequently exhibits original 2- and 3-dimensional works and photo exhibitions.

Style Exhibits all styles, all genres. Prefers artifacts of Hispanic cultural and educational interests.

Terms "Our function is to promote cultural awareness (not to be a sales gallery)." Retail price set by the artist. Artist is encouraged to donate 15% of sales to help with operating costs. Gallery provides insurance, promotion, contract, shipping costs to gallery; artist pays shipping costs from gallery. Prefers artwork framed.

Submissions Send query letter with résumé, slides, bio, business card and reviews. Call or write for appointment to show portfolio of photographs and slides. Responds in 2 weeks. Finds artists through recruiting, networking, advertising and word of mouth.

RICHARD LEVY GALLERY

514 Central Ave. SW, Albuquerque NM 87102. (505)766-9888. E-mail: info@levygallery.com. Web site: www.levygallery.com. **Director:** Viviette Hunt. Estab. 1992. Open Tuesday-Saturday, 11-4. Closed during art fairs (always noted on voice message). Located on Central Ave. between 5th and 6th. Clients include upscale.

Media Considers all media. Most frequently exhibits paintings, prints and photography.

Style Contemporary art.

Submissions Submissions by e-mail preferred. "Please include images and any other pertinent information (artist's statment, bio, etc.). When sending submissions by post, please include slides or photographs and SASE for return of materials."

Tips "Portfolios are reviewed at the gallery by invitation or appointment only."

LIMITED EDITIONS & COLLECTIBLES

697 Haddon Ave., Collingswood NJ 08108. (856)869-5228. Fax: (856)869-5228. E-mail: jdl697ltd @juno.com. Web site: www.ltdeditions.net. **Owner:** John Daniel Lynch, Sr. For-profit gallery. Estab. 1997. Approached by 24 artists/year. Exhibited artists include Richard Montmurro, James Allen Flood and Gino Hollander. Open all year. Located in downtown Collingswood; 700 sq. ft. Overall price range: $190-20,000; most work sold at $450.

Media Considers all media and all types of prints. Most frequently exhibits acrylic, watercolors and oil.

Style Considers all styles and genres.

Terms Artwork is accepted on consignment, and there is a 30% commission. Retail price set by the artist. Gallery provides insurance, promotion and contract. Accepted work should be framed, mounted and matted. Does not require exclusive representation locally.

Submissions Call or write to arrange a personal interview to show portfolio. Send query letter with bio, business card and résumé. Responds in 1 month. Finds artists through word of mouth, portfolio reviews, art exhibits, and referrals by other artists.

LOS ANGELES ART ASSOCIATION/GALLERY 825

825 N. La Cienega Blvd., Los Angeles CA 90069. (310)652-8272. Fax: (310)652-9251. E-mail: gallery825@laaa.org. Web site: www.laaa.org. **Executive Director:** Peter Mays. Nonprofit gallery. Estab. 1925. Sponsors 16 exhibits/year. Average display time: 4-5 weeks. Open Tuesday-Saturday, 10-5. Overall price range: $200-5,000; most work sold at $600.

Media Considers all media and original handpulled prints. ''Fine art only. No crafts.'' Most frequently exhibits mixed media, oil/acrylic and watercolor.

Style Exhibits all styles.

Retail price set by artist. Gallery provides promotion.

Submissions Submit 2 pieces during biannual screening date. Responds immediately following screening. Call for screening dates.

Tips ''Bring work produced in the last three years. No commercial work (i.e., portraits/advertisements).

MAIN STREET GALLERY

105 Main Street, P.O. Box 161, Groton NY 13073. (607)898-9010. E-mail: maingal@localnet.com. Web site: www.mainstreetgal.com. **Directors:** Adrienne Smith and Roger Smith. For-profit gallery, art consultancy. Estab. 2003. Exhibits 15 emerging, mid-career and established artists. Sponsors 7 exhibits/year. Average display time: 5-6 weeks. Open all year; Thursday/Saturday 12-6; Sunday 1-5; closed January and February. Located in the village of Groton in the Finger Lakes Region of New York, 20 minutes to Ithaca; 900 sq. ft. Clients include local community, tourists, upscale. Overall price range: $120-5,000.

Media Considers all media. Considers prints, including engravings, etchings, linocuts, lithographs, mezzotints and woodcuts. Most frequently exhibits painting, sculpture, ceramics, prints.

Style Considers all styles and genres.

Terms Artwork is accepted on consignment (40% commission). Retail price set by the artist. Gallery provides insurance, promotion and contract. Accepted work should be framed, mounted and matted. Requires exclusive representation locally.

Submissions Write to arrange personal interview to show portfolio of photographs and slides. Send query letter with artist's statement, bio, brochure, photographs, résumé, reviews, SASE and slides. Returns material with SASE. Responds to queries in 4 weeks, only if interested. Finds artists through art exhibits, portfolio reviews, referrals by other artists, submissions and word of mouth.

MALTON GALLERY

2643 Erie Ave., Cincinnati OH 45208. (513)321-8614. Fax: (513)321-8716. E-mail: info@maltona rtgallery.com. Web site: www.maltonartgallery.com. **Director:** Sylvia Rombis. Retail gallery. Estab. 1974. Represents about 100 emerging, mid-career and established artists. Exhibits 20 artists/year. Exhibited artists include Carol Henry, Mark Chatterley, Terri Hallman and Esther Levy. Sponsors 7 shows/year (2-person shows alternate with display of gallery artists). Average display time: 1 month. Open all year; Tuesday-Saturday, 11-5. Located in high-income neighborhood shopping district; 2,500 sq. ft. Clientele: private and corporate. Overall price range: $250-10,000; most work sold at $400-2,500.

Media Considers oil, acrylic, drawing, sculpture, watercolor, mixed media, pastel, collage and original handpulled prints.

Style Exhibits all styles. Genres include contemporary landscapes, figurative and narrative and abstractions work.

Terms Accepts work on consignment (50% commission). Retail price set by artist (sometimes in consultation with gallery). Gallery provides insurance, promotion, contract and shipping costs from gallery; artist pays shipping costs to gallery. Prefers framed works for canvas; unframed works for paper.

Submissions Send query letter with résumé, slides or photographs, reviews, bio and SASE. Responds in 4 months. Files résumé, review or any printed material. Slides and photographs are returned.

Tips "Never drop in without an appointment. Be prepared and professional in presentation. This is a business. Artists themselves should be aware of what is going on, not just in the 'art world,' but with everything."

✠ MARKEIM ART CENTER

Lincoln Ave. and Walnut St., Haddonfield NJ 08033. (856)429-8585. Fax: (856)429-8585. E-mail: markeim@verizon.net. Web site: www.markeimartcenter.org. **Executive Director:** Elizabeth Madden. Nonprofit gallery. Estab. 1956. Sponsors 10-11 exhibits/year. Average display time: 4 weeks. Overall price range: $75-1,000; most work sold at $350.

Media Considers all media. Must be original. Most frequently exhibits paintings, photography and sculpture.

Style Exhibits all styles and genres.

Terms Charges 30% commission. Accepted work should be framed, mounted or unmounted, matted or unmatted. "Artists from New Jersey and Delaware Valley region are preferred. Work must be professional and high quality."

Submissions Send slides by mail for consideration. Include SASE, résumé and letter of intent. Responds in 1 month.

Tips "Be patient and flexible with scheduling. Look not only for one-time shows, but for opportunities to develop working relationships with a gallery. Establish yourself locally and market yourself outward."

MARLBORO GALLERY

Prince George's Community College, Largo MD 20774-2199. (301)322-0965. Fax: (301)808-0418. E-mail: tberault@pgcc.edu. Web site: http://academic.pg.cc.md.us. **Curator/Director:** Thomas A. Berault. Nonprofit gallery. Estab. 1976. Interested in emerging, mid-career and established artists. Sponsors 4 solo and 4 group shows/year. Average display time: 1 month. Seasons for exhibition: September-May. 2,100 sq. ft. with 10-ft. ceilings and 25-ft. clear story over 50% of spacetrack lighting (incandescent) and daylight. Clientele: 100% private collectors. Overall price range: $200-10,000; most work sold at $500-700.

Media Considers all media. Most frequently exhibits acrylics, oils, photographs, watercolors and sculpture.

Style Exhibits mainly expressionism, neo-expressionism, realism, photorealism, minimalism, primitivism, painterly abstraction, conceptualism and imagism. Exhibits all genres. "We are open to all serious artists and all media. We will consider all proposals without prejudice."

Terms Accepts artwork on consignment. Retail price set by artist. Exclusive area representation not required. Gallery provides insurance. Artist pays for shipping. Artwork must be ready for display.

Submissions Send cover letter with résumé, CD or slides, SASE, photographs, artist's statement and bio. Portfolio review requested if interested in artist's work. Portfolio should include slides and photographs. Responds every 6 months. Files résumé, bio and slides. Finds artists through word of mouth, visiting exhibitions and submissions.

Tips Impressed by originality. "Indicate if you prefer solo shows or will accept inclusion in group show chosen by gallery."

N JAIN MARUNOUCHI GALLERY

24 W. 57th St., New York NY 10019. (212)969-9660. Fax: (212)969-9715. E-mail: jainmar@aol.c
om. Web site: www.jainmargallery.com. **President:** Ashok Jain. Retail gallery. Estab. 1991.
Represents 30 emerging artists. Exhibited artists include Fernando Pomalaza and Pauline Gag-
non. Open all year; Tuesday-Saturday, 11-5:30. Located in New York Gallery Bldg., 800 sq. ft.
100% of space for special exhibitions. Clients include corporate and designer. 50% of sales are
to private collectors, 50% corporate collectors. Overall price range $1,000-20,000; most work
sold at $5,000-10,000.

Media Considers oil, acrylic and mixed media. Most frequently exhibits oil, acrylic and collage.

Style Exhibits painterly abstraction. Prefers abstract and landscapes.

Terms Accepts work on consignment (50% commission). Retail price set by artist. Offers cus-
tomer discount. Gallery provides contract; artist pays for shipping costs. Prefers artwork framed.

Submissions Send query letter with résumé, brochure, slides, reviews and SASE. Portfolio re-
view requested if interested in artist's work. Portfolio should include originals, photographs,
slides, transparencies and reviews. Responds in 1 week. Finds artists through referrals and
promotions.

N NEDRA MATTEUCCI GALLERIES

1075 Paseo De Peralta, Santa Fe NM 87501. (505)982-4631. Fax: (505)984-0199. E-mail: inquiry
@matteucci.com. Web site: www.matteucci.com. **Director of Advertising/Public Relations:**
Cynthia Laureen Vogt. For-profit gallery. Estab. 1972. Main focus of gallery is on deceased artists
of Taos, Sante Fe and the West. Approached by 20 artists/year. Represents 100 established
artists. Exhibited artists include Dan Ostermiller and Glenna Goodacre. Sponsors 3-5 exhibits/
year. Average display time 1 month. Open all year; Monday-Saturday, 830-5. Clients include
upscale.

Media Considers ceramics, drawing, oil, pen & ink, sculpture and watercolor. Most frequently
exhibits oil, watercolor and bronze sculpture.

Style Exhibits impressionism. Most frequently exhibits impressionism, modernism and realism.
Genres include Americana, figurative work, landscapes, portraits, Southwestern, Western and
wildlife.

Terms Artwork is accepted on consignment. Retail price set by the gallery and the artist. Requires
exclusive representation within New Mexico.

Submissions Write to arrange a personal interview to show portfolio of transparencies. Send
query letter with bio, photographs, resume' and SASE.

N MAXWELL FINE ARTS

1204 Main St., Peekskill NY 10566-2606. (914)737-8622. Fax: (914)788-5310. E-mail: devitomax
@aol.com. **Partner/Co-Director:** W. Maxwell. For-profit gallery and outdoor sculpture garden.
Estab. 2000. Approached by 25 artists/year. Exhibits 18 emerging and established artists. Exhib-
ited artists include Ruth Hardinger and Leslie Lew. Sponsors 5-6 exhibits/year. Average display
time 8 weeks. Open all year; Friday-Saturday, 12-5. Closed July/August. Located in Peekskill,
NY downtown artist district; 800 sq. ft. in 1850s carriage house. Clients include local community
and upscale. 10% of sales are to corporate collectors. Overall price range $100-10,000; most
work sold at $600.

Media Considers acrylic, ceramics, collage, drawing, glass, mixed media, oil, paper, pastel, pen
& ink, indoor and outdoor sculpture and watercolor. Most frequently exhibits paintings, draw-
ings and prints. Considers all types of prints.

Style Considers all styles and genres. Most frequently exhibits abstract, conceptual and representational.

Terms Artwork is accepted on consignment and there is a 40% commission. Retail price set by the gallery in consultation with the artist. Gallery provides promotion. Accepted work should be framed. Does not require exclusive representation locally.

Submissions Mail portfolio for review. Send query letter with artist's statement, bio, photocopies, résumé, SASE and slides. Returns material with SASE. Responds in 1 month. Files résumé and photos. Finds artists through word of mouth, submissions, art exhibits and referrals by other artists.

Tips "Take a workshop on Business of Art."

MAYANS GALLERIES, LTD.

601 Canyon Rd., Santa Fe NM 87501. (505)983-8068. E-mail: arte2@aol.com. Web site: www.art net.com/mayans.html. **Director:** Ernesto Mayans. Retail gallery and art consultancy. Estab. 1977. Publishes books, catalogs and portfolios. Overall price range: $200-5,000.

Media Considers oil, acrylic, watercolor, pastel, pen & ink, drawings, mixed media, sculpture, photography and original handpulled prints. Most frequently exhibits oil, photography, and lithographs.

Style Exhibits 20th century American and Latin American art. Genres include landscapes and figurative work.

Terms Accepts work on consignment (50% commission). Retail price set by gallery and artist. Exclusive area representation required. Size limited to 11×20 maximum.

Submissions Arrange a personal interview to show portfolio. Send query by mail with SASE for consideration. Responds in 2 weeks.

Tips "Please call before submitting."

N MCGOWAN FINE ART, INC.

10 Hills Ave., Concord NH 03301. (603)225-2515. Fax: (603)225-7791. E-mail: art@mcgowanfine art.com. Web site: www.mcgowanfineart.com. **Gallery Director:** Sarah Chaffee. Owner/Art Consultant: Mary McGowan. Retail gallery and art consultancy. Estab. 1980. Represents emerging, mid-career and established artists. Sponsors 8 shows/year. Average display time 1 month. Located just off Main Street. 50% of space for special exhibitions. Clients include residential and corporate. Most work sold at $125-9,000.

Media Considers oil, acrylic, watercolor, pastel, mixed media, collage, works on paper, sculpture, woodcuts, wood engravings, linocuts, engravings, mezzotints, etchings, lithographs and serigraphs. Most frequently exhibits sculpture, watercolor and oil/acrylic.

Style Exhibits painterly abstraction, landscapes, etc.

Terms Accepts work on consignment (50% commission). Retail price set by artist. Gallery provides insurance and promotion; negotiates payment of shipping costs. Prefers artwork unframed.

Submissions Send query letter with résumé, 5-10 slides and bio. Responds in 1 month. Files materials.

Tips "I am interested in the number of years you have been devoted to art. Are you committed? Do you show growth in your work?"

N MCLEAN PROJECT FOR THE ARTS

McLean Community Center, 1234 Ingleside Ave., McLean VA 22101. (703)790-1953. Fax: (703)790-1012. E-mail: nsausser@mpaart.org. Web site: www.mpaart.org. **Exhibitions Direc-**

tor: Nancy Sausser. Nonprofit visual arts center; alternative space. Estab. 1962. Represents emerging, mid-career and established artists from the mid-Atlantic region. Exhibited artists include Yuriko Yamaguchi and Christopher French. Sponsors 12-15 shows/year. Average display time: 5-6 weeks. Open Tuesday-Friday, 10-4; Saturday, 1-5. Luminous "white cube" type of gallery, with moveable walls; 3,000 sq. ft.. 85% of space for special exhibitions. Clientele: local community, students, artists' families. 100% private collectors. Overall price range: $200-15,000; most work sold at $800-1,800.

Media Considers all media except graphic design and traditional crafts; all types of prints except posters. Most frequently exhibits painting, sculpture and installation.

Style Exhibits all styles, all genres.

Terms Artwork is accepted on consignment (25% commission). Retail price set by the artist. Gallery provides insurance and promotion. Artist pays for shipping costs. Prefers framed artwork (if on paper).

Submissions Accepts only artists from Maryland, District of Columbia, Virginia and some regional mid-Atlantic. Send query letter with résumé, slides, reviews and SASE. Responds within 4 months. Artists' bios, slides and written material kept on file for 2 years. Finds artists through referrals by other artists and curators, and by visiting exhibitions and studios.

Tips Visit the gallery several times before submitting proposals, so that the work you submit fits the framework of art presented.

MCMURTREY GALLERY

3508 Lake St., Houston TX 77098. (713)523-8238. Fax: (713)523-0932. E-mail: info@mcmurtreyg allery.com. **Owner:** Eleanor McMurtrey. Retail gallery. Estab. 1981. Represents 20 emerging and mid-career artists. Exhibited artists include Robert Jessup and Jean Wetta. Sponsors 10 shows/ year. Average display time: 1 month. Open all year. Located near downtown; 2,600 sq. ft. Clients include corporations. 75% of sales are to private collectors, 25% corporate collectors. Overall price range: $400-17,000; most work sold at $1,800-6,000.

Media Considers oil, acrylic, pastel, drawings, mixed media, collage, works on paper, photography and sculpture. Most frequently exhibits mixed media, acrylic and oil.

Style Exhibits figurative, narrative, painterly abstraction and realism.

Terms Accepts work on consignment (50% commission). Retail price set by gallery and artist. Prefers artwork framed.

Submissions Send query letter with résumé, images and SASE. Call for appointment to show portfolio of originals and slides.

Tips "Be aware of the work the gallery exhibits and act accordingly. Please make an appointment."

▣ MERIDIAN MUSEUM OF ART

628 25th Ave., Meridian MS 39302. (601)693-1501. E-mail: meridianmuseum@aol.com. Web site: www.meridianmuseum.org. **Director:** Terence Heder. Museum. Estab. 1970. Represents emerging, mid-career and established artists. Interested in seeing the work of emerging artists. Exhibited artists include Jere Allen, Patt Odom, James Conner, Bonnie Busbee, Charlie Busler, Terry Cherry, Alex Loeb and Gary Chapman. Sponsors 15 shows/year. Average display time: 5 weeks. Open all year; Tuesday-Sunday, 1-5. Located downtown; 3,060 sq. ft. This figures refers to exhibit spaces only. The entire museum is about 6,000 sq. ft.; housed in renovated Carnegie Library building, originally constructed 1912-13. 50% of space for special exhibitions. Clientele: general public. Overall price range: $150-2,500; most work sold at $300-1,000.

• Sponsors annual Bi-State Art Competition for Mississippi and Alabama artists.

Media Considers all media.

Style Exhibits all styles, all genres.

Terms Work available for sale during exhibitions (25% commission). Retail price set by the artist. Gallery provides insurance and promotion; shipping costs are shared. Prefers framed artwork.

Submissions Prefers artists from Mississippi, Alabama and the Southeast. Send query letter with résumé, slides, bio and SASE. Responds in 3 months. Finds artists through submissions, referrals, work included in competitions and visiting exhibitions.

N MIKHAIL ZAKIN GALLERY AT OLD CHURCH

561 Piermont Rd., Demarest NJ 07627. (201)767-7160. Fax: (201)767-0497. E-mail: gallery@tasoc.org. Web site: www.tasoc.org. **Contact:** Rachael Faillace, gallery director. Nonprofit gallery. Established. 1974. 10-exhibition season includes contemporary emerging and established regional artist, NJ Annual Small Works Show, student and faculty group exhibitions, among others; Gallery hours:9:30 A.M.- 5:30 P.M, Monday through Friday. Call for weekend and evening hours.

Media The gallery shows work in all media.

Style All styles and genres are considered.

Making Contact & Terms 35% commission fee charged on all gallery sales. Gallery provides promotion and contract.

Submissions Submission guidelines are available on the gallery's web site. Small Works prospectus available online. Mainly finds artists through referrals by other artists and artist registries.

Tips ''Follow guidelines available online.''

MILL BROOK GALLERY & SCULPTURE GARDEN

236 Hopkinton Rd., Concord NH 03301. (603)226-2046. E-mail: artsculpt@mindspring.com. Web site: www.themillbrookgallery.com. For-profit gallery. Estab. 1996. Exhibits 70 artists. Sponsors 7 exhibits/year. Average display time: 6 weeks. Open Tuesday-Saturday, 11-5 (April 1 to December 24); open by appointment December 25 to March 31. Outdoor juried sculpture exhibit; 3 rooms inside for exhibitions; 1,800 sq. ft. Overall price range: $8-30,000; most work sold at $500-1,000.

Media Considers acrylic, ceramics, collage, drawing, glass, mixed media, oil, pastel, sculpture, watercolor, etchings, mezzotints, serigraphs and woodcuts. Most frequently exhibits oil, acrylic and pastel.

Style Considers all styles. Most frequently exhibits color field/conceptualism, expressionism. Genres include landscapes. Prefers more contemporary art.

Terms Artwork is accepted on consignment (50% commission). Retail price set by the artist. Gallery provides insurance, promotion and contract. Accepted work should be framed and matted.

Submissions Write to arrange a personal interview to show portfolio of photographs, slides. Send query letter with artist's statement, bio, photocopies, photographs, résumé, slides, SASE. Submission of art work: Accept CD's, web sites, slides, and digital images. Responds to all artists within month, only if interested. Finds artists through word of mouth, submissions, art exhibits, referrals by other artists.

N MOBILE MUSEUM OF ART

4850 Museum Dr., Mobile AL 36608-1917. (251)208-5200. E-mail: prichelson@mobilemuseumof art.com. Web site: www.MobileMuseumOfArt.com. **Director:** Tommy McPherson. Clientele tourists and general public. Sponsors 6 solo and 12 group shows/year. Average display time 6-8 weeks. Interested in emerging, mid-career and established artists. Overall price range $100-5,000; most artwork sold at $100-500.

Media Considers all media and all types of visual art.

Style Exhibits all styles and genres. "We are a general fine arts museum seeking a variety of styles, media and time periods." Looking for "historical significance."

Terms Accepts work on consignment (20% commission). Retail price set by artist. Exclusive area representation not required. Gallery provides insurance, promotion, contract; shipping costs are shared. Prefers framed artwork.

Submissions Send query letter with résumé, brochure, business card, slides, photographs, bio and SASE. Write to schedule an appointment to show a portfolio, which should include slides, transparencies and photographs. Replies only if interested within 3 months. Files résumés and slides. All material is returned with SASE if not accepted or under consideration.

Tips "Be persistent but friendly!"

NEVADA MUSEUM OF ART

160 W. Liberty St., Reno NV 89501. (775)329-3333. Fax: (775)329-1541. Web site: www.nevadaa rt.org. **Curator:** Ann Wolfe. Estab. 1931. Sponsors 12-15 exhibits/year. Average display time: 2-3 months.

Media Considers all media.

Style Exhibits all styles and genres.

Terms Acquires art "by committee following strict acquisition guidelines per the mission of the institution."

Submissions Send query letter with slides. Write to schedule an appointment to show a portfolio. "No phone calls and no e-mails, please."

Tips "The Nevada Museum of Art is a private, nonprofit institution dedicated to providing a forum for the presentation of creative ideas through its collections, educational programs, exhibitions and community outreach. We specialize in art addressing the environment and the altered landscape."

NEW VISIONS GALLERY, INC.

1000 N. Oak Ave., Marshfield WI 54449. (715)387-5562. E-mail: newvisions.gallery@verizon.n et. Web site: www.newvisionsgallery.org. **Executive Director:** Mary Peck. Nonprofit educational gallery. Represents emerging, mid-career and established artists. Organizes a variety of group and thematic shows, sponsors Marshfield Art Fair; "Culture and Agriculture" annual invitational exhibit of art with agricultural themes. Does not represent artists on a continuing basis but does accept exhibition proposals. Average display time: 6 weeks. Open all year; Monday-Friday, 9-5:30; Saturday 11-3. 1,500 sq. ft. Price range varies with exhibit. Small gift shop with original jewelry, notecards and crafts at $10-50. "We do not show 'country crafts.' "

Media Considers all media.

Style Exhibits all styles and genres.

Terms Accepts work on consignment (35% commission). Retail price set by artist. Gallery provides insurance and promotion. Prefers artwork framed.

Submissions Send query letter with résumé, high-quality slides or digital images and SASE. Label slides with size, title, media.

NORTHWEST ART CENTER

Minot State University, 500 University Ave. W., Minot ND 58707. (701)858-3264. Fax: (701)858-3894. E-mail: nac@minotstateu.edu. Web site: www.minotstateu.edu/nac. **Director:** Avis R. Veikley. Nonprofit gallery. Estab. 1970. Represents emerging, mid-career and established artists. Sponsors 18-20 shows/year. Average display time: 4-6 weeks. Open all year. Two galleries—Hartnett Hall Gallery: Monday-Friday, 8-4:30; The Library Gallery: Sunday-Thursday, 8-9. Located on university campus; 1,000 sq. ft. 100% of space for special exhibitions. 100% private collectors. Overall price range: $100-40,000; most work sold at $100-4,000.

Media Considers all media. Emphasis on contemporary works on paper.

Style Exhibits all styles, all genres.

Terms Retail price set by the artist. 30% commission. Gallery provides insurance, promotion and contract; shipping costs are shared. Prefers framed artwork.

Submissions Send query letter with résumé, bio, artist's statement, slides and SASE. Sponsors 2 national juried shows each year; prospectus available on Web site. Call for appointment to show portfolio of originals, photographs, slides and transparencies. Responds in 4 months. Files all material. Finds artists through submissions, visiting exhibitions, word of mouth.

N NOVUS, INC.

439 Hampton Green, Peachtree City GA 30269. (770)487-0706. Fax: (770)487-2112. E-mail: novu sus@bellsouth.net. **Vice President:** Pamela Marshall. Art dealer. Estab. 1987. Represents 200 emerging, mid-career and established artists. Clientele corporate, hospitality, healthcare. 5% private collectors, 95% corporate collectors. Overall price range $500-20,000; most work sold at $800-5,000.

Media Considers oil, acrylic, watercolor, pastel, mixed media, collage, paper, sculpture, ceramics, craft, fiber, glass, photography, and all types of prints.

Style Exhibits all styles. Genres include landscapes, abstracts, florals and figurative work. Prefers landscapes, abstract and figurative.

Terms Accepts work on consignment (50% commission). Retail price set by the artist. Gallery provides promotion and contract; shipping costs are shared. Prefers artwork unframed.

Submissions Send query letter with résumé, slides, brochure and reviews. Write for appointment to show portfolio of originals, photographs and slides. Responds only if interested within 1 month. Files slides and bio. Finds artists through agents, visiting exhibitions, word of mouth, art publications and sourcebooks, submissions.

Tips "Send complete information and pricing. Do not expect slides and information back. Keep the dealer updated with current work and materials."

OPENING NIGHT FRAMING SERVICES & GALLERY

2836 Lyndale Ave. S., Minneapolis MN 55408-2108. (612)872-2325. Fax: (612)872-2385. E-mail: deen@onframe-art.com. Web site: www.onframe-art.com. **Contact:** Deen Braathen. Estab. 1974. Exhibits 15 emerging and mid-career artists. Sponsors 4 exhibits/year. Open all year; Monday-Friday, 8:30-5; Saturday, 10:30-4.

Media Considers acrylic, ceramics, collage, drawing, fiber, glass, oil, paper, sculpture and watercolor.

Style Exhibits local and regional art.

Terms Artwork is accepted on consignment, and there is a 50% commission. Retail price set by the gallery. Gallery provides insurance, promotion and contract.

Submissions "E-mail Deen with cover letter, artist statement, and visuals."

OPUS 71 FINE ARTS

(formerly Opus 71 Galleries, Headquarters), 4115 Carriage Dr., Villa P-2, Misty Oaks, Pompano Beach FL 33069. (954)974-4739. E-mail: lionxsx@aol.com. **Co-Directors:** Charles Z. Candler III and Gary R. Johnson. Retail and wholesale private gallery, alternative space, art consultancy and salon style organization. Estab. 1969. Represents 40 (15-20 on regular basis) emerging, mid-career and established artists/year. Open by appointment only. Clientele: upscale, local, international and regional. 75% private collectors; 25% corporate collectors. Overall price range: $200-85,000; most work sold at $500-7,500.

- This gallery is a division of The Leandros Corporation. Other divisions include The Alexander Project and Opus 71 Art Projects.

Media Considers oil, acrylic, pastel, pen & ink, drawing, mixed media, collage, sculpture and ceramics; types of prints include woodcuts and wood engravings. Most frequently exhibits oils or acrylic, bronze and marble sculpture and pen & ink or pastel drawings.

Style Exhibits expressionism, neo-expressionism, primitivism, painterly abstraction, surrealism, conceptualism, minimalism, color field, postmodern works, impressionism, photorealism, hard-edge geometric abstraction (paintings), realism and imagism. Exhibits all genres. Prefers figural, objective and nonobjective abstraction and realistic bronzes (sculpture).

Terms Accepts work on consignment or buys outright. Retail price set by "consulting with the artist initially." Gallery provides insurance (with limitations), promotion and contract; artist pays for shipping to gallery and for any return of work. Prefers artwork framed, unless frame is not appropriate.

Submissions Telephone call is important. Call for appointment to show portfolio of photographs and actual samples. "We will not look at slides." Responds in 2 weeks. Files résumés, press clippings and some photographs. "Artists approach us from a far flung area. We currently have artists from about 12 states and 4 foreign countries. Most come to us. We approach only a handful of artists annually."

Tips "Know yourself . . . be yourself . . . ditch the jargon. Quantity of work available not as important as quality and the fact that the presenter is a working artist. We don't want hobbyists."

⚱ ORANGE COUNTY CENTER FOR CONTEMPORARY ART

117 N. Sycamore St., Santa Ana CA 92701. (714)667-1517. E-mail: grau@prodigy.net. Web site: www.occca.org. **Exhibitions Director:** Pamela Grau Twena. Cooperative, nonprofit gallery. Exhibits emerging and mid-career artists. 26 members. Sponsors 12 shows/year. Average display time: 1 month. Open all year; Thursday and Sunday, 12-5; Friday and Saturday, 12-9; Monday-Wednesday by appointment. Opening receptions first Saturday of every month, 7-10 pm. Gallery space: 5,500 sq. ft. 25% of time for special exhibitions; 75% of time for gallery artists. Membership fee: $30/month.

Media Considers all media—contemporary work.

Terms Co-op membership fee plus a donation of time. Retail price set by artist.

Submissions Accepts artists generally in and within 50 miles of Orange County. Send query letter with SASE. Responds in 1 week.

Tips "This is an artist-run nonprofit. Send SASE for application prospectus. Membership involves 10 hours per month of volunteer work at the gallery or gallery-related projects."

THE PARTHENON

Centennial Park, Nashville TN 37201. (615)862-8431. Fax: (615)880-2265. E-mail: susan@parthe non.org. Web site: www.parthenon.org. **Curator:** Susan E. Shockley. Nonprofit gallery in a full-size replica of the Greek Parthenon. Estab. 1931. Exhibits the work of emerging to mid-career artists. Sponsors 10-12 shows/year. Average display time: 3 months. Clientele: general public, tourists. Overall price range: $300-2,000. "We also house a permanent collection of American paintings (1765-1923)."

Media Considers "nearly all" media.

Style "Interested in both objective and non-objective work. Professional presentation is important."

Terms "Sales request a 20% donation." Retail price set by artist. Gallery provides a contract and limited promotion. The Parthenon does not represent artists on a continuing basis.

Submissions Send images via CD, résumé and artist's statement addressed to curator.

Tips "We plan our gallery calendar at least one year in advance."

PENTIMENTI GALLERY

145 N. Second St., Philadelphia PA 19106. (215)625-9990. E-mail: mail@pentimenti.com. Web site: www.pentimenti.com. **Director:** Christine Pfister. Commercial gallery. Estab. 1992. Represents 20-30 emerging, mid-career and established artists. Sponsors 7-9 exhibits/year. Average display time: 4-6 weeks. Open all year; Wednesday-Friday, 11-5; weekends, 12-5. Closed Sundays, August, Christmas and New Year. Located in the heart of Old City Cultural district in Philadelphia. Overall price range: $250-12,000; most work sold at $1,500-7,000.

Media Considers all media. Most frequently exhibits paintings of all media.

Style Exhibits conceptualism, minimalism, postmodernism, painterly abstraction, and representational works. Most frequently exhibits postmodernism, minimalism and conceptualism.

Terms Artwork is accepted on consignment (50% commission). Retail price set by the gallery and the artist. Gallery provides insurance and promotion. Requires exclusive representation locally.

Submissions Please review our guidelines in our Web site at http://www.pentimenti.com.

N PETERS VALLEY CRAFT EDUCATION CENTER

19 Kuhn Rd., Layton NJ 07851. (973)948-5200. Fax: (973)948-0011. E-mail: info@petersvalley.o rg. Web site: www.petersvalley.org. **Gallery Manager:** Mikal Brutzman. Nonprofit gallery and store -consignment. Estab. 1970. Approached by about 200 artists/year. Represents about 400 emerging, mid-career and established artists. Exhibited artists include William Abranowitz and Clyed Butcher. Average display time for store items varies. Gallery exhibitions approx. one month duration. Open year round, 10am-6pm. Located in northwestern New Jersey in Delaware Water Gap National Recreation Area; 2 floors; approximately 3,000 sq. ft. Clients include local community, students, tourists and upscale. 5% of sales are to corporate collectors. Overall price range $5-3,000; most work sold at $100 -300.

Media Considers all media and all types of prints. Also exhibits non-referential, mixed media, collage and sculpture.

Style Considers all styles. Most frequently exhibits contemporary fine art and craft.

Terms Artwork is accepted on consignment and there is a 60% commission. Retail price set by the gallery in conjunction with artist. Gallery provides insurance and promotion. Accepted work should be framed, mounted and matted. Does not require exclusive representation locally. Accepts only artists from North America.

Submissions Call or write to arrange a personal interview to show portfolio. Send query letter with artist's statement, bio, résumé and images . Returns material with SASE. Responds when space is available. Files résumé and bio. Finds artists through submissions, art exhibits, art fairs, and referrals by other artists.

Tips "Send images and artist's info first and follow up with an e-mail."

THE PHOENIX GALLERY

210 11th Ave. at 25th St., Suite 902, New York NY 10001. (212)226-8711. E-mail: info@phoenix-gallery.com. Web site: www.phoenix-gallery.com. **Director**: Linda Handler. Nonprofit gallery. Estab. 1958. 32 members. Exhibits the work of emerging, mid-career and established artists. Exhibited artists include Gretl Bauer and Jae Hi Ahn. Sponsors 10-12 shows/year. Average display time: 1 month. Open Tuesday-Saturday, 11:30-6. Located in Chelsea; 180 linear ft. "We have a movable wall that can divide the gallery into two large spaces." 100% of space for special exhibitions. 75% of sales are to private collectors, 25% corporate clients, also art consultants. Overall price range: $50-20,000; most work sold at $300-10,000.

- The Phoenix Gallery actively reaches out to the members of the local community, scheduling juried competitions, dance programs, poetry readings, book signings, plays, artists speaking on art panels and lectures. A special exhibition space, The Project Room, has been established for guest-artist exhibits.

Media Considers oil, acrylic, watercolor, pastel, pen & ink, drawings, mixed media, collage, works on paper, sculpture, ceramic, photography, original handpulled prints, woodcuts, engravings, wood engravings, linocuts, etchings and photographs. Most frequently exhibits oil, acrylic and watercolor.

Style Exhibits painterly abstraction, minimalism, realism, photorealism, hard-edge geometric abstraction and all styles.

Terms Co-op membership fee plus donation of time for active members, not for inactive or associate members (25% commission). Retail price set by gallery. Offers customer discounts and payment by installment. Gallery provides promotion and contract; artist pays for shipping. Prefers framed artwork.

Submissions Send query letter with résumé, slides and SASE. Call for appointment to show portfolio of slides. Responds in 1 month. Only files material of accepted artists. The most common mistakes artists make in presenting their work are "incomplete résumé, unlabeled slides and an application that is not filled out properly. We find new artists by advertising in art magazines and art newspapers, word of mouth, and inviting artists from our juried competition to be reviewed for membership."

Tips "Come and see the gallery-meet the director."

PORTFOLIO ART GALLERY

2007 Devine St., Columbia SC 29205. (803)256-2434. E-mail: artgal@portfolioartgal.com. Web site: www.portfolioartgal.com. **Owner**: Judith Roberts. Retail gallery and art consultancy. Estab. 1980. Represents 40-50 emerging, mid-career and established artists. Exhibited artists include Juko Ono Rothwell, Sigmund Abeles and Shannon Bueker. Sponsors 3 shows/year. Average

display time: 3 months. Open all year. Located in a 1930s shopping village, 1 mile from downtown; 2,000 sq. ft.; features 12-ft. ceilings. 100% of space for work of gallery artists. "A unique feature is glass shelves where matted and small to medium pieces can be displayed without hanging on the wall." Clientele: professionals, collectors, corporations; 70% professionals and collectors, 30% corporate. Overall price range: $150-12,500; most work sold at $600-$3,000.

- Art Gallory Director, Judith Roberts has a fine arts degree with an intensive in printmaking and is a former art teacher. Also named " A Top 100 Retailer of American Crafts."

Media Considers oil, acrylic, watercolor, pastel, mixed media, collage, works on paper, sculpture, ceramic, glass, original handpulled prints, woodcuts, wood engravings, linocuts, engravings, mezzotints, etchings, lithographs and serigraphs. Most frequently exhibits oils, acrylics, ceramics and sculpture, and original jewelry.

Style Exhibits neo-expressionism, painterly abstraction, imagism, minimalism, color field, impressionism, and realism. Genres include landscapes and figurative work. Prefers landscapes/seascapes, painterly abstraction and figurative work. "I especially like mixed media pieces, original prints and oil paintings. Pastel medium and watercolors are also favorites, as well as kinetic sculpture and whimsical clay pieces."

Terms Accepts work on consignment (40% commission). Retail price set by gallery and artist. Offers payment by installments. Gallery provides insurance, promotion and contract; artist pays for shipping. Artwork may be framed or unframed.

Submissions Send query letter with bio and images via e-mail, CD or slides. Write for appointment to show portfolio of originals, slides, photographs and transparencies. Responds within 1 month, only if interested. Files tearsheets, brochures and slides. Finds artists through visiting exhibitions and referrals.

Tips "The most common mistake beginning artists make is showing all the work they have ever done. I want to see only examples of recent best work—unframed, originals (no copies)—at portfolio reviews."

THE PRINT CENTER

1614 Latimer St., Philadelphia PA 19103. (215)735-6090. Fax: (215)735-5511. E-mail: info@print center.org. Web site: www.printcenter.org. Nonprofit gallery. Estab. 1915. Exhibits emerging, mid-career and established artists. Approached by 500 artists/year. Sponsors 11 exhibits/year. Average display time: 2 months. Open all year; Tuesday-Saturday, 11-5:30. Closed December 21-January 6. Gallery houses 3 exhibit spaces as well as a separate Gallery Store. Located in historic Rittenhouse area of Philadelphia. Clients include local community, students, tourists and high end collectors. 30% of sales are to corporate collectors. Overall price range: $15-15,000; most work sold at $200.

Media Considers all forms of printmaking, photography and digital printing. Accepts original artwork only—no reproductions.

Style Considers all styles and genres.

Terms Accepts artwork on consignment (50% commission). Retail price set by the artist. Gallery provides insurance, promotion and contract. Accepted work should be framed and matted for exhibitions; unframed for Gallery Store. Does not require exclusive representation locally. Only accepts prints and photos.

Submissions Must be member to submit work—member's work is reviewed by Curator and Gallery Store Manager. See Web site for membership application. Finds artists through submissions, art exhibits and membership.

QUEENS COLLEGE ART CENTER

Benjamin S. Rosenthal Library, Queens College, Flushing NY 11367-1597. (718)997-3770. Fax: (718)997-3536. E-mail: artcenter@qc.cuny.edu. Web site: qcpages.qc.cuny.edu/Art_Library/cal endar.html. **Director:** Suzanna Simor. Curator: Alexandra de Luise. Assistant Curator: Tara Tye Mathison. Estab. 1955. Average display time: 6 weeks. Overall price range: $100-3,000.

Media Considers all media.

Style Open to all styles and genres; decisive factors are originality and quality.

Terms Charges 40% commission. Accepted work can be framed or unframed, mounted or unmounted, matted or unmatted. Sponsors openings. Artist is responsible for providing/arranging refreshments and cleanup.

Submissions Send query letter with resume, samples and SASE. Responds in 1 month.

▧ MARCIA RAFELMAN FINE ARTS

10 Clarendon Ave., Toronto ON M4V 1H9 Canada. (416)920-4468. Fax: (416)968-6715. E-mail: info@mrfinearts.com. Web site: www.mrfinearts.com. **President:** Marcia Rafelman. Gallery Director: Meghan Richardson. Semi-private gallery. Estab. 1984. Average display time: 1 month. Gallery is centrally located in Toronto; 2,000 sq. ft. on 2 floors. Clients include local community, tourists and upscale. 40% of sales are to corporate collectors. Overall price range: $800-25,000; most work sold at $1,500.

Media Considers all media. Most frequently exhibits photography, painting and graphics. Considers all types of prints.

Style Exhibits geometric abstraction, minimalism, neo-expressionism, primitivism and painterly abstraction. Most frequently exhibits high realism paintings. Considers all genres except Southwestern, Western and wildlife.

Terms Artwork is accepted on consignment (50% commission); net 30 days. Retail price set by the gallery and the artist. Gallery provides insurance, promotion and contract. Requires exclusive representation locally.

Submissions Mail or e-mail portfolio for review; include bio, photographs, reviews. Responds within 2 weeks, only if interested. Finds artists through word of mouth, submissions, art fairs, referrals by other artists.

▧ RAHR-WEST ART MUSEUM

610 N. Eighth St., Manitowoc WI 54220. (920)683-4501. Fax: (920)683-5047. E-mail: rahrwest@manitowoc.org. Web site: www.rahrwestartmuseum.org. **Contact:** Barbara Bundy-Jost. Museum. Estab. 1950. Five thematic exhibits, preferably groups of mid-career and established artists. Sponsors 8-10 shows/year. Average display time 6-8 weeks. Open all year; Monday-Friday, 10-4; Wednesday, 10-8; weekends, 11-4. Closed major holidays. Clients include local community and tourists. Overall price range $50-2,200; most work sold at $150-200.

Media Considers all media and all types of original prints except postersor glicee' prints. Most frequently exhibits painting, pastel and original prints.

Style Considers all styles. Most frequently exhibits impressionism, realism and various abstraction. Genres include figurative work, florals, landscapes and portraits.

Terms Artwork is accepted on consignment and there is a 30% commission. Retail price set by the artist. Gallery provides insurance. Accepted work should be framed with hanging devices attached.

Galleries

Submissions Send query letter with artist's statement, bio, SASE and slides. Returns material only if requested with with SASE if not considered. Otherwise slides are filed with contact info and bio. Responds only if interested.

RAIFORD GALLERY

1169 Canton St., Roswell GA 30075. (770)645-2050. Fax: (770)992-6197. E-mail: raifordgallery@ mindspring.com. Web site: www.raifordgallery.com. For-profit gallery. Estab. 1996. Approached by many artists/year. Represents 400 mid-career and established artists. Exhibited artists include Cathryn Hayden (collage, painting and photography) and Richard Jacobus (metal). Sponsors 4 exhibits/year. Average display time: 4 weeks. Open all year; Tuesday-Friday, 10-6; Saturday, 10-5. Located in historic district of Roswell; 4,500 sq. ft. in an open 2-story timber-frame space. Clients include local community, tourists and upscale. Overall price range: $10-2,000; most work sold at $200-300.
Media Considers all media except installation. Most frequently exhibits painting, sculpture and glass.
Style Exhibits contemporary American art & craft.
Terms Artwork is accepted on consignment, and there is a 50% commission. Retail price set by the artist. Gallery provides insurance, promotion and contract. Accepted work should be framed. Requires exclusive representation locally.
Submissions Call or write to arrange a personal interview to show portfolio of photographs, slides and originals. Send query letter with artist's statement, bio, brochure, photocopies, photographs, SASE. Returns material with SASE. Finds artists through submissions, portfolio reviews, art exhibits and art fairs.

RAMSAY MUSEUM

1128 Smith St., Honolulu HI 96817. (808)537-ARTS. Fax: (808)531-MUSE. E-mail: ramsay@lava. net, ramsaymuseum@art.net. Web site: www.ramsaymuseum.org. **CEO:** Ramsay. Gallery, museum shop, permanent exhibits and artists' archive documenting over 200 exhibitions including 500 artists of Hawaii. Estab. 1981. Open all year; Monday-Friday, 10-5; Saturday, 10-4. Located in downtown historic district; 5,000 sq. ft.; historic building with courtyard. Displaying permanent collection of Ramsay quill & ink originals spanning 50 years. Clientele: 50% tourist, 50% local; 25% private collectors, 75% corporate collectors.
Media Especially interested in ink.
Style Currently focusing on the art of tattoo.
Terms Accepts work on consignment. Retail price set by the artist.
Submissions Send query letter with résumé, bio, 20 slides, SASE. Write for appointment to show portfolio of original art. Responds within 1 month, only if interested. Files all material that may be of future interest.
Tips "Keep a record of all artistic endeavors for future use, and to show your range to prospective commissioners and galleries. Prepare your gallery presentation packet with the same care that you give to your art creations. Quality counts more than quantity. Show samples of current work with an exhibit concept in writing."

N ANNE REED GALLERY

P.O. Box 597, Ketchum ID 83340. (208)726-3036. Fax: (208)726-9630. E-mail: info@annereedgal lery.com. Web site: www.annereedgallery.com. **Director:** Muffet Jones. Retail Gallery. Estab.

1980. Represents mid-career and established artists. Exhibited artists include Thomas Brummett, John Buck, Deborah Butterfield, Guy Dill, Bella Feldman, Josh Garber, Kenro Izu, Robert Kelly, Mathias Kessler, Frank Lobdell, Ricardo Mazal, John McCormick, Manuel Neri, Dan Rizzie, Boaz Vaadia, Peter Woytuk, and Hiro Yokose. Sponsors 10 exhibitions/year. Average display time 1 month. Open all year. Located at 391 First Avenue North. 10% of space for special exhibitions; 90% of space for gallery artists. Clientele: 80% private collectors, 20% corporate collectors.

Media Most frequently exhibits sculpture, wall art and photography.

Style Exhibits expressionism, abstraction, conceptualism, impressionism, photorealism, realism. Prefers contemporary.

Terms Accepts work on consignment. Retail price set by gallery and artist. Sometimes offers customer discounts and payment by installment. Gallery provides insurance, promotion, contract and shipping costs from gallery. Prefers artwork framed.

Submissions Contact the gallery before sending any work. Anne Reed Gallery is not responsible for unsolicited materials.

Tips ''Please send only slides or other visuals of current work accompanied by updated résumé. Check gallery representation prior to sending visuals. Always include SASE.''

▣ RIVER GALLERY

400 E. Second St., Chattanooga TN 37403. (423)265-5033, ext. 5. Fax: (423)265-5944. E-mail: details@river-gallery.com. **Owner Director:** Mary R. Portera. Retail gallery. Estab. 1992. Represents 100 emerging, mid-career and established artists/year. Exhibited artists include Leonard Baskin and Scott E. Hill. Sponsors 12 shows/year. Display time 1 month. Open all year; Monday-Saturday, 10-5; Sunday, 1-5. Located in Bluff View Art District in downtown area; 2,500 sq. ft.; restored early New Orleans-style 1900s home; arched openings into rooms. 20% of space for special exhibitions; 80% of space for gallery artists. Clients include upscale tourists, local community. 95% of sales are to private collectors, 5% corporate collectors. Overall price range $5-10,000; most work sold at $200-2,000.

Media Considers all media. Most frequently exhibits oil, original prints, photography, watercolor, mixed media, clay, jewelry, wood, glass and sculpture.

Style Exhibits all styles and genres. Prefers painterly abstraction, impressionism, photorealism.

Terms Accepts work on consignment (50% commission). Retail price set by the gallery. Gallery provides insurance, promotion and contract; shipping costs are shared. Prefers artwork framed.

Submissions Send query letter with resume, slides, bio, photographs, SASE, reviews and artist's statement. Call or e-mail for appointment to show portfolio of photographs and slides. Files all material unless we are not interested then we return all information to artist. Finds artists through word of mouth, referrals by other artists, visiting art fairs and exhibitions, submissions, ads in art publications.

▣ ROGUE GALLERY & ART CENTER

40 S. Bartlett, Medford OR 97501. (541)772-8118. Fax: (541)772-0294. E-mail: judy@roguegallery.org. Web site: www.roguegallery.org. **Executive Director:** Judy Barnes. Nonprofit sales rental gallery. Estab. 1961. Represents emerging, mid-career and established artists. Sponsors 8 shows/year. Average display time 6 weeks. Open all year; Tuesday-Friday, 10-5; Saturday, 11-3. Located downtown; main gallery 240 running ft. (2,000 sq. ft.); rental/sales and gallery shop, 1,800 sq. ft.; classroom facility, 1,700 sq. ft. ''This is the only gallery/art center/exhibit space of its kind

in the region, excellent facility, good lighting." 33% of space for special exhibitions; 33% of space for gallery artists. 95% of sales are to private collectors. Overall price range $100-5,000; most work sold at $400-1,000.

Media Considers all media and all types of prints. Most frequently exhibits mixed media, drawing, installation, painting, sculpture, watercolor.

Style Exhibits all styles and genres.

Terms Accepts work on consignment (35% commission to members; 40% non-members). Retail price set by the artist. Gallery provides insurance, promotion and contract; in the case of main gallery exhibit.

Submissions Send query letter with résumé, 10 slides, bio and SASE. Call or write for appointment. Responds in 1 month.

Tips "The most important thing an artist needs to demonstrate to a prospective gallery is a cohesive, concise view of himself as a visual artist and as a person working with direction and passion."

ALICE C. SABATINI GALLERY

1515 SW 10th Ave., Topeka KS 66604-1374. (785)580-4516. Fax: (785)580-4496. E-mail: sbest@t scpl.org. Web site: www.tscpl.org. **Gallery Director:** Sherry Best. Nonprofit gallery. Estab. 1976. Exhibits emerging, mid-career and established artists. Sponsors 6-8 shows/year. Average display time: 6 weeks. Open all year; Monday-Friday, 9-9; Saturday, 9-6; Sunday, 12-9. Located 1 mile west of downtown; 2,500 sq. ft.; security, track lighting, plex top cases; 5 moveable walls. 100% of space for special exhibitions and permanent collections. Overall price range: $150-$5,000.

Media Considers oil, fiber, acrylic, sculpture, glass, watercolor, mixed media, ceramic, pastel, collage, metal work, woodcuts, wood engravings, linocuts, engravings, mezzotints, etchings, lithographs, photography, and installation. Most frequently exhibits ceramic, oil and prints.

Style Exhibits neo-expressionism, painterly abstraction, postmodern works and realism. Prefers painterly abstraction, realism and neo-expressionism.

Terms Retail price set by artist. Gallery provides insurance; artist pays for shipping costs. Prefers artwork framed. Does not handle sales.

Submissions Usually accepts regional artists. Send query letter with résumé and 12-24 images. Call or write for appointment to show portfolio. Responds in 2 months. Files résumé. Finds artists through visiting exhibitions, word of mouth and submissions.

Tips "Find out what each gallery requires from you and what their schedule for reviewing artists' work is. Do not go in unannounced. Have good-quality images. If reproductions are bad, they probably will not be looked at. Have a dozen or more to show continuity within a body of work. Your entire body of work should be at least 50 pieces. Competition gets heavier each year. We look for originality."

SAPER GALLERIES

433 Albert Ave., East Lansing MI 48823. (517)351-0815. E-mail: roy@sapergalleries.com. Web site: www.sapergalleries.com. **Director:** Roy C. Saper. Retail gallery. Estab. in 1978; in 1986 designed and built new addition. Displays the work of 150 artists, mostly mid-career, and artists of significant national prominence. Exhibited artists include Picasso, Peter Max, Rembrandt. Sponsors 2 shows/year. Average display time: 2 months. Open all year. Located downtown; 5,700 sq. ft. 50% of space for special exhibitions. Clients include students, professionals, experienced and new collectors. 80% of sales are to private collectors, 20% corporate collectors. Overall price range: $100-100,000; most work sold at $1,000.

Media Considers oil, acrylic, watercolor, pastel, drawings, mixed media, collage, paper, sculpture, ceramic, craft, glass and original handpulled prints. Considers all types of prints except offset reproductions. Most frequently exhibits intaglio, serigraphy and sculpture. "Must be of highest professional quality."

Style Exhibits expressionism, painterly abstraction, surrealism, postmodern works, impressionism, realism, photorealism and hard-edge geometric abstraction. Genres include landscapes, florals, southwestern and figurative work. Prefers abstract, landscapes and figurative. Seeking extraordinarily talented, outstanding artists who will continue to produce exceptional work.

Terms Accepts work on consignment (negotiable commission); or buys outright for negotiated percentage of retail price. Retail price set by the artist. Offers payment by installments. Gallery provides insurance, promotion and contract; shipping costs are shared. Prefers artwork unframed (gallery frames).

Submissions Prefers digital pictures e-mailed to roy@sapergalleries.com. Call for appointment to show portfolio of originals or photos of any type. Responds in 1 week. Files any material the artist does not need returned. Finds artists mostly through New York Artexpo.

Tips "Present your very best work to galleries that display works of similar style, quality and media. Must be outstanding, professional quality. Student quality doesn't cut it. Must be great. Be sure to include prices and SASE."

ⓝ WILLIAM & FLORENCE SCHMIDT ART CENTER

Southwestern Illinois College, Belleville IL 62221. E-mail: libby.reuter@swic.edu. Web site: www.schmidtartcenter.com. **Contact:** Libby Reuter, executive director. Nonprofit gallery. Estab. 2001. Exhibits emerging, mid-career and established artists. Sponsors 10-12 exhibits/year. Average display time 6-8 weeks. Open Tuesday-Saturday, 11-5. Closed during college holidays. Clients include local community, students and tourists.

Media Considers all media. Most frequently exhibits oil, ceramics, photography. Considers all types of prints.

Style Considers all styles.

Submissions Mail or e-mail portfolio for review. Send query letter with artist's statement, bio and slides or digital images. Returns material with SASE. Finds artists through art fairs and exhibits, portfolio reviews, referrals by other artists, submissions and word of mouth.

SECOND STREET GALLERY

115 Second St. SE, Charlottesville VA 22902. (434)977-7284. Fax: (434)979-9793. E-mail: ssg@secondstreetgallery.org. Web site: www.secondstreetgallery.org. **Director:** Catherine Barber. Estab. 1973. Sponsors approximately 12 exhibits/year. Average display time: 1 month. Open Tuesday-Saturday, 11-6; 1st Friday of every month, 6-8, with Artist Talk at 6:30. Overall price range: $300-2,000.

Media Considers all media, except craft. Most frequently exhibits sculpture, paintings, prints and photographs.

Style Exhibits the best of contemporary artistic expression.

Terms Artwork is accepted on consignment (30% commission).

Submissions Reviews slides/CDs in fall; $15 processing fee. Submit 10 slides or a powerpoint CD for review; include artist's statement, cover letter, bio/résumé, and most importantly, a SASE. Responds in 2 months.

Tips Looks for work that is "cutting edge, innovative, unexpected."

Ⓝ ANITA SHAPOLSKY GALLERY

152 E. 65th St., (patio entrance), New York NY 10065. (212)452-1094. Fax: (212)452-1096. E-mail: ashapolsky@nyc.rr.com. Web site: www.anitashapolskygallery.com. For-profit gallery. Estab. 1982. Exhibits established artists. Exhibited artists include Ernest Briggs, painting; Michael Loew, painting ; Buffie Johnson, painting; William Manning, painting; Clement Meadmore, sculpture; Betty Parsons, painting and sculpture and others. Open all year; Wednesday-Saturday, 11-6. Call for summer hours. Clients include local community and upscale.

Media Considers acrylic, collage, drawing, mosaic, mixed media, oil, paper, sculpture, etchings, lithographs, serigraphs. Most frequently exhibits oil, acrylic and sculpture.

Style Exhibits expressionism and geometric abstraction and painterly abstraction.

Terms Prefers only 1950s and 1960s abstract expressionism.

Submissions Mail portfolio for review in May and October only. Send query letter with artist's statement, bio, SASE and slides. Returns material with SASE.

SOUTH DAKOTA ART MUSEUM

South Dakota State University, Box 2250, Brookings SD 57007. (605)688-5423 or (866)805-7590. Fax: (605)688-4445. Web site: www.SouthDakotaArtMuseum.com. **Curator of Exhibits:** John Rychtarik. Estab. 1970. Sponsors 15 exhibits/year. Average display time: 4 months. Open Monday-Friday, 10-5; Saturday, 10-4; Sunday, 12-4. Closed state holidays. Six galleries offer 26,000 sq. ft. of exhibition space. Overall price range: $200-6,000; most work sold at $500.

Media Considers all media and all types of prints. Most frequently exhibits painting, sculpture and fiber.

Style Considers all styles.

Terms Artwork is accepted on consignment (30% commission). Retail price set by the artist. Gallery provides insurance and promotion. Accepted 2D work must be framed and ready to hang.

Submissions Send query letter with artist's statement, bio, résumé, slides, SASE. Responds within 3 months, only if interested. Finds artists through word of mouth, portfolio reviews, art exhibits, referrals by other artists.

SPACES

2220 Superior Viaduct, Cleveland OH 44113. (216)621-2314. E-mail: info@spacesgallery.org. Web site: www.spacesgallery.org. Artist-run alternative space. Estab. 1978. "Exhibitions feature artists who push boundaries by experimenting with new forms of expression and innovative uses of media, presenting work of emerging artists and established artists with new ideas. SPACE Lab is open to all artists, inlcuding students who wish to create a short-term experimental installation in the gallery. The SPACES World Artist Program gives visiting national and international artists the opportunity to create new work and interact with the Northeast Ohio community." Sponsors 4-5 shows/year. Average display time: 8 weeks. Open all year; Tuesday-Sunday. Located in Cleveland; 6,000 sq. ft.; "warehouse space with row of columns."

Media Considers all media. Most frequently exhibits installation, painting, video and sculpture.

Style "Style not relevant; presenting challenging new ideas is essential."

Terms Artists are provided honoraria, and 20% commission is taken on work sold. Gallery provides insurance, promotion and contract.

Submissions Contact SPACES for deadline and application. Also seeking curators interested in pursuing exhibition ideas.

SPAIGHTWOOD GALLERIES, INC.

P.O. Box 1193, Upton MA 01568-6193. (508)529-2511. E-mail: sptwd@verizon.net. Web site: www.spaightwoodgalleries.com. **President:** Sonja Hansard-Weiner. Vice President: Andy Weiner. For-profit gallery. Estab. 1980. Exhibits mostly established artists. 'Artists' page on our Web site http://spaightwoodgalleries.com/Pages/Artists.html (almost 10,000 works from late 15th century to present in inventory)." Sponsors 4 exhibits/year. Average display time: 3 months. Open by appointment. Located in a renovated ex-Unitarian Church; basic space is 90×46 ft; ceilings are 25 ft. high at center, 13 ft. at walls. See http://spaightwoodgalleries.com/Pages/Upton.html for views of the gallery. Clients include mostly Internet and visitors drawn by Internet; we are currently trying to attract visitors from Boston and vicinity via advertising and press releases." 2% of sales are to corporate collectors. Overall price range: $175-125,000; most work sold at $1,000-4,000.

Media Considers all media except installations, photography, glass, craft, fiber. Most frequently exhibits original prints, drawing and ceramic sculpture, occasionally paintings.

Style Exhibits old master to contemporary; most frequently impressionist and post-impressionist (Cassatt, Renoir, Cezanne, Signac, Gauguin, Bonnard), Fauve (Matisse, Rouault, Vlaminck, Derain) modern (Picasso, Matisse, Chagal, Miro, Giacometti), German Expressionist (Heckel, Kollwitz, Kandinsky, Schmidt-Rottluff), Surrealist (Miro, Fini, Tanning, Ernst, Lam, Matta); COBRA (Alechinsky, Appel, Jorn), Abstract Expressionist (Tapies, Tal-Coat, Saura, Lledos, Bird, Mitchell, Frankenthaler, Olitski), Contemporary (Claude Garache, Titus-Carmel, Joan Snyder, John Himmelfarb, Manel Lledos, Jonna Rae Brinkman). Most frequently exhibits modern, contemporary, impressionist and post-impressionist. Work shown is part of our inventory; we buy mostly at auction. In the case of some artists, we buy directly from the artist or the publisher; in a few cases we have works on consignment."

Making Contact Terms Retail price set by both artist and gallery. Accepted work should be unmatted and unframed. Requires exclusive representation locally.

Submissions Prefers link to Web site with bio, exhibition history and images. Returns material with SASE. Responds to queries only if interested. Finds artists through art exhibits (particularly museum shows), referrals by other artists, books.

Tips high-quality art."

STATE OF THE ART GALLERY

120 W. State St., Ithaca NY 14850. (607)277-1626 or (607)277-4950. E-mail: gallery@soag.org. Web site: www.soag.org. Cooperative gallery. Estab. 1989. Sponsors 12 exhibits/year. Average display time: 1 month. Open Wednesday-Friday, 12-6; weekends, 12-5. Located in downtown Ithaca; 2 rooms; about 1,100 sq. ft. Overall price range: $100-6,000; most work sold at $200-500.

Media Considers all media and all types of prints. Most frequently exhibits sculpture, paintings, mixed media.

Style Considers all styles and genres.

Terms There is a co-op membership fee plus a donation of time. There is a 10% commission for members, 30% for nonmembers. Retail price set by the artist. Gallery provides promotion and contract. Accepted work must be ready to hang.

Submissions Write for membership application. Finds artists through word of mouth, submissions, portfolio reviews, art exhibits, referrals by other artists.

STATE STREET GALLERY

1804 State St., La Crosse WI 54601. (608)782-0101. E-mail: ssg1804@yahoo.com. Web site: www.statestreetartgallery.com. **President:** Ellen Kallies. Retail gallery. Estab. 2000. Approached by 15 artists/year. Represents 40 emerging, mid-career and established artists. Exhibited artists include Diane French, Phyllis Martino, Michael Martino and Barbara Hart Decker. Sponsors 6 exhibits/year. Average display time: 4-6 months. Open all year; Tuesday-Friday, 10-4; Saturday, 10-2; closed Saturdays in July. Located across from the University of Wisconsin/La Crosse on one of the main east/west streets. "We are next to a design studio; parking behind gallery." Clients include local community, tourists, upscale. 40% of sales are to corporate collectors, 60% to private collectors. Overall price range: $150-25,000; most work sold at $500-5,000.

Media Considers acrylic, collage, drawing, glass, mixed media, oil, pastel, sculpture, watercolor and photography. Most frequently exhibits oil, dry pigment, drawing, watercolor and mixed media collage. Considers all types of prints.

Style Considers all styles and genres. Most frequently exhibits contemporary representational, realistic watercolor, collage.

Terms Artwork is accepted on consignment (40% commission). Retail price set by the gallery and the artist. Gallery provides insurance, promotion, contract. Accepted work should be framed and matted.

Submissions Call to arrange a personal interview or mail portfolio for review. Send query letter with artist's statement, photographs or slides. Returns material with SASE. Responds in 1 month. Finds artists through word of mouth, art exhibits, art fairs, and referrals by other artists.

Tips "Be organized; be professional in presentation; be flexible! Most collectors today are savvy enough to want recent works on archival-quality papers/boards, mattes, etc. Have a strong and consistant body of work to present."

N STUDIO 7 FINE ARTS

400 Main St., Pleasanton CA 94566. (925)846-4322. E-mail: jaime@studio7finearts.com. Web site: www.studio7finearts.com. **Owners:** Jaime Dowell. Retail gallery. Estab. 1981. Represents/exhibits established artists. Sponsors 10 shows/year. Average display time 3 weeks. Open all year. Located in historic downtown Pleasanton; 5,000 sq. ft.; excellent lighting from natural and halogen sources. 30% of space for special exhibitions; 70% of space for gallery artists. Clientele "wonderful, return customers." 99% private collectors, 1% corporate designer collectors. Overall price range $100-80,000; most work sold at under $2,000-3,000.

Media Considers oil, acrylic, watercolor, pastel, drawing, mixed media, collage, paper, sculpture, ceramics, fine craft, glass, woodcuts, engravings, lithographs, mezzotints, serigraphs and etchings. Most frequently exhibits oil, acrylic, etching, watercolor, handblown glass, jewelry and sculpture.

Style Exhibits painterly abstraction and impressionism. Genres include landscapes and figurative work. Prefers landscapes, figurative and abstract.

Terms Work only on consignment. Retail price set by the artist. Gallery provides promotion and contract and shares in shipping costs.

Submissions Prefers artists from the Bay Area. Send query e-mail with several examples of work representing current style. Call for appointment to show portfolio of originals. Responds only if interested within 1 month. Finds artists through word of mouth and "my own canvassing."

Tips "Be prepared! Please come to your appointment with an artist statement, an inventory listing including prices, a résumé, and artwork that is ready for display."

⚏ STUDIO GALLERY

2108 R Street NW, Washington DC 20008. (202)232-8734. E-mail: info@studiogallerydc.com. Web site: www.studiogallerydc.com. **Director:** Adah Rose Bitterbaum. Cooperative and non-profit gallery. Estab. 1964. Exhibits the work of 30 emerging, mid-career and established local artists. Sponsors 11 shows/year. Average display time 1 month. Gallery for rent the last of August. Located downtown in the Dupont Circle area; 700 sq. ft.; "gallery backs onto a court-yard, which is a good display space for exterior sculpture and gives the gallery an open feeling." Clientele: private collectors, art consultants and corporations. 85% private collectors; 8% corporate collectors. Overall price range $300-10,000; most work sold at $500-3,000.

Media Considers glass, oil, acrylic, watercolor, pastel, pen & ink, drawings, mixed media, collage, works on paper, sculpture, ceramic, fiber, original handpulled prints, woodcuts, lithographs, monotypes, linocuts and etchings. Most frequently exhibits oil, acrylic and paper.

Style Considers all styles. Most frequently exhibits A bstract and Figurative Paintings, Landscapes, Indoor and Outdoor Sculpture and Mixed Media.

Terms Co-op membership fee plus a donation of time (65% commission).

Submissions Send query letter with SASE. Artists must be local or willing to drive to Washington for monthly meetings and receptions. Artist is informed as to when there is a membership opening and a selection review. Files artist's name, address, telephone.

Tips "This is a cooperative gallery. Membership is decided by the gallery membership. Ask when the next review for membership is scheduled. An appointment for a portfolio review with the director is required before the jurying process, however. Dupont Circle is an exciting gallery scene with a variety of galleries. First Fridays from 6-8 for all galleries of DuPont Circle."

⚏ SWOPE ART MUSEUM

25 S. Seventh St., Terre Haute IN 47807-3604. (812)238-1676. Fax: (812)238-1677. E-mail: info@swope.org. Web site: www.swope.org. Nonprofit museum. Estab. 1942. Approached by approximately 10 artists/year. Represents 1-3 mid-career and established artists. Average display time 4-6 weeks. Open all year; Tuesday-Friday, 10-5; Saturday, 12-5; Closed Sunday, Mondays and national holidays. Located in downtown Terre Haute in a Renaissance-revival building with art deco interior.

Media Considers all media. Most frequently exhibits paintings, sculpture, and works on paper. Considers all types of prints except posters.

Style Exhibits American art of all genres. Exhibits permanent collection with a focus on mid 20th century regionalism and Indiana artists but includes American art from all 50 states from 1800's to today.

Terms Focuses on local and regional artists (size and weight of works are limited because we do not have a freight elevator).

Submissions Send query letter with artist's statement, brochure, CD or slides, resume and SASE (if need items returned). Returns material with SASE. Responds in 5 months. Files only what fits the mission statement of the museum for special exhibitions. Finds artists through word of mouth, and annual juried exhibition at the museum.

Tips The Swope has physical limitations due to its historic interior but is willing to consider newer media unconventional media and installations.

⚏ SWORDS INTO PLOWSHARES PEACE CENTER AND GALLERY

33 E. Adams Ave., Detroit MI 48226. (313)963-7575. Fax: (313)963-2569. E-mail: swordsintoplowshares@prodigy.net. Web site: www.swordsintoplowshares.org. **Director**: Wendy Hamilton.

Nonprofit peace center and gallery. Established 1985. Presents 3-4 major shows/year. Open Tuesday, Thursday and Saturday, 11-3 or by appointment. Located in downtown Detroit in the Theater District; 2,881 sq. ft.; 1 large gallery, 3 small galleries. 100% of space for special exhibitions. Clients include walk-in, church, school and community groups. 100% of sales are to private collectors. Overall price range: $75-6,000; most work sold at $75-700.

Media Considers all media and all types of prints.

Terms Retail price set by the artist. Gallery provides insurance and promotion.

Submissions Accepts artists primarily from Michigan and Ontario. Send query letter with statement on how work relates to theme. Responds in 2 months. Finds artists through lists from Michigan Council of the Arts and Windsor Council of the Arts.

SYNCHRONICITY FINE ARTS

106 W. 13th St., New York NY 10011. (646)230-8199. Fax: (646)230-8198. E-mail: synchspa@bestweb.net. Web site: www.synchronicityspace.com. Nonprofit gallery. Estab. 1989. Approached by several hundred artists/year. Exhibits 12-16 emerging and established artists. Sponsors 6 exhibits/year. Average display time: 1 month. Open Tuesday-Saturday, 12-6. Closed for 2 weeks in August. Clients include local community, students, tourists and upscale. 20% of sales are to corporate collectors. Overall price range: $1,500-10,000; most work sold at $3,000-5,000.

Media Considers acrylic, collage, drawing, mixed media, oil, paper, pastel, pen & ink, sculpture, watercolor, engravings, etchings, mezzotints and woodcuts. Most frequently exhibits oil, sculpture and photography.

Style Exhibits color field, expressionism, impressionism, postmodernism and painterly abstraction. Most frequently exhibits semi-abstract and semi-representational abstract. Genres include figurative work, landscapes and portraits.

Terms Retail price set by the gallery. Gallery provides insurance, promotion and contract. Accepted work should be framed, mounted and matted.

Submissions Write or call to arrange a personal interview to show portfolio of photographs, slides and transparencies. Send query letter with photocopies, photographs, résumé, SASE and slides. Returns material with SASE. Responds in 3 weeks. Files materials unless artist requests return. Finds artists through submissions, portfolio reviews, art exhibits and referrals by other artists.

🅽 JOHN SZOKE EDITIONS

591 Broadway, 3rd Floor, New York NY 10012. (212)219-8300. Fax: (212)219-0864. E-mail: info@johnszokeeditions.com. Web site: www.johnszokeeditions.com. **President:** John Szoke. Retail gallery and art dealer/publisher. Estab. 1974. Specializing in works on paper and prints by 20th century masters as well as contemporary artists; with special emphasis on Picasso. Contemporary artists include: Christo, Jim Dine, Helen Frankenthaler, Richard Haas, Damien Hirst, Jasper Johns, Alex Katz, Ellsworth Kelly, Jeff Koons, Peter Milton, Julian Opie, Robert Rauschenber, Larry Rivers, Donald Sultan, and Wayne Thiebaud. Modern Masters include: Picasso, Cocteau and Matisse. Catalogues Raisonne Published: Janet Fish, Richard Haas and Jeannette Pasin Sloan. Open all year. Located downtown in Soho. Clients include other dealers and collectors. 20% of sales are to private collectors.

🅽 TEW GALLERIES INC.

The Galleries of Peachtree Hills, 425 Peachtree Hills Ave., Unit 24, Atlanta GA 30305. Phone: (404)869-0511. Fax: (404) 869-0512. E-mail: info@timothytew.com. Web site: www.timothytew

.com. **Contact:** Jules Bekker, Director. For-profit gallery. Estab. 1989. Exhibits selected emerging and mid-career artists. Approached by 100 artists/year; represents or exhibits 17-20 artists/year. Exhibited artists include Deedra Ludwig, encaustic, mixed media, oil, pastel painting; Kimo Minton, polychrome on Cottonwood, bronze sculptures. Sponsors 8 exhibits/year. Average display time 28 days. Open Monday-Friday, 9-6; Saturdays, 11-5. Located in a prestigious arts and antiques complex. Total of 3,600 sq. ft. divided over three floors. Clients include upscale and corporate. 15% of sales are to corporate collectors. Overall price range: $1,800-40,000; most work sold at $4,500 or less.

Media Considers all media except craft and photography. Most frequently exhibits oil on canvas, works on paper and small to medium scale sculptures.

Style Considers all styles.

Terms Artwork is accepted on consignment and there is a 50% commission. Retail price set by the gallery and the artist. Requires exclusive representation locally.

Submissions Send digital PDF by e-mail. Mail CD of portfolio with bio, artist statement and resume for review. Returns material with SASE. Responds to queries only if interested within 8 weeks. Files digital files only if interested. Finds artists through art exhibits, portfolio review, referrals by other artists and submissions.

Tips A minimum of 12 good quality images of recent work on digital media. Include all biographical material on the CD along with image.

JILL THAYER GALLERIES AT THE FOX

1700 20th St., Bakersfield CA 93301-4329. (661)328-9880. E-mail: jill@jillthayer.com. Web site: www.jillthayer.com. **Director:** Jill Thayer. For profit gallery. Estab. 1994. Represents 25+ emerging, mid-career and established artists of regional and international recognition. Features 6-8 exhibits/year. Average display time: 6 weeks. Open Friday-Saturday, 1-4 or by appointment. Closed holidays. Located at the historic Fox Theater, built in 1930. Thayer renovated the 400-sq.-ft. space in 1994. The gallery features large windows, high ceilings, wood floor and bare wire, halogen lighting system. Clients include regional and southern California upscale. 25% of sales are to corporate collectors. Overall price range: $250-10,000; most work sold at $2,500.

Media Considers all media, originals only. Exhibits painting, drawing, photography, sculpture, assemblage, glass.

Style Exhibits contemporary, abstract, and representational work.

Terms Artwork is accepted on consignment for duration of exhibit (50% commission). Artist pays all shipping and must provide insurance. Retail price set by the gallery and the artist. Gallery provides marketing, mailer design, and partial printing. Artist shares cost of printing, mailings and receptions.

Submissions Send query letter with artist's statement bio, résumé, exhibition list, reviews, SASE and 12 slides. Responds in 1 month if interested. Finds artists through submissions and portfolio reviews.

Tips ''When submitting to galleries, be concise, professional, send up-to-date package (art and info) and slide sheet of professionally documented work.''

NATALIE AND JAMES THOMPSON ART GALLERY

School of Art Design, San Jose CA 95192-0089. (408)924-4723. Fax: (408)924-4326. E-mail: thompsongallery@cadre.sjsu.com. Web site: www.sjsu.edu. **Director:** Jo Farb Hernandez. Non-profit gallery. Approached by 100 artists/year. Sponsors 6 exhibits/year of emerging, mid-career

and established artists. Average display time: 1 month. Open during academic year; Tuesday, 11-4, 6-7:30; Monday, Wednesday-Friday, 11-4. Closed semester breaks, summer and weekends. Clients include local community, students and upscale.

Media Considers all media and all types of prints.

Style Considers all styles and genres.

Terms Retail price set by the artist. Gallery provides insurance, transportation and promotion. Accepted work should be framed and/or ready to display. Does not require exclusive representation locally.

Submissions Send query letter with artist's statement, bio, résumé, reviews, SASE and slides. Returns material with SASE.

N THORNE-SAGENDORPH ART GALLERY

Keene State College, Wyman Way, Keene NH 03435-3501. (603)358-2720. E-mail: thorne@keene.edu. Web site: www.keene.edu/tsag. **Director:** Maureen Ahern. Nonprofit gallery. Estab. 1965. In addition to exhibitions of national and international art, the Thorne shows local artist as well as KSC faculty and student work. 600 members. Exhibited artists include Jules Olitski and Fritz Scholder. Sponsors 5 shows/year. Average display time 4-6 weeks. Open Saturday-Wednesday, 12-4; Thursday and Friday evenings till 7, summer s, Wednesday-Sunday, 12-4, closed Monday & Tuesday. Follows academic schedule. Located on campus; 4,000 sq. ft.; climate control, security. 50% of space for special exhibitions. Clients include local community and students.

Media Considers all media and all types of prints.

Style Exhibits Considers all styles.

Terms Gallery takes 40% commission on sales. Retail price set by the artist. Gallery provides insurance, promotion and contract; shipping costs are shared. Artwork must be framed.

Submissions Artist's portfolio should include photographs and transparencies. Responds only if interested within 2 months. Returns all material.

N THROCKMORTON FINE ART

145 E. 57th St., 3rd Floor, New York NY 10022. (212)223-1059. Fax: (212)223-1937. E-mail: throckmorton@earthlink.net. Web site: www.throckmorton-nyc.com. **Contact:** Kraige Block, director. For-profit gallery. Exhibits 15 emerging, mid-career and established artists/year. Exhibited artists include Ruven Afanador and Flor Garpuno. Average display time 1 month. Open all year; Tuesday-Saturday, 11-5. Located in the Hammacher Schlemmer Building; 4,000 square feet; 1,000 square feet exhibition space. Clients include local community and upscale. Overall price range $1,000-75,000; most work sold at $2,500.

Media Most frequently exhibits photography, antiquities. Also considers gelatin, platinum and albumen prints.

Style Exhibits expressionism. Genres include Latin American.

Terms Retail price of the art set by the gallery. Gallery provides insurance and promotion. Requires exclusive representation locally. Accepts only artists from Latin America. Prefers only b&w and color photography.

Submissions Call or write to arrange personal interview to show portfolio of photographs. Returns material with SASE. Responds to queries only if interested within 2 weeks. Files bios and résumés. Finds artists through portfolio reviews, referrals by other artists and submissions.

⃝ TOUCHSTONE GALLERY

406 7 St. NW, Washington DC 20004-2217. (202)347-2787. Fax: (202)347-3339. E-mail: info@tou chstonegallery.com. Web site: www.touchstonegallery.com. Contact: Ksenia Grishkova, Director. Artist owned gallery. Estab. 1976. Represents emerging and established artists. Approached by 100+ artists a year; represents over 30 artists. Open Wednesday-Saturday from 11-5; Sundays from 12-5. Located downtown Washington, DC. Large main gallery with several additional exhibition areas. High ceilings. Clients include local community, designer, corporations and tourists. Overall price range $100 - $8,000.

Media/Style All media, including engravings, etchings, linocuts, lithographs, mezzotints, serigraphs and woodcuts.

Terms To be a member artists there is a membership fee plus a donation of time. Gallery takes 40-60% commission on sales. Rental option is available to rent Annex A, $1000/month; Annex B, $900/month or Annex C, $700. No commission taken on Annex sales. Retail price set by artist. Gallery provides contract and promotion. Accepted work should be framed and matted. Exclusive area representation not required.

Submissions The gallery juries for new members meet the 4th Wednesday of each month. All interested artists may apply. No fee required. See gallery Web site for details.

Tips Visit gallery's Web site first to learn about renting Annex rooms and how to become an artist member. Please call with additional questions. Show 10-25 images that are cohesive in subject, style and presentation.''

ULRICH MUSEUM OF ART

Wichita State University, 1845 Fairmount St., Wichita KS 67260-0046. (316)978-3664. Fax: (316)978-3898. E-mail: ulrich@wichita.edu. Web site: www.ulrich.wichita.edu. **Director:** Dr. Patricia McDonnell. Estab. 1974. Wichita's premier venue for modern and contemporary art. Presents 6 shows/year. Open Tuesday-Friday, 11-5; Saturday and Sunday, 1-5; closed Mondays and major holidays. Admission is always free.

Media ''Exhibition program includes all range of media.''

Style ''Style and content of exhibitions aligns with leading contemporary trends.''

Submissions ''For exhibition consideration, send cover letter with artist's statement, bio, sample printed material and visuals, SASE.'' Responds in 3 months.

VALE CRAFT GALLERY

230 W. Superior St., Chicago IL 60610. (312)337-3525. Fax: (312)337-3530. E-mail: peter@valecr aftgallery.com. Web site: www.valecraftgallery.com. **Owner:** Peter Vale. Retail gallery. Estab. 1992. Represents 100 emerging, mid-career artists/year. Exhibited artists include Tana Acton, Mark Brown, Tina Fung Holder, John Neering and Kathyanne White. Sponsors 4 shows/year. Average display time: 3 months. Open all year; Tuesday-Friday, 10:30-5:30; Saturday, 11-5. Located in River North gallery district near downtown; 2,100 sq. ft.; lower level of prominent gallery building; corner location with street-level windows provides great visibility. Clientele: private collectors, tourists, people looking for gifts, interior designers and art consultants. Overall price range: $50-2,000; most work sold at $100-500.

Media Considers paper, sculpture, ceramics, craft, fiber, glass, metal, wood and jewelry. Most frequently exhibits fiber wall pieces, jewelry, glass, ceramic sculpture and mixed media.

Style Exhibits contemporary craft. Prefers decorative, sculptural, colorful, whimsical, figurative, and natural or organic.

Terms Accepts work on consignment (50% commission). Retail price set by the artist. Gallery provides insurance, promotion, contract and shipping costs from gallery; artist pays shipping costs to gallery.

Submissions Accepts only craft media. No paintings, prints, or photographs. By mail: send query letter with résumé, bio or artist's statement, reviews if available, 10-20 slides, CD of images (in JPEG format) or photographs (including detail shots if possible), price list, record of previous sales, and SASE if you would like materials returned to you. By e-mail: include a link to your Web site or send JPEG images, as well as any additional information listed above. Call for appointment to show portfolio of originals and photographs. Responds in 2 months. Files résumé (if interested). Finds artists through submissions, art and craft fairs, publishing a call for entries, artists' slide registry and word of mouth.

Tips "Call ahead to find out if the gallery is interested in showing the particular type of work that you make. Try to visit the gallery ahead of time or check out the gallery's Web site to find out if your work fits into the gallery's focus. I would suggest you have at least 20 pieces in a body of work before approaching galleries."

VIENNA ARTS SOCIETY—ART CENTER

115 Pleasant St., Vienna VA 22180. (703)319-3971. E-mail: teresa@tlcillustration.com. Web site: www.viennaartssociety.org. **Director:** Teresa Ahmad. Nonprofit rental gallery and art center. Estab. 1969. Exhibits emerging, mid-career and established artists. Approached by 100-200 artists/year; exhibits 50-100 artists. "Anyone to become a member of the Vienna Arts Society has the opportunity to exhibit their work." Sponsors 3 exhibits/year. Average display time: 3-4 weeks. Open Tuesday-Saturday, 10-4. Closed Federal holidays. Located off Route 123, approximately 3 miles south of Beltway 495; historic building in Vienna; spacious room with modernized hanging system; 3 display cases for 3D, glass, sculpture, jewelry, etc. Clients include local community, students and tourists. Overall price range: $100-1,500; most work sold at $200-500.

Media Considers all media except basic crafts. Most frequently exhibits watercolor, acrylic and oil.

Style Considers all styles.

Terms Artwork is accepted on consignment, and there is a 25% commission. There is a rental fee that covers 1 month, "based on what we consider a 'featured artist' exhibit." Gallery handles publicity with the artist. Retail price set by the artist. Gallery provides promotion and contract. Accepted work must be framed or matted. "We do accept 'bin pieces' matted and shrink wrapped." VAS members can display at any time. Non-members will be asked for a rental fee when space is available.

Submissions Call. Responds to queries in 2 weeks. Finds artists through art fairs and exhibits, referrals by other artists and membership.

VILLA JULIE COLLEGE GALLERY

1525 Green Spring Valley Rd., Stevenson MD 21153. (443)334-2163. Fax: (410)486-3552. E-mail: dea-dian@mail.vjc.edu. Web site: www.vjc.edu. **Contact:** Diane DiSalvo. College/university gallery. Estab. 1997. Approached by many artists/year. Represents numerous emerging, mid-career and established artists. Sponsors 14 exhibits/year. Average display time: 8 weeks. Open all year; Monday-Tuesday and Thursday-Friday, 11-5; Wednesday, 11-8; Saturday, 1-4. Located in the Greenspring Valley, 5 miles north of downtown Baltimore; beautiful space in renovated academic center and student center. "We do not take commission; if someone is interested in an artwork we send them directly to the artist."

Media Considers all media. Most frequently exhibits painting, sculpture, photography and works on paper, installation and new media.

Style Considers all styles and genres.

Terms Artwork is accepted on consignment (no commission). Retail price set by the artist. Gallery provides insurance. Does not require exclusive representation locally. Has emphasis on mid-Atlantic regional artists but does not set geographic limitations.

Submissions Write to arrange a personal interview to show portfolio of slides. Send query letter with artist's statement, bio, résumé, reviews, SASE, CD, or slides. Returns material with SASE. Responds in 3 months. Files bio, statement, reviews and letter, but will return slides or CD. Finds artists through word of mouth, submissions, portfolio reviews, art exhibits, and referrals by other artists.

Tips "Be clear and concise, and have good visual representatation of your work."

ⓝ VISUAL ARTS CENTER, WASHINGTON PAVILION OF ARTS & SCIENCE

301 S. Main, Sioux Falls SD 57104. (605)367-6000. Fax: (605)367-7399. E-mail: info@washington pavilion.org. Web site: washingtonpavilion.org. Nonprofit museum. Estab. 1961. Open Monday-Saturday, 10-5; Sundays 12-5.

Media Considers all media.

Style Exhibits local, regional and national artists.

Submissions Send query letter with résumé and slides.

ⓝ ⓔ VOLCANO ART CENTER GALLERY

P.O. Box 129, Volcano HI 96785. (808)967-7565. Fax: (808)967-8512. E-mail: gallery@volcanoart center.org. Web site: www.volcanoartcenter.org. **Gallery Manager:** Fia Mattice. Nonprofit gallery to benefit arts education; nonprofit organization. Estab. 1974. Represents 300 emerging, mid-career and established artists/year. 1,400 member organization. Exhibited artists include Dietrich Varez and Brad Lewis. Sponsors 8 shows/year. Average display time 6 weeks. Open all year; daily 9-5 except Christmas. Located Hawaii Volcanoes National Park; 3,000 sq. ft.; in the historic 1877 Volcano House Hotel. 15% of space for special exhibitions; 85% of space for gallery artists. Clientele affluent travelers from all over the world. 95% private collectors, 5% corporate collectors. Overall price range $20-12,000; most work sold at $50-400.

Media Considers all media, all types of prints. Most frequently exhibits wood, ceramics, glass and 2 dimensional.

Style Prefers traditional Hawaiian, contemporary Hawaiian and contemporary fine crafts.

Terms "Artists must become Volcano Art Center members." Accepts work on consignment (50% commission). 10% discount to VAC members is absorbed by the organization. Retail price set by the gallery. Gallery provides promotion and contract; artist pays shipping costs to gallery.

Submissions Prefers work relating to the area and by Hawaii resident artists. Call for appointment to show portfolio. Responds only if interested within 1 month. Files "information on artists we represent."

WAILOA CENTER

Hawaii Division of State Parks, Department of Land & Natural Resources, P.O. Box 936, Hilo HI 96721. (808)933-0416. Fax: (808)933-0417. E-mail: wailoa@yahoo.com. **Director:** Codie M. King. Nonprofit gallery and museum. Focus is on propagation of the culture and arts of the Hawaiian Islands and their many ethnic backgrounds. Estab. 1968. Represents/exhibits 300

emerging, mid-career and established artists. Interested in seeing work of emerging artists. Sponsors 36 shows/year. Average display time: 1 month. Open all year; Monday, Tuesday, Thursday and Friday, 8:30-4:30; Wednesday, 12-4:30; closed weekends and state holidays. Located downtown; 10,000 sq. ft.; 4 exhibition areas. Clientele: tourists, upscale, local community and students. Overall price range: $25-25,000; most work sold at $1,500.

Media Considers all media and most types of prints. No giclée prints; original artwork only. Most frequently exhibits mixed media.

Style Exhibits all styles. "We cannot sell, but will refer buyer to artist." Gallery provides some promotion. Artist pays for shipping, invitation, and reception costs. Artwork must be framed.

Submissions Send query letter with résumé, slides, photographs and reviews. Call for appointment to show portfolio of photographs and slides. Responds in 3 weeks. Finds artists through word of mouth, referrals by other artists, visiting art fairs and exhibitions, submissions.

Tips "We welcome all artists, and try to place them in the best location for the type of art they create. Drop in and let us review what you have."

N WASHINGTON PRINTMAKERS GALLERY

1732 Connecticut Ave. NW, 2nd Floor, Washington DC 20009. (202)332-7757. E-mail: info@washingtonprintmakers.com. Web site: www.washingtonprintmakers.com. **Director:** Karisa Senavitis. Cooperative gallery. Estab. 1985. Exhibits 40 emerging and mid-career artists/year. Exhibited artists include Lee Newman, Max-Karl Winkler, Trudi Y. Ludwig and Margaret Adams Parker. Sponsors 12 exhibitions/year. Average display time 1 month. Open all year; Tuesday-Thursday, 12-6; Friday, 12-9; Saturday-Sunday, 12-5. Located downtown in Dupont Circle area. 100% of space for gallery artists. Clientele varied. 90% private collectors, 10% corporate collectors. Overall price range $65-1,500; most work sold at $200-400.

Media Considers all types of original prints, hand pulled by artist. No posters. Most frequently exhibits etchings, lithographs, serigraphs, relief prints.

Style Considers all styles and genres.

Terms Co-op membership fee plus donation of time (40% commission). Retail price set by artist. Gallery provides promotion. Purchaser pays shipping costs of work sold.

Submissions Send query letter. Call for appointment to show portfolio of original prints. Responds in 1 month.

Tips "There is a monthly jury for prospective members. Call to find out how to present work. We are especially interested in artists who exhibit a strong propensity for not only the traditional conservative approaches to printmaking, but also the looser, more daring and innovative experimentation in technique."

MARCIA WEBER/ART OBJECTS, INC.

1050 Woodley Rd., Montgomery AL 36106. (334)262-5349. Fax: (334)567-0060. E-mail: weberart@mindspring.com. Web site: www.marciaweberartobjects.com. **Owner:** Marcia Weber. Retail, wholesale gallery. Estab. 1991. Represents 21 emerging, mid-career and established artists/year. Exhibited artists include Woodie Long, Jimmie Lee Sudduth, Michael Banks, Mose Tolliver, Mary Whitfield, Malcah Zeldis. Open all year by appointment or by chance, weekday afternoons. Located in Old Cloverdale near downtown in older building with hardwood floors. 100% of space for gallery artists. Clientele: tourists, upscale. 90% private collectors, 10% corporate collectors. Overall price range: $300-20,000; most work sold at $300-4,000.

● This gallery owner specializes in the work of self-taught, folk, or outsider artists. This gallery shows each year in New York, Chicago and Atlanta.

Media Considers all media except prints. Must be original one-of-a-kind works of art. Most frequently exhibits acrylic, oil, found metals, found objects and enamel paint.

Style Exhibits genuine contemporary folk/outsider art, self-taught art and some Southern antique original works.

Terms Accepts work on consignment (variable commission) or buys outright. Gallery provides insurance, promotion and contract if consignment is involved. Prefers artwork unframed so the gallery can frame it.

Submissions "Folk/outsider artists usually do not contact dealers. They have a support person or helper, who might write or call, send query letter with photographs, artist's statement." Call or write for appointment to show portfolio of photographs, original material. Finds artists through word of mouth, other artists and "serious collectors of folk art who want to help an artist get in touch with me." Gallery also accepts consignments from collectors.

Tips "An artist is not a folk artist or an outsider artist just because their work resembles folk art. They have to *be* folks who began creating art without exposure to fine art. Outsider artists live in their own world outside the mainstream and create art. Academic training in art excludes artists from this genre." Prefers artists committed to full-time creating.

⚡ WEST END GALLERY

5425 Blossom, Houston TX 77007. (713)861-9544. E-mail: kpackl1346@aol.com. **Owner:** Kathleen Packlick. Retail gallery. Estab. 1991. Exhibits emerging and mid-career artists. Open all year. Located 5 mintues from downtown Houston; 800 sq. ft.; "The gallery shares the building (but not the space) with West End Bicycles." 75% of space for special exhibitions; 25% of space for gallery artists. Clientele: 100% private collectors. Overall price range: $30-2,200; most work sold at $300-600.

Media Considers oil, pen & ink, acrylic, drawings, watercolor, mixed media, pastel, collage, woodcuts, wood engravings, linocuts, engravings, mezzotints, etchings, lithographs and serigraphs. Prefers collage, oil and mixed media.

Style Exhibits conceptualism, minimalism, primitivism, postmodern works, realism and imagism. Genres include landscapes, florals, wildlife, portraits and figurative work.

Terms Accepts work on consignment (40% commission). Retail price set by artist. Payment by installment is available. Gallery provides promotion; artist pays shipping costs. Prefers framed artwork.

Submissions Accepts only artists from Houston area. Send query letter with slides and SASE. Portfolio review requested if interested in artist's work.

Ⓝ PHILIP WILLIAMS POSTERS

122 Chambers St, New York NY 10007. (212)513-0313. E-mail: postermuseum@gmail.com. Web site: www.postermuseum.com. **Contact:** Philip Williams. Retail and wholesale gallery. Represents/exhibits vintage posters 1870-1960. Open all year; Monday-Sunday, 11-7.

Terms Prefers artwork unframed.

Submissions Prefers vintage posters and outsider artist. Send query letter with photographs.

THE WING GALLERY

13636 Ventura Blvd., Sherman Oaks CA 91423 (mailing address only). (818)981-WING and (800)422-WING. Fax: (805)955-0440. E-mail: robin@winggallery.com. Web site: www.winggallery.com. **Director:** Robin Wing. Retail gallery. Estab. 1975. Represents 100+ emerging, mid-

career and established artists. Clientele: 80% private collectors, 20% corporate collectors. Overall price range: $50-$50,000; most work sold at $150-$5,000.

Media Considers oil, acrylic, watercolor, drawings, original handpulled prints, offset reproductions, engravings, lithographs, monoprints and serigraphs.

Style Exhibits primitivism, impressionism, realism and photorealism. Genres include landscapes, Americana, Southwestern, Western, Asian, wildlife and fantasy.

Terms Accepts work on consignment (40-50% commission). Retail price set by gallery and artist. Sometimes offers customer discounts and payment by installments. Only accepts unframed artwork.

Submissions E:mail robin@winggallery.com or send query letter with résumé, slides, bio, brochure, photographs, SASE, reviews and price list. Send complete information with your work regarding price, size, medium, etc., and make an appointment before dropping by. Portfolio reviews requested if interested in artist's work. Responds in 2 months. Files current information and slides. Finds artists through agents, by visiting exhibitions, word of mouth, various publications, submissions and referrals.

Tips Artists should have a "professional presentation" and "consistent quality."

WOMEN & THEIR WORK ART SPACE

1710 Lavaca St., Austin TX 78701. (512)477-1064. Fax: (512)477-1090. E-mail: info@womenand theirwork.org. Web site: www.womenandtheirwork.org. **Associate Director:** Katherine McQueen. Alternative space and nonprofit gallery. Estab. 1978. Approached by more than 200 artists/year. Sponsors 8-10 solo and seasonal juried shows of emerging and mid-career Texas women. Exhibited artists include Margarita Cabrera, Misty Keasler, Karyn Olivier, Angela Fraleigh and Liz Ward. Average display time: 5 weeks. Open Monday-Friday, 9-6; Saturday, 12-5. Closed holidays. Located downtown; 2,000 sq. ft. Clients include local community, students, tourists and upscale. 10% of sales are to corporate collectors. Overall price range: $500-5,000; most work sold at $800-1,000.

Media Considers all media. Most frequently exhibits photography, sculpture, installation and painting.

Style Exhibits contemporary works of art.

Terms Selects artists through an Artist Advisory Panel and Curatorial/Jury process. Pays artists to exhibit. Takes 25% commission if something is sold. Retail price set by the gallery and the artist. Gallery provides insurance, promotion and contract. Accepted work should be framed, mounted and matted. Accepts Texas women in solo shows only; all other artists, male or female, in one annual curated show. See Web site for more information.

Submissions See Web site for current Call for Entries. Returns materials with SASE. Filing of material depends on artist and if he/she is a member. Online Slide Registry on Web site for members. Finds artists through submissions and annual juried process.

Tips Send quality slides/digital images, typed résumé, and clear statement with artistic intent. 100% archival material required for framed works.

WOMEN'S CENTER ART GALLERY

University of California at Santa Barbara, Student Resource Building 1220, Santa Barbara CA 93106-7190. (805)893-3778. Fax: (805)893-3289. E-mail: sharon.hoshida@sa.ucsb.edu. Web site: www.sa.ucsb.edu/women'scenter. **Program Director:** Sharon Hoshida. Nonprofit gallery. Estab. 1973. Approached by 200 artists/year; represents or exhibits 50 artists. Sponsors 4 exhib-

its/year. Average display time: 11 weeks. Open Monday-Thursday, 10-9; Friday, 10-5. Closed UCSB campus holidays. Exhibition space is roughly 750 sq. ft. Clients include local community and students. Overall price range: $10-1,000; most work sold at $300.

Media Considers all media and all types of prints. Most frequently exhibits acrylic, mixed media and photography.

Style Considers all styles and genres. Most frequently exhibits post modernism, feminist art and abstraction.

Terms Artwork is accepted on consignment (no commission). Retail price set by the artist. Gallery provides insurance and promotion. Accepted work should be framed. Preference given to residents of Santa Barbara County.

Submissions Mail portfolio for review. Send query letter with artist's statement, bio, photocopies, photographs, résumé, slides, SASE. Responds within 3 months, only if interested. Finds artists through word of mouth, portfolio reviews, art exhibits, e-mail and promotional calls to artists.

Tips ''Complete your submission thoroughly and include a relevent statement pertaining to the specific exhibit.''

WOODWARD GALLERY

133 Eldridge St., Ground Floor, New York NY 10002. (212)966-3411. Fax: (212)966-3491. E-mail: Art@WoodwardGallery.net. Web site: www.WoodwardGallery.net. **Director:** John Woodward. **Owner:** Kristine Woodward. For-profit gallery. Estab. 1994. Exhibits emerging, mid-career and established artists. Approached by more than 2,000 artists/year; represents 10 artists in their stable. Exhibited artists include Cristina Vergano (oil on canvas/wood panel), Susan Breen (oil on wood or paper), Margaret Morrison (oil on canvas/wood panel and paper). Also features work by Andy Warhol, Richard Hambleton, Jean-Michel Basquiat and Robert Indiana. Sponsors 6 exhibits/year. Average display time: 2 months. Open Tuesday-Saturday, 11-6; August by private appointment only. Clients include local community, tourists, upscale, and other art dealers. 20% of sales are to corporate collectors. Overall price range: $1,000.USD - 5,000,000.USD; most work sold at $10,000.USD - $200,000.USD

Media Considers acrylic, collage, drawing, mixed media, oil, paper, pastel, pen ink, sculpture, watercolor. Most frequently exhibits canvas, paper and sculpture. Considers all types of prints.

Style Most frequently exhibits realism/surrealism, pop, abstract and landscapes, graffiti. Genres include figurative work, florals, landscapes and portraits.

Making Contact Terms Artwork is bought outright (net 30 days) or consigned. Retail price set by the gallery.

Submissions Call before sending anything! Send query letter with artist's statement, bio, brochure, photocopies, photographs, reviews and SASE. Returns material with SASE. Finds artists through referrals or submissions.

Tips artist must follow our artist review criteria, which is available every new year (first or second week of January) with updated policy from our director.''

YEISER ART CENTER INC.

200 Broadway, Paducah KY 42001-0732. (270)442-2453. E-mail: info@theyeiser.org. Web site: www.theyeiser.org. **Contact:** Ms. Landee Bryant, executive director, or Ms. Trish Boyd, administrative specialist. Nonprofit gallery. Estab. 1957. Exhibits emerging, mid-career and established artists. 450 members. Sponsors 8-10 shows/year. Average display time: 6-8 weeks. Open all

year. Located downtown; 1,800 sq. ft.; "in historic building that was farmer's market." 90% of space for special exhibitions. Clientele: professionals and collectors. 90% private collectors. Overall price range: $200-8,000; most artwork sold at $200-1,000.

Media Considers all media. Prints considered include original handpulled prints, woodcuts, wood engravings, linocuts, mezzotints, etchings, lithographs and serigraphs.

Style Exhibits all styles and genres.

Terms Gallery takes 40% commission on all sales (60/40 split). Expenses are negotiated.

Submissions Send résumé, slides, bio, SASE and reviews. Responds in 3 months.

Tips "Do not call. Give complete information about the work—media, size, date, title, price. Have good-quality slides of work, indicate availability, and include artist statement. Presentation of material is important."

YELLOWSTONE GALLERY

216 W. Park St., P.O. Box 472, Gardiner MT 59030. (406)848-7306. E-mail: jckahrs@aol.com. Web site: yellowstonegallery.com. **Owner:** Jerry Kahrs. Retail gallery. Estab. 1985. Represents 20 emerging and mid-career artists/year. Exhibited artists include Mary Blain and Nancy Glazier. Sponsors 2 shows/year. Average display time: 2 months. Located downtown; 3,000 sq. ft. 25% of space for special exhibitions; 50% of space for gallery artists. Clientele: tourist and regional. 90% private collectors, 10% corporate collectors. Overall price range: $25-8,000; most work sold at $75-600.

Media Considers oil, acrylic, watercolor, ceramics, craft and photography; types of prints include wood engravings, serigraphs, etchings and posters. Most frequently exhibits watercolors, oils and limited edition, signed and numbered reproductions.

Style Exhibits impressionism, photorealism and realism. Genres include Western, wildlife and landscapes. Prefers wildlife realism, Western and watercolor impressionism.

Terms Accepts work on consignment (45% commission). Retail price set by the artist. Gallery provides contract; artist pays for shipping. Prefers artwork framed.

Submissions Send query letter with brochure or 10 slides. Write for appointment to show portfolio of photographs. Responds in 1 month. Files brochure and biography. Finds artists through word of mouth, regional fairs and exhibits, mail and periodicals.

Tips "Don't show up unannounced without an appointment."

N LEE YOUNGMAN GALLERIES

1316 Lincoln Ave., Calistoga CA 94515. (707)942-0585. Fax: (707)942-6657. E-mail: leeyg@sbcglobal.net. Web site: www.leeyoungmangalleries.com. **Owner:** Ms. Lee Love Youngman. Retail gallery. Estab. 1985. Represents 40 established artists. Exhibited artists include Ralph Love and Paul Youngman. Sponsors 3 shows/year. Average display time 1 month. Open all year. Located downtown; 3,000 sq. ft.; "contemporary decor." Clientele 100% private collectors. Overall price range $500-24,000; most artwork sold at $1,000-3,500.

Media Considers oil, acrylic, watercolor and sculpture. Most frequently exhibits oils, bronzes and alabaster.

Style Exhibits impressionism and realism. Genres include landscapes, Figurative, Western and still life. Interested in seeing American realism. No abstract art.

Terms Accepts work on consignment (50% commission). Retail price set by gallery. Customer discounts and payment by installment are available. Gallery provides insurance and promotion. Artist pays for shipping to and from gallery. Prefers framed artwork.

Submissions Accepts only artists from Western states. ''No unsolicited portfolios.'' Portfolio review requested if interested in artist's work. ''The most common mistake artists make is coming on weekends, the busiest time, and expecting full attention.'' Finds artists through publication, submissions and owner's knowledge.

Tips ''Don't just drop in—make an appointment. No agents.''

ZENITH GALLERY

413 Seventh St. NW, Washington DC 20004. E-mail: art@zenithgallery.com. Web site: www.zen ithgallery.com. **Owner/Director:** Margery E. Goldberg. For-profit gallery. Estab. 1978. Exhibits emerging, mid-career and established artists. Open Tuesday-Friday, 11-6; Saturday, 11-7; Sunday, 12-5. Three rooms; 2,400 sq. ft. of exhibition space. Clients include local community, tourists and upscale. 50% of sales are to corporate collectors. Overall price range: $5,000-15,000.

Media Considers all media.

Terms Requires exclusive representation locally for solo exhibitions.

Submissions Send query letter with artist's statement, bio, résumé, reviews, brochures, images on CD, SASE. Returns material with SASE. Responds to most queries if interested. Finds artists through art fairs/exhibits, portfolio reviews, referrals by other artists, submissions and word of mouth.

Tips ''The review process can take anywhere from one month to one year. Please be patient and do not call the gallery for acceptance information.'' Visit Web site for detailed submission guidelines before sending any materials.

Magazines

Magazines are a major market for freelance illustrators. The best proof of this fact is as close as your nearest newsstand. The colorful publications competing for your attention are chock-full of interesting illustrations, cartoons and caricatures. Since magazines are generally published on a monthly or bimonthly basis, art directors look for dependable artists who can deliver on deadline and produce quality artwork with a particular style and focus.

Art that illustrates a story in a magazine or newspaper is called editorial illustration. You'll notice that term as you browse through the listings. Art directors look for the best visual element to hook the reader into the story. In some cases this is a photograph, but often, especially in stories dealing with abstract ideas or difficult concepts, an illustration makes the story more compelling. A whimsical illustration can set the tone for a humorous article, or an edgy caricature of movie stars in boxing gloves might work for an article describing conflicts within a film's cast. Flip through a dozen magazines in your local drugstore and you will quickly see that each illustration conveys the tone and content of articles while fitting in with the magazine's "personality."

The key to success in the magazine arena is matching your style to appropriate publications. Art directors work to achieve a synergy between art and text, making sure the artwork and editorial content complement each other.

TARGET YOUR MARKETS

Read each listing carefully. Knowing how many artists approach each magazine will help you understand how stiff your competition is. (At first, you might do better submitting to art directors who aren't swamped with submissions.) Look at the preferred subject matter to make sure your artwork fits the magazine's needs. Note the submission requirements and develop a mailing list of markets you want to approach.

Visit newsstands and bookstores. Look for magazines not listed in *Artist's & Graphic Designer's Market*. Check the cover and interior; if illustrations are used, flip to the masthead (usually a box in one of the beginning pages) and note the art director's name. The circulation figure is also relevant; the higher the circulation, the higher the art director's budget (generally). When art directors have a good budget, they tend to hire more illustrators and pay higher fees.

Look at the credit lines next to each illustration. Notice which illustrators are used often in the publications you wish to work with. You will see that each illustrator has a very definite style. After you have studied dozens of magazines, you will understand what types of illustrations are marketable.

Although many magazines can be found at a newsstand or library, some of your best markets may not be readily available. If you can't find a magazine, check the listing in *Artist's & Graphic Designer's Market* to see if sample copies are available. Keep in mind that many magazines also provide artists' guidelines on their Web sites.

CREATE A PROMO SAMPLE

Focus on one or two *consistent* styles to present to art directors in sample mailings. See if you can come up with a style that is different from every other illustrator's style, if only slightly. No matter how versatile you may be, limit styles you market to one or two. That way, you'll be more memorable to art directors. Choose a style or two that you enjoy and can work in relatively quickly. Art directors don't like surprises. If your sample shows a line drawing, they expect you to work in that style when they give you an assignment. It's fairly standard practice to mail nonreturnable samples: either postcard-size reproductions of your work, photocopies or whatever is requested in the listing. Some art directors like to see a résumé; some don't.

MORE MARKETING TIPS

- **Don't overlook trade magazines and regional publications.** While they may not be as glamorous as national consumer magazines, some trade and regional publications are just as lavishly produced. Most pay fairly well, and the competition is not as fierce. Until you can get some of the higher-circulation magazines to notice you, take assignments from smaller magazines. Alternative weeklies are great markets as well. Despite their modest payment, there are many advantages to working with them. You learn how to communicate with art directors, develop your signature style, and learn how to work quickly to meet deadlines. Once the assignments are done, the tearsheets become valuable samples to send to other magazines.
- **Develop a spot illustration style in addition to your regular style.** "Spots"—illustrations that are half-page or smaller—are used in magazine layouts as interesting visual cues to lead readers through large articles or to make filler articles more appealing. Though the fee for one spot is less than for a full layout, art directors often assign five or six spots within the same issue to the same artist. Because spots are small in size, they must be all the more compelling. So send art directors a sample showing a few powerful small pieces along with your regular style.
- **Invest in a fax machine, e-mail and graphics software.** Art directors like to work with illustrators who have fax machines and e-mail, because they can quickly fax or e-mail a layout with a suggestion. The artist can send back a preliminary sketch or "rough" for the art director to approve. They also appreciate it if you can e-mail digital files of your work.
- **Get your work into competition annuals and sourcebooks.** The term "sourcebook" refers to the creative directories published annually to showcase the work of freelancers. Art directors consult these publications when looking for new styles. Many listings mention if an art director uses sourcebooks. Some directories like *The Black Book*, *American Showcase* and *RSVP* carry paid advertisements costing several thousand dollars per page. Other annuals, like the *PRINT Regional Design Annual* or *Communication Arts Illustration Annual*, feature award winners of various competitions. An entry fee and some great images can put your work in a competition directory and in front of art directors across the country.
- **Consider hiring a rep.** If after working successfully on several assignments you decide to make magazine illustration your career, consider hiring an artists' representative to market your work for you. (See the Artists' Reps section, beginning on page 451.)

Helpful Resources

For More Info

- A great source for new magazine leads is in the business section of your local library. Ask the librarian to point out the business and consumer editions of the *Standard Rate and Data Service (SRDS)* and *Bacon's Magazine Directory.* These huge directories list thousands of magazines and will give you an idea of the magnitude of magazines published today. Another good source is a yearly directory called *Samir Husni's Guide to New Consumer Magazines,* also available in the business section of the public library and online at www.mrmagazine.com. *Folio* magazine provides information about new magazine launches and redesigns.

- Each year the Society of Publication Designers sponsors a juried competition, the winners of which are featured in a prestigious exhibition. For information about the annual competition, contact the Society of Publication Designers at (212)223-3332 or visit their Web site at www.spd.org.

- Networking with fellow artists and art directors will help you find additional success strategies. The Graphic Artists Guild (www.gag.org), The American Institute of Graphic Artists (www.aiga.org), your city's Art Directors Club (www.adcglobal.org) or branch of the Society of Illustrators (www.societyillustrators.org) hold lectures and networking functions. Attend one event sponsored by each organization in your city to find a group you are comfortable with, then join and become an active member.

AARP THE MAGAZINE

601 E St. NW, Washington DC 20049. (202)434-2277. Fax: (202)434-6451. Web site: www.aarpm agazine.org. **Design Director:** Eric Seidman. Art Director: Courtney Murphy-Price. Estab. 2002. Bimonthly 4-color magazine emphasizing health, lifestyles, travel, sports, finance and contemporary activities for members 50 years and over. Circ. 21 million.

Illustration Approached by 200 illustrators/year. Buys 30 freelance illustrations/issue. Assigns 60% of illustrations to well-known or "name" illustrators; 30% to experienced but not well-known illustrators; 10% to new and emerging illustrators. Works on assignment only. Considers digital, watercolor, collage, oil, mixed media and pastel.

First Contact & Terms Samples are filed "if I can use the work." Do not send portfolio unless requested. Portfolio can include original/final art, tearsheets, slides and photocopies and samples to keep. Originals are returned after publication. Buys first rights. Pays on completion of project: $700-3,500.

Tips "We generally use people with strong conceptual abilities. I request samples when viewing portfolios."

ABA BANKING JOURNAL

American Bankers Association, 345 Hudson St., 12th Floor, New York NY 10014-4502. (212)620-7256. Fax: (212)633-1165. E-mail: wwilliams@sbpub.com. Web site: www.ababj.com. **Creative Director:** Wendy Williams. Associate Creative Director: Phil Desiere. Estab. 1908. Monthly association journal; 4-color with contemporary design. Emphasizes banking for middle and upper level banking executives and managers. Circ. 31,440.

Illustration Buys 4-5 illustrations/issue from freelancers. Features charts & graphs, computer, humorous and spot illustration. Assigns 20% of illustrations to new and emerging illustrators. Themes relate to stories, primarily financial, from the banking industry's point of view; styles vary, realistic, surreal. Uses full-color illustrations. Works on assignment only.

First Contact & Terms Illustrators: Send finance-related postcard sample and follow-up samples every few months. To send a portfolio, send query letter with brochure and tearsheets, promotional samples or photographs. Negotiates rights purchased. **Pays on acceptance**; $250-950 for color cover; $250-450 for color inside; $250-450 for spots. Accepts previously published material. Returns original artwork after publication.

Tips Must have experience illustrating for business or financial publications.

▦ ACTIVE LIFE

Windhill Manor, Leeds Rd., Shipley, W. Yorkshire BD18 1BP United Kingdom. E-mail: info@acti velife.co.uk. Web site: www.activelife.co.uk. **Managing Editor:** Helene Hodge. Estab. 1990. Bimonthly consumer magazine emphasizing lively lifestyle for people over age 50. Circ. 240,000.

Illustration Approached by 200 illustrators/year. Buys 12 illustrations/issue. Features humorous illustration. Prefers family-related themes, pastels and bright colors. Assigns 20% of illustration to well-known or ''name'' illustrators; 60% to experienced, but not well-known illustrators; 20% to new and emerging illustrators.

First Contact & Terms Send nonreturnable samples. Accepts Mac-compatible disk submissions. Samples are filed. Responds within 1 month. Will contact artist for portfolio review if interested. Buys all rights. Pays on publication. Finds illustrators through promotional samples.

Tips ''We use all styles, but more often 'traditional' images.''

ADVANSTAR LIFE SCIENCES

6200 Canooga Ave., 2nd Floor Woodland Hills, CA 91367. (818)593-5000. E-mail: mec.art@adva nstar.com. Web site: www.advanstar.com. Estab. 1909. Publishes 9 health-related publications and special products. Uses freelance artists for ''most editorial illustration in the magazines.''

Cartoons Prefers general humor topics (workspace, family, seasonal); also medically related themes. Prefers single-panel b&w drawings and washes with gagline.

Illustration Interested in all media, including 3D, electronic and traditional illustration. Needs editorial and medical illustration that varies ''but is mostly on the conservative side.'' Works on assignment only.

First Contact & Terms Cartoonists: Send unpublished cartoons only with SASE to Jeanne Sabatie, cartoon editor. Pays $115. Buys first world publication rights. Illustrators: Send samples to Sindi Price. Samples are filed. Responds only if interested. Write for portfolio review. Buys nonexclusive worldwide rights. Pays $1,000-1,500 for color cover; $250-800 for color inside; $200-600 for b&w. Accepts previously published material. Originals are returned at job's completion.

ADVENTURE CYCLIST

150 E. Pine St., Missoula MT 59802. (406)721-1776. Fax: (406)721-8754. E-mail: gsiple@adventu recycling.org. Web site: www.adventurecycling.org. **Art Director:** Greg Siple. Estab. 1974. Journal of adventure travel by bicycle, published 9 times/year. Circ. 43,000.

Illustration Buys 1 illustration/issue. Has featured illustrations by Margie Fullmer, Ludmilla Tomova and Anita Dufalla. Works on assignment only.

First Contact & Terms Illustrators: Send printed samples. Samples are filed. Will contact artist for portfolio review if interested. Pays on publication, $50-350. Buys one-time rights. Originals returned at job's completion.

ADVOCATE, PKA'S PUBLICATION

1881 Co. Rt. 2, Prattsville NY 12468. (518)299-3103. **Art Editor:** C.J. Karlie. Estab. 1987. Bi-monthly b&w literary tabloid. *"Advocate* provides aspiring artists, writers and photographers the opportunity to see their works published and to receive byline credit toward a professional portfolio so as to promote careers in the arts." The Gaited Horse Association Newsletter is published within the pages of *Advocate.* Circ. 10,000. Sample copies with guidelines available for $4 with SASE.

Cartoons Open to all formats.

Illustration Buys 10-15 illustrations/issue. Considers pen & ink, charcoal, linoleum-cut, wood-cut, lithograph, pencil or photos, "either black & white or color prints (no slides). We are especially looking for horse-related art and other animals." Also needs editorial and entertainment illustration.

First Contact & Terms Cartoonists: Send query letter with SASE and submissions for publication. Illustrators: Send query letter with SASE and photos of artwork (b&w or color prints only). "Good-quality photocopy or stat of work is acceptable as a submission." No simultaneous submissions. Samples are not filed and are returned by SASE. Portfolio review not required. Responds in 6 weeks. Buys first rights. Pays cartoonists/illustrators in contributor's copies. Finds artists through submissions and from knowing artists and their friends.

Tips "No postcards are acceptable. Many artists send us postcards to review their work. They are not looked at. Artwork should be sent in an envelope with a SASE."

AGING TODAY

833 Market St., San Francisco CA 94103. (415)974-9619. Fax: (415)974-0300. Web site: www.asa ging.org. **Editor:** Paul Kleyman. Estab. 1979. *"Aging Today* is the bimonthly black & white newspaper of The American Society on Aging. It covers news, public policy issues, applied research and developments/trends in aging." Circ. 10,000. Accepts previously published artwork. Originals returned at job's completion if requested. Sample copies available on request.

Cartoons Approached by 50 cartoonists/year. Buys 1-2 cartoons/issue. Prefers political and social satire cartoons; single, double or multiple panel with or without gagline, b&w line drawings. Samples returned by SASE. Responds only if interested. Buys one-time rights.

Illustration Approached by 50 illustrators/year. Buys 1 illustration/issue. Works on assignment only. Prefers b&w line drawings and some washes. Considers pen & ink. Needs editorial illustration.

First Contact & Terms Cartoonists: Send query letter with brochure and roughs. Illustrators: Send query letter with brochure, SASE and photocopies. Pays cartoonists $25, with fees for illustrations, $25-50 for b&w covers or inside drawings. Samples are not filed and are returned

by SASE. Responds only if interested. To show portfolio, artist should follow up with call and/ or letter after initial query. Buys one-time rights.

Tips "Send brief letter with two or three applicable samples. Don't send hackneyed cartoons that perpetuate ageist stereotypes."

AIM: AMERICA'S INTERCULTURAL MAGAZINE

P.O. Box 390, Milton WA 98354-0390. (253)815-9030. E-mail: apiladoone@aol.com. Web site: www.aimmagazine.org. **Contact:** Ruth Apilado. Estab. 1973. Quarterly b&w magazine with 2-color cover. Readers are those "wanting to eliminate bigotry and desiring a world without inequalities in education, housing, etc." Circ. 7,000. Sample copy available for $5; art submission guidelines free for SASE.

Cartoons Approached by 12 cartoonists/week. Buys 10-15 cartoons/year. Uses 1-2 cartoons/ issue. Prefers themes related to education, environment, family life, humor in youth, politics and retirement; single-panel with gagline. Especially needs "cartoons about the stupidity of racism."

Illustration Approached by 4 illustrators/week. Uses 4-5 illustrations/issue; half from freelancers. Prefers pen & ink. Subjects include current events, education, environment, humor in youth, politics and retirement.

First Contact & Terms Cartoonists: Send samples with SASE. Illustrators: Provide brochure to be kept on file for future assignments. Samples are not returned. Responds in 3 weeks. Buys all rights on a work-for-hire basis. Pays on publication. Pays cartoonists $5-15 for b&w line drawings. Pays illustrators $25 for b&w cover illustrations. Accepts previously published, photocopied and simultaneous submissions.

Tips "We could use more illustrations and cartoons with people from all ethnic and racial backgrounds in them. We also use material of general interest. Artists should show a representative sampling of their work and target the magazine's specific needs. Nothing on religion."

ALASKA MAGAZINE

301 Arctic Slope Ave., Suite 300, Anchorage AK 99518-3035. (907)272-6070. Fax: (907)275-2117. Web site: www.alaskamagazine.com. **Art Director:** Tim Blum. Estab. 1935. Monthly 4-color regional consumer magazine featuring Alaskan issues, stories and profiles exclusively. Circ. 200,000.

Illustration Approached by 200 illustrators/year. Buys 1-4 illustrations/issue. Has featured illustrations by Bob Crofut, Chris Ware, Victor Juhaz and Bob Parsons. Features humorous and realistic illustrations. Works on assignment only. Assigns 50% to new and emerging illustrators. 50% of freelance illustration demands knowledge of Illustrator, Photoshop and QuarkXPress.

First Contact & Terms Send postcard or other nonreturnable samples. Accepts Mac-compatible disk submissions. Samples are not returned. Responds only if interested. Will contact artist for portfolio review if interested. Buys first North American serial rights and electronic rights; rights purchased vary according to project. Pays on publication. Pays illustrators $125-300 for color inside; $400-600 for 2-page spreads; $125 for spots.

Tips "We work with illustrators who grasp the visual in a story quickly and can create quality pieces on tight deadlines."

ⓝ ALL ANIMALS

700 Professional Dr., Gaithersburg, MD 20879. (301)258-3192. Fax: (301)721-6468. E-mail: jcork @humanesociety.org. Web site: www.humanesociey.org. **Chief Design Director:** Jennifer Cork. Estab. 1954. Bi-Monthly 4-color magazine focusing on The Humane Society of the United States news and animal protection issues. Circ. 450,000. Features natural history, realistic and spot illustration. Accepts previously published artwork. Originals are returned at job's completion. Art guidelines not available.

Work by assignment only. Themes vary. E-mail portfolio Web site link or mail query letter with samples. Responds in 1 month. **Pays on acceptance**; $300-500 for full page inside; $400-700 for 2-page spreads; $75-200 for spots.

ⓝ ALTERNATIVE THERAPIES IN HEALTH AND MEDICINE

InnoVision Communications Health Media, 2995 Wilderness Place, Suite 205, Boulder CO 80301. (303)440-7402. Fax: (303)440-7446. E-mail: lee@innovisionhm.com. Web site: www.alternat ive-therapies.com. **Creative Director:** Lee Dixson. Estab. 1995. Bimonthly trade journal. *"Alternative Therapies* is a peer-reviewed medical journal established to promote integration between alternative and cross-cultural medicine with conventional medical traditions." Circ. 2 5,000. Sample copies available.

Illustration Buys 6 illustrations/year. Purchase fine art for the covers, not graphic art or cartoons."

First Contact & Terms Send e-mail with samples or link to Web site. Responds within 10 days. Will contact artist if interested. Samples should include subject matter consistent with impressionism, expressionism, and surrelaism. Buys one-time and reprint rights. Pays on publication; negotiable. Accepts previously published artwork. Originals returned at job's completion. Finds artists through Web sites, galleries, and word of mouth.

AMERICA

106 W. 56th St., New York NY 10019. (212)581-1909. Fax: (212)399-3596. Web site: www.ameri camagazine.org. **Associate Editor:** James Martin. Estab. 1904. Weekly Catholic national magazine published by US Jesuits. Circ. 46,000.

Illustration Buys 3-5 illustrations/issue. Has featured illustrations by Michael O'Neill McGrath, William Hart McNichols, Tim Foley, Stephanie Dalton Cowan. Features realistic illustration and spot illustration. Assigns 45% of illustrations to new and emerging illustrators. Considers all media.

First Contact & Terms Illustrators: Send printed samples and tearsheets. Buys first rights. Pays on publication; $300 for color cover; $150 for color inside.

Tips "We look for illustrators who can do imaginative work for religious, educational or topical articles. We will discuss the article with the artist and usually need finished work in two to three weeks. A fast turnaround is extremely valuable."

AMERICAN AIRLINES NEXOS

4333 Amon Carter Blvd., Ft. Worth TX 76155. (817)967-1804. Fax: (817)963-9976. E-mail: marco. rosales@aa.com. Web site: www.nexosmag.com. **Art Director:** Marco Rosales. Bimonthly inflight magazine published in Spanish and Portuguese that caters to "the affluent, highly-educated Latin American frequent traveler residing in the U.S. and abroad." Circ. 270,400.

Illustration Approached by 300 illustrators/year. Buys 50 illustrations/year. Features humorous and spot illustrations of business and families.

First Contact & Terms Send postcard sample. After introductory mailing, send follow-up post-card sample every 6 months. Pays $100-250 for color inside. Pays on publication. Buys one-time rights. Finds freelancers through submissions.

AMERICAN FITNESS

15250 Ventura Blvd., Suite 200, Sherman Oaks CA 91403. (818)905-0040, ext. 200. Fax: (818)990-5468. E-mail: americanfitness@afaa.com. Web site: www.americanfitness.com; www. afaa.com. **Editor:** Meg Jordan. Bimonthly magazine for fitness and health professionals. Official publication of the Aerobics and Fitness Association of America, the world's largest fitness educa-tor. Circ. 42,900.

Illustration Approached by 12 illustrators/month. Assigns 2 illustrations/issue. Works on assign-ment only. Prefers ''very sophisticated'' 4-color line drawings. Subjects include fitness, exercise, wellness, sports nutrition, innovations and trends in sports, anatomy and physiology, body composition.

First Contact & Terms Send postcard promotional sample. Acquires one-time rights. Accepts previously published material. Original artwork returned after publication.

Tips ''Excellent source for never-before-published illustrators who are eager to supply full-page lead artwork.''

AQUARIUM FISH INTERNATIONAL

(formerly *Aquarium Fish Magazine*), P.O. Box 6050, Mission Viejo CA 92690. (949)855-8822. Fax: (949)855-3045. E-mail: aquariumfish@bowtieinc.com. Web site: www.aquariumfish.com. **Editor:** Russ Case. Estab. 1988. Monthly magazine covering fresh and marine aquariums. Photo guidelines available for SASE with first-class postage or on Web site.

Cartoons Approached by 30 cartoonists/year. Themes should relate to aquariums and ponds.

First Contact & Terms Buys one-time rights. Pays $35 for b&w and color cartoons.

THE ARTIST'S MAGAZINE

F + W Media, Inc., 4700 E. Galbraith Rd., Cincinnati OH 45236. E-mail: tamedit@fwpubs.com. Web site: www.artistsmagazine.com. **Art Director:** Daniel Pessell. Emphasizes the techniques of working artists for the serious beginning, amateur and professional artist. Published 10 times/ year. Circ. 180,000. Sample copy available for $4.99 U.S., $7.99 Canadian or international; remit in U.S. funds.

● Sponsors annual contest. Send SASE for more information.

Cartoons Buys 3-4 cartoons/year. Must be related to art and artists.

Illustration Buys 2-3 illustrations/year. Has featured illustrations by Susan Blubaugh, Sean Kane, Jamie Hogan, Steve Dininno and Kathryn Adams. Features humorous and realistic illustration. Works on assignment only.

First Contact & Terms Cartoonists: Contact Cartoon Editor. Send query letter with brochure, photocopies, photographs and tearsheets to be kept on file. Prefers photostats or tearsheets as samples. Samples not filed are returned by SASE. Buys first rights. **Pays on acceptance.** Pays cartoonists $65. Pays illustrators $350-1,000 for color inside, $100-500 for spots. Occasionally accepts previously published material. Returns original artwork after publication.

Tips ''Research past issues of publication and send samples that fit the subject matter and style of target publication.''

⚅ ASCENT MAGAZINE

837 Rue Gilford, Montreal QC H2J 1P1 Canada. (514)499-3999. Fax: (514)499-3904. E-mail: assistant_editor@ascentmagazine.com. Web site: www.ascentmagazine.com. **Assistant Editor:** Luna Allison. Estab. 1999. Quarterly consumer magazine focusing on yoga and engaged spirituality; b&w with full-color cover. Circ. 7,500. Sample copies are available for $7. Art guidelines available on Web site or via e-mail (design@ascentmagazine.com).

Illustration Approached by 20-40 illustrators/year. Prefers b&w, or color artwork that will reproduce well in b&w. Assigns 50% to new and emerging illustrators. 50% of freelance illustration demands knowledge of Illustrator, InDesign and Photoshop.

First Contact & Terms Send postcard sample or query letter with b&w photocopies, samples, URL. Accepts e-mail submissions with link to Web site or image file. Prefers Mac-compatible TIFF files. Samples are filed. Responds in 2 months. Will contact artist for portfolio review if interested. Portfolio should include b&w and color, finished art, photographs and tearsheets. Pays $200-500 for color cover; $50-350 for b&w inside. Pays on publication. Buys first rights, electronic rights. Original artwork returned upon request. Finds freelancers through agents, submissions, magazines and word of mouth.

Tips "We encourage artwork that is abstract, quirky and unique. It should connect with the simplicity of the magazine's design, and be accessible and understandable to our readers, who vary greatly in age and artistic appreciation. For commissioned artwork, the piece should relate to the narrative style of the article it will illustrate."

AUTOMOBILE MAGAZINE

120 E. Liberty St., 2nd Floor, Ann Arbor MI 48104-4193. (734)994-3500. Web site: www.automobilemag.com. **Art Director:** Molly Jean. Estab. 1986. Monthly 4-color automobile magazine for upscale lifestyles. Circ. 650,000. Art guidelines are specific for each project.

Illustration Buys illustrations mainly for spots and feature spreads. Works with 5-10 illustrators/year. Buys 2-5 illustrations/issue. Works on assignment only. Considers airbrush, mixed media, colored pencil, watercolor, acrylic, oil, pastel and collage. Needs editorial and technical illustrations.

First Contact & Terms Send query letter with brochure showing art style, résumé, tearsheets, slides, photographs or transparencies. Show automobiles in various styles and media. "This is a full-color magazine; illustrations of cars and people must be accurate." Samples are returned only if requested. "I would like to keep something in my file." Responds to queries/submissions only if interested. Buys first rights and one-time rights. Pays $200 and up for color inside. Pays $2,000 maximum depending on size of illustration. Finds artists through mailed samples.

Tips "Send samples that show cars drawn accurately with a unique style and imaginative use of medium."

BABYBUG®

Cricket Magazine Group, Carus Publishing, 70 E. Lake St., Suite 300, Chicago IL 60601. Web site: www.cricketmag.com. **Contact:** Art Submissions Coordinator. Managing Art Director: Suzanne Beck. Estab. 1994. A listening and looking magazine for infants and toddlers ages 6 months to 2 years. Published monthly except for combined May/June and July/August issues. Art guidelines available on Web site.

● See also listings in this section for other magazines published by the Cricket Magazine Group: *LADYBUG, SPIDER, CRICKET* and *CICADA*.

Illustration Buys 23 illustrations/issue. Works on assignment only.

First Contact & Terms Send photocopies, photographs or tearsheets to be kept on file. Samples are returned by SASE if requested. Responds in 3 months. Buys all rights. **Pays 45 days after acceptance**: $750 for color cover; $250 for color full page; $100 for color spots; $50 for b&w spots.

Tips ''Before attempting to illustrate for *BABYBUG*, be sure to familiarize yourself with this age group, and read several issues of the magazine. Please do not query first.''

BACKPACKER MAGAZINE

Rodale, Inc., 33 E. Minor St., Emmaus PA 18098. (610)967-8296. E-mail: mbates@backpacker.com. Web site: www.backpacker.com. **Art Director:** Matthew Bates. Estab. 1973. Consumer magazine covering nonmotorized wilderness travel. Circ. 306,500.

Illustration Approached by 200-300 illustrators/year. Buys 10 illustrations/issue. Considers all media. 60% of freelance illustration demands knowledge of FreeHand, Photoshop, Illustrator, QuarkXPress.

First Contact & Terms Send query letter with printed samples, photocopies and/or tearsheets. Send follow-up postcard sample every 6 months. Accepts disk submissions compatible with QuarkXPress, Illustrator and Photoshop. Samples are filed and are not returned. Art director will contact artist for portfolio review of color photographs, slides, tearsheets and/or transparencies if interested. Buys first rights or reprint rights. Pays on publication. Finds artists through submissions and other printed media.

Tips *Backpacker* does not buy cartoons. ''Know the subject matter, and know *Backpacker Magazine*.''

BALTIMORE JEWISH TIMES

Alter Communications, Inc., 1040 Park Ave., Suite 200, Baltimore MD 21201. (410)752-3504. Fax: (443)451-0702. E-mail: artdirector@jewishtimes.com. Web site: www.jewishtimes.com. **Editorial Designer:** Lisa Drobek. Weekly b&w tabloid with 4-color cover. Emphasizes special interests to the Jewish community for largely local readership. Circ. 13,000. Sample copies available.

Alter Communications also publishes *Style*, a Baltimore lifestyle magazine; *Chesapeake Life*, which covers lifestyle topics in southern Maryland and the Eastern Shore; and *PaperDoll*, Baltimore's first magazine devoted exclusively to shopping. See www.alteryourview.com for more information on these publications.

Illustration Approached by 50 illustrators/year. Buys 4-6 illustrations/year. Works on assignment only. Prefers high-contrast, b&w illustrations.

First Contact & Terms Illustrators: Send query letter with brochure showing art style or tearsheets and photocopies. Samples not filed are returned by SASE. Responds if interested. To show a portfolio, mail appropriate materials or write/call to schedule an appointment. Portfolio should include original/final art, final reproduction/product and color tearsheets and photostats. Buys first rights. Pays on publication: $500 for b&w or color cover; $50-100 for b&w inside. Accepts previously published artwork. Returns original artwork after publication, if requested.

Tips Finds artists through word of mouth, self-promotion and sourcebooks. Sees trend toward ''more freedom of design integrating visual and verbal.''

BALTIMORE MAGAZINE

1000 Lancaster St., Suite 400, Baltimore MD 21202-4382. (410)752-4200. Fax: (410)625-0280. E-mail: wamanda@baltimoremagazine.net. Web site: www.baltimoremagazine.net. **Art Director:** Amanda White-Iseli. Assistant Art Director: Kathryn Swartz. Estab. 1908. Monthly city magazine featuring news, profiles and service articles. Circ. 57,000. Sample copies available for $2.50 each.

Illustration Approached by 300 illustrators/year. Buys 4 illustrations/issue. Works on assignment only. Considers all media, depending on assignment. 10% of freelance work demands knowledge of QuarkXPress, FreeHand, Illustrator or Photoshop, or any other program that is saved as a TIFF or PICT file.

First Contact & Terms Illustrators: Send postcard sample. Accepts disk submissions. Samples are filed. Will contact for portfolio review if interested. Originals returned at job's completion. Buys one-time rights. Pays on publication: $200-1,500 for color inside; 60 days after invoice. Finds artists through sourcebooks, publications, word of mouth, submissions.

Tips All art is freelance—humorous front pieces, feature illustrations, etc. Does not use cartoons.

BARTENDER MAGAZINE

P.O. Box 158, Liberty Corner NJ 07938-0158. (908)766-6006. Fax: (908)766-6607. E-mail: barmag @aol.com. Web site: www.bartender.com. **Art Director:** Doug Swenson. Editor: Jackie Foley. Estab. 1979. Quarterly 4-color trade journal emphasizing restaurants, taverns, bars, bartenders, bar managers, owners, etc. Circ. 150,000.

Cartoons Approached by 10 cartoonists/year. Buys 3 cartoons/issue. Prefers bar themes; single-panel.

Illustration Approached by 5 illustrators/year. Buys 1 illustration/issue. Works on assignment only. Prefers bar themes. Considers any media.

First Contact & Terms Cartoonists: Send query letter with finished cartoons. Buys first rights. Illustrators: Send query letter with brochure. Samples are filed. Negotiates rights purchased. Pays on publication. Pays cartoonists $50 for b&w and $100 for color inside. Pays illustrators $500 for color cover.

BAY WINDOWS

46 Plympton St., 5th Floor, Boston MA 02118. (617)266-6670, ext. 204. Fax: (617)266-5973. E-mail: mmaguire@baywindows.com. Web site: www.baywindows.com. **Editorial Design Manager**: Matt Maguire. Estab. 1983. Weekly newspaper "targeted to politically-aware lesbians, gay men and other political allies publishing non-erotic news and features"; b&w with 2-color cover. Circ. 60,000. Sample copies available.

Cartoons Approached by 25 cartoonists/year. Buys 1-2 cartoons/issue. Buys 50 cartoons/year. Preferred themes include politics and lifestyles. Prefers double and multiple panel, political and editorial cartoons with gagline; b&w line drawings.

Illustration Approached by 60 illustrators/year. Buys 1 illustration/issue. Buys 50 illustrations/year. Works on assignment only. Preferred themes include politics; "humor is a plus." Considers pen & ink and marker drawings. Needs computer illustrators familiar with Illustrator or Free-Hand.

First Contact & Terms Cartoonists: Send query letter with roughs. Samples are returned by SASE if requested by artist. Illustrators: Send query letter with photostats and SASE. Samples are filed. Responds in 6 weeks, only if interested. Portfolio review not required. Rights purchased

vary according to project. Pays on publication. Pays cartoonists $50-100 for b&w only. Pays illustrators $100-125 for cover; $75-100 for b&w inside; $75 for spots. Accepts previously published artwork. Original artwork returned after publication.

THE BEAR DELUXE

P.O. Box 10342, Portland OR 97296. (503)242-1047. E-mail: bear@orlo.org. Web site: www.orlo. org. **Art Director**: Kristin Rogers. Editor-in-Chief: Tom Webb. Estab. 1993. Quarterly consumer magazine emphasizing environmental writing and visual art. Circ. 46,000. Sample copy available for $5. Art guidelines available for SASE with first-class postage.

Cartoons Approached by 50 cartoonists/year. Buys 5 cartoons/issue. Prefers work related to environmental, outdoor, media, arts. Prefers single-panel, political, humorous, b&w line drawings.

Illustration Approached by 50 illustrators/year. Has featured illustrations by Matt Wuerker, Ed Fella, Eunice Moyle and Ben Rosenberg. Uses caricatures of politicians, charts graphs, natural history and spot illustration. Assigns 30% of illustrations to new and emerging illustrators. 30% of freelance illustration demands knowledge of Illustrator, Photoshop and FreeHand.

First Contact & Terms Cartoonists: Send query letter with b&w photocopies and SASE. Samples are filed or returned by SASE. Responds in 4 months. Illustrators: Send postcard sample and nonreturnable samples. Accepts Mac-compatible disk submissions. Send EPS or TIFF files. Samples are filed or returned by SASE. Responds only if interested. Portfolios may be dropped off by appointment. Buys first rights. Pays on publication. Pays cartoonists $10-50 for b&w. Pays illustrators $200 for b&w or color cover; $15-75 for b&w or color inside; $15-75 for 2-page spreads; $20 for spots. Finds illustrators through word of mouth, gallery visits and promotional samples.

Tips are actively seeking new illustrators and visual artists, and we encourage people to send samples. Most of our work (besides cartoons) is assigned out as editorial illustration or independent art. Indicate whether an assignment is possible for you. Indicate your fastest turn-around time. We sometimes need people who can work with two- to three-week turn-around or faster.''

BIRD WATCHER'S DIGEST

P.O. Box 110, Marietta OH 45750. (740)373-5285. Fax: (740)373-8443. E-mail: editor@birdwatchersdigest.com. Web site: www.birdwatchersdigest.com. Estab. 1978. Bimonthly magazine covering birds and bird watching for bird watchers and birders (backyard and field; veteran and novice). Circ. 90,000. Sample copies available for $3.99. Art guidelines available on Web site or free for SASE.

Illustration Buys 1-2 illustrations/issue. Has featured illustrations by Julie Zickefoose, Tom Hirata, Kevin Pope and Jim Turanchik. Assigns 15% of illustrations to new and emerging illustrators.

First Contact & Terms Send samples or tearsheets. Responds in 2 months. Buys one-time rights. Pays $50 minimum for b&w; $100 minimum for color. Previously published material OK. Original work returned after publication.

BIRMINGHAM PARENT

Evans Publishing LLC, 115-C Hilltop Business Dr., Pelham AL 35124. (205)739-0090. Fax: (205)739-0073. E-mail: carol@birminghamparent.com. Web site: www.birminghamparent.com. Estab. 2004. Monthly magazine serving parents of families in Central Alabama/Birmingham

with news pertinent to them. Circ. 40,000 + . Art guidelines free with SASE or on Web site.

Cartoons Approached by 2-3 cartoonists/year. Buys 12 cartoons/year. Prefers fun, humorous, parenting issues, nothing controversial. Format: single panel. Media: color washes.

Illustration Approached by 2 illustrators/year. Assigns 5% of illustrations to new and emerging illustrators. 95% of freelance work demands computer skills. Freelancers should be familiar with InDesign, QuarkXPress, Photoshop.

First Contact & Terms E-mail submissions accepted with link to Web site. Portfolio not required. Pays cartoonists $0-25 for b&w or color cartoons. Pays on publication. Buys electronic rights, first North American serial rights.

Tips "We do very little freelance artwork. We are still a small publication and don't have space or funds for it. Our art director provides the bulk of our needs. It would have to be outstanding for us to consider purchasing right now."

BITCH: Feminist Response to Pop Culture

2904 NE Alberta St. #N, Portland OR 97211-7034. E-mail: bitch@bitchmagazine.com. Web site: www.bitchmagazine.com. **Contact:** Art Director. Estab. 1996. Quarterly b&w magazine "devoted to incisive commentary on our media-driven world. We examine popular culture in all its forms for women and feminists of all ages." Circ. 80,000.

Illustration Approached by 300 illustrators/year. Buys 3-7 illustrations/issue. Features caricatures of celebrities, conceptual, fashion and humorous illustration. Work on assignment only. Prefers b&w ink drawings and photo collage. Assigns 90% of illustrations to experienced but not well-known illustrators; 8% to new and emerging illustrators; 2% to well-known or "name" illustrators.

First Contact & Terms Send postcard sample, nonreturnable samples. Accepts Mac-compatible disk submissions. Samples are filed and are not returned. Will contact artist for portfolio review if interested. Finds illustrators through magazines and word of mouth.

Tips "We have a couple of illustrators we work with regularly, but we are open to others. Our circulation has been doubling annually, and we are distributed internationally. Read our magazine and send something we might like."

BOTH SIDES NOW

10547 State Hwy. 110 N., Tyler TX 75704-3731. (903)592-4263. E-mail: bothsidesnow@prodigy. net. Web site: www.bothsidesnow.info. **Editor/Publisher:** Elihu Edelson. Alternative zine covering the interface between spirituality and politics from a New Age perspective. Quarterly, computer printed publication. Circ. 200. Accepts previously published material. Original artwork returned by SASE. Sample copy $2.

Cartoons Buys various number of cartoons/issue. Prefers fantasy, political satire, spirituality, religion and exposes of hypocrisy as themes. Prefers single or multipanel b&w line drawings.

Illustration Buys variable amount of illustrations/issue. Prefers fantasy, surrealism, spirituality and realism as themes. Color work will be reproduced in grayscale.

First Contact & Terms Cartoonists: Send query letter or E-mail: with typical examples. Illustrators: Send query letter or e-mail with résumé and examples. Samples not filed are returned by SASE. Responds in 3 months. Pays cartoonists/illustrators on publication in copies and subscription.

Tips "Pay close attention to listing and Web site FAQ page. Do not send angst-laden downers, please."

☒ BOW & ARROW HUNTING MAGAZINE

265 S. Anita Dr., #120, Orange CA 92868-3343. (714)939-9991. Fax: (714)939-9909. E-mail: editorial@bowandarrowhunting.com. Web site: www.bowandarrowhunting.com. **Editor:** Joe Bell. Emphasizes the sport of bowhunting. Circ. 97,000. Published 9 times per year. Art guidelines free for SASE with first-class postage. Original artwork returned after publication.

Cartoons Buys occasional cartoon. Prefers single panel with gag line; b&w line drawings.

Illustration Buys 2-6 illustrations/issue; all from freelancers. Has featured illustrations by Tes Jolly and Cisco Monthay. Assigns 25% of illustrations to new and emerging illustrators. Prefers live animals/game as themes.

First Contact & Terms Cartoonists: Send finished cartoons. Illustrators: Send samples. Prefers photographs or original work as samples. Especially looks for perspective, unique or accurate use of color and shading, and an ability to clearly express a thought, emotion or event. Samples returned by SASE. Responds in 2 months. Portfolio review not required. Buys first rights. Pays on publication; $500 for color cover; $100 for color inside; $50-100 for b&w inside.

BREWERS ASSOCIATION

736 Pearl St., Boulder CO 80302. (303)447-0816, ext. 127. Fax: (303)447-2825. E-mail: kelli@brewersassociation.org. Web site: www.beertown.org. **Magazine Art Director:** Kelli Gomez. Estab. 2005 (merger of the Association of Brewers and the Brewers' Assocation of America). "Our nonprofit organization hires illustrators for two magazines, *Zymurgy* and *The New Brewer*, each published bimonthly. *Zymurgy* is the journal of the American Homebrewers Association. The goal of the AHA division is to promote public awareness and appreciation of the quality and variety of beer through education, research and the collection and dissemination of information." Circ. 10,000. "*The New Brewer* is the journal of the Brewers Association. It offers practical insights and advice for breweries that range in size from less than 500 barrels per year to more than 500,000. Features articles on brewing technology and problem solving, pub and restaurant management, and packaged beer sales and distribution, as well as important industry news and industry sales and market share performance." Circ. 3,000.

Illustration Approached by 50 illustrators/year. Buys 3-6 illustrations/year. Prefers beer and homebrewing themes. Considers all media.

Design Prefers local design freelancers with experience in Photoshop, QuarkXPress, Illustrator.

First Contact & Terms Illustrators: Send postcard sample or query letter with printed samples, photocopies, tearsheets; follow-up sample every 3 months. Accepts disk submissions with EPS, TIFF or JPEG files. "We prefer samples we can keep." No originals accepted; samples are filed. Responds only if interested. Art director will contact artist for portfolio review if interested. Buys one-time rights. Pays 60 days net on acceptance. Pays illustrators $700-800 for color cover; $200-300 for b&w inside; $200-400 for color inside. Pays $150-300 for spots. Finds artists through agents, sourcebooks and magazines (Society of Illustrators, *Graphis*, *PRINT*, *Colorado Creative*), word of mouth, submissions. Designers: Send query letter with printed samples, photocopies, tearsheets.

Tips "Keep sending promotional material for our files. Anything beer-related for subject matter is a plus. We look at all styles."

☒ BUGLE

5705 Grant Creek Road, Missoula MT 59808. (406)523-4500. Fax: (406)523-4550. E-mail: cs@rmef.org. Web site: www.elkfoundation.org. Estab. 1984. Bimonthly 4-color outdoor conservation and hunting magazine for a nonprofit organization. Circ. 150,000.

Illustration Approached by 10-15 illustrators/year. Buys 3-4 illustrations/issue. Has featured illustrations by Pat Daugherty, Cynthie Fisher, Joanna Yardley and Bill Gamradt. Features natural history illustration, humorous illustration, realistic illustrations and maps. Preferred subjects wildlife and nature. "Open to all styles." Assigns 60% of illustrations to well-known or "name" illustrators; 20% to experienced but not well-known illustrators; 20% to new and emerging illustrators.

First Contact & Terms Illustrators: E-mail with query letter and pdf of samples or link to portfolio. Will contact artist for portfolio review if interested. **Pays on acceptance**; $250-400 for b&w, $250-400 for color cover; $100-150 for b&w, $100-200 for color inside; $150-300 for 2-page spreads; $50 for spots. Finds illustrators through existing contacts and magazines.

Tips "We are looking for elk, other wildlife and habitat. Attention to accuracy and realism."

BULLETIN OF THE ATOMIC SCIENTISTS

77 W. Washington Street, Suite 2120., Chicago IL 60602. (773)702-2555. Fax: (773)702-0725. E-mail: joy@thebulletin.org. Web site: www.thebulletin.org. **Managing Editor:** John Rezek. Art Director: Joy Olivia Miller. Estab. 1945. Bimonthly magazine of international affairs and nuclear security. Circ. 15,000.

Cartoons Approached by 15-30 cartoonists/year. Buys 2 cartoons/issue. Prefers single panel, humor related to global security, b&w/color washes and line drawings.

Illustration Approached by 30-40 illustrators/year. Buys 2-3 illustrations/issue.

First Contact & Terms Send postcard sample and photocopies. Buys one-time and digital rights. Responds only if interested. **Pays on acceptance.**

Tips "We're eager to see cartoons that relate to our editorial content, so it's important to take a look at the magazine before submitting items."

BUSINESS LAW TODAY

321 N. Clark St., 20th Floor, Chicago IL 60610. (312)988-5000. Fax: (312)988-5444. E-mail: tedhamsj@staff.abanet.org. Web site: www.abanet.org/buslaw/blt. **Art Director:** Jill Tedhams. Estab. 1992. Bimonthly magazine covering business law. Circ. 60,291. Art guidelines not available.

Cartoons Buys 20-24 cartoons/year. Prefers business law and business lawyers themes. Prefers single panel, humorous, b&w line drawings with gaglines. Use of women and persons of color in contemporary settings is important. Prefer cartoons submitted electronically by e-mail.

Illustration Buys 6-9 illustrations/issue. Has featured illustrations by Sean Kane, Max Licht and Jim Starr. Features whimsical, realistic and computer illustrations. Assigns 10% of illustrations to new and emerging illustrators. Prefers editorial illustration. Considers all media. 10% of freelance illustration demands knowledge of Photoshop, Illustrator and QuarkXPress.

First Contact & Terms Cartoonists: Send to tedhamsj@staff.abanet.org or palmerj@staff.abanet. org. Responds only if interested. Illustrators: "We will accept work compatible with QuarkXPress version 7 or InDesign CS3. Send JPG, EPS or TIFF files." Samples are filed and are not returned. Responds only if interested. Buys one-time rights. Pays on publication. Pays cartoonists $200 minimum for b&w. Pays illustrators $850 for color cover; $520 for b&w inside, $650 for color inside; $175 for b&w spots.

Tips "Although our payment may not be the highest, accepting jobs from us could lead to other projects, since we produce many publications at the ABA. Sending samples (three to four pieces) works best to get a sense of your style; that way I can keep them on file.

BUSINESS TRAVEL NEWS

770 Broadway, New York NY 10003. (646)654-4439. Fax: (646)654-4455. E-mail: ewong@btnonl ine.com. Web site: www.btnonline.com. **Art Director:** Eric Wong. Estab. 1984. Bimonthly 4-color trade publication focusing on business and corporate travel news/management. Circ. 50,000.

Illustration Approached by 300 illustrators/year. Buys 4-8 illustrations/month. Features charts & graphs, computer illustration, conceptual art, informational graphics and spot illustrations. Preferred subjects: business concepts, electronic business and travel. Assigns 30% of illustrations to well-known, experienced and emerging illustrators.

First Contact & Terms Illustrators: Send postcard or other nonreturnable samples. Samples are filed. Buys first rights. **Pays on acceptance**: $600-900 for color cover; $250-350 for color inside. Finds illustrators through artists' promotional material and sourcebooks.

Tips ''Send your best samples. We look for interesting concepts and print a variety of styles. Please note we serve a business market.''

CAT FANCY

P.O. Box 6050, Mission Viejo CA 92690-6050 (for UPS or overnight deliveries: 3 Burroughs Dr., Irvine CA 92618). (949)855-8822. E-mail: catsupport@catchannel.com. Web site: www.catchan nel.com. **Contact:** Art Editor. Monthly 4-color consumer magazine dedicated to the love of cats. Circ. 290,000. Sample copy available for $5.50. Art guidelines available for SASE or on Web site.

Cartoons Occasionally uses single-panel cartoons as filler. Cartoons must feature a cat or cats and should fit single-column width (2¼) or double-column width (4½).

Illustration Needs editorial, medical and technical illustration and images of cats. Works on assignment only.

First Contact & Terms Send query letter with brochure, high-quality photocopies (preferably color), tearsheets and SASE. Responds in 6-8 weeks. Buys one-time rights. Pays on publication. Pays cartoonists $35 for b&w line drawings. Pays illustrators $35-75 for spots; $75-150 for color inside; more for packages of multiple illustrations.

Tips ''Seeking creative and innovative illustrators that lend a modern feel to our magazine. Please review a sample copy of the magazine before submitting your work to us.''

CATHOLIC FORESTER

P.O. Box 3012, Naperville IL 60566-7012. (630)983-4900. Fax: (630)983-4057. E-mail: magazine @catholicforester.com. Web site: www.catholicforester.com. **Contact:** Art Director. Estab. 1883. ''*Catholic Forester* is the national member magazine for Catholic Order of Foresters, a not-for-profit fraternal insurance organization. We use general interest articles, art and photos. Audience is small town and urban middle-class, patriotic, Roman Catholic and traditionally conservative.'' National quarterly 4-color magazine. Circ. under 100,000. Accepts previously published material. Sample copy for 9.5×11 SASE with 3 first-class stamps.

Illustration Buys and commissions editorial illustration. No gag or panel cartoons.

First Contact & Terms Illustrators: Will contact for portfolio review if interested. Requests work on spec before assigning job. Buys one-time rights, North American serial rights or reprint rights. Pays on publication. Pays $30 for b&w, $75-300 for color. Turn-around time for completed artwork usually 2 weeks.

Tips ''Know the audience; always read the article and ask art director questions. Be timely.''

CED (COMMUNICATIONS, ENGINEERING & DESIGN MAGAZINE)

Advantage Business Media, 6041 S. Syracuse Way, Suite 310, Greenwood Village CO 80111-9402. (973)920-7709. E-mail: don.ruth@advantagemedia.com. Web site: www.cedmagazine.com. **Senior Art Director:** Don Ruth. Estab. 1978. Monthly trade journal; "the premier magazine of broadband technology." Circ. 25,000. Sample copies and art guidelines available.

Illustration Buys 1 illustration/issue. Works on assignment only. Features caricatures of celebrities; realistic illustration; charts and graphs; informational graphics and computer illustrations. Prefers cable TV industry themes. Considers watercolor, airbrush, acrylic, colored pencil, oil, charcoal, mixed media, pastel, computer disk formatted in Photoshop, Illustrator or FreeHand. Assigns 10% of illustrations to new and emerging illustrators.

First Contact & Terms Contact only through artist rep. Samples are filed. Call for appointment to show portfolio. Portfolio should include final art, b&w/color tearsheets, photostats, photographs and slides. Rights purchased vary according to project. **Pays on acceptance.** Pays illustrators $400-800 for color cover; $125-400 for b&w and color inside; $250-500 for 2-page spreads; $75-175 for spots. Accepts previously published work. Original artwork not returned at job's completion.

Tips "Be persistent; come in person if possible. Be willing to change in mid course; be willing to have finished work rejected. Make sure you can draw and work fast."

CHARLOTTE MAGAZINE

127 W. Worthington Ave., Suite 208, Charlotte NC 28203-4474. (704)335-7181. Fax: (704)335-3739. E-mail: carrie.campbell@charlottemagazine.com. Web site: www.charlottemagazine.com. **Art Director:** Carrie Campbell. Estab. 1995. Monthly 4-color city-based consumer magazine for Charlotte and surrounding areas. Circ. 40,000. Sample copy free for #10 SAE with first-class postage.

Illustration Approached by many illustrators/year. Buys 1-5 illustrations/issue. Features caricatures of celebrities and politicians; computer illustration; humorous illustration; natural history, realistic and spot illustration. Prefers wide range of media/conceptual styles. Assigns 20% of illustrations to new and emerging illustrators.

First Contact & Terms Illustrators: Send postcard sample and follow-up postcard every 6 months. Send non-returnable samples. Accepts e-mail submissions. Send EPS or TIFF files. Samples are filed. Responds only if interested. Portfolio review not required. Finds illustrators through promotional samples and sourcebooks.

Tips "We are looking for diverse and unique approaches to illustration. Highly creative and conceptual styles are greatly needed. If you are trying to get your name out there, we are a great avenue for you."

CHESAPEAKE BAY MAGAZINE

1819 Bay Ridge Ave., Annapolis MD 21403. (410)263-2662. Fax: (410)267-6924. E-mail: kashley @cbmmag.net. Web site: www.cbmmag.net. **Art Director:** Karen Ashley. Estab. 1972. Monthly 4-color magazine focusing on the boating environment of the Chesapeake Bay—including its history, people, places, events, environmental issues and ecology. Circ. 45,000. Original artwork returned after publication upon request. Sample copies free for SASE with first-class postage. Art guidelines available.

Illustration Approached by 12 illustrators/year. Buys 2-3 technical and editorial illustrations/ issue. Has featured illustrations by Jim Paterson, Kim Harroll, Jan Adkins, Tamzin B. Smith,

Marcy Ramsey, Peter Bono, Stephanie Carter and James Yang. Assigns 50% of illustrations to new and emerging illustrators. Considers pen & ink, watercolor, collage, acrylic, marker, colored pencil, oil, charcoal, mixed media and pastel. Also digital. Usually prefers watercolor or acrylic for 4-color editorial illustration. "Style and tone are determined by the artist after he/she reads the story."

First Contact & Terms Illustrators: Send query letter with résumé, tearsheets and photographs. Samples are filed. Make sure to include contact information on each sample. Responds only if interested. Publication will contact artist for portfolio review if interested. Portfolio should include "anything you've got." No b&w photocopies. Buys one-time rights. "Price decided when contracted." Pays illustrators $100-300 for quarter-page or spot illustrations; up to $1,200 for spreads—four-color inside.

Tips "Our magazine design is relaxed, fun, oriented toward people who enjoy recreation on the water. Boating interests remain the same. But for the Chesapeake Bay boater, water quality and the environment are more important now than in the past. Colors brighter. We like to see samples that show the artist can draw boats and understands our market environment. Send tearsheets or send Web site information. We're always looking. Artist should have some familiarity with the appearance of different types of boats, boating gear and equipment."

▣ CHESS LIFE

P.O. Box 3967, Crossville TN 38557. (931)787-1234. Fax: (931)787-1200. Web site: www.uschess .org. **Editor:** Daniel Lucas. Estab. 1939. Official publication of the United States Chess Federation. Contains news of major chess events with special emphasis on American players, plus columns of instruction, general features, historical articles, personality profiles, tournament reports, cartoons, quizzes, humor and short stories. Monthly b&w with 4-color cover. Design is "text-heavy with chess games." Circ. 70,000/month. Accepts previously published material and simultaneous submissions. Sample copy for SASE with 6 first-class stamps; art guidelines for SASE with first-class postage.

Also publishes children's magazine, *Chess Life For Kids* every other month. Same submission guidelines apply.

Cartoons Approached by 5-10 cartoonists/year. Buys 0-12 cartoons/year. All cartoons must be chess related. Prefers single panel with gagline; b&w line drawings.

Illustration Approached by 10-20 illustrators/year. Works with 4-5 illustrators/year from freelancers. Buys 8-10 illustrations/year. Uses artists mainly for cartoons and covers. All must have a chess motif. Works on assignment, but will also consider unsolicited work.

First Contact & Terms Cartoonists: Send query letter with brochure showing art style. Material kept on file or returned by SASE. Illustrators: Send query letter with samples or e-mail Dan Lucas at dlucas@uschess.org. Responds in 2 months. Negotiates rights purchased. Pays on publication. Pays cartoonists $25. Pays illustrators $150, b&w cover; $300, color cover; $25 inside.

CHRISTIAN HOME & SCHOOL

3350 E. Paris Ave. SE, Grand Rapids MI 49512. (616)957-1070. Fax: (616)957-5022. E-mail: rogers@csionline.org. Web site: www.CSIonline.org. **Senior Editor:** Roger W. Schmurr. Quarterly 4-color magazine emphasizing current, crucial issues affecting the Christian home for parents who support Christian education. Circ. 66,000. Sample copy for 9×12 SASE with 4 first-class stamps; art guidelines for SASE with first-class postage.

Cartoons Prefers family and school themes.

Illustration Buys approximately 2 illustrations/issue. Has featured illustrations by Patrick Kelley, Rich Bishop and Pete Sutton. Features humorous, realistic and computer illustration. Assigns 75% of illustrations to experienced but not well-known illustrators; 25% to new and emerging illustrators. Prefers pen & ink, charcoal/pencil, colored pencil, watercolor, collage, marker and mixed media. Prefers family or school life themes. Works on assignment only.

First Contact & Terms Illustrators: Send query letter with résumé, tearsheets, photocopies or photographs. Show a representative sampling of work. Samples returned by SASE, or "send one or two samples art director can keep on file." Will contact if interested in portfolio review. Buys first rights. Pays on publication. Pays cartoonists $75 for b&w. Pays illustrators $300 for 4-color full-page inside. Finds most artists through references, portfolio reviews, samples received through the mail and artist reps.

CICADA®

Cricket Magazine Group, Carus Publishing, 70 E. Lake St., Suite 300, Chicago IL 60601. Web site: www.cricketmag.com. **Contact:** Art Submissions Coordinator. Managing Art Director: Suzanne Beck. Estab. 1998. Bimonthly literary magazine for teenagers. Art guidelines available on Web site.

• See also listings in this section for other magazines published by the Cricket Magazine Group: *BABYBUG, LADYBUG, SPIDER* and *CRICKET*.

First Contact & Terms "We at The Cricket Magazine Group know that teenagers' interests and tastes constantly evolve, and we want *CICADA* to evolve with them. Therefore we are re-examining the scope, focus, and format of *CICADA*, and are no longer accepting submissions for the magazine in its current format. Please check our Web site periodically for updates on our submission guidelines."

CINCINNATI CITYBEAT

811 Race St., 5th Floor, Cincinnati OH 45202. (513)665-4700. Fax: (513)665-4369. E-mail: shughes@citybeat.com. Web site: www.citybeat.com. **Art Director:** Sean Hughes. Estab. 1994. Weekly alternative newspaper emphasizing issues, arts and events. Circ. 50,000.

• Please research alternative weeklies before contacting this art director. He reports receiving far too many inappropriate submissions.

Cartoons Approached by 30 cartoonists/year. Buys 1 cartoon/year.

Illustration Buys 1-3 illustrations/issue. Features caricatures of celebrities and politicians, computer and humorous illustration. Prefers work with a lot of contrast. Assigns 40% of illustrations to new and emerging illustrators. 10% of freelance illustration demands knowledge of Illustrator, Photoshop, FreeHand, QuarkXPress.

First Contact & Terms Cartoonists: Send query letter with samples. Illustrators: Send postcard sample or query letter with printed samples and follow-up postcard every 4 months. Accepts Mac-compatible disk submissions. Send EPS, TIFF or PDF files. Samples are filed. Responds in 2 weeks, only if interested. Buys one-time rights. Pays on publication. Pays cartoonists $10-100 for b&w, $30-100 for color, $10-35 for comic strips. Pays illustrators $75-150 for b&w cover, $150-250 for color cover, $10-50 for b&w inside, $50-75 for color inside, $75-150 for 2-page spreads. Finds illustrators through word of mouth and artists' samples.

CINCINNATI MAGAZINE

200 Carew Tower, 441 Vine St., Cincinnati OH 45202. (513)421-4300. Fax: (513)562-2746. E-mail: gsaunders@cintimag.emmis.com. Web site: www.cincinnatimagazine.com. **Art Director**: Grace Saunders. Estab. 1960. Monthly 4-color lifestyle magazine for the city of Cincinnati. Circ. 30,000.

Illustration Approached by 200 illustrators/year. Works on assignment only.

First Contact & Terms Send digital samples only. Responds only if interested. Buys one-time rights or reprint rights. Accepts previously published artwork. Original artwork returned at job's completion. Pays on publication: $500-800 for features; $200-450 for spots.

Tips Prefers traditional media with an interpretive approach. No cartoons or mass-market computer art.

CIRCLE K MAGAZINE

Kiwanis International, 3636 Woodview Trace, Indianapolis IN 46268. (317)875-8755. Fax: (317)879-0204. E-mail: magazine@kiwanis.org. Web site: www.circlek.org. **Art Director:** Maria Malandrakis. Estab. 1968. Magazine published 3 times/year for college-age students, emphasizing service, leadership, etc. Circ. 12,000. Free sample copy for SASE with 3 first-class postage stamps.

Kiwanis International also publishes *Kiwanis* and *Key Club* magazines; see separate listings in this section.

Illustration Approached by more than 30 illustrators/year. Buys 1-2 illustrations/issue. Works on assignment only. Needs editorial illustration. ''We look for variety.''

First Contact & Terms Send query letter with photocopies, photographs, tearsheets and SASE. Samples are filed. Will contact for portfolio review if interested. Portfolio should include tearsheets and slides. Originals and sample copies returned to artist at job's completion. **Pays on acceptance**: $100 for b&w cover; $250 for color cover; $50 for b&w inside; $150 for color inside.

CITY SHORE MAGAZINE

200 E. Las Olas Blvd., Ft. Lauderdale FL 33301-2299. (954)356-4685. Fax: (954)356-4612. E-mail: gcarannante@sun-sentinel.com. Web site: www.cityandshore.com. **Art Director:** Greg Carannante. Estab. 2000. Bimonthly ''luxury lifestyle magazine published for readers in South Florida.'' Circ. 42,000. Sample copies available for $4.95.

Illustration ''We rarely use illustrations, but when we do, we prefer sophisticated, colorful styles, with lifestyle-oriented subject matter. We don't use illustration whose style is dark or very edgy.''

First Contact & Terms Accepts e-mail submissions with image file.

CLARETIAN PUBLICATIONS

205 W. Monroe, Chicago IL 60606. (312)236-8682. Fax: (312)236-8207. E-mail: wrightt@claretians.org. **Art Director:** Tom Wright. Estab. 1960. Monthly magazine ''covering the Catholic family experience and social justice.'' Circ. 40,000. Sample copies and art guidelines available.

Illustration Approached by 20 illustrators/year. Buys 4 illustrations/issue. Considers all media.

First Contact & Terms Illustrators: Send postcard sample and query letter with printed samples and photocopies or e-mail with an attached Web site to visit. Accepts disk submissions compatible with EPS or TIFF. Samples are filed. Responds only if interested. Art director will contact artist for portfolio review if interested. Negotiates rights purchased. **Pays on acceptance.** $100-400 for color inside.

Tips "We like to employ humor in our illustrations and often use clichés with a twist and appreciate getting art in digital form."

N CLEANING BUSINESS

P.O. Box 1273, Seattle WA 98111. (206)824-3207. Fax: (206)622-6876. E-mail: wgriffin@cleanin gconsultants.com. Web site: www.cleaningbusiness.com. **Publisher:** Bill Griffin. Submissions Editor: Bill S. Quarterly e-magazine with technical, management and human relations emphasis for self-employed cleaning and maintenance service contractors and workers. Internet publication. Prefers to purchase all rights. Simultaneous submissions OK "if sent to noncompeting publications." Original artwork returned after publication if requested by SASE.

Cartoons Buys 1-2 cartoons/issue. Must be relevant to magazine's readership. Prefers b&w line drawings.

Illustration Buys approximately 12 illustrations/year including some humorous and cartoon-style illustrations.

First Contact & Terms Illustrators: Send query letter with samples. *"Don't* send samples unless they relate specifically to our market." Samples returned by SASE. Buys all rights. Responds only if interested. Pays for illustration by project $3-15. Pays on publication.

Tips "Our budget is limited. Those who require high fees are wasting their time. We are interested in people with talent and ability who seek exposure and publication. Our readership is people who work for and own businesses in the cleaning industry, such as maid services; janitorial contractors; carpet, upholstery and drapery cleaners; fire, odor and water damage restoration contractors; etc. If you have material relevant to this specific audience, we would definitely be interested in hearing from you. We are also looking for books, games, videos, software, jokes and reports related to the cleaning industry."

THE CLERGY JOURNAL

6160 Carmen Ave. E., Inver Grove Heights MN 55076-4422. (800)328-0200. Fax: (888)852-5524. E-mail: sfirle@logosstaff.com. Web site: www.logosproductions.com. **Editor:** Sharon Firle. Magazine for professional clergy and church business administrators; 2-color with 4-color cover. Monthly (except June, August and December). Circ. 4,000.

This publication is one of many published by Logos Productions and Woodlake Books.

Cartoons Buys cartoons from freelancers on religious themes.

First Contact & Terms Cartoonists: Send SASE. Responds in 1 month. Pays $25 on publication. Original artwork returned after publication if requested.

CLEVELAND MAGAZINE

1422 Euclid Ave., Suite 730, Cleveland OH 44115. (216)771-2833. Fax: (216)781-6318. E-mail: sluzewski@clevelandmagazine.com. Web site: www.clevelandmagazine.com. **Contact:** Gary Sluzewski. Monthly city magazine, with 4-color cover, emphasizing local news and information. Circ. 45,000.

Illustration Approached by 100 illustrators/year. Buys 3-4 editorial illustrations/issue on assigned themes. Sometimes uses humorous illustrations. 40% of freelance work demands knowledge of InDesign, Illustrator or Photoshop.

First Contact & Terms Illustrators: Send postcard sample with brochure or tearsheets. E-mail: submissions must include sample. Accepts disk submissions. Please include application softwa re. Call or write for appointment to show portfolio of printed samples, final reproduction/produ

ct, color tearsheets and photographs. Pays $300-700 for color cover; $75-300 for b&w inside; $150-400 for color inside; $75-350 for spots.

Tips "Artists are used on the basis of talent. We use many talented college graduates just starting out in the field. We do not publish gag cartoons but do print editorial illustrations with a humorous twist. Full-page editorial illustrations usually deal with local politics, personalities and stories of general interest. Generally, we are seeing more intelligent solutions to illustration problems and better techniques. The economy has drastically affected our budgets; we pick up existing work as well as commissioning illustrations."

COBBLESTONE, DISCOVER AMERICAN HISTORY

Cobblestone Publishing, Inc., 30 Grove St., Suite C, Peterborough NH 03458-1438. (603)924-7209. Fax: (603)924-7380. E-mail: adillon@caruspus.com. Web site: www.cobblestonepub.com. **Art Director:** Ann Dillon. Publishes 9 times a year. Our magazine emphasizes on American history; features nonfiction, supplemental nonfiction, fiction, biographies, plays, activities and poetry for children ages 8-14. Circ. 38,000. Accepts previously published material and simultaneous submissions. Sample copy $5.97 plus $2 shipping; art guidelines on Web site. Material must relate to theme of issue; subjects and topics published in guidelines for SASE. Freelance work demands knowledge of Illustrator, Photoshop and QuarkXPress.

Other magazines published by Cobblestone include *Calliope* (world history), *Dig* (archaeology for kids), *Faces* (cultural anthropology), *Odyssey* (science), all for kids ages 8-15, and *Appleseeds* (social studies), for ages 7-9.

Illustration Buys 2-5 illustrations/issue. Prefers historical theme as it pertains to a specific feature. Works on assignment only. Has featured illustrations by Annette Cate, Beth Stover, David Kooharian. Features caricatures of celebrities and politicians, humorous, realistic illustration, informational graphics, computer and spot illustration. Assigns 15% of illustrations to new and emerging illustrators.

First Contact & Terms Send query letter with brochure, résumé, business card and b&w photocopies or tearsheets to be kept on file or returned by SASE. Write for appointment to show portfolio. Buys all rights. Pays on publication; $20-125 for b&w inside; $40-225 for color inside. Artists should request illustration guidelines.

Tips "Study issues of the magazine for style used. Send update samples once or twice a year to help keep your name and work fresh in our minds. Send nonreturnable samples we can keep on file; we're always interested in widening our horizons."

⬛ COMMON GROUND

#204-4381 Fraser St., Vancouver BC V5V 4G4 Canada. (604)733-2215. Fax: (604)733-4415. E-mail: admin@commonground.ca. Web site: www.commonground.ca. **Contact:** Art Director. Estab. 1982. Monthly consumer magazine focusing on health and cultural activities and holistic personal resource directory. Circ. 70,000. Accepts previously published artwork and cartoons. Original artwork is returned at job's completion. Sample copies for SASE with first-class Canadian postage or International Postage Certificate.

Illustration Approached by 20-40 freelance illustrators/year. Buys 1-2 freelance illustrations/issue. Prefers all themes and styles. Considers cartoons, pen & ink, watercolor, collage and marker.

First Contact & Terms Illustrators: Send query letter with brochure, photographs, SASE and photocopies. Samples are filed or are returned by SASE if requested by artist. Responds only if interested. Buys one-time rights. Payment varies.

Tips ''Send photocopies of your top one-three inspiring works in black & white or color. Can have all three on one sheet of 8½×11 paper or all in one color copy. I can tell from that if I am interested.''

CONSTRUCTION EQUIPMENT OPERATION AND MAINTENANCE

Construction Publications, Inc., 829 2nd Avenue SE, Cedar Rapids IA 52406. (319)366-1597. E-mail: chuckparks@constpub.com. Web site: www.constructionpublications.com. **Editor-in-Chief:** Chuck Parks. Estab. 1948. Bimonthly b&w tabloid with 4-color cover. Co vers heavy construction and industrial equipment for contractors, machine operators, mechanics and local government officials involved with construction. Circ. 67,000. Free sample copy.

Cartoons Buys 8-10 cartoons/issue. Interested in themes ''related to heavy construction industry'' or ''cartoons that make contractors and their employees 'look good' and feel good about themselves''; single -panel.

First Contact & Terms Cartoonists : Send finished cartoons and SASE. Responds in 2 weeks. Original artwork not returned after publication. Buys all rights, but may reassign rights to artist after publication. Pays $5 0 for b&w. Reserves right to rewrite captions.

DAVID C. COOK

(formerly Cook Communications Ministries), 4050 Lee Vance View, Colorado Springs CO 80918-7100. (719)536-0100. Web site: www.cookministries.org. **Design Manager:** Jeff Barnes. Publisher of teaching booklets, books, take-home papers for Christian market, ''all age groups.'' Art guidelines available for SASE with first-class postage only.

Illustration Buys about 10 full-color illustrations/month. Has featured illustrations by Richard Williams, Chuck Hamrick and Ron Diciani. Assigns 5% of illustrations to new and emerging illustrators. Features realistic illustration, Bible illustration, computer and spot illustration. Works on assignment only.

First Contact & Terms Illustrators: Send tearsheets, color photocopies of previously published work; include self-promo pieces. No samples returned unless requested and accompanied by SASE. **Pays on acceptance**: $400-700 for color cover; $250-400 for color inside; $150-250 for b&w inside; $500-800 for 2-page spreads; $50-75 for spots. Considers complexity of project, skill and experience of artist, and turnaround time when establishing payment. Buys all rights.

Tips ''We do not buy illustrations or cartoons on speculation. Do *not* send book proposals. We welcome those just beginning their careers, but it helps if the samples are presented in a neat and professional manner. Our deadlines are generous but must be met. Fresh, dynamic, the highest of quality is our goal; art that appeals to everyone from preschoolers to senior citizens; realistic to humorous, all media.''

ℕ COPING WITH CANCER

P.O. Box 682268, Franklin TN 37068. (615)790-2400. Fax: (615)794-0179. E-mail: editor@coping mag.com. Web site: www.copingmag.com. **Editor:** Laura Shipp. Estab. 1987. ''*Coping with Cancer* is a bimonthly, nationally-distributed consumer magazine dedicated to providing the latest oncology news and information of greatest interest and use to its readers. Readers are cancer survivors, their loved ones, support group leaders, oncologists, oncology nurses and other allied health professionals. The style is very conversational and, considering its sometimes technical subject matter, quite comprehensive to the layman. The tone is upbeat and generally positive,

clever and even humorous when appropriate, and very credible." Circ. 90,000. Sample copy available for $3. Art guidelines for SASE with first-class postage. Guidelines are available at www.copingmag.com.

COSMOGIRL!

300 W. 57th St., New York NY 10019. Web site: www.cosmogirl.com. **Contact:** Art Department. Estab. 1996. Monthly 4-color consumer magazine designed as a cutting-edge lifestyle publication exclusively for teenage girls. Circ. 1.5 million.

Illustration Approached by 350 illustrators/year. Buys 6-10 illustrations/issue. Features caricatures of celebrities and music groups, fashion, humorous and spot illustration. Preferred subject is teens. Assigns 10% of illustrations to well-known or "name" illustrators; 80% to experienced but not well-known illustrators; 10% to new and emerging illustrators.

First Contact & Terms Send postcard sample and follow-up postcard every 6 months. Samples are filed. Responds only if interested. Buys first rights. **Pays on acceptance.** Pay varies. Finds illustrators through sourcebooks and samples.

COSMOPOLITAN

300 W. 57th St., New York NY 10019-3741. E-mail: jlanuza@hearst.com. Web site: www.cosmo politan.com. **Art Director:** John Lanuza. Estab. 1886. Monthly 4-color consumer magazine for contemporary women covering a broad range of topics including beauty, health, fitness, fashion, relationships and careers. Circ. 3,021,720.

Illustration Approached by 300 illustrators/year. Buys 10-12 illustrations/issue. Features beauty, humorous and spot illustration. Preferred subjects include women and couples. Prefers trendy fashion palette. Assigns 5% of illustrations to new and emerging illustrators.

First Contact & Terms Send postcard sample and follow-up postcard every 4 months. Samples are filed. Responds only if interested. Buys first North American serial rights. **Pays on acceptance**: $1,000 minimum for 2-page spreads; $450-650 for spots. Finds illustrators through sourcebooks and artists' promotional samples.

CRICKET®

Cricket Magazine Group, Carus Publishing, 70 E. Lake St., Suite 300, Chicago IL 60601. Web site: www.cricketmag.com. **Contact:** Art Submissions Coordinator. Senior Art Director: Karen Kohn. Estab. 1973. Monthly literary magazine for young readers, ages 9-14. Art guidelines available on Web site.

See also listings in this section for other magazines published by the Cricket Magazine Group: *BABYBUG*, *LADYBUG*, *SPIDER* and *CICADA*.

Illustration Works with 75 illustrators/year. Buys 600 illustrations/year. Considers pencil, pen & ink, watercolor, acrylic, oil, pastels, scratchboard, and woodcut. "While we need humorous illustration, we cannot use work that is overly caricatured or 'cartoony.' We are always looking for strong realism. Many assignments will require artist's research into a particular scientific field, world culture, or historical period." Works on assignment only.

First Contact & Terms Send photocopies, photographs or tearsheets to be kept on file. Samples are returned by SASE if requested. Responds in 3 months. Buys all rights. **Pays 45 days after acceptance**: $750 for color cover; $250 for color full page; $100 for color spots; $50 for b&w spots.

Tips "Before attempting to write for *CRICKET*, be sure to familiarize yourself with this age group, and read several issues of the magazine. Please do not query first."

DAKOTA COUNTRY

P.O. Box 2714, Bismark ND 58502. (701)255-3031. Fax: (701)255-5038. E-mail: dcmag@btinet.n et. Web site: www.dakotacountrymagazine.com. **Publisher:** Bill Mitzel. Estab. 1979. *Dakota Country* is a monthly hunting and fishing magazine with readership in North and South Dakota. Features stories on all game animals and fish and outdoors. Basic 3-column format, full-color throughout magazine, 4-color cover, feature layout. Circ. 14,200. Accepts previously published artwork. Original artwork is returned after publication. Sample copies for $2; art guidelines for SASE with first-class postage.

Cartoons Likes to buy cartoons in volume. Prefers outdoor themes, hunting and fishing. Prefers multiple or single panel cartoon with gagline; b&w line drawings.

Illustration Features humorous and realistic illustration of the outdoors. Portfolio review not required.

First Contact & Terms Send query letter with samples of style. Samples not filed are returned by SASE. Responds to queries/submissions within 2 weeks. Negotiates rights purchased. **Pays on acceptance.** Pays cartoonists $10-20, b&w. Pays illustrators $20-25 for b&w inside; $12-30 for spots.

Tips "Always need good-quality hunting and fishing line art and cartoons."

Ⓝ DC COMICS

AOL-Time Warner, Dept. AGDM, 1700 Broadway, 5th Floor, New York NY 10019. (212)636-5990. Fax: (212)636-5977. Web site: www.dccomics.com. **Vice President Design and Retail Product Development:** Georg Brewer. Monthly 4-color comic books for ages 7-25. Circ. 6,000,000. Original artwork is returned after publication.

- See DC Comics's listing in Book Publishers section. *DC Comics* does not read or accept unsolicited submissions of ideas, stories or artwork.

DERMASCOPE

Geneva Corporation, 4402 Broadway Blvd., Ste. 14, Garland TX 75043. (469)429-9300. Fax: (469)429-9301. E-mail: saundra@dermascope.com. Web site: www.dermascope.com. **Production Manager:** Saundra Brown. Estab. 1978. Monthly magazine/trade journal, 128-page magazine for aestheticians, plastic surgeons and stylists. Circ. 15,000. Sample copies and art guidelines available.

Illustration Approached by 5 illustrators/year. Prefers illustrations of "how-to" demonstrations. Considers digital media. 100% of freelance illustration demands knowledge of Photoshop, Illustrator, InDesign, Fractil Painter.

First Contact & Terms Accepts disk submissions. Samples are not filed. Responds only if interested. Rights purchased vary according to project. Pays on publication.

THE EAST BAY MONTHLY

1301 59th St., Emeryville CA 94608. (510)658-9811. Fax: (510)658-9902. E-mail: artdirector@the monthly.com. Web site: www.themonthly.com. **Art Director:** Andreas Jones. Estab. 1970. Monthly consumer tabloid; b&w with 4-color cover. Editorial features are general interests (art, entertainment, business owner profiles) for an upscale audience. Circ. 81,000. Sample copy and guidelines available for SASE with 5 oz. first-class postage.

Cartoons Approached by 75-100 cartoonists/year. Buys 3 cartoons/issue. Prefers single-panel, b&w line drawings; "any style, extreme humor."

Illustration Approached by 150-200 illustrators/year. Buys 2 illustrations/issue. Prefers pen & ink, watercolor, acrylic, colored pencil, oil, charcoal, mixed media and pastel. No nature or architectural illustrations.

Design Occasionally needs freelancers for design and production. 100% of freelance design requires knowledge of PageMaker, Macromedia FreeHand, Photoshop, QuarkXPress, Illustrator and InDesign.

First Contact & Terms Cartoonists: Send query letter with finished cartoons. Illustrators: Send postcard sample or query letter with tearsheets and photocopies. Designers: Send query letter with résumé, photocopies or tearsheets. Accepts submissions on disk, Mac-compatible with Macromedia FreeHand, Illustrator, Photoshop, PageMaker, QuarkXPress or InDesign. Samples are filed or returned by SASE. Responds only if interested. Write for appointment to show portfolio of thumbnails, roughs, b&w tearsheets and slides. Buys one-time rights. Pays 15 days after publication. Pays cartoonists $35 for b&w. Pays illustrators $100-200 for b&w inside; $25-50 for spots. Pays for design by project. Accepts previously published artwork. Originals returned at job's completion.

EMERGENCY MEDICINE MAGAZINE

7 Century Dr., Suite 302, Parsippany NJ 07054-4603. (973)206-3434. Web site: www.emedmag.com. **Art Director:** Karen Blackwood. Estab. 1969. Emphasizes emergency medicine for emergency physicians, emergency room personnel, medical students. Monthly. Circ. 80,000. Returns original artwork after publication. Art guidelines not available.

Illustration Works with 10 illustrators/year. Buys 1-2 illustrations/issue. Has featured illustrations by Scott Bodell, Craig Zuckerman and Steve Oh. Features realistic, medical and spot illustration. Assigns 70% of illustrations to well-known or "name" illustrators; 30% to experienced, but not well-known illustrators. Works on assignment only.

First Contact & Terms Send postcard sample or query letter with brochure, photocopies, photographs, tearsheets to be kept on file. Samples not filed are not returned. Accepts disk submissions. To show a portfolio, mail appropriate materials. Responds only if interested. Buys first rights. Pays $1,200-1,700 for color cover; $200-500 for b&w inside; $500-800 for color inside; $250-600 for spots.

⊠ ⊡ EVENT

Douglas College, New Westminster BC V3L 5B2 Canada. (604)527-5293. Fax: (604)527-5095. E-mail: event@douglas.bc.ca. Web site: event.douglas.bc.ca. **Editor:** Rick Maddocks. Managing Editor: Ian Cockfield. Estab. 1971. For " those interested in literature and writing"; b&w with 4-color cover. Published 3 times/year. Circ. 1,150. Art guidelines available on Web site. CD-Rom of artwork returned after publication. Sample back issue for $9. Current issue for $12.

Illustrations Buys approximately 3 photographs/year. Has featured illustrations by Sharalee Regehr, Michael Downs and Jesus Romeo Galdamez. Assigns 50% of illustrations to new and emerging illustrators. Uses freelancers mainly for covers. "Interested in drawings and prints, b&w line drawings, photographs and lithographs for cover, and thematic or stylistic series of 3 works. SASE (Canadian postage or IRCs).

First Contact & Terms Reponse time varies; generally 4 months. Buys first North American serial rights. Pays on publication, $150 for color cover, 2 free copies plus 10 extra covers.

F+W MEDIA, INC.

4700 E. Galbraith Rd., Cincinnati OH 45236. Web site: www.fwpublications.com. Publishes special interest magazines and books in a broad variety of consumer enthusiast categories. Also operates book clubs, conferences, trade shows, Web sites and education programs—all focused on the same consumer hobbies and enthusiast subject areas where the magazines and book publishing programs specialize.

- Magazines published by F+W include *The Artist's Magazine*, *Horticulture*, *HOW*, *PRINT*, *Watercolor Artist* and *Writer's Digest*. See separate listings in this section as well as F+W's listing in the Book Publishers section for more information and specific guidelines.

FAMILY TIMES PUBLICATIONS

P.O. Box 16422, St. Louis Park MN 55416. (952)922-6186. Fax: (952)922-3637. E-mail: aobrien@familytimesinc.com. Web site: www.familytimesinc.com. **Editor/Art Director:** Annie O-Brien. Estab. 1991. Bimonthly tabloid. Circ. 60,000. Sample copies available with SASE. Art guidelines available—e-mail for guidelines.

- Publishes *Family*, *Grandparent* and *Baby and Best Times*.

Illustration Approached by 6 illustrators/year. Buys 33 illustrations/year. Has featured illustrations by primarily local illustrators. Preferred subjects: children, families, teen. Preferred all media. Assigns 2% of illustrations to new and emerging illustrators. Freelancers should be familiar with Illustrator, Photoshop. E-mail submissions accepted with link to Web site, accepted with image file at 72 dpi. Mac-compatible. Prefers JPEG. Samples are filed. Responds only if interested. Portfolio not required. Company will contact artist for portfolio review if interested. Pays illustrators $300 for color cover, $100 for b&w inside, $225 for color inside. Pays on publication. Buys one-time rights, electronic rights. Finds freelancers through artists' submissions, sourcebooks, online.

First Contact & Terms Illustrators: Send query via email with samples or link to samples.

Tips "Looking for fresh, family friendly styles and creative sense of interpretation of editorial."

FANTAGRAPHICS BOOKS, INC.

7563 Lake City Way NE, Seattle WA 98115. (206)524-1967. Fax: (206)524-2104. E-mail: fbicomix @fantagraphics.com. Web site: www.fantagraphics.com. **Contact:** Submissions Editor. Estab. 1976. Publishes comic books and graphic novels—all genres except superheroes. Recent titles: *Love and Rockets*; *Hate*; *Eightball*; *Black Hole*; *Blab*; *Penny Century*. Circ. 8,000-30,000. Sample copy: $3; free catalog. Art submission guidelines available on Web site.

- See additional listing in the Book Publishers section.

Cartoons Approached by 500 cartoonists/year. "Fantagraphics is looking for artists who can create an entire product or who can work as part of an established team." Most titles are b&w.

First Contact & Terms Send query letter with photocopies that display storytelling capabilities, or submit a complete package. All artwork is creator-owned. Buys one-time rights. Payment terms vary.

Tips "We prefer not to see illustration work unless there is some accompanying comics work. We also do not want to see unillustrated scripts. Be sure to include basic information like name, address, phone number, etc. Also include SASE. In comics, I see a trend toward more personal styles. In illustration in general, I see more and more illustrators who got started in comics, appearing in national magazines."

FEDERAL COMPUTER WEEK

3141 Fairview Park Dr., Suite 777, Falls Church VA 22042. (703)876-5131. Fax: (703)876-5126. E-mail: jeffrey_langkau@fcw.com. Web site: www.fcw.com. **Creative Director:** Jeff Langkau. Estab. 1987. Trade publication for federal, state and local government information technology professionals. Circ. 120,000.

Illustration Approached by 50-75 illustrators/year. Buys 5-6 illustrations/month. Features charts & graphs, computer illustrations, informational graphics, spot illustrations of business subjects. Assigns 5% of illustrations to well-known or "name" illustrators; 85% to experienced but not well-known illustrators; 10% to new and emerging illustrators.

First Contact & Terms Send postcard or other nonreturnable samples. Accepts Mac-compatible disk submissions. Samples are filed. Will contact artist for portfolio review if interested. Rights purchased vary according to project. Pays $800-1,200 for color cover; $600-800 for color inside; $200 for spots. Finds illustrators through samples and sourcebooks.

Tips "We look for people who understand 'concept' covers and inside art, and very often have them talk directly to writers and editors."

FIRST FOR WOMEN

270 Sylvan Ave., Englewood Cliffs NJ 07632. (201)569-6699. Fax: (201)569-6264. E-mail: dearpaige@firstforwomen.com. Web site: www.firstforwomen.com. **Creative Director:** Francois Baron. Estab. 1988. Mass market consumer magazine for younger women, published every 3 weeks. Circ. 1.4 million. Sample copies and art guidelines available upon request.

Cartoons Buys 10 cartoons/issue. Prefers humorous cartoons; single-panel b&w washes and line drawings. Prefers themes related to women's issues.

Illustration Approached by 100 illustrators/year. Buys 1 illustration/issue. Works on assignment only. Preferred themes are humorous, sophisticated women's issues. Considers all media.

First Contact & Terms Cartoonists: Send query letter with photocopies. Illustrators: Send query letter with any sample or promo that can be kept on file. Samples are filed and will be returned by SASE only if requested. Responds only if interested. Will contact artist for portfolio review if interested. Buys one-time rights. **Pays on acceptance.** Pays cartoonists $150 for b&w. Pays illustrators $200 for b&w; $300 for color. Originals returned at job's completion. Finds artists through promo mailers and sourcebooks.

Tips Uses humorous or conceptual illustrations for articles where photography won't work. "Use the mail—no phone calls, please."

GEORGIA MAGAZINE

P.O. Box 1707, Tucker GA 30085-1707. (770)270-6950. Fax: (770)270-6995. E-mail: ann.orowski@georgiaemc.com. Web site: www.georgiamagazine.org. **Editor:** Ann Orowski. Estab. 1945. Monthly consumer magazine promoting electric co-ops (largest read publication by Georgians for Georgians). Circ. 480,000 members.

Cartoons Approached by 10 cartoonists/year. Buys 2 cartoons/year. Prefers electric industry theme. Prefers single-panel, humorous, b&w washes and line drawings.

Illustration Approached by 10 illustrators/year. Prefers electric industry theme. Considers all media. 50% of freelance illustration demands knowledge of Illustrator and QuarkXPress.

Design Uses freelancers for design and production. Prefers local designers with magazine experience. 80% of design demands knowledge of Photoshop, Illustrator, QuarkXPress and InDesign.

First Contact & Terms Cartoonists: Send query letter with photocopies. Samples are filed and

not returned. Illustrators: Send postcard sample or query letter with photocopies. Designers: Send query letter with printed samples and photocopies. Accepts disk submissions compatible with QuarkXPress 7.5. Samples are filed or returned by SASE. Responds in 2 months if interested. Rights purchased vary according to project. **Pays on acceptance.** Pays cartoonists $50 for b&w, $50-100 for color. Pays illustrators $50-100 for b&w, $50-200 for color. Finds illustrators through word of mouth and submissions.

GIRLFRIENDS MAGAZINE

PMB 30, 3181 Mission St., San Francisco CA 94110-4515. E-mail: staff@girlfriendsmag.com. Web site: www.girlfriendsmag.com. **Contact:** Art Director. Estab. 1994. Monthly lesbian magazine. Circ. 30,000. Sample copies available for $4.95. Art guidelines available for #10 SASE with first-class postage.

Illustration Approached by 50 illustrators/year. Buys 3-4 illustrations/issue. Features caricatures of celebrities and realistic, computer and spot illustration. Considers all media and styles. Assigns 40% of illustrations to new and emerging illustrators. 10% of freelance illustration demands knowledge of Illustrator, QuarkXPress.

First Contact & Terms Send query letter with printed samples, tearsheets, résumé, SASE and color copies. Accepts disk submissions compatible with QuarkXPress (JPEG files). Samples are filed or returned by SASE on request. Responds in 6-8 weeks. To show portfolio, artist should follow up with call and/or letter after initial query. Portfolio should include color, final art, tearsheets, transparencies. Rights purchased vary according to project. Pays on publication: $50-200 for color inside; $150-300 for 2-page spreads; $50-75 for spots. Finds illustrators through word of mouth and submissions.

Tips "Read the magazine first. We like colorful work; ability to turn around in two weeks."

GLASS FACTORY DIRECTORY

Box 2267, Hempstead NY 11551. (516)481-2188. E-mail: manager@glassfactorydir.com. Web site: www.glassfactorydir.com. **Manager:** Liz Scott. Annual listing of glass manufacturers in US, Canada and Mexico.

Cartoons Receives an average of 1 submission/month. Buys 5-10 cartoons/issue. Cartoons should pertain to glass manufacturing (flat glass, fiberglass, bottles and containers; no mirrors). Prefers single and multiple panel b&w line drawings with gagline. Prefers roughs or finished cartoons. "We do not assign illustrations. We buy from submissions only."

First Contact & Terms Send SASE. Usually gets a review and any offer back to you within a month. Buys all rights. **Pays on acceptance**; $30.

Tips "We don't carry cartoons about broken glass, future, past or present. We can't use stained glass cartoons—there is a stained glass magazine. We will not use any cartoons with any religious theme. Since our directory is sold world-wide, caption references should consider that we do have a international readership."

THE GOLFER

516 Fifth Ave., Suite 304, New York NY 10036-7510. (212)867-7070. Fax: (212)867-8550. E-mail: webmaster@thegolfermag.com. Web site: www.thegolfermag.com. **Contact:** Art Director. Estab. 1994. Bimonthly "sophisticated golf magazine with an emphasis on travel and lifestyle." Circ. 254,865.

Illustration Approached by 200 illustrators/year. Buys 6 illustrations/issue. Considers all media.

First Contact & Terms Send postcard sample. "We will accept work compatible with QuarkX-Press 3.3. Send EPS files." Samples are not filed and are not returned. Responds only if interested. Rights purchased vary according to project. Pays on publication. Payment to be negotiated.
Tips "I like sophisticated, edgy, imaginative work. We're looking for people to interpret sport, not draw a picture of someone hitting a ball."

GOLFWEEK

1500 Park Center Dr., Orlando FL 32835. Fax: (407)563-7077. E-mail: smiller@golfweek.com. Web site: www.golfweek.com. **Art Director**: Scott Miller. Weekly golf magazine for the accomplished golfer. Covers the latest golfing news and all levels of competitive golf from amateur and collegiate to juniors and professionals. Includes articles on golf course architecture as well as the latest equipment and apparel. Circ. 119,000.
Illustration Approached by 200 illustrators/year. Buys 20 illustrations/year. Has featured illustrations by Roger Schillerstrom. Features caricatures of golfers and humorous illustrations of golf courses and golfers. Assigns 20% to new and emerging illustrators. 5% of freelance illustration demands knowledge of Photoshop.
First Contact & Terms Send postcard sample. After introductory mailing, send follow-up postcard sample every 3-6 months. Accepts e-mail submissions with link to Web site. Prefers JPEG files. Samples are filed. Responds only if interested. Pays illustrators $400-1,000 for color cover; $400-500 for color inside. Pays on publication. Buys one-time rights. Finds freelancers through submissions and sourcebooks.
Tips "Look at our magazine. Know golf."

N THE GREEN MAGAZINE

226 W. 37th St., Floor 9, New York NY 10018-6605. (212)629-4920. Fax: (212)629-4932. E-mail: info@thegreenmagazine.com. Web site: www.thegreenmagazine.com. **Art Director**: Cesar Cruz. Estab. 2002. Bimonthly consumer magazine for the affluent minority golf enthusiast featuring articles on personalities, travel and leisure, business and etiquette. Circ.: 150,000.
Illustration Few used, but will consider solicitations.
First Contact & Terms Illustrators: Send postcard sample or photocopies. After sending introductory mailing, send follow-up postcard sample every 2-3 months. Company will contact artist for portfolio review if interested. Pays illustrators $100-350 for color inside. Buys one-time rights. Finds freelancers through artists' submissions.

GREENPRINTS

P.O. Box 1355, Fairview NC 28730. (828)628-1902. E-mail: patstone@atlantic.net. Web site: www.greenprints.com. **Editor:** Pat Stone. Estab. 1990. Quarterly magazine "that covers the personal, not the how-to, side of gardening." Circ. 13,000. Sample copy for $5; art guidelines available on Web site or free for #10 SASE with first-class postage.
Illustration Approached by 46 illustrators/year. Works with 15 illustrators/issue. Has featured illustrations by Claudia McGehee, P. Savage, Marilynne Roach and Jean Jenkins. Assigns 30% of illustrations to emerging and 5% to new illustrators. Prefers plants and people. Considers b&w only.
First Contact & Terms Illustrators: Send query letter with photocopies, SASE and tearsheets. Samples accepted by US mail only. Accepts e-mail queries without attachments. Samples are filed or returned by SASE. Responds in 2 months. Buys first North American serial rights. Pays

on publication; $250 maximum for color cover; $100-125 for b&w inside; $25 for spots. Finds illustrators through word of mouth, artist's submissions.

Tips "Read our magazine and study the style of art we use. Can you do both plants and people? Can you interpret as well as illustrate a story?"

◪ GUIDEPOSTS PUBLICATIONS

16 E. 34th St., New York NY 10016. Fax: (212)684-1311. E-mail: fmessina@guideposts.org. Web site: www.guidepostsmag.com. **Creative Director:** Francesca Messina. Mangaging Art Director: Donald Partyka. Estab. 1995. Bimonthly magazine featuring true stories of angel encounters and angelic behavior. Circ. 1,000,000. Art guidelines posted on Web site.

- Publishes 3 titles out of New York office: *Guideposts*, a monthly magazine with a circulation of 2.6 million; *Angels On Earth*, a bi-monthly magazine with a circulation of 500,000; a new start-up lifestyle and spirituality magazine, *Positive Thinking*.

Illustration Approached by 500 illustrators/year. Buys 5-10 illustrations/issue. Has featured illustrations by Kinuko Craft, Gary Kelley, Rafal Olbinski. Features computer, whimsical, reportorial, humorous, conceptual, realistic and spot illustration. Assigns 40% of illustrations to well-known or "name" illustrators; 40% to experienced but not well-known illustrators; 20% to new and emerging illustrators. Prefers conceptual/realistic, "soft" styles. Considers all media.

First Contact & Terms Illustrators: Please send nonreturnable promotional materials, slides or tearsheets. Accepts disk submissions compatible with Photoshop, Illustrator. Samples are filed. Send *only* nonreturnable samples. Art director will contact artist for portfolio review of color slides and transparencies if interested. Rights purchased vary. **Pays on acceptance**; $500-2,500 for color cover; $500-2,000 2-page spreads; $300-500 for spots. For more information, see Web site. Finds artists through reps , *American Showcase*, *Society of Illustrators Annual*, submissions and artist's Web sites.

Tips "Please study our magazine and be familiar with the content presented."

GUITAR PLAYER

1111 Bayhill Dr., Suite 125, San Bruno CA 94066. (650)238-0300. Fax: (650)238-0261. E-mail: phaggard@musicplayer.com. Web site: www.guitarplayer.com. **Art Director:** Paul Haggard. Estab. 1975. Monthly 4-color magazine focusing on technique, artist interviews, etc. Circ. 150,000.

Illustration Approached by 15-20 illustrators/week. Buys 5 illustrations/year. Works on assignment only. Features caricatures of celebrities; realistic, computer and spot illustration. Assigns 33% of illustrations to new and emerging illustrators. Prefers conceptual, "outside, not safe" themes and styles. Considers pen & ink, watercolor, collage, airbrush, digital, acrylic, mixed media and pastel.

First Contact & Terms Send query letter with brochure, tearsheets, photographs, photocopies, photostats, slides and transparencies. Accepts disk submissions compatible with Mac. Samples are filed. Responds only if interested. Will contact artist for portfolio review if interested. Buys first rights. Pays on publication: $200-400 for color inside; $400-600 for 2-page spreads; $200-300 for spots.

HARPER'S MAGAZINE

666 Broadway, 11th Floor, New York NY 10012. (212)420-5720. Fax: (212)228-5889. E-mail: stacey@harpers.org. Web site: www.harpers.org. **Art Director:** Stacey D. Clarkson. Estab. 1850.

Monthly 4-color literary magazine covering fiction, criticism, essays, social commentary and humor.

Illustration Approached by 250 illustrators/year. Buys 5-10 illustrations/issue. Has featured illustrations by Ray Bartkus, Steve Brodner, Tavis Coburn, Hadley Hooper, Ralph Steadman, Raymond Verdaguer, Andrew Zbihlyj, Danijel Zezelj. Features intelligent concept-oriented illustration. Preferred subjects: literary, artistic, social, fiction-related. Prefers intelligent, original thought and imagery in any media. Assigns 25% of illustrations to new and emerging illustrators. 10% of freelance illustration demands knowledge of Photoshop.

First Contact & Terms Send nonreturnable samples. Accepts Mac-compatible disk submissions. Samples are filed and are not returned. Will contact artist for portfolio review if interested. Portfolios may be dropped off for review the last Wednesday of any month. Buys first North American serial rights. Pays on publication: $250-400 for b&w inside; $450-1,000 for color inside; $450 for spots. Finds illustrators through samples, annuals, reps, other publications.

Tips "Intelligence, originality and beauty in execution are what we seek. A wide range of styles is appropriate; what counts most is content."

ⓝ HEARTLAND BOATING MAGAZINE

319 N. Fourth St., Suite 650, St. Louis MO 63102. (314)241-4310. Fax: (314)241-4207. E-mail: info@heartlandboating.com. Web site: www.heartlandboating.com. **Art Director:** John R. "Jack" Cassady. Estab. 1989. Specialty magazine published 8 times/year devoted to power (cruisers, houseboats) and sail boating enthusiasts throughout middle America. The content is both informative and humorous and reflects "the challenge, joy and excitement of boating on America's inland waterways." Circ. 10,000. Sample copies available for $5. Art guidelines available for SASE with first-class postage or on Web site.

Cartoons On assignment only.

Illustration On assignment only. Prefers boating-related themes. Considers pen & ink.

First Contact & Terms Send postcard sample or query letter with SASE, photocopies and tearsheets. Samples are filed or returned by SASE. Responds in about 2 months. Portfolio review not required. First North American Reproduction and Web rights normally purchased. Pays on publication. Rates negotiated. Originals are returned at job's completion.

HEAVY METAL

100 N. Village Rd., Suite 12, Rookville Center NY 11570. Web site: www.metaltv.com. **Contact:** Submissions. Estab. 1977. Consumer magazine. "*Heavy Metal* is the oldest illustrated fantasy magazine in U.S. history."

• See additional listing in the Book Publishers section.

HIEROGLYPHICS MAGAZINE

24272 Sunnybrook Circle, Lake Forest CA 92630-3853. (949)215-4319. Fax: (949)215-4792. E-mail: hieroglyphic@cox.net. **President:** Deborah Boldt. Estab. 2007. Monthly and online literary magazine. "*Hieroglyphics* is a new and developing children's educational, science, and history magazine. It's mission is to present Africa's ancient history from the pre-written history period forward, traveling back and forth through time and history. *Hieroglyphics* is dedicated to children and empowering them with a positive self image. Our readers can explore achievements in science and history through wholesome adventure stories that will develop reading skills and increase critical thinking skills." Sample copies and art submission guidelines available for SASE.

Cartoons Buys 20-30 cartoons/year. Needs 4-6 cartoons/issue. Interested in "upbeat, positive vocabulary for children ages 2-12; cartoons involving concept of black children, family life, science and historical Egypt/Africa, modern science, and morality." Prefers humorous cartoons; single or multiple panel color washes.

Illustration Buys more than 200 illustrations/year. Features realistic, scientific and natural history illustrations, "from child's point of view; more graphic than cartoon; upbeat." Subjects include children, families, pets, games and puzzles, "black characters (especially children) within a background environment in ancient Africa/Egypt, science, sailing, carpentery, hunting, fishing, farming, mining and the arts; also in modern times." Prefers watercolor, pen & ink, colored pencil, mixed media. 15% of assignments are given to new and emerging illustrators.

First Contact & Terms Cartoonists: Send samples, photocopies, roughs, SASE. Illustrators: Send query letter with photocopies, tearsheets, SASE. After introductory mailing, send follow-up postcard every 4 months. Accepts e-mail submissions with link to Web site or Windows-compatible image files (JPEG or TIFF). Samples are kept on file or are returned by SASE. Responds in 2 months. Will contact artist for portfolio review if interested. Portfolio should include original, finished art. Pays cartoonists $20-100 for color cartoons; $50-500 for comic strips. Pays illustrators $600-2,000 for color cover; $50-2,000 for color inside. **Pays on acceptance.** Buys all rights (work for hire basis). Finds freelancers through submissions, word of mouth magazines and Internet.

Tips "We look for professional-level drawing and the ability to interpret a juvenile story. Drawings of children are especially needed. We like attention to detail. Please research history for details and ideas."

HIGH COUNTRY NEWS

119 Grand Ave., P.O. Box 1090, Paonia CO 81428-1090. (970)527-4898. Fax: (970)527-4897. E-mail: cindy@hcn.org. Web site: www.hcn.org. **Art Director:** Cindy Wehling. Estab. 1970. Biweekly nonprofit newspaper. High Country News covers environmental, public lands and community issues in the 10 western states. Circ. 24,000. Art guidelines at www.hcn.org/about/guidelines.jep.

Cartoons Buys 1 editorial cartoon/issue. Only issues affecting Western environment. Prefers single panel, political, humorous on topics currently being covered in the paper. Color or b&w. Professional quality only.

Illustration Considers all media if reproducible.

First Contact & Terms Cartoonists: Send query letter with finished cartoons and photocopies. Illustrators: Send query letter with printed samples and photocopies. Accepts e-mail and disk submissions compatible with QuarkXPress and Photoshop. Samples are filed or returned by SASE. Responds only if interested. Rights purchsed vary according to project. Pays on publication. Pays cartoonists $50-125 depending on size used. Pays illustrators $100-200 for color cover; $35-100 for inside. Finds illustrators through magazines, newspapers and artist's submissions.

HIGHLIGHTS FOR CHILDREN

803 Church St., Honesdale PA 18431. (570)253-1080. Fax: (570)253-0179. E-mail: eds@highlights-corp.com. Web site: www.highlights.com. **Art Director:** Cynthia Faber Smith. Editor-in-Chief: Christine French Clark. Monthly 4-color magazine for children up to age 12. Circ. approx. 2 million. Art guidelines available for SASE with first-class postage.

Cartoons Receives 20 submissions/week. Buys 2-4 cartoons/issue. Interested in upbeat, positive

cartoons involving children, family life or animals; single or multiple panel. "One flaw in many submissions is that the concept or vocabulary is too adult, or that the experience necessary for its appreciation is beyond our readers. Frequently, a wordless self-explanatory cartoon is best."

Illustration Buys 30 illustrations/issue. Works on assignment only. Prefers "realistic and stylized work; upbeat, fun, more graphic than cartoon." Pen & ink, colored pencil, watercolor, marker, cut paper and mixed media are all acceptable. Discourages work in fluorescent colors.

First Contact & Terms Cartoonists: Send roughs or finished cartoons and SASE. Illustrators: Send query letter with photocopies, SASE and tearsheets. Samples are kept on file. Responds in 10 weeks. Buys all rights on a work-for-hire basis. **Pays on acceptance.** Pays cartoonists $20-40 for line drawings. Pays illustrators $1,400 for color front and back covers; $50-$700 for color inside. "We are always looking for good hidden pictures. We require a picture that is interesting in itself and has the objects well-hidden. Usually an artist submits pencil sketches. In no case do we pay for any preliminaries to the final hidden pictures. Hidden pictures should be submitted to Juanita Galuska."

Tips "We have a wide variety of needs, so I would prefer to see a representative sample of an illustrator's style."

HISPANIC MAGAZINE

6355 NW 36th St., Virginia Gardens FL 33166. (305)774-3550. Fax: (305)774-3578. E-mail: tailer. senior@page1media.com. Web site: www.hispanicmagazine.com. **Art Director:** Tailer Senior. Estab. 1987. Monthly 4-color consumer magazine for Hispanic Americans. Circ. 250,000.

Illustration Approached by 100 illustrators/year. Buys 5 illustrations/issue. Has featured illustrations by Will Terry, A.J. Garces and Sonia Aguirre. Features caricatures of politicians, humorous illustrations, realistic illustrations, charts & graphs, spot illustrations and computer illustration. Prefers business subjects, men and women. Prefers pastel and bright colors. Assigns 80% of illustrations to experienced, but not well-known illustrators; 20% to new and emerging illustrators.

First Contact & Terms Illustrators: Send nonreturnable postcard samples. Accepts Mac-compatible disk submissions. Send EPS or TIFF files. Samples are filed. Responds only if interested. Will contact artist for portfolio review if interested. Buys one-time rights. Pays on publication: $500-1,000 for color cover; $800 maximum for color inside; $300 maximum for b&w inside; $250 for spots.

Tips "Concept is very important—to take an idea or a story and to be able to find a fresh perspective. I like to be surprised by the artist."

▣ HORSE ILLUSTRATED

P.O. Box 8237, Lexington KY 40533. E-mail: horseillustrated@bowtieinc.com. Web site: www.h orseillustrated.com. **Editor:** Elizabeth Moyer. Estab. 1976. Monthly consumer magazine providing "information for responsible horse owners." Circ. 192,000. Art guidelines available on Web site.

Cartoons Approached by 200 cartoonists/year. Buys 1 or 2 cartoons/issue. Prefers satire on horse ownership ("without the trite clichés"); single-panel b&w line drawings with gagline.

Illustration Approached by 60 illustrators/year. Buys 1 illustration/issue. Prefers realistic, mature line art; pen & ink spot illustrations of horses. Assigns 10% of illustrations to new and emerging illustrators.

First Contact & Terms Cartoonists: Send query letter with brochure, roughs and finished car-

toons. Illustrators: Send query letter with SASE and photographs. Samples are not filed and are returned by SASE. Responds in 6 weeks. Portfolio review not required. Buys first rights or one-time rights. Pays on publication. Pays cartoonists $40 for b&w. Finds artists through submissions.

Tips "We only use spot illustrations for breed directory and classified sections. We do not use much, but if your artwork is within our guidelines, we usually do repeat business. *Horse Illustrated* needs illustrators who know equine anatomy, as well as human anatomy with insight into the horse world."

HORTICULTURE MAGAZINE

98 N. Washington St., Boston MA 02114. (617)742-5600. Fax: (617)367-6364. E-mail: joan.moyers@fwpubs.com. Web site: www.hortmag.com. **Contact:** Joan Moyers. Estab. 1904. Monthly magazine for all levels of gardeners (beginners, intermediate, highly skilled). "*Horticulture* strives to inspire and instruct avid gardeners of every level." Circ. 300,000. Art guidelines available.

Illustration Approached by 75 freelance illustrators/year. Buys 10 illustrations/issue. Works on assignment only. Features realistic illustration; informational graphics; spot illustration. Assigns 20% of illustrations to new and emerging illustrators. Prefers tight botanicals; garden scenes with a natural sense to the clustering of plants; people; hands and "how-to" illustrations. Considers all media.

First Contact & Terms Send query letter with brochure, résumé, SASE, tearsheets, slides. Samples are filed or returned by SASE. Art Director will contact artist for portfolio review if interested. Buys one-time rights. Pays 1 month after project completed. Payment depends on complexity of piece; $800-1,200 for 2-page spreads; $150-250 for spots. Finds artists through word of mouth, magazines, submissions/self-promotions, sourcebooks, agents/reps, art exhibits.

Tips "I always go through sourcebooks and request portfolio materials if a person's work seems appropriate and is impressive."

HOUSE BEAUTIFUL

300 W. 57th St., 24th Floor, New York NY 10019-3741. Web site: www.housebeautiful.com. **Contact:** Art Director. Estab. 1896. Monthly consumer magazine about interior decorating. Emphasis is on classic and contemporary trends in decorating, architecture and gardening. The magazine is aimed at both the professional and nonprofessional interior decorator. Circ. 1.3 million. Sample copies available.

Illustration Approached by 75-100 illustrators/year. Buys 2-3 illustrations/issue. Works on assignment only. Prefers contemporary, conceptual, interesting use of media and styles. Considers all media.

First Contact & Terms Send postcard-size sample. Samples are filed only if interested and are not returned. Will contact artist for portfolio review of final art, photographs, slides, tearsheets and good quality photocopies if interested. Buys one-time rights. Pays on publication: $600-700 for color inside; $600-700 for spots (99% of illustrations are done as spots).

Tips "We find most of our artists through submissions of either portfolios or postcards. Sometimes we will contact an artist whose work we have seen in another publication. Some of our artists are found through reps and annuals."

HOW MAGAZINE

F + W Media, Inc., 4700 E. Galbraith Rd., Cincinnati OH 45236. E-mail: editorial@howdesign.com. Web site: www.howdesign.com. Estab. 1985. Bimonthly trade journal covering creativity, business and technology for graphic designers. Circ. 40,000. Sample copy available for $8.50.

- Sponsors 2 annual conferences for graphic artists, as well as annual Promotion, International, Interactive and In-House Design competitions. See Web site for more information.

Illustration Approached by 100 illustrators/year. Buys 4-8 illustrations/issue. Works on assignment only. Considers all media, including photography and computer illustration.

First Contact & Terms Illustrators: Send nonreturnable samples. Accepts disk submissions. Responds only if interested. Buys first rights or reprint rights. Pays on publication: $350-1,000 for color inside. Original artwork returned at job's completion.

Tips "Send good samples that reflect the style and content of illustration commonly featured in the magazine. Be patient; art directors get a lot of samples."

HR MAGAZINE

1800 Duke St., Alexandria VA 22314. (703)535-6860. Fax: (703)548-9140. E-mail: janderson@shrm.org. Web site: www.shrm.org. **Art Director:** John Anderson Jr. Estab. 1948. Monthly trade journal dedicated to the field of human resource management. Circ. 200,000.

Illustration Approached by 70 illustrators/year. Buys 6-8 illustrations/issue. Prefers people, management and stylized art. Considers all media.

First Contact & Terms Illustrators: Send query letter with printed samples. Accepts disk submissions. Illustrations can be attached to e-mails. *HR Magazine* is Macintosh based. Samples are filed. Art director will contact artist for portfolio review if interested. Rights purchased vary according to project. Requires artist to send invoice. Pays within 30 days. Pays $700-2,500 for color cover; $200-1,800 for color inside. Finds illustrators through sourcebooks, magazines, word of mouth and artist's submissions.

IDEALS MAGAZINE

Published by Ideals Publications, A Guideposts Company, 2636 Elm Hill Pike., Suite 120, Nashville TN 37214. (615)333-0478. Fax: (888)815-2759. Web site: www.idealspublications.com. **Editor:** Melinda Rathjen. Estab. 1944. 4-color quarterly general interest magazine featuring poetry and text appropriate for the family. Circ. 25,000. Sample copy $4. Art guidelines free with #10 SASE with first-class postage or view on Web site.

Illustration Approached by 100 freelancers/year. Buys 4 or less illustrations/issue. Uses freelancers mainly for flowers, plant life, wildlife, realistic people illustrations and botanical (flower) spot art. Prefers seasonal themes. Prefers watercolors. Assigns 90% of illustrations to experienced illustrators; 10% to new and emerging illustrators. "Are not interested in computer generated art. No electronic submissions."

First Contact & Terms Illustrators: Send nonreturnable samples or tearsheets. Samples are filed. Responds only if interested. Do not send originals. Buys artwork for hire. Pays on publication; payment negotiable.

Tips "For submissions, target our needs as far as style is concerned, but show representative subject matter. Artists are strongly advised to be familiar with our magazine before submitting samples of work."

THE INDEPENDENT WEEKLY

P.O. Box 2690, Durham NC 27715. (919)286-1972. Fax: (919)286-4274. E-mail: mbshain@indyw eek.com. Web site: www.indyweek.com. **Art Director:** Maria Bilinski Shain. Estab. 1982. Weekly b&w with 4-color cover tabloid; general interest alternative. Circ. 50,000. Original artwork is returned if requested. Sample copies for SASE with first-class postage.

Illustration Buys 10-15 illustrations/year. Prefers local (North Carolina) illustrators. Has featured illustrations by Tyler Bergholz, Keith Norvel, V. Cullum Rogers, Nathan Golub. Works on assignment only. Considers pen & ink; b&w, computer generated art and color.

First Contact & Terms Samples are filed or are returned by SASE if requested. Responds only if interested. E-mail for appointment to show portfolio or mail tearsheets. Pays on publication; $150 for cover illustrations; $25-$50 for inside illustrations.

Tips "Have a political and alternative 'point of view.' Understand the peculiarities of newsprint. Be easy to work with. No prima donnas."

JUDICATURE

2700 University Ave., Des Moines IA 50311. E-mail: drichert@ajs.org. Web site: www.ajs.org. **Contact:** David Richert. Estab. 1917. Journal of the American Judicature Society. 4-color bimonthly publication. Circ. 6,000. Accepts previously published material and computer illustration. Original artwork returned after publication. Sample copy for SASE with $1.65 postage; art guidelines not available.

Cartoons Approached by 10 cartoonists/year. Buys 1-2 cartoons/issue. Interested in "sophisticated humor revealing a familiarity with legal issues, the courts and the administration of justice."

Illustration Approached by 20 illustrators/year. Buys 1-2 illustrations/issue. Has featured illustrations by Estelle Carol, Mary Chaney, Jerry Warshaw and Richard Laurent. Features humorous and realistic illustration; charts & graphs; computer and spot illustration. Works on assignment only. Interested in styles from "realism to light humor." Prefers subjects related to court organization, operations and personnel. Freelance work demands knowledge of Quark and FreeHand.

Design Needs freelancers for design. 100% of freelance work demands knowledge of Quark and FreeHand.

First Contact & Terms Cartoonists: Send query letter or e-mail with samples of style and SASE. Responds in 2 weeks. Illustrators: Send query letter, SASE, photocopies, tearsheets or brochure showing art style (can be sent electronically). Publication will contact artist for portfolio review if interested. Portfolio should include roughs and printed samples. Wants to see "black & white and color, along with the title and synopsis of editorial material the illustration accompanied." Buys one-time rights. Negotiates payment. Pays cartoonists $35 for unsolicited b&w cartoons. Pays illustrators $250-375 for 2-, 3- or 4-color cover; $250 for b&w full page, $175 for b&w half page inside; $75-100 for spots. Pays designers by the project.

Tips "Show a variety of samples, including printed pieces and roughs."

KENTUCKY LIVING

P.O. Box 32170, Louisville KY 40232. (502)451-2430. Fax: (502)459-1611. E-mail: e-mail@kentu ckyliving.com. Web site: www.kentuckyliving.com. **Editor:** Paul Wesslund. Monthly 4-color magazine emphasizing Kentucky-related and general feature material for Kentuckians living outside metropolitan areas. Circ. 500,000. Sample copies available.

Cartoons Approached by 10-12 cartoonists/year.

Illustration Buys occasional illustrations. Works on assignment only. Prefers b&w line art.

First Contact & Terms Illustrators: Send query letter with résumé and samples. Samples not filed are returned only if requested. Buys one-time rights. **Pays on acceptance.** Pays cartoonists $30 for b&w. Pays illustrators $50 for b&w inside. Accepts previously published material. Original artwork returned after publication if requested.

KEY CLUB MAGAZINE

(formerly *Keynoter*), Kiwanis International, 3636 Woodview Trace, Indianapolis IN 46268. (317)875-8755. Fax: (317)879-0204. E-mail: magazine@kiwanis.org. Web site: www.keyclub.o rg. **Art Director:**Maria Malandrakis. Quarterly 4-color magazine with "contemporary design for mature teenage audience." Circ. 170,000. Free sample copy for SASE with 3 first-class postage stamps.

- • Kiwanis International also publishes *Circle K* and *Kiwanis* magazines; see separate listings in this section.

Illustration Buys 3 editorial illustrations/issue. Works on assignment only.

First Contact & Terms Include SASE. Responds in 2 weeks. "Freelancers should call our Production and Art Department for interview." Previously published, photocopied and simultaneous submissions OK. Original artwork is returned after publication by request. Buys first rights. **Pays on receipt of invoice**: $100 for b&w cover; $250 for color cover; $50 for b&w inside; $150 for color inside.

Ⓝ KID ZONE

2923 Troost Ave., Kansas City MO 64109. (816)931-1900. Fax: (816)412-8306. E-mail: vlfolsom@ wordaction.com. **Editor:** Virginia L. Folsom. Estab. 1974. Weekly 4-color story paper; "for 8-10 year olds of the Church of the Nazarene and other holiness denominations. Material is based on everyday situations with Christian principles applied." Circ. 40,000. Originals are not returned at job's completion. Sample copies and guidelines for SASE with first-class postage.

Cartoons Approached by 15 cartoonists/year. Buys 52 cartoons/year. "Cartoons need to be humor for children—not about them." Spot cartoons only. Prefers artwork with children and animals; single panel.

First Contact & Terms Cartoonists: Send finished cartoons. Samples not filed are returned by SASE. Responds in 2 months. Buys all rights. Pays $15 for b&w.

Tips No "fantasy or science fiction situations or children in situations not normally associated with Christian attitudes or actions."

KIPLINGER'S PERSONAL FINANCE

1729 H St. NW, Washington DC 20006. (202)887-6416. Fax: (202)331-1206. E-mail: ccurrie@kipl inger.com. Web site: www.kiplinger.com. **Art Director:** Cynthia L. Currie. Estab. 1947. Monthly 4-color magazine covering personal finance issues such as investing, saving, housing, cars, health, retirement, taxes and insurance. Circ. 800,000.

Illustration Approached by 350 illustrators/year. Buys 4-6 illustrations/issue. Works on assignment only. Has featured illustrations by Lloyd Miller, Nick Dewar, Alison Sieffer and James O'Brien. Features computer, conceptual editorial and spot illustration. Assigns 5% of illustrations to new and emerging illustrators. Interested in editorial illustration in new styles, including computer illustration.

First Contact & Terms Illustration: Send postcard samples. Accepts Mac-compatible CD submis-

sions. Samples are filed or returned by SASE if requested by artist. Will contact artist for portfolio review if interested. Buys one-time rights. Pays on publication: $400-1,200 for color inside; $250-500 for spots. Finds illustrators through reps, online, magazines, *Workbook* and award books. Originals are returned at job's completion.

KIWANIS MAGAZINE
Kiwanis International, 3636 Woodview Trace, Indianapolis IN 46268. (317)875-8755. Fax: (317)879-0204. E-mail: magazine@kiwanis.org. Web site: www.kiwanis.org. **Art Director:** Maria Malandrakis. Estab. 1918. Bimonthly 4-color magazine emphasizing civic and social betterment, business, education and domestic affairs for business and professional persons. Circ. 240,000. Free sample copy for SASE with 4 first-class postage stamps.
 • Kiwanis International also publishes *Circle K* and *Key Club* magazines; see separate listings in this section.

Illustration Buys 1-2 illustrations/issue. Assigns themes that correspond to themes of articles. Works on assignment only. Keeps material on file after in-person contact with artist.

First Contact & Terms Illustration: Include SASE. Responds in 2 weeks. To show a portfolio, mail appropriate materials (out of town/state) or call or write for appointment. Portfolio should include roughs, printed samples, final reproduction/product, color and b&w tearsheets, photostats and photographs. Original artwork returned after publication by request. Buys first rights. **Pays on acceptance**; $600-1,000 for cover; $400-800 for inside; $50-75 for spots. Finds artists through talent sourcebooks, references/word of mouth and portfolio reviews.

Tips "We deal direct—no reps. Have plenty of samples, particularly those that can be left with us. Too many student or unassigned illustrations in many portfolios."

L.A. PARENT MAGAZINE
443 E. Irving Dr., Suite A, Burbank CA 91504-2447. (818)846-0400. Fax: (818)841-4380. E-mail: carolyn.graham@parenthood.com. Web site: www.laparent.com. **Editor:** Carolyn Graham. Estab. 1979. Magazine. A monthly regional magazine for parents. 4-color throughout; "bold graphics and lots of photos of kids and families." Circ. 120,000. Accepts previously published artwork. Originals are returned at job's completion.

Illustration Buys 2 freelance illustrations/issue. Assigns 50% of illustrations to experienced but not well-known illustrators; 50% to new and emerging illustrators. Works on assignment only.

First Contact & Terms Send postcard sample. Accepts disk submissions compatible with Illustrator 5.0 and Photoshop 3.0. Samples are filed or returned by SASE. Responds in 2 months. To show a portfolio, mail thumbnails, tearsheets and photostats. Buys one-time rights or reprint rights. **Pays on publication**: $300 color cover; $75 for b&w inside; $50 for spots.

Tips "Show an understanding of our publication. Since we deal with parent/child relationships, we tend to use fairly straightforward work. Also looking for images and photographs that capture an L.A. feel. Read our magazine and find out what we're all about."

LADIES' HOME JOURNAL
125 Park Ave., New York NY 10017. (212)455-1293. Fax: (212)455-1313. E-mail: lhj@meredith.com. Web site: www.lhj.com. **Art Director**: Donni Alley. Estab. 1883. Monthly consumer magazine celebrating the rich values of modern family life. Topics include beauty, fashion, nutrition, health, medicine, home decorating, parenting, self-help, personalities and current events. Circ. 412,087.

Illustration Features caricatures of celebrities, humorous illustration and spot illustrations of families, women and pets.

First Contact & Terms Send postcard sample with URL. After introductory mailing, send follow-up postcard sample every 3-6 months. Samples are filed. Responds only if interested. Pays $200-500 for color inside. Buys one-time rights. Finds freelancers through submissions and sourcebooks.

LADYBUG®

Cricket Magazine Group, Carus Publishing, 70 E. Lake St., Suite 300, Chicago IL 60601. Web site: www.cricketmag.com. **Contact:** Art Submissions Coordinator. Managing Art Director: Suzanne Beck. Estab. 1990. Monthly 4-color magazine emphasizing literature and activities for children ages 2-6. Circ. 140,000. Art guidelines available on Web site.

- See also listings in this section for other magazines published by the Cricket Magazine Group: *BABYBUG*, *SPIDER*, *CRICKET* and *CICADA*.

Illustration Buys 200 illustrations/year. Prefers realistic styles (animal, wildlife or human figure); occasionally accepts caricatures. Works on assignment only.

First Contact & Terms Send photocopies, photographs or tearsheets to be kept on file. Samples are returned by SASE if requested. Responds in 3 months. Buys all rights. **Pays 45 days after acceptance**: $750 for color cover; $250 for color full page; $100 for color spots; $50 for b&w spots.

Tips "Before attempting to illustrate for *LADYBUG*, be sure to familiarize yourself with this age group, and read several issues of the magazine. Please do not query first."

THE LOOKOUT

8805 Governor's Hill Drive Suite 400, Cincinnati OH 45249. (513)728-6866. Fax: (513)931-0950. E-mail: lookout@standardpub.com. Web site: www.lookoutmag.com. **Administrative Assistant:** Sheryl Overstreet. Weekly 4-color magazine for conservative Christian adults and young adults. Circ. 85,000. Sample copy available for $1.

Illustration Prefers both humorous and serious, stylish illustrations featuring Christian families. "We no longer publish cartoons."

First Contact & Terms Illustrators: Send postcard or other nonreturnable samples.

Tips Do not send e-mail submissions.

NA'AMAT WOMAN

350 Fifth Ave., Suite 4700, New York NY 10118. (212)563-5222. Fax: (212)563-5710. E-mail: judith@naamat.org. Web site: www.naamat.org. **Editor:** Judith Sokoloff. Estab. 1926. Quarterly magazine for Jewish women, covering a wide variety of topics that are of interest to the Jewish community. Affiliated with NA'AMAT USA (a nonprofit organization). Sample copies available for $1 each.

Illustration Approached by 30 illustrators/year. Buys 2-3 illustrations/issue. We publish in 4-color through out the issue. Has featured illustrations by Julie Delton, Ilene Winn-Lederer, Avi Katz and Yevgenia Nayberg.

First Contact & Terms Illustrators: Send query letter with tearsheets. Samples are filed or are returned by SASE if requested by artist. Responds only if interested. Will contact artist for portfolio review if interested. Portfolio should include tearsheets and final art. Rights purchased vary according to project. Pays on publication. Pays illustrators $150-250 for cover; $75-100 for

inside. Finds artists through sourcebooks, publications, word of mouth, submissions. Originals are returned at job's completion.

Tips "Give us a try! We're small, but nice."

THE NATION

33 Irving Place, 8th Floor, New York NY 10003. (212)209-5400. Fax: (212)982-9000. E-mail: studio@stevenbrowerdesign.com. Web site: www.thenation.com. **Art Director:** Steven Brower. Estab. 1865. Weekly journal of "left/liberal political opinion, covering national and international affairs, literature and culture." Circ. 100,000. Sample copies available.

- *The Nation*'s art director works out of his design studio at Steven Brower Design. You can send samples to *The Nation* and they will be forwarded.

Illustration Approached by 50 illustrators/year. Buys 1-3 illustrations/issue. Works with 15 illustrators/year. Has featured illustrations by Peter O. Zierlien, Ryan Inzana, Tim Robinson and Karen Caldecott. Buys illustrations mainly for spots and feature spreads. Works on assignment only. Considers all media.

First Contact & Terms Send e-mail. Samples are filed or are returned by SASE. Responds only if interested. Buys first rights. Pays $135 for color inside. Originals are returned after publication upon request.

Tips "On top of a defined style, artist must have a strong and original political sensibility."

Ⓝ THE NATIONAL NOTARY

P.O. Box 2402, Chatsworth CA 91313-2402. (818)739-4000. Fax: (818)700-1942 (Attn: Editorial Department). E-mail: publications@nationalnotary.org. Web site: www.nationalnotary.org. **Managing Editor:** Philip W. Browne. Editorial Supervisor: Consuelo Israelson. Emphasizes "notaries public and notarization—goal is to impart knowledge, understanding and unity among notaries nationwide and internationally." Readers are notaries of varying primary occupations (legal, government, real estate and financial), as well as state and federal officials and foreign notaries. Bimonthly. Circ. 300,000. Original artwork not returned after publication. Sample copy $5.

- Also publishes *Notary Bulletin*.

Cartoons Approached by 5-8 cartoonists/year. Cartoons "must have a notarial angle"; single or multiple panel with gagline, b&w line drawings.

Illustration Approached by 3-4 illustrators/year. Uses about 3 illustrations/issue; buys all from local freelancers. Works on assignment only. Themes vary, depending on subjects of articles. 100% of freelance work demands knowledge of Illustrator, QuarkXPress or FreeHand.

First Contact & Terms Cartoonists: Send samples of style. Illustrators: Send business card, samples and tearsheets to be kept on file. Samples not returned. Responds in 6 weeks. Call for appointment. Buys all rights. Negotiates pay.

Tips "We are very interested in experimenting with various styles of art in illustrating the magazine. We generally work with Southern California artists, as we prefer face-to-face dealings."

Ⓝ NATION'S RESTAURANT NEWS

425 Park Ave., 6th Floor, New York NY 10022-3506. (212)756-5000. Fax: (212)756-5215. Web site: www.nrn.com. **Art Director:** Joe Anderson. Assistant Art Director: Alexis Henry. Estab. 1967. Weekly 4-color trade publication/tabloid. Circ. 100,000.

Illustration Buys 2-3 illustrations/year. Features illustrations of business subjects in the food ser-

vice industry. Prefers pastel and bright colors. Assigns 5% of illustrations to well-known or "name" illustrators; 70% to experienced but not well-known illustrators; 25% to new and emerging illustrators. 20% of freelance illustration demands knowledge of Illustrator or Photoshop.

First Contact & Terms Illustrators: Send postcard sample or other nonreturnable samples, such as tearsheets. Accepts MAC-compatible disk submissions. Send EPS files. Samples are filed. Will contact artist for portfolio review if interested. Buys one-time rights. Pays on publication; $1,000-1,500 for color cover; $300-400 for b&w inside; $275-350 for color inside; $450-500 for spots. Finds illustrators through *Creative Black Book* and *LA Work Book*, *Directory of Illustration* and *Contact USA*.

NEW HAMPSHIRE MAGAZINE

150 Dow St., Manchester NH 03101. (603)624-1442. Fax: (603)624-1310. E-mail: slaughlin@nh.com. Web site: www.nhmagazine.com. **Creative Director:** Susan Laughlin. Estab. 1990. Monthly 4-color magazine emphasizing New Hampshire lifestyle and related content. Circ. 26,000.

Illustration Approached by 300 illustrators/year. Has featured illustrations by Brian Hubble and Stephen Sauer. Features lifestyle illustration, charts & graphs and spot illustration. Prefers conceptual illustrations to accompany articles. Assigns 50% to experienced but not well-known illustrators; 50% to new and emerging illustrators.

First Contact & Terms Send postcard sample and follow-up postcard every 3 months. Samples are filed. Portfolio review not required. Negotiates rights purchased. Pays on publication. Pays $75-250 for color inside; $150-500 for 2-page spreads; $125 for spots.

Tips "Lifestyle magazines want 'uplifting' lifestyle messages, not dark or disturbing images."

NEW MOON: THE MAGAZINE FOR GIRLS AND THEIR DREAMS

2 W. First St. #101, Duluth MN 55802. (218)728-5507. Fax: (218)728-0314. E-mail: girl@newmoon.org. Web site: www.newmoon.org. **Executive Editor:** Kate Freeborn. Estab. 1992. Bimonthly 4-color cover, 4-color inside consumer magazine. Circ. 30,000. Sample copies are $7.00.

Illustration Buys 3-4 illustrations/issue. Has featured illustrations by Andrea Good, Liza Ferneyhough, Liza Wright. Features realistic illustrations, informational graphics and spot illustrations of children, women and girls. Prefers colored work. Assigns 30% of illustrations to new and emerging illustrators.

First Contact & Terms Illustrators: Send postcard sample or other nonreturnable samples. Final work can be submitted electronically or as original artwork. Send EPS files at 300 dpi or greater, hi-res. Samples are filed. Responds only if interested. Portfolio review not required. Buys one-time rights. Pays on publication; $400 maximum for color cover; $200 maximum for inside.

Tips "Be very familiar with the magazine and our mission. We are a magazine for girls ages 8-14 and look for illustrators who portray people of all different shapes, sizes and ethnicities in their work. Women and girl artists preferred. See cover art guidelines at www.newmoon.org.

NURSEWEEK

860 Santa Teresa Blvd., San Jose, CA 95119. (408) 249-5877. Fax: (408) 574-1207. E-mail: ykim@gannetthg.com. Web site: www.nurse.com. **Art Director:** Young Kim. "*Nurseweek* is a biweekly 4-color letter size magazine mailed free to registered nurses nationwide. Combined circulation of all publications is over 1 million. *Nurseweek* provides readers with nursing-related news and features that encourage and enable them to excel in their work and that enhance the profession's image by highlighting the many diverse contributions nurses make. In order to provide a com-

plete and useful package, the publication's article mix includes late-breaking news stories, news features with analysis (including in-depth bimonthly special reports), interviews with industry leaders and achievers, continuing education articles, career option pieces and reader dialogue (Letters, Commentary, First Person)." Sample copy $3. Art guidelines not available. Needs computer-literate freelancers for production. 90% of freelance work demands knowledge of Quark, PhotoShop, Illustrator, Adobe Acrobat.

Illustration Approached by 10 illustrators/year. Buys 1 illustration/year. Prefers pen ink, watercolor, airbrush, marker, colored pencil, mixed media and pastel. Needs medical illustration.

Design Needs freelancers for design. 60% of design demands knowledge of Photoshop CS2, QuarkXPress 6.1, Indesign. Prefers local freelancers. Send query letter with brochure, resume, SASE and tear sheets.

Photographs: Stock photograph used 80%

First Contact Terms Illustrators: Send query letter with brochure, tear sheets, photographs, photocopies, photostats, slides and transparencies. Samples are not filed and are returned by SASE if requested by artist. Publication will contact artist for portfolio review if interested. Portfolio should include final art samples, photographs. Buys all rights. Pays on publication; $150 for blk, $250 for color cover; $100 for b, $175 for color inside. Finds artists through sourcebooks

O&A MARKETING NEWS

Kal Publications, 559 S. Harbor Blvd., Suite A, Anaheim CA 92805-4525. (714)563-9300. Fax: (714)563-9310. Web site: www.kalpub.com. **Editor:**Kathy Laderman. Estab. 1966. Bimonthly trade publication about the service station/petroleum marketing industry. Circ. 6,000.

Cartoons Approached by 10 cartoonists/year. Buys 1-2 cartoons/issue. Prefers humor that relates to service station industry. Prefers single panel, humorous, b&w line drawings.

First Contact & Terms Cartoonists: Send b&w photocopies, roughs or samples and SASE. Samples are returned by SASE. Responds in 1 month.Buys one-time rights. Pays on acceptance; $10 for b&w.

Tips "We run a cartoon (at least one) in each issue of our trade magazine. We're looking for a humorous take on business-specifically the service station/petroleum marketing/carwash/quick lube industry that we cover."

N OHIO MAGAZINE

1422 Euclid Ave., Cleveland OH 44115. (216)771-2833 or (800)210-7923. Fax: (216) 781-6318. E-mail: lblake@ohiomagazine.com. Web site: www.ohiomag.com/magazine. **Art Director:** Lesley Blake. 12 issues/year focusing on the beauty, adventure and fun in Ohio. Circ. 90,000. Previously published work OK. Original artwork returned after publication. Sample copy $2.50; Artist Guidelines available at www.ohiomagazine.com/photo.

Illustration Approached by 70+ illustrators/year. Use as needed. Works on assignment only. Has featured illustrations by A.G. Ford, Ellyn Lusis, D. Brent Campbell, Jeff Suntala and Daniel Casconcellos. Assigns 10% of illustrations to new and emerging illustrators. Considers pen, ink, watercolor, acrylic, marker, colored pencil, oil mixed media and pasted. 20% of freelance work demands knowledge of Illustrator, InDesign, and Photoshop and Illustrator CS2 or higher.

Design Needs freelancers for design and production. 100% of freelance work demands knowledge of InDesign, Photoshop and Illustrator CS2 or higher.

First Contact Terms Illustrators: Send postcard sample, brochure or e-mail. Designers: Send cover letter, résumé and 5-10 samples of work. Samples maybe submitted on disk or by Web

site. Files should be high-resolution Adobe PDF's. Responds in 1 month. Art director will request portfolio review if interested. Portfolio should include color tearsheets, printouts and/or final art. Buys one-time rights. **Pays on acceptance**. Finds artists through submissions and gallery shows.

Tips Please have aknowledge of magazine and audience before submitting.

ON EARTH

40 W. 20th St., New York NY 10011. (212)727-2700. Fax: (212)727-1773. E-mail: OnEarth@nrdc. org. Web site: www.nrdc.org. **Art Director:** Gail Ghezzi. Associate Art Director: Irene Huang. Estab. 1979. Quarterly "award-winning environmental magazine exploring politics, nature, wildlife, science and solutions to problems." Circ. 140,000.

Illustration Buys 4 illustrations/issue.

First Contact & Terms Illustrators: Send postcard sample. "We will accept work compatible with QuarkXPress, Illustrator 8.0, Photoshop 5.5 and below." Responds only if interested. Buys one-time rights. Also may ask for electronic rights. Pays $100-300 for b&w inside. Payment for spots varies. Finds artists through sourcebooks and submissions.

Tips "We prefer 4-color. Our illustrations are often conceptual, thought-provoking, challenging. We enjoy thinking artists, and we encourage ideas and exchange."

THE OPTIMIST

4494 Lindell Blvd., St. Louis MO 63108-2404. (314)371-6000. Fax: (314)371-6006. E-mail: melissa.budrow@optimist.org. Web site: www.optimist.org. **Graphics Coordinator:** Melissa Budrow. Quarterly 4-color magazine with 4-color cover that emphasizes activities relating to Optimist clubs in U.S. and Canada (civic-service clubs). "Magazine is mailed to all members of Optimist clubs. Average age is 42; most are management level with some college education." Circ. 100,000. Sample copy available for SASE.

Cartoons Buys 2 cartoons/issue. Has featured cartoons by Joe Engesssei, Randy Glasbergen and Tim Oliphant. Prefers themes of general interest family-orientation, sports, kids, civic clubs. Prefers color, single-panel, with gagline. No washes.

First Contact & Terms Send query letter with samples. Send art on a disk if possible (Macintosh compatible). Submissions returned by SASE. Buys one-time rights. **Pays on publication:** $30 for b&w or color.

Tips "Send clear cartoon submissions, not poorly photocopied copies."

OREGON QUARTERLY

130 Chapman Hall, 5228 University of Oregon, Eugene OR 97403-5228. (541)346-5048. Fax: (541)346-5571. E-mail: quarterly@uoregon.edu. Web site: www.oregonquarterly.com. **Art Director:** Tim Jordan. Editor: Guy Maynard. Estab. 1919. Quarterly 4-color alumni magazine. Emphasizes regional (Northwest) issues and events as addressed by University of Oregon faculty members and alumni. Circ. 91,000. Sample copies available for SASE with first-class postage.

Illustration Approached by 25 illustrators/year. Buys 1-2 illustrations/issue. Prefers story-related themes and styles. Interested in all media.

First Contact & Terms Illustrators: Send query letter with résumé, SASE and tearsheets. Samples are filed unless accompanied by SASE. Responds only if interested. Portfolio review not required. Buys one-time rights for print and electronic versions. **Pays on acceptance**; rates negotiable. Accepts previously published artwork. Originals are returned at job's completion.

Tips "Send postcard or URL, not portfolio."

OUR STATE: DOWN HOME IN NORTH CAROLINA

P.O. Box 4552, Greensboro NC 27404. (336)286-0600. Fax: (336)286-0100. E-mail: art_director@ ourstate.com. Web site: www.ourstate.com. **Art Director:** Shay Sprinkles. Estab. 1933. Monthly 4-color consumer magazine featuring travel, history and culture of North Carolina. Circ. 130,000. Art guidelines free for #10 SASE with first-class postage.

Illustration Approached by 6 illustrators/year. Buys 12 illustrations/issue. Features maps of towns in North Carolina. Prefers pastel and bright colors. Assigns 100% to new and emerging illustrators. 100% of freelance illustration demands knowledge of Illustrator.

First Contact & Terms Illustrators: Send postcard sample or nonreturnable samples. Samples are not filed and are not returned. Portfolio review not required. Buys one-time rights. Pays on publication: $400-600 for color cover; $75-350 for b&w inside; $75-350 for color inside; $350 for 2-page spreads. Finds illustrators through word of mouth.

OUT OF THE BOXX

P.O. Box 2158, Daly City CA 94017-2158. Phone/fax: (650)755-4827. E-mail: outoftheboxx@eart hlink.net. Web site: www.outoftheboxx.lookscool.com. **Editor:** Joy Miller. Art Director/Publisher: L.A. Miller. Estab. 2007. Monthly trade journal for cartoonists, humor writers, art collectors. Sample copy available for $5 ($8 foreign). Art guidelines available for #10 SASE with first-class postage.

Cartoons Buys front cover cartoon. Slant toward cartooning or the cartoonist. Black & White. Pays = $25/On Acceptance. Inside spot cartoons, general slants. Pays = $15-20/On Acceptance.

Illustration Buys 1-2 illustrations/issue. Has featured work by Jack Cassady, Steve Langille, Art McCourt, Thom Bluemel and Brewster Allison. Considers pen & ink, mixed media.

First Contact & Terms Send query letter with business card, promo sheet, photocopied samples, SASE. Include all contact information (name, postal mail & e-mail adresses, URL, phone/fax numbers). Samples are filed. Responds in 1-2 months. Buys reprint rights. Works on assignment only. **Pays on acceptance.** Pays cartoonists $20/front cover, $15/inside spots; pays illustrators $20-30.

Tips "We welcome both professional and amateur cartoonist ."

OVER THE BACK FENCE MAGAZINE

2947 Interstate Pkwy., Brunswick OH 44212. (330)220-2483. Fax: (330)220-3083. E-mail: rockya @longpointmedia.com. Web site: www.backfencemagazine.com. **Creative Director:** Rocky Alten. Estab. 1994. Bi-monthly consumer magazine emphasizing southern Ohio topics. Circ. 15,000. Sample copy available for $5; illustrator's guidelines can be found on the Web site.

Illustration Features humorous and realistic illustration; informational graphics and spot illustration. Assigns 50% of illustration to experienced but not well-known illustrators; 50% to new and emerging illustrators.

First Contact & Terms Illustrators: Send query letter with photocopies, tearsheets and SASE. See guidelines on Web site. Samples are occasionally filed or returned by SASE. Responds in 3 months. Creative director will contact artist for portfolio review if interested. Buys one-time rights. Pays $100 for b&w and color covers; $25-100 for b&w and color inside; $25-200 for 2-page spreads; $25-100 for spots. Finds illustrators through word of mouth and submissions.

Tip Our readership enjoys our warm, friendly approach. The artwork we select will possess the same qualities.

PARADE MAGAZINE

711 Third Ave., New York NY 10017-4014. (212)450-7000. Fax: (212)450-7284. E-mail: ira_yoffe @parade.com. Web site: www.parade.com. **Creative Director:** Ira Yoffe. Weekly emphasizing general-interest subjects. Circ. 36 million. Sample copies available. Art guidelines available for SASE with first-class postage.

Illustration Works on assignment only.

Design Needs freelancers for design. 100% of freelance work demands knowledge of Photoshop, Illustrator, InDesign and QuarkXPress. Prefers local freelancers.

First Contact & Terms Illustrators: Send query letter with brochure, résumé, business card, postcard and/or tearsheets to be kept on file. Designers: Send query letter with résumé. Call or write for appointment to show portfolio. Responds only if interested. Buys first rights, occasionally all rights. Pays for design by the project, by the day or by the hour depending on assignment.

Tips "Provide a good balance of work."

PC MAGAZINE

Ziff Davis Media, 28 E. 28th St., 11th Floor, New York NY 10016. (212)503-3500. Fax: (212)503-5580. Web site: www.pcmag.com. **Art Director:** Richard Demler. Estab. 1983. Monthly consumer magazine featuring comparative lab-based reviews of current PC hardware and software. Circ. 750,000. Sample copies available.

Illustration Approached by 100 illustrators/year. Buys 5-10 illustrations/issue. Considers all media.

First Contact & Terms Send postcard sample and/or printed samples, photocopies, tearsheets. Accepts CD or e-mail submissions. Samples are filed. Portfolios may be dropped off and should include tearsheets and transparencies; art department keeps for one week to review. **Pays on acceptance.** Payment negotiable for cover and inside; $350 for spots.

PHI DELTA KAPPAN

408 N. Union Street, Bloomington IN 47405-3800 . (812)339-1156. Fax: (812)339-0018. Web site: www.pdkintl.org/kappan/kappan.htm. **Design Director:** Carol Bucheri. Journal covers issues in education, policy, research findings and opinion. Readers include members of the education organization Phi Delta Kappa as well as non-member subscribers—school administrators, teachers, and policy makers. Published 10 times/year, September-June. Circ. 50,000. Sample copy available for $8 plus $5.50 S&H. Journal is available in most public and university libraries.

Cartoons Approached by more than 100 cartoonists/year. Looks for well-drawn cartoons that reflect our multi-racial, multi-ethnic, non-gender-biased world. Cartoon content must be related to education. Submit packages of 10-25 cartoons, 1 per 8×11 sheet, with SASE. Allow 2 months for review. Do not send submissions April 1-May 30. Note that we do not accept electronic submissions of cartoons.

Illustration Approached by more than 100 illustrators/year. We have moved away from using much original illustration and now rely primarily on stock illustration to supplement an increased use of photography. Send plain-text e-mail with link to your online portfolio. Look for serious conceptual art to illustrate complex and often abstract themes. We also use humorous illustrations. Purchases royalty-free stock and one-time print and electronic rights for original work. Submission guidelines available online at Web site.

PN/PARAPLEGIA NEWS

2111 E. Highland Ave., Suite 180, Phoenix AZ 85016-4702. (602)224-0500. Fax: (602)224-0507. E-mail: anngarvey@pnnews.com. Web site: www.pn-magazine.com. **Art Director:** Ann Garvey. Estab. 1947. Monthly 4-color magazine emphasizing wheelchair living for wheelchair users, rehabilitation specialists. Circ. 30,000. Accepts previously published artwork. Original artwork not returned after publication. Sample copy free for large-size SASE with $3 postage.

Cartoons Buys 3 cartoons/issue. Prefers line art with wheelchair theme. Prefers single panel b&w line drawings with or without gagline.

Illustration Prefers wheelchair living or medical and financial topics as themes. 50% of freelance work demands knowledge of QuarkXPress, Photoshop or Illustrator.

First Contact & Terms Cartoonists: Send query letter with finished cartoons to be kept on file. Responds only if interested. Buys all rights. **Pays on acceptance.** Illustrators: Send postcard sample. Accepts disk submissions compatible with Illustrator 10.0 or Photoshop 7.0. Send EPS, TIFF or JPEG files. Samples not filed are returned by SASE. Publication will contact artist for portfolio review if interested. Portfolio should include final reproduction/product, color and b&w tearsheets, photostats, photographs. Pays on publication. Pays cartoonists $10 for b&w. Pays illustrators $250 for color cover; $25 for b&w inside, $50 for color inside.

Tips "When sending samples, include something that shows a wheelchair user. We regularly purchase cartoons that depict wheelchair users."

POCKETS

P.O. Box 340004, 1908 Grand AV, Nashville TN 37203-0004. (615)340-7333. Fax: (615)340-7267. E-mail: pockets@upperroom.org. Web site: www.pockets.org. **Editor:** Lynn W. Gilliam. Devotional magazine for children 6-12. 4-color. Monthly except January/February. Circ. 100,000. Accepts one-time previously published material. Original artwork returned after publication. Sample copy for 9×12 or larger SASE with 4 first-class stamps.

Illustration Approached by 50-60 illustrators/year. Features humorous, realistic and spot illustration. Assigns 15% of illustrations to new and emerging illustrators. Uses variety of styles; 4-color, flapped traditional art or digital, appropriate for children. Realistic, fable and cartoon styles.

First Contact & Terms Illustrators: Send postcard sample, brochure, photocopies, and tearsheets with SASE. No fax submissions accepted. Also open to more unusual art forms cut paper, embroidery, etc. Samples not filed are returned by SASE only. No response without SASE." Buys one-time and reserves or reprint rights. **Pays on acceptance;** $600 flat fee for 4-color covers; $75-350 for color inside.

Tips "Assignments made in consultation with out-of-house designer. Send samples to our designer Chris Schechner, Schechner & Associates, 408 Inglewood Dr., Richardson, TX 75080."

N PRESBYTERIANS TODAY

100 Witherspoon St., Louisville KY 40202. (502)569-5637. Fax: (502)569-8632. E-mail: today@pcusa.org. Web site: www.pcusa.org/today. **Art Director:** Linda Crittenden. Estab. 1830. 4-color; official church magazine emphasizing Presbyterian news and informative and inspirational features. Publishes 10 issues year. Circ. 50,000. Originals are returned after publication if requested. Some feature illustrations may appear on Web site. Sample copies for SASE with first-class postage.

Cartoons Approached by 20-30 cartoonists/year. Buys 1 freelance cartoon/issue. Prefers general religious material; single panel.

Illustration Approached by more than 50 illustrators/year. Buys 1-2 illustrations/issue, 15 illus-
trations/year from freelancers. Works on assignment only. Media varies according to need.
First Contact & Terms Cartoonists: Send roughs and/or finished cartoons.
Responds in 1 month. Rights purchased vary according to project.
Illustrators: Send query letter with tearsheets. Samples are filed and not returned. Responds
only if interested. Buys one-time rights. Pays cartoonists $25, b&w. Pays illustrators $150-350,
cover; $80-250, inside.

⚙ PRISM INTERNATIONAL

University of British Columbia, Buchanan E462, 1866 Main Mall, Vancouver BC V6T 1Z1 Canada.
(604)822-2514. Fax: (604)822-3616. E-mail: prism@interchange.ubc.ca. Web site: www.prism.a
rts.ubc.ca. Estab. 1959. Quarterly literary magazine. "We use cover art for each issue." Circ.
1,200. Sample copies available for $10 each; art guidelines free for SASE with first-class Canadian
postage.
Illustration Buys 1 cover illustration/issue. Has featured illustrations by Mark Ryden, Mark
Mothersbaugh, Annette Allwood, The Clayton Brothers, Maria Capolongo, Mark Korn, Scott
Bakal, Chris Woods, Kate Collie and Angela Grossman. Features representational and nonrepre-
sentational fine art. Assigns 50% of illustrations to experienced but not well-known illustrators;
50% to new and emerging illustrators. "Most of our covers are full color artwork and sometimes
photography; on occasion we feature a black & white cover."
First Contact & Terms Illustrators: Send postcard sample. Accepts submissions on disk compati-
ble with CorelDraw 5.0 (or lower) or other standard graphical formats. Most samples are filed;
those not filed are returned by SASE if requested by artist. Responds in 6 months. Portfolio
review not required. Buys first rights. "Image may also be used for promotional purposes related
to the magazine." Pays on publication: $250 Canadian and 4 copies of magazine. Original art-
work is returned to the artist at job's completion. Finds artists through word of mouth and going
to local exhibits.
Tips "We are looking for fine art suitable for the cover of a literary magazine. Your work should
be polished, confident, cohesive and original. Please send postcard samples of your work. As
with our literary contest, we will choose work that is exciting and which reflects the contempo-
rary nature of the magazine."

REFORM JUDAISM

633 Third Ave., 7th Floor, New York NY 10017-6778. (212)650-4240. Fax: (212)650-4249. E-mail:
rjmagazine@urj.org. Web site: www.reformjudaismmag.org. **Managing Editor:** Joy Weinberg.
Estab. 1972. Quarterly magazine. "The official magazine of the Reform Jewish movement. It
covers developments within the movement and interprets world events and Jewish tradition
from a Reform perspective. "Circ. 310,000. Accepts previously published artwork. Originals
returned at jobs completion. Sample copies available for $3.50.
Cartoons Prefers political themes tying into editorial coverage.
Illustration Buys 5-8 illustrations/issue. Works on assignment. 10% of freelance work demands
computer skills.
First Contact & Terms Cartoonists: Send query letter with copy of finished cartoons that do not
have to be returned. Send with self-addressed stamped postcard offering 3 choices: Yes, we are
interested; No, unfortunately we will pass on publication; Maybe, we will consider and be back
in touch with you. Illustrators: Send query letter with brochure and/or tearsheets. Samples are

filed and artists are contacted when the right fit presents itself. **Pays on publication**; varies according to project. Finds artists' submissions.

RESTAURANT HOSPITALITY

1300 E. Ninth St., Cleveland OH 44114. (216)931-9942. Fax: (216)696-0836. E-mail: chris.roberto @penton.com. **Group Creative Director:** Chris Roberto. Circ. 123,000. Estab. 1919. Monthly trade publication emphasizing restaurant management ideas, business strategies and foodservice industry trends. Readers are independent and chain restaurant operators, executives and chefs.

Illustration Approached by 150 illustrators/year. Buys 3-5 illustrations per issue (combined assigned and stock). Prefers food- and business-related illustration in a variety of styles. Has featured illustrations by Mark Shaver, Paul Watson and Brian Raszka. Assigns 10% of illustrations to well-known or "name" illustrators; 60% to experienced but not well-known illustrators; and 30% to new and emerging illustrators. Welcomes stock submissions.

First Contact & Terms Illustrators: Postcard samples preferred. Follow-up card every 3-6 months. Buys one-time rights. **Pays on acceptance.** Payment range varies for full page or covers; $300-350 quarter-page; $250-350 for spots. Finished illustrations must be delivered as hi-res digital. E-mail or FTP preferred.

Tips "I am always open to new approaches—contemporary, modern visuals that explore various aspects of the restaurant industry and restaurant experience. Please include a web address on your sample so I can view an online portfolio."

RURAL HERITAGE

Dept. AGDM, P.O. Box 2067, Cedar Rapids IA 52406-2067. (319)362-3027. Fax: (319)362-3046. E-mail: editor@ruralheritage.com. Web site: www.ruralheritage.com. **Editor:** Gail Damerow. Estab. 1976. Bimonthly farm magazine "published in support of modern-day farming and logging with draft animals (horses, mules, oxen)." Circ. 8,000. Sample copy for $8 postpaid; art guidelines not available.

- Editor stresses the importance of submitting cartoons that deal only with farming and logging using draft animals.

Cartoons Approached by "not nearly enough" cartoonists who understand our subject. Buys 2 or more cartoons/issue. Prefers bold, clean, minimalistic draft animals and their relationship with the teamster. "No unrelated cartoons!" Prefers single panel, humorous, b&w line drawings with or without gagline.

First Contact & Terms Cartoonists: Send query letter with finished cartoons and SASE. Samples accepted by US mail only. Samples are not filed (unless we plan to use them—then we keep them on file until used) and are returned by SASE. Responds in 2 months. Buys first North American serial rights or all rights rarely. Pays on publication; $10 for one-time rights; $20 for all rights.

Tips "Know draft animals (horses, mules, oxen, etc.) well enough to recognize humorous situations intrinsic to their use or that arise in their relationship to the teamster. Our best contributors read *Rural Heritage* and get their ideas from the publication's content."

THE SCHOOL ADMINISTRATOR

801 N. Quincy St., Suite 700, Arlington VA 22203-1730. (703)875-0753. Fax: (703)528-2146. E-mail: lgriffin@aasa.org. Web site: www.aasa.org. **Managing Editor:** Liz Griffin. Monthly association magazine focusing on education. Circ. 22,000.

Cartoons Approached by 15 editorial cartoonists/year. Buys 11 cartoons/year. Prefers editorial/ humorous, b&w line drawings only. Humor should be appropriate to a CEO of a school system, not a classroom teacher or parent.''

Illustration Approached by 60 illustrators/year. Buys 2-3 illustrations/issue. Has featured illustrations by Ralph Butler, Paul Zwolak, and Heidi Younger. Features spot and computer illustrations. Preferred subjects education K-12 and leadership. Assigns 90% of illustrations to our existing stable of illustrators. Considers all media. Requires willingness to work within tight budget. **Contact & Terms** Cartoonists: Send photocopies and SASE. Buys one-time rights. **Pays on acceptance.** Send nonreturnable samples. Samples are filed and not returned. Responds only if interested. Print rights purchased. Pays on publication. Pays illustrators $800 for color cover. Finds illustrators through word of mouth, stock illustration source and Creative Sourcebook.

Tips Check out our Web site. Send illustration samples to: Melissa Kelly, Auras Design, 8435 Georgia Ave., Silver Spring MD 20910.''

SCRAP

1615 L St. NW, Suite 600, Washington DC 20036-5610. (202)662-8547. Fax: (202)626-0947. E-mail: kentkiser@scrap.org. Web site: www.scrap.org. **Publisher:** Kent Kiser. Estab. 1987. Bimonthly 4-color trade publication that covers all aspects of the scrap recycling industry. Circ. 12,700.

Cartoons ''We occasionally run single-panel cartoons that focus on the recycling theme/business.''

Illustration Approached by 100 illustrators/year. Buys 0-2 illustrations/issue. Features realistic illustrations, business/industrial/corporate illustrations and international/financial illustrations. Prefered subjects business subjects. Assigns 10% of illustrations to new and emerging illustrators.

First Contact & Terms Illustrators: Send postcard sample. Samples are filed. Portfolio review not required. Buys first North American serial rights. **Pays on acceptance**; $1,200-2,000 for color cover; $300-1,000 for color inside. Finds illustrators through creative sourcebook, mailed submissions, referrals from other editors, and ''direct calls to artists whose work I see and like.''

Tips ''We're always open to new talent and different styles. Our main requirement is the ability and willingness to take direction and make changes if necessary. No prima donnas, please. Send a postcard to let us see what you can do.''

N SEATTLE MAGAZINE

1505 Western Ave., Suite 500, Seattle WA 98101. Phone/fax: (206)284-1750. E-mail: sue.boylan @seattlemag.com. Web site: www.seattlemag.com. **Art Director:** Sue Boylan. Estab. 1992. Monthly urban lifestyle magazine covering Seattle. Circ. 48,000. E-mail art director directly for art guidelines.

Illustration Approached by hundreds of illustrators/year. Buys 2 illustrations/issue. Considers all media. ''We can scan any type of illustration.''

First Contact & Terms Illustrators: Prefers e-mail submissions. Samples are filed. Responds only if interested. Art director will contact artist for portfolio review of color, final art and transparencies if interested. Buys one-time rights. Sends payment on 25th of month of publication. Pays on publication; $150-1,100 for color cover; $50-400 for b&w; $50-1,100 for color inside; $50-400 for spots. Finds illustrators through agents, sourcebooks such as *Creative Black Book*, *LA*

Workbook, online services, magazines, word of mouth, artist's submissions, etc.

Tips "Good conceptual skills are the most important quality that I look for in an illustrator as well as unique skills."

SIERRA MAGAZINE

85 Second St., 2nd Floor, San Francisco CA 94105-3441. (415)977-5572. Fax: (415)977-5794. E-mail: sierra.letters@sierraclub.org. Web site: www.sierraclub.org. **Art Director:** Martha Geering. Bimonthly consumer magazine featuring environmental and general interest articles. Circ. 750,000.

Illustration Buys 8 illustrations/issue. Considers all media. 10% of freelance illustration demands computer skills.

First Contact & Terms Send postcard samples or printed samples, SASE and tearsheets, or link to web portfolio. Samples are filed and are not returned. Responds only if interested. Art director will contact artist for portfolio review if interested. Buys one-time rights. Finds illustrators through illustration and design annuals, illustration Web sites, sourcebooks, submissions, magazines, word of mouth.

SKILLSUSA CHAMPIONS

14001 SkillsUSA Way, P.O. Box 3000, Leesburg VA 20177. (703)777-8810. Fax: (703)777-8999. E-mail: thall@skillsusa.org. Web site: www.skillsusa.org. **Editor:** Tom Hall. Estab. 1965. Quarterly 4-color magazine. "*SkillsUSA Champions* is primarily a features magazine that provides motivational content by focusing on successful members. SkillsUSA is an organization of 300,000 students and teachers in technical, skilled and service careers. Circ. 300,000. Sample copies available.

Illustration Approached by 4 illustrators/year. Works on assignment only. Prefers positive, youthful, innovative, action-oriented images. Considers pen & ink, watercolor, collage, airbrush and acrylic.

Design Needs freelancers for design. 100% of freelance work demands knowledge of Adobe CS.

First Contact & Terms Illustrators: Send postcard sample. Designers: Send query letter with brochure. Accepts disks compatible with FreeHand 5.0, Illustrator CS3, PageMaker 7.0 and InDesign CS3. Send Illustrator, FreeHand and EPS files. Portfolio should include printed samples, b&w and color tearsheets and photographs. Accepts previously published artwork. Originals returned at job's completion (if requested). Rights purchased vary according to project. **Pays on acceptance.** Pays illustrators $200-300 for color; $100-300 for spots. Pays designers by the project.

Tips "Send samples or a brochure. These will be kept on file until illustrations are needed. Don't call! Fast turnaround helpful. Due to the unique nature of our audience, most illustrations are not re-usable; we prefer to keep art."

SKIPPING STONES

P.O. Box 3939, Eugene OR 97403-0939. (541)342-4956. E-mail: Info@SkippingStones.org. Web site: www.SkippingStones.org. **Editor:** Arun Toke. Estab. 1988. Bimonthly b&w (with 4-color cover) consumer magazine. International nonprofit multicultural awareness and nature education magazine for today's youth. Circ. 2,000 (and on the Web). Sample copy available for $5. Art guidelines are free for SASE with first-class postage.

Cartoons Prefers multicultural, social issues, nature/ecology themes. Requests b&w washes and

line drawings. Has featured cartoons by Lindy Wojcicki of Florida. Prefers cartoons by youth under age 19.

Illustration Approached by 100 illustrators/year. Buys 10-20 illustrations/year. Has featured illustrations by Sarah Solie, Wisconsin; Alvina Kong, California; Elizabeth Wilkinson, Vermont; Inna Svjatova, Russia; Jon Bush, Massachusetts. Features humorous illustration, informational graphics, natural history and realistic, authentic illustrations. Preferred subjects children and teens. Prefers pen & ink. Assigns 80% of work to new and emerging illustrators. Recent issues have featured Multicultural artists—their life and works.

First Contact & Terms Cartoonists: Send b&w photocopies and SASE. Illustrators: Send nonreturnable photocopies and SASE. Samples are filed or returned by SASE. Responds in 3 months if interested. Portfolio review not required. Buys first rights, reprint rights. Pays on publication 1-4 copies, no monetary compensation. Finds illustrators through word of mouth, artists' promo samples.

Tips "We are a gentle, non-glossy, ad-free magazine not afraid to tackle hard issues. We are looking for work that challenges the mind, charms the spirit, warms the heart, handmade, nonviolent, global, for youth 8-15 with multicultural/nature content. Please, no aliens or unicorns. We are especially seeking work by young artists under 19 years of age! People of color and international artists are especially encouraged."

SLACK PUBLICATIONS

6900 Grove Rd., Thorofare NJ 08086-9447. (856)848-1000. Fax: (856)853-5991. E-mail: lbaker@slackinc.com. Web site: www.slackinc.com. **Creative Director:** Linda Baker. Estab. 1960. Publishes 22 medical publications dealing with clinical and lifestyle issues for people in the medical professions. Accepts previously published artwork. Originals returned at job's completion. Art guidelines not available.

Illustration Approached by 50 illustrators/year. Buys 2 illustrations/issue. Works on assignment only. Features stylized and realistic illustration; charts & graphs; informational graphics; medical, computer and spot illustration. NO CARTOONS. Assigns 5% of illustrations to well-known or "name" illustrators; 90% to experienced but not well-known illustrators; 5% to new and emerging illustrators. Prefers digital submissions.

First Contact & Terms Send query letter with tearsheets, photographs, photocopies, slides and transparencies. Samples are filed and are returned by SASE if requested by artist. Responds to the artist only if interested. To show a portfolio, mail b&w and color tearsheets, slides, photostats, photocopies and photographs. Negotiates rights purchased. Pays on publication; $400-600 for color cover; $100-200 for b&w inside; $100-350 for color inside; $50-150 for spots.

Tips "Send samples."

SPIDER®

Cricket Magazine Group, Carus Publishing, 70 E. Lake St., Suite 300, Chicago IL 60601. Web site: www.cricketmag.com. **Contact:** Art Submissions Coordinator. Managing Art Director: Suzanne Beck. Estab. 1994. Monthly literary and activity magazine for children ages 6-9. Circ. 70,000. Art guidelines available on Web site.

• See also listings in this section for other magazines published by the Cricket Magazine Group: *BABYBUG, LADYBUG, CRICKET* and *CICADA*.

Illustration Buys 20 illustrations/issue; 240 illustrations/year. Uses color artwork only. Works on assignment only.

First Contact & Terms Send photocopies, photographs or tearsheets to be kept on file. Samples are returned by SASE if requested. Responds in 3 months. Buys all rights. Pays 45 days after acceptance: $750 for color cover; $250 for color full page; $100 for color spots; $50 for b&w spots.

Tips "Before attempting to illustrate for *SPIDER*, be sure to familiarize yourself with this age group, and read several issues of the magazine. Please do not query first."

ℕ SPORTS 'N SPOKES

2111 E. Highland Ave., Suite 180, Phoenix AZ 85016-4702. (602)224-0500. Fax: (602)224-0507. E-mail: anngarvey@pnnews.com. Web site: www.sportsnspokes.com. **Art and Production Director:** Ann Garvey. Published 6 times a year. Consumer magazine with emphasis on sports and recreation for the wheelchair user. Circ. 15,000. Accepts previously published artwork. Sample copies for large SASE and $3.00 postage.

Cartoons Buys 3-5 cartoons/issue. Prefers humorous cartoons; single panel b&w line drawings with or without gagline. Must depict some aspect of wheelchair sport and/or recreation.

Illustration Works on assignment only. Considers pen & ink, watercolor and computer-generated art. 50% of freelance work demands knowledge of Illustrator, QuarkXPress or Photoshop.

First Contact & Terms Cartoonists: Send query letter with finished cartoons. Responds in 3 months. Buys all rights. **Pays on acceptance**; $10 for b&w. Illustrators: Send postcard sample or query letter with résumé and tearsheets. Accepts CD submissions compatible with Illustrator 10.0 or Photoshop 7.0. Send EPS, TIFF or JPEG files. Samples are filed or returned by SASE if requested by artist. Responds to the artist only if interested. Publication will contact artist for portfolio review if interested. Portfolio should include color tearsheets. Buys one-time rights and reprint rights. Pays on publication; $250 for color cover; $25 for b&w inside; $50 for color inside.

Tips "We have not purchased an illustration or used a freelance designer for many years. We regularly purchase cartoons with wheelchair sports/recreation theme."

⬛ SUB-TERRAIN MAGAZINE

P.O. Box 3008, MPO, Vancouver BC V6B 3X5 Canada. (604)876-8710. Fax: (604)879-2667. E-mail: subter@portal.ca. Web site: www.subterrain.ca. **Editor:** Brian Kaufman. Estab. 1988. Published 3 times a year. Partial full colour literary magazine featuring contemporary literature of all genres. Art guidelines for SASE with first-class postage.

Cartoons Prefers single panel cartoons.

Illustration Assigns 50% of illustrations to new and emerging illustrators.

First Contact & Terms Send query letter with photocopies. Samples are filed. Responds if interested. Portfolio review not required. Buys first rights, first North American serial rights, one-time rights or reprint rights. Pays $35-100 (Canadian), plus contributor copies.

Tips "Take the time to look at an issue of the magazine to get an idea of the kind of material we publish."

TECHNICAL ANALYSIS OF STOCKS & COMMODITIES

Technical Analysis, Inc., 4757 California Ave. SW, Seattle WA 98116-4499. (206)938-0570. Fax: (206)938-1307. E-mail: cmorrison@traders.com. Web site: www.traders.com. **Art Director:** Christine Morrison. Estab. 1982. Monthly traders' magazine for stocks, bonds, futures, commodities, options, mutual funds. Circ. 66,000. Sample copies available for $5 each. Art guidelines on Web site.

• This magazine has received several awards, including the Step by Step Design Annual, American Illustration IX, XXIII, XIV, Society of Illustrators Annuals 40, 46, 48, 49. Parent company also publishes *Working Money*, a general interest financial magazine with similar cartoon and illustration needs. (See also separate listing for Technical Analysis, Inc., in the Book Publishers section.)

Cartoons Approached by 10 cartoonists/year. Buys 1-4 cartoons/issue. Prefers humorous cartoons, single-panel b&w line drawings with gagline.

Illustration Approached by 100 illustrators/year. Buys 6 illustrations/issue. Works on assignment only. Features humorous, realistic, computer (occasionally) and spot illustrations.

First Contact & Terms Cartoonists: Send query letter with finished cartoons (non-returnable copies only). Illustrators: Send e-mail JPEGs, brochure, tearsheets, photographs, photocopies, photostats, slides. Accepts disk submissions compatible with any Adobe products (TIFF or EPS files). Samples are filed and are not returned. Art director will contact artist for portfolio review if interested. Portfolio should include b&w and color tearsheets, slides, photostats, photocopies, final art and photographs. Buys one-time rights and reprint rights. Pays on publication. Pays cartoonists $35 for b&w. Pays illustrators $135-350 for color cover; $165-220 for color inside; $105-150 for b&w inside. Accepts previously published artwork.

Tips ''Looking for creative, imaginative and conceptual types of illustration that relate to articles' concepts. Also interested in caricatures with market charts and computers. Send a few copies of black & white and color work with or without cover letter. If I'm interested, I will call.''

▣ TEXAS PARKS & WILDLIFE

4200 Smith School Rd, Austin TX 78744. (512)387-8793. Fax: (512)389-8397. E-mail: magazine@ tpwd.state.tx.us. Web site: www.tpwmagazine.com. **Art Director:** Andres Carrasco. Estab. 1942. Monthly magazine ''containing information on state parks, wildlife conservation, hunting and fishing, environmental awareness.'' Circ. 180,000. Sample copies for #10 SASE with first-class postage.

Illustration 100% of freelance illustration.

First Contact & Terms Illustrators: Send postcard sample. Samples are not filed and are not returned. Responds only if interested. Buys one-time rights. Pays on publication; negotiable. Finds illustrators through magazines, word of mouth, artist's submissions.

Tips ''Read our magazine.''

TRAINS

P.O. Box 1612, 21027 Crossroads Circle, Waukesha WI 53187. (262)796-8776. Fax: (262)796-1778. E-mail: tdanneman@kalmbach.com. Web site: www.trains.com. **Art Director:** Thomas G. Danneman. Estab. 1940. Monthly magazine about trains, train companies, tourist RR, latest railroad news. Circ. 133,000. Art guidelines available.

• Published by Kalmbach Publishing. Also publishes *Classic Toy Trains*, *Astronomy*, *Finescale Modeler*, *Model Railroader*, *Model Retailer*, *Classic Trains*, *Bead and Button*, *Birder's World*.

Illustration 100% of freelance illustration demands knowledge of Photoshop CS 5.0, Illustrator CS 8.0.

First Contact & Terms Illustrators: Send query letter with printed samples, photocopies and tearsheets. Accepts disk submissions (opticals) or CDs, using programs above. Samples are filed. Art director will contact artist for portfolio review of color tearsheets if interested. Buys one-time rights. Pays on publication.

Tips ''Quick turnaround and accurately built files are a must.''

⊠ UNIQUE OPPORTUNITIES, The Physician's Resource

214 So 8th St., Suite 502, Louisville KY 40202-2738. (502)589-8250. Fax: (502)587-0848. E-mail: barb@uoworks.com. Web site: www.uoworks.com. **Publisher and Design Director**: Barbara Barry. Estab. 1991. Bimonthly trade journal. Audience is physicians looking for a new practice. Editorial focus is on practice-related issues.'' Circ. 80,000. Prefers files in jpeg, tiff, or pdf format.
Illustration Buys 1 illustrations/issue. Works on assignment and/or stock. Considers pen ink, mixed media, collage, pastel and computer illustration. Prefers computer illustration.
First Contact & Terms Illustrators: Views online portfolios. E-mail digital files. Buys first or one-time rights. Pays 30 days after acceptance; $700 for color cover; $250 for spots. Finds artists through Internet only. Do not send samples in the mail.

UTNE READER

12 N. 12th St., #400, Minneapolis MN 55403. (612)338-5040. Fax: (612)338-6043. Web site: www.utne.com. **Art Director:** Stephanie Glaros. Estab. 1984 by Eric Utne. Bimonthly digest featuring articles and reviews from the best of alternative media; independently published magazines, newsletters, books, journals and Web sites. Topics covered include national and international news, history, art, music, literature, science, education, economics and psychology. Circ. 250,000.

 • *Utne Reader* seeks to present a lively diversity of illustration and photography "voices." We welcome artistic samples which exhibit a talent for interpreting editorial content.

First Contact & Terms "We are always on the lookout for skilled artists with a talent for interpreting editorial content, and welcome examples of your work for consideration. Because of our small staff, busy production schedule, and the volume of samples we receive, however, we ask that you read and keep in mind the following guidelines. We ask that you not call or e-mail seeking feedback, or to check if your package has arrived. We wish we could be more generous in this regard, but we simply don't have the staff or memory capacity to recall what has come in (SASEs and reply cards will be honored). Send samples that can be quickly viewed and tacked to a bulletin board. Single-sided postcards are preferred. Make sure to include a link to your online portfolio, so we can easily view more samples of your work. DO NOT SEND cover letters, résumés, and gallery or exhibition lists. Be assured, if your art strikes us as a good fit for the magazine, we will keep you in mind for assignments. Clearly mark your full name, address, phone number, Web site address and e-mail address on everything you send. Please do not send original artwork or original photographs of any kind."

⊠ VANCOUVER MAGAZINE

2608 Granville St., Suite 560, Vancouver BC V6H 3V3 Canada. (604)877-7732. Fax: (604)877-4823. E-mail: rwatson@vancouvermagazine.com. Web site: www.vancouvermagazine.com. **Art Director:** Randall Watson. Monthly 4-color city magazine. Circ. 50,000.
Illustration Approached by 100 illustrators/year. Buys 4 illustrations/issue. Has featured illustrations by Melinda Beck, Jordin Isip, Geoffrey Grahn, Craig Larotonda, Christopher Silas Neal, Nate Williams and Juliette Borda. Features editorial and spot illustrations. Prefers conceptual, modern, original, alternative, bright and graphic use of color and style. Assigns 10% of work to new and emerging illustrators.
First Contact & Terms Send e-mail with Web site and contact link. Send postcard or other nonreturnable samples and follow-up samples every 3 months. Samples are filed. Responds only if interested. Portfolio may be dropped off every Tuesday and picked up the following day.

Magazines

Buys one-time and Internet rights. **Pays on acceptance**; negotiable. Finds illustrators through magazines, agents, *Showcase.*

Tips "We stick to tight deadlines. Aggressive, creative, alternative solutions encouraged. No phone calls, please."

VEGETARIAN JOURNAL

P.O. Box 1463 Dept. IN, Baltimore MD 21203-1463. (410)366-8343. E-mail: vrg@vrg.org. Web site: www.vrg.org. **Editor:** Debra Wasserman. Estab. 1982. Quarterly nonprofit vegetarian magazine that examines the health, ecological and ethical aspects of vegetarianism. "Highly educated audience including health professionals." Circ. 20,000. Accepts previously published artwork. Originals returned at job's completion upon request. Sample copies available for $3.

Cartoons Approached by 4 cartoonists/year. Buys 1 cartoon/issue. Prefers humorous cartoons with an obvious vegetarian theme; single panel b&w line drawings.

Illustration Approached by 20 illustrators/year. Buys 6 illustrations/issue. Works on assignment only. Prefers strict vegetarian food scenes (no animal products). Considers pen & ink, watercolor, collage, charcoal and mixed media.

First Contact & Terms Cartoonists: Send query letter with roughs. Illustrators: Send query letter with photostats. Samples are not filed and are returned by SASE if requested by artist. Responds in 2 weeks. Portfolio review not required. Rights purchased vary according to project. **Pays on acceptance.** Pays cartoonists $25 for b&w. Pays illustrators $25-50 for b&w/color inside. Finds artists through word of mouth and job listings in art schools.

Tips Areas most open to freelancers are recipe section and feature articles. "Review magazine first to learn our style. Send query letter with photocopy sample of line drawings of food."

WATERCOLOR ARTIST

(formerly *Watercolor Magic*), 4700 E. Galbraith Rd., Cincinnati OH 45236. (513)531-2690. Fax: (513)531-2902. E-mail: wcmedit@aol.com. Web site: www.watercolormagic.com. **Art Director:** Cindy Rider. Editor: Kelly Kane. Estab. 1995. Bi-monthly 4-color consumer magazine to "help artists explore and master watermedia." Circ. 92,000. Art guidelines free for #10 SASE with first-class postage.

First Contact & Terms Illustration: Pays on publication. Finds illustrators through word of mouth, visiting art exhibitions, unsolicited queries, reading books.

Tips "We are looking for watermedia artists who are willing to teach special aspects of their work and their techniques to our readers."

WESTWAYS

3333 Fairview Rd., A327, Costa Mesa CA 92808. (714)885-2396. Fax: (714)885-2335. E-mail: vaneyke.eric@aaa-calif.com. **Creative Director:** Eric Van Eyke. Estab. 1918. Bimonthly lifestyle and travel magazine. Circ. 3,000,000+.

Illustration Approached by 20 illustrators/year. Buys 2-6 illustrations/year. Works on assignment only. Preferred style is "arty—tasteful, colorful." Considers pen & ink, watercolor, collage, airbrush, acrylic, colored pencil, oil, mixed media and pastel.

First Contact & Terms Illustrators: Send e-mail with link to Web site or query letter with brochure, tearsheets and samples. Samples are filed. Responds only if interested; "could be months after receiving samples." Buys first rights. **Pays on acceptance of final art:** $250 minimum for color inside. Original artwork returned at job's completion.

WOODENBOAT MAGAZINE

P.O. Box 78, Brooklin ME 04616-0078. (207)359-4651. Fax: (207)359-8920. E-mail: olga@woode nboat.com. Web site: www.woodenboat.com. **Art Director:** Olga Lange. Estab. 1974. Bimonthly magazine for wooden boat owners, builders and designers. Circ. 106,000. Previously published work OK. Sample copy for $6. Art guidelines free for SASE with first-class postage.

Illustration Approached by 10-20 illustrators/year. Buys 2-10 illustrations/issue on wooden boats or related items. Uses some illustration, usually by several regularly appearing artists, but occasionally featuring others.

Design Not currently using freelancers.

First Contact & Terms Illustrators: Send postcard sample or query letter with printed samples and tearsheets. Designers: Send query letter with tearsheets, résumé and slides. Samples are filed. Does not report back. Artist should follow up with call. Pays on publication. Pays illustrators $50-$400 for spots.

Tips "We work with several professionals on an assignment basis, but most of the illustrative material that we use in the magazine is submitted with a feature article. When we need additional material, however, we will try to contact a good freelancer in the appropriate geographic area."

WRITER'S DIGEST

F + W Media, Inc., 4700 E. Galbraith Rd., Cincinnati OH 45236. E-mail: writersdig@fwpubs.com. Web site: www.writersdigest.com. Bimonthly magazine emphasizing freelance writing for freelance writers. Circ. 140,000. Art guidelines free for SASE with first-class postage.

- Submissions are also considered for inclusion in annual *Writer's Yearbook* and other one-shot publications.

Illustration Buys 2-4 feature illustrations/issue. Theme: the writing life. Works on assignment only. Send postcard or any printed/copied samples to be kept on file (no larger than $8\frac{1}{2} \times 11$).

First Contact & Terms Prefers postal mail submissions to keep on file. Final art may be sent via e-mail. Prefers EPS, TIFF or JPEG files, 300 dpi. Buys one-time rights. **Pays on acceptance:** $500-1,000 for color cover; $100-800 for color inside.

Tips "I like having several samples to look at. Online portfolios are great."

Book Publishers

Walk into any bookstore and start counting the number of images you see on books and calendars. The illustrations you see on covers and within the pages of books are, for the most part, created by freelance artists. Publishers rarely have enough artists on staff to generate such a vast array of styles. If you like to read and work creatively to solve problems, the world of book publishing could be a great market for you.

The artwork appearing on a book cover must grab readers' attention and make them want to pick up the book. It must show at a glance what type of book it is and who it is meant to appeal to. In addition, the cover has to include basic information such as title, the author's name, the publisher's name, blurbs and price.

Most assignments for freelance work are for jackets/covers. The illustration on the cover, combined with typography and the layout choices of the designer, announce to the prospective readers at a glance the style and content of a book. Suspenseful spy novels tend to feature stark, dramatic lettering and symbolic covers. Fantasy and science fiction novels, as well as murder mysteries and historical fiction, might show a scene from the story on their covers. Visit a bookstore and then decide which kinds of books interest you and would be best for your illustration style.

Book interiors are also important. The page layouts and illustrations direct readers through the text and complement the story, particularly in children's books and textbooks. Many publishing companies hire freelance designers with computer skills to design interiors on a contract basis. Look within each listing for the subheading Book Design to find the number of jobs assigned each year and how much is paid per project.

Finding your best markets

The first paragraph of each listing describes the types of books each publisher specializes in. You should submit only to publishers who specialize in the types of books you want to illustrate or design. There's no use submitting to a publisher of literary fiction if you want to illustrate children's picture books.

The publishers in this section are just the tip of the iceberg. You can find additional publishers by visiting bookstores and libraries and looking at covers and interior art. When you find covers you admire, write down the name of the books' publishers in a notebook. If the publisher is not listed in *Artist's & Graphic Designer's Market*, go to your public library and ask to look at a copy of *Literary Market Place*, also called *LMP*, published annually by Information Today, Inc. The cost of this large directory is prohibitive to most freelancers, but you should become familiar with it if you plan to work in the book publishing industry. Though it won't tell you how to submit to each publisher, it does give art directors' names. Also be sure to visit publishers' Web sites—many offer artist's guidelines.

Publishing Terms to Know

Important

- **Mass market** paperbacks are sold at supermarkets, newsstands, drugstores, etc. They include romance novels, diet books, mysteries and novels by popular authors like Stephen King.

- **Trade books** are the hardcovers and paperbacks found only in bookstores and libraries. The paperbacks are larger than those on the mass market racks, and are printed on higher-quality paper and often feature matte-paper jackets.

- **Textbooks** contain plenty of illustrations, photographs and charts to explain their subjects.

- **Small press** books are produced by small, independent publishers. Many are literary or scholarly in theme and often feature fine art on their covers.

- **Backlist titles** or **reprints** refer to publishers' titles from past seasons that continue to sell year after year. These books are often updated and republished with freshly designed covers to keep them up to date and attractive to readers.

How to submit

Send one to five nonreturnable samples along with a brief letter. Never send originals. Most art directors prefer samples that can fit in file drawers. Bulky submissions are considered a nuisance. After sending your initial introductory mailing, you should follow up with postcard samples every few months to keep your name in front of art directors. If you have an e-mail account and can send TIFF or JPEG files, check the publishers' preferences to see if they will accept submissions via e-mail.

Getting paid

Payment for design and illustration varies depending on the size of the publisher, the type of project and the rights purchased. Most publishers pay on a per-project basis, although some publishers of highly illustrated books (such as children's books) pay an advance plus royalties. Small, independent presses may only pay in copies.

Children's book illustration

Working in children's books requires a specific set of skills. You must be able to draw the same characters in a variety of poses and situations. Many publishers are expanding their product lines to include multimedia projects. While a number of children's book publishers are listed in this book, *Children's Writer's & Illustrator's Market*, also published by Writer's Digest Books, is an invaluable resource if you enter this field. See page 523 for more information, or visit www.fwbookstore.com to order the most recent edition. You may also want to consider joining the Society of Children's Book Writers and Illustrators (www.scbwi.org), an international organization that offers support, information, and lots of networking opportunities.

Helpful Resources

For More Info If you decide to focus on book publishing, become familiar with *Publishers Weekly*, the trade magazine of the industry. Its Web site, www.publishers weekly.com, will keep you abreast of new imprints, publishers that plan to increase their title selection, and the names of new art directors. You should also look for articles on book illustration and design in *HOW* (www. howdesign.com), *PRINT* (www.printmag.com) and other graphic design magazines. Helpful books include *By Its Cover: Modern American Book Cover Design* (Princeton Architectural Press), *Front Cover: Great Book Jacket and Cover Design* (Mitchell Beazley), and *Jackets Required: An Illustrated History of American Book Jacket Design, 1920-1950* (Chronicle Books).

HARRY N. ABRAMS, INC.

115 W. 18th St., New York NY 10011. (212)206-7715. Fax: (212)519-1210. Web site: www.hnabo oks.com. **Director, Art and Design:** Mark LaRiviere. Estab. 1951. Publishes hardcover originals, trade paperback originals and reprints. Types of books include fine art and illustrated books. Publishes 240 titles/year. 60% require freelance design. Visit Web site for art submission guidelines.

Needs Uses freelance designers to design complete books including jackets and sales materials. Uses illustrators mainly for maps and occasional text illustration. 100% of freelance design and 50% of illustration demands knowledge of Illustrator, InDesign or QuarkXPress and Photoshop. Works on assignment only.

First Contact & Terms Send query letter with résumé, tearsheets, photocopies. Accepts disk submissions or Web address. Samples are filed "if work is appropriate." Samples are returned by SASE if requested by artist. Portfolio should include printed samples, tearsheets and/or photocopies. Originals are returned at job's completion, with published product. Finds artists through word of mouth, submissions, attending art exhibitions and seeing published work.

Book Design Assigns several freelance design jobs/year. Pays by the project.

▣ ACROPOLIS BOOKS, INC.

553 Constitution Ave, Camerillo CA 93012-8510. (805) 322-9010. Fax: (800)-843-6960 E-mail: acropolisbooks@mindspring.com. Web site: www.acropolisbooks.com. **Vice President Operations:** Christine Lindsey. Imprints include Awakening. Publishes hardcover originals and reprints; trade paperback originals and reprints. Types of books include mysticism and spiritual. Specializes in books of higher consciousness. Recent titles: *The Journey Back to the Fathers Home* and *Showing Forth the Presence of God* by Joel S. Goldsmith. Publishes 4 titles/year. 30% require freelance design. Catalog available.

Needs Approached by 7 illustrators and 5 designers/year. Works with 2-3 illustrators and 2-3

designers/year. Knowledge of Photoshop and QuarkXPress useful in freelance illustration and design.

First Contact & Terms Designers: Send brochure and résumé. Illustrators: Send query letter with photocopies and résumé. Samples are filed. Responds in 2 months. Will contact artist for portfolio review if interested. Buys all rights.

Book Design Assigns 3-4 freelance design jobs/year. Pays by the project.

Jackets/Covers Assigns 3-4 freelance design jobs/year. Pays by the project.

Tips "We are looking for people who are familiar with our company and understand our focus."

ADAMS MEDIA

F + W Media, Inc., 57 Littlefield St., Avon MA 02322. (508)427-7116. Fax: (508)427-6790. E-mail: frank.rivera@adamsmedia.com. Web site: www.adamsmedia.com. **Art Director**: Frank Rivera. Estab. 1980. Publishes hardcover originals; trade paperback originals and reprints. Types of books include biography, business, gardening, pet care, cookbooks, history, humor, instructional, New Age, nonfiction, reference, self-help and travel. Specializes in business and careers. Recent titles: *1001 Books to Read for Every Mood*; *Green Christmas*; *The Bride's Survival Guide*. Publishes 260 titles/year. 20% require freelance illustration. Book catalog free by request.

• Imprints include Polka Dot Press, Platinum Press and Provenance Press. See also separate listing for F + W Media, Inc., in this section.

Needs Works with 8 illustrators and 7-10 designers/year. Buys less than 100 freelance illustrations/year. Uses freelancers mainly for jacket/cover illustration, text illustration and jacket/cover design. 100% of freelance work demands computer skills. Freelancers should be familiar with InDesign, Illustrator and Photoshop.

First Contact & Terms Send postcard sample of work. Samples are filed. Art director will contact artist for portfolio review if interested. Portfolio should include tearsheets. Rights purchased vary according to project, but usually buys all rights.

Jackets/Covers Assigns 50 freelance design jobs/year. Pays by the project, $500-1,100.

Text Illustration Assigns 30 freelance illustration jobs/year.

▣ ALLYN & BACON PUBLISHERS

75 Arlington St., Suite 300, Boston MA 02116. (617)848-7328. E-mail: linda.knowles@ablongman.com. Web site: www.ablongman.com. **Art Director:** Linda Knowles. Estab. 1868. Publishes more than 300 hardcover and paperback college textbooks/year. 60% require freelance cover designs. R Subject areas include education, psychology and sociology, political science, theater, music and public speaking. Recent titles: *Criminal Justice*; *Including Students with Special Needs*; *Social Psychology*.

Needs Designers must be strong in book cover design and contemporary type treatment. 50% of freelance work demands knowledge of Illustrator, Photoshop and FreeHand.

Jackets/Covers Assigns 100 design jobs and 2-3 illustration jobs/year. Pays for design by the project, $500-1,000. Pays for illustration by the project, $500-1,000. Prefers sophisticated, abstract style in pen & ink, airbrush, charcoal/pencil, watercolor, acrylic, oil, collage and calligraphy.

Tips "Keep stylistically and technically up to date. Learn *not* to over-design. R ead instructions and ask questions. Introductory letter must state experience and include at least photocopies of your work. If I like what I see, and you can stay on budget, you'll probably get an assignment. Being pushy closes the door. We primarily use designers based in the Boston area."

AMERICAN JUDICATURE SOCIETY

2700 University Ave., Des Moines IA 50311. (773)973-0145. Fax: (773)338-9687. E-mail: drichert @ajs.org. Web site: www.ajs.org. **Editor:** David Richert. Estab. 1913. Publishes journals and books. Specializes in courts, judges and administration of justice. Publishes 5 titles/year; 75% require freelance illustration. Catalog available on web site free for SASE.

Needs Approached by 20 illustrators and 6 designers/year. Works with 3-4 illustrators and 1 designer/year. Prefers local designers. Uses freelancers mainly for illustration. 100% of freelance design demands knowledge of QuarkXPress, FreeHand, Photoshop and Illustrator.

First Contact & Terms Designers: Send query letter with photocopies. Illustrators: Send query letter with photocopies and tearsheets. Send follow-up postcard every 3 months. Samples are not filed and are returned by SASE. Responds in 1 month. Will contact artist for portfolio review of photocopies, roughs and tearsheets if interested. Buys one-time rights.

Book Design Assigns 1-2 freelance design jobs/year. Pays by the project, $500-1,000.

Text Illustration Assigns 10 freelance illustration jobs/year. Pays by the project, $75-375.

ⓃAMHERST MEDIA, INC.

175 Rano St., Suite 200, Buffalo NY 14207. (716)874-4450. Fax: (716)874-4508. Web site: www.A mherstMedia.com. **Publisher:** Craig Alesse. Estab. 1974. Company publishes trade paperback originals. Types of books include instructional and reference. Specializes in photography, how-to. Publishes 30 titles/year. Recent titles include: *Portrait Photographer's Handbook*; *Creating World Class Photography*. 20% require freelance illustration; 80% require freelance design.

Needs Approached by 12 freelancers/year. Works with 3 freelance illustrators and 3 designers/ year. Uses freelance artists mainly for illustration and cover design. Also for jacket/cover illustration and design and book design. 80% of freelance work demands knowledge of QuarkXPress or Photoshop. Works on assignment only.

First Contact & Terms Send brochure, résumé and photographs. Samples are filed. Responds only if interested. Art director will contact artist for portfolio review if interested. Rights purchased vary according to project. Originals are returned at job's completion. Finds artists through word of mouth.

Book Design Assigns 12 freelance design jobs/year. Pays for design by the hour $25 minimum; by the project $2,000.

Jackets/Covers Assigns 12 freelance design and 4 illustration jobs/year. Pays $200-1200. Prefers computer illustration (QuarkXPress/Photoshop).

Text Illustration Assigns 12 freelance illustration jobs/year. Pays by the project. Only accepts computer illustration (QuarkXPress).

ANDREWS MCMEEL PUBLISHING, LLC

Andrews McMeel Universal, 4520 Main St., Kansas City MO 64111-7701. (816)932-6700. Fax: (816)932-6781. E-mail: tlynch@amuniversal.com. Web site: www.andrewsmcmeel.com. **Art Director:** Tim Lynch. Estab. 1972. Publishes hardcover originals and reprints; trade paperback originals and reprints. Types of books include humor, gift, instructional, nonfiction, reference, cooking. Specializes in calendars and comic strip collection books. Recent titles include *ModMex*, *Nobu West*, *The Blue Day Book* and *Complete Calvin and Hobbes*. Publishes 200 titles/year; 10% require freelance illustration; 80% require freelance design.

• See also listings for Universal Press Syndicate and uclick (other divisions of Andrews Mc-Meel Universal) in the Syndicates & Cartoon Features section.

Needs Prefers freelancers experienced in book jacket design. Freelance designers must have knowledge of Illustrator, Photoshop, QuarkXPress, or InDesign. Food photographers experienced in cook book photography.

First Contact & Terms Send sample sheets and Web address or contact through artists' rep. Samples are filed and not returned. Responds only if interested. Portfolio review not required. Rights purchased vary according to project.

Book Design Assigns 60 freelance design jobs and 20 illustration jobs/year. Pays for design $600-3,000.

Tips "We want designers who can read a manuscript and design a concept for the best possible cover. Communicate well and be flexible with design." Designer portfolio review once a year in New York City.

N ANTARCTIC PRESS

7272 Wurzbach, Suite 204, San Antonio TX 78240. (210)614-0396. Fax: (210)614-5029. E-mail: rod_espinosa@antarctic-press.com or apcog@hotmail.com. Web site: www.antarctic-press.com. **Contact:** Rod Espinosa, submissions editor. Estab. 1985. Publishes CD ROMs, mass market paperback originals and reprints, trade paperback originals and reprints. Types of books include adventure, comic books, fantasy, humor, juvenile fiction. Specializes in comic books. Publishes 18 titles/year. Recent titles include: *Ninja High School*; *Gold Digger*; *Twilight X*. 50% requires freelance illustration. Book catalog free with 9 × 12 SASE ($3 postage). Submission guidelines on Web site.

Needs Approached by 60-80 illustrators/year. Works with 12 illustrators/year. Prefers local illustrators. 100% of freelance illustration demands knowledge of Photoshop.

First Contact & Terms Do not send originals. Send copies only. Accepts e-mail submissions from illustrators. Prefers Mac-compatible, Windows-compatible, TIFF, JPEG files. Samples are filed or returned by SASE. Portfolios may be dropped off every Monday-Friday. Portfolio should include b&w, color finished art. All submissions must include finished comic book art, 10 pages minimum. Buys first rights. Rights purchased vary according to project. Finds freelancers through anthologies published, artist's submissions, Internet, word of mouth. Payment is made on royalty basis after publication.

Text Illustration Negotiated.

Tips "You must love comics and be proficient in doing sequential art."

ART DIRECTION BOOK CO. INC.

456 Glenbrook Rd., Glenbrook CT 06906. (203)353-1441. Fax: (203)353-1371. **Production Manager:** Karyn Mugmon. Publishes hardcover and paperback originals on advertising design and photography. Titles include *Scan This Book* and *Most Happy Clip Art* (disks), *101 Absolutely Superb Icons* (book and disk) and *American Corporate Identity #11*. Publishes 10-12 titles/year. Book catalog free on request.

Needs Works with 2-4 freelance designers/year. Uses freelancers mainly for graphic design.

First Contact & Terms Send query letter to be filed and arrange to show portfolio of 4-10 tearsheets. Portfolios may be dropped off Monday-Friday. Samples returned by SASE. Buys first rights. Originals are returned to artist at job's completion. Advertising design must be contemporary. Finds artists through word of mouth.

Book Design Assigns 8 freelance design jobs/year. Pays $350 maximum.

Jackets/Covers Assigns 8 freelance design jobs/year. Pays $350 maximum.

ARTIST'S & GRAPHIC DESIGNER'S MARKET

Writer's Digest Books, F + W Media, Inc., 4700 E. Galbraith Rd., Cincinnati OH 45236. E-mail: artdesign@fwpubs.com. Web site: www.artists-market.com. **Contact:** Alice Pope, managing editor. Annual directory of markets for illustrators, cartoonists, graphic designers and fine artists.

Needs Buys 10-30 illustrations/year. "I need examples of art that have been sold to the listings in *Artist's & Graphic Designer's Market*. Look through this book for examples. The art must have been freelanced; it cannot have been done as staff work. Include the name of the listing that purchased or exhibited the work, what the art was used for, and (if possible) the payment you received. Bear in mind that interior art is reproduced in black & white, so the higher the contrast, the better. I also want to see promo cards, business cards and tearsheets."

First Contact & Terms Send e-mail with JPEG files (at least 300 dpi), or mail printed samples or tearsheets. "Because *Artist's & Graphic Designer's Market* is published only once a year, submissions are kept on file for the upcoming edition until selections are made. Material is then returned by SASE if requested." Buys one-time rights. Pays $75 to the owner of reproduction rights, as well as a free copy of *Artist's & Graphic Designer's Market* when published.

ATHENEUM BOOKS FOR YOUNG READERS

Imprint of Simon & Schuster Children's Publishing Division. 1230 Avenue of the Americas, New York NY 10020. (212)698-7000. Fax: (212)698-2798. Web site: www.simonsayskids.com. **Executive Art Director:** Ann Bobco. Publishes hardcover originals, picture books for young kids, nonfiction for ages 8-12 and novels for middle-grade and young adults. Types of books include biography, historical fiction, history, nonfiction. Recent titles: *Olivia Saves the Circus* by Ian Falconer; *Zeely* by Virginia Hamilton. Publishes 60 titles/year. 100% require freelance illustration. Book catalog free by request.

Needs Approached by hundreds of freelance artists/year. Works with 40-50 illustrators/year. "We are interested in artists of varying media and are trying to cultivate those with a fresh look appropriate to each title."

First Contact & Terms Send postcard sample of work or send query letter with tearsheets, résumé and photocopies. Samples are filed. Responds only if interested. Art Director will contact artist for portfolio review if interested. Portfolio should include final art if appropriate, tearsheets, and folded and gathered sheets from any picture books you've had published. Rights purchased vary according to project. Originals are returned at job's completion. Finds artists through submissions, magazines ("I look for interesting editorial illustrators"), word of mouth.

Jackets/Covers Assigns 20 freelance illustration jobs/year. Pays by the project, $1,200-1,800. "I am not interested in generic young adult illustrators."

Text Illustration Pays by the project, $500-2,000.

BAEN BOOKS

P.O. Box 1188, Wake Forest NC 27587. (919)570-1640. Fax: (919)570-1644. E-mail: artdirector@baen.com. Web site: www.baen.com. **Art Director:** Toni Weisskopf. Estab. 1983. Publishes science fiction and fantasy. Recent titles include *1634: The Baltic War* and *By Slanderous Tongues*. Publishes 60-70 titles/year; 90% require freelance illustration/design. Book catalog free on request.

Needs Approached by 500 freelancers/year. Works with 10 illustrators and 3 designers/year. 50% of work demands computer skills.

First Contact & Terms Designers: Send query letter with résumé, color photocopies, color tear-

sheets and SASE. Illustrators: Send query letter with color photocopies, slides, color tearsheets and SASE. Samples are filed. Originals are returned to artist at job's completion. Buys exclusive North American book rights.

Jackets/Covers Assigns 64 design and 64 illustration jobs/year. Pays by the project. Pays designers $200 minimum; pays illustrators $1,000 minimum.

Tips Wants to see samples within science fiction/fantasy genre only. "Do not send black & white illustrations or surreal art. Please do not waste our time and your postage with postcards. Serious submissions only."

BECKER&MAYER!

11120 NE 33rd Place, Suite 101, Bellevue WA 98004-1444. (425)827-7120. Fax: (425)828-9659. E-mail: infobm@beckermayer.com. Web site: www.beckermayer.com. **Contact:** Adult or juvenile design department. Estab. 1973. Publishes nonfiction biography, humor, history and coffee table books. Recent titles: *The Art of Wine Tasting*; *Stan Lee's Amazing Marvel Universe*; *World War II Aircraft*; *The Secret World of Fairies*; *Disney Trivia Challenge*. Publishes 100+ titles/year. 10% require freelance design; 75% require freelance illustration. Book catalog available on Web site.

- becker&mayer! is spelled in all lower case letters with an exclamation mark. Publisher requests that illustration for children's books be sent to Juvenile Submissions. All other illustration should be sent to Adult Submissions.

Needs Works with 6 designers and 20-30 illustrators/year. Freelance design work demands skills in FreeHand, InDesign, Illustrator, Photoshop, QuarkXPress. Freelance illustration demands skills in FreeHand, Illustrator, Photoshop.

First Contact & Terms Designers: Send query letter with résumé and tearsheets. Illustrators: Send query letter, nonreturnable postcard sample, résumé and tearsheets. After introductory mailing, send follow-up postcard every 6 months. Does not accept e-mail submissions. Samples are filed. Responds only if interested. Will request portfolio review of color finished art, roughs, thumbnails and tearsheets, only if interested. Rights purchased vary according to project.

Text illustration Assigns 30 freelance illustration jobs a year. Pays by the project.

Tips "Our company is divided into adult and juvenile divisions; please send samples to the appropriate division. No phone calls!"

BLOOMSBURY CHILDREN'S BOOKS USA

175 Fifth Avenue, 8th Floor, New York NY 10011. (212)727-8300. Fax: (212)727-0984. E-mail: bloomsbury.kids@bloomsburyusa.com. Web site: www.bloomsburyusa.com. **Senior Designer:** Lizzy Bromley. Estab. 2001. Publishes hardcover and trade paperback originals and reprints. Types of books include children's picture books, fantasy, humor, juvenile and young adult fiction. Recent titles: *Ruby Sings the Blues*; *The Last Burp of Mac McGerp*. Publishes 50 titles/year. 50% require freelance design; 100% require freelance illustration. Book catalog not available.

Needs Works with 5 designers and 20 illustrators/year. Prefers local designers. 100% of freelance design work demands knowledge of Illustrator, QuarkXPress and Photoshop.

First Contact & Terms Designers: Send postcard sample or query letter with brochure, résumé, tearsheets. Illustrators: Send postcard sample or query letter with brochure, photocopies and SASE. After introductory mailing, send follow-up postcard sample every 6 months. Samples are filed or returned by SASE. Responds only if interested. Will contact artist for potfolio review if interested. Buys all rights. Finds freelancers through word of mouth.

Jackets/Covers Assigns 5 freelance cover illustration jobs/year.

BLUE DOLPHIN PUBLISHING, INC.

P.O. Box 8, Nevada City CA 95959. (530)477-1503. Fax: (530)477-8342. E-mail: bdolphin@blued olphinpublishing.com. Web site: www.bluedolphinpublishing.com. **President:** Paul M. Clemens. Estab. 1985. Publishes hardcover and trade paperback originals. Types of books include biography, cookbooks, humor and self-help. Specializes in comparative spiritual traditions, lay psychology and health. Recent titles include *Vegan Inspiration*, *Consciousness Is All*, *Embracing the Miraculous*, *Mary's Message to the World*, and *The Fifth Gospel*. Publishes 20 titles/year; 25% require freelance illustration; 30% require freelance design. Books are "high quality on good paper, with laminated dust jacket and color covers." Book catalog free upon request.

Needs Works with 5-6 freelance illustrators and designers/year. Uses freelancers mainly for book cover design; also for jacket/cover and text illustration. "More hardcovers and mixed media are requiring box design as well." 50% of freelance work demands knowledge of PageMaker, QuarkXPress, FreeHand, Illustrator, Photoshop, CorelDraw, InDesign and other IBM-compatible programs. Works on assignment only.

First Contact & Terms Send postcard sample or query letter with brochure and photocopies. Samples are filed or are returned by SASE if requested. Responds "whenever work needed matches portfolio." Originals are returned to artist at job's completion. Sometimes requests work on spec before assigning job. Considers project's budget when establishing payment. Negotiates rights purchased. Considers buying second rights (reprint rights) to previously published work.

Book Design Assigns 3-5 jobs/year. Pays by the hour, $10-15; or by the project, $300-900.

Jackets/Covers Assigns 5-6 design and 5-6 illustration jobs/year. Pays by the hour, $10-15; or by the project, $300-900.

Text Illustration Assigns 1-2 jobs/year. Pays by the hour, $10-15; or by the project, $300-900.

Tips "Send query letter with brief sample of style of work. We usually use local people, but are always looking for something special. Learning good design is more important than designing on the computer, but we are very computer-oriented. Basically we look for original artwork of any kind that will fit the covers for the subjects we publish. Please see our online catalog of over 250 titles to see what we have selected so far."

BOOK DESIGN

P.O. Box 193, Moose WY 83012-0193. Phone/fax: (307)733-6248. **Art Director:** Robin Graham. Specializes in high-quality hardcover and paperback originals. Recent titles: *Tales of the Wolf*; *Wildflowers of the Rocky Mountains*; *Mattie: A Woman's Journey West*; *Cubby in Wonderland*; *Windswept*; *The Iron Shirt*. Publishes more than 12 titles/year.

Needs Works with 20 freelance illustrators and 10 designers/year. Works on assignment only. "We are looking for top-notch quality only." 90% of freelance work demands knowledge of PageMaker and FreeHand for electronic submissions.

First Contact & Terms Send query letter with "examples of past work and one piece of original artwork that can be returned." Samples not filed are returned by SASE if requested. Responds in 20 days. Originals are not returned. Write for appointment to show portfolio. Negotiates rights purchased.

Book Design Assigns 6 freelance design jobs/year. Pays by the project, $50-3,500.

Jackets/Covers Assigns 2 freelance design and 4 illustration jobs/year. Pays by the project, $50-3,500.

Text Illustration Assigns 26 freelance jobs/year. Prefers technical pen illustration, maps (using

airbrush, overlays etc.), watercolor illustration for children's books, calligraphy and lettering for titles and headings. Pays by the hour, $5-20; or by the project, $50-3,500.

BOYDS MILLS PRESS
815 Church St., Honesdale PA 18431. (570)253-1164. Fax: (570)253-0179. Web site: www.boyds millspress.com. **Art Director:** Tim Gillner. Estab. 1990. Trade division of Highlights for Children, Inc. Publishes hardcover originals and reprints. Types of books include fiction, nonfiction, picture books and poetry. Recent titles: *A Splendid Friend, Indeed* by Suzanne Bloom; *Wings of Light: The Migration of the Yellow Butterfly* by Stephen R. Swinburne (illustrated by Bruce Hiscock); *All Aboard! Passenger Trains Around the World* by Karl Zimmermann (photographs by the author). Publishes 50 titles/year. 25% require freelance illustration/design.

Needs Works with 25-30 freelance illustrators and 5 designers/year. Prefers illustrators with book experience, but also uses illustrators of all calibers of experience. Uses freelancers mainly for picture books, poetry books, and jacket art. Works on assignment only.

First Contact & Terms Send sample tearsheets, color photocopies, postcards, or electronic submissions. If electronic samples are submitted, low-res JPEGs or links to Web sites are best. Samples are not returned. Samples should include color and b&w. Rights purchased vary according to project. Originals are returned at job's completion. Finds artists through submissions, sourcebooks, agents, Internet, and other publications.

Book Design Assigns 2-3 design/illustration jobs/year. Pays by the project.

Jackets/Covers Assigns 2-3 design/illustration jobs/year. Pays by the project.

Text Illustration Pays by the project.

Tips "Please don't send samples that need to be returned."

CACTUS GAME DESIGN, INC.
751 Tusquittee St., Hayesville, NC 28904. (828)389-1536. Fax: (828)389-1534. E-mail: rob@cact usgamedesign.com. Web site: www.cactusgamedesign.com. **Art Director:** Rob Anderson. Estab. 1995. Publishes comic books, game/trading cards, posters/calendars, CD-ROM/online games and board games. Main style/genre of games: science fiction, fantasy and Biblical. Recent products: *Outburst Bible Edition*; *Redemption 2nd Edition*; *Gil's Bible Jumble*. Publishes 2-3 titles or products/year. 100% require freelance illustration; 25% require freelance design.

Needs Approached by 100 illustrators and 10 designers/year. Works with 10 illustrators and 1 designer/year. Prefers freelancers experienced in fantasy and Biblical art. 100% of freelance design demands knowledge of Illustrator and Photoshop.

First Contact & Terms Send query letter with résumé and photocopies. Accepts disk submissions in Windows format. Send via CD, floppy disk, Zip as TIFF, GIF or JPEG files. Samples are filed. Responds only if interested. Portfolio review not required. Rights purchased vary according to project. Finds freelancers through submissions and word of mouth.

Visual Design Assigns 30-75 freelance design jobs/year. Pays for design by the hour, $20.

Book Covers/Posters/Cards Pays for illustration by the project, $25-250. "Artist must be aware of special art needs associated with Christian retail environment."

Tips "We like colorful action shots."

CANDLEWICK PRESS
2067 Massachusetts Ave., Cambridge MA 02140. (617)661-3330. Fax: (617)661-0565. Web site: www.candlewick.com. **Art Aquisitions:** Anne Moore. Estab. 1992. Publishes hardcover, trade

paperback children's books. Publishes 200 titles/year. 100% require freelance illustration. Book catalog not available.

Needs Works with 170 illustrators and 1-2 designers/year. 100% of freelance design demands knowledge of Photoshop, Illustrator or QuarkXPress.

First Contact & Terms Designers: Send query letter with résumé. Illustrators: Send query letter with photocopies. Accepts nonreturnable disk submissions from illustrators. Samples are filed and are not returned. Will contact artist for portfolio review of artwork and tearsheets if interested. Rights purchased vary according to project.

Text Illustration Finds illustrators through agents, sourcebooks, word of mouth, submissions, art schools.

Tips "We generally use illustrators with prior trade book experience."

CENTERSTREAM PUBLISHING

P.O. Box 17878, Anaheim Hills CA 92817-7878. (714)779-9390. Fax: (714)779-9390. E-mail: centerstrm@aol.com. Web site: www.centerstream-usa.com. **Production:** Ron Middlebrook. Estab. 1978. Publishes DVDs, audio tapes, and hardcover and softcover originals. Types of books include music reference, biography, music history and music instruction. Recent titles include *Melodic Lines for the Intermediate Guitarist* (book/CD pack), *The Banjo Music of Tony Ellis*, *The Early Minstrel Banjo* and *More Dobro* (DVD). Publishes 10-20 titles/year; 100% require freelance illustration. Book catalog free for 6×9 SAE with 2 first-class stamps.

Needs Approached by 12 illustrators/year. Works with 3 illustrators/year.

First Contact & Terms Illustrators: Send postcard sample or tearsheets. Accepts Mac-compatible disk submissions. Samples are not filed and are returned by SASE. Responds only if interested. Buys all rights, or rights purchased vary according to project.

CHILDREN'S BOOK PRESS

965 Mission St., Suite 425, San Francisco CA 94103-2961. (866)935-2665. Fax: (415)543-2665. E-mail: submissions@childrensbookpress.org. Web site: www.childrensbookpress.org. **Contact:** Submissions. Estab. 1975. Nonprofit publishing house that "promotes cooperation and understanding through multicultural and bilingual literature, offering children a sense of their culture, history and importance." Publishes hardcover originals and trade paperback reprints. Types of books include juvenile picture books only. Specializes in multicultural. Publishes 4 titles/year. 100% require freelance illustration and design.

Needs Approached by 1,000 illustrators and 20 designers/year. Works with 2 illustrators and 2 designers/year. Prefers local designers experienced in QuarkXPress (designers) and previous children's picture book experience (illustrators). Uses freelancers for 32-page picture book design. 100% of freelance design demands knowledge of Photoshop, Illustrator and QuarkXPress.

First Contact & Terms Send query letter with color photocopies, résumé, bio and SASE. Responds in 8-10 weeks, only if interested or if SASE is included. Will contact artist for portfolio review if interested. Buys all rights.

Book Design Assigns 2 freelance design jobs/year. Pays by the project.

Text Illustration Assigns 2 freelance illustration jobs/year. Pays royalty.

Tips "We look for a multicultural experience. We are especially interested in the use of bright colors and non-traditional instructive approach."

⨳ CHOWDER BAY BOOKS

P.O. Box 5542, Lake Worth FL 33466-5534. E-mail: acquisitions@chowderbaybooks.com. Web site: www.chowderbaybooks.com. **Acquisitions Editor:** Anna Valencia. Estab. 2007. Publishes hardcover originals, trade paperback originals and reprints. Types of books include mainstream fiction, experimental fiction, fantasy, humor, juvenile, young adult, preschool, instructional, biography. Publishes 8-10 titles/year. 100% require freelance design and illustration. Book catalog available on Web site.

● See also listing for Pinestein Press in this section.

Needs Approached by 200 designers and 480 illustrators/year. Works with 2 designers and 4 illustrators/year. 80% of freelance design work demands skills in Photoshop and QuarkXPress. 80% of freelance illustration work demands skills in FreeHand and Photoshop.

First Contact & Terms Send postcard sample with URL. Accepts e-mail submissions with link to Web site. Prefers Windows-compatible JPEG, TIFF or GIF files. Samples are filed and are not returned. Responds only if interested. Rights purchased vary according to project. Finds freelancers through submissions, word of mouth, magazines, Internet.

Jackets/Covers Assigns 8 illustration jobs/year. Pays by the project; varies.

Text Illustration Assigns 4 illustration jobs/year. Pays by the project; varies.

Tips ''We're always willing to look at online portfolios. The best way to direct us there is via a simple postcard with URL. We are a young company with serious goals and a focus on creativity. While we are unable to respond directly to all inquiries or submissions, we do review everything that hits our inboxes (both e-mail and snail mail). Look for us at industry exhibits and conferences. We often seek new talent at industry events.''

CHURCH PUBLISHING, INC.

(formerly Morehouse Publishing Group), 445 Fifth Ave., New York NY . (212)592-6414. Fax: 212) 779-3392. E-mail: morehouse@morehousepublishing.org. Web site: www.churchpublishing.org. Estab. 1884. Company publishes trade paperback and hardcover originals and reprints. Books are religious. Specializes in spirituality, Christianity/contemporary issues. Publishes 30 titles/year. Recent titles include *A Wing and a Prayer*, by Katharine Jefferts Schori; *God of the Sparrow*, by Jaroslau Vajda, illustrated by Preston McDaniels. Book catalog free by request.

Needs Works with 1-2 illustrators/year. Prefers freelancers with experience in religious (particularly Christian) topics. Also uses original artall media. Works on assignment only.

First Contact & Terms Send query letter with résumé and photocopies. Samples are filed. Portfolio review not required. Usually buys one-time rights. Finds artists through freelance submissions, *Literary Market Place* and mostly word of mouth.

Text Illustration Assigns 1-2 freelance illustration jobs/year.

Tips ''Prefer using freelancers who are located in central Pennsylvania and are available for meetings when necessary.''

⨳ THE COUNTRYMAN PRESS

(Division of W.W. Norton & Co., Inc.), Box 748, Woodstock VT 05091. (802)457-4826. Fax: (802)457-1678. E-mail: countrymanpress@wwnorton.com. Web site: www.countrymanpress.com. **Contact:** Managing Editor. Estab. 1976. Book publisher. Publishes hardcover originals and reprints, and trade paperback originals and reprints. Types of books include history, cooking, travel, nature and recreational guides. Specializes in recreational (biking/hiking) guides. Publishes 60 titles/year. Titles include: *The King Arthur Flour Baker's Companion* and *Maine: An*

Explorer's Guide. 10% require freelance illustration; 60% require freelance cover design. Book catalog free by request.

Needs Works with 7 designers/year. Uses freelancers for jacket/cover and book design. Works on assignment only. Prefers working with computer-literate artists/designers with knowledge of Photoshop, Illustrator, QuarkXPress and InDesign.

First Contact & Terms Send query letter with appropriate samples. Samples are filed. Responds to the artist only if interested. To show portfolio, e-mail PDF. Negotiates rights purchased.

Book Design Assigns 10 freelance design jobs/year. Pays for design by the project, $1,000-1,500.

Jackets/Covers Assigns 10 freelance design jobs/year. Pays for design $1,000-1,500.

CRC PRODUCT SERVICES

2850 Kalamazoo Ave. SE, Grand Rapids MI 49560. (616)224-0780. Fax: (616)224-0834. Web site: www.crcna.org. **Art Director:** Dean Heetderks. Estab. 1866. Publishes hardcover and trade paperback originals and magazines. Types of books include instructional, religious, young adult, reference, juvenile and preschool. Specializes in religious educational materials. Publishes 8-12 titles/year. 85% require freelance illustration. 5% require freelance art direction.

Needs Approached by 30-45 freelancers/year. Works with 12-16 freelance illustrators/year. Prefers freelancers with religious education, cross-cultural sensitivities. Uses freelancers for jacket/cover and text illustration. Works on assignment only.

First Contact & Terms Send query letter with brochure, résumé, tearsheets, photographs, photocopies, slides and transparencies. Submissions will not be returned. Illustration guidelines are available on Web site. Samples are filed. Portfolio should include thumbnails, roughs, finished samples, color slides, tearsheets, transparencies and photographs. Buys one-time rights. Originals are returned at job's completion.

Jackets/Covers Assigns 2-3 freelance illustration jobs/year. Pays by the project, $200-1,000.

Text Illustration Assigns 50-100 freelance illustration jobs/year. Pays by the project, $75-100. "This is high-volume work. We publish many pieces by the same artist."

Tips "Be absolutely professional. Know how people learn and be able to communicate a concept clearly in your art."

CRUMB ELBOW PUBLISHING

73487 E Buggy Trl. Dr., Rhododendron OR 97049. **Publisher:** Michael P. Jones. Estab. 1979. Publishes juvenile, educational, environmental, nature, historical, multicultural, travel and guidebooks. Publishes 40 titles/year. 75% require freelance illustration; 75% require freelance design.

Needs Approached by 250 freelancers/year. Works with 200 illustrators and 10 designers/year. Uses freelancers for jacket/cover design and illustration, text illustration, book and catalog design, calendars, prints, note cards. 50% of freelance work demands computer skills. Works on assignment only.

First Contact & Terms Send query letter with brochure, SASE, tearsheets and photocopies. Samples are filed or returned by SASE if requested by artist. Responds in 1 month. Request portfolio review in original query. Portfolio should include book dummy, final art, photographs, roughs, slides and tearsheets. Buys one-time rights. Originals are returned at job's completion.

Book Design Assigns 200 freelance cover illustrations/year. Pays by the project, $50-250 or in published copies.

Jackets/Covers Assigns 35 freelance design and 60 illustration jobs/year. Pays by the project, $50-250 or in published copies.

Text Illustration Assigns 40 freelance illustration jobs/year. Pays by the project, $50-250 or in published copies. Prefers pen & ink.

Tips "We find talented individuals to illustrate our projects any way we can. Generally artists hear about us and want to work with us. We are a very small company that gives beginners a chance to showcase their talents in a book project; and yet, more established artists are in touch with us because our projects are interesting (like American Indian mythology, The Oregon Trail, wildlife, etc.)."

DARK HORSE

10956 SE Main, Milwaukie OR 97222. E-mail: dhcomics@darkhorse.com. Web site: www.darkh orse.com. **Contact:** Submissions. Estab. 1986. Publishes mass market and trade paperback origi- nals. Types of books include comic books and graphic novels. Specializes in comic books. Recent titles include: *B.P.R.D.: The Universal Machine #2*, by Mike Mignola; *Star Wars: Knights of the Old Republic #4*, by John Jackson Miller; *Usagi Yojimbo #93*, by Stan Sakai. Book catalog available on Web site.

First Contact & Terms Send photocopies (clean, sharp, with name, address and phone number written clearly on each page). Samples are not filed and not returned. Responds only if interested. Company will contact artist for portfolio review interested.

Tips "If you're looking for constructive criticism, show your work to industry professionals at conventions."

JONATHAN DAVID PUBLISHERS, INC.

68-22 Eliot Ave., Middle Village NY 11379. (718)456-8611. Fax: (718)894-2818. E-mail: submissi ons@jdbooks.com. Web site: www.jdbooks.com. **Contact:** Editorial Review. Estab. 1948. Pub- lishes hardcover and paperback originals. Types of books include biography, religious, young adult, reference, juvenile and cookbooks. Specializes in Judaica. Titles include *Drawing a Crowd* and *The Presidents of the United States & the Jews*. Publishes 25 titles/year. 50% require freelance illustration; 75% require freelance design.

Needs Approached by numerous freelancers/year. Works with 5 freelance illustrators and 5 designers/year. Prefers freelancers with experience in book jacket design and jacket/cover illus- tration. 100% of design and 5% of illustration demand computer literacy. Works on assignment only.

First Contact & Terms Designers: Send query letter with résumé and photocopies. Illustrators: Send postcard sample and/or query letter with photocopies, résumé. Samples are filed. Produc- tion coordinator will contact artist for portfolio review if interested. Portfolio should include color final art and photographs. Buys all rights. Originals are not returned. Finds artists through submissions.

Book Design Assigns 15-20 freelance design jobs/year. Pays by the project.

Jackets/Covers Assigns 15-20 freelance design and 4-5 illustration jobs/year. Pays by the proj- ect.

Tips First-time assignments are usually book jackets, mechanicals and artwork.

N DC COMICS

Time Warner Entertainment, 1700 Broadway, 5th Floor, New York NY 10019. (212)636-5400. Fax: (212)636-5481. Web site: www.dccomics.com. **Vice President of Design and Retail Pro- duce Development:** Georg Brewer. Estab. 1948. Publishes hardcover originals and reprints,

mass market paperback originals and reprints, trade paperback originals and reprints. Types of books include adventure, comic books, fantasy, horror, humor, juvenile, science fiction. Specializes in comic books. Publishes 1,000 titles/year.

- DC Comics does not accept unsolicited submissions.

DIAL BOOKS FOR YOUNG READERS

Penguin Group USA, 345 Hudson St., New York NY 10014. (212)414-3412. Fax: (212)414-3398. Web site: http://us.penguingroup.com. **Art Director:** Lily Malcom. Specializes in juvenile and young adult hardcover originals. Recent titles: *Snowmen at Night* by Caralyn and Mark Buchner; *The Surprise Visitor* by Juli Kangas. Publishes 50 titles/year. 100% require freelance illustration. Books are "distinguished children's books."

Needs Approached by 400 freelancers/year. Works with 40 freelance illustrators/year. Prefers freelancers with some book experience. Works on assignment only.

First Contact & Terms Send query letter with photocopies, tearsheets and SASE. Samples are filed or returned by SASE. Responds only if interested. Considers complexity of project, skill and experience of artist and project's budget when establishing payment. Rights purchased vary.

Jackets/Covers Assigns 8 illustration jobs/year. Pays by the project.

Text Illustration Assigns 40 freelance illustration jobs/year. Pays by the project.

Tips "Never send original art. Never send art by e-mail, fax or CD. Please do not phone, fax or e-mail to inquire after your art submission."

N EDUCATIONAL IMPRESSIONS, INC.

116 Washington Ave., Hawthorne NJ 07507. (973)423-4666. Fax: (973)423-5569. E-mail: awpeller@optionline.net. Web site: www.awpeller.com. **Art Director:** Karen Birchak. Estab. 1983. Publishes original workbooks with 2-4 color covers and b&w text. Types of books include instructional, juvenile, young adult, reference, history and educational. Specializes in all educational topics. Publishes 4-12 titles/year. Recent titles include: *September, October and November*, by Rebecca Stark; *Tuck Everlasting*; *Walk Two Moons Lit Guides*. Books are bright and bold with eye-catching, juvenile designs/illustrations.

Needs Works with 1-5 freelance illustrators/year. Prefers freelancers who specialize in children's book illustration. Uses freelancers for jacket/cover and text illustration. Also for jacket/cover design. 50% of illustration demands knowledge of QuarkXPress and Photoshop. Works on assignment only.

First Contact & Terms Send query letter with tearsheets, SASE, résumé and photocopies. Samples are filed. Art director will contact artist for portfolio review if interested. Buys all rights. Interested in buying second rights (reprint rights) to previously published work. Originals are not returned. Prefers line art for the juvenile market. Sometimes requests work on spec before assigning a job.

Book Design Pays by the project, $20 minimum.

Jackets/Covers Pays by the project, $20 minimum.

Text Illustration Pays by the project, $20 minimum.

Tips "Send juvenile-oriented illustrations as samples."

E EDWARD ELGAR PUBLISHING INC.

9 Dewey Court, Northampton MA 01060-3815. (413)584-5551. Fax: (413)584-9933. E-mail: submissions@e-elgar.com. Web site: www.e-elgar.com. Estab. 1986. Publishes hardcover originals

and textbooks. Types of books include instructional, nonfiction, reference, textbooks, academic monographs, references in economics and business and law. Recent titles: *Asia-Specific Geopolitics*; *Climate and Trade Policy*; *Corporate Culture and Environmental Practice*. Publishes 200 titles/year.

● This publisher uses only freelance designers. Its academic books are produced in the United Kingdom. Direct Marketing material is done in U.S. There is no call for illustration.

Needs Approached by 2-4 designers/year. Works with 2 designers/year. Prefers local designers experienced in direct mail and academic publishing. 100% of freelance design demands knowledge of Photoshop, InDesign.

First Contact & Terms Send query letter with printed samples. Accepts Mac-compatible disk submissions. Samples are filed. Will contact artist for portfolio review if interested. Buys one-time rights or rights purchased vary according to project. Finds freelancers through word of mouth, local sources (i.e., phone book, newspaper, etc.).

F+W MEDIA, INC.

4700 E. Galbraith Rd., Cincinnati OH 45236. Web site: www.fwpublications.com. **Art Directors:** Grace Ring, Marissa Bowers, Wendy Dunning, Michelle Thompson. Publishes 120 books/year for writers, artists, graphic designers and photographers, plus selected trade (humor, lifestyle, home improvement) titles. Books are heavy on type-sensitive design.

● Imprints include Writer's Digest Books, TOW Books, HOW Books, Betterway Books, North Light Books, IMPACT Books, Popular Woodworking Books, Memory Makers Books, Adams Media, David & Charles, Krause Publications. See separate listings for Adams, IMPACT and North Light in this section for recent titles and specific guidelines. See also F+W's listing in the Magazines section.

Needs Works with 10-20 freelance illustrators and less than 5 designers/year. Uses freelancers for jacket/cover design and illustration, text illustration, direct mail and book design. Works on assignment only.

First Contact & Terms Send nonreturnable photocopies of printed work to be kept on file. Art director will contact artist for portfolio review if interested. Considers buying second rights (reprint rights) to previously published illustrations. ''We like to know where art was previously published.'' Finds illustrators and designers through word of mouth and submissions/self promotions.

Book Design Pays by the project, $600-1,000.

Jackets/Covers Pays by the project, $750.

Text Illustration Pays by the project, $100 minimum.

Tips ''Don't call. Send appropriate samples we can keep. Clearly indicate what type of work you are looking for.''

▣ FANTAGRAPHICS BOOKS, INC.

7563 Lake City Way NE, Seattle WA 98115. (206)524-1967. Fax: (206)524-2104. E-mail: fbicomix @fantagraphics.com. Web site: www.fantagraphics.com. **Contact:** Submissions Editor. Estab. 1976. Publishes hardcover and trade paperback originals and reprints. Types of books include contemporary, experimental, mainstream, historical, humor and erotic. ''All our books are comic books or graphic stories.'' Recent titles: *Love & Rockets*; *Hate*; *Eightball*; *Acme Novelty Library*; *The Three Paradoxes*. Publishes 100 titles/year. 10% require freelance illustration. Book catalog free by request. Art submission guidelines available on Web site.

● See additional listing in the Magazines section.

Needs Approached by 500 freelancers/year. Works with 25 freelance illustrators/year. Must be interested in and willing to do comics. Uses freelancers for comic book interiors and covers.

First Contact & Terms Send query letter addressed to Submissions Editor with résumé, SASE, photocopies and finished comics work. Samples are not filed and are returned by SASE. Responds only if interested. Call or write for appointment to show portfolio of original/final art and b&w samples. Buys one-time rights or negotiates rights purchased. Originals are returned at job's completion. Pays royalties.

Tips "We want to see completed comics stories. We don't make assignments, but instead look for interesting material to publish that is pre-existing. We want cartoonists who have an individual style, who create stories that are personal expressions."

FORT ROSS INC.

26 Arthur Place, Yonkers NY 10701. (914)375-6448. E-mail: fortross@optonline.net or vkartsev2 000@yahoo.com. Web site: www.fortrossinc.com. **Executive Director:** Dr. Vladimir P. Kartsev. Represents leading Russian, Polish, Spanish, etc., publishing companies in the US and Canada. Estab. 1992. Hardcover originals, mass market paperback originals and reprints, and trade paperback reprints. Works with adventure, fantasy, horror, romance, science fiction. Specializes in romance, science fiction, fantasy, mystery. Publishes 5 titles/year. Represents 500 titles/year. Recent titles include: translations of *Judo*, by Vladamir Putin; *The Redemption*, by Howard Fast. 100% requires freelance illustration. Book catalog not available.

 ● "We have drastically changed the exterior of books published in Europe using classical American illustrations and covers."

Needs Approached by 100 illustrators/year. Works with 40 illustrators/year. Prefers freelancers experienced in romance, science fiction, fantasy, mystery cover art.

First Contact & Terms Illustrators: Send query letter with printed samples, photocopies, SASE, tearsheets. Accepts Windows-compatible disk submissions. Send EPS files. Samples are filed. Will contact artist for portfolio review if interested. Buys secondary rights. Finds freelancers through agents, networking events, sourcebooks, *Black Book*; *RSVP*; *Spectrum*.

Jackets/Covers Buys up to 1,000 illustrations/year. Pays for illustration by the project, $50-150 for secondary rights (for each country). Prefers experienced romance, mystery, science fiction, fantasy cover illustrators.

Tips "Fort Ross is the best place for experienced cover artists to sell secondary rights for their images in Russia, Poland, Spain, Czech Republic, countries of the former USSR, Central and Eastern Europe. We prefer realistic, thoroughly executed expressive images on our covers."

FULCRUM PUBLISHING

16100 Table Mountain Parkway #300, Golden CO 80403. (303)277-1623. Fax: (303)279-7111. Web site: www.fulcrum-books.com. **Contact:** Art Director. Estab. 1984. Book publisher. Publishes hardcover originals and trade paperback originals and reprints. Types of books include biography, Native American, reference, history, self help, children's, teacher resource books, travel, humor, gardening and nature. Specializes in history, nature, teacher resource books, travel, Native American, environmental and gardening. Publishes 50 titles/year. Recent titles include: *Broken Trail*, by Alan Geaffrion; *Anton Wood: The Boy Murderer*, by Dick Kreck. 15% requires freelance illustration; 15% requires freelance design. Book catalog free by request.

Needs Uses freelancers mainly for cover and interior illustrations for gardening books. Also for

other jacket/covers, text illustration and book design. Works on assignment only.

First Contact & Terms Send query letter with tearsheets, photographs, photocopies and photostats. Samples are filed. Responds to artist only if interested. To show portfolio, mail b&w photostats. Buys one-time rights. Originals are returned at job's completion.

Book Design Pays by the project.

Jackets/Covers Pays by the project.

Text Illustration Pays by the project.

Tips Previous book design experience a plus.

GALISON BOOKS/MUDPUPPY PRESS

28 W. 44th St., New York NY 10036. (212)354-8840. Fax: (212)391-4037. E-mail: carole@galison .com. Web site: www.galison.com. **Art Director:** Carole Otypka. Publishes note cards, journals, stationery, children's products. Publishes 120 titles/year.

 • See additional listing in the Greeting Cards, Gifts & Products section.

Needs Works with 20 illustrators. Assigns 5-10 freelance cover illustrations/year. Some freelance design demands knowledge of Photoshop, Illustrator and QuarkXPress.

First Contact & Terms Send photocopies, printed samples, tearsheets or e-mail with link to Web site. Samples are filed or returned by SASE. Will contact artist for portfolio review if interested. Rights purchased vary according to project.

GEM GUIDES BOOK CO.

315 Cloverleaf Dr., Suite F, Baldwin Park CA 91706. (626)855-1611. Fax: (626)855-1610. E-mail: gembooks@aol.com. Web site: www.gemguidesbooks.com. **Editors:** Kathy Mayerski and Nancy Fox. Estab. 1964. Book publisher and wholesaler of trade paperback originals and reprints. Types of books include rocks and minerals, guide books, travel, history and regional (western U.S.). Specializes in travel and local interest (western Americana). Recent titles include *Geodes: Nature's Treasures* by Brad L. Cross and June Culp Zeither, *Baby's Day Out in Southern California: Fun Places to Go with Babies and Toddlers* by Jobea Holt, *Fee Mining and Rockhounding Adventures in the West 2/E* by James Martin and Jeannette Hathaway Monaco, and *Moving to Arizona 5/E* by Dorothy Tegeler. Publishes 7 titles/year; 100% require freelance cover design.

Needs Approached by 12 freelancers/year. Works with 1 designer/year. Uses freelancers mainly for covers. 100% of freelance work demands knowledge of Quark, Illustrator, Photoshop. Works on assignment only.

First Contact & Terms Send query letter with brochure, résumé and SASE; or e-mail. Samples are filed. Editor will contact artist for portfolio review if interested. Requests work on spec before assigning a job. Buys all rights. Originals are not returned. Finds artists through word of mouth and "our files."

Jackets/Covers Pays by the project.

GIBBS SMITH, PUBLISHER

P.O. Box 667, Layton UT 84041. (801)544-9800. Fax: (801)546-8853. E-mail: staylor@gibbs-smith.com. Web site: www.gibbs-smith.com. **Contact:** Suzanne Taylor, VP/editorial director. Estab. 1969. Imprints include Sierra Book Club for Children and Hill Street Press. Company publishes hardcover and trade paperback originals. Types of books include children's activity books, architecture and design books, cookbooks, humor, juvenile, western. Publishes 100 titles/year. Recent titles include *Pink Princess Tea Parties and the Pocket Guide to Mischief.* 10%

requires freelance illustration; 90% requires freelance design. Book catalog free for 8×11 SASE with $1.24 postage.

Needs Approached by 250 freelance illustrators and 50 freelance designers/year. Works with 5 freelance illustrators and 15 designers/year. Designers may be located anywhere with Broadband service. Uses freelancers mainly for cover design and book layout, cartoon illustration, children's book illustration. 100% of freelance design demands knowledge of QuarkXPress or Indesign. 70% of freelance illustration demands knowledge of Photoshop, Illustrator and FreeHand.

First Contact Terms Designers: Send samples for file. Illustrators: Send printed samples and photocopies. Samples are filed. Responds only if interested. Finds freelancers through submission packets and illustration annuals.

Book Design Assigns 90 freelance design jobs/year. Pays by the project, $12-15/page.

Jackets/Covers Assigns 90 freelance design jobs and 5 illustration jobs/year. Pays for design by the project, $500-800. Pays for illustration by the project.

Text Illustration Assigns 1 freelance illustration job/year. Pays by the project.

THE GRADUATE GROUP

P.O. Box 370351, West Hartford CT 06137-0351. (860)233-2330. E-mail: graduategroup@hotmail.com. Web site: www.graduategroup.com. **President:** Mara Whitman. Estab. 1967. Publishes trade paperback originals. Types of books include instructional and reference. Specializes in internships and career planning. Recent titles include *Create Your Ultimate Résumé, Portfolio, and Writing Samples: An Employment Guide for the Technical Communicator* by Mara W. Cohen Ioannides. Publishes 35 titles/year; 10% require freelance illustration and design. Book catalog free by request.

Needs Approached by 20 freelancers/year. Works with 1 freelance illustrator and 1 designer/year. Prefers local freelancers only. Uses freelancers for jacket/cover illustration and design; direct mail, book and catalog design. 5% of freelance work demands computer skills. Works on assignment only.

First Contact & Terms Send query letter with brochure and résumé. Samples are not filed. Responds only if interested. Write for appointment to show portfolio.

GREAT QUOTATIONS PUBLISHING

8102 Lemont Rd., #300, Woodridge IL 60517. (630)390-3580. Fax: (630)390-3585. **Contact:** Melanie Moorhouse. Estab. 1985. Imprint of Greatime Offset Printing. Publishes hardcover, trade paperback and mass market paperback originals. Types of books include humor, inspiration, motivation and books for children. Specializes in gift books. Recent titles: *Only a Sister Could Be Such a Good Friend*; *Words From the Coach*. Publishes 50 titles/year. 50% require freelance illustration and design. Book catalog available for $3 with SASE.

Needs Approached by 100 freelancers/year. Works with 20 designers and 20 illustrators/year. Uses freelancers to illustrate and/or design books and catalogs. 50% of freelance work demands knowledge of QuarkXPress and Photoshop. Works on assignment only.

First Contact & Terms Send letter of introduction and sample pages. Name, address and telephone number should be clearly displayed on the front of the sample. All appropriate samples will be placed in publisher's library. Design Editor will contact artist under consideration, as prospective projects become available. Rights purchased vary according to project.

Jackets/Covers Assigns 20 freelance cover illustration jobs/year. Pays by the project, $300-3,000.

Text Illustration Assigns 30 freelance text illustration jobs/year. Pays by the project, $100-1,000.
Tips "We're looking for bright, colorful cover design on a small-size book cover (around 6×6). Outstanding humor or motivational titles will be most in demand."

GROUP PUBLISHING—BOOK PRODUCT

P.O. Box 481, Loveland CO 80539. (970)669-3836. Fax: (970)292-4391. Web site: www.group.c om. **Art Directors:** Jeff Storm (children's/women's books), Michael Paustian (curriculum), Lisa Harris (Vacation Bible School). Senior Project Manager: Pam Clifford (books). Company publishes books, Bible curriculum products (including puzzles, posters, etc.), clip art resources and audiovisual materials for use in Christian education for children, youth and adults. Publishes 35-40 titles/year. Recent titles include: *Group's Scripture Scrapbook Series*, *The Dirt on Learning*; *Group's Hands-On Bible Curriculum*; *Group's Treasure Serengeti Trek Vacation Bible School*; *Faith Weaver Bible Curriculum*.

• See additional listing in the Magazines section.

Needs Uses freelancers for cover illustration and design. 100% of design and 50% of illustration demand knowledge of InDesign CS2, Photoshop 7.0, Illustrator 9.0. Occasionally uses cartoons in books and teacher's guides. Uses b&w and color illustration on covers and in product interiors.

First Contact & Terms Contact Jeff Storm, Marketing Art Director, if interested in cover design or illustration. Contact if interested in book and curriculum interior illustration and design and curriculum cover design. Send query letter with nonreturnable b&w or color photocopies, slides, tearsheets or other samples. Accepts disk submissions. Samples are filed, additional samples may be requested prior to assignment. Responds only if interested. Rights purchased vary according to project.

Jackets/Covers Assigns minimum 15 freelance design and 10 freelance illustration jobs/year. Pays for design, $250-1,200; pays for illustration, $250-1,200.

Text Illustration Assigns minimum 20 freelance illustration projects/year. **Pays on acceptance.** $40-200 for b&w (from small spot illustrations to full page). Fees for color illustration and design work vary and are negotiable. Prefers b&w line or line and wash illustrations to accompany lesson activities.

Tips "We prefer contemporary, nontraditional styles appropriate for our innovative and upbeat products and the creative Christian teachers and students who use them. We seek experienced designers and artists who can help us achieve our goal of presenting biblical material in fresh, new and engaging ways. Submit design/illustration on disk. Self promotion pieces help get you noticed. Have book covers/jackets, brochure design, newsletter or catalog design in your portfolio. Include samples of Bible or church-related illustration."

GRYPHON PUBLICATIONS

P.O. Box 209, Brooklyn NY 11228-0209. Web site: www.gryphonbooks.com. Estab. 1983. Publishes hardcover originals, trade paperback originals and reprints, reference books and magazines. Types of books include science fiction, mystery and reference. Specializes in crime fiction and bibliography. Recent titles: *Difficult Lives* by James Salli; *Vampire Junkies* by Norman Spinrad. Publishes 20 titles/year. 40% require freelance illustration; 10% require freelance design. Book catalog free for #10 SASE.

• Also publishes *Hardboiled*, a quarterly magazine of noir fiction, and *Paperback Parade*, a magazine for paperback readers and collectors.

Needs Approached by 75-200 freelancers/year. Works with 10 freelance illustrators and 1 de-

signer/year. Prefers freelancers with "professional attitude." Uses freelancers mainly for book and magazine cover and interior illustrations; also for jacket/cover, book and catalog design. Works on assignment only.

First Contact & Terms Send query letter with résumé, SASE, tearsheets or photocopies. Samples are filed. Responds in 2 weeks, only if interested. Buys one-time rights. "I will look at reprints if they are of high quality and cost effective." Originals are returned at job's completion if requested. Send b&w samples only.

Jackets/Covers Assigns 2 freelance design and 5-6 illustration jobs/year. Pays by the project, $25-150.

Text Illustration Assigns 2 freelance jobs/year. Pays by the project, $10-100. Prefers b&w line drawings.

Tips "It is best to send photocopies of your work with an SASE and query letter. Then we will contact on a freelance basis."

GUERNICA EDITIONS

11 Mount Royal Ave., Toronto ON M6H 2S2 Canada. (416)658-9888. Fax: (416)657-8885. E-mail: guernicaeditions@cs.com. Web site: www.guernicaeditions.com. **Publisher/Editor:** Antonio D'Alfonso. Estab. 1978. Book publisher and literary press specializing in translation. Publishes trade paperback originals and reprints. Types of books include contemporary and experimental fiction, biography and history. Specializes in ethnic/multicultural writing and translation of European and Quebecois writers into English. Recent titles include *Peace Tower* by F.G. Paci (artist Hono Lulu) and *Medusa Subway* by Clara Blackwood (artist Normand Cousineau). Publishes 20-25 titles/year; 40-50% require freelance illustration. Book catalog available for SAE; include IRC if sending from outside Canada.

Needs Approached by 6 freelancers/year. Works with 6 freelance illustrators/year. Uses freelancers mainly for jacket/cover illustration.

First Contact & Terms Send query letter with résumé, SASE (or SAE with IRC), tearsheets, photographs and photocopies. Samples are filed or are returned by SASE if requested by artist. Responds only if interested. To show portfolio, mail photostats, tearsheets and dummies. Buys one-time rights. Originals are not returned at job completion.

Jackets/Covers Assigns 10 freelance illustration jobs/year. Pays by the project, $150-200.

Tips "We really believe that the author should be aware of the press they work with. Try to see what a press does and offer your own view of that look. We are looking for strong designers. We have three new series of books, so there is a lot of place for art work."

HARVEST HOUSE PUBLISHERS

990 Owen Loop N., Eugene OR 97402. (541)343-0123. Fax: (541)242-8819. **Contact:** Cover Coordinator. Specializes in hardcover and paperback editions of Christian evangelical adult fiction and nonfiction, children's books, gift books and youth material. Publishes 100-125 titles/year. Recent titles include: *Why is the Sky Blue?*; *Power of a Praying Teen*; *Discovering Your Divine Assignment*; *My Little Angel.* Books are of contemporary designs which compete with the current book market.

Needs Works with 1-2 freelance illustrators and 4-5 freelance designers/year. Uses freelance artists mainly for cover art. Also uses freelance artists for text illustration. Works on assignment only.

First Contact & Terms Send query letter with brochure, résumé, tearsheets and photographs.

Art director will contact artist for portfolio review if interested. Requests work on spec before assigning a job. Originals may be returned at job's completion. Buys all rights. Finds artists through word of mouth and submissions/self-promotions.

Book Design Pays by the project.

Jackets/Covers Assigns 100-125 design and less than 5 illustration jobs/year. Pays by the project.

Text Illustration Assigns less than 5 jobs/year. Pays by the project.

◨ HAY HOUSE, INC.

P.O. Box 5100, Carlsbad CA 92018-5100. (760)431-7695 or (800)431-7695. Fax: (760)431-6948. E-mail: csalinas@hayhouse.com. Web site: www.hayhouse.com. **Art Director:** Christy Salinas. Publishes hardcover originals and reprints, trade paperback originals and reprints, CDs, DVDs and VHS tapes. Types of books include self-help, mind-body-spirit, psychology, finance, health and fitness, nutrition, astrology. Recent titles include *Inspiration, Your Ultimate Calling* by Wayne Dyer,*If You Could See What I See* by Sylvia Browne, *Left to Tell* by Immaculee Illibagiza. Publishes 175 titles/year; 40% require freelance illustration; 30% require freelance design.

• Hay House is also looking for people who design for the gift market.

Needs Approached by 50 illustrators and 5 designers/year. Works with 20 illustrators and 2-5 designers/year. Uses freelancers mainly for cover design and illustration. 80% of freelance design demands knowledge of Photoshop, Illustrator, QuarkXPress. 20% of titles require freelance art direction.

First Contact & Terms Send e-mail to csalinas@hayhouse.com or send non-returnable samples to the address above. Art director will contact if interested. Buys all rights. Finds freelancers through word of mouth and submissions.

Illustrations Purchases 200+ illustrations per year. A project such as illustrated "card deck" with affirmations may have 50 original illustrations. Illustrators must have a strong ability to conceptualize.

Tips "We look for freelancers with experience in graphic design, desktop publishing, printing processes, production and illustrators with strong ability to conceptualize."

HEAVY METAL

100 N. Village Rd., Suite 12, Rookvill Center NY 11570. Web site: www.metaltv.com. **Contact:** Submissions. Estab. 1977. Publishes trade paperback originals. Types of books include comic books, fantasy and erotic fiction. Specializes in fantasy. Recent titles: *The Universe of Cromwell*; *Serpieri Clone*. Art guidelines available on Web site.

• See additional listing in the Magazines section.

First Contact & Terms Send contact information (mailing address, phone, fax, e-mail), photocopies, photographs, SASE, slides. Samples are returned only by SASE. Responds in 3 months.

Tips "Please look over the kinds of work we publish carefully so you get a feel for what we are looking for."

⊕ ◨ HEMKUNT PUBLISHERS PVT. LTD.

A-78, Naraina Industrial Area Phase I, New Delhi 110028 India. 011-91-11 4141-2083, 2579-0032 or 2579-5079. E-mail: hemkunt@ndf.vsnl.net.in. Web site: www.hemkuntpublishers.com. **Chief Executive:** Mr. G.P. Singh. Director of Marketing: Arvinder Singh. Director of Production: Deepinder Singh. Specializes in educational text books, illustrated general books for children, and books for adults on various subjects. Subjects include religion, history, etc. Recent titles

include *Semlicemente Italiano—Simple Italian Recipes*, *More Tales of Birbal and Akbar*, *Bedtime Stories from Around the World*. Publishes 10-15 new titles/year.

Needs Works with 30-40 illustrators and 3-5 designers/year. Uses freelancers mainly for illustration and cover design; also for jacket/cover illustration. Works on assignment only.

First Contact & Terms Send query letter with résumé and samples to be kept on file. Prefers photographs and tearsheets as samples. Samples not filed are not returned. Art director will contact artist for portfolio review if interested. Requests work on spec before assigning a job. Originals are not returned. Considers complexity of project, skill and experience of artist and project's budget when establishing payment. Buys all rights. Interested in buying second rights (reprint rights) to previously published artwork.

Book Design Assigns 40-50 freelance design jobs/year. Payment varies.

Jackets/Covers Assigns 30-40 freelance design jobs/year. Pays $20-50.

Text Illustration Assigns 30-40 freelance jobs/year. Pays by the project.

HIPPOCRENE BOOKS INC.

171 Madison Ave., Suite 1602, New York NY 10016. (212)685-4371. Fax: (212)779-9338. Web site: www.hippocrenebooks.com. **Editor:** Priti Gress. Estab. 1971. Publishes hardcover originals and trade paperback reprints. Types of books include cookbooks, history, nonfiction, reference, travel, dictionaries, foreign language, bilingual. Specializes in dictionaries, cookbooks. Publishes 60 titles/year. Recent titles include *Hippocrene Children's Illustrated Foreign Language Dictionaries*; *St. Patrick's Secrets*; *American Proverbs*.

Needs Approached by 150 illustrators and 50 designers/year. Works with 2 illustrators and 3 designers/year. Prefers local freelancers experienced in line drawings.

First Contact & Terms Designers: Send query e-mail with small attachment or Web site link.

Jackets/Covers Assigns 4 freelance design and 2 freelance illustration jobs/year. Pays by the project.

Text Illustration Assigns 4 freelance illustration jobs/year. Pays by the project.

Tips "We prefer traditional illustrations appropriate for gift books and cookbooks."

HOLIDAY HOUSE

425 Madison Ave., New York NY 10017. (212)688-0085. Fax: (212)421-6134. Web site: www.holi dayhouse.com. **Director of Art and Design:** Claire Counihan. Editor-in-Chief: Regina Griffin. Specializes in hardcover children's books. Recent titles: *Jazz* by Walter Dean Myers; *Freedom Walkers* by Russell Freedman; *Traveling Tom and the Leprechaun* by Teresa Bateman. Publishes 70 titles/year. 75% require illustration. Art submission guidelines available on Web site.

Needs Accepts art suitable for children and young adults only. Works on assignment only.

First Contact & Terms Send cover letter with photocopies and SASE. Samples are filed or are returned by SASE. Request portfolio review in original query. Responds only if interested. Originals are returned at job's completion. Finds artists through submissions and agents.

Jackets/Covers Assigns 5-10 freelance illustration jobs/year. Pays by the project, $900-1,200.

Text Illustrations Assigns 35 freelance jobs/year (picture books). Pays royalty.

HOMESTEAD PUBLISHING

P.O. Box 193, Moose WY 83012. Phone/fax: (307)733-6248. Web site: www.homesteadpublishin g.net. **Contact:** Art Director. Estab. 1980. Publishes hardcover and paperback originals. Types of books include art, biography, history, guides, photography, nonfiction, natural history, and

general books of interest. Recent titles: *Cubby in Wonderland*; *Windswept*; *Banff-Jasper Explorer's Guide*. Publishes more than 6 print, 100 online titles/year. 75% require freelance illustration. Book catalog free for SAE with 4 first-class stamps.

Needs Works with 20 freelance illustrators and 10 designers/year. Prefers pen & ink, airbrush, pencil and watercolor. 25% of freelance work demands knowledge of PageMaker or FreeHand. Works on assignment only.

First Contact & Terms Send query letter with printed samples to be kept on file or write for appointment to show portfolio. For color work, slides are suitable; for b&w, technical pen, photostats. Samples not filed are returned by SASE only if requested. Responds in 10 days. Rights purchased vary according to project. Originals are not returned.

Book Design Assigns 6 freelance design jobs/year. Pays by the project, $50-3,500.

Jackets/Covers Assigns 2 freelance design and 4 illustration jobs/year. Pays by the project, $50-3,500.

Text Illustration Assigns 50 freelance illustration jobs/year. Prefers technical pen illustration, maps (using airbrush, overlays, etc.), watercolor illustrations for children's books, calligraphy and lettering for titles and headings. Pays by the hour, $5-20; or by the project, $50-3,500.

Tips "We are using more graphic, contemporary designs and looking for exceptional quality."

IDEALS PUBLICATIONS INC.

A division of Guideposts, 2636 Elm Hill Pike, Suite 120, Nashville TN 37211. (615)333-0478. Web site: www.idealsbooks.com. **Publisher:** Patricia Pingry. Art Director: Eve DeGrie. Estab. 1944. Imprints include: Candy Cane Press, Williamson Books. Company publishes hardcover originals and *Ideals* magazine. Specializes in nostalgia and holiday themes. Publishes 100 book titles and 6 magazine issues/year. Recent titles include: *Blessings of a Husband's Love*, *Dear Santa*. 50% require freelance illustration. Guidelines free for #10 SASE with 1 first-class stamp or on Web site.

Needs Approached by 100 freelancers/year. Works with 10-12 freelance illustrators/year. Prefers freelancers with experience in illustrating people, nostalgia, botanical flowers. Uses freelancers mainly for flower borders (color), people and spot art. Also for text illustration, jacket/cover and book design. Works on assignment only.

First Contact & Terms Send tearsheets which are filed. Responds only if interested. Buys all rights. Finds artists through submissions.

Text Illustration Assigns 75 freelance illustration jobs/year. Pays by the project. Prefers watercolor or gouache.

Tips "Looking for illustrations with unique perspectives, perhaps some humor, that not only tells the story but draws the reader into the artist's world. We accept all styles."

IMAGE COMICS

1942 University Ave., Suite 305, Berkeley CA 94704. E-mail: info@imagecomics.com. Web site: www.imagecomics.com. **Contact:** Erik Larsen. Estab. 1992. Publishes comic books, graphic novels. Recent titles include: *Athena Inc.*; *Noble Causes Family Secrets #2*; *Powers #25*. See this company's Web site for detailed guidelines.

Needs "We are looking for good, well-told stories and exceptional artwork that run the gamut in terms of both style and genre."

First Contact & Terms Send proposals only. See Web site for guidelines. No e-mail submissions. All comics are creator-owned. Image only wants proposals for comics, not "art submissions."

Proposals/samples not returned. Do not include SASE. Responds as soon as possible.

Tips ''Please do not try to 'impress' us with all the deals you've lined up or testimonials from your Aunt Matilda. We are only interested in the comic.''

IMPACT BOOKS

F + W Media, Inc., 4700 E. Galbraith Rd., Cincinnati OH 45236. (513)531-2690. Fax: (513)531-2686. E-mail: pam.wissman@fwpubs.com. Web site: www.impact-books.com. **Editorial Director:** Pam Wissman. Publishes trade paperback originals. Specializes in illustrated art instruction books. Recent titles: *DragonArt* by Jessica Peffer; *Dreamscapes* by Stephanie Pui-Mun Law; *Hi-Fi Color for Comics* by Brian and Kristy Miller; *Comic Artist's Photo Reference: People and Poses* by Buddy Scalera. Publishes 12 titles/year. Book catalog free with 9×12 SASE (6 first-class stamps).

 • IMPACT Books publishes titles that emphasize illustrated how-to-draw-fantasy and comics art instruction. Currently emphasizing fantasy art, traditional American comics styles, including humor; and Japanese-style (manga and anime). This market is for experienced comic-book artists who are willing to work with an IMPACT editor to produce a step-by-step how-to book about the artist's creative process. See also separate listing for F + W Media, Inc., in this section.

Needs Approached by 30 author-artists/year. Works with 12 author-artists/year.

First Contact & Terms Send query letter or e-mail; digital art, tearsheets, photocopies, photographs, transparencies or slides; résumé, SASE and URL. Accepts Mac-compatible e-mail submissions (TIFF or JPEG). Samples may be filed but are usually returned. Responds only if interested. Company will contact artist for portfolio review of color finished art, digital art, roughs, photographs, slides, tearsheets and/or transparencies if interested. Buys all rights. Finds freelancers through submissions, conventions, Internet and word of mouth.

Tips Submission guidelines available online at www.impact-books.com/submit_work.asp.

INNER TRADITIONS INTERNATIONAL/BEAR & COMPANY

One Park St., Rochester VT 05767. (802)767-3174. Fax: (802)767-3726. E-mail: peri@innertraditions.com. Web site: www.innertraditions.com. **Art Director:** Peri Ann Swan. Estab. 1975. Publishes hardcover originals and trade paperback originals and reprints. Types of books include self-help, psychology, esoteric philosophy, alternative medicine, Eastern religion, and art books. Recent titles include *Mystery of the Crystal Skulls*, *Thai Yoga Massage* and *Science and the Akashic Field*. Publishes 65 titles/year; 10% require freelance illustration; 5% require freelance design. Book catalog free by request.

Needs Works with 3-4 freelance illustrators and 3-4 freelance designers/year. 100% of freelance design demands knowledge of QuarkXPress, InDesign or Photoshop. Buys 10 illustrations/year. Uses freelancers for jacket/cover illustration and design. Works on assignment only.

First Contact & Terms Send query letter with résumé, tearsheets, photocopies, photographs, slides and SASE. Accepts disc submissions. Samples are filed if interested; returned by SASE if requested by artist. Responds only if interested. To show portfolio, mail tearsheets, photographs, slides and transparencies. Rights purchased vary according to project. Originals returned at job's completion. Pays by the project.

Jackets/Covers Assigns approximately 10 design and illustration jobs/year. Pays by the project.

◪ JIREH PUBLISHING COMPANY

P.O. Box 1911, Suisun City CA 94585-1911. (510)276-3322. E-mail: jaholman@jirehpublishing.com. Web site: www.jirehpublishing.com. **Editor:** J. Holman. Publishes CD-ROMs, hardcover and trade paperback originals. Types of books include adventure and religious (fiction); instructional, religious and e-books (nonfiction). Recent titles include *Accessible Bathroom Design* and *The Art of Seeking God*. Publishes 2 titles/year; 85% require freelance design; 50% require freelance illustration. Book catalog not available; see Web site for current titles.

Needs Approached by 15 designers and 12 illustrators/year. Works with 2 designers and 1 illustrator/year. 85% of design work and 75% of illustration work demands knowledge of Corel Draw, Illustrator and Photoshop.

First Contact & Terms Designers/Illustrators: Send postcard samples with résumé, URL. Samples are filed. Responds only if interested. Will contact artist for portfolio review if interested. Portfolio should include color finished art. Rights purchased vary according to project. Finds freelancers through art reps, submissions and Internet.

Jackets/Covers Assigns 2 freelance cover illustration jobs/year. Pays for illustration by the project, $1,000 minimum. Prefers experienced Christian cover designers.

Text Illustration Assigns 1 freelance illustration job/year. Pays $50 minimum/hour.

Tips "Be experienced in creating Christian cover designs for fiction and nonfiction titles."

KAEDEN BOOKS

P.O. Box 16190, Rocky River OH 44116. (440)617-1400. Fax: (440)617-1403. Web site: www.kaeden.com. Estab. 1989. Publishes children's books. Types of books include picture books and early juvenile. Specializes in elementary educational content. Recent titles include *Adventures of Sophie Bean: The Red Flyer Roller Coaster*, *Sammy Gets a Bath*, *Where is Muffin*, and *A Skateboard for Alex*. Publishes 8-20 titles/year; 90% require freelance illustration. Book catalog available upon request.

- Kaeden Books is now providing content for ThinkBox.com and the TAE KindlePark Electronic Book Program.

Needs Approached by 100-200 illustrators/year. Works with 5-10 illustrators/year. Prefers freelancers experienced in juvenile/humorous illustration and children's picture books. Uses freelancers mainly for story illustration.

First Contact & Terms Designers: Send query letter with brochure and résumé. Illustrators: Send postcard sample or query letter with photocopies, photographs, printed samples or tearsheets, no larger than 8½×11. Samples are filed and not returned. Responds only if interested. Art director will contact artist for portfolio review if interested. Buys all rights.

Text Illustration Assigns 8-20 jobs/year. Pays by the project. Looks for a variety of styles.

Tips "We look for professional-level drawing and rendering skills, plus the ability to interpret a juvenile story. There is a tight correlation between text and visual in our books, plus a need for attention to detail. Drawings of children are especially needed. Please send only samples that pertain to our market."

◨ KALMBACH PUBLISHING CO.

21027 Crossroads Circle, P.O. Box 1612, Waukesha WI 53187. (262)796-8776. Fax: (262)796-1142. E-mail: tford@kalmbach.com. Web site: www.kalmbach.com. **Books Art Director:** Tom Ford. Estab. 1934. Types of books include reference and how-to books for serious hobbyists in the railfan, model railroading, plastic modeling, and toy train collecting/operating hobbies. Also

publishes books and booklets on jewelry-making, beading and general crafts. Publishes 50+ new titles/year. Recent titles include: *Legendary Lionel Trains*, by John Grams and Terry Thompson; *The Model Railroader's Guide to Industries Along the Tracks*, by Jeff Wilson; *Tourist Trains 2005—The 40th Annual Guide to Tourist Railroads and Museums*; and *Chic&Easy Beading, 100 Fast and Fun Fashion Jewelry Projects*, edited by Alice Korach.

Needs 10-20% require freelance illustration; 10-20% require freelance design. Book catalog free upon request. Approached by 25 freelancers/year. Works with 2 freelance illustrators and 2 graphic designers/year. Prefers freelancers with experience in the hobby field. Uses freelance artists mainly for book layout/design and line art illustrations. Freelancers should have the most recent versions of Adobe InDesign, Photoshop and Illustrator. Projects by assignment only.

First Contact & Terms Send query letter with résumé, tearsheets and photocopies. No phone calls please. Samples are filed and will not be returned. Art Director will contact artist for portfolio review. Finds artists through word of mouth, submissions. Assigns 10-12 freelance design jobs/ year. Pays by the project, $500-3,000. Assigns 3-5 freelance illustration jobs/year. Pays by the project, $250-2,000.

Tips First-time assignments are usually illustrations or book layouts. Complex projects (i.e., track plans, 100+ page books) are given to proven freelancers. Admires freelancers who present an organized and visually strong portfolio that meet deadlines and follow instructions carefully.

KIRKBRIDE BIBLE CO. INC.

B.B. Kirkbride Bible Co., Inc., 335 W. 9th St., Indianapolis IN 46202-0606. (317)633-1900. Fax: (317)633-1444. E-mail: gage@kirkbride.com. Web site: www.kirkbride.com. **President:** Michael B. Gage. Estab. 1915. Publishes Thompson Chain-Reference Bible hardcover originals and quality leather bindings styles and translations of the Bible. Types of books include reference and religious. Specializes in reference and study material. Publishes 6 main titles/year. Recent titles include: *The Thompson Student Bible* and *The Thompson Chain-Reference Centennial Edition*. 2% require freelance illustration; 10% require freelance design. Catalog available.

Needs Approached by 1-2 designers/year. Works with 1-2 designers/year. Prefers freelancers experienced in layout and cover design. Uses freelancers mainly for artwork and design. 100% of freelance design and most illustration demands knowledge of PageMaker, Indesign, Photoshop, Illustrator and QuarkXPress. 5-10% of titles require freelance art direction.

First Contact & Terms Designers: Send query letter with portfolio of recent works, printed samples and resume. Illustrators: Send query letter with Photostats, printed samples and resume. Accepts disk submissions compatible with QuarkXPress or Photoshop files 4.0 or 3.1. Samples are filed. Responds only if interested. Rights purchased vary according to project.

Book Design Assigns 1 freelance design job/year. Pays by the hour $100 minimum.

Jackets/Covers Assigns 1-2 freelance design jobs and 1-2 illustration jobs/year. Pays for design by the project, $100-1,000. Pays for illustration by the project, $100-1,000. Prefers modern with traditional text.

Text Illustration Assigns 1 freelance illustration/year. Pays by the project, $100-1,000. Prefers traditional. Finds freelancers through sourcebooks and references.

Tips "Quality craftsmanship is our top concern, and it should be yours also!"

DENIS KITCHEN PUBLISHING CO., LLC

P.O. Box 2250, Amherst MA 01004-2250. (413)259-1627. Fax: (413)259-1812. E-mail: publishing @deniskitchen.com. Web site: www.deniskitchenpublishing.com. **Contact:** Denis Kitchen or

Steven Krupp. Estab. 1999 (previously Kitchen Sink Press, 1969-1999). Publishes hardcover originals and trade paperback originals. Types of books include art prints, coffee table books, graphic novels, illustrated books, postcard books, and boxed trading cards. Specializes in comix and graphic novels. Recent titles include *Heroes of the Blues* by R. Crumb, *Grasshopper Ant* by Harvey Kurtzman and *Mr. Natural Postcard Book* by R. Crumb. Publishes 4-6 titles/year; 50% require freelance design; 10% require freelance illustration. Book catalog not available.

Needs Approached by 50 illustrators and 100 designers/year. Works with 6 designers and 2 illustrators/year. Prefers local designers. 90% of freelance design work demands knowledge of InDesign and Photoshop. Freelance illustration demands InDesign, Photoshop and sometimes old-fashioned brush and ink.

First Contact Terms Postcards showing style are the best introduction in our experience.. After introductory mailing, send follow-up postcard sample every 6 months. More elaborate samples are filed or returned by SASE. Responds in 4-6 weeks. Portfolio not required. Finds freelancers through artist's submissions, art exhibits/fairs and word of mouth.

Jackets/Covers Assigns 2-3 freelance cover illustrations/year.

B. KLEIN PUBLICATIONS

P.O. Box 6578, Delray Beach FL 33482. (561)496-3316. Fax: (561)496-5546. **Editor:** Bernard Klein. Estab. 1955. Publishes reference books, such as the *Guide to American Directories*. Publishes approximately 15-20 titles/year. 25% require freelance illustration; 25% require freelance art direction. Book catalog free on request.

Needs Works with 1-3 freelance illustrators and 1-3 designers/year. Uses freelancers for jacket design and direct mail brochures.

First Contact & Terms Submit résumé and samples. Pays $50-300.

LAREDO PUBLISHING CO./RENAISSANCE HOUSE DBA

465 West View Ave., Englewood NJ 07631. (201)408-4048. Fax: (201)408-5011. E-mail: laredo@renaissancehouse.net. Web site: renaissancehouse.net. **Art Director:** Sam Laredo. Estab. 1991. Publishes juvenile and preschool textbooks. Specializes in Spanish texts, educational/readers. Recent titles include *Legends of America* (series of 21 titles), *Extraordinary People* (series of 6 titles) and *Breast Health with Nutribionics*. Publishes 16 titles/year.

Needs Approached by 10 illustrators and 2 designers/year. Works with 2 designers/year. Uses freelancers mainly for book development. 100% of freelance design demands knowledge of Photoshop, Illustrator, QuarkXPress. 20% of titles require freelance art direction.

First Contact & Terms Designers: Send query letter with brochure, photocopies. Illustrators: Send photocopies, photographs, resume, slides, tearsheets. Samples are not filed and are returned by SASE. Responds only if interested. Portfolio review required for illustrators. Art director will contact artist for portfolio review if interested. Portfolio should include book dummy, photocopies, photographs, tearsheets and artwork portraying children. Buys all rights or negotiates rights purchased.

Book Design Assigns 5 freelance design jobs/year. Pays for design by the project.

Jacket/Covers Pays for illustration by the project, page.

Text Illustration Pays by the project, page.

LEE & LOW BOOKS

95 Madison Ave., #1205, New York NY 10016-7801. (212)779-4400. Fax: (212)532-6035. E-mail: general@leeandlow.com. Web site: www.leeandlow.com. **Editor-in-Chief:** Louise May. Estab.

1991. Publishes hardcover originals and reprints for the juvenile market. Specializes in multicultural children's books. Titles include *Rent Party Jazz* by William Miller; *Where On Earth Is My Bagel?* by Frances Park and Ginger Park; and *Love to Mama*, edited by Pat Mora. Publishes 12-15 titles/year. 100% require freelance illustration and design. Book catalog available.

Needs Approached by 100 freelancers/year. Works with 12-15 freelance illustrators and 4-5 designers/year. Uses freelancers mainly for illustration of children's picture books. 100% of design work demands computer skills. Works on assignment only.

First Contact & Terms Contact through artist rep or send query letter with brochure, résumé, SASE, tearsheets or photocopies. Samples of interest are filed. Art director will contact artist for portfolio review if interested. Portfolio should include color tearsheets and dummies. Rights purchased vary according to project. Originals are returned at job's completion.

Book Design Pays by the project.

Text Illustration Pays by the project.

Tips "We want an artist who can tell a story through pictures and who is familiar with the children's book genre. We are now also developing materials for older children, ages 8-12, so we are interested in seeing work for this age group, too. Lee & Low Books makes a special effort to work with writers and artists of color and encourages new talent. We prefer filing samples that feature children, particularly from diverse backgrounds."

LERNER PUBLISHING GROUP

241 First Ave. N., Minneapolis MN 55401. (612)332-3344. Fax: (612)332-7615. E-mail: info@lernerbooks.com. Web site: www.lernerbooks.com. **Art Director:** Zach Marell. Estab. 1959. Publishes educational books for young people. Subjects include animals, biography, history, geography, science and sports. Publishes 200 titles/year. 100% require freelance illustration. Recent titles: *Colorful Peacocks*; *Ethiopia in Pictures*. Book catalog free on request. Art submission guidelines available on Web site.

Needs Uses 10-12 freelance illustrators/year. Uses freelancers mainly for book illustration; also for jacket/cover design and illustration, book design and text illustration.

First Contact & Terms Send bio/résumé with slides, JPEG or PDF files on disk, photocopies or tearsheets showing skill in children's book illustration. Samples are kept on file or are returned by SASE. Responds in 2 weeks, only if SASE included. Considers skill and experience of artist and turnaround time when establishing payment. Pays by the project, $500-3,000 average, or advance plus royalty. Considers buying second rights (reprint rights) to previously published artwork.

Tips "Send samples showing active children, not animals or still life. Don't send original art. Look at our books to see what we do."

MITCHELL LANE PUBLISHERS, INC.

P.O. Box 196, Hockessin DE 19707. (302)234-9426. Fax: (302)234-4742. Web site: www.mitchelllane.com. **Publisher:** Barbara Mitchell. Estab. 1993. Publishes library bound originals. Types of books include biography. Specializes in multicultural biography for young adults. Recent titles include *Disaster in the Indian Ocean* and *Tsunami 2004*. Publishes 85 titles/year; 50% require freelance illustration; 50% require freelance design.

Needs Approached by 20 illustrators and 5 designers/year. Works with 2 illustrators/year. Prefers freelancers experienced in illustrations of people. Looks for cover designers and interior book designers.

First Contact & Terms Send query letter with printed samples, photocopies. Interesting samples are filed and are not returned. Will contact artist for portfolio review if interested. Buys all rights.

Jackets/Covers Prefers realistic portrayal of people.

MODERN PUBLISHING

155 E. 55th St., New York NY 10022. (212)826-0850. Fax: (212)758-4166. E-mail: ewhite@moder npublishing.com. Web site: www.modernpublishing.com. **Art Director:** Erik White. Specializes in children's coloring and activity books, novelty books, hardcovers, paperbacks (both generic and based on licensed characters). Recent titles include Fisher Price books, Care Bears books, The Wiggles books, Bratz and Lil' Bratz books. Publishes approximately 200 titles/year.

Needs Approached by 15-30 freelancers/year. Works with 25-30 freelancers/year. Works on assignment and royalty.

First Contact & Terms Send query letter with résumé and samples. Samples are not filed and are returned by SASE only if requested. Responds only if interested. Originals not returned. Considers turnaround time, complexity of work and rights purchased when establishing payment.

Jackets/Covers Pays by the project, $100-250/cover, usually 2-4 books/series.

Text Illustration Pays by the project, $35-75/page; line art, 24-384 pages per book, usually 2-4 books/series. Pays $50-125/page; full-color art.

▣ MORGAN KAUFMANN PUBLISHERS

30 Corporate Dr., Suite 400, Burlington MA 01803-4252. (781)313-4700. Fax: (781)221-1615. E-mail: mkp@mkp.com. Web site: www.mkp.com. Estab. 1984. Publishes computer science books for academic and professional audiences in paperback, hardback and book/CD-ROM packages. Publishes 60 titles/year. 75% require freelance interior illustration; 100% require freelance text and cover design; 15% require freelance design and production of 4-color inserts.

• Morgan Kaufmann is now part of Elsevier (www.elsevier.com).

Needs Approached by 150-200 freelancers/year. Works with 10-15 freelance illustrators and 10-15 designers/year. Uses freelancers for covers, text design and technical and editorial illustration, design and production of 4-color inserts. 100% of freelance work demands knowledge of at least one of the following Illustrator, QuarkXPress, Photoshop, Ventura, Framemaker, or laTEX (multiple software platform). Works on assignment only.

First Contact & Terms Send query letter with samples. Samples must be nonreturnable or with SASE. "No calls, please." Samples are filed. Production editor will contact artist for portfolio review if interested. Portfolio should include final printed pieces. Buys interior illustration on a work-for-hire basis. Buys first printing and reprint rights for text and cover design. Finds artists primarily through word of mouth and submissions.

Book Design Assigns freelance design jobs for 40-50 books/year. Pays by the project. Prefers Illustrator and Photoshop for interior illustration and QuarkXPress for 4-color inserts.

Jackets/Covers Assigns 40-50 freelance design; 3-5 illustration jobs/year. Pays by the project. Uses primarily stock photos. Prefers designers take cover design through production to film and MatchPrint. "We're interested in a look that is different from the typical technical publication." For covers, prefers modern, clean, spare design, with emphasis on typography and high-impact imagery.

Tips "Although experience with book design is an advantage, sometimes artists from another field bring a fresh approach, especially to cover design."

MOUNTAIN PRESS PUBLISHING CO.

P.O. Box 2399, Missoula MT 59806. (406)728-1900. Fax: (406)728-1635. E-mail: info@mtnpress. com. Web site: www.mountain-press.com. **Design and Production**: Kim Ericsson and Jeannie Painter. Estab. 1960s. Company publishes trade paperback originals and reprints; some hardcover originals and reprints. Types of books include western history, geology, natural history/ nature. Specializes in geology, natural history, history, horses, western topics. Publishes 20 titles/year. Book catalog free by request.

Needs Approached by 100 freelance artists/year. Works with 2-5 freelance illustrators/year. Buys 5-10 freelance illustrations/year. Prefers artists with experience in book illustration and design, book cover illustration. Uses freelance artists for jacket/cover illustration, text illustration and maps. 100% of design work demands knowledge of InDesign, Photoshop, Illustrator. Works on assignment only.

First Contact & Terms Send query letter with résumé, SASE and any samples. Samples are filed or are returned by SASE. Responds only if interested. Project editor will contact artist for portfolio review if interested. Buys one-time rights or reprint rights depending on project. Originals are returned at job's completion. Finds artists through submissions, word of mouth, sourcebooks and other publications.

Book Design Pays by the project.

Jackets/Covers Assigns 0-1 freelance design and 3-6 freelance illustration jobs/year. Pays by the project.

Text Illustration Assigns 0-1 freelance illustration jobs/year. Pays by the project.

Tips First-time assignments are usually book cover/jacket illustration or map drafting; text illustration projects are given to "proven" freelancers.

NEW ENGLAND COMICS (NEC PRESS)

732 Washington St., Norwood MA 02062-3548. (781)769-3470. Fax: (781)769-2853. E-mail: office@newenglandcomics.com. Web site: www.newenglandcomics.com. Types of books include comic books and games. Book catalog available on Web site.

Needs Seeking pencillers and inkers. Not currently interested in new stories.

First Contact & Terms Send SASE and 2 pages of pencil or ink drawings derived from the submissions script posted on Web site. Responds in 2 weeks (with SASE only).

Tips Visit Web site for submissions script. Do not submit original characters or stories. Do not call.

NORTH LIGHT BOOKS

F+W Media, Inc., 4700 E. Galbraith Rd., Cincinnati OH 45236. (513)531-2690. Fax: (513)531-2686. E-mail: jamie.markle@fwpubs.com; christine.doyle@fwpubs.com; pam.wissman@fwpubs.com. Web site: www.fwpublications.com. **Publisher:** Jamie Markle. **Editorial Craft Director:** Christine Doyle. **Editorial Director Fine Art:** Pam Wissman. Publishes trade paperback and hardback originals. Specializes in fine art, craft and decorative painting instruction books. Recent titles: *Acrylic Revolution*; *Watercolor in Motion*; *Oil Painter's Solution Book: Landscapes*; *Knit One, Embellish Too*; *Taking Flight*; *Warm Fuzzies*. Publishes 75 titles/year. Book catalog available for SASE with 6 first-class stamps.

• This market is for experienced fine artists and crafters who are willing to work with a North Light editor to produce a step-by-step how-to book about the artist's creative process. See also separate listing for F+W Media, Inc., in this section.

Needs Approached by 100 author-artists/year. Works with 50 artists/year.

First Contact & Terms Send query letter with photographs, digital images. Accepts e-mail submissions. Samples are not filed and are returned. Responds only if interested. Company will contact artist for portfolio review if interested. Buys all rights. Finds freelancers through art competitions, art exhibits, submissions, Internet and word of mouth.

Tips "Include 30 examples of artwork, book idea, outline and a step-by-step demonstration. Submission guidelines posted on Web site at www.fwpublications.com/authorguidelines.asp."

NORTHWOODS PRESS

Conservatory of American Letters, P.O. Box 298, Thomaston ME 04861. (207)226-7528. E-mail: cal@americanletters.org. Web site: www.americanletters.org. **Editor:** Robert Olmsted. Estab. 1972. Specializes in hardcover and paperback originals of poetry. Publishes approximately 6 titles/year. Titles include: *Aesop's Eagles*. 10% require freelance illustration. Book catalog for SASE.

- The Conservatory of American Letters publishes the *Northwoods Journal*, a quarterly literary magazine. They're seeking cartoons and line art and pay cash on acceptance. Get guidelines from Web site.

Needs Approached by 40-50 freelance artists/year. Works with 1-2 illustrators/year. Uses freelance artists mainly for cover illustration. Rarely uses freelance artists for text illustration.

First Contact & Terms Send query letter to be kept on file. Art Director will contact artist for portfolio review if interested. Sometimes requests work on spec before assigning a job. Considers complexity of project, skill and experience of artist, project's budget, turnaround time and rights purchased when establishing payment. Buys one-time rights and occasionally all rights. Originals are returned at job's completion.

Book Design Pays by the project, $10-100.

Jackets/Covers Assigns 2-3 design jobs and 4-5 illustration jobs/year. Pays by the project, $10-100.

Text Illustration Pays by the project, $5-20.

Tips Portfolio should include "art suitable for book covers—contemporary, usually realistic."

OCP (OREGON CATHOLIC PRESS)

5536 NE Hassalo, Portland OR 97213-3638. E-mail: gust@ocp.org. Web site: www.ocp.org. **Creative Director:** Gus Torres. Division estab. 1997. Publishes religious and liturgical books specifically for, but not exclusively to, the Roman Catholic market. Publishes 2-5 titles/year; 30% require freelance illustration. Book catalog available for 9×12 SASE with first-class postage.

- OCP (Oregon Catholic Press) is a nonprofit publishing company, producing music and liturgical publications used in parishes throughout the United States, Canada, England and Australia. See additional listings in the Magazines and Record Labels sections.

Tips "I am always looking for appropriate art for our projects. We tend to use work already created on a one-time-use basis, as opposed to commissioned pieces. I look for tasteful, not overtly religious art."

◘ OCTAMERON PRESS

1900 Mount Vernon Ave., Alexandria VA 22301. (703)836-5480. Fax: (703)836-5650. Web site: www.octameron.com. **Editorial Director:** Karen Stokstod. Estab. 1976. Publishes paperback originals. Specializes in college financial and college admission guides. Recent titles: *College Match*; *The Winning Edge*. Publishes 9 titles/year.

Needs Approached by 25 freelancers/year. Works with 1-2 freelancers/year. Works on assignment only.

First Contact & Terms Send query letter with brochure showing art style or résumé and photocopies. Samples not filed are returned if SASE is included. Considers complexity of project and project's budget when establishing payment. Rights purchased vary according to project.

Jackets/Covers Works with 1-2 designers and illustators/year on 15 different projects. Pays by the project, $500-1,000.

Text Illustration Works with variable number of artists/year. Pays by the project, $35-75. Prefers line drawings to photographs.

Tips ''The look of the books we publish is friendly! We prefer humorous illustrations.''

THE OVERLOOK PRESS

141 Wooster St., New York NY 10012. (212)965-8400. Fax: (212)965-9834. Web site: www.overl ookpress.com. **Contact:** Art Director. Estab. 1970. Book publisher. Publishes hardcover originals. Types of books include contemporary and experimental fiction, health/fitness, history, fine art and children's books. Recent titles: *Right-Ho*, *Jeeves* by P.G. Wodehouse. Publishes 90 titles/ year. 60% require freelance illustration; 40% require freelance design. Book catalog free for SASE.

Needs Approached by 10 freelance artists/year. Works with 4 freelance illustrators and 4 freelance designers/year. Buys 5 freelance illustrations/year. Prefers local artists only. Uses freelance artists mainly for jackets. Works on assignment only.

First Contact & Terms Send query letter with printed samples or other nonreturnable material. Samples are filed. To show a portfolio, mail tearsheets and slides. Buys one-time rights. Originals returned to artist at job's completion.

Jackets/Covers Assigns 10 freelance design jobs/year. Pays by the project, $250-350.

▣ PALACE PRESS

(formerly Mandala Publishing), 17 Paul Dr., San Rafael CA 94903. (415)526-1370. Fax: (415)884-0500. E-mail: lisa@palacepress.com. Web site: www.insighteditions.com. **Contact:** Lisa Fitzpatrick, acquiring editor. Estab. 1987. Publishes art and photography books, calendars, journals, postcards and greeting card box sets. Types of books include pop culture, fine art, photography, spiritual, philosophy, art, biography, coffee table books, cookbooks, instructional, religious, travel, and nonfiction. Specializes in art books, spiritual. Publishes 12 titles/year. Recent titles include: *Ramayana A Tale of Gods & Demons*; *Prince of Dharma The Illustrated Life of the Buddha*. 100% requires freelance design and illustration. Book catalog free on request.

Needs Approached by 50 illustrators/year. Works with 12 designers and 12 illustrators/year. Location of designers/illustrators not a concern.

First Contact & Terms Send photographs and résumé. Accepts disk submissions from designers and illustrators. Prefers Mac-compatible, TIFF and JPEG files. Samples are filed. Responds only if interested. Company will contact artist for portfolio review if interested. Buys first, first North American serial, one-time and reprint rights. Rights purchased vary according to project. Finds freelancers through artist's submissions, word of mouth.

Jackets/Covers Assigns 3 freelance cover illustration jobs/year. Pays for illustration by the project.

Text Illustration Assigns 2 freelance illustration jobs/year. Pays by the project.

Tips ''Look at our published books and understand what we represent and how your work could fit.''

PAPERCUTZ

40 Exchange Place, Suite 1308, New York NY 10005. (800)886-1223. Fax: (212)643-1545. E-mail: salicrup@papercutz.com. Web site: www.papercutz.com. **Editor-in-Chief:** Jim Salicrup. Estab. 2005. "Independent publisher of graphic novels based on popular existing properties aimed at the teen and tween market." Publishes hardcover and paperback originals, distributed by Holtzbrinck Publishers. Recent titles: *Nancy Drew*; *The Hardy Boys*; *Tales from the Crypt*. Publishes 10+ titles/year. Book catalog free upon request.

Needs Uses licensed characters/properties aimed at teen/tween market. Not looking for original properties at this time. "Looking for professional comics writers able to write material for teens and tweens without dumbing down the work, and comic book artists able to work in animated or manga styles." Also has a need for inkers, colorists, letterers.

First Contact & Terms Send low-res files of comic art samples or a link to Web site. Attends New York comic book conventions, as well as the San Diego Comic-Con, and will review portfolios if time allows. Responds in 1-2 weeks. Pays an advance against royalties.

Tips "Be familiar with our titles—that's the best way to know what we're interested in publishing. If you are somehow attached to a successful teen or tween property and would like to adapt it into a graphic novel, we may be interested."

Ⓝ PARENTING PRESS, INC.

11065 Fifth Ave. NE, #F, Seattle WA 98125. (206)364-2900. Fax: (206)364-0702. E-mail: office@p arentingpress.com. Web site: www.parentingpress.com. **Contact:** Carolyn Threadgill, publisher. Estab. 1979. Publishes trade paperback originals and hardcover originals. Types of books include nonfiction; instruction and parenting. Specializes in parenting and social skill building books for children. Recent titles include: *The Way I Feel*; *Is This a Phase?*; *What About Me?* 100% requires freelance design; 100% requires freelance illustration. Book catalog free on request.

Needs Approached by 10 designers/year and 100 illustrators/year. Works with 2 designers/year. Prefers local designers. 100% of freelance design work demands knowledge of Photoshop, QuarkXPress, and InDesign.

First Contact & Terms Send query letter with brochure, SASE, postcard sample with photocopies, photographs and tearsheets. After introductory mailing, send follow-up postcard sample every 6 months. Accepts e-mail submissions. Prefers Windows-compatible, TIFF, JPEG files. Samples returned by SASE if not filed. Responds only if interested. Company will contact artist for portfolio review if interested. Portfolio should include b&w or color tearsheets. Rights purchased vary according to project.

Jackets/Covers Assigns 4 freelance cover illustrations/year. Pays for illustration by the project $300-1,000. Prefers appealing human characters, realistic or moderately stylized.

Text Illustration Assigns 3 freelance illustration jobs/year. Pays by the project or shared royalty with author.

Tips "Be willing to supply 2-4 roughs before finished art."

PAULINE BOOKS & MEDIA

50 Saint Paul's Ave., Boston MA 02130-3491. (617)522-8911. Fax: (617)541-9805. E-mail: design @paulinemedia.com. Web site: www.pauline.org. **Art Director:** Sr. Mary Joseph Peterson. Estab. 1932. Publishes hardcover and trade paperback originals. Religious publishers; types of books include instructional biography/lives of the saints, reference, history, self-help, prayer, children's fiction. For Adults, teens and children. Also produces music and spoken recordings."

Publishes 30-40 titles/year. Art guidelines available. Send requests and art samples with SASE using first-class postage.

Needs Approached by 50 freelancers/year. Works with 10-20 freelance illustrators/year. Knowledge and use of QuarkXPress, InDesign, Illustrator, Photoshop, etc., is valued.

First Contact & Terms Postcards, tearsheets, photocopies, include web site address if you have one. Samples are filed or returned by SASE. Responds only if interested. Rights purchased; work for hire or exclusive rights.

Jackets/Covers Assigns 3-4 freelance illustration jobs/year. Pays by the project.

Text Illustration Assigns 6-10 freelance illustration jobs/year. Pays by the project.

PAULIST PRESS

997 Macarthur Blvd., Mahwah NJ 07430. (201)825-7300. Fax: (201)825-8345. E-mail: pmcmahon @paulistpress.com. Web site: www.paulistpress.com. **Managing Editor:** Paul McMahon. Estab. 1857. Publishes hardcover and trade paperback originals, juvenile and textbooks. Types of books include religion, theology, and spirituality including biography. Specializes in academic and pastoral theology. Recent titles include *He Said Yes*, *Finding Purpose in Narnia*, and *Our Daily Bread*. Publishes 90 titles/year; 5% require freelance illustration; 5% require freelance design.

• Paulist Press also publishes the general trade imprint **HIDDENSPRING**.

Needs Prefers local freelancers particularly for juvenile titles, jacket/cover, and text illustration. Prefers knowledge of QuarkXPress. Works on assignment only.

First Contact & Terms Send query letter with brochure, resume and tearsheets. Samples are filed. Portfolio review not required. Originals are returned at job's completion if requested.

Cover Design Pays by the project, $400-800.

PEACHTREE PUBLISHERS

1700 Chattahoochee Ave., Atlanta GA 30318. (404)876-8761. Fax: (404)875-2578. E-mail: hello@pe achtree-online.com. Web site: www.peachtree-online.com. **Art Director:** Loraine Joyner. **Production Manager:** Melanie McMahon Ives. Estab. 1977. Publishes hardcover and trade paperback originals. Types of books include children's picture books, young adult fiction, early reader fiction, middle reader fiction and nonfiction, parenting, regional. Specializes in children's and young adult titles. Publishes 24-30 titles/year. 100% require freelance illustration. Call for catalog.

Needs Approached by 750 illustrators/year. Works with 15-20 illustrators. Normally do not use book designers. "When possible, send samples that show your ability to depict subjects or characters in a consistent manner. See our Web site to view styles of artwork we utilize."

First Contact Terms Illustrators: Send color photocopies or tearsheets or self-promotional pieces. Accepts Mac-compatible disk submissions, but not preferred. Samples are returned by SASE only. We do not open email attachments, but will visit a web site. Responds only if interested, and cannot acknowledge receipt of submissions. Will contact artist for portfolio review if interested. Rights purchased vary according to project. Finds freelancers through submission packets, agents and sourcebooks, including *Directory of Illustration* and *Picturebook*.

Jackets/Covers Assigns 18-20 illustration jobs/year. Prefers acrylic, oils, watercolor, or mixed media on flexible material for scanning, or digital files. Pays for illustration by the project.

Text Illustration Assigns 4-6 freelance illustration jobs/year. Pays by the project.

Tips We are an independent, award-winning, high-quality house with a limited number of new titles per season, therefore each book must be a jewel. We expect the illustrator to bring creative insights which expand the readers' understanding of the storyline through visual clues not necessarily expressed within the text itself."

N PEN NOTES, INC.

2385 7th St., East Meadow NY 11554-3106. (516)796-3939. Fax: (516)796-3773. E-mail: pennotes @worldnet.att.net. Web site: www.PenNotes.com. **President**: Lorette Konezny. Produces learning books for children ages 3 and up. Clients: bookstores, toy stores and parents.

Needs Prefers artists with book or advertising experience. Works on assignment only. Each year assigns 1-2 books (with 24 pages of art) to freelancers. Uses freelancers for children's illustration, P-O-P display and design and mechanicals for catalog sheets for children's books. 100% of freelance design and up to 50% of illustration demands computer skills. Prefers knowledge of press proofs on first printing. Prefers imaginative, realistic style with true perspective and color. 100% of titles require freelance art direction.

First Contact & Terms Designers: Send brochure, resume 9, SASE, tearsheets and photocopies. No e-mails. Illustrators: Send sample with tearsheets. Samples are filed. Call or write for appointment to show portfolio or mail final reproduction/product, color and b&w tearsheets and photostats. Pays for design by the hour, $15-36; by the project, $60-125. Pays for illustration by the project, $60-500/page. Buys all rights.

Tips "Everything should be provided digitally. The style must be geared for children's toys. Looking for realistic/cartoon outline with flat color. You must work on deadline schedule set by printing needs. Must have full range of professional and technical experience for press proof. All work is property of Pen Notes, copyright property of Pen Notes."

PENGUIN GROUP (USA) INC.

375 Hudson St., New York NY 10014. (212)366-2000. Fax: (212)366-2666. Web site: www.penguingroup.com. **Art Director:** Paul Buckley. Publishes hardcover and trade paperback originals.

Needs Works with 100-200 freelance illustrators and 100-200 freelance designers/year. Uses freelancers mainly for jackets, catalogs, etc.

First Contact & Terms Send query letter with tearsheets, photocopies and SASE. Rights purchased vary according to project.

Book Design Pays by the project; amount varies.

Jackets/Covers Pays by the project; amount varies.

PENNY-FARTHING PRESS, INC.

2000 W. Sam Houston Pkwy. S., Suite 550, Houston TX 77042-3652. (713)780-0300. Fax: (713)780-4004. E-mail: corp@pfpress.com. Web site: www.pfpress.com. **Contact:** Submissions Editor. Publishes hardcover and trade paperback originals. Types of books include adventure, comic books, fantasy, science fiction. Specializes in comics and graphic novels. Recent titles: *Captain Gravity*; *The Victorian Act II*; *Self-Immolation*. Book catalog and art guidelines available on Web site.

First Contact & Terms Pencillers: Send 3-5 penciled pages "showing story-telling skills and versatility. Do not include dialogue or narrative boxes." Inkers: Send at least 3-5 samples (full-sized and reduced to letter-sized) showing interior work. "Include copies of the pencils." Illustrators: Send color photocopies. "Please do not send oversized copies." Samples are returned by SASE ONLY. Submissions in the form of URLs may be e-mailed to submissions@pfpress.com with PFP Art Submission as the subject line. See Web site for specific instructions. Responds in several months. Do not call to check on status of your submission.

Tips "Do not send originals."

❏ PEREGRINE

40 Seymour Ave., Toronto ON M4J 3T4 Canada. (416)461-9884. Fax: (416)461-4031. E-mail: peregrine@peregrine-net.com. Web site: www.peregrine-net.com. **Creative Director:** Kevin Davies. Estab. 1993. Publishes role-playing game books, audio music, and produces miniatures supplements. Game styles/genres include science fiction, cyberpunk, mythology, fantasy, military, horror and humor. Game/product lines include *Murphy's World* (role-playing game); *Bob, Lord of Evil* (role-playing game); *Adventure Areas* (miniatures supplements); *Grit Multi-Genre Miniatures Rules*; *Adventure Audio*. Publishes 1-2 titles or products/year. 90% require freelance illustration; 10% require freelance design. Art guidelines available on Web site.

Needs Approached by 20 illustrators and 2 designers/year. Works with 2-5 artists/year. Uses freelance artists mainly for interior art (b&w, grayscale) and covers (color). Prefers freelancers experienced in anatomy, structure, realism, cartoon and grayscale. 100% of freelance design demands knowledge of Illustrator, Photoshop, InDesign and QuarkXPress.

First Contact & Terms Send query letter with résumé, business card. Illustrators: Send photocopies and/or tearsheets (5-10 samples). Accepts digital submissions in Mac format via CD or e-mail attachment as EPS, TIFF or JPEG files at 72-150 ppi (for samples) and 300 ppi (for finished work). Paper and digital samples are filed and are not returned. Responds only if interested. Send self-promotion photocopy and follow-up postcard every 9-12 months. Portfolio review not required. Rights purchased vary according to project. Finds freelancers through conventions, Internet and word of mouth.

Book Covers/Posters/Cards Assigns 1-2 illustration jobs/year. Pays for illustration by the project.

Text Illustration Assigns 1-5 illustration jobs/year (grayscale/b&w). Pays $50-100 for full page; $10-25 for half page. "Payment varies with detail of image required and artist's experience."

Tips "Check out our existing products on our Web site. Make sure at least half of the samples you submit reflect the art styles we're currently publishing. Other images can be provided to demonstrate your range of capability."

PLAYERS PRESS

P.O. Box 1132, Studio City CA 91614. (818)789-4980. E-mail: playerspress@att.net. **Associate Editor:** Jean Sommers. Specializes in plays and performing arts books. Recent titles include *Costumes and Settings: v3, v4, & v5*; *Principles of Stage Combat*; *Choreographing the Stage Musical*; *Scenery, Design and Fabrication*.

Needs Works with 3-15 illustrators and 1-3 designers/year. Uses freelancers mainly for play covers; also for text illustration. Works on assignment only.

First Contact & Terms Send query letter with brochure showing art style or résumé and samples. Samples are filed or are returned by SASE. Request portfolio review in original query. Art director will contact artist for portfolio review if interested. Portfolio should include thumbnails, final reproduction/product, tearsheets, photographs and "as much information as possible." Sometimes requests work on spec before assigning a job. Buys all rights. Considers buying second rights (reprint rights) to previously published work, depending on usage. "For costume books this is possible."

Book Design Pays by the project, rate varies.

Jackets/Covers Pays by the project, rate varies.

Text Illustration Pays by the project, rate varies.

Tips "Supply what is asked for in the listing and don't waste our time with calls and unnecessary

Book Publishers

cards. We usually select from those who submit samples of their work which we keep on file. Keep a permanent address so you can be reached.''

PRO LINGUA ASSOCIATES

P.O. Box 1348, Brattleboro VT 05302-1348. (802)257-7779. Fax: (802)257-5117. E-mail: andy@ProLinguaAssociates.com. Web site: www.ProlinguaAssociates.com. **President:** Arthur A. Burrows. Estab. 1980. Publishes textbooks. Specializes in language textbooks. Recent titles: *Writing Strategies*; *Dictations for Discussion*. Publishes 3-8 titles/year. Most require freelance illustration. Book catalog free by request.

Needs Approached by 10 freelance artists/year. Works with 2-3 freelance illustrators/year. Uses freelance artists mainly for pedagogical illustrations of various kinds; also for jacket/cover and text illustration. Works on assignment only.

First Contact & Terms Send postcard sample and/or query letter with brochure, photocopies and photographs. Samples are filed. Responds in 1 month. Portfolio review not required. Buys all rights. Originals are returned at job's completion if requested. Finds artists through word of mouth and submissions.

Text Illustration Assigns 5 freelance illustration jobs/year. Pays by the project, $200-1,200.

G.P. PUTNAM'S SONS, BOOKS FOR YOUNG READERS

Penguin Group USA, 345 Hudson St., 14th Floor, New York NY 10014-3657. (212)366-2000. Web site: http://us.penguingroup.com. **Art Director:** Cecilia Yung. Publishes hardcover juvenile books. Publishes 84 titles/year. Free catalog available.

Needs Illustration on assignment only.

First Contact & Terms Provide flier, tearsheet, brochure and photocopy to be kept on file for possible future assignments. Samples are returned by SASE only. ''We take drop-offs on Tuesday mornings before noon and return them to the front desk after 4 p.m. the same day. Please call Ryan Thomann in advance with the date you want to drop of your portfolio. Do not send samples via e-mail or CDs.''

Jackets/Covers Uses full-color illustrations with realistic painterly style.

Text Illustration Uses a wide cross section of styles for story and picture books.

PUSSYWILLOW

1212 Punta Gorda St. #13, Santa Barbara CA 93103. (805)899-2145. E-mail: bandanna@cox.net. **Publisher:** Birdie Newborn. Estab. 2002. Publishes fiction trade paperback originals. Types of books include erotic classics in translation. Recent titles include *Wife of Bath* and *Aretino's Sonnetti Lussuriosi*.

Needs Sensual art.

First Contact & Terms Send samples, not originals. Responds in 3 months, only if interested.

Jackets/Covers Pays at least $100.

Text Illustration Pays by the project. Will do subsidy publishing.

Tips ''Send samples we can keep on file.''

QUITE SPECIFIC MEDIA GROUP LTD.

7373 Pyramid Place, Hollywood CA 90046. (323)851-5797. Fax: (323)851-5798. E-mail: info@quitespecificmedia.com. Web site: www.quitespecificmedia.com. **President:** Ralph Pine. Estab. 1967. Publishes hardcover originals and reprints, trade paperback reprints and textbooks. Spe-

cializes in costume, fashion, theater and performing arts books. Recent titles: *Understanding Fashion History*; *The Medieval Tailor's Assistant*. Publishes 12 titles/year. 10% require freelance illustration; 60% require freelance design.

- Imprints of Quite Specific Media Group Ltd. include Drama Publishers, Costume & Fashion Press, By Design Press, EntertainmentPro and Jade Rabbit.

Needs Works with 2-3 freelance designers/year. Uses freelancers mainly for jackets/covers; also for book, direct mail and catalog design and text illustration. Works on assignment only.

First Contact & Terms Send query letter with brochure and tearsheets. Samples are filed. Responds only if interested. Rights purchased vary according to project. Originals not returned. Pays by the project.

RAINBOW BOOKS, INC.

P.O. Box 430, Highland City FL 33846-0430. (863)648-4420. Fax: (863)647-5951. E-mail: rbibook s@aol.com. Web site: www.rainbowbooksinc.com. **Media Buyer:** Betsy A. Lampe. Estab. 1979. Publishes hardcover and trade paperback originals. Types of books include instruction, adventure, biography, travel, self-help, mystery and reference. Specializes in nonfiction, self-help, mystery fiction, and how-to. Recent titles include *Teen Grief Relief* and *Building Character Skills in the Out-of-Control Child*. Publishes 15-20 titles/year.

Needs Approached by hundreds of freelance artists/year. Works with 2 illustrators/year. Prefers freelancers with experience in cover design and line illustration. Uses freelancers for jacket/cover illustration/design and text illustration. Needs computer-literate freelancers for design, illustration and production. 90% of freelance work demands knowledge of draw or design software programs. Works on assignment only.

First Contact & Terms Send brief query, tearsheets, photographs and book covers or jackets. Samples are not returned. Responds in 2 weeks. Art director will contact artist for portfolio review if interested. Portfolio should include b&w and color tearsheets, photographs and book covers or jackets. Rights purchased vary according to project. Originals are returned at job's completion.

Jackets/Covers Assigns 10 freelance illustration jobs/year. Pays by the project, $250-1,000.

Text Illustration Pays by the project. Prefers pen & ink or electronic illustration.

Tips "Nothing Betsy Lampe receives goes to waste. After consideration for Rainbow Books, Inc., artists/designers are listed for free in her newsletter (Florida Publishers Association *Sell More Books!* Newsletter), which goes out to over 100 independent presses. Then, samples are taken to the art department of a local school to show students how professional artists/designers market their work. Send samples (never originals); be truthful about the amount of time needed to complete a project; learn to use the computer. Study the competition (when doing book covers); don't try to write cover copy; learn the publishing business (attend small-press seminars, read books, go online, make friends with the local sales reps of major book manufacturers). Pass along what you learn. Do not query via e-mail attachment."

▣ RAINBOW PUBLISHERS

P.O. Box 261129, San Diego CA 92196. (800)331-7337. Fax: (800)331-0297. E-mail: rbpub@earth link.net. **Creative Director:** Sue Miley. Estab. 1979. Publishes trade paperback originals. Types of books include religious books, reproducible Sunday School books for children ages 2-12, and Bible teaching books for children and adults. Recent titles include *Favorite Bible Children*; *Make It Take It Crafts*; *Worship Bulletins for Kids*; *Cut, Color & Paste*; *God's Girls*; *Gotta Have God*; *God*

and Me. Publishes 20 titles/year. Book catalog available for SASE with 2 first-class stamps.

Needs Approached by hundreds of illustrators and 50 designers/year. Works with 5-10 illustrators and 5-10 designers/year. 100% of freelance design and illustration demands knowledge of Illustrator, Photoshop and QuarkXPress.

First Contact & Terms Send query letter with printed samples, SASE and tearsheets. Samples are filed or returned by SASE. Responds only if interested. Will contact artist for portfolio review if interested. Finds freelancers through samples sent and personal referrals.

Book Design Assigns 25 freelance design jobs/year. Pays for design by the project, $350 minimum. Pays for art direction by the project, $350 minimum.

Jackets/Covers Assigns 25 freelance design jobs and 25 illustration jobs/year. "Prefers computer generated-high energy style with bright colors appealing to kids." Pays for design and illustration by the project, $350 minimum. "Prefers designers/illustrators with some Biblical knowledge."

Text Illustration Assigns 20 freelance illustration jobs/year. Pays by the project, $500 minimum. "Prefers black & white line art, preferably computer generated with limited detail yet fun."

Tips "We look for illustrators and designers who have some Biblical knowledge and excel in working with a fun, colorful, high-energy style that will appeal to kids and parents alike. Designers must be well versed in Quark, Illustrator and Photoshop, know how to visually market to kids and have wonderful conceptual ideas!"

RANDOM HOUSE CHILDREN'S BOOKS

Random House, Inc., 1745 Broadway, 10th Floor, New York NY 10019. (212)782-9000. Fax: (212)782-9452. Web site: www.randomhouse.com/kids. Largest English-language children's trade book publisher. Specializes in books for preschool children through young adult readers, in all formats from board books to activity books to picture books and novels. Recent titles: *How Many Seeds in a Pumpkin?*; *How Not to Start Third Grade*; *Spells & Sleeping Bags*; *The Power of One*. Publishes 250 titles/year. 100% require freelance illustration.

- The Random House publishing divisions hire their freelancers directly. To contact the appropriate person, send a cover letter and résumé to the department head at the publisher as follows: "Department Head" (e.g., Art Director, Production Director), "Publisher/Imprint" (e.g., Knopf, Doubleday, etc.), 1745 Broadway New York, NY 10019. See www.randomhouse. com/kids/about/imprints.html for details of imprints.

Needs Works with 100-150 freelancers/year. Works on assignment only.

First Contact & Terms Send query letter with résumé, tearsheets and printed samples; no originals. Samples are filed. Negotiates rights purchased.

Book Design Assigns 5 freelance design jobs/year. Pays by the project.

Text Illustration Assigns 150 illustration jobs/year. Pays by the project.

⚓ RED DEER PRESS

1800 Fourth St. SW, #1512, Calgary AB T2S 2S5 Canada. (403)509-0800. Fax: (403)228-6503. Please send queries by e-mail only. E-mail: rdp@reddeerpress.com. Web site: www.reddeerpres s.com. **Publisher:** Richard Dionne. Estab. 1975. Publishes hardcover and trade paperback originals. Types of books include contemporary and mainstream fiction, fantasy, biography, preschool, juvenile, young adult, sports, political science, and humor. Specializes in contemporary adult and juvenile fiction, picture books and natural history for children. Recent titles include *Broken Arrow* and *The Book of Michael*. 100% of titles require freelance illustration; 30% require freelance design. Book catalog available for SASE with Canadian postage.

Needs Approached by 50-75 freelance artists/year. Works with 10-12 freelance illustrators and 2-3 freelance designers/year. Buys 50 freelance illustrations/year. Prefers artists with experience in book and cover illustration. Also uses freelance artists for jacket/cover and book design and text illustration. Works on assignment only.

First Contact & Terms Send query letter with résumé by e-mail only. Terms on project basis.

Book Design Assigns 3-4 design and 6-8 illustration jobs/year. Pays by the project.

Jackets/Covers Assigns 6-8 design and 10-12 illustration jobs/year. Pays by the project, $300-1,000 Canadian.

Text Illustration Assigns 3-4 design and 4-6 illustration jobs/year. Pays by the project. May pay advance on royalties.

Tips Looks for freelancers with a proven track record and knowledge of Red Deer Press. "Send a quality portfolio, preferably with samples of book projects completed."

RED WHEEL/WEISER

500 Third St., Suite 230, San Francisco CA 94107. (415)978-2665. Fax: (415)869-1022. E-mail: dlinden@redwheelweiser.com. Web site: www.redwheelweiser.com. **Creative Director:** Donna Linden. Publishes trade hardcover and paperback originals and reprints. Imprints: Red Wheel (spunky self-help); Weiser Books (metaphysics/oriental mind-body-spirit/esoterica); Conari Press (self-help/inspirational). Publishes 50 titles/year.

Needs Uses freelancers for jacket/text design and illustration.

First Contact & Terms Designers: Send résumé, photocopies and tearsheets. Illustrators: Send photocopies, photographs, SASE and tearsheets. "We can use art or photos. I want to see samples I can keep." Samples are filed or are returned by SASE only if requested by artist. Responds only if interested. Originals are returned to artist at job's completion. To show portfolio, mail tearsheets, color photocopies. Considers complexity of project, skill and experience of artist, project's budget, turnaround time and rights purchased when establishing payment. Buys one-time nonexclusive royalty-free rights. Finds most artists through references/word of mouth, portfolio reviews and samples received through the mail.

Jackets/Covers Assigns 20 design jobs/year. Must have trade book design experience in the subjects we publish.

Tips "Send samples by mail, preferably in color. We work electronically and prefer digital art-work or scans. Do not send drawings of witches, goblins and demons for Weiser Books; we don't put those kinds of images on our covers. Please take a moment to look at our books before submitting anything; we have characteristic looks for all three imprints."

🅽 SCHOOL GUIDE PUBLICATIONS

210 North Ave., New Rochelle NY 10801. (800)433-7771. Fax: (914)632-3412. E-mail: info@scho olguides.com. Web site: www.schoolguides.com. **Art Director:** Melvin Harris. Assistant Art Director: Tory Ridder. Estab. 1935. Types of books include reference and educational directories. Specializes in college recruiting publications. Recent titles include *School Guide*; *Graduate School Guide*; *College Transfer Guide*; *Armed Services Veterans Education Guide*; *College Conference Manual*. 25% requires freelance illustration; 75% requires freelance design.

Needs Approached by 10 illustrators and 10 designers/year. Prefers local freelancers. Prefers freelancers experienced in book cover and brochure design. 100% of freelance design and illustration demands knowledge of Illustrator, Photoshop, QuarkXPress.

First Contact & Terms Send query letter with printed samples. Accepts Mac-compatible disk

submissions. Send EPS files. Samples are filed. Responds only if interested. Will contact artist for portfolio review if interested. Rights purchased vary according to project. Finds freelancers through word of mouth.

Book Design Assigns 2 freelance design and 2 art direction projects/year.

Jackets/Covers Assigns 1 freelance design jobs/year.

SOUNDPRINTS

353 Main Ave., Norwalk CT 06851-1552. (203)846-2274. Fax: (203)846-1776. E-mail: soundprint s@soundprints.com. Web site: www.soundprints.com. **Art Director:** Meredith Campbell Britton. Estab. 1989. Publishes hardcover originals. Types of books include juvenile. Specializes in wildlife, worldwide habitats, social studies and history. Recent titles include *Black Bear Cub at Sweet Berry Trail*, by Laura Gates Galvin; *Hermit Crab's Home: Safe in a Shell*, by Janet Halfmann. Publishes 30 titles/year; 100% require freelance illustration. Book catalog available for 9 × 12 SASE with $1.21 postage.

Needs Works with 8-10 illustrators/year. Prefers freelancers with experience in realistic wildlife illustration and children's books. Heavy visual research required of artists. Uses freelancers for illustrating children's books (covers and interiors).

First Contact & Terms E-mail samples. Art director will contact artist if interested . Originals are returned at job's completion. Finds artists through agents, sourcebooks, reference, unsolicited submissions.

Text Illustration Assigns 12-14 freelance illustration jobs/year.

Tips "We want realism, not cartoons. Animals illustrated are not anthropomorphic. Artists who love to produce realistic, well-researched wildlife and habitat illustrations, and who care deeply about the environment, are most welcome."

N STAR PUBLISHING

940 Emmett Ave., Belmont CA 94002. (650)591-3505. Fax: (650)591-3898. E-mail: mail@starpub lishing.com. Web site: www.starpublishing.com. **Publisher:** Stuart Hoffman. Estab. 1978. Specializes in original paperbacks and textbooks on science, art, business. Publishes 12 titles/year. 33% require freelance illustration. Titles include: *Microbiology Techniques*; *Food Microbiology*; *Geology*.

TORAH AURA PRODUCTIONS; ALEF DESIGN GROUP

4423 Fruitland Ave., Los Angeles CA 90058. (323)585-7312. Fax: (323)585-0327. E-mail: misrad @torahaura.com. Web site: www.torahaura.com. **Art Director**: Jane Golub. Estab. 1981. Publishes Jewish educational textbooks. Types of books include textbooks. Specializes in textbooks for Jewish schools. Recent titles: *Artzeinu: An Israel Encounter*; *Celebrating the Jewish Year 5768 Calendar*. Publishes 15 titles/year. 85% require freelance illustration. Book catalog free for 9 × 12 SAE with 10 first-class stamps.

Needs Approached by 50 illustrators and 20 designers/year. Works with 3 illustrators/year.

First Contact & Terms Illustrators: Send postcard sample and follow-up postcard every 6 months, printed samples, photocopies. Accepts Windows-compatible disk submissions. Samples are filed. Will contact artist for portfolio review if interested. Rights purchased vary according to project. Finds freelancers through submission packets.

Covers Assigns 6-10 illustration jobs/year. Pays by the project.

⊠ TORMONT PUBLICATIONS INC.

5532 St. Patrick, Montreal QC H4E 1A8 Canada. (514)954-1441. Fax: (514)954-1443. E-mail: sherry.segal@tormont.ca. **Publisher:** Sherry Segal. Estab. 1986. Specializes in children's books and stationery products. Publishes 60+ titles/year.

Needs Looking for creative and professional freelance illustrators, layout artists and graphic designers with experience in children's publishing. Must be able to work on strict deadlines with Illustrator, InDesign, QuarkXPress and Photoshop.

First Contact & Terms Send portfolio by e-mail or postal mail. Art Director will contact artist only if there is interest. Buys all rights. Does not pay royalties.

Tips Tormont produces children's books that target the 3- to 7-year age group.

TYNDALE HOUSE PUBLISHERS, INC.

351 Executive Dr., Carol Stream IL 60188. E-mail: talindaiverson@tyndale.com. Web site: www.tyndale.com. **Art Buyer:** Talinda Iverson. Estab. 1962. Publishes hardcover and trade paperback originals. Specializes in children's books on "Christian beliefs and their effect on everyday life." Publishes 150 titles/year. 15% require freelance illustration.

Needs Approached by 200-250 freelance artists/year. Works with 5-7 illustrators.

First Contact & Terms Send query letter and tearsheets only. Samples are filed or are returned by SASE. Responds only if interested. Considers complexity of project, skill and experience of artist, project's budget and rights purchased when establishing payment. Negotiates rights purchased. Originals are returned at job's completion except for series logos.

Jackets/Covers Assigns 5-10 illustration jobs/year. Prefers progressive but friendly style. Pays by the project, no royalties.

Text Illustration Assigns 1-5 jobs/year. Prefers progressive but friendly style. Pays by the project.

Tips "Only show your best work. We are looking for illustrators who can tell a story with their work and who can draw the human figure in action when appropriate."

⊠ WEIGL EDUCATIONAL PUBLISHERS LIMITED

6325-10th St. SE, Calgary AB T2H 2Z9 Canada. (403)233-7747. Fax: (403)233-7769. E-mail: linda@weigl.com. Web site: www.weigl.com. **Contact:** Managing Editor. Estab. 1979. Textbook and library series publisher catering to juvenile and young adult audience. Specializes in social studies, science-environmental, life skills, multicultural American and Canadian focus. Titles include: The titles are *Structural Wonders, Backyard Animals* and *Learning to Write.* Publishes more than 100 titles/year. Book catalog free by request.

Needs Approached by 300 freelancers/year. Uses freelancers only during peak periods. Prefers freelancers with experience in children's text illustration in line art/watercolor. Uses freelancers mainly for text illustration or design; also for direct mail design. Freelancers should be familiar with QuarkXPress 5.0, Illustrator 10.0 and Photoshop 7.0.

First Contact & Terms Send résumé for initial review prior to selection for interview. Limited freelance opportunities. Graphic designers required on site. Extremely limited need for illustrators. Samples are returned by SASE if requested by artist. Responds only if interested. Write for appointment to show portfolio of original/final art (small), b&w photostats, tearsheets and photographs. Rights purchased vary according to project.

Text Illustration Pays on per-project basis, depending on job. Prefers line art and watercolor appropriate for elementary and secondary school students.

WHITE MANE PUBLISHING COMPANY, INC.

73 W. Burd St., P.O. Box 708, Shippensburg PA 17257. (717)532-2237. Fax: (717)532-6110. Web site: www.whitemane.com. **Vice President:** Harold Collier. Estab. 1987. Publishes hardcover originals and reprints, trade paperback originals and reprints. Types of books include historical biography, biography, history, juvenile, nonfiction and young adult. Publishes 70 titles/year. 10% require freelance illustration. Book catalog free with SASE.

Needs Works with 2-3 illustrators and 2 designers/year.

First Contact & Terms Send query letter with printed samples. Samples are filed. Interested only in historic artwork. Responds only if interested. Will contact artist for portfolio review if interested. Rights purchased vary according to project. Finds freelancers through submission packets and postcards.

Jackets/Covers Assigns 8 illustration jobs/year. Pays for design by the project.

Tips Uses art for covers only—historical scenes for young adults.

ALBERT WHITMAN & COMPANY

6340 Oakton, Morton Grove IL 60053-2723. (847)581-0033. Fax: (847)581-0039. E-mail: mail@a whitmanco.com. Web site: www.albertwhitman.com. **Art Director:** Carol Gildar. Publishes hardcover originals. Specializes in juvenile fiction and nonfiction—many picture books for young children. Recent titles include *Callie Cat, Ice Skater,* by Eileen Spinelli, art by Anne Kennedy; *The Frog with the Big Mouth*, by Teresa Bateman, art by Will Terry; *Bravery Soup*, by Maryann Cocca-Leffler. Publishes 35 titles/year; 100% require freelance illustration.

Needs Prefers working with artists who have experience illustrating juvenile trade books. Works on assignment only.

First Contact & Terms Illustrators: Send postcard sample and tearsheets. "One sample is not enough. We need at least three. Do *not* send original art through the mail." Accepts disk submissions. Samples are not returned. Responds "if we have a project that seems right for the artist. We like to see evidence that an artist can show the same children and adults in a variety of moods, poses and environments." Rights purchased vary. Original work returned at job's completion.

Cover/Text Illustration Cover assignment is usually part of text illustration assignment. Assigns 2-3 covers per year. Prefers realistic and semi-realistic art. Pays by flat fee for covers; royalties for picture books.

Tips Books need "a young look—we market to preschoolers and children in grades 1-3." Especially looks for "an artist's ability to draw people (especially children) and to set an appropriate mood for the story. Please do NOT submit cartoon art samples or flat digital illustrations."

WILSHIRE BOOK CO.

9731 Variel Ave., Chatsworth CA 91311. E-mail: mpowers@mpowers.com. Web site: www.mpo wers.com. **President:** Melvin Powers. Publishes trade paperback originals and reprints. Types of books include Internet marketing, humor, instructional, New Age, psychology, self-help, inspirational and other types of nonfiction. Recent titles include *Think Like a Winner!*; *The Dragon Slayer with a Heavy Heart*; and *The Knight in Rusty Armor*. Publishes 25 titles/year; 100% require freelance design.

Needs Uses freelancers mainly for book covers.

First Contact & Terms Send query letter with fee schedule, tearsheets, photostats, photocopies (copies of previous book covers).

Book Design Assigns 25 freelance design jobs/year.

Jackets/Covers Assigns 25 cover jobs/year.

Greeting Cards, Gifts & Products

The companies listed in this section contain some great potential clients for you. Although greeting card publishers make up the bulk of the listings, you'll also find many businesses that need images for all kinds of other products. We've included manufacturers of everyday items such as paper plates, napkins, banners, shopping bags, T-shirts, school supplies, personal checks and calendars, as well as companies looking for fine art for limited edition collectibles.

TIPS FOR GETTING STARTED

1. Read the listings carefully to learn exactly what products each company makes and the specific styles and subject matter they use.

2. Browse store shelves to see what's out there. Take a notebook and jot down the types of cards and products you see. If you want to illustrate greeting cards, familiarize yourself with the various categories of cards and note which images tend to appear again and again in each category.

3. Pay attention to the larger trends in society, such as diversity, patriotism, and the need to feel connected to others. Fads such as reality TV and scrapbooking, as well as popular celebrities, often show up in images on cards and gifts. Trends can also be spotted in movies and on Web sites.

GUIDELINES FOR SUBMISSION

- Do *not* send originals. Companies want to see photographs, photocopies, printed samples, computer printouts, tearsheets or slides. Many also accept digital files on disc or via e-mail.
- Artwork should be upbeat, brightly colored, and appropriate to one of the major categories or niches popular in the industry.
- Make sure each sample is labeled with your name, address, phone number, e-mail address and Web site.
- Send three to five appropriate samples of your work to the contact person named in the listing. Include a brief cover letter with your initial mailing.
- Enclose a self-addressed, stamped envelope if you need your samples back.
- Within six months, follow up with another mailing to the same listings and additional card and gift companies you have researched.

Don't overlook the collectibles market

Limited edition collectibles, such as ornaments, figurines and collector plates, appeal to a wide audience and are a lucrative niche for artists. To do well in this field, you have to be

Greeting Card Basics

Important

- **Approximately 7 billion** greeting cards are purchased annually, generating more than $7.5 billion in retail sales.

- **Women** buy more than 80% of all greeting cards.

- **Seasonal cards** express greetings for more than 20 different holidays, including Christmas, Easter and Valentine's Day. Christmas cards account for 60% of seasonal greeting card sales.

- **Everyday cards** express nonholiday sentiments. The "everyday" category includes get well cards, thank you cards, sympathy cards, and a growing number of person-to-person greetings. There are cards of encouragement that say "Hang in there!" and cards to congratulate couples on staying together, or even getting divorced! There are cards from "the gang at the office" and cards to beloved pets. Check store racks for possible "everyday" occasions.

- **Categories** are further broken down into the following areas: **traditional**, **humorous** and **alternative**. "Alternative" cards feature quirky, sophisticated or offbeat humor.

- **There are more than 2,000 greeting card publishers in America,** ranging from small family businesses to major corporations.

flexible enough to take suggestions. Companies test-market products to find out which images will sell the best, so they will guide you in the creative process. For a collectible plate, for example, your work must fit into a circular format or you'll be asked to extend the painting out to the edge of the plate.

Popular themes for collectibles include animals (especially kittens and puppies), children, dolls, TV nostalgia, and patriotic, Native American, wildlife, religious (including madonnas and angels), gardening, culinary and sports images.

E-cards

If you are at all familiar with the Internet, you know that electronic greeting cards are very popular. Many can be sent for free, but they drive people to Web sites and can, therefore, be a smart marketing tool. The most popular e-cards are animated, and there is an increasing need for artists who can animate their own designs for the Web, using Flash animation. Search the Web and visit sites such as www.hallmark.com, www.bluemountain.com and www.americangreetings.com to get an idea of the variety of images that appear on e-cards. Companies often post their design needs on their Web sites.

PAYMENT AND ROYALTIES

Most card and product companies pay set fees or royalty rates for design and illustration. Card companies almost always purchase full rights to work, but some are willing to negotiate for other arrangements, such as greeting card rights only. If the company has ancillary plans

in mind for your work (calendars, stationery, party supplies or toys), they will probably want to buy all rights. In such cases, you may be able to bargain for higher payment. For more tips, see Copyright Basics on page 18.

Helpful Resources

For More Info

Greetings etc. (www.greetingsmagazine.com) is the official publication of the **Greeting Card Association** (www.greetingcard.org). Subscribe online, and sign up for a free monthly e-newsletter.

Party & Paper is a trade magazine focusing on the party niche. Visit www.partypaper.com for industry news and subscription information.

The National Stationery Show is the ''main event'' of the greeting card industry. Visit www.nationalstationeryshow.com to learn more.

KURT S. ADLER, INC.

7 W. 34th St., Suite 100, New York NY 10001-3019. (212)924-0900. Fax: (212)807-0575. E-mail: info@kurtadler.com. Web site: www.kurtadler.com. **President:** Howard Adler. Estab. 1946. Manufacturer and importer of Christmas ornaments and giftware products. Produces collectible figurines, decorations, gifts, ornaments.

Needs Prefers freelancers with experience in giftware. Considers all media. Will consider all styles appropriate for Christmas ornaments and giftware. Produces material for Christmas, Halloween.

First Contact & Terms Send query letter with brochure, photocopies, photographs. Responds within 1 month. Will contact for portfolio review if interested. Payment negotiable.

Tips ''We rely on freelance designers to give our line a fresh, new approach and innovative new ideas.''

Ⓝ ALEF JUDAICA, INC.

13310 S. Figueroa St., Los Angeles CA 90061. (310)202-0024. Fax: (310)202-0940. E-mail: alon@ alefjudaica.com. Web site: www.alefjudaica.com. **President:** Alon Rozov. Estab. 1979. Manufacturer and distributor of a full line of Judaica, including menorahs, Kiddush cups, greeting cards, giftwrap, tableware, etc.

Needs Approached by 15 freelancers/year. Works with 10 freelancers/year. Buys 75-100 freelance designs and illustrations/year. Prefers local freelancers with experience. Works on assignment only. Uses freelancers for new designs in Judaica gifts (menorahs, etc.) and ceramic Judaica. Also for calligraphy, pasteup and mechanicals. All designs should be upper scale Judaica.

First Contact & Terms Mail brochure, photographs of final art samples. Art director will contact artist for portfolio review if interested, or portfolios may be dropped off every Friday. Sometimes requests work on spec before assigning a job. Pays $300 for illustration/design; pays royalties of 10%. Considers buying second rights (reprint rights) to previously published work.

ALLPORT EDITIONS

2337 NW York St., Portland OR 97210-2112. (503)223-7268. Fax: (503)223-9182. E-mail: art@all port.com. Web site: www.allport.com. **Contact:** Creative Director. Estab. 1983. Produces greeting cards. Specializes in regional designs (American Cities and States). Currently only working with hand-rendered art (pen and ink, watercolor, acrylic, etc.). Art guidelines available on Web site.

Needs Approached by 200 freelancers/year. Works with 3- 5 freelancers/year. Licenses 60 freelance designs and illustrations/year. Prefers art scaleable to card size. Produces material for holidays, birthdays and everyday. Submit seasonal material 1 year in advance.

First Contact & Terms Send query letter with photocopies and SASE. Accepts submissions on disk compatible with PC-formatted TIFF or JPEG files. Samples are filed or returned by SASE. Responds in 3-5 months, "if response is requested." Rights purchased vary according to project. All contracts on royalty basis. Finds freelancers mainly through submissions.

Tips "Submit enough samples for us to get a feel for your style/collection. Two is probably too few; forty is too many."

AMCAL, INC.

MeadWestvaco Consumer & Office Products, 4751 Hempstead Station Dr., Kettering OH 45429. (937)495-6323. Fax: (937)495-3192. E-mail: calendars@meadwestvaco.com. Web site: www.am calart.com or www.meadwestvaco.com. Publishes calendars, note cards, Christmas cards and other stationery items and books. Markets to a broad distribution channel, including better gifts, books, department stores and larger chains throughout U.S. Some sales to Europe, Canada and Japan. "We look for illustration and design that can be used in many ways: calendars, note cards, address books and more, so we can develop a collection. We license art that appeals to a widely female audience."

Needs Prefers work in horizontal format. No gag humor or cartoons. Art guidelines available for SASE with first-class postage or on Web site.

First Contact & Terms Send query letter with brochure, résumé, photographs, slides, tearsheets and transparencies. Include a SASE for return of material. Responds within 6 weeks. Will contact artist for portfolio review if interested. Pays for illustration by the project, advance against royalty.

Tips "Research what is selling and what's not. Go to gift shows and visit lots of stationery stores. Read all the trade magazines. Talk to store owners."

▣ AMERICAN GREETINGS CORPORATION

One American Rd., Cleveland OH 44144. (216)252-7300. Fax: (216)252-6778. E-mail: dan.weiss @amgreetings.com. Web site: www.americangreetings.jobs. Estab. 1906. Produces greeting cards, stationery, calendars, paper tableware products, giftwrap and ornaments. Also recruiting for AG Interactive.

Needs Prefers designers with experience in illustration, graphic design, surface design and calligraphy. Also looking for skills in motion graphics, Photoshop, animation and strong drawing skills. Usually works from a list of 100 active freelancers.

First Contact & Terms Apply online. "Do not send samples." Pays $300 and up based on complexity of design. Does not offer royalties.

Tips "Get a BFA in graphic design with a strong emphasis on typography."

ANW CRESTWOOD; THE PAPER COMPANY; PAPER ADVENTURES

501 Ryerson Rd., Lincoln Park NJ 07035. (973)406-5000. Fax: (973)709-9494. E-mail: katey@an wcrestwood.com. Web site: www.anwcrestwood.com. **Creative Department Contact:** Katey Franceschini. Estab. 1901. Produces stationery, scrapbook and paper crafting. Specializes in stationery, patterned papers, stickers and related paper products.

Needs Approached by 100 freelancers/year. Works with 20 freelancers/year. Buys or licenses 150 freelance illustrations and design pieces/year. Prefers freelancers with experience in illustration/fine art, stationery design/surface design. Works on assignment only. Considers any medium that can be scanned.

First Contact & Terms Mail or e-mail nonreturnable color samples. Company will call if there is a current or future project that is relative. Accepts Mac-compatible disk and e-mail submissions. Samples are filed for future projects. Will contact artist for more samples and to discuss project. Pays for illustration by the project, $100 and up. Also considers licensing for complete product collections. Finds freelancers through trade shows and *Artist's & Graphic Designer's Market*.

Tips ''Research the craft and stationery market and send only appropriate samples for scrapbooking, cardcrafting and stationery applications. Send lots of samples, showing your best, neatest and cleanest work with a clear concept.''

APPLEJACK ART PARTNERS

P.O. Box 1527, Manchester Center VT 05255. (802)362-3662. Fax: (802)362-3286. E-mail: jess@a pplejackart.com. Web site: www.applejackart.com. Manager of Art Sourcing and Artist Support: Jess Rogers. Licenses art for bookmarks, calendars, collectible figurines, decorative housewares, decorations, games, giftbags, gifts, giftwrap, greeting cards, limited edition plates, mugs, ornaments, paper tableware, party supplies, personal checks, posters, prints, school supplies, stationery, T-shirts, textiles, toys, wallpaper, etc.

- Long-established poster companies Bernard Fine Art, Hope Street Editions and Rose Selavy of Vermont are divisions of Applejack Art Partners. Applejack publishes art for decorative wall decor and fine art.

Needs Seeking extensive artwork for use on posters and a wide cross section of product categories. Looking for variety of styles and subject matter. Art guidelines free for SASE with first-class postage. Considers all media and all styles. Produces material for all holidays.

First Contact Terms Send color photocopies, photographs, tearsheets, CD-ROM. No e-mail submissions. Accepts disk submissions compatible with Photoshop. Samples are filed or returned by SASE only. Responds in 1 month. Will contact artist for portfolio review if interested.

AR-EN PARTY PRINTERS, INC.

8225 N. Christiana Ave., Skokie IL 60076. (847)673-7390. Fax: (847)673-7379. E-mail: info@ar-en.net. Web site: www.ar-en.com. **Owner:** Gary Morrison. Estab. 1978. Produces stationery and paper tableware products. Makes personalized party accessories for weddings and all other affairs and special events.

Needs Works with 1-2 freelancers/year. Buys 10 freelance designs and illustrations/year. Works on assignment only. Uses freelancers mainly for new designs; also for calligraphy. Looking for contemporary and stylish designs, especially b&w line art (no grayscale) to use for hot stamping dyes. Prefers small (2×2) format.

First Contact & Terms Send query letter with brochure, résumé and SASE. Samples are filed or returned by SASE if requested by artist. Responds in 2 weeks. Will contact artist for portfolio

review if interested. Rights purchased vary according to project. Pays by the hour, $40 minimum; by the project, $750 minimum.

Tips "My best new ideas always evolve from something I see that turns me on. Do you have an idea/style that you love? Market it. Someone out there needs it."

ART LICENSING INTERNATIONAL INC.

711 S Osprey Ave, Ste 1, Sarasota FL 34236. (941)966-4042. Fax: (941)296-7345. E-mail: artlicensing@comcast.net. Web site: www.out-of-the-blue.us. **President:** Michael Woodward. Licenses art and photography for fine art prints, canvas giclees for hotels and offices, wall decor, calendars, paper products and greeting cards.

- See additional listings for this company in the Posters & Prints and Artists' Reps sections. See also listing for Out of the Blue in this section.

ARTFUL GREETINGS

P.O. Box 52428, Durham NC 27717. (919)484-0100. Fax: (919)484-3099. E-mail: myw@artfulgreetings.com. Web site: www.artfulgreetings.com. **Vice President of Operations:** Marian Whittedalderman. Estab. 1990. Produces bookmarks, greeting cards, T-shirts and magnetic notepads. Specializes in multicultural subject matter, all ages.

Needs Approached by 200 freelancers/year. Works with 10 freelancers/year. Buys 20 freelance designs and illustrations/year. No b&w art. Uses freelancers mainly for cards. Considers bright color art, no photographs. Looking for art depicting people of all races. Prefers a multiple of 2 sizes: 5×7 and 5½×8. Produces material for Christmas, Mother's Day, Father's Day, graduation, Kwanzaa, Valentine's Day, birthdays, everyday, sympathy, get well, romantic, thank you, woman-to-woman and multicultural. Submit seasonal material 1 year in advance.

First Contact & Terms Designers: Send photocopies, SASE, slides, transparencies (call first). Illustrators: Send photocopies (call first). May send samples and queries by e-mail. Samples are filed. Artist should follow up with call or letter after initial query. Will contact for portfolio review of color slides and transparencies if interested. Negotiates rights purchased. Pays for illustration by the project, $50-100. Finds freelancers through word of mouth, NY Stationery Show.

Tips "Don't sell your one, recognizable style to all the multicultural card companies."

N ARTISTS TO WATCH

1766 E. Highway 36, Maplewood MN 55109. E-mail: submissions@artiststowatch.com. Web site: www.artiststowatch.com. **Owner:** Kathryn Shaw. "Manufacturer of high-quality greeting cards featuring the work of contemporary international artists. We have national and international distribution—great exposure for accomplished artists."

Needs Seeks artists with distinctive style, visual appeal, and mature skills. Art guidelines available. Considers all media and all types of prints.

First Contact & Terms Send 10-12 samples of work. Include SASE if you'd like work returned. E-mail small JPEG files or Web site URL. Responds in 6 weeks. "Send something that is representative of your work. We'll call you if we'd like to see more. Use of artwork is compensated with royalty payments."

ARTVISIONS™

Web site: www.artvisions.com. Licensing agency. "Not currently seeking new talent. However, we are always willing to view the work of top-notch established artists. For details and contact information, please see our listing in the Artists' Reps section."

N THE ASHTON-DRAKE GALLERIES

9200 N. Maryland Ave., Niles IL 60714. E-mail: adartist@ashtondrake.com. Web site: www.colle ctiblestoday.com. Estab. 1985. Direct response marketer of collectible dolls, ornaments and figurines. Clients consumers, mostly women of all age groups.

Needs Approached by 300 freelance artists/year. Works with 250 freelance doll artists, sculptors, costume designers and illustrators/year. Works on assignment only. Uses freelancers for illustration, wigmaking, porcelain decorating, shoemaking, costuming and prop making. Prior experience in giftware design and doll design a plus. Subject matter includes babies, toddlers, children, brides and fashion. Prefers ''cute, realistic and natural human features.''

First Contact & Terms Send or e-mail query letter with résumé and copies of samples to be kept on file. Prefers photographs, tearsheets or photostats as samples. Samples not filed are returned. Responds in 1 month. Compensation by project varies. Concept illustrations are done ''on spec.'' Sculptors receive contract for length of series on royalty basis with guaranteed advances.

Tips ''Please make sure we're appropriate for you. Visit our Web site before sending samples!''

BARTON-COTTON INC.

9755 Patuxent Woods Dr., Suite 300, Columbia MD 21046 (410)247-4800. Fax: (410)-247-2548. E-mail: tammy.severe@bartoncotton.com. Web site: www.bartoncotton.com. **Art Buyer:** Tammy Severe. Produces religious greeting cards, commercial all-occasion, Christmas cards, wildlife designs and spring note cards. Licenses wildlife art, photography, traditional Christmas art for note cards, Christmas cards, calendars and all-occasion cards.

Needs Buys 150-200 freelance illustrations/year. Submit seasonal work any time. Free art guidelines for SASE with first-class postage and sample cards; specify area of interest (religious, Christmas, spring, etc.).

First Contact & Terms Send query letter with résumé, tearsheets, photocopies or slides. Submit full-color work only (watercolor, gouache, pastel, oil and acrylic). Previously published work and simultaneous submissions accepted. Responds in 1 month. Pays by the project. Pays on acceptance.

Tips ''Good draftsmanship is a must. Spend some time studying current market trends in the greeting card industry. There is an increased need for creative ways to paint traditional Christmas scenes with up-to-date styles and techniques.''

N FREDERICK BECK ORIGINALS

51 Bartlett Ave., Pittsfield MA 01201. (413)443-0973. Fax: (413)445-5014. **Art Director:** Mark Brown. Estab. 1953. Produces silk screen printed Christmas cards, traditional to contemporary.

● This company is under the same umbrella as Editions Limited and Gene Bliley Stationery. One submission will be seen by all companies, so there is no need to send three mailings. Frederick Beck and Editions Limited designs are a little more high end than Gene Bliley designs. The cards are sold through stationery and party stores, where the customer browses through thick binders to order cards, stationery or invitations imprinted with customer's name. Though some of the same cards are repeated or rotated each year, all companies are always looking for fresh images. Frederick Beck and Gene Bliley's sales offices are still in North Hollywood, CA, but art director works from Pittsfield office.

N BEISTLE COMPANY

1 Beistle Plaza, Shippensburg PA 17257-9623. (717)532-2131. Fax: (717)532-7789. E-mail: beistle @cvn.net. Web site: www.beistle.com. Art Director: Rick Buterbaugh. Estab. 1900. Manufac-

turer of paper and plastic decorations, party goods, gift items, tableware and greeting cards. Targets general public, home consumers through P-O-P displays, specialty advertising, school market and other party good suppliers.

Needs Approached by 250-300 freelancers/year. Works with 50 freelancers/year. Prefers artists with experience in designer gouache illustration. Also needs digital art (Macintosh platform or compatible). Art guidelines available. Looks for full-color, camera-ready artwork for separation and offset reproduction. Works on assignment only. Uses freelance artists mainly for product rendering and brochure design and layout. Prefers digital art using various styles and techniques. 50% of freelance design and 50% of illustration demand knowledge of QuarkXPress, Illustrator, Photoshop or Painter.

First Contact & Terms Send query letter with résumé and color reproductions with SASE. Samples are filed or returned by SASE. Art director will contact artist for portfolio review if interested. Sometimes requests work on spec before assigning a job. Pays by the project. Considers buying second rights (reprint rights) to previously published work. Finds artists through word of mouth, magazines, submissions/self-promotions, sourcebooks, agents, visiting artists' exhibitions, art fairs and artists' reps.

Tips "Our primary interest is in illustration; often we receive freelance propositions for graphic designbrochures, logos, catalogs, etc. These are not of interest to us as we are manufacturers of printed decorations. Send color samples rather than b&w."

▣ BEPUZZLED/UNIVERSITY GAMES
2030 Harrison St., San Francisco CA 94110. (415)503-1600. Fax: (415)503-0085. E-mail: info@ug ames.com. Web site: www.universitygames.com/bepuzzled/default.asp. **Creative Services Manager:** Susan King. Estab. 1986. Produces games and puzzles for children and adults. "Bepuzzled mystery jigsaw games challenge players to solve an original whodunit thriller by matching clues in the mystery with visual clues revealed in the puzzle."

Needs Works with 20 freelance artists/year. Buys 20-40 designs and illustrations/year. Prefers local artists with experience in children's book and adult book illustration. Uses freelancers mainly for box cover art, puzzle images and character portraits. All illustrations are done to spec. Considers many media.

First Contact & Terms Send query letter with brochure, résumé, tearsheets or other nonreturnable samples. Samples are filed. Art director will contact artist for portfolio review if interested. Portfolio should include original/final art and photographs. Original artwork is returned at the job's completion. Sometimes requests work on spec before assigning a job. Pays by the project, $300-3,000. Finds artists through word of mouth, magazines, submissions, sourcebooks, agents, galleries, reps, etc.

BERGQUIST IMPORTS, INC.
1412 Hwy. 33 S., Cloquet MN 55720. (218)879-3343. Fax: (218)879-0010. E-mail: bbergqu106@a ol.com. Web site: www.bergquistimports.com. **President:** Barry Bergquist. Estab. 1948. Produces paper napkins, mugs and tile. Wholesaler of mugs, decorator tile, plates and dinnerware.

• See additional listing in the Posters & Prints section.

Needs Approached by 25 freelancers/year. Works with 5 freelancers/year. Buys 50 designs and illustrations/year. Prefers freelancers with experience in Scandinavian designs. Works on assignment only. Also uses freelancers for calligraphy. Produces material for Christmas, Valentine's Day and everyday. Submit seasonal material 6-8 months in advance.

First Contact & Terms Send query letter with brochure, tearsheets and photographs. Samples are returned, not filed. Responds in 2 months. Request portfolio review in original query. Artist should follow up with a letter after initial query. Portfolio should include roughs, color tearsheets and photographs. Rights purchased vary according to project. Originals are returned at job's completion. Requests work on spec before assigning a job. Pays by the project, $50-300; average flat fee of $100 for illustration/design; or royalties of 5%. Finds artists through word of mouth, submissions/self-promotions and art fairs.

ℕ BERWICKOFFRAY

350 Clark Drive., Budd Lake NJ 07828. (973)527-6137. Fax: (973)527-6170. E-mail: pattijo.smith @berwickoffray.com. **Contact:** Patti Jo Smith, business unit manager of design and new product. Estab. 1900. Produces ribbons. ''We're a ribbon company—for ribbon designs we look to the textile design studios and textile-oriented people; children's designs, craft motifs, fabric trend designs, floral designs, Christmas designs, bridal ideas, etc. Our range of needs is wide, so we need various looks.''
Needs Looking for artists able to translate a trend or design idea into a $1\frac{1}{2}$ to $2\frac{1}{2}$ inch width ribbon. Produce ribbons for Fall/Christmas, Valentines, Easter, Bridal and everyday.
First Contact & Terms Send postcard sample or query letter with résumé or call.

ℕ GENE BLILEY STATIONERY

12011 Sherman Rd., N. Hollywood CA 91605. (818)765-4550. Fax: (866)998-5808. E-mail: info@ chatsworthcollection.com. Web site: www.chatsworthcollection.com. **Art Director:** Mark Brown. General Manager: Gary Lainer. Sales Manager: Ron Pardo. Estab. 1967. Produces stationery, family-oriented birth announcements and invitations for most events and Christmas cards.
- This company also owns Editions Limited and Frederick Beck Originals. One submission will be seen by both companies. See listing for Editions Limited/Frederick Beck.

ℕ BLOOMIN' FLOWER CARDS

4734 Pearl St., Boulder CO 80301. (800)894-9185. Fax: (303)545-5273. E-mail: don@bloomin.c om. Web site: http://bloomin.com. **President:** Don Martin. Estab. 1995. Produces greeting cards, stationery and gift tags—all embedded with seeds.
Needs Approached by 100 freelancers/year. Works with 5-8 freelancers/year. Buys 5-8 freelance designs and illustrations/year. Art guidelines available. Uses freelancers mainly for card images. Considers all media. Looking for florals, garden scenes, holiday florals, birds, and butterflies— bright colors, no photography. Produces material for Christmas, Easter, Mother's Day, Father's Day, Valentine's Day, Earth Day, birthdays, everyday, get well, romantic and thank you. Submit seasonal material 8 months in advance.
First Contact & Terms Designers: Send query letter with color photocopies and SASE or electronic files. Illustrators: Send postcard sample of work, color photocopies or e-mail. Samples are filed or returned with letter if not interested. Responds if interested. Portfolio review not required. Rights purchased vary according to project. Pays royalties for design. Pays by the project or royalties for illustration. Finds freelancers through word of mouth, submissions, and local artists' guild.
Tips ''All submissions MUST be relevant to flowers and gardening.''

BLUE MOUNTAIN ARTS

P.O. Box 4959, Boulder CO 80306. (303) 449-0536. Fax: (800) 545-8573. E-mail: jkauflin@sps.com. Web site: www.sps.com. **Art Director:** Jody Kauflin. Estab. 1970. Produces books, bookmarks, calendars, greeting cards, mugs and prints. Specializes in handmade-looking greeting cards, calendars and books with inspirational or whimsical messages accompanied by colorful hand-painted illustrations.

Needs Art guidelines free with SASE and first-class postage or on Web site. Uses freelancers mainly for hand-painted illustrations. Considers all media. Product categories include alternative cards, alternative/humor, conventional, cute, inspirational and teen. Submit seasonal material 10 months in advance. Art size should be 5×7 vertical format for greeting cards.

First Contact & Terms Send query letter with photocopies, photographs, SASE and tearsheets. Send no more than 5 illustrations initially. No phone calls, faxes or e-mails. Samples are filed or are returned by SASE. Responds in 2 months. Portfolio not required. Buys all rights. Pays freelancers flat rate: $150-250/illustration if chosen. Finds freelancers through submissions and word of mouth.

Tips "We are an innovative company, always looking for fresh and unique art styles to accompany our sensitive or whimsical messages. We also welcome illustrated cards accompanied with your own editorial content. We strive for a handmade look. We love color! We don't want photography! We don't want slick computer art! Do in-store research to get a feel for the look and content of our products. We want illustrations for printed cards, NOT E-CARDS! We want to see illustrations that fit with our existing looks, and we also want fresh, new and exciting styles and concepts. Remember that people buy cards for what they say. The illustration is a beautiful backdrop for the message."

▥ BLUE MOUNTAIN WALLCOVERINGS

(formerly Imperial Home Decor Group), 15 Akron Rd., Toronto ON M8W 1T3 Canada. (416)251-1678. Fax: (416)251-8968. Web site: www.blmtn.com. **Contact:** Dan Scott. Produces wallpaper.

Needs Works with 20-50 freelancers/year. Prefers local designers/illustrators with experience in wallpaper. Art guidelines available. Product categories include conventional, country, juvenile and teen. 5% of freelance work demands knowledge of Photoshop.

- Blue Mountain Wallcoverings acquired Imperial Home Decor Group, Inc. (IHDG) in February 2004, creating one of the largest manufacturers and distributors of wallcoverings in the world.

First Contact & Terms Send brochure, photocopies and photographs. Samples are filed. Responds only if interested. Company will contact artist for portfolio review of color, finished art, original art, photographs, transparencies if interested. Buys rights for wallpaper and/or all rights. Pays freelancers by the project. Finds freelancers through agents, artists' submissions and word of mouth.

▥ BLUE SKY PUBLISHING

6595 Odell Place, Suite C, Boulder CO 80301. (303)530-4654. E-mail: bspinfo@blueskypublishing.net. Web site: www.blueskypublishing.net. **Contact:** Robert Marqueen. Estab. 1989. Produces greeting cards. "At Blue Sky Publishing, we are committed to producing contemporary fine art greeting cards that communicate reverence for nature and all creatures of the earth, that express the powerful life-affirming themes of love, nurturing and healing, and that share different cultural perspectives and traditions, while maintaining the integrity of our artists' work. Our main-

stay is our photographic card line of Winter in the West and other breathtaking natural scenes. We use well known landmarks in Arizona, New Mexico, Colorado and Utah for cards that businesses in the West purchase as their corporate holiday greeting cards.''

Needs Approached by 500 freelancers/year. Works with 3 freelancers/year. Licenses 10 fine art pieces/year. Works with freelancers from all over U.S. Prefers freelancers with experience in fine art media: oils, oil pastels, acrylics, calligraphy, vibrant watercolor and fine art photography. ''We primarily license existing pieces of art or photography. We rarely commission work.'' Looking for colorful, contemporary images with strong emotional impact. Art guidelines for SASE with first-class postage. Produces cards for all occasions. Submit seasonal material 1 year in advance.

First Contact & Terms Send query letter with SASE, slides or transparencies. Samples are filed or returned if SASE is provided. Responds in 4 months if interested. Transparencies are returned at job's completion. Pays royalties of 3% with a $150 advance against royalties. Buys greeting card rights for 5 years (standard contract; sometimes negotiated).

Tips ''We're interested in seeing artwork with strong emotional impact. Holiday cards are what we produce in biggest volume. We are looking for joyful images; cards dealing with relationships, especially between men and women, with pets, with Mother Nature and folk art. Vibrant colors are important.''

ⓝ THE BRADFORD EXCHANGE

9333 Milwaukee Ave., Niles IL 60714. (847)581-8217. Fax: (847)581-8221. E-mail: squigley@bra dfordexchange.com. Web site: www.collectiblestoday.com. **Artist Relations:** Suzanne Quigley. Estab. 1973. Produces and markets collectible products, including collector plates, ornaments, music boxes, cottages and figurines.

Needs Approached by thousands of freelancers/year. ''We're seeking talented freelance designers, illustrators and artists to work with our product development teams.'' Prefers artists with experience in rendering painterly, realistic, ''finished'' scenes. Uses freelancers for all work including concept sketching, border designs, sculpture. Traditional representational style is best, depicting children, pets, wildlife, homes, religious subjects, fantasy art, animation, celebrities, florals or songbirds in idealized settings.

First Contact & Terms Prefers designers send color references or samples of work you have done or a CD, along with a résumé and additional information. Please do not send original work or items that are one of a kind. Samples are filed in our Artist Resource file and are reviewed by product development team members as concepts are created that would be appropriate for your work. Art Director will contact artist only if interested. ''We offer competitive compensation.''

ASHLEIGH BRILLIANT ENTERPRISES

117 W. Valerio St., Santa Barbara CA 93101. (805)682-0531. **President:** Ashleigh Brilliant. Publishes postcards.

● See additional listing in the Syndicates & Cartoon Features section.

Needs Buys up to 300 designs/year. Freelancers may submit designs for word-and-picture postcards, illustrated with line drawings.

First Contact & Terms Submit $5\frac{1}{2} \times 3\frac{1}{2}$ horizontal b&w line drawings and SASE. Responds in 2 weeks. Buys all rights. Pays $60 minimum.

Tips ''Since our approach is very offbeat, it is essential that freelancers first study our line.

Otherwise, you will just be wasting our time and yours. We supply a catalog and sample set of cards for $2 plus SASE.''

BRISTOL GIFT CO., INC.

P.O. Box 425, Washingtonville NY 10992. (845)496-2821. Fax: (845)496-2859. E-mail: bristol6@frontiernet.net. Web site: www.bristolgift.net. **President:** Matthew Ropiecki. Estab. 1988. Specializes in framed pictures for inspiration and religious markets. Art guidelines available for SASE.

Needs Approached by 5-10 freelancers/year. Works with 2 freelancers/year. Buys 15-30 freelance designs and illustrations/year. Works on assignment only. Uses freelancers mainly for design; also for calligraphy, P-O-P displays, Web design and mechanicals. Prefers 16×20 or smaller. 10% of design and 60% of illustration require knowledge of PageMaker or Illustrator. Produces material for Christmas, Mother's Day, Father's Day and graduation. Submit seasonal material 6 months in advance.

First Contact & Terms Send query letter with brochure and photocopies. Samples are filed or returned. Responds in 2 weeks. Will contact artist for portfolio review if interested. Portfolio should include roughs. Requests work on spec before assigning a job. Originals are not returned. Pays by the project, $30-50 or royalties of 5-10%. Rights purchased vary according to project. Interested in buying second rights (reprint rights) to previously published artwork.

BRUSH DANCE INC.

165 N. Redwood Dr., Suite 200, San Rafael CA 94903. (800)531-7445. Fax: (415)491-4938. E-mail: art@brushdance.com. Web site: www.brushdance.com. **Art Director:** Liz Kalloch. Estab. 1989. Produces greeting cards, stationery, blank journals, illustrated journals, boxed notes, calendars, holiday cards and magnets. The line of Brush Dance products is inspired by the interplay of art and words. ''We develop products that combine powerful and playful words and images that act as daily reminders to inspire, connect, challenge and support.''

Needs Approached by 200 freelancers/year. Works with 3-5 freelancers/year. Uses freelancers for illustration, photography and calligraphy. Looking for nontraditional work conveying emotion or message. ''We are also interested in artists who are using both images and original words in their work.''

First Contact & Terms Check Web site for guidelines. Send query letter and tearsheets or color copies of your work. ''Don't send us transparencies, and never send originals.'' Samples are filed or returned by SASE. Pays on a royalty basis with percentage depending on product. Finds artists through word of mouth, submissions, art shows.

Tips *''Please* do your research, and look at our Web site to be sure your work will fit into our line of products.''

▨ CAMPAGNA FURNITURE

7500 E. Pinnacle Peak Rd. H221, Scottsdale AZ 85255. (480)563-2577. Fax: (480)563-7459. E-mail: laurajmorse@hotmail.com. Web site: campagnafurniture.com. **Vice President:** Laura Morse. Estab. 1994. Produces furniture. Specializes in powder room vanities and entertainment units.

Needs Approached by 80 freelancers/year. Works with 12 freelancers/year. Buys 100 freelance designs and/or illustrations/year. Uses freelancers mainly for decoupage. Considers all media. Product categories include floral, Trompe L'Oeil.

First Contact & Terms Send query letter with tearsheets, photocopies and photographs. Accepts e-mail submissions with link to website and submissions with image file. Prefers Windows-compatible, JPEG files. Samples are not filed and returned by SASE. Responds only if interested. Portfolio not required but should include finished art. Buys rights for furniture. Pays freelancers by the project $100 minimum-$200 maximum. Finds freelancers through word of mouth and artists' submissions.

Tips "We will consider new themes which individual artists might think appropriate for our cabinetry."

ℕ CAN CREATIONS, INC.

Box 848576, Pembroke Pines FL 33084. (954)581-3312. E-mail: judy@cancreations.com. Web site: www.cancreations.com. **President:** Judy Rappoport. Estab. 1984. Manufacturer of Cello wrap.

Needs Approached by 8-10 freelance artists/year. Works with 2-3 freelance designers/year. Assigns 5 freelance jobs/year. Prefers local artists only. Works on assignment only. Uses freelance artists mainly for "design work for cello wrap." Also uses artists for advertising design, illustration and layout; brochure design; posters; signage; magazine illustration and layout. "We are not looking for illustrators at the present time. Most designs we need are graphic and we also need designs which are geared toward trends in the gift industry. Looking for a graphic website designer for graphics on Web site only."

First Contact & Terms Send query letter with tearsheets and photostats. Samples are not filed and are returned by SASE only if requested by artist. Responds in 2 weeks. Call or write to schedule an appointment to show a portfolio, which should include roughs and b&w tearsheets and photostats. Pays for design by the project, $75 minimum. Pays for illustration by the project, $150 minimum. Considers client's budget and how work will be used when establishing payment. Negotiates rights purchased.

Tips "We are looking for simple designs geared to a high-end market."

ℕ CANETTI DESIGN GROUP INC.

P.O. Box 57, Pleasantville NY 10570. (914)238-3159. Fax: (914)238-0106. E-mail: info@canettide signgroup.com. **Marketing Vice President:** M. Berger. Estab. 1982. Produces photo frames, writing instruments, kitchen accessories and product design.

Needs Approached by 50 freelancers/year. Works with 10 freelancers/year. Works on assignment only. Uses freelancers mainly for illustration/computer. Also for calligraphy and mechanicals. Considers all media. Looking for contemporary style. Needs computer-literate freelancers for illustration and production. 80% of freelance work demands knowledge of Illustrator, Photoshop, Quark.

First Contact & Terms Send postcard-size sample of work and query letter with brochure. Samples are not filed. Portfolio review not required. Buys all rights. Originals are not returned. Pays by the hour. Finds artists through agents, sourcebooks, magazines, word of mouth and artists' submissions.

ℕ CAPE SHORE, INC.

Division of Downeast Concepts, 86 Downeast Dr., Yarmouth ME 04096. (207)846-3726. Fax: (207)846-1019. E-mail: capeshore@downeastconcepts.com. Web site: www.downeastconcepts.com. **Contact:** Melody Martin-Robie, creative director. Estab. 1947. "Cape Shore is concerned

with seeking, manufacturing and distributing a quality line of gifts and stationery for the souvenir and gift market." Licenses art by noted illustrators with a track record for paper products and giftware. Guidelines available on website.

Needs Approached by 100 freelancers/year. Works with 50 freelancers/year. Buys 400 freelance designs and illustrations/year. Prefers artists and product designers with experience in gift product, hanging ornament and stationery markets. Art guidelines available free for SASE. Uses freelance illustration for boxed note cards, Christmas cards, ornaments, home accessories, ceramics and other paper products. Considers all media. Looking for skilled wood carvers with a warm, endearing folk art style for holiday gift products.

First Contact & Terms "Do not telephone; no exceptions." Send query letter with color copies. Samples are filed or are returned by SASE. Art director will contact artist for portfolio review if interested. Portfolio should include finished samples, printed samples. Pays for design by the project, advance on royalties or negotiable flat fee. Buys varying rights according to project.

Tips "Cape Shore is looking for realistic detail, good technique, and traditional themes or very high quality contemporary looks for coastal as well as inland markets. We will sometimes buy art for a full line of products, or we may buy art for a single note or gift item. Proven success in the giftware field a plus, but will consider new talent and exceptional unpublished illustrators."

CARDMAKERS

P.O. Box 236, Lyme NH 03768. Phone/fax: (603)795-4422. E-mail: info@cardmakers.com. Web site: www.cardmakers.com. **Principal:** Peter Diebold. Estab. 1978. Produces greeting cards. "We produce cards for special interests and greeting cards for businesses—primarily Christmas. We also publish everyday cards for stockbrokers and boaters."

- CardMakers requests if you send submissions via e-mail, please keep files small. When sending snail mail, please be aware they will only respond if SASE is included.

Needs Approached by more than 300 freelancers/year. Works with 5-10 freelancers/year. Buys 20-40 designs and illustrations/year. Prefers professional-caliber artists. Art guidelines available on Web site only. "Please do not e-mail us for same." Works on assignment only. Uses freelancers mainly for greeting card design and calligraphy. Considers all media. "We market 5×7 cards designed to appeal to individual's specific interest—boating, building, cycling, stocks and bonds, etc." Prefers an upscale look. Submit seasonal ideas 6-9 months in advance.

First Contact & Terms Designers: Send brief sample of work. Illustrators: Send postcard sample or query letter with brief sample of work. "One good sample of work is enough for us. A return postcard with boxes to check off is wonderful. Phone calls are out; fax is a bad idea." Samples are filed. Responds only if interested. Portfolio review not required. Pays flat fee of $100-300, depending on many variables. Rights purchased vary according to project. Interested in buying second rights (reprint rights) to previously published work, if not previously used for greeting cards. Finds artists through word of mouth, exhibitions and *Artist's & Graphic Designer's Market* submissions.

Tips "We like to see new work in the early part of the year. It's important that you show us samples *before* requesting submission requirements. Getting published and gaining experience should be the main objective of freelancers entering the field. We favor fresh talent (but do also feature seasoned talent). PLEASE be patient waiting to hear from us! Make sure your work is equal to or better than that which is commonly found in use presently. Go to a large greeting card store. If you think you're as good or better than the artists there, continue!"

CAROLE JOY CREATIONS, INC.

1087 Federal Rd., Unit #8, Brookfield CT 06804. Fax: (203)740-4495. Web site: www.carolejoy.com. **President:** Carole Gellineau. Estab. 1985. Produces greeting cards. Specializes in cards, notes and invitations for people who share an African heritage.

Needs Approached by 200 freelancers/year. Works with 5-10 freelancers/year. Buys 100 freelance designs, illustrations and calligraphy/year. Will license design where appropriate. Also interested in licensing 12 coordinated images for calendars. Prefers artists "who are thoroughly familiar with, educated in and sensitive to the African-American culture." Works on assignment only. Uses freelancers mainly for greeting card art; also for calligraphy. Considers full color only. Looking for realistic, traditional, Afrocentric, colorful and upbeat style. Prefers 11×14. 20% of freelance design work demands knowledge of Illustrator, Photoshop and QuarkXPress. Produces material for Christmas, Easter, Mother's Day, Father's Day, graduation, Kwanzaa, Valentine's Day, birthdays and everyday; also for sympathy, get well, romantic, thank you, serious illness and multicultural cards. Submit seasonal material 1 year in advance.

First Contact & Terms Send query letter with brochure, photocopies, photographs and SASE. No phone calls or slides. No e-mail addresses. Responds to street address only. Calligraphers: send samples and compensation requirements. Samples are not filed and are returned with SASE only within 6 months. Responds only if interested. Portfolio review not required. Buys all rights. Pays for illustration by the project. Does not pay royalties; will license at one-time flat rate.

Tips "Excellent illustration skills are necessary, and designs should be appropriate for African-American social expression. Writers should send verse that is appropriate for greeting cards and avoid lengthy, personal experiences. Verse and art should be uplifting. We need coordinated themes for calendars."

CASE STATIONERY CO., INC.

14304 29th Rd., Flushing NY 11354. (718)886-4382. E-mail: case@casestationery.com. Web site: www.casestationery.com. **President:** Jerome Sudnow. Vice President: Joyce Blackwood. Estab. 1954. Produces stationery, notes, memo pads and tins for mass merchandisers in stationery and housewares departments.

Needs Approached by 10 freelancers/year. Buys 50 freelance designs/year. Works on assignment only. Buys design and/or illustration mainly for stationery products. Uses freelancers for mechanicals and ideas. Produces materials for Christmas; submit 6 months in advance. Likes to see youthful and traditional styles, as well as English and French country themes. 10% of freelance work requires computer skills.

First Contact & Terms Send query letter with résumé, tearsheets, photostats, photocopies, slides and photographs. Samples not filed are returned. Responds ASAP. Call or write for appointment to show portfolio. Original artwork is not returned. Pays by the project. Buys first rights or one-time rights.

Tips "Find out what we do. Get to know us. We are creative and know how to sell a product."

N CEDCO PUBLISHING CO.

P.O. Box 9740, San Rafael CA 94912-9740. E-mail: licensingadministrator@cedco.com. Web site: www.cedco.com. **Contact:** Licensing Department. Estab. 1982. Produces 200 upscale calendars and books. Art guidelines available on Web site.

Needs Approached by 500 freelancers/year. "We never give assignment work." Uses freelancers mainly for stock material and ideas. "We use either 35mm slides or 4×5s of the work."

First Contact & Terms "No phone calls accepted." Send query letter with nonreturnable photocopies and tearsheets. Samples are filed. "Also send list of places where your work has been published." Responds only if interested. To show portfolio, mail thumbnails and b&w photostats, tearsheets and photographs, or e-mail JPEG files. Original artwork is returned at the job's completion. Pays by the project. Buys one-time rights. Interested in buying second rights (reprint rights) to previously published work. Finds artists through art fairs and licensing agents.

Tips "Full calendar ideas encouraged!"

CENTRIC CORP.

6712 Melrose Ave., Los Angeles CA 90038. (323)936-2100. Fax: (323)936-2101. E-mail: centric@juno.com. Web site: www.centriccorp.com. **President:** Sammy Okdot. Estab. 1986. Produces products such as watches, pens, T-shirts, pillows, clocks, and mugs. Specializes in products that feature nostalgic, humorous, thought-provoking images or sayings on them and some classic licensed celebrities.

Needs Looking for freelancers who know Photoshop, QuarkXPress and Illustrator well.

First Contact & Terms Send examples of your work. Pays when project is completed.

Tips "Research the demographics of buyers who purchase Elvis, Lucy, Marilyn Monroe, James Dean, Betty Boop and Bettie Page products to know how to 'communicate a message' to the buyer."

☒ CHARTPAK/FRANCES MEYER, INC.

1 River Road, Leeds MA 01053. (800)628-1910. Fax: (800)762-7918. E-mail: lana@chartpak.com. Web site: www.chartpak.com. **Contact:** Lana Casiello, creative director. Estab. 1979. Produces scrapbooking products, stickers and stationery.

- Acquired by Chartpak, Inc. in 2003, the Frances Meyer brand produces scrapbooking and paper crafting products including patterned paper, stickers and paper.

Needs We currently work with 5-6 illustrators a year and accept hand rendered pieces as well as digital artwork. Work on assignment as well as altering existing works only shown outside the paper crafting market. Looking for children's themes, seasonal themes, holiday, baby, wedding, graduation, party themes and more.

First Contact & Terms Send query letter with examples or tearsheets, SASE, and as much information as is necessary to show diversity of style and creativity. No originals please. No response or return of samples without SASE with appropriate postage. Company will contact artist for portfolio review if interested. Responds in 2-3 months. All artwork will be used for presentation, in which the illustrator may request a fee. Complete payment for artwork and royalty options are negotiable and due to the illustrator once the piece goes into production.

Tips "Generally, we are looking to work with a few talented and committed artists for an extended period of time. We show our buyers designs on an ongoing basis for nine months out of the year, and it may take up to nine months to determine whether a piece will make it to the production stage of the process. If an item sells, it will remain in the line."

☒ CITY MERCHANDISE INC.

241 41st St., P.O. Box 320081, Brooklyn NY 11232. (718)832-2931. Fax: (718)832-2939. E-mail: citymdse@aol.com. **Executive Assistant:** Martina Santoli. Produces calendars, collectible figurines, gifts, mugs, souvenirs of New York.

Needs Works with 6-10 freelancers/year. Buys 50-100 freelance designs and illustrations/year.

"We buy sculptures for our casting business." Prefers freelancers with experience in graphic design. Works on assignment only. Uses freelancers for most projects. Considers all media. 50% of design and 80% of illustration demand knowledge of Photoshop, QuarkXPress, Illustrator. Does not produce holiday material.

First Contact & Terms Designers: Send query letter with brochure, photocopies, résumé. Illustrators and/or cartoonists: Send postcard sample of work only. Sculptors: Send résumé and slides, photos or photocopies of their work. Samples are filed. Include SASE for return of samples. Responds in 2 weeks. Portfolios required for sculptors only if interested in artist's work. Buys all rights. Pays by project.

N CLAY ART

239 Utah Ave., South San Francisco CA 94080-6802. (650)244-4970. Fax: (650)244-4979. **Art Director:** Jenny McClain Doores. Estab. 1979. Produces giftware and home accessory products cookie jars, salt & peppers, mugs, pitchers, platters and canisters. Line features innovative, contemporary or European tableware and hand-painted designs.

Needs Approached by 70 freelancers/year. Prefers freelancers with experience in 3-D design of giftware and home accessory items. Works on assignment only. Uses freelancers mainly for illustrations and 3-D design. Seeks humorous, whimsical, innovative work.

First Contact & Terms Send query letter with résumé, SASE, tearsheets and photocopies. Samples are filed. Responds only if interested. Call for appointment to show portfolio of thumbnails, roughs, final art, color photostats, tearsheets, slides and dummies. Negotiates rights purchased. Originals are returned at job's completion. Pays by project. Prefers buying artwork outright.

N CLEO, INC.

4025 Viscount Ave., Memphis TN 38118. (901)369-6657 or (800)289-2536. Fax: (901)369-6376. E-mail: cpatat@cleowrap.com. Web site: www.cleowrap.com. **Senior Director of Creative Resources:** Claude Patat. Estab. 1953. Produces giftwrap and gift bags. "Cleo is the world's largest Christmas giftwrap manufacturer. Other product categories include some seasonal product. Mass market for all age groups."

Needs Approached by 25 freelancers/year. Works with 40-50 freelancers/year. Buys more than 200 freelance designs and illustrations/year. Uses freelancers mainly for giftwrap and gift bags (designs). Also for calligraphy. Considers most any media. Looking for fresh, imaginative as well as classic quality designs for Christmas. 30" repeat for giftwrap. Art guidelines available. Submit seasonal material at least a year in advance.

First Contact & Terms Send query letter with slides, SASE, photocopies, transparencies and speculative art. Accepts submissions on disk. Samples are filed if interested or returned by SASE if requested by artist. Responds only if interested. Rights purchased vary according to project; usually buys all rights. Pays flat fee. Also needs package/product designers, pay rate negotiable. Finds artists through agents, sourcebooks, magazines, word of mouth and submissions.

Tips "Understand the needs of the particular market to which you submit your work."

COMSTOCK CARDS, INC.

600 S. Rock Blvd., Suite 15, Reno NV 89502. (775)856-9400. Fax: (775)856-9406. E-mail: production@comstockcards.com. Web site: www.comstockcards.com. **Contact:** Production Assistant. Estab. 1986. Produces greeting cards, giftbags and invitations. Styles include alternative and adult humor, outrageous and shocking themes. Art guidelines available for SASE with first-class postage.

Needs Approached by 250-350 freelancers/year. Works with 30-35 freelancers/year. "Especially seeking artists able to produce outrageous adult-oriented cartoons." Uses freelancers mainly for cartoon greeting cards. No verse or prose. Gaglines must be brief. Prefers 5×7 final art. Produces material for all occasions. Submit holiday concepts 6 months in advance.

First Contact & Terms Send query letter with SASE, tearsheets or photocopies. Samples are not usually filed and are returned by SASE if requested. Responds only if interested. Portfolio review not required. Originals are not returned. Pays royalties of 5%. Pays by the project, $50-150 minimum; may negotiate other arrangements. Buys all rights.

CONCORD LITHO

92 Old Turnpike Rd., Concord NH 03301. (603)225-3328 or (800)258-3662. Fax: (603)225-6120. Web site: www.concordlitho.com. **Contact:** Art Librarian. Estab. 1958. Produces greeting cards, stationery, posters, giftwrap, specialty paper products for nonprofit direct mail fundraising.

Needs Licenses artwork, illustration and photography. Considers all media but prefers watercolor. Art needs range from all-occasion and holiday greeting cards to religious subjects, wildlife, florals, nature, scenics, cute and whimsical. Always looking for traditional religious art. Produces printed material for Christmas, Valentine's Day, Mother's Day, Father's Day, Easter, Thanksgiving, New Year, birthdays, everyday and other religious dates. Submit seasonal material minimum 6-8 months in advance.

Specs Accepts images in digital format, original artwork and transparencies on rare occasions. Requires digital files via CD/DVD at 300 dpi (TIFF, EPS, JPEG).

First Contact & Terms Send introductory letter with with nonreturnable photographs, samples, or photocopies of work. Will keep samples that have strong potential for use on file. Also accepts submissions on disk. "Indicate whether work is for style only and if it is available." Responds in 3 months. Portfolio review not required. Rights purchased vary according to project. Pays by the project, $200-800. "No phone calls, please."

Tips Send quality samples or copies.

COURAGE CARDS

3915 Golden Valley Rd., Minneapolis MN 55422. (888)413-3323. E-mail: artsearch@courage.org. Web site: www.couragecards.org. **Art and Production Manager:** Laura Brooks. Estab. 1970. Courage Cards are holiday cards that are produced to support the programs of Courage Center, a nonprofit provider of rehabilitation services that helps people with disabilities live more independently.

Needs Seeking holiday art appropriate for greeting cards—including traditional, winter, nostalgic, religious, ethnic and world peace designs. Features artists with disabilities, but all artists are encouraged to enter the annual Courage Card Art Search. Submission guidelines available on Web site.

First Contact & Terms Call or e-mail name and address to receive Art Search guidelines, which are mailed in early May for the July 31 entry deadline. Artist retains ownership of the art. Pays $400 licensing fee in addition to nationwide recognition through distribution of more than 500,000 catalogs and promotional pieces, Internet, TV, radio and print advertising.

Tips "Do not send originals. Entries should be sent with a completed Art Search guidelines form. The Selection Committee chooses art that will reproduce well as a card. We need colorful contemporary and traditional images for holiday greetings. Participation in the Courage Cards Art Search is a wonderful way to share your talents and help people live more independently."

CREATIF LICENSING

31 Old Town Crossing, Mt. Kisco NY 10549. (914)241-6211. E-mail: info@creatifusa.com. Web site: www.creatifusa.com. **Licensing Contact:** Marcie Silverman. Estab. 1975. "Creatif is a licensing agency that represents artists and brands." Licensing art for commercial applications on consumer products in the gift, stationery and home furnishings industries.

Needs Looking for unique art styles and/or concepts that are applicable to multiple products and categories.

First Contact & Terms Send query letter with photocopies, photographs, SASE or tearsheets. Does not accept e-mail attachments but will review website links. Responds in 2 months. Samples are returned with SASE. Creatif will obtain licensing agreements on behalf of the artists, negotiate and manage the licensing programs and pay royalties. Artists are responsible for filing all copyright and trademark. Requires exclusive representation of artists.

Tips "We are looking to license talented and committed artists. It is important to understand current trends, and design with specific products in mind."

CREEGAN CO., INC.

The Creegan Animation Factory, 508 Washington St., Steubenville OH 43952. (740)283-3708. Fax: (740)283-4117. E-mail: creegans@weir.net. Web site: www.creegans.com. **President:** Dr. G. Creegan. Estab. 1961. "The Creegan Company designs and manufactures animated characters, costume characters and life-size audio animatronic air-driven characters. All products are custom made from beginning to end."

• Recently seen on the Travel Channel and Made in America with John Ratzenberger.

Needs Prefers local artists with experience in sculpting, latex, oil paint, molding, etc. Artists sometimes work on assignment basis. Uses freelancers mainly for design comps. Also for mechanicals. Produces material for all holidays and seasons, Christmas, Valentine's Day, Easter, Thanksgiving, Halloween and everyday. Submit seasonal material 3 months in advance.

First Contact & Terms Send query letter with résumé and nonreturnable photos or other samples. Samples are filed. Responds. Write for appointment to show portfolio of final art, photographs. Originals returned. Rights purchased vary according to project.

SUZANNE CRUISE CREATIVE SERVICES, INC.

7199 W. 98th Terrace, #110, Overland Park KS 66212. (913)648-2190. Fax: (913)648-2110. E-mail: artagent@cruisecreative.com. Web site: www.cruisecreative.com. **President:** Suzanne Cruise. Estab. 1990. Art agent representing artists for licensing in categories such as calendars, craft papers, decorative housewares, fabric giftbags, gifts, giftwrap, greeting cards, home decor, keychains, mugs, ornaments, prints, scrap booking, stickers, tabletop, and textiles. "We are a full-service licensing agency, as well as a full-service creative agency representing both licensed artists and children's book illustrators. "Our services include, but are not limited to, screening manufacturers for quality and distribution, negotiating rights, overseeing contracts and payments, sending artists' samples to manufacturers for review, and exhibiting artists' work at major trade shows annually." Art guidelines available on Website.

Needs Seeks established and emerging artists with distinctive styles suitable for the ever-changing consumer market. Looking for artists that manufacturers cannot find, or artist who are looking for a well-established licensing agency to fully represent their work. We represent established licensing artists as well as artists whose work has the potential to become a classic license. "We work with artists who offer a variety of styles, and we license their work to manufacturers

of goods that include, but are not limited to: gifts, home decor, greeting cards, gift wrap and bags, paper party ware and textiles. We look for work that has popular appeal and we prefer that portfolio contain both seasonal as well as every day images. It can be traditional, whimsical, floral, juvenile, cute or contemporary in style.''

First Contact & Terms Send query letter with color copies, a lo res disc with color copies, samples or lo res jpegs. Please send no original art. Samples are returned only if accompanied by SASE. Responds only if interested. Portfolio required. Request portfolio review in original query.

Tips ''Walk a few trade shows and familiarize yourself with the industries you want your work to be in. Attend a few of the panel.discussions that are put on during the shows to get to know the business a little better.''

N CSI CHICAGO INC.

4353 N. Lincoln Ave., Chicago IL 60618. (773)665-2226. Fax: (773)665-2228. E-mail: customstud ios123@yahoo.com. Web site: www.custom-studios.com. **President:** Gary Wing. Estab. 1966. We specialize in designing and screen printed custom T-shirts, coffee mugs, bumper stickers, balloons and over 1,000 other products for schools, business promotions, fundraising and for our own line of stock designs for retail sale.

Needs Works with 7 freelance illustrators/year. Assigns 10-12 freelance jobs/year. Needs b&w illustrations (some original and some from customer's sketch). Uses artists for direct mail and brochures/fliers, but mostly for custom and stock T-shirt designs. We are open to new stock design ideas the artist may have.''

First Contact & Terms Send query letter with resume, email black & white and color PDF, TIF or EPS art files to be kept on file. We will not return mailes originals or samples.'' Responds in 1 week-to a month. Pays for design and illustration by the hour, $20-35; by the project, $50-150. Considers turnaround time and rights purchased when establishing payment. For designs submitted to be used as stock T-shirt designs, pays 5-10% royalty. Stock designs should be something that the general public would buy and especially Chicago type designs for souvenir shirts. Rights purchased vary according to project.

Tips Send 5-10 good copies of your best work. We would like to see more PDF illustrations or copies, not originals. Do not get discouraged if your first designs sent are not accepted.''

CURRENT, INC.

1005 E. Woodmen Rd., Colorado Springs CO 80920. (719)594-4100. Fax: (719)531-2564. Web site: www.currentcatalog.com, www.colorfulimages.com, www.LillianVernon.com, www.Pape rDirect.com Art and Licensing. **Creative Business Manager:** Dana Grignano. Estab. 1950. Produces bookmarks, calendars, collectible plates, decorative housewares, decorations, giftbags, gifts, giftwrap, greeting cards, mugs, ornaments, school supplies, stationery, T-shirts. Specializes in seasonal and everyday social expressions products and personalized paper products.

Needs Works with hundreds of freelancers/year. Buys 700 freelance designs and illustrations/ year. Prefers freelancers with experience in greeting cards and textile industries. Uses freelancers mainly for cards, wraps, calendars, gifts, calligraphy. Considers all media. Product categories include business, conventional, cute, cute/religious, juvenile, religious, teen. Freelancers should be familiar with Photoshop, Illustrator and FreeHand. Produces material for all holidays and seasons and everyday. Submit seasonal material year-round. Looking for artists who can draw 3-D designs for custom made ornaments, wall decor, and gifts.

First Contact & Terms Send query letter with photocopies, tearsheets, brochure and photographs. Samples are filed. Responds only if interested. Will contact artist for portfolio review if interested. Buys all rights. Pays by the project; $50-500. Finds freelancers through agents, submissions, sourcebooks.

Tips "Review Web site or catalog prior to sending work."

DALOIA DESIGN

100 Norwich E., West Palm Beach FL 33417. (561)697-4739. E-mail: daloiades@aol.com. **Owner/Designer:** Peter Daloia. Estab. 1983. Produces art for stationery and gift products such as magnets, photo frames, coasters, bookmarks, home decor, etc.

Needs Approached by 20-30 freelancers/year. Uses freelancers for product art. Freelancers must know software appropriate for project, including PageMaker, Photoshop, QuarkXPress, Illustrator or "whatever is necessary."

First Contact & Terms Send samples of your work. Samples are filed and are not returned. Responds only if interested. Payment "depends on project and use." Negotiates rights purchased.

Tips "Keep an open mind, strive for excellence, push limitations."

Ⓝ DESIGN DESIGN, INC.

P.O. Box 2266, Grand Rapids MI 49501. (616)774-2448. Fax: (616)774-4020. **Creative Director:** Tom Vituj. Produces humorous and traditional fine art greeting cards, stationery, magnets, sticky notes, giftwrap/tissue and paper plates/napkins.

Needs Uses freelancers for all of the above products. Considers most media. Produces cards for everyday and all holidays. Submit seasonal material 1 year in advance.

First Contact & Terms Send query letter with appropriate samples and SASE. Samples are not filed and are returned by SASE if requested by artist. To show portfolio, send color copies, photographs or slides. Do not send originals. Pays various royalties per product development.

Ⓝ DESIGNER GREETINGS, INC.

Box 140729, Staten Island NY 10314. (718)981-7700. Fax: (718)981-0151. E-mail: info@designer greetings.com. Web site: www.designergreetings.com. **Art Director:** Fern Gimbelman. Produces all types of greeting cards. Produces alternative, general, informal, inspirational, contemporary, juvenile and studio cards and giftwrap.

Needs Works with 16 freelancers/year. Buys 250-300 designs and illustrations/year. Art guidelines free for SAE with first-class postage or on Web site. Works on assignment only both traditionally and digitally. Also uses artists for airbrushing and pen & ink. No specific size required. Produces material for all seasons; submit seasonal material 6 months in advance. Also needs package/product design and web design.

First Contact & Terms Send query letter with tearsheets, photocopies or other samples. Samples are filed or are returned only if requested. Responds in 2 months. Appointments to show portfolio are only made after seeing style of artwork. Originals are not returned. Pays flat fee. Buys all greeting card rights. Artist guidelines on Web site. Do not send electronic submissions.

Tips "We are willing to look at any work through traditional mail (photocopies, etc.). Appointments are given after I personally speak with the artist (by phone)."

DIMENSIONS CRAFTS LLC

1801 N 12th St., Reading PA 19604. (610)939-9900. Fax: (610)939-9666. E-mail: pam.keller@dim ensions-crafts.com. Web site: www.dimensions-crafts.com. **Designer Relations Coordinator:** Pamela Keller. Produces craft kits including but not limited to needlework, stained glass, paint-by-number, kids bead crafts and stamps. "We are a craft manufacturer with emphasis on sophisticated artwork and talented designers. Products include needlecraft kits, paint-by-number, and stamps for paper crafting. Primary market is women, all ages."

Needs Approached by 50-100 freelancers/year. Works with 200 freelancers/year. Develops more than 400 freelance designs and illustrations/year. Uses freelancers mainly for the original artwork for each product. Art guidelines for SASE with first-class postage. In-house art staff adapts for needlecraft. Considers all media. Looking for fine art, realistic representation, good composition, more complex designs than some greeting card art; fairly tight illustration with good definition; also whimsical, fun characters. Produces material for Christmas, everyday, birth, wedding and anniversary records. Majority of products are everyday decorative designs for the home.

First Contact & Terms Send cover letter with CD, color brochure, tearsheets, photographs or photocopies. Samples are filed "if artwork has potential for our market." Samples are returned by SASE only if requested by artist. Responds in 1 month. Portfolio review not required. Originals are returned at job's completion. Pays by project, royalties of 2-5%; sometimes purchases outright. Finds artists through magazines, trade shows, word of mouth, licensors/reps.

Tips "Current popular subjects in our industry florals, wildlife, garden themes, ocean themes, celestial, cats, birds, Southwest/Native American, juvenile/baby and whimsical."

Ⓝ DLM STUDIO

2563 Princeton Rd., Cleveland Heights OH 44118. (216)881-8888. Fax: (216)274-9308. E-mail: pat@dlmstudio.com. Web site: www.dlmstudio.com. **Vice President:** Pat Walker. Estab. 1984. Produces fabrics/packaging/wallpaper. Specializes in wallcovering, border and mural design, entire package with fabrics, also ultra-wide "mural" borders. Also licenses artwork for wall murals.

Needs Approached by 40-80 freelancers/year. Works with 20-40 freelancers/year. Buys hundreds of freelance designs and illustrations/year. Art guidelines free for SASE with first-class postage. Works on assignment and some licensing. Uses freelancers mainly for designs, color work. Looking for traditional, country, floral, texture, woven, menswear, children's and novelty styles. 50% of freelance design work demands computer skills. Wallcovering CAD experience a plus. Produces material for everyday.

First Contact & Terms Illustrators: Send query letter with photocopies, examples of work, résumé and SASE. Accepts disk submissions compatible with Illustrator or Photoshop files (Mac), also accepts digital files on CD or DVD. Samples are filed or returned by SASE on request. Responds in 1 month. Request portfolio review of color photographs and slides in original query, follow-up with letter after initial query. Rights purchased vary according to project. Pays by the project, $500-1,500, "but it varies." Finds freelancers through agents and local ads, word of mouth.

Tips "Send great samples, especially childrens and novelty patterns, and also modern, organic textures and bold conteporary graphic work and digital files are very helpful. Study the market closely; do very detailed artwork."

Ⓝ EDITIONS LIMITED/FREDERICK BECK

12011 Sherman Road., N. Hollywood CA 91605. (800)998-0323. Fax: (866)998-5808. E-mail: mark@chatsworthcollection.com. Web site: www.chatsworthcollection.com. **Art Director:**

Mark Brown. Estab. 1958. Produces holiday greeting cards, personalized and box stock and stationery.

- Editions Limited joined forces with Frederick Beck Originals. The company also runs Gene Bliley Stationery. See editorial comment under Frederick Beck Originals for further information. Mark Brown is the art director for all three divisions.

Needs Approached by 100 freelancers/year. Works with 20 freelancers/year. Buys 50-100 freelance designs and illustrations/year. Prefers freelancers with experience in silkscreen. Art guidelines available. Uses freelancers mainly for silkscreen greeting cards. Also for separations and design. Considers offset, silkscreen, thermography, foil stamp. Looking for traditional holiday, a little whimsy, contemporary designs. Size varies. Produces material for Christmas, graduation, Hannukkah, New Year, Rosh Hashanah and Valentine's Day. Submit seasonal material 15 months in advance.

First Contact & Terms Designers: Send query letter with brochure, photocopies, photographs, résumé, tearsheets. Samples are filed. Responds in 1 month. Will contact artist for portfolio review of b&w, color, final art, photographs, photostats, roughs if interested. Buys all rights. Pays $150-300/design. Finds freelancers through word of mouth, past history.

☒ EISENHART WALLCOVERINGS CO.

400 Pine St., Hanover PA 17331. (717)632-5918. Fax: (717)632-2321. Web site: www.eisenhartwallcoverings.com. **Co-Design Center Administrators:** Gen Huston and Teresa Schnetzka. Licensing: Joanne Berwager. Estab. 1940. Produces custom and residential wallpaper, borders, murals and coordinating fabrics. Licenses various types of artwork for wall coverings. Manufactures and imports residential and architectural wallcovering under the Ashford House®, Eisenhart® and Color Tree® collections.

Needs Works with 10-20 freelancers/year. Buys 25-50 freelance designs and illustrations/year. Prefers freelancers with experience in wallcovering design, experience with Photoshop helpful. Uses freelancers mainly for wallpaper design/color. Also for P-O-P. Looking for traditional as well as novelty designs.

First Contact & Terms Designers should contact by e-mail. Illustrators: Send query letter with color copies. Samples are filed. Samples are returned by SASE if requested. Responds in 2 weeks. Artist should contact after 2 weeks. Will contact for portfolio review if interested. Buys all rights. Pays by design, varies. Finds freelancers through artists' submissions.

ENCORE STUDIOS, INC.

17 Industrial West, Clifton NJ 07012. (800)526-0497. E-mail: artdept@encorestudios.com. Web site: www.encorestudios.com. Estab. 1979. Produces personalized wedding, bar/bat mitzvah, party and engraved invitations, birth announcements, stationery, and holiday cards.

Needs Approached by 50-75 freelance designers/year. Works with 20 freelancers/year. Prefers freelancers with experience in creating concepts for holiday cards, invitations, announcements and stationery. "We are interested in designs for any category in our line. Looking for unique type layouts, textile designs and initial monograms for stationery and weddings, holiday logos, Hebrew monograms for our bar/bat mitzvah line, and religious art for Bar/Bat Mitzvah." Considers b&w or full-color art. Looking for "elegant, graphic, sophisticated contemporary designs." 50% of freelance work demands knowledge of Macintosh, Illustrator, Photoshop, Quark XPress. Submit seasonal material all year.

First Contact & Terms Send e-mail with Jpg. or Pdf. attachments or send query letter with

brochure, résumé, SASE, tearsheets, photographs, photocopies or slides. Samples are filed or are returned by SASE if requested by artist. Responds in 2 weeks only if interested. Write for appointment to show portfolio, or mail appropriate materials. Portfolio should include roughs, finished art samples, b&w photographs or slides. Pays by the project. Negotiates rights purchased.

⃞ ENESCO GROUP INC.

225 Windsor Dr., Itasca IL 60143-1225. (630)875-5300. Fax: (630)875-5350. Web site: www.enes co.com. **Contact:** New Submissions/Licensing. Producer and importer of fine gifts, home decor and collectibles, such as resin, porcelain bisque and earthenware figurines, plates, hanging ornaments, bells, picture frames, decorative housewares. Clients gift stores, card shops and department stores.

Needs Works with multiple freelance artists/year. Prefers artists with experience in gift product and packaging development. Uses freelancers for rendering, illustration and sculpture. 50% of freelance work demands knowledge of Photoshop, QuarkXPress or Illustrator.

First Contact & Terms Send query letter with résumé, tearsheets and/or photographs. Samples are filed or are returned. Responds in 2 weeks. Pays by the project. Submitter may be required to sign a submission agreement.

Tips "Contact by mail only. It is better to send samples and/or photocopies of work instead of original art. All will be reviewed by Senior Creative Director, Executive Vice President and Licensing Director. If your talent is a good match to Enesco's product development, we will contact you to discuss further arrangements. Please do not send slides. Have a well-thought-out concept that relates to gift products before mailing your submissions."

EPIC PRODUCTS INC.

2801 S. Yale St., Santa Ana CA 92704. (800)548-9791. Fax: (714)641-8217. E-mail: mdubow@epi cproductsinc.com. Web site: www.epicproductsinc.com. Estab. 1978. Produces paper tableware products and wine and spirits accessories. "We manufacture products for the gourmet/house-wares market; specifically products that are wine-related. Many have a design printed on them."

Needs Approached by 50-75 freelance artists/year. Works with 10-15 freelancers/year. Buys 25-50 designs and illustrations/year. Prefers artists with experience in gourmet/housewares, wine and spirits, gift and stationery.

First Contact & Terms Send query letter with résumé and photocopies. Samples are filed. Write for appointment to show portfolio. Portfolio should include thumbnails, roughs, final art, b&w and color. Buys all rights. Originals are not returned. Pays by the project.

⃞ EQUITY MARKETING, INC.

6330 San Vicente, Los Angeles CA 90048. (323)932-4300. Web site: www.equity-marketing.com. **President, Chief Creative Director:** Kim Thomsen. Specializes in design, development and production of promotional, toy and gift items, especially licensed properties from the entertainment industry. Clients include Tyco, Applause, Avanti and Ringling Bros. and worldwide licensing relationships with Disney, Warner Bros., 20th Century Fox and Lucas Film.

Needs Needs product designers, sculptors, packaging and display designers, graphic designers and illustrators. Prefers local freelancers only with whimsical and cartoon styles. Products are typically targeted at children. Works on assignment only.

First Contact & Terms Send résumé and nonreturnable samples. Will contact for portfolio review

if interested. Rights purchased vary according to project. Pays for design by the project, $50-1,200. Pays for illustration by the project, $75-3,000. Finds artists through word of mouth, network of design community, agents/reps.

Tips "Gift items will need to be simply made, priced right and of quality design to compete with low prices at discount houses."

FANTAZIA MARKETING CORP.

65 N. Chicopee St., Chicopee MA 01020. (413)534-7323. Fax: (413)534-4572. E-mail: fantazia@charter.net. Web site: www.fantaziamarketing.com. **President:** Joel Nulman. Estab. 1979. Produces toys and high-end novelty products (lamps, banks and stationery items in over-sized form).

Needs Will review anything. Prefers artists with experience in product development. "We're looking to increase our molded products." Uses freelancers for P-O-P displays, paste-up, mechanicals, product concepts. 50% of design requires computer skills.

First Contact & Terms Send query letter with résumé. Samples are filed. Responds in 2 weeks. Call for appointment to show portfolio. Portfolio should include roughs and dummies. Originals not returned. Rights purchased vary according to project. Pays by project. Royalties negotiable.

Ⓝ FENTON ART GLASS COMPANY

700 Elizabeth St., Williamstown WV 26187. (304)375-6122. Fax: (304)375-7833. E-mail: AskFenton@FentonArtGlass.com. Web site: www.Fentonartglass.com. **Design Director:** Nancy Fenton. Estab. 1905. Produces collectible figurines, gifts. Largest manufacturer of handmade colored glass in the US.

- Design Director Nancy Fenton says this company rarely uses freelancers because they have their own staff of artisans. "Glass molds aren't very forgiving," says Fenton. Consequently it's a difficult medium to work with. There have been exceptions. "We were really taken with Linda Higdon's work," says Fenton, who worked with Higdon on a line of historical dresses.

Needs Uses freelancers mainly for sculpture and ceramic projects that can be translated into glass collectibles. Considers clay, ceramics, porcelain figurines. Looking for traditional artwork appealing to collectibles market.

First Contact & Terms Send query letter with brochure, photocopies, photographs, résumé and SASE. Samples are filed. Responds only if interested. Negotiates rights purchased. Pays for design by the project; negotiable.

FIDDLER'S ELBOW

101 Fiddler's Elbow Rd., Middle Falls NY 12848. (518)692-9665. Fax: (518)692-9186. E-mail: Inquiries@fiddlerselbow.com. Web site: www.fiddlerselbow.com. **Art and Licensing Coordinator:** Christy Phelan. Estab. 1974. Produces decorative housewares, gifts, pillows, totes, soft sculpture, doormats, kitchen textiles, and and pet feeding mats.

Needs Introduces 100+ new products/year. Currently uses freelance designs and illustrations. Looking for adult contemporary, traditional, dog, cat, horse, botanical and beach themes. Main images with supporting art helpful in producing collections.

First Contact & Terms Send digital or hardcopy submissions by mail. Samples are filed or returned by SASE. Responds generally within 4 months if interested. "Please, no phone calls."

Tips "Please visit Web site first to see if art is applicable to current lines and products."

ℕ FISHER-PRICE

636 Girard Ave., E. Aurora NY 14052. (716)687-3983. Fax: (716)687-5281. Web site: www.fisher-price.com. **Director of Product Art:** Henry Schmidt. Estab. 1931. Manufacturer of toys and other children's products.

Needs Approached by 10-15 freelance artists/year. Works with 25-30 freelance illustrators and sculptors and 15-20 freelance graphic designers/year. Assigns 100-150 jobs to freelancers/year. Prefers artists with experience in children's style illustration and graphics. Works on assignment only. Uses freelancers mainly for product decoration (label art). Prefers all media and styles except loose watercolor. Also uses sculptors. 25% of work demands knowledge of FreeHand, Illustrator, Photoshop and FreeForm (sculptors).

- This company has two separate art departments Advertising and Packaging, which does catalogs and promotional materials, and Product Art, which designs decorations for actual toys. Be sure to specify your intent when submitting material for consideration. Art director told *AGDM* he has been receiving more e-mail and disk samples. He says it's a convenient way for him or his staff to look at work.

First Contact & Terms Send query letter with nonreturnable samples showing art style or photographs. Samples are filed. Responds only if interested. Call to schedule an appointment to show a portfolio. Portfolio should include original, final art and color photographs and transparencies. Pays for design and illustration by the hour, $25-50. Buys all rights.

ℕ FOTOFOLIO, INC.

561 Broadway, New York NY 10012. (212)226-0923. Fax: (212)226-0072. E-mail: submissions@fotofolio.com. Web site: www.fotofolio.com. Estab. 1976. Publishes art and photographic postcards, greeting cards, notecards, books, t-shirts and postcards books.

Needs Buys 60-120 freelance designs and illustrations/year. Reproduces existing works. Primarily interested in photography and contemporary art. Produces material for Christmas, Valentine's Day, birthday and everyday. Submit seasonal material 8 months in advance. Art guidelines for SASE with first-class postage.

First Contact & Terms Send query letter with SASE % Editorial Dept. Samples are filed or are returned by SASE if requested by artist. Editorial Coordinator will contact artist for portfolio review if interested. Originals are returned at job's completion. Pays by the project, $7\frac{1}{2}$-15% royalties. Rights purchased vary according to project. Finds artists through word of mouth, magazines, submissions/self-promotions, sourcebooks, agents, visiting artist's exhibitions, art fairs and artists' reps.

Tips "When submitting materials, present a variety of your work (no more than 40 images) rather than one subject/genre."

ℕ THE FRANKLIN MINT

Franklin Center PA 19091-0001. (610)459-7975. Fax: (610)459-6463. Web site: www.franklinmint.com. **Artist Relations Manager:** Cathy La Spada. Estab. 1964. Direct response marketing of high-quality collectibles. Produces collectible porcelain plates, prints, porcelain and coldcast sculpture, figurines, fashion and traditional jewelry, ornaments, precision diecast model cars, luxury board games, engineered products, heirloom dolls and plush, home decor items and unique gifts. Clients general public worldwide, proprietary houselist of 8 million collectors and 55 owned-and-operated retail stores. Markets products in countries worldwide, including USA, Canada, United Kingdom and Japan.

Needs Approached by 3,000 freelance artists/year. Contracts 500 artists/sculptors per year to work on 7,000-8,000 projects. Uses freelancers mainly for illustration and sculpture. Considers all media. Considers all styles. 80% of freelance design and 50% of illustration demand knowledge of PageMaker, FreeHand, Photoshop, Illustrator, QuarkXPress and 3D Studio Eclipse (2D). Accepts work in SGI format. Produces material for Christmas and everyday.

First Contact & Terms Send query letter, résumé, SASE and samples (clear, professional full-color photographs, transparencies, slides, greeting cards and/or brochures and tearsheets). Sculptors send photographic portfolios. Do not send original artwork. Samples are filed or returned by SASE. Responds in 2 months. Portfolio review required for illustrators and sculptors. Company gives feedback on all portfolios submitted. Payment varies.

Tips "In search of artists and sculptors capable of producing high quality work. Those willing to take art direction and to make revisions of their work are encouraged to submit their portfolios."

GAGNE WALLCOVERING, INC.

1771 N Hercules Ave., Clearwater FL 33765. (727)461-1812. Fax: (727)447-6277. E-mail: info@g agnewall.com. Web site: www.gagnewall.com. **Studio Director:** Linda Vierk. Estab. 1977. Produces wall murals and wallpaper. Specializes in residential and commercial wallcoverings, borders and murals encompassing a broad range of styles and themes for all age groups.

Needs Approached by 12-20 freelancers/year. Works with 20 freelancers/year. Buys 150 freelance designs and/or illustrations/year. Considers oils, watercolors, pastels, colored pencil, gouache, acrylic—"just about anything two-dimensional." Artists should check current wallcovering collections to see the most common techniques and media used.

First Contact & Terms Send brochure, color photocopies, photographs, slides, tearsheets, "actual painted or printed sample of artist's hand if possible." Samples are filed. Responds only if interested. Portfolio not required. "We usually buy all rights to a design, but occasionally consider other arrangements." Pays by the project, $500-1,200. Finds freelancers through magazines, licensing agencies, trade shows and word of mouth.

Tips "We are usually looking for traditional florals, country/folk art, juvenile and novelty designs. We do many borders and are always interested in fine representational art. Panoramic borders and murals are also a special interest. Be aware of interior design trends, both in style and color. Visit a wallcovering store and see what is currently being sold. Send us a few samples of your best quality, well-painted, detailed work."

GALISON/MUDPUPPY PRESS

28 W. 44th St., Suite 1411, New York NY 10036. (212)354-8840. Fax: (212)391-4037. E-mail: Julia@galison.com and cynthia@galison.com. Web site: www.galison.com. **Art Director:** Julia Hecomovich (for Galison and Holiday). **Creative Director:** Cynthia Matthews (children's illustration) Estab. 1978. Produces boxed greeting cards, stationery, puzzles, address books, specialty journals and fine paper gifts. Many projects are done in collaboration with museums around the world.

Needs Works with 10-15 freelancers/year. Buys 20 designs and illustrations/year. Works on assignment only. Uses freelancers mainly for illustration. Considers all media. Also produces material for holidays (Christmas, Hanukkah and New Year). Submit seasonal material 1 year in advance.

First Contact & Terms Send postcard sample, photocopies, résumé, tearsheets (no unsolicited original artwork) and SASE. Accepts submissions on disk compatible with Photoshop, Illustrator

or QuarkXPress (but not preferred). Samples are filed. Responds only if interested. Request portfolio review in original query. Art Director will contact artist for portfolio review if interested. Portfolio should include color photostats, slides, tearsheets and dummies. Originals are returned at job's completion. Pays by project. Rights purchased vary according to project. Finds artists through word of mouth, magazines and artists' reps.

Tips "Looking for great presentation and artwork we think will sell and be competitive within the gift market. Please visit our Web site to see if your style is compatible with our design aesthetic."

GALLANT GREETINGS CORP.

4300 United Parkway, Schiller Park IL 60176. (847)671-6500. Fax: (847)233-2499. E-mail: joanlac kouitz@gallantgreetings.com. Web site: www.gallantgreetings.com. **Vice President Product Development:** Joan Lackouitz. Estab. 1966. Creator and publisher of seasonal and everyday greeting cards, gift wrap and gift bags as well as stationery products.

First Contact & Terms Samples are filed or returned. Will respond within 3 weeks if interested. Do not send originals.

ⓝ GALLERY GRAPHICS, INC.

P.O. Box 502, Noel MI 64854. (417)475-6191. Fax: (417)475-6494. E-mail: info@gallerygraphics. com. Web site: gallerygraphics.com. **Art Director:** Olivia Jacob. Estab. 1979. Produces calendars, gifts, greeting cards, stationery, prints, notepads, notecards. Gift company specializing primarily in nostalgic, country and other traditional designs.

Needs Approached by 100 freelancers/year. Works with 10 freelancers/year. Buys 100 freelance illustrations/year. Art guidelines free for SASE with first-class postage. Uses freelancers mainly for illustration. Considers any 2-dimensional media. Looking for country, teddy bears, florals, traditional. Prefers 16×20 maximum. Produces material for Christmas, Valentine's Day, birthdays, sympathy, get well, thank you. Submit seasonal material 8 months in advance.

First Contact & Terms Accepts printed samples or Photoshop files. Send TIFF or EPS files. Samples are filed or returned by SASE. Will contact artist for portfolio review of color photographs, photostats, slides, tearsheets, transparencies if interested. Payment negotiable. Finds freelancers through submissions and word of mouth.

Tips "Be flexible and open to suggestions."

ⓝ C.R. GIBSON, CREATIVE PAPERS

404 BNA Drive, Building 200, Suite 600, Nashville TN 37217. (615)724-2900. Fax: (615)391-3166. Web site: www.crgibson.com. **Vice President of Creative:** Ann Cummings. Producer of stationery and gift products, baby, kitchen and wedding collections. Specializes in baby, children, feminine, floral, wedding and kitchen-related subjects, as well as holiday designs. 80% require freelance illustration; 15% require freelance design. Gift catalog free by request.

Needs Approached by 200-300 freelance artists/year. Works with 30-50 illustrators and 10-30 designers/year. Assigns 30-50 design and 30-50 illustration jobs/year. Uses freelancers mainly for covers, borders and cards. 50% of freelance work demands knowledge of QuarkXPress, FreeHand and Illustrator. Works on assignment only.

First Contact & Terms Send query letter with brochure, résumé, tearsheets and photocopies. Samples are filed or are returned. Responds only if interested. Request portfolio review in original query. Portfolio should include thumbnails, finished art samples, color tearsheets and photo-

graphs. Return of original artwork contingent on contract. Sometimes requests work on spec before assigning a job. Interested in buying second rights (reprint rights) to previously published work. "Payment varies due to complexity and deadlines." Finds artists through word of mouth, magazines, artists' submissions/self-promotion, sourcebooks, agents, visiting artist's exhibitions, art fairs and artists' reps.

Tips "The majority of our mechanical art is executed on the computer with discs and laser runouts given to the engraver. Please give a professional presentation of your work."

⋈ GLITTERWRAP, INC.

701 Ford Rd., Rockaway NJ 07866. (973)625-4200, ext. 265. Fax: (973)625-0399. **Creative Director:** Melissa Camacho. Estab. 1987. Produces giftwrap, gift totes and allied accessories. Also photo albums, diaries and stationery items for all ages—party and special occasion market.

Needs Approached by 50-100 freelance artists/year. Works with 10-15 artists/year. Buys 10-30 designs and illustrations/year. Art guidelines available. Prefers artists with experience in textile design who are knowledgeable in repeat patterns or surface, or designers who have experience with the gift industry. Uses freelancers mainly for occasional on-site Mac production at hourly rate of $15-25. Freelance work demands knowledge of QuarkXPress, Illustrator and Photoshop. Considers many styles and mediums. Style varies with season and year. Consider trends and designs already in line, as well as up and coming motifs in gift market. Produces material for baby, wedding and shower, florals, masculine, Christmas, graduation, birthdays, Valentine's Day, Hanukkah and everyday. Submit seasonal material 6-8 months in advance.

First Contact & Terms Send query letter with brochure, tearsheets, or color copies of work. Do not send original art, photographs, transparencies or oversized samples. Samples are not returned. Responds in 3 weeks. "To request our submission guidelines send SASE with request letter. To request catalogs send 11×14 SASE with $3.50 postage. Catalogs are given out on a limited basis." Rights purchased vary according to project.

Tips "Giftwrap generally follows the fashion industry lead with respect to color and design. Adult birthday and baby shower/birth are fast-growing categories. There is a need for good/fresh/fun typographic birthday general designs in both adult and juvenile categories."

⋈ GLOBAL GRAPHICS & GIFTS LLC.

16781 Chagrin Blvd. #333, Shaker Heights OH 44120. E-mail: fredw@globalgraphics-gifts.com. Web site: www.globalgraphics-gifts.com. President: Fred Willingham. Estab. 1995. Produces calendars, e-cards, giftbags, giftwrap/wrapping paper, greeting cards, party supplies and stationery. Specializes in all types of cards including traditional, humorous, inspirational, juvenile and whimsical.

Needs Works with 5-10 freelancers/year. Buys 50-100 freelance designs and/or illustrations/year. Uses freelancers mainly for illustration and photography. Product categories include African American, alternative/humor, conventional, cute, cute/religious, Hispanic, inspirational, juvenile, religious and teen. Produces material for baby congrats, birthday, Christmas, congratulations, Easter, everyday, Father's Day, First Communion/Confirmation, get-well/sympathy, graduation, Mother's Day, Valentine's Day and wedding/anniversary. Submit seasonal material 1 year in advance. Art size should be 12×18 or less. 5% of freelance digital art and design work demands knowledge of FreeHand, Illustrator, InDesign, Photoshop.

First Contact & Terms Send postcard sample with brochure, photocopies and tearsheets. Send follow-up postcard every 3 months. Samples are filed. Responds only if interested. Portfolio not

required. Buys all rights. Pays freelancers by the project $150 minimum-$400 maximum. Finds freelancers through agents, artists' submissions and word of mouth.

Tips "Make sure artwork is clean. Our standards for art are very high. Only send upbeat themes, nothing depressing. Only interested in wholesome images."

⃞N GOES LITHOGRAPHING COMPANY SINCE 1879

42 W. 61st St., Chicago IL 60621-3999. (773)684-6700. Fax: (773)684-2065. E-mail: goeslitho@a meritech.net. Web site: www.goeslitho.com. **Contact:** Eric Goes. Estab. 1879. Produces stationery/letterheads, custom calendars to sell to printers and office product stores.

Needs Approached by 5-10 freelance artists/year. Works with 2-3 freelance artists/year. Buys 4-30 freelance designs and illustrations/year. Art guidelines for SASE with first-class postage. Uses freelance artists mainly for designing holiday letterheads. Considers pen & ink, color, acrylic, watercolor. Prefers final art 17×22, CMYK color compatible. Produces material for Christmas, Halloween and Thanksgiving.

First Contact & Terms "Send non-returnable examples for your ideas." Responds in 1-2 months if interested. Pays $100-200 on final acceptance. Buys first rights and reprint rights.

Tips "Keep your art fresh and be aggressive with submissions."

⃞N GRAHAM & BROWN

3 Corporate Dr., Cranbury NJ 08512. (609)395-9200. Fax: (609)395-9676. E-mail: ncaucino@gra hambrownusa.com. Web site: www.grahambrown.com. Estab. 1946. Produces residential wall coverings and home decor products.

Needs Prefers freelancers for designs. Also for artwork. Produces material for everyday.

First Contact & Terms Designers: Send query letter with photographs. Illustrators: Send postcard sample of work only to the attention of Nicole Caucino. Samples are filed or returned. Responds only if interested. Buys all rights. For illustration pays a variable flat fee.

GREAT AMERICAN PUZZLE FACTORY

(Division of Fundex Games Ltd), 1570 S. Perry., Plainfield IN 46168. (203)838-4240. Fax: (203)801-5230. E-mail: pduncan@greatamericanpuzzle.com. Web site: www.greatamericanpuz zle.com. **President:** Pat Duncan. Licensing: Patricia Duncan. Estab. 1975. Produces jigsaw puzzles and games for adults and children. Licenses various illustrations for puzzles (children's and adults').

Needs Approached by 200 freelancers/year. Works with 80 freelancers/year. Buys 70 designs and illustrations/year. Uses freelancers mainly for puzzle material. Looking for "fun, busy and colorful" work. 100% of graphic design requires knowledge of QuarkXPress, Illustrator or Photoshop.

First Contact & Terms Send postcard sample and/or 3 representative samples via e-mail. Do not send seasonal material. Also accepts e-mail submissions. Do not send originals or transparencies. Samples are filed or are returned. Art director will contact artist for portfolio review if interested. Original artwork is returned at job's completion. Pays flat fee of $600-1,000, work for hire. Royalties of 5-6% for licensed art (existing art only). Interested in buying second rights (reprint rights) to previously published work.

Tips "All artwork should be *bright*, cheerful and eye-catching. 'Subtle' is not an appropriate look for our market. Decorative motifs not appropriate. Visit stores and visit Web sites for appropriateness of your art. No black and white. Looking for color, detail, and emotion."

GREAT ARROW GRAPHICS

2495 Main St., Suite 457, Buffalo NY 14214. (716)836-0408. Fax: (716)836-0702. E-mail: design@greatarrow.com. Web site: www.greatarrow.com. **Art Director:** Lisa Samar. Estab. 1981. Produces greeting cards and stationery. ''We produce silkscreened greeting cards—seasonal and everyday—to a high-end design-conscious market.''

Needs Approached by 150 freelancers/year. Works with 75 freelancers/year. Buys 350-500 images/year. Art guidelines can be downloaded at www.greatarrow.com/guidelines.asp. Prefers freelancers with experience in silkscreen printing process. Uses freelancers for greeting card design only. Considers all 2-dimensional media. Looking for sophisticated, classic, contemporary or cutting edge styles. Requires knowledge of Illustrator or Photoshop. Produces material for all holidays and seasons. Submit seasonal material 1 year in advance.

First Contact & Terms Send query letter with photocopies. Accepts submissions on disk compatible with Illustrator or Photoshop or e-mail jpegs. Samples will not be returned, do not send originals until the images are accepted. Responds in 6 weeks if we are interested. Art director will contact artist for portfolio review if interested. Portfolio should include color roughs, final art, photographs and transparencies. Originals are returned at job's completion. Pays royalties of 5% of net sales. Rights purchased vary according to project.

Tips ''We are interested in artists familiar with the assets and limitations of screenprinting, but we are always looking for fun new ideas and are willing to give help and guidance in the silkscreen process. Be original, be complete with ideas. Don't be afraid to be different . . . forget the trends . . . do what you want. Make your work as complete as possible at first submission. The National Stationery Show in New York City is a great place to make contacts.''

HALLMARK CARDS, INC.

P.O. Box 419580, Kansas City MO 64141-6580. Web site: www.hallmark.com. Estab. 1931.
- Because of Hallmark's large creative staff of full-time employees and their established base of freelance talent capable of fulfilling their product needs, they do not accept unsolicited freelance submissions.

N I HAMPSHIRE PEWTER COMPANY

43 Mill St., Wolfeboro NH 03894-1570. (603)569-4944. Fax: (603)569-4524. E-mail: gifts@hampshirepewter.com. Web site: www.hampshirepewter.com. **President:** Abe Neudorf. Estab. 1974. Manufacturer of handcast pewter tableware, accessories and Christmas ornaments. Clients jewelry stores, department stores, executive gift buyers, tabletop and pewter specialty stores, churches and private consumers.

Needs Works with 3-4 freelance artists/year. ''Prefers New-England based artists.'' Works on assignment only. Uses freelancers mainly for illustration and models. Also for brochure and catalog design, product design, illustration on product and model-making.

First Contact & Terms Send query letter with photocopies. Samples are not filed and are returned only if requested. Call for appointment to show portfolio, or mail b&w roughs and photographs. Pays for design and sculpture by the hour or project. Considers complexity of project, client's budget and rights purchased when determining payment. Buys all rights.

Tips ''Inform us of your capabilities. For artists who are seeking a manufacturing source, we will be happy to bid on manufacturing of designs under private license to the artists, all of whose design rights are protected. If we commission a project, we intend to have exclusive rights to the designs by contract as defined in the Copyright Law, and we intend to protect those rights.''

Ⓝ HANNAH-PRESSLEY PUBLISHING

1232 Schenectady Ave., Brooklyn NY 11203-5828. (718)451-1852. Fax: (718)629-2014. **President:** Melissa Pressley. Estab. 1993. Produces calendars, giftwrap, greeting cards, stationery, murals. "We offer design, illustration, writing and printing services for advertising, social and commercial purposes. We are greeting card specialists."

Needs Approached by 10 freelancers/year. Works on assignment only. Uses freelancers mainly for pattern design, invitations, advertising, cards. Also for calligraphy, mechanicals, murals. Considers primarily acrylic and watercolor, but will consider others. Looking for upscale, classic; rich and brilliant colors; traditional or maybe Victorian; also adult humor. Produces material for Christmas, Mother's Day, Father's Day, graduation, Kwanzaa, Valentine's Day, birthdays, everyday, ethnic cards (black, Hispanic, Caribbean), get well, thank you, sympathy, Secretary's Day.

First Contact & Terms Send query letter with slides, color photocopies, résumé, SASE. Samples are filed or returned by SASE. Responds only if interested. Company will contact artist for portfolio review if interested. Portfolio should include b&w, color, final art, slides. Rights purchased vary according to project. Payment varies according to project. Finds freelancers through submissions, *Creative Black Book*.

Tips "Please be honest about your expertise and experience."

HARLAND CLARKE

(formerly Clarke American), P.O. Box 460, San Antonio TX 78292-0460. (210)694-1473. Fax: (210)558-9265. E-mail: acollins@clarkeamerican.com. Web site: www.clarkeamerican.com. **Product Marketing Manager:** Ashley Collins. Estab. 1874. Produces checks and other products and services sold through financial institutions. "We're a national printer seeking original works for check series, consisting of one, three or five scenes. Looking for a variety of themes, media and subjects for a wide market appeal."

Needs Uses freelancers mainly for illustration and design of personal checks. Considers all media and a range of styles. Prefers to see art at twice the size of a standard check.

First Contact & Terms Send postcard sample or query letter with résumé and brochure (or Web address if work is online). "Indicate whether the work is available; do not send original art." Samples are filed and are not returned. Responds only if interested. Rights purchased vary according to project. Payment for illustration varies by the project.

Tips "Keep red and black in the illustration to a minimum for image processing."

Ⓝ HEART STEPS INC.

E. 502 Highway 54, Waupaca WI 54981. (715)258-8141. Fax: (715)256-9170. **Contact:** Debra McCormick. Estab. 1993. Produces greeting cards, marble and bronze plaques, photo frames, gift boxes, framed art, scrapbooking items and stationery. Specializes in inspirational items.

Needs Prefers freelancers with experience in watercolor. Works on assignment only. Uses freelancers mainly for completing the final watercolor images. Considers original art. Looking for watercolor fine art, floral, juvenile and still life. Prefers 10×14. Produces material for Christmas, Mother's Day, Father's Day, graduation, birthday, everyday, inspirational, encouragement, woman-to-woman. Submit seasonal material 8 months in advance.

First Contact & Terms Designers: Send query letter with brochure, photocopies, photographs, résumé and SASE. Illustrators: Send query letter with photocopies and résumé. Samples are filed. Responds in 2 months. Request portfolio review in original query. Rights purchased vary

according to project. Pays by the project for design; $100-300 for illustration. Finds freelancers through gift shows and word of mouth.

Tips "Don't overlook opportunities with new, small companies!"

Ⓝ MARIAN HEATH GREETING CARDS

9 Kendrick Rd., Wareham MA 02571. (508)291-0766. Fax: (508)295-5992. E-mail: talktous@renc ards.com. Web site: www.marianheath.com. **Creative Director:** Molly DelMastro. Estab. 1950. Greeting card company supporting independent card and gift shop retailers. Produces greeting cards, giftbags, giftwrap, stationery and ancillary products.

Needs Approached by 100 freelancers/year. Works with 35-45 freelancers/year. Buys 500 freelance designs and illustrations/year. Prefers freelancers with experience in social expression. Art guidelines free for SASE with first-class postage or e-mail requesting guidelines. Uses freelancers mainly for greeting cards. Considers all media and styles. Generally $5\frac{1}{4} \times 7\frac{1}{4}$ unless otherwise directed. Will accept various sizes due to digital production/manipulation. 30% of freelance design and illustration work demands knowledge of Photoshop, Illustrator, QuarkXPress. Produces material for all holidays and seasons and everyday. Submit seasonal material 1 year in advance.

First Contact & Terms Designers: Send query letter with photocopies, résumé and SASE. OK to send slides, tearsheets and transparencies if necessary. Illustrators: Send query letter with photocopies, résumé, tearsheets and SASE. Accepts Mac-formatted JPEG disk submissions. Samples are filed or returned by SASE. Responds within 1-3 months. Will contact artist for portfolio review of color, final art, slides, tearsheets and transparencies. Pays for illustration by the project; flat fee or royalties; varies per project. Finds freelancers through agents, reps, submissions, licensing and design houses.

Ⓝ HIGH RANGE DESIGNS

P.O. Box 346, Victor ID 83455-0346. (208)787-2277. Fax: (208)787-2276. E-mail: hmiller@highra ngedesigns.com. **President:** Hondo Miller. Estab. 1989. Produces T-shirts. "We produce screen-printed garments for recreational sport-oriented markets and resort markets, which includes national parks. Subject matter includes, but is not limited to, skiing, climbing, hiking, biking, fly fishing, mountains, out-of-doors, nature, canoeing and river rafting, Native American, wildlife and humorous sayings that are text only or a combination of text and art. Our resort market customers are men, women and kids looking to buy a souvenir of their vacation experience or activity. People want to identify with the message and/or the art on the T-shirt."

- According to High Range Designs art guidelines, it is easiest to break into HRD with designs related to fly fishing, downhill skiing, snowboarding or river rafting. The guidelines suggest that your first submission cover one or more of these topics. The art guidelines for this company are detailed and include suggestions on where to place design on the garment.

Needs Approached by 20 freelancers/year. Works with 3-8 freelancers/year. Buys 10-20 designs and illustration/year. Prefers artists with experience in screen printing. Uses freelancers mainly for T-shirt ideas, artwork and color separations.

First Contact & Terms Send query letter with résumé, SASE and photocopies. Accepts submissions on disk compatible with FreeHand 8.0 and Illustrator 8.0. Samples are filed or are returned by SASE if requested by artist. Responds in 6 months. Company will contact artist for portfolio review if interested. Portfolio should include b&w thumbnails, roughs and final art. Originals are returned at job's completion. Pays by the project, royalties of 5% based on actual sales. Buys garment rights.

Tips "Familiarize yourself with screen printing and T-shirt art that sells. Must have knowledge of color separations process. We look for creative design styles and interesting color applications. Artists need to be able to incorporate the colors of the garments as part of their design thinking, as well as utilize the screen-printing medium to produce interesting effects and textures. However, sometimes simple is best. Four-color process will be considered if highly marketable. Be willing to work with us on design changes to get the most marketable product. Know the industry. Art that works on paper will not necessarily work on garments. No cartoons please."

HOFFMASTER GROUP, INC.

2920 N. Main St., Oshkosh WI 54903. (920)235-9330. Fax: (920)235-1642. **Art and Marketing Services Manager:** Paul Zuehlke. Produces decorative disposable paper tableware including: placemats, plates, tablecloths and napkins for institutional and consumer markets. Printing includes offset, letterpress and up to six color flexographic napkin printing.

Needs Approached by 10-15 freelancers/year. Works with 4-6 freelancers/year. Prefers freelancers with experience in paper tableware products. Art guidelines and specific design needs based on current market are available from Creative Managers. Looking for trends and traditional styles. Prefers 9" round artwork with coordinating 5" square image. Produces material for all holidays and seasons and everyday. Special need for seasonal material.

First Contact & Terms Send query letter with photocopies, résumé, appropriate samples by mail or fax only. Ideas may be sent in a color rough sketch. Accepts disk submissions compatible with Adobe Creative Suite 2. Samples are filed or returned by SASE if requested by artist. Responds in 90 days, only if interested. Creative Manager will contact artist for portfolio review if interested. Prefers to buy artwork outright. Rights purchased vary according to project. Pays by the project: $350-1,500. Amounts vary according to project. May work on a royalty arrangement for recognized properties. Finds freelancers through art fairs and artists' reps.

Tips Looking for new trends and designs appropriate for plates and napkins.

ⓝ HOME INTERIORS & GIFTS

1649 Frankford Rd. W., Carrollton TX 75007. (972)695-1000. Fax: (972)695-1062. **Art Director:** Robbin Allen. Estab. 1957. Produces decorative framed art in volume to public by way of shows in the home. "H.I.&G. is a direct sales company. We sell nationwide with over 71,000 consultants in our sales force. We work with artists to design products for our new product line yearly. We work with some publishers now, but wish to work with more artists on a direct basis."

Needs Approached by 75 freelance artists/year. Works with 25-30 freelancers/year. "We carry approximately 500-600 items in our line yearly." Prefers artists with knowledge of current colors and the decorative art market. "We give suggestions, but we do not dictate exacts. We would prefer the artists express themselves through their individual style. We will make correction changes that will enhance each piece for our line." Uses freelance artists mainly for artwork to be framed (oil and watercolor work mostly). Also for calligraphy. Considers oil, watercolor, acrylic, pen & ink, pastels, mixed media. "We sell to middle America for the most part."

First Contact & Terms Send query letter with résumé, SASE, photographs, slides and transparencies. Samples are filed or are returned by SASE. Art director will contact artist for portfolio review if interested. Portfolio should include color slides, photographs. Requests work on spec before assigning a job. Pays royalties. Royalties are discussed on an individual basis. Buys reprint rights. E-mail JPEGs to jberger@homeinteriors.com or acarter@homeinteriors.com.

Tips "This is a great opportunity for the artist who is willing to learn our market. The artist will work with our design department to stay current with our needs."

ⓝ IGPC

460 W. 34th St., 10th Floor, New York NY 10001. (212)629-7979. Fax: (212)629-3350. E-mail: artdept@igpc.net. Web site: www.igpc.net. Art Director: Aviva Darab. Agent to foreign governments. "We produce postage stamps and related items on behalf of 40 different foreign governments."

Needs Approximately 10 freelance graphic artists. Prefers artists within metropolitan New York or tri-state area. Must have extremely sophisticated computer, design and composition and prepress skills, as well as keen research ability. Artwork must be focused and alive (4-color). Artist's pricing needs to be competitive. Works on assignment only. Uses artists for postage stamp art. Must have expert knowledge of Photoshop and Quark/InDesign. Illustrator a plus.

First Contact & Terms E-mail only. Send samples as PDFs or link to a web portfolio. Art Director will contact artist for portfolio review if interested. Portfolio should contain "4-color illustrations of realistic, flora, fauna, technical subjects, autos or ships." Sometimes requests work on spec before assigning a job. Pays by the project. Consider government allowance per project when establishing payment.

Tips "Artists considering working with IGPC must have excellent drawing and/or rendering abilities in general or specific topics, i.e., flora, fauna, transport, famous people, etc.; typographical skills; the ability to create artwork with clarity and perfection. Familiarity with printing process and print call-outs a plus. Generally, the work we require is realistic art. In some cases, we supply the basic layout and reference material; however, we appreciate an artist who knows where to find references and can present new and interesting concepts. Initial contact should be made by appointment. Have fun!"

THE IMAGINATION ASSOCIATION/THE FUNNY APRON COMPANY

P.O. Box 1780, Lake Dallas TX 75065-1780. (940)498-3308. Fax: (940)498-1596. E-mail: ellice@f unnyaprons.com. Web site: www.funnyaprons.com. **Creative Director:** Ellice Lovelady. Estab. 1992. Our primary focus is now on our subdivision, The Funny Apron Company, that manufactures humorous culinary-themed aprons and T-shirts for the gourmet marketplace."

Needs Works with 6 freelancers/year. Artists must be fax/e-mail accessible and able to work on fast turnaround. Check website to determine if your style fits our art direction. 100% of freelance work DEMANDS knowledge of Illustrator, Corel Draw, or programs with ability to electronically send vector-based artwork. (Photoshop alone is not sufficient.) Currently not accepting text or concepts.

First Contact & Terms Send query letter with brochure, photographs, SASE and photocopies. E-mail inquiries must include a LINK to a website to view artwork. Do not send unsolicited attachments, they are automatically deleted. Samples are filed or returned by SASE if requested by artist. Company will contact artist if interested. Negotiates rights and payment terms. Finds artists via word of mouth from other freelancers or referrals from publishers.

Tips Looking for artist "with a style we feel we can work with and a professional attitude. Understand that sometimes we require several revisions before final art, and all under tight deadlines. Even if we can't use your style, be persistent! Stay true to your creative vision and don't give up!"

ⓘ INCOLAY STUDIOS INCORPORATED

12927 S. Budlong Ave., Gardena CA 90247. (800)462-6529. E-mail: info@incolayusa.com. Web site: www.incolayusa.com. **Art Director:** Louise Hartwell. Estab. 1966. Manufacturer. "We reproduce antiques in Incolay Stone, all handcrafted here at the studio."

Needs Prefers local artists with experience in carving bas relief. Uses freelance artists mainly for carvings; also for product design and model making.

First Contact & Terms Send query letter with résumé, or call to discuss. Samples not filed are returned. Responds in 1 month. Call for appointment to show portfolio. Pays 5% of net sales. Negotiates rights purchased.

Tips "Let people know that you are available and want work. Do the best you can. Discuss the concept and see if it is right for your talent."

ℕ INKADINKADO, INC.

1801 North 12th St., Reading PA 19604. (610)939-9900 or (800)523-8452. Fax: (610)939-9666. E-mail: customer.service@inkadinkado.com. Web site: www.inkadinkado.com. **Creative Director:** Mark Nelson, licensing contact. Pamela Keller, designer relations coordinator. Estab. 1978. Creates artistic rubber stamps, craft kits, and craft accessories. Also offers licenses to illustrators depending upon number of designs interested in producing and range of style by artist. Distributes to craft, gift and toy stores and specialty catalogs.

Needs Works mainly with in house illustrators and designers. Uses freelancers mainly for illustration, lettering, line drawing, type design. Considers pen & ink. Themes include animals, education, holidays and nature. Prefers small; about 3×3. work demands knowledge of Photoshop, Illustrator and in Design. Produces material for all holidays and seasons. Submit seasonal material 6-8 months in advance.

First Contact & Terms Designers and Illustrators: Send query letter with 6 nonreturnable samples. Accepts submissions on disk. Samples are filed and not returned. Responds only if interested. Company will contact artist for portfolio review of b&w and final art if interested. Pays for illustration by the project, $100-250/piece. Rights purchased vary according to project. Stamps, pays $50-100/project.

Tips "Work small. The average size of an artistic rubber stamp is 3×3 line art without color stands the best chance of acceptance."

INNOVATIVE ART

(formerly Portal Publications, Ltd.), 100 Smith Ranch Rd., Suite 210, San Rafael CA 94903. (415) 526-630 or (800)227-1720. Fax: (415)382-3377. Web site: www.portalpub.com. **Senior Art Director:** Andrea Smith. Estab. 1954. Publishes greeting cards, calendars, posters, wall decor, framed prints. Art guidelines available for SASE or on Web site.

● See additional listing in the Posters & Prints section.

Needs Approached by more than 1,000 freelancers artists/year. Offers up to 400 or more assignments/year. Works on assignment only. Considers any media. Looking for "beautiful, charming, provocative, humorous images of all kinds." 90% of freelance design demands knowledge of the most recent versions of Illustrator, QuarkXPress and Photoshop. Submit seasonal material 1 year in advance.

First Contact & Terms "No submission will be considered without a signed guidelines form, available on our Web site at www.portalpub.com/contact/ArtistSubmissionForm.pdf; or contact Robin O'Conner at (415)526-6362."

Tips "Ours is an increasingly competitive business, so we look for the highest quality and most unique imagery that will appeal to our diverse market of customers."

INTERCONTINENTAL GREETINGS LTD.

38 West 32nd Street, Suite 910, New York NY 10001. (212)683-5830. Fax: (212)779-8564. E-mail: art@intercontinental-ltd.com. Web site: www.intercontinental-ltd.com. **Creative Director:** Jerra Parfitt. Estab. 1967. Sells reproduction rights of designs to manufacturers of multiple products around the world. Rep resents artists in 50 different countries. "Our clients specialize in greeting cards, giftware, giftwrap, calendars, postcards, prints, posters, stationery, paper goods, food tins, playing cards, tabletop, bath and service ware and much more."

● See additional listing in the Posters & Prints section.

Needs Approached by several hundred artists/year. Seeking creative decorative art in traditional and computer media (Photoshop and Illustrator work accepted). Prefers artwork previously made with few or no rights pending. Graphics, sports, occasions (i.e., Christmas, baby, birthday, wedding), humorous, "soft touch," romantic themes, animals. Accepts seasonal/holiday material any time. Prefers artists/designers experienced in greeting cards, paper products, tabletop and giftware.

First Contact & Terms Query with samples. Send unsolicited CDs or DVDs by mail. "Please do not send original artwork." Upon request, submit portfolio for review. Provide résumé, business card, brochure, flier, tearsheets or slides to be kept on file for possible future assignments. "Once your art is accepted, we require original color art—Photoshop files on disc (Mac, TIFF, 300 dpi); 4×5, 8×10 transparencies; 35mm slides. We will respond only if interested (will send back nonaccepted artwork in SASE if provided)." Pays on publication. No credit line given. Offers advance when appropriate. Sells one-time rights and exclusive product rights. Simultaneous submissions and previously published work OK. "Please state reserved rights, if any."

Tips Recommends the annual New York SURTEX and Licensing shows. In portfolio samples, wants to see "a neat presentation, thematic in arrangement, consisting of a series of interrelated images (at least 6). In addition to having good drawing/painting/designing skills, artists should be aware of market needs and trends."

JILLSON & ROBERTS

3300 W. Castor St., Santa Anna CA 92704-3908. (714)424-0111. Fax: (714)424-0054. E-mail: janel.kaeden@jillsonroberts.com. Web site: www.jillsonroberts.com. **Art Director:** Janel Doran. Estab. 1974. Specializes in gift wrap, totes, printed tissues and accessories using recycled/recyclable products. Art guidelines available on Web site.

Needs Works with 10 freelance artists/year. Prefers artists with experience in giftwrap design. Considers all media. "We are looking for colorful graphic designs as well as humorous, sophisticated, elegant or contemporary styles." Produces material for Christmas, Valentine's Day, Hanukkah, Halloween, graduation, birthdays, baby announcements and everyday. Submit 3-6 months before holiday.

First Contact & Terms Send color copies or photocopies. Samples are kept on file. Responds in up to 2 months. Simultaneous submissions to other companies is acceptable. "If your work is chosen, we will contact you to discuss final art preparation, procedures and payment."

Tips "We are particularly interested in baby shower and wedding shower designs."

Ⓝ KALAN LP

97 S. Union Ave., Lansdowne PA 19050. (610)623-1900 ext. 341. Fax: (610)623-0366. E-mail: dumlauf@kalanlp.com. Web site: www.kalanlp.com. **Art Director:** Chris Wiemer. Copywriter: David Umlauf. Estab. 1973. Produces giftbags, greeting cards, school supplies, stationery and novelty items such as keyrings, mouse pads, shot glasses and magnets.

Needs Approached by 50-80 freelancers/year. Buys 100 freelance designs and illustrations/year. Art guidelines are available. Uses freelancers mainly for fresh ideas, illustration and design. Considers all media and styles. Some illustration demands knowledge of Photoshop 7.0 and Illustrator 10. Produces material for major holidays such as Christmas, Mother's Day, Valentine's Day; plus birthdays and everyday. Submit seasonal material 9-10 months in advance.

First Contact & Terms Designers: Send query letter with photocopies, photostats and résumé. Illustrators and cartoonists: Send query letter with photocopies and résumé. Accepts disk submissions compatible with Illustrator 10 or Photoshop 7.0. Send EPS files. Samples are filed. Responds in 1 month if interested in artist's work. Will contact artist for portfolio review of final art if interested. Buys first rights. Pays by the project, $75 and up. Finds freelancers through submissions and newspaper ads.

KEMSE AND COMPANY

P.O. Box 14334, Arlington TX 76094. (888)656-1452. Fax: (817)446-9986. E-mail: kim@kemsean dcompany.com. Web site: www.kemseandcompany.com. **Contact:** Kimberly See. Estab. 2003. Produces stationery. Specializes in multicultural stationery and invitations.

Needs Approached by 10-12 freelancers/year. Works with 5-6 freelancers/year. Buys 15-20 freelance designs and/or illustrations/year. Considers all media. Product categories include African American and Hispanic. Produces material for all holidays and seasons, birthday, graduation and woman-to-woman. Submit seasonal material 8 months in advance. 75% of freelance work demands knowledge of FreeHand, Illustrator, QuarkXPress and Photoshop.

First Contact & Terms Send query letter with photocopies, résumé and SASE. Accepts e-mail submissions with image file. Prefers Windows-compatible, JPEG files. Samples are filed. Responds only if interested. Company will contact artist for portfolio review if interested. Portfolio should include color, finished art, roughs and thumbnails. Buys all rights and reprint rights. Pays freelancers by the project. Finds freelancers through submissions.

☒ KENZIG KARDS, INC.

2300 Julia Goldbach Ave., Ronkonkoma NY 11779-6317. (631)737-1584. Fax: (631)737-8341. E-mail: kenzigkards@aol.com. **President:** Jerry Kenzig. Estab. 1999. Produces greeting cards and stationery. Specializes in greeting cards (seasonal and everyday) for a high-end, design-conscious market (all ages).

Needs Approached by 75 freelancers/year. Works with 3 freelancers/year. Prefers local designers/illustrators, but will consider freelancers working anywhere in the U.S. Art guidelines free with SAE and first-class postage. Uses freelancers mainly for greeting cards/design and calligraphy. Considers watercolor, colored pencils; most media. Product categories include alternative/humor, business and cute. Produces material for baby congrats, birthday, cards for pets, Christmas, congratulations, everyday, get well, sympathy, Valentine's Day and wedding/anniversary. Submit seasonal material 6 months in advance. Art size should be 5×7 or $5^3/4 \times 5^3/4$ square. 20% of freelance work demands knowledge of Illustrator, QuarkXPress and Photoshop.

First Contact & Terms Send query letter with brochure, résumé and tearsheets. After introductory mailing, send follow-up postcard sample every 6 months. Samples are filed. Responds in 2 weeks. Company will contact artist for portfolio review if interested. Portfolio should include color, original art, roughs and tearsheets. Buys one-time rights and reprint rights for cards and mugs. Negotiates rights purchased. Pays freelancers by the project, $150-350; royalties (subject to negotiation). Finds freelancers through industry contacts (Kenzig Kards, Inc., is a member of the Greeting Card Association), submissions and word of mouth.

Tips "We are open to new ideas and different approaches within our niche (i.e., dog- and cat-themed designs, watercolor florals, etc.). We look for bright colors and cute, whimsical art. Floral designs require crisp colors."

KID STUFF MARKETING

929 SW University Blvd., Suite B-1, Topeka KS 66619-0235. (785)862-3707. Fax: (785)862-1424. E-mail: michael@kidstuff.com. Web site: www.kidstuff.com. **Senior Creative Director:** Michael Oden. Estab. 1982. Produces collectible figurines, toys, kids' meal sacks, edutainment activities and cartoons for restaurants and entertainment venues worldwide.

Needs Approached by 50 freelancers/year. Works with 10 freelancers/year. Buys 30-50 freelance designs and illustrations/year. Works on assignment only. Uses freelancers mainly for illustration, activity or game development and sculpting toys. Considers all media. Looking for humorous, child-related styles. Freelance illustrators should be familiar with Photoshop, Illustrator, FreeHand and QuarkXPress. Produces material for Christmas, Easter, Halloween, Thanksgiving, Valentine's Day and everyday. Submit seasonal material 3 months in advance.

First Contact & Terms Illustrators and Cartoonists: Send query letter with photocopies or e-mail JPEG files. Sculptors, calligraphers: Send photocopies. Samples are filed or returned by SASE. Responds only if interested. Portfolio review not required. Pays by the project, $250-5,000 for illustration or game activities. Finds freelancers through word of mouth and artists' submissions.

THE LANG COMPANIES

P.O. Box 55, Delafield WI 53018. (262)646-3399. Web site: www.lang.com. **Product Development Coordinator:** Yvonne Moroni. Estab. 1982. Produces high-quality linen-embossed greeting cards, stationery, calendars, boxes and gift items. Art guidelines available for SASE.

Needs Approached by 300 freelance artists/year. Works with 40 freelance artists/year. Uses freelancers mainly for card and calendar illustrations. Considers all media and styles. Looking for traditional and nonabstract country-inspired, folk, contemporary and fine art styles. Produces material for Christmas, birthdays and everyday. Submit seasonal material 6 months in advance.

First Contact & Terms Send query letter with SASE and brochure, tearsheets, photostats, photographs, slides, photocopies or transparencies. Samples are returned by SASE if requested by artist. Responds in 6 weeks. Pays royalties based on net wholesale sales. Rights purchased vary according to project.

Tips "Research the company and submit compatible art. Be patient awaiting a response."

Ⓝ LEGACY PUBLISHING GROUP

75 Green St., Clinton MA 01510. (800)322-3866 or (978)368-8711. Fax: (978)368-7867. Web site: legacypublishinggroup.com. **Contact:** Art Department. Produces bookmarks, calendars, gifts, Christmas and seasonal cards and stationery pads. Specializes in journals, note cards, address and recipe books, coasters, placemats, magnets, book marks, albums, calendars and grocery pads.

Needs Works with 8-10 freelancers/year. Buys 25-30 freelance designs and illustrations/year. Prefers traditional art. Art guidelines available for SASE. Works on assignment only. Uses freelancers mainly for original art for product line. Considers all color media. Looking for traditional, contemporary, garden themes and Christmas. Produces material for Christmas, everyday (note cards) and cards for teachers.

First Contact & Terms Illustrators: Send query letter with photocopies, photographs, résumé, tearsheets, SASE and any good reproduction or color copy. We accept work compatible with Adobe or QuarkXPress plus color copies. Samples are filed. Responds in 2 weeks. Company will contact artist for portfolio review if interested. Portfolio should include color photographs, slides, tearsheets and printed reproductions. Buys all rights. Pays for illustration by the project, $600-1,000. Finds freelancers through word of mouth and artists' submissions.

Tips "Get work out to as many potential buyers as possible. *Artist's & Graphic Designer's Market* is a good source. Initially, plan on spending 80% of your time on self-promotion."

⊠ ⊠ THE LEMON TREE STATIONERY CORP.

95 Mahan St., West Babylon NY 11704. (631)253-2840. Fax: (631)253-3369. Web site: www.lem ontreestationery.com. **Contact:** Lucy Mlexzko. Estab. 1969. Produces birth announcements, Bar Mitzvah and Bat Mitzvah invitations and wedding invitations.

Needs Buys 100-200 pieces of calligraphy/year. Prefers local designers. Works on assignment only. Uses Mac designers. Also for calligraphy, mechanicals, paste-up, P-O-P. Looking for tradi-tional, contemporary. 50% of freelance work demands knowledge of Photoshop, QuarkXPress, Illustrator.

First Contact & Terms Send query letter with résumé. Calligraphers send photocopies of work. Samples are not filed and are not returned. Responds only if interested. Company will contact artist for portfolio review of final art, photostats, thumbnails if interested. Pays for design by the project. Pays flat fee for calligraphy.

Tips "Look around at competitors' work to get a feeling of the type of art they use."

⊠ LIFE GREETINGS

P.O. Box 468, Little Compton RI 02837. (401)635-4918. **Editor:** Kathy Brennan. Estab. 1973. Produces greeting cards. Religious, inspirational greetings.

Needs Approached by 25 freelancers/year. Works with 5 freelancers/year. Uses freelancers mainly for greeting card illustration. Also for calligraphy. Considers all media but prefers pen & ink and pencil. Prefers $4\frac{1}{2} \times 6\frac{1}{4}$—no bleeds. Produces material for Christmas, religious/liturgi-cal events, baptism, first communion, confirmation, ordination, etc.

First Contact & Terms Send query letter with photocopies. Samples are filed or returned by SASE if requested by artist. Responds only if interested. Portfolio review not required. Originals are not returned. Pays by the project. **"We pay on acceptance."** Finds artists through submis-sions.

⊠ THE LOLO COMPANY

6755 Mira Mesa Blvd., Suite 123-410, San Diego, CA 92121. (800)760-9930. Fax: (800)234-6540. E-mail: products@lolofun.com. Web site: www.lolofun.com. **Creative Director:** Robert C. Paul. Estab. 1995. Publishes board games. Recent games include "Bucket Blast," "It-DAH-gan," "Run Around Fractions" and "You're It."

Needs Approached by 1 illustrator and 1 designer/year. Works with 2 illustrators and 2 design-ers/year. Prefers humorous work. Uses freelancers mainly for product design and packaging. 100% of freelance design and illustration demands knowledge of Illustrator, Photoshop and QuarkXPress.

First Contact & Terms Preferred submission package is a self-promotional postcard sample. Send 5 printed samples or photographs. Accepts disk submissions in Windows format; send via

Zip as EPS. Samples are filed. Will contact artist for portfolio review if interested. Portfolio should include artwork of characters in sequence, color photocopies, photographs, transparencies of final art and roughs. Rights purchased vary according to project. Finds freelancers through word of mouth and Internet.

LPG GREETINGS, INC.

813 Wisconsin Street, Walworth WI 53184. (262)275-5600. Fax: (262)275-5609. E-mail: judy@lp ggreetings.com. Web site: www.lpggreetings.com. **Creative Director:** Judy Cecchi. Estab. 1992. Produces greeting cards. Specializes in boxed Christmas cards.

Needs Approached by 50-100 freelancers/year. Works with 20 freelancers/year. Buys 70 free-lance designs and illustrations/year. Art guidelines can be found on LPG's website.Uses freelanc-ers mainly for original artwork for Christmas cards. Considers any media. Looking for traditional and humorous Christmas. Greeting cards can be vertical or horizontal; 5×7 or 6×8. Usually prefers 5×7. Submit seasonal material 1 year in advance.

First Contact & Terms Send query letter with photocopies. Samples are filed if interested or returned by SASE. Portfolio review not required. Will contact artist for portfolio if interested. Rights purchased vary according to project. Pays for design by the project. For illustration: pays flat fee. Finds freelancers through word of mouth and artists' submissions. Please do not send unsolicited samples via e-mail; they will not be considered.

Tips "Be creative with fresh new ideas."

Ⓝ LUNT SILVERSMITHS

298 Federal St., P.O. Box 1010, Greenfield MA 01302-1010. (413)774-2774. Fax: (413)774-4393. E-mail: alunt@luntsilver.com. Web site: www.luntsilver.com. **Director of Design:** Alexander C. Lunt. Estab. 1902. Produces collectibles, gifts, Christmas ornaments, babyware, tabletop products, sterling and steel flatware.

Needs Approached by 1-2 freelancers/year. Works with 1-2 freelancers/year. Contracts 35 prod-uct models/year. Prefers freelancers with experience in tabletop product, model-making. Uses freelancers mainly for model-making, prototypes and cad engineering. Also for mechanicals. Considers clay, plastaline, resins, hard models. Looking for traditional, florals, sentimental, contemporary. 50% of freelance design work demands knowledge of Photoshop, Illustrator, Cad. Produces material for all holidays and seasons, Christmas, Valentine's Day, everyday.

First Contact & Terms Designers and sculptors should send query letter with brochure, photo-copies, photographs, résumé. Sculptors should also send résumé and photos. Accepts disk sub-missions created digitally. Samples are filed or returned by SASE. Responds in 1 week only if interested. Will contact for portfolio review if interested. Portfolio should include photographs, photostats, slides. Rights purchased vary according to project. Pays for design, illustration and sculpture according to project.

MADISON PARK GREETINGS

1407 11th Ave., Seattle WA 98122-3901. (206)324-5711. Fax: (206)324-5822.E-mail: info@madp ark.com. Web site: www.madisonparkgreetings.com. **Art Director**: Megan Gandt. Estab. 1977. Produces greeting cards, stationery.

Needs Approached by 1,000 freelancers/year. Works with 20 freelancers/year.
Buys 100 freelance designs and illustrations/year. Art guidelines available free for SASE. Works on assignment only. Uses freelancers mainly for greeting cards; also for calligraphy. Considers all paper-related media.

Produces material for Christmas, Easter, Mother's Day, Father's Day, graduation, New Year, Valentine's Day, birthdays, everyday, sympathy, get well, anniversary, baby congratulations, wedding, thank you, expecting, friendship. Are interested in floral and whimsical imagery, as well as humor.'' Submit seasonal material 10 months in advance.

First Contact & Terms Designers: Send photocopies. Illustrators: Send postcard sample or photocopies. Accepts submissions on disk. Send JPEG or PDF files. Samples are not returned. Will contact artist for portfolio review of color, final art, roughs if interested. Rights purchased and royalties vary according to project.

MIXEDBLESSING

P.O. Box 97212, Raleigh NC 27624-7212. (919)847-7944. Fax: (919)847-6429. E-mail: mixedblessing@earthlink.com. Web site: www.mixedblessing.com. **President:** Elise Okrend. Licensing: Philip Okrend. Estab. 1990. Produces interfaith greeting cards combining Jewish and Christian as well as multicultural images for all ages. Licenses holiday artwork for wrapping paper, tote bags, clothing, paper goods and greeting cards.

Needs Approached by 10 freelance artists/year. Works with 10 freelancers/year. Buys 20 designs and illustrations/year. Provides samples of preferred styles upon request. Works on assignment only. Uses freelancers mainly for card illustration. Considers watercolor, pen & ink and pastel. Prefers final art 5×7. Produces material for Christmas and Hanukkah. Submit seasonal material 10 months in advance.

First Contact & Terms Send nonreturnable samples for review. Samples are filed. Responds only if interested. Originals are returned at job's completion. Sometimes requests work on spec before assigning a job. Pays flat fee of $125-500 for illustration/design. Buys all rights. Finds artists through visiting art schools.

Tips ''I see growth ahead for the industry. Go to and participate in the National Stationery Show.''

N J.T. MURPHY CO.

200 W. Fisher Ave., Philadelphia PA 19120. (215)329-6655. **President:** Jack Murphy. Estab. 1937. Produces greeting cards and stationery. ''We produce a line of packaged invitations, thank-you notes and place cards for retail.''

Needs Approached by 12 freelancers/year. Works with 4 freelancers/year. Buys 8 freelance designs and illustrations/year. Prefers local freelancers with experience in graphics and greeting cards. Uses freelancers mainly for concept, design and finished artwork for invitations and thank-yous. Looking for graphic, contemporary or traditional designs. Prefers 4×5⅛ but can work double size. Produces material for graduation, birthdays and everyday. Submit seasonal material 9 months in advance.

First Contact & Terms Send nonreturnable samples. Responds in 1 month. Company will contact artist for portfolio review if interested. Rights purchased vary. Originals not returned. Payment negotiated.

N NALPAC, LTD.

1111 E. Eight Mile Rd., Ferndale MI 48220. (248)541-1140. Fax: (248)544-9126. E-mail: ralph@nalpac.com. **President, licensing:** Ralph Caplan. Estab. 1971. Produces coffee mugs gift bags, trendy gift and novelty items, and T-shirts for gift and mass merchandise markets. Licenses all kinds of artwork for T-shirts, mugs and gifts.

Needs Approached by 10-15 freelancers/year. Works with 2-3 freelancers/year. Buys 70 designs and illustrations/year. Works on assignment only. Considers all media. Needs computer-literate freelancers for design, illustration and production. 60% of freelance work demands computer skills.

First Contact & Terms Send query letter with brochure, résumé, SASE, photographs, photocopies, slides and transparencies. Samples are filed or are returned by SASE if requested by artist. Responds in 1 month. Call for appointment to show portfolio. Usually buys all rights, but rights purchased may vary according to project. Also needs package/product designers, pay rate varies. Pays for design and illustration by the hour $10-25; or by the project $40-500, or offers royalties of 4-10%.

N NAPCO MARKETING

7800 Bayberry Rd., Jacksonville FL 32256-6893. (904)737-8500. Fax: (904)737-9526. E-mail: napco@leading.com. **Art Director:** Robert Keith. Estab. 1940. NAPCO Marketing supplies floral, garden and home interior markets with middle to high-end products. Clients wholesale.

 • NAPCO Marketing has a higher-end look for their floral market products.

Needs Works with 15 freelance illustrators and designers/year. 50% of work done on a freelance basis. No restrictions on artists for design and concept. Art guidelines available for SASE with first-class postage. Works on assignment only. Uses freelancers mainly for mechanicals and product design. "Need artists that are highly skilled in illustration for three-dimensional products."

First Contact & Terms Designers: Send query letter with brochure, résumé, photocopies, photographs, SASE, tearsheets and "any samples we can keep on file." Illustrators send brochure, résumé, photocopies, photographs and SASE. If work is in clay, send photographs. Samples are filed or returned by SASE. Responds in 2 weeks. Artist should follow up with letter after initial query. Portfolio should include samples which show a full range of illustration style. Sometimes requests work on spec before assigning a job. Pays for design by the project, $50-500. Pays by the project for illustration, $50-2,000. Pays $15/hour for mechanicals. Buys all rights. Considers buying second rights (reprint rights) to previously published work. Finds artists through word of mouth and self-promotions.

Tips "We are very selective in choosing new people. We need artists that are familiar with three-dimensional giftware and floral containers."

⚜ NATIONAL DESIGN CORP.

12121 Scripps Summit Drive, Suite 200, San Diego CA 92131. (858)674-6040. Fax: (858)674-4120. Web site: www.nationaldesign.com. **Creative Director:** Christopher Coats. Estab. 1985. Produces gifts, writing instruments and stationery accoutrements. Markets include gift/souvenir and premium markets.

Needs Works with 3-4 freelancers/year. Buys 3 freelance designs and illustrations/year. Prefers local freelancers only. Works on assignment only. Uses freelancers mainly for design illustration; also for prepress production on Mac. Considers computer renderings to mimic traditional medias. Prefers children's and contemporary styles. 100% of freelance work demands knowledge of Illustrator and InDesign, Freehand and Photoshop. Produces material for Christmas and everyday.

First Contact & Terms Send query letter with photocopies, résumé, SASE. Accepts submissions on disk. "Contact by phone for instructions." Samples are filed and are returned if requested.

Company will contact artist for portfolio review of color, final art, tearsheets if interested. Rights purchased vary according to project. Payments depends on complexity, extent of project(s).

Tips "Must be well traveled to identify with gift/souvenir markets internationally. Fresh ideas always of interest."

N NEW DECO, INC.

23123 Sunfield Dr., Boca Raton FL 33433. (800)543-3326. Fax: (561)488-9743. E-mail: newdeco @mindspring.com. Web site: newdeco.com. **President:** Brad Hugh Morris. Estab. 1984. Produces greeting cards, posters, fine art prints and original paintings.

Needs Specializing in pool and billiard artwork only. Works with 5-10 freelancers/year. Buys 8-10 designs and 5-10 illustrations/year. Uses artwork for original paintings, limited edition graphics, greeting cards, giftwrap, calendars, paper tableware, poster prints, etc. Licenses artwork for posters and prints.

First Contact & Terms Send query letter with brochure, résumé, tearsheets, slides and SASE. Samples not filed are returned by SASE. Responds in 10 days only if interested. To show portfolio, send e-mail. Pays royalties of 5-10%. Negotiates rights purchased.

Tips "Do not send original art at first." Contact only if you have an original image relating to Pool and Billiards.

N NEW ENGLAND CARD CO.

Box 228, West Ossipee NH 03890. (603)539-5095. E-mail: GLP@nhland.com. Web site: www.nh land.com. **Owner:** Harold Cook. Estab. 1980. Produces greeting cards and prints of New England scenes which can be viewed on our Web site.

Needs Approached by 75 freelancers/year. Works with 10 freelancers/year. Buys more than 24 designs and illustrations/year. Prefers freelancers with experience in New England art. Art guidelines available. Considers oil, acrylic and watercolor. Looking for realistic styles. Prefers art proportionate to 5×7. Produces material for all holidays and seasons. "Submit all year."

First Contact & Terms Send query letter with SASE, photocopies, slides and transparencies. Samples are filed or are returned. Responds in 2 months. Artist should follow up after initial query. Pays by project. Rights purchased vary according to project, but "we prefer to purchase all rights."

Tips "Once you have shown us samples, follow up with new art."

N-M LETTERS, INC.

662 Bullocks Point Ave., Riverside RI 02915. (401)433-0040. Fax: (800)989-2051. E-mail: help@n mletters.com. Web site: www.nmletters.com. **President:** Judy Mintzer. Estab. 1982. Produces announcements and invitations that are "sweet and sassy, cool and sophisticated, playful and edgy."

Needs Approached by 2-5 freelancers/year. Works with 2 freelancers/year. Prefers local artists only. Works on assignment only. Produces material for parties, weddings and Bar/Bat Mitzvahs. Submit seasonal material 6 months in advance.

First Contact & Terms Send query letter with résumé. Responds in 1 month, only if interested. Call for appointment to show portfolio of b&w roughs. Original artwork is not returned. Pays by the project.

NOBLE WORKS

P.O. Box 1275, Hoboken NJ 07030. (201)420-0095. Fax: (201)420-0679. E-mail: info@noblework sinc.com. Web site: www.nobleworksinc.com. **Contact:** Art Department. Estab. 1981. Produces greeting cards, notepads, gift bags and gift products. Specializes in trend-oriented, hip urban greeting cards. ''Always pushing the envelope, our cards redefine the edge of sophisticated, sassy, and downright silly fun.'' Art guidelines available for SASE with first-class postage.

Needs Looking for humorous, ''off-the-wall'' adult contemporary and editorial illustration. Produces material for Christmas, Mother's Day, Father's Day, graduation, Halloween, Valentine's Day, birthdays, thank you, anniversary, get well, astrology, sympathy, etc. Submit seasonal material 18 months in advance.

First Contact & Terms Designers: Send query letter with photocopies, SASE, tearsheets, transparencies. Illustrators and Cartoonists: Send query letter with photocopies, tearsheets, SASE. After introductory mailing, send follow-up postcard sample every 8 months. Responds in 1 month. Buys reprint rights. Pays for design and illustration by the project. Finds freelancers through sourcebooks, illustration annuals, referrals.

N ⚡ NORTHERN CARDS

5694 Ambler Dr., Mississauga ON L4W 2K9 Canada. (905)625-4944. Fax: (905)625-5995. E-mail: ggarbacki@northerncards.com. Web site: northerncards.com. **Product Coordinator:** Greg Garbacki. Estab. 1992. Produces 3 brands of greeting cards.

Needs Approached by 200 freelancers/year. Works with 25 freelancers/year. Buys 75 freelance designs and illustrations/year. Uses freelancers for ''camera-ready artwork and lettering.'' Art guidelines for SASE with first-class postage. Looking for traditional, sentimental, floral and humorous styles. Prefers $5^1/_2 \times 7^3/_4$ or 5×7. Produces material for Christmas, Easter, Mother's Day, Father's Day, graduation, Valentine's Day, birthdays and everyday. Also sympathy, get well, someone special, thank you, friendship, new baby, good-bye and sorry. Submit seasonal material 6 months in advance.

First Contact & Terms Designers: Send query letter with brochure, photocopies, slides, résumé and SASE. Illustrators and Cartoonists: Send photocopies, tearsheets, résumé and SASE. Lettering artists send samples. Samples are filed or returned by SASE. Responds only if interested. Pays flat fee, $200 (CDN). Finds freelancers through newspaper ads, gallery shows and Internet.

Tips ''Research your field and the company you're submitting to. Send appropriate work only.''

NOVO CARD PUBLISHERS INC.

7570 N. Croname Road, Niles IL 60714. (847)763-0077. Fax: (847)763-0022. E-mail: art@novocar d.net. Web site: www.novocard.net. Estab. 1927. Produces all categories of greeting cards.

Needs Approached by 200 freelancers/year. Works with 30 freelancers/year. Buys 300 or 400 pieces/year from freelance artists. Art guidelines free for SASE with first-class postage. Uses freelancers mainly for illustration and text. Also for calligraphy. Considers all media. Prefers crop size $5 \times 7^3/_4$, bleed $5^1/_4 \times 8$. Knowledge of Photoshop, Illustrator and QuarkXPress, and Indesign helpful. Produces material for all holidays and seasons and everyday. Submit seasonal material 8 months in advance.

First Contact & Terms Designers: Send brochure, photocopies, photographs and SASE. Illustrators and Cartoonists: Send photocopies, photographs, tearsheets and SASE. Calligraphers: Send b&w copies. Accepts disk submissions compatible with Macintosh QuarkXPress 4.0 and Windows 95. Art samples are not filed and are returned by SASE only. Written samples

retained on file for future assignment with writer's permission. Responds in 2 months. Pays for design and illustration by the project, $75-200.

OATMEAL STUDIOS

P.O. Box 138, Rochester VT 05767. (802)767-3171. Fax: (802)767-9890. E-mail: sales@oatmealst udios.com. Web site: www.oatmealstudios.com. **Creative Director:** Helene Lehrer. Estab. 1979. Publishes humorous greeting cards and notepads, creative ideas for everyday cards. Art guidelines available for SASE with first-class postage.

Needs Approached by approximately 300 freelancers/year. Buys 100-150 freelance designs and illustrations/year. Considers all media.

First Contact & Terms Write for art guidelines; send query letter with SASE, slides, roughs, printed pieces or brochure/flyer to be kept on file. "If brochure/flyer is not available, we ask to keep one slide or printed piece; color or b&w photocopies also acceptable for our files." Samples are returned by SASE. Responds in 6 weeks. Negotiates payment.

Tips "We're looking for exciting and creative, humorous (not cutesy) illustrations and single-panel cartoons. If you can write copy and have a humorous cartoon style all your own, send us your ideas! We do accept artwork without copy, too."

ℕ THE OCCASIONS GROUP

(formerly Blue Sheet Marketing) 1710 Roe Crest Dr., North Mankato MN 56003. Fax: (507)625-3388. E-mail: dknutson@theoccasionsgroup.com. Web site: www.executive-greetings.com. **Creative Director:** Deb Knutson. Produces calendars, greeting cards, stationery, posters, memo pads, advertising specialties. Specializes in Christmas, everyday, dental, healthcare greeting cards and postcards, and calendars for businesses and professionals.

Needs Art guidelines available free for SASE. Works with 20-30 freelancers/year. Buys approximately 300 freelance designs and illustrations/year. Prefers freelancers with experience in greeting cards. Works on assignment only. Uses freelancers mainly for illustration, calligraphy, lettering, humorous writing, cartoons. Prefers traditional Christmas and contemporary and conservative cartoons. Some design work demands knowledge of Photoshop, Illustrator, QuarkXPress abd InDesign. Produces material for Christmas, Thanksgiving, birthdays, everyday.

First Contact & Terms Designers: Send brochure, résumé, tearsheets. Illustrators and cartoonists: Send tearsheets. After introductory mailing, send follow-up postcard sample every 6 months. Calligraphers: Send photocopies of their work. Accepts Mac-compatible disk submissions. Samples are filed. Buys one-time or all rights. Pays for illustration by the project, $250-500. Finds freelancers through agents, other professional contacts, submissions and recommendations.

OUT OF THE BLUE

711 S Osprey Ave, Ste 1, Sarasota FL 34236. (941)966-4042. Fax: (941)296-7345. E-mail: outofthe blue.us@mac.com. Web site: www.out-of-the-blue.us. **President:** Michael Woodward. "We specialize in creating 'Art Brands.' We are looking for fine art, decorative art photography that we can license for product categories such as posters and fine art prints, limited edition giclees, greeting cards, calendars, stationery, gift products and the home decor market. We specialize particulary in the fine art print/poster market."

● This company is a division of Art Licensing International, Inc. (see separate listings in the Posters & Prints and Artists' Reps sections as well as in this section).

Needs Collections of art, illustrations or photography that have wide consumer appeal. "CD or e-mail presentations preferred, but photocopies/flyers are acceptable. Keep files to 250K or below."

First Contact & Terms Send samples on CD (JPEG files), short bio, color photocopies and SASE. E-mail submissions also accepted. "Terms are 50/50 with no expense to artist as long as artist can provide high-res scans if we agree on representation." Submission guidelines are available on Web site at www.out-of-the-blue.us/submissions.html.

Tips "Pay attention to trends and color palettes. Artists need to consider actual products when creating new art. Look at products in retail outlets and get a feel for what is selling well. Get to know the markets you want to sell your work to."

N P.S. GREETINGS, INC.

5730 N. Tripp Ave., Chicago IL 60646. (773)267-6150. Fax: (773)267-6055. E-mail: artdirector@p sgreetings.com. Web site: www.psgreetings.com. **Contact:** Art Director. Manufacturer of boxed greeting and counter cards. Artists' guidelines are posted on Web site, or send SASE.

Needs Receives submissions from 300-400 freelance artists/year. Works with 50-100 artists/year on greeting card designs. Publishes greeting cards for everyday and holidays. 70% of work demands knowledge of QuarkXPress, Illustrator and Photoshop.

First Contact & Terms All requests as well as submissions must be accompanied by SASE. "Samples will *not* be returned without SASE!" Responds in 1 month. Pays flat fee. Buys exclusive worldwide rights for greeting cards and stationery.

Tips "Our line includes a whole spectrum from everyday needs (florals, scenics, feminine, masculine, humorous, cute) to every major holiday (from New Year's to Thanksgiving) with a very extensive Christmas line. We continue to grow every year and are always looking for innovative talent."

N PAINTED HEARTS

1222 N. Fair Oaks Ave., Pasadena CA 91103. (626)798-3633. Fax: (626)296-8890. E-mail: richard @paintedhearts.com. Web site: www.paintedhearts.com. **Sales Manager:** Richard Crawford. President: Susan Kinney. Estab. 1988. Produces greeting cards, stationery, invitations and note cards.

Needs Approached by 75 freelance artists/year. Works with 6 freelancers/year. Art guidelines free for SASE with first-class postage or by e-mail. Works on assignment only. Uses freelancers mainly for design. Produces material for all holidays and seasons, birthdays and everyday. Submit seasonal material 1 year in advance.

First Contact & Terms Send art submissions and writers submissions Attn: Richard Crawford or use e-mail. Send query letter with résumé, SASE and color photocopies. Samples are returned with SASE. Responds only if interested. Write for appointment to show portfolio, which should include original and published work. Rights purchased vary according to project. Originals returned at job's completion. Pays royalties of 5%.

Tips "Familiarize yourself with our card line." This company is seeking "young artists (in spirit!) looking to develop a line of cards. We're looking for work that is compatible but adds to our look, which is bright, clean watercolors. We need images that go beyond just florals to illustrate and express the occasion."

Ⓝ PANDA INK

Woodland Hills CA 91367. (818)340-8061. Fax: (818)883-6193. E-mail: ruthluvph@socal.rr.com.
Art Director: Ruth Ann Epstein. Estab. 1982. Produces greeting cards, stationery, calendars and magnets. Products are Judaic, general, everyday, anniversary, etc. Also has a metaphysical line of cards.

Needs Approached by 8-10 freelancers/year. Works with 1-2 freelancers/year. Buys 3-4 freelance designs and illustrations/year. Uses freelancers mainly for design, card ideas. Considers all media. Looking for bright, colorful artwork, no risque, more ethnic. Prefers 5×7. Produces material for all holidays and seasons, Christmas, Valentine's Day, Mother's Day, Father's Day, Easter, Hanukkah, Passover, Rosh Hashanah, graduation, Thanksgiving, New Year, Halloween, birthdays and everyday. Submit seasonal material 6 months in advance.

First Contact & Terms Send query letter with résumé, SASE, tearsheets and photocopies. Samples are filed. Responds in 1 month. Portfolio review not required. Rights purchased vary according to project. Originals are returned at job's completion. Pay is negotiable; pays flat fee of $20; royalties of 2% (negotiable). Finds artists through word of mouth and submissions. "We have no guidelines available."

Tips "Looking for bright colors and cute, whimsical art. Be professional. Always send SASE. Make sure art fits company format."

PAPER MAGIC GROUP INC.

401 Adams Ave., Scranton PA 18510. (800)278-4085. Fax: (570)961-3863. E-mail: careers@papermagic.com. Web site: www.papermagic.com. **Creative Director:** Don French. Estab. 1984. Produces greeting cards, stickers, vinyl wall decorations, 3D paper decorations. "We publish seasonal cards and decorations for the mass market. We use a wide variety of design styles."

Needs Works with 60 freelance artists/year. Prefers artists with experience in greeting cards. Work is by assignment; or send submissions on spec. Designs products for Christmas and Valentine's Day. Also uses freelancers for lettering and art direction.

First Contact & Terms Send query letter with résumé, samples (color photocopies) and SASE. Samples are filed or are returned by SASE if requested by artist. Responds in 2 months. Originals not returned. Pays by the project, $350-2,000 average. Buys all rights.

Tips "Please, experienced illustrators only."

Ⓝ PAPER MOON GRAPHICS, INC.

Box 34672, Los Angeles CA 90034. (310)287-3949. Fax: (310)287-2588. E-mail: moonguys@aol.com. Web site: www.papermoon.com. **Contact:** Creative Director. Estab. 1977. Produces greeting cards and stationery. "We publish greeting cards with a friendly, humorous approach—dealing with contemporary issues."

- Paper Moon is a contemporary, alternative card company. Traditional art is not appropriate for this company.

Needs Works with 40 artists/year. Buys 200 designs/illustrations/year. Buys illustrations mainly for greeting cards and stationery. Art guidelines for SASE with first-class postage. Produces material for everyday, holidays and birthdays. Submit seasonal material 6 months in advance.

First Contact & Terms Send query letter with brochure, tearsheets, photostats, photocopies, slides and SASE. Samples are filed or are returned only if requested by artist and accompanied by SASE. Responds in 10 weeks. To show a portfolio, mail color roughs, slides and tearsheets. Original artwork is returned to the artist after job's completion. Pays average flat fee of $350/design; $350/illustration. Negotiates rights purchased.

Tips "We're looking for bright, fun style with a contemporary look. Artwork should have a young 20s and 30s appeal." A mistake freelance artists make is that they "don't know our product. They send inappropriate submissions, not professionally presented and with no SASE."

☒ PAPERPRODUCTS DESIGN U.S. INC.
60 Galli Dr., Suite 1, Novato CA 94949. (415)883-1888. Fax: (415)883-1999. E-mail: carol@paper productdesign.com. Web site: www.paperproductsdesign.com. **President:** Carol Florsheim. Estab. 1990. Produces paper napkins, plates, designer tissue, giftbags and giftwrap, porcelain accessories. Specializes in high-end design, fashionable designs.

Needs Approached by 50-100 freelancers/year. Buys multiple freelance designs and illustrations/year. Artists do not need to write for guidelines. They may send samples to the attention of Carol Florsheim at any time. Uses freelancers mainly for designer paper napkins. Looking for very stylized/clean designs and illustrations. Prefers $6\frac{1}{2} \times 6\frac{1}{2}$. Produces seasonal and everyday material. Submit seasonal material 9 months in advance.

First Contact & Terms Designers: Send brochure, photocopies, photographs, tearsheets. Samples are not filed and are returned if requested with SASE. Responds in 6 weeks. Request portfolio review of color, final art, photostats in original query. Rights purchased vary according to project. Pays for design and illustration by the project in advances and royalties. Finds freelancers through agents, *Workbook*.

Tips "Shop the stores, study decorative accessories, fashion clothing. Read European magazines. We are a design house."

☒ PICKARD CHINA
782 Pickard Ave., Antioch IL 60002. (847)395-3800. Web site: www.pickardchina.com. **President:** Eben C. Morgan, Jr. Estab. 1893. Manufacturer of fine china dinnerware. Clients: Upscale specialty stores and department stores. Current clients include Gearys, Marshall Field's and Gump's.

Needs Assigns 2-3 jobs to freelance designers/year. Prefers designers for china pattern development with experience in home furnishings. Tabletop experience is a plus but not required.

First Contact & Terms Send query letter with résumé and color photographs, tearsheets, slides or transparencies showing art styles. Samples are filed or are returned if requested. Art Director will contact artist for portfolio review if interested. Negotiates rights purchased. May purchase designs outright, work on royalty basis (usually 2%) or negotiate nonrefundable advance against royalties.

☒ MARC POLISH ASSOCIATES
P.O. Box 3434, Margate NJ 08402. (609)823-7661. E-mail: mpolish@verizon.net. Web site: www .justtoiletpaper.com. **President:** Marc Polish. Estab. 1972. Produces T-shirts and sweatshirts. "We specialize in printed T-shirts, sweatshirts, printed bathroom tissue, paper towels and coasters. Our market is the gift and mail order industry, resort shops and college bookstores."

Needs Works with 6 freelancers/year. Designs must be convertible to screenprinting. Produces material for Christmas, Valentine's Day, Mother's Day, Father's Day, Hanukkah, graduation, Halloween, birthdays and everyday.

First Contact & Terms Send query letter with brochure, tearsheets, photographs, photocopies, photostats and slides. Samples are filed or are returned. Responds in 2 weeks. To show portfolio, mail anything to show concept. Originals returned at job's completion. Pays royalties of 6-10%. Negotiates rights purchased.

Tips "We like to laugh. Humor sells. See what is selling in the local mall or department store. Submit anything suitable for T-shirts. Do not give up. No idea is a bad idea. It sometimes might have to be changed slightly to fit into a marketplace."

⊞ THE POPCORN FACTORY

13970 W. Laurel Dr., Lake Forest IL 60045. E-mail: abromley@thepopcornfactory.com. Web site: www.thepopcornfactory.com. **Director of Merchandising:** Ann Bromley. Estab. 1979. Manufacturer of popcorn packed in exclusive designed cans and other gift items sold via catalog for Christmas, Halloween, Valentine's Day, Easter and year-round gift giving needs.

Needs Works with 6 freelance artists/year. Assigns up to 20 freelance jobs/year. Works on assignment only. Uses freelancers mainly for cover illustration. Occasionally uses artists for advertising, brochure and catalog design and illustration. 100% of freelance catalog work requires knowledge of QuarkXPress and Photoshop.

First Contact & Terms Send query letter with photocopies, photographs or tearsheets. Samples are filed. Responds in 1 month. Write for appointment to show portfolio, or mail finished art samples and photographs. Pays for design by the hour, $50 minimum. Pays for catalog design by the page. Pays for illustration by project, $250-2,000. Considers complexity of project, skill and experience of artist, and turnaround time when establishing payment. Buys all rights.

Tips "Send classic illustration, graphic designs or a mix of photography/illustration. We can work from b&w concepts—then develop to full 4-color when selected. *Do not send art samples via e-mail.*"

PORTERFIELD'S FINE ART LICENSING

437 Tuttle Avenue, Suite 319, Sarasota, FL 34243. (800)660-8345. E-mail: art@porterfieldsfineart .com. Web site: www.porterfieldsfineart.com. **President:** Lance J. Klass. Licenses representational, Christmas, holiday, seasonal, Americana, and many other subjects. We're a major, nationally recognized full-service licensing agency." Estab. 1994. Functions as a full-service licensing representative for individual artists wishing to license their work into a wide range of consumer-oriented products. We are one of the fastest growing art licensing agencies in North America, as well as the best-known art licensing site on the Internet, rated #1 in art licensing by Google for over 8 years, and recently #1 on MSN, Yahoo and Ask.com as well. Stop by our site for more information about how to become a Porterfield's artist and have us represent you and your work for licenses in wall and home decor, home fabrics, stationery and all paper products, crafts, giftware and many other fields."

Needs Approached by more than 1,000 artists/year. Licenses many designs and illustrations/year. Prefers commercially oriented artists who can create beautiful pieces of art that people want to look at again and again, and that will help sell products to the core consumer, that is, women over 30 who purchase 85% of all consumer goods in America." Art guidelines listed on Web site. Considers existing works first. Considers any media—oil, pastel, watercolor, acrylics, digital. "We are seeking artists who have exceptional artistic ability and commercial savvy, who study the market for trends and who would like to have their art and their talents introduced to the broad public. Artists must be willing to work hard to produce art for the market."

First Contact Terms Visit company's Web site to read needs and submission guidelines. E-mail JPEG files or your URL, or send query letter with tearsheets, photographs, and photocopies. SASE required for return of materials. Responds in several weeks. Will contact for further portfolio review if interested. Licenses primarily on a royalty basis.

Tips "We are impressed first and foremost by level of ability, even if the subject matter is not something we would use. Thus, a demonstration of competence is the first step; hopefully the second would be that demonstration using subject matter that we believe would be commercially marketable onto a wide and diverse array of consumer products. We work with artists to help them with the composition of their pieces for particular media. We treat artists well, and actively represent them to potential licensees. Instead of trying to reinvent the wheel yourself and contact everyone 'cold,' we suggest you look at getting a licensing agent or rep whose particular abilities complement your art. We specialize in the application of art to home decor and accessories, home fabrics, prints and wall decor, and also print media such as cards, stationery, calendars, and many other products. The trick is to find the right rep whom you feel you can work with "someone who really loves your art (whatever it is), who is interested in investing financially in promoting your work, and whose specific contacts and abilities can help further your art in the marketplace."

N PRATT & AUSTIN COMPANY, INC.

1 Cabot St., Holyoke MA 01040. (800)848-8020, ext. 577. E-mail: bruce@specialtyll.com. **Contact:** Bruce Pratt. Estab. 1931. Produces envelopes, tablets, invitations, scrapbook pages, stationery, greeting cards, three ring binders, clip boards, game boards, and calendars. Does not produce greeting cards. "Our market is the modern woman at all ages. Design must be bright, cute, busy and elicit a positive response."

• Now a division of Specialty Loose Leaf Inc.

Needs Approached by 100-200 freelancers/year. Works with 10 freelancers/year. Buys 50-100 designs and illustrations/year. Art guidelines available. Uses freelancers mainly for concept and finished art. Also for calligraphy.

First Contact & Terms Send nonreturnable samples, such as postcard or color copies. Samples are filed or are returned by SASE if requested. Will contact for portfolio review if interested. Portfolio should include thumbnails, roughs, color tearsheets and slides. Pays flat fee. Rights purchased vary. Interested in buying second rights (reprint rights) to previously published work. Finds artists through submissions and agents.

THE PRINTERY HOUSE OF CONCEPTION ABBEY

P.O. Box 12, Conception MO 64433. (660)944-3110. Fax: (660)944-3116. E-mail: art@printeryhouse.org. Web site: www.printeryhouse.org. **Art Director:** Brother Michael Marcotte, O.S.B. Creative Director: Ms. Lee Coats. Estab. 1950. Publishes religious greeting cards. Licenses art for greeting cards and wall prints. Specializes in religious Christmas and all-occasion themes for people interested in religious, yet contemporary, expressions of faith. Card designs are meant to speak to the heart. They feature strong graphics, calligraphy and other appropriate styles.

Needs Approached by 100 freelancers/year. Works with 40 freelancers/year. Art guidelines and technical specifications available on website. Uses freelancers for product illustration and lettering. Looking for dignified styles and solid religious themes. Has preference for high quality broad edged pen lettering with simple backgrounds/illustrations. Produces seasonal material for Christmas and Easter as well as the religious birthday, get well, sympathy, thank you, etc. Digital work is accepted in Photoshop or Illustrator format.

First Contact & Terms Send query letter with résumé, photocopies, CDs, photographs, slides or tearsheets. Calligraphers send samples of printed or finished work. Nonreturnable samples preferred or else samples with SASE. Accepts disk submissions compatible with Photoshop or

Illustrator. Send TIFF or EPS files. Usually responds within 3-4 weeks. To show portfolio, mail appropriate materials only after query has been answered. "Generally, we continue to work with artists once we have accepted their work." Pays flat fee of $300-$500 for illustration/design, and $100-$200 for calligraphy. Usually buys exclusive reproduction rights for a specified format, but artist retains copyright for any other usage.

Tips "Remember that our greeting cards need to have a definite Christian/religious dimension but not overly sentimental. It must be good quality artwork. We sell mostly via catalogs so artwork has to reduce well for catalog."

ℕ PRISMATIX, INC.

324 Railroad Ave., Hackensack NJ 07601. (201)525-2800 or (800)222-9662. Fax: (201)525-2828. E-mail: prismatix@optonline.net. **Vice President:** Miriam Salomon. Estab. 1977. Produces novelty humor programs. "We manufacture screen-printed novelties to be sold in the retail market."

Needs Works with 3-4 freelancers/year. Buys 100 freelance designs and illustrations/year. Works on assignment only. 90% of freelance work demands computer skills.

First Contact & Terms Send query letter with brochure, résumé. Samples are filed. Responds only if interested. Portfolio should include color thumbnails, roughs, final art. Payment negotiable.

PRIZM INC.

P.O. Box 80, Wamego KS 66547. (785)776-1613. Fax: (785)776-6550. E-mail: info@prizm-inc.com. Web site: www.pipka.com/content/22.htm. **President of Product Development:** Michele Johnson. Produces and markets figurines, decorative housewares, gifts, and ornaments. Manufacturer of exclusive figurine lines.

Needs Approached by 20 freelancers/year. Art guidelines free for SASE with first-class postage. Works on assignment only. Uses freelancers mainly for figurines, home decor items. Also for calligraphy. Considers all media. Looking for traditional, old world style, sentimental, folkart. Produces material for Christmas, Mother's Day, everyday. Submit seasonal material 1 year in advance.

First Contact & Terms Send query letter with photocopies, résumé, SASE, slides, tearsheets. Samples are filed. Responds in 2 months if SASE is included. Will contact for portfolio review of color, final art, slides. Rights purchased vary according to project. Pays royalties plus payment advance; negotiable. Finds freelancers through artist submissions, decorative painting industry.

Tips "People seem to be more family oriented—therefore more wholesome and positive images are important. We are interested in looking for new artists and lines to develop. Send a few copies of your work with a concept."

ℕ PRODUCT CONCEPT MFG.

5061 N. 30th St., #104, Colorado Springs CO 80919. (719)594-4054. Fax: (719)594-4183. **President:** Susan Ross. Estab. 1986. New product development agency. "We work with a variety of companies in the gift and greeting card market in providing design, new product development and manufacturing services."

- This company has recently added children's books to its product line.

Needs Works with 20-25 freelancers/year. Buys 400 designs and illustrations/year. Prefers freelancers with 3-5 years experience in gift and greeting card design. Works on assignment only. Buys freelance designs and illustrations mainly for new product programs. Also for calligraphy,

P-O-P display and paste-up. Considers all media. 25% of freelance work demands knowledge of Illustrator, Streamline, QuarkXPress or FreeHand. Produces material for all holidays and seasons.

First Contact & Terms Send query letter with résumé, tearsheets, photocopies, slides and SASE. Samples are filed or are returned by SASE if requested by artist. Responds in 1 month. To show portfolio, mail color and b&w roughs, final reproduction/product, slides, tearsheets, photostats and photographs. Originals not returned. Pays average flat fee of $300 or pays by the project, $300-2,000. Rights purchased vary according to project.

Tips "Be on time with assignments." Looking for portfolios that show commercial experience.

PRUDENT PUBLISHING

65 Challenger Rd., Ridgefield Park NJ 07660. (201)641-7900. Fax: (201)641-9356. Web site: www.gallerycollection.com. **Creative Coordinator:** Marian Francesco. Estab. 1928. Produces greeting cards. Specializes in business/corporate all-occasion and holiday cards. Art guidelines available.

Needs Buys calligraphy. Uses freelancers mainly for card design, illustrations and calligraphy. Considers traditional media. Prefers no cartoons or cute illustrations. Prefers $5\frac{1}{2} \times 7\frac{7}{8}$ horizontal format (or proportionate). Produces material for Christmas, Thanksgiving, birthdays, everyday, sympathy, get well and thank you.

First Contact & Terms Designers, illustrators and calligraphers: Send query letter with brochure, photostats, photocopies, tearsheets. Samples are filed or returned by SASE if requested. Responds ASAP. Portfolio review not required. Buys all rights. No royalty or licensing arrangements. Payment is negotiable. Finds freelancers through submissions, magazines, sourcebooks, agents and word of mouth.

Tips "No cartoons."

▨ RECO INTERNATIONAL CORPORATION

706 Woodlawn Ave., Cambridge OH 43725. (740)432-8800. Fax: (740)432-8811. E-mail: hreich@reco.com. Web site: www.reco.com. Manufacturer/distributor of limited editions, collector's plates, 3-dimensional plaques, lithographs and figurines. Sells through retail stores and direct marketing firms.

Needs Works with freelance and contract artists. Uses freelancers under contract for plate and figurine design, home decor and giftware. Prefers romantic and realistic styles.

First Contact & Terms Send query letter and brochure to be filed. Write for appointment to show portfolio. Art director will contact artist for portfolio review if interested. Negotiates payment. Considers buying second rights (reprint rights) to previously published work or royalties.

Tips "Have several portfolios available. We are very interested in new artists. We go to shows and galleries, and receive recommendations from artists we work with."

RECYCLED PAPER GREETINGS INC.

111 N. Canal St., Suite 700, Chicago IL 60606-7206. (773)348-6410. Fax: (773)281-1697. Web site: www.recycled.com. **Art Directors:** Gretchen Hoffman, John LeMoine. Publishes greeting cards, adhesive notes and imprintable stationery.

Needs Buys 1,000-2,000 freelance designs and illustrations. Considers b&w line art and color—"no real restrictions." Looking for "great ideas done in your own style with messages that reflect your own slant on the world." Prefers 5×7 vertical format for cards. "Our primary interest is

greeting cards.'' Produces seasonal material for all major and minor holidays including Jewish holidays. Submit seasonal material 18 months in advance; everyday cards are reviewed throughout the year.

First Contact & Terms Send SASE to the Art Department or view Web site for artist's guidelines. ''Please do not send slides, CD's or tearsheets. We're looking for work done specifically for greeting cards.'' Responds in 2 months. Portfolio review not required. Originals returned at job's completion. Sometimes requests work on spec before assigning a job. Pays average flat fee of $250 for illustration/design with copy. Some royalty contracts. Buys card rights.

Tips ''Remember that a greeting card is primarily a message sent from one person to another. The art must catch the customer's attention, and the words must deliver what the front promises. We are looking for unique points of view and manners of expression. Our artists must be able to work with a minimum of direction and meet deadlines. There is a renewed interest in the use of recycled paper; we have been the industry leader in this for over three decades.''

RED FARM STUDIO

1135 Roosevelt Ave., Pawtucket RI 02862-0347. (401)728-9300. Fax: (401)728-0350. **Contact:** Creative Director. Estab. 1955. Produces greeting cards and stationery from original watercolor art. Also produces coloring books and paintable sets. Specializes in nautical and contemporary themes. Uses freelancers for greeting cards, notes, Christmas cards. Considers watercolor artwork for cards, notes and stationery; b&w linework and tonal pencil drawings for coloring books and paintable sets. Looking for accurate, detailed, realistic work, though some looser watercolor styles are also acceptable. Produces material for Christmas and everyday occasions. Also interested in traditional, realistic artwork for religious line Christmas, Easter, Mother's and Father's Day and everyday subjects, including realistic portrait and figure work, such as the Madonna and Child.

First Contact & Terms First send query letter and #10 SASE to request art guidelines. Submit printed samples, transparencies, color copies or photographs with a SASE. Samples not filed are returned by SASE. Art director will contact artist for portfolio review if interested. Pays flat fee of $250-350 for card or note illustration/design, or pays by project, $250-1000. Buys all rights. ''No photography, please.''

Tips ''We are interested in clean, bright and fun work. Our guidelines will help to explain our needs.''

THE REGAL LINE

P.O. Box 2052, Cedar Rapids IA 52406. (319)364-0233. Fax: (319)363-6437. E-mail: info@regalli ne.com. Web site: www.regalline.com. **President:** Jeff Scherrman. Estab. 1913. Produces printed merchandise used by funeral directors, such as acknowledgments, register books and prayer cards. Art guidelines free for SASE.

 ● Acme Graphics manufactures a line of merchandise for funeral directors. Floral subjects, religious subjects and scenes are their most popular products.

Needs Approached by 30 freelancers/year. Considers pen & ink, watercolor and acrylic. ''We will send a copy of our catalog to show type of work we do.'' Art guidelines available for SASE with first-class postage. Looking for religious, inspirational, church window, floral and nature art. Also uses freelancers for calligraphy and lettering.

First Contact & Terms Designers: Send query letter with résumé, photocopies, photographs, slides and transparencies. Illustrators: Send postcard sample or query letter with brochure, pho-

tocopies, photographs, slides and tearsheets. Accepts submissions on disk. Samples are not filed and are returned by SASE. Responds in 10 days. Call or write for appointment to show portfolio of roughs. Originals are returned. Requests work on spec before assigning a job. Pays by the project, $50 minimum or flat fee. Buys all rights.

Tips "Send samples or prints of work from other companies. No modern art. Some designs are too expensive to print. Learn all you can about printing production. Please refer to Web site for examples of appropriate images!"

RENAISSANCE GREETING CARDS

Box 845, Springvale ME 04083. (207)324-4153. Fax: (207)324-9564. E-mail: talktous@rencards.com. Web site: www.rencards.com. **Art Director:** Jennifer Stockless. Estab. 1977. Publishes greeting cards; "current approaches" to all-occasion cards and seasonal cards. "We're an alternative card company with a unique variety of cards for all ages, situations and occasions."

Needs Approached by 500-600 artists/year. Buys 300 illustrations/year. Occasionally buys calligraphy. Art guidelines on Web site, and available free for SASE with first-class postage. Full-color illustrations only. Produces materials for all holidays and seasons and everyday. Submit art 18 months in advance for fall and Christmas material; approximately 1 year in advance for other holidays.

First Contact & Terms Send query letter with SASE. To show portfolio, mail color copies, tearsheets, slides or transparencies. Packaging with sufficient postage to return materials should be included in the submission. Responds in 2 months. Originals are returned to artist at job's completion. Sometimes requests work on spec before assigning a job. Pays for design by the project, $150-300 advance on royalties or flat fee, negotiable. Also needs calligraphers, pay rate negotiable. Finds artists mostly through submissions/self-promotions.

Tips "Do some 'in store' research first to get familiar with a company's product/look in order to decide if your work is a good fit. It can take a lot of patience to find the right company or situation. Especially interested in trendy styles as well as humorous and whimsical illustration. Start by requesting guidelines, and then send a small (10-12) sampling of 'best' work, preferably color copies or slides (with SASE for return). Indicate if the work shown is available or only samples. We're doing more designs with special effects like die-cutting and embossing. We're also starting to use more computer-generated art and electronic images."

RIGHTS INTERNATIONAL GROUP, LLC

500 Paterson Plank Rd., Union City NJ 07030. (201)239-8118. Fax: (201)222-0694. E-mail: rhazaga@rightsinternational.com. Web site: www.rightsinternational.com. **Contact:** Robert Hazaga. Estab. 1996. Agency for cross licensing. Licenses images for manufacturers/publishers of giftware, stationery, posters and home furnishings.

• See additional listing in the Posters & Prints section.

Needs Approached by 50 freelancers/year. Uses freelancers mainly for creative, decorative art for the commercial and designer market; also for textile art. Considers oil, acrylic, watercolor, mixed media, pastels and photography.

First Contact & Terms Send brochure, photocopies, photographs, SASE, slides, tearsheets or transparencies. Accepts disk submissions compatible with PC format. Responds in 1 month. Will contact for portfolio review if interested. Negotiates rights purchased and payment.

RITE LITE LTD., THE JACOB ROSENTHAL JUDAICA COLLECTION

333 Stanley Ave., Brooklyn NY 11207. (718)498-1700. Fax: (718)498-1251. E-mail: products@rit eliteltd.com. Web site: www.riteliteltd.com. Estab. 1948. Manufacturer and distributor of a full range of Judaica. Clients include department stores, galleries, gift shops, museum shops and jewelry stores.

Needs Looking for new menorahs, mezuzahs, children's Judaica, Passover and matza plates. Works on assignment only. Must be familiar with Jewish ceremonial objects or design. Also uses artists for illustration, and product design. Most of freelance work requires knowledge of Illustrator and Photoshop. Produces material for Hannukkah, Passover and other Jewish Holidays. Submit seasonal material 1 year in advance.

First Contact & Terms Designers: Send query letter with brochure or resume and photographs. Illustrators: Send photocopies. Do not send originals. Samples are filed. Responds in 1 month, only if interested. Art Director will contact for portfolio review if interested. Portfolio should include color tear sheets, photographs and slides. Pays flat fee per design. Buys all rights. Finds artists through word of mouth.

Tips "Be open to the desires of the consumers. Don't force your preconceived notions on them through the manufacturers. Know that there is one retail price, one wholesale price and one distributor price."

ROMAN, INC.

472 Brighton Dr., Bloomingdale IL 60108-3100. (630)705-4600. Fax: (630)705-4601. E-mail: dswe tz@roman.com. Web site: www.roman.com. **Vice President:** Julie Puntch. Estab. 1963. Produces collectible figurines, decorative housewares, decorations, gifts, limited edition plates, ornaments. Specializes in collectibles and giftware to celebrate special occasions.

Needs Approached by 25-30 freelancers/year. Works with 3-5 freelancers/year. Uses freelancers mainly for graphic packaging design, illustration. Considers variety of media. Looking for traditional-based design. Roman also has an inspirational niche. 80% of freelance design and illustration demands knowledge of Photoshop, QuarkXPress, Illustrator. Produces material for Christmas, Mother's Day, graduation, Thanksgiving, birthdays, everyday. Submit seasonal material 1 year in advance.

First Contact & Terms Send query letter with photocopies. Samples are filed or returned by SASE. Responds in 2 months if artist requests a reply. Portfolio review not required. Pays by the project. Finds freelancers through submissions and word of mouth.

RUBBERSTAMPEDE

2690 Pellisier Place, City of Industry CA 90601. (562)695-7969. Fax: (800)546-6888. E-mail: advisor@deltacreative.com. Web site: www.deltacreative.com. **Director of Marketing:** Peggy Smith. Estab. 1978. Produces art and novelty rubber stamps, kits, glitter pens, ink pads, papers, stickers, scrapbooking products.

Needs Approached by 30 freelance artists/year. Works with 10-20 freelance artists/year. Buys 200-300 freelance designs and illustrations/year. Uses freelance artists for calligraphy, P-O-P displays, and original art for rubber stamps. Considers pen & ink. Looks for whimsical, feminine style and fashion trends. Produces seasonal material Christmas, Valentine's Day, Easter, Hanukkah, Thanskgiving, Halloween, birthdays and everyday (includes wedding, baby, travel, and other life events). Submit seasonal material 9 months in advance.

First Contact & Terms Send nonreturnable samples. Samples are filed. Responds only if interested. Pays by the hour, $15-50; by the project, $50-1,000. Rights purchased vary according to project. Originals are not returned.

RUSS BERRIE AND COMPANY

111 Bauer Dr., Oakland NJ 07436. (800)631-8465. **Director Paper Goods:** Penny Shaw. Produces greeting cards, bookmarks and calendars. Manufacturer of impulse gifts for all age groups.
- This company is no longer taking unsolicited submissions.

N THE SARUT GROUP

P.O. Box 110495, Brooklyn NY 11211. (718)387-7484. Fax: (718)387-7467. E-mail: far@sarut.com. Web site: www.thesarutgroup.com. **Vice President Marketing:** Frederic Rambaud. Estab. 1979. Produces museum quality science and nature gifts. "Marketing firm with 20 employees. 36 trade shows a year. No reps. All products are exclusive. Medium- to high-end market."
Needs Approached by 4-5 freelancers/year. Works with 4 freelancers/year. Uses freelancers mainly for new products. Seeks contemporary designs. Produces material for all holidays and seasons.
First Contact & Terms Samples are returned. Responds in 2 weeks. Write for appointment to show portfolio. Rights purchased vary according to project.
Tips "We are looking for concepts; products, not automatically graphics."

N ⊕ SECOND NATURE, LTD.

10 Malton Rd., London W105UP United Kingdom. E-mail: contact@secondnature.co.uk. Web site: www.secondnature.co.uk. **Contact:** Rod Schragger. Greeting card publisher specializing in unique 3-D/handmade cards and special finishes.
Needs Prefers interesting new contemporary but commercial styles. Also calligraphy and Web design. Art guidelines available. Produces material for Christmas, Valentine's Day, Mother's Day and Father's Day. Submit seasonal material 19 months in advance.
First Contact & Terms Send query letter with samples showing art style. Samples not filed are returned only if requested by artist. Responds in 2 months. Originals are not returned at job's completion. Pays flat fee.
Tips "We are interested in all forms of paper engineering or anything fresh and innovative."

N PAULA SKENE DESIGNS

1250 45th St., Suite 240, Emeryville CA 94608. (510)654-3510. Fax: (510)654-3496. E-mail: paulaskenedesi@aol.com. **Contact:** Paula Skene, owner/president. Specializes in all types of cards and graphic design as well as foil stamping and embossing. "We do not use any cartoon art. We only use excellent illustration or fine art."
Needs Works with 1-2 freelancers/year. Works on assignment only. Produces material for all holidays and seasons, everyday.
First Contact & Terms Designers, Artists, and illustrators send tearsheets and photocopies. Do not send more than two examples. Samples are returned. Responds in 1 week. Buys all rights. Pays for design and illustration by the project.

SPARROW & JACOBS

6701 Concord Park Dr., Houston TX 77040. (713)329-9400. Fax: (713)744-8799. E-mail: sparrowart@gabp.com. **Contact:** Product Merchandiser. Estab. 1986. Produces calendars, greeting cards, postcards and other products for the real estate industry.

Needs Buys up to 300 freelance photographs and illustrations/year including illustrations for postcards and greeting cards. Considers all media. Looking for new product ideas featuring residential front doors, homes and home-related images, flowers, landscapes, cute animals, holiday themes and much more. "Our products range from, but are not limited to, humorous illustrations and comical cartoons to classical drawings and unique paintings to, striking photography, humorous illustrations, classical drawings and unique paintings." Produces material for Christmas, Easter, Mother's Day, Father's Day, Halloween, New Year, Thanksgiving, Valentine's Day, July 4th, birthdays, everyday, time change. Submit seasonal material 1 year in advance.

First Contact & Terms Send query letter with color photocopies, photographs or tearsheets. We also accept e-mail submissions of low-resolution images. If sending slides, do not send originals. We are not responsible for slides lost or damaged in the mail. Samples are filed or returned in your SASE.

SPENCER GIFTS, LLC

6826 Black Horse Pike, Egg Harbor Twp. NJ 08234-4197. (609)645-5526. Fax: (609)645-5797. E-mail: james.stevenson@spencergifts.com. Web site: www.spencersonline.com. **Contact:** James Stevenson. Licensing: Carl Franke. Estab. 1965. Retail gift chain located in approximately 750 stores in 43 states including Hawaii and Canada. Includes new retail chain stores named Spirit Halloween Superstores.

- Products offered by store chain include posters, T-shirts, games, mugs, novelty items, cards, 14K jewelry, neon art, novelty stationery. Spencer's is moving into a lot of different product lines, such as custom lava lights and Halloween costumes and products. Visit a store if you can to get a sense of what they offer.

Needs Assigns 10-15 freelance jobs/year. Prefers artists with professional experience in advertising design. Uses artists for illustration (hard line art, fashion illustration, airbrush). Also needs product and fashion photography (primarily jewelry), as well as stock photography. Uses a lot of freelance computer art. 50% of freelance work demands knowledge of InDesign, Illustrator, Photoshop and QuarkXPress. Also needs color separators, production and packaging people. "You don't necessarily have to be local for freelance production."

First Contact & Terms Send postcard sample or query letter with *nonreturnable* brochure, resume and photocopies, including phone number where you can be reached during business hours. Accepts submissions on disk. James Stevenson will contact artist for portfolio review if interested. Will contact only upon job need. Considers buying second rights (reprint rights) to previously published work. Finds artists through sourcebooks.

Tips "Become proficient in as many computer programs as possible."

ℕ ST. ARGOS CO., INC.

11040 W. Hondo Pkwy., Temple City CA 91780. (626)448-8886. Fax: (626)579-9133. **Manager:** Su-Chen Liang. Estab. 1987. Produces greeting cards, giftwrap, Christmas decorations, paper boxes, tin boxes, bags, puzzles, cards.

Needs Approached by 3 freelance artists/year. Works with 2 freelance artists/year. Buys 3 freelance designs and illustrations/year. Prefers artists with experience in Victorian or country style. Uses freelance artists mainly for design. Produces material for all holidays and seasons. Submit seasonal material 6 months in advance.

First Contact & Terms Send query letter with résumé and slides. Samples are filed. Art Director will contact artist for portfolio review if interested. Portfolio should include color samples. Originals are not returned. Pays royalties of 7.5%. Negotiates rights purchased.

⟦N⟧ STANDARD CELLULOSE & NOV CO., INC.

90-02 Atlantic Ave., Ozone Park NY 11416. (718)845-3939. Fax: (718)641-1170. **President:** Stewart Sloane. Estab. 1932. Produces giftwrap and seasonal novelties and decorations.

Needs Approached by 10 freelance artists/year. Works with 1 freelance artist/year. Buys 3-4 freelance designs and illustrations/year. Prefers local artists only. Uses freelance artists mainly for design packaging. Also uses freelance artists for P-O-P displays, all media appropriate for display and P-O-P. Produces material for all holidays and seasons, Christmas, Easter, Halloween and everyday. Submit 6 months before holiday.

First Contact & Terms Send query letter or call for appointment. Samples are not filed and are returned. Responds only if interested. Call to schedule an appointment to show a portfolio. "We will then advise artist what we want to see in portfolio." Original artwork is not returned at the job's completion. Payment negotiated at time of purchase. Rights purchased vary according to project.

STARFISH & DREAMS

(formerly NRN Designs, Inc.), 3291 Industry Way, Signal Hill CA 90755. (562)985-0608. Fax: (888)978-2734. E-mail: sales@starfishanddreams.com. Web site: www.starfishanddreams.com. **Art Director:** Linda Braun. Produces high-end invitations and announcements, photocards, and calendars.

Needs Looking for freelance artists with innovative ideas and formats for invitations and scrapbooking products. Works on assignment only. Produces stickers and other material for Christmas, Easter, graduation, Halloween, Hanukkah, New Year, Thanksgiving, Valentine's Day, birthdays, everyday, (sympathy, get well, etc.). Submit seasonal material 1 year in advance.

First Contact & Terms E-mail query with link to your Web site or mail photocopies or other nonreturnable samples. Responds only if interested. Portfolios required from designers. Company will contact artist for portfolio review if interested. Rights purchased vary according to project. Pays for design by the project.

⟦N⟧ STOTTER & NORSE

1000 S. Second St., Plainfield NJ 07063. (908)754-6330. Fax: (908)757-5241. E-mail: sales@stotternorse.com. Web site: www.stotternorse.com. **V.P. of Sales:** Larry Speichler. Estab. 1979. Produces barware, serveware, placemats and a broad range of tabletop products.

Needs Buys 20 designs and illustrations/year. Art guidelines not available. Works on assignment only. Uses freelancers mainly for product design. Seeking trendy styles. Final art should be actual size. Produces material for all seasons. Submit seasonal material 6 months in advance.

First Contact and Terms Send query letter with brochure and résumé. Samples are filed. Responds in 1 month or does not reply, in which case the artist should call. Call for appointment to show portfolio. Negotiates rights purchased. Originals returned at job's completion if requested. Pays flat fee and royalties; negotiable.

SUNSHINE ART STUDIOS, INC.

270 Main St., Agawan MA 01001. (413)82-8700. Fax: (413)821-8701. E-mail: info@sunshinecards.com. Web site: www.sunshinecards.com. **Art Director:** Alicia Orsi. Estab. 1921. Produces greeting cards, stationery and calendars that are sold in own catalog, appealing to all age groups.

Needs Works with 50 freelance artists/year. Buys 100 freelance designs and illustrations/year. Prefers artists with experience in greeting cards. Art guidelines available for SASE with first-

class postage. Works on assignment only. Uses freelancers for greeting cards, stationery and gift items. Also for calligraphy. Considers all media. Looking for traditional or humorous look. Produces material for Christmas, birthdays and everyday. Submit seasonal material 6-8 months in advance.

First Contact & Terms Send query letter with brochure, résumé, SASE, tearsheets and slides. Samples are filed or are returned by SASE if requested by artist. Responds only if interested. Portfolio should include finished art samples and color tearsheets and slides. Originals not returned. Pays by the project, $450-700. Pays $100-150/piece for calligraphy and lettering. Buys all rights.

SYRACUSE CULTURAL WORKERS

P.O. Box 6367, Syracuse NY 13217. (315)474-1132. Fax: (877)265-5399. E-mail: karenk@syracus eculturalworkers.com. Web site: www.syracuseculturalworkers.com. **Art Director:** Karen Kerney. Estab. 1982. Produces posters, note cards, postcards, greeting cards, T-shirts and calendars that are feminist, progressive, radical, multicultural, lesbian/gay allied, racially inclusive and honoring of elders and children. Publishes and distributes peace and justice resources through their Tools For Change catalog.

• See additional listing in the Posters & Prints section.

Needs Approached by many freelancers/year. Works with 50 freelancers/year. Buys 40-50 freelance fine art images and illustrations/year. Considers all media (in slide form). Art guidelines available on Web site or free for SASE with first-class postage. Specifically seeking artwork celebrating peace-making diverstiy, people's history and community building. "Our mission is to help sustain a culture that honors diversity and celebrates community; that inspires and nurtures justice, equality and freedom; that respects our fragile Earth and all its beings; that encourages and supports all forms of creative expression." Themes include environment, positive parenting, positive gay and lesbian images, multiculturalism and cross-cultural adoption.

First Contact & Terms Send query letter with slides, brochures, photocopies, photographs, tearsheets, transparencies and SASE. Samples are filed or returned by SASE. Responds in 1 month with SASE. Will contact for portfolio review if interested. Buys one-time rights. Pays flat fee, $85-450; royalties of 4-6% gross sales. Finds artists through submissions and word of mouth.

Tips "Please do NOT send original art or slides. Rather, send photocopies, printed samples or duplicate slides. Also, one postcard sample is not enough for us to judge whether your work is right for us. Include return postage if you would like your artwork/slides returned. December and January are major art selection months."

ⓃTALICOR, INC.

901 Lincoln Parkway, Plainwell MI 49080. (269)685-2345. E-mail: nikkih@talicor.com. Web site: www.talicor.com. **President:** Nicole Hancock. Estab. 1971. Manufacturer and distributor of educational and entertainment games and toys. Clients chain toy stores, department stores, specialty stores and Christian bookstores.

Needs Works with 4-6 freelance illustrators and designers/year. Prefers local freelancers. Works on assignment only. Uses freelancers mainly for game design. Also for advertising, brochure and catalog design, illustration and layout; product design; illustration on product; P-O-P displays; posters and magazine design.

First Contact & Terms Send query letter with tearsheets, samples or postcards. Samples are not filed and are returned only if requested. Responds only if interested. Call or write for appointment

to show portfolio. Pays for design and illustration by the project, $100-3,000. Negotiates rights purchased. Accepts digital submissions via e-mail.

TJ'S CHRISTMAS

7101 College Blvd. Suite#1538, Overland Park KS 66210. (913)888-8338. Fax: (913)888-8350. E-mail: ed@imitchell.com. Web site: www.imitchell.com. **Creative Coordinator:** Edward Mitchell. Estab. 1983. Manufactures, imports, and distributes figurines, decorative accessories, ornaments and other Christmas decorations as well as some general gift products. Also sells some Halloween, Thanksgiving, gardening, 3-D art (woodcarving and sculptures) and everyday home decor items. Targets two primary channels: 1) gift including hospital gift shops, and card shops; and 2) home decor retailers and decorators.

Needs Only considers licensing of finished 2d artwork as well as 3d sculptures in any medium. We are always looking for unique and innovative designs. Prefer emailing or mailing images for consideration.

First Contact & Terms Pays advance against royalties of 5%. Additional terms can be negotiated. Please specify whether the submission is for decorators or gift shops, and the intended product format for the design (i.e. ornament, figurine, bottle stopper, paper bag, etc).

Tips "We typically stay away from selling mass markets. We are looking for something that's unique and different. Something that would make the perfect gift. Try combining innovative editorial with your product idea. Or think about what you would give to a loved one if they were at the hospital."

ⓝ UNITED DESIGN

1600 N. Main St., Noble OK 73068. (405)872-4433. Fax: (405)360-4442. E-mail: ghaynes@united-design.com. Web site: www.united-design.com. **Product Development Assistant:** Gayle Haynes. Produces collectible figurines, decorative housewares, garden. Specializes in giftware frames, animal sculpture, garden ornament, figurines.

Needs Approached by 300 freelancers/year. Works with 70 freelancers/year. Buys 300 freelance designs and illustrations/year; also 500-1,000 sculptures/year. Prefers freelancers with experience in sculpting and/or design for sampling. Considers sculpy, plastilene, wood. Produces material for seasonal and everyday home decor.

First Contact & Terms Designers and sculptors: Send query letter with brochure, photocopies, photographs, résumé, SASE. No 3D samples or slides. Samples are filed (unless otherwise directed by submitter) or returned by SASE. Will contact within 3 weeks for portfolio review if interested. Rights purchased vary according to project. Pays by the project based on experience, expertise. Royalty arrangements vary. Finds freelancers through word of mouth, submissions, Internet.

Tips "Please familiarize yourself with our subject matter before submitting portfolio. You must possess creativity, high technical ability while meeting deadlines."

ⓝ VERMONT T'S

354 Elm St., Chester VT 05143. (802)875-2091. Fax: (802)875-4480. E-mail: vtts@vermontel.net. **President:** Thomas Bock. Commercial screenprinter, specializing in T-shirts and sweatshirts. Vermont T's produces custom as well as tourist-oriented silkscreened sportswear. Does promotional work for businesses, ski-resorts, tourist attractions and events.

Needs Works with 3-5 freelance artists/year. Uses artists for graphic designs for T-shirt silkscreening. Prefers pen & ink, calligraphy and computer illustration.

First Contact & Terms Send query letter with brochure. Samples are filed or are returned only if requested. Responds in 10 days. To show portfolio, mail photostats. Pays for design by the project, $400-1,200. Negotiates rights purchased. Finds most artists through portfolio reviews and samples.

Tips "Have samples showing rough through completion. Understand the type of linework needed for silkscreening."

VILLAGE NOTE CARDS

742 Elmhurst Circle, Claremont CA 91711-2946. (909)437-0808. Fax: (206)339-3765. E-mail: gifts@villagenotecards.com. Web site: www.villagenotecards.com. **Owner:** Diane Cooley. Estab. 2007. Produces fine art note cards—blank inside, suitable for all occasions. "All cards are custom printed and assembled by hand." Art guidelines available on Web site.

Needs Considers all media. "We especially like illustrations and watercolor. Special consideration is given to art that portrays subjects or scenes related to Claremont, California." Final art size should be up to 8×10; "We will digitally scale art to card size."

First Contact & Terms Send photographs, photocopies, transparencies, URL or CD formatted for PC (with files in TIFF or JPEG format). Does not accept e-mail submissions, except URL link. Samples are not filed and are not returned. Responds only if interested. Buys electronic and reprint rights for cards. Pays in merchandise and offers Internet exposure with credit line. Finds freelancers through submissions, word of mouth, Internet.

Tips "We are open to artists who are new to the market. Mail submissions of 4-10 samples that are similar in style (we sell cards in matched sets as well as individually). Query is not necessary. Current needs include, but are not limited to, color illustrations of botanicals and herbs. Please e-mail questions rather than calling."

⬛ WANDA WALLACE ASSOCIATES

323 E. Plymouth, Suite 2, Inglewood CA 90302. (310)419-0376. Fax: (310)419-0382. E-mail: wandawallacefoundation@yahoo.com. Web site: www.wandawallacefoundation.com. **President:** Wanda Wallace. Estab. 1980. Nonprofit organization produces greeting cards and posters for general public appeal. "We produce black art prints, posters, originals and other media."

● This publisher is doing more educational programs, touring schools nationally with artists.

Needs Approached by 10-12 freelance artists/year. Works with varying number of freelance artists/year. Buys varying number of designs and illustrations/year from freelance artists. Prefers artists with experience in black/ethnic art subjects. Uses freelance artists mainly for production of originals and some guest appearances. Considers all media. Produces material for Christmas. Submit seasonal material 4-6 months in advance.

First Contact & Terms Send query letter with any visual aid. Some samples are filed. Policy varies regarding answering queries and submissions. Call or write to schedule an appointment to show a portfolio. Rights purchased vary according to project. Art education instruction is available. Pays by the project.

WARNER PRESS, INC.

1201 E. Fifth St., Anderson IN 46012. (800)741-7721. **Creative Director:** Curtis Corzine. E-mail: krhodes@warnerpress.org. Web site: www.warnerpress.org. Estab. 1884. Warner Press is the publication board for the Church of God. Produces church bulletins and church supplies such as postcards and children's materials. "We produce products for the Christian market. Our

main markets are the Church and Christian bookstores. We provide products for all ages.'' Art submission guidelines on Web site.

Needs Approached by 50 freelancers/year. Works with 15-20 freelancers/year. Buys 200 free-lance designs and illustrations/year. Works on assignment only. Uses freelancers for all products, including bulletins and coloring books. Considers all media and photography. 100% of production work demands knowledge of Photoshop, Illustrator and InDesign.

First Contact & Terms Send postcard or query letter with samples. Do not send originals. Creative Director will contact artist for portfolio review if interested. Samples are filed or returned if SASE included. Pays by the project. Buys all rights (occasionally varies).

Tips "Subject matter must be appropriate for Christian market. Most of our art purchases are for children's materials.''

N CAROL WILSON FINE ARTS, INC.

Box 17394, Portland OR 97217. (503)261-1860. E-mail: info@carolwilsonfinearts.com. Web site: www.carolwilsonfinearts.com. **Contact:** Gary Spector. Estab. 1983. Produces greeting cards and fine stationery products.

Needs Romantic floral and nostalgic images. "We look for artists with high levels of training, creativity and ability.''

First Contact & Terms Write or call for art guidelines. No original artwork on initial inquiry. Samples not filed are returned by SASE.

Tips "We are seeing an increased interest in romantic fine arts cards and very elegant products featuring foil, embossing and die-cuts.''

ZITI PUBLISHING

601 S. Sixth St., St. Charles MO 63301. E-mail: mail@zitipublishing.com. Web site: www.zitipublishing.com. Estab. 2006. **Owner:** Salvatore Venture. Produces greeting cards. Specializes in architectural holiday cards for design professionals. Art guidelines available via e-mail.

Needs Buys 3 freelance designs and/or illustrations/year. Uses freelancers for architectural-related illustrations. Considers all media. Produces material for greeting cards, mainly Christmas and Thanksgiving. Submit seasonal material at any time. Final art size should be "proportional to and at least" 5×7 inches.

First Contact & Terms Accepts e-mail submissions with Windows-compatible image files or link to Web site. "E-mail attachments are preferred, but anything that accurately shows the work is fine.'' After introductory mailing, send follow-up postcard sample every 6 months. Samples are filed or returned by SASE if requested. Responds only if interested. "We purchase exclusive rights for the use of illustrations/designs on greeting cards and do not prevent artists from using images on other non-greeting card items. Artist retains all copyrights and can end the agreement for any reason.'' Pays $50 advance and 5% royalties at the end of the season. Finds freelancers through submissions.

Tips "We need unusual and imaginative illustrations that relate to architecture for general greeting cards and especially the Christmas holiday season—architecture plus snow, holiday decorations/colors/symbols, etc. Present your ideas for cards if your portfolio does not include such work. We will consider your card ideas in terms of your style, and we will consider any media and any style.''

Posters & Prints

Have you ever noticed, perhaps at the opening of an exhibition or at an art fair, that though you have many paintings on display, everybody wants to buy the same one? Do friends, relatives and co-workers ask you to paint duplicates of work you've already sold? Many artists turn to the print market because they find certain images have a wide appeal and will sell again and again. This section lists publishers and distributors who can produce and market your work as prints or posters. It is important to understand the difference between the terms "publisher" and "distributor" before you begin your research. Art *publishers* work with you to publish a piece of your work in print form. Art *distributors* assist you in marketing a pre-existing poster or print. Some companies function as both publisher and distributor. Look in the first paragraph of each listing to determine if the company is a publisher, distributor or both.

RESEARCH THE MARKET

Some listings in this section are fine art presses, and others are more commercial. Read the listings carefully to determine which companies create editions for the fine art market or for the decorative market. Visit galleries, frame shops, furniture stores and other retail outlets that carry prints to see where your art fits in. You may also want to visit designer showrooms and interior decoration outlets.

To further research this market, check each company's Web site or send for their catalog. Some publishers will not send their catalogs because they are too expensive, but you can often ask to see one at a local poster shop, print gallery, upscale furniture store or frame shop. Examine the colors in the catalogs to make sure the quality is high.

What to send

To approach a publisher, send a brief query letter, a short bio, a list of galleries that represent your work, and five to 10 slides or whatever samples they specify in their listing. It helps to send printed pieces or tearsheets as samples, as these show publishers that your work reproduces well and that you have some understanding of the publication process. Most publishers will accept digital submissions via e-mail or CD.

Signing and numbering your editions

Before you enter the print arena, follow the standard method of signing and numbering your editions. You can observe how this is done by visiting galleries and museums and talking to fellow artists.

If you are creating a limited edition—with a specific, set number of prints—all prints

Your Publishing Options

Important

1 Working with a commercial poster manufacturer or art publisher. If you don't mind creating commercial images and following current trends, the decorative market can be quite lucrative. On the other hand, if you work with a fine art publisher, you will have more control over the final image.

2 Working with a fine art press. Fine art presses differ from commercial presses in that press operators work side by side with you every step of the way, sharing their experience and knowledge of the printing process. You may be charged a fee for the time your work is on the press and for the expert advice of the printer.

3 Working at a co-op press. Instead of approaching an art publisher, you can learn to make your own hand-pulled original prints—such as lithographs, monoprints, etchings or silk-screens. If there is a co-op press in your city, you can rent time on a press and create your own editions. It can be rewarding to learn printing skills and have the hands-on experience. You also gain total control of your work. The drawback is you have to market your images yourself by approaching galleries, distributors and other clients.

4 Self-publishing. Several national printing companies advertise heavily in artists' magazines, encouraging artists to publish their own work. If you are a saavy marketer who understands the ins and outs of trade shows and direct marketing, this is a viable option. However, it takes a large investment up front, whether you work with a printing company or choose to do everything on your own. If you contract with a printer, you could end up with a thousand prints taking up space in your basement. On the other hand, if you are a good marketer, you could end up selling them all and making a much larger profit than if you had gone through an art publisher or poster company.

Another option is to create the prints yourself, from your computer, using a high-quality digital printer and archival paper. You can make the prints as needed, which will save money.

5 Marketing through distributors. If you choose the self-publishing route but don't have the resources to market your prints, distributors will market your work in exchange for a percentage of sales. Distributors have connections with all kinds of outlets like retail stores, print galleries, framers, college bookstores and museum shops.

should be numbered, such as 35/100. The largest number is the total number of prints in the edition; the smaller number is the sequential number of the actual print. Some artists hold out ten percent as artist's proofs and number them separately with AP after the number (e.g., 5/100 AP). Many artists sign and number their prints in pencil.

Types of prints

Original prints. Original prints may be woodcuts, engravings, linocuts, mezzotints, etchings, lithographs or serigraphs (see Glossary on page 529 for definitions). What distinguishes them is that they are produced by hand by the artist (and consequently often referred to as hand-pulled prints). In a true original print, the work is created specifically to be a print. Each print is considered an original because the artist creates the artwork directly on the plate, woodblock, etching stone or screen. Original prints are sold through specialized print galleries, frame shops and high-end decorating outlets, as well as fine art galleries.

Offset reproductions and posters. Offset reproductions, also known as posters and image prints, are reproduced by photochemical means. Since plates used in offset reproductions do not wear out, there are no physical limits on the number of prints that can be made. Quantities, however, may still be limited by the publisher in order to add value to the edition.

Giclée prints. As color-copier technology matures, inkjet fine art prints, also called giclées, are gaining popularity. Iris prints, images that are scanned into a computer and output on oversized printers, are even showing up in museum collections.

Canvas transfers. Canvas transfers are becoming increasingly popular. Instead of, and often in addition to, printing an image on paper, the publisher transfers the image onto canvas so the work has the look and feel of a painting. Some publishers market limited editions of 750 prints on paper, along with a smaller edition of 100 of the same image on canvas. The edition on paper might sell for $150 per print, while the canvas transfer would be priced higher, perhaps selling for $395.

Pricing criteria for limited editions and posters

Because original prints are always sold in limited editions, they command higher prices than posters, which are not numbered. Since plates for original prints are made by hand, and as a result can only withstand a certain amount of use, the number of prints pulled is limited by the number of impressions that can be made before the plate wears out. Some publishers impose their own limits on the number of impressions to increase a print's value. These limits may be set as high as 700 to 1,000 impressions, but some prints are limited to just 250 to 500, making them highly prized by collectors.

A few publishers buy work outright for a flat fee, but most pay on a royalty basis. Royalties for hand-pulled prints are usually based on retail price and range from 5 to 20 percent, while percentages for posters and offset reproductions are lower (from 2½ to 5 percent) and are based on the wholesale price. Be aware that some publishers may hold back royalties to cover promotion and production costs; this is not uncommon.

Prices for prints vary widely depending on the quantity available; the artist's reputation; the popularity of the image; the quality of the paper, ink and printing process. Because prices for posters are lower than for original prints, publishers tend to select images with high-volume sales potential.

Negotiating your contract

As in other business transactions, ask for a contract and make sure you understand and agree to all the terms before you sign. Make sure you approve the size, printing method, paper, number of images to be produced, and royalty terms. Other things to watch for include insurance terms, marketing plans, and a guarantee of a credit line or copyright notice.

Always retain ownership of your original work. Negotiate an arrangement in which you're selling publication rights only. You'll also want to sell rights only for a limited period of time. That way you can sell the image later as a reprint or license it for other use (e.g., as a calendar or note card). If you are a perfectionist about color, make sure your contract gives you final approval of your print. Stipulate that you'd like to inspect a press proof prior to the print run.

MORE INDUSTRY TIPS

Find a niche. Consider working within a specialized subject matter. Prints with Civil War themes, for example, are avidly collected by Civil War enthusiasts. But to appeal to Civil War buffs, every detail, from weapons and foliage in battlefields to uniform buttons, must be historically accurate. Signed limited editions are usually created in a print run of 950 or so and can average about $175-200; artist's proofs sell from between $195-250, with canvas transfers selling for $400-500. The original paintings from which images are taken often sell for thousands of dollars to avid collectors.

Sport art is another lucrative niche. There's a growing trend toward portraying sports figures from football, basketball and racing (both sports car and horse racing) in prints that include both the artist's and the athlete's signatures. Movie stars and musicians from the 1950s (such as James Dean, Marilyn Monroe and Elvis) are also cult favorites, but any specialized style (such as science fiction/fantasy or wildlife art) can be a marketable niche. See the index starting on page 546 for more ideas.

Work in a series. It is easier to market a series of small prints exploring a single theme than to market single images. A series of similar prints works well in long hospital corridors, office meeting rooms or restaurants. "Paired" images also are rather profitable. Hotels often purchase two similar prints for each of their rooms.

Study trends. If you hope to get published by a commercial art publisher or poster company, realize your work will have a greater chance of acceptance if you use popular colors and themes.

Attend trade shows. Many artists say it's the best way to research the market and make contacts. It's also a great way for self-published artists to market their work. DECOR Expo is held each year in four cities: Atlanta, New York, Orlando and Los Angeles. For more information, call (888)608-5300 or visit www.decor-expo.com. Artexpo is held every spring in New York, and now also every fall in Las Vegas. The SOLO Independent Artists' Pavilion, a special section of Artexpo dedicated to showcasing the work of emerging artists, is the ultimate venue for artists to be discovered. See www.artexpos.com for more information.

Insider Tips

Tips

- Read industry publications, such as *DECOR* magazine (www.decorm agazine.com) and *Art Business News* (www.artbusinessnews.com), to get a sense of what sells.

- To find out what trade shows are coming up in your area, check the event calendars in industry trade publications. Many shows, such as the DECOR Expo (www.decor-expo.com), coincide with annual stationery or gift shows, so if you work in both the print and greeting card markets, be sure to take that into consideration. Remember, traveling to trade shows is a deductible business expense, so don't forget to save your receipts!

- Consult *Business and Legal Forms for Fine Artists*, by Tad Crawford (Allworth Press) for sample contracts.

ACTION IMAGES INC.

7148 N. Ridgeway, Lincolnwood IL 60712. (847)763-9700. Fax: (847)763-9701. E-mail: actionim @aol.com. Web site: www.actionimagesinc.com. **President:** Tom Green. Estab. 1989. Art publisher of sport art. Publishes limited edition prints, open edition posters as well as direct printing on canvas. Specializes in sport art prints for events such as the Super Bowl, Final Four, Stanley Cup, etc. Clients include retailers, distributors, sales promotion agencies.

Needs "Ideally seeking sport artists/illustrators who are accomplished in both traditional and computer-generated artwork as our needs often include tight deadlines, exacting attention to detail and excellent quality. Primary work relates to posters and T-shirt artwork for retail and promotional material for sporting events." Considers all media. Artists represented include Cheri Wenner, Andy Wenner, Ken Call, Konrad Hack and Alan Studt. Approached by approximately 25 artists/year.

First Contact & Terms Send JPEG or PDF files via e-mail or mailed disk (compatible with Mac) and color printouts. Samples are filed. Responds only if interested. If interested in samples, will ask to see more of artist's work. Pays flat fee: $1,000-2,000. Buys exclusive reproduction rights. Rarely acquires original painting. Provides insurance while work is at firm and outbound in-transit insurance. Promotional services vary depending on project. Finds artists through recommendations from other artists, word of mouth and submissions.

Tips "If you're a talented artist/illustrator and know your PhotoShop/Illustrator software, you have great prospects."

ARNOLD ART STORE & GALLERY

210 Thames St., Newport RI 02840. (401)847-2273 or (800)352-2234. Fax: (401)848-0156. E-mail: info@arnoldart.com. Web site: www.arnoldart.com. **Owner:** Bill Rommel. Estab. 1870. Poster company; art publisher/distributor; gallery specializing in marine art. Publishes/distributes limited and unlimited editions, fine art prints, offset reproductions and posters.

Needs Seeking creative, fashionable, decorative art for the serious collector, commercial and designer markets. Considers oil, acrylic, watercolor, mixed media, pastel, pen & ink, sculpture. Prefers sailing images—Americas Cup or other racing images. Artists represented include Kathy Bray, Thomas Buechner and James DeWitt. Editions are created by working from an existing painting. Approached by 100 artists/year. Publishes/distributes the work of 10-15 established artists/year.

First Contact & Terms Send query letter with 4-5 photographs. Samples are filed or returned by SASE. Call to arrange portfolio review. Pays flat fee, royalties or consignment. Negotiates rights purchased; rights purchased vary according to project. Provides advertising and promotion. Finds artists through word of mouth.

N ⊕ THE ART GROUP

146-150 Royal College St., London NW1 OTA United Kingdom. E-mail: mail@artgroup.com. Web site: www.artgroup.com. **Contact:** Research Dept. Rights Director. Fine art card and poster publisher/distributor handling posters for framers, galleries, museums, department stores and gift shops. Current clients include IKEA, Habitat, Ann Viney ARGOS, Next, WH Smith, Paper Chase.

Needs Considers all media and broad subject matter. Fine art contemporary; digitally created artwork. Publishes the work of 100-200 mid-career and 200-400 established artists/year. Distributes the work of more than 2,000 artists/year.

First Contact & Terms Send query letter with brochure, photostats, photographs, photocopies, slides and transparencies. Samples are filed or are returned. Responds in 1 month. Publisher/ Distributor will contact artists for portfolio review if interested.

Tips "Send only relevant samples of work. Visit poster and card shops to understand the market a little more before submitting ideas. Be clear and precise."

ART IMPRESSIONS, INC.

23586 Calabasas Rd., Suite 210, Calabasas CA 91302. (818)591-0105. Fax: (818)591-0106. E-mail: info@artimpressionsinc.com. Web site: www.artimpressionsinc.com. **Creative Director:** Jennifer Ward. Estab. 1990. Licensing agent. Clients: major manufacturers worldwide. Current clients include Tripp NYC, Lounge Fly, Random House, Springs Industries, 3M and Mead West-vaco.

Needs Seeking art for the commercial market, "especially art geared towards fashion/streetwear market." Considers oil, acrylic, mixed media, pastel and photography. No abstracts or nudes. Artists represented include Skelanimals, Corky Mansfield, Jessica Louise, Schim Schimmel, Valerie Tabor-Smith, Celine Dion and Josephine Wall. Approached by over 70 artists/year.

First Contact & Terms Send query letter with photocopies, photographs, slides, transparencies or tearsheets and SASE. Accepts disk submissions. Samples are not filed and are returned by SASE. Responds in 2 months. Will contact artist for portfolio review if interested. Artists are paid percentage of licensing revenues generated by their work. No advance. Requires exclusive representation of artist. Provides advertising, promotion, written contract and legal services. Finds artists through art exhibitions, word of mouth, publications and submissions.

Tips "Artists should have at least 25 images available and be able to reproduce new collections several times a year. Artwork must be available on disc and be of reproduction quality."

⚡ ART IN MOTION

2000 Brigantine Dr., Coquitlam BC V3K 7B5 Canada. (604)525-3900 or (800)663-1308. Fax: (604)525-6166 or (877)525-6166. E-mail: artistrelations@artinmotion.com. Web site: www.artinmotion.com. **Contact:** Artist Relations. Publishes, licenses and distributes open edition reproductions. Licenses all types of artwork for all industries, including wallpaper, fabric, stationery and calendars. Clients: galleries, high-end retailers, designers, distributors (worldwide) and picture frame manufacturers.

Needs "Our collection of imagery reflects today's interior decorating tastes; we publish a wide variety of techniques. View our collection online before submitting. However, we are always interested in new looks, directions and design concepts." Considers oil and mixed media.

First Contact & Terms Submit portfolio for review. Pays royalties of 10%. Royalties paid monthly. "Art In Motion covers all associated costs to reproduce and promote your artwork."

Tips "We are a world leader in fine art publishing with distribution in over 72 countries. The publishing process utilizes the latest technology and state-of-the-art printing equipment and uses the finest inks and papers available. Artist input and participation are highly valued and encouraged at all times. We warmly welcome artist inquiries. Contact us via e-mail, or direct us to your Web site; also send slides or color copies of your work (all submissions will be returned)."

ART LICENSING INTERNATIONAL INC.

711 S Osprey Ave, Ste 1, Sarasota FL 34236. (941)966-4042. Fax: (941)296-7345. E-mail: artlicens ing@comcast.net. Web site: www.out-of-the-blue.us. **President:** Michael Woodward. Estab.

1986. Licenses images internationally for a range of products—particularly fine art posters and prints for interior design industry, as well as greeting cards and stationery.

- See additional listings for this company in the Greeting Cards, Gifts & Products and Artists' Reps sections. See also listing for Out of the Blue in the Greeting Cards, Gifts & Products section.

First Contact & Terms Send a CD and photocopies or e-mail JPEGs or a link to your Web site. Send SASE for return of material. Commission rate is 50%.

Tips "Artwork for prints and posters should be in pairs or sets of four or more, pay close attention to trends and color palettes related to the home decor market."

THE ART PUBLISHING GROUP

165 Chubb Ave., Lyndhurst NJ 07071. (201)842-8500 or (800)760-3058. Fax: (201)842-8546. E-mail: submitart@theartpublishinggroup.com. Web site: www.theartpublishinggroup.com. **Contact:** Artist Submissions. Estab. 1973. Publisher and distributor of limited editions, open editions, and fine art prints and posters. Clients: galleries and custom frame shops worldwide.

- Divisions of The Art Publishing Group include APG Collection, Front Line Art Publishing, Modernart Editions and Scafa Art. See Web site for details of each specific line. Submission guidelines are the same for all.

Needs Seeking decorative art for the commercial and designer markets. Considers oil, watercolor, mixed media, pastel and acrylic. Prefers fine art, abstract and contemporary, floral, representational, still life, decorative, collage, mixed media. Size: 16×20. Editions are created by collaborating with the artist or by working from an existing painting. Approached by 200 artists/year. Publishes the work of 10-15 emerging artists/year. Distributes the work of 100 emerging artists/year.

First Contact & Terms Submit no more than 4 JPEGs (maximum 300KB each) via e-mail. Also accepts CDs, color copies, photographs "or any any other medium that best represents your art. DO NOT send original art, transparencies or slides. If you want your samples returned, be sure to include a SASE." Responds in 6 weeks. Will contact artist for portfolio review if interested. Pays flat fee of $200-300 or royalties of 10%. Offers advance against royalties. Provides insurance while work is at firm, shipping to firm and written contract.

Tips "If you want your submission to be considered for a specific line within The Art Publishing Group, please indicate that in your cover letter."

◪ ART SOURCE

210 Cochrane Dr., Unit 3, Markham ON L3R 8E6 Canada. (905)475-8181. Fax: (905)479-4966. E-mail: lou@artsource.ca. Web site: www.artsource.ca. **President:** Lou Fenninger. Estab. 1979. Poster company and distributor. Publishes/distributes hand-pulled originals, limited editions, unlimited editions, canvas transfers, fine art prints, monoprints, monotypes, offset reproductions and posters. Clients: galleries, decorators, frame shops, distributors, corporate curators, museum shops and gift shops.

Needs Seeking creative, fashionable and decorative art for the designer market. Considers oil, acrylic, watercolor, mixed media, pastel and pen & ink. Editions are created by collaborating with the artist and by working from an existing painting. Approached by 50 artists/year. Publishes the work of 5 emerging, 5 mid-career and 10 established artists/year. Distributes the work of 5 emerging, 5 mid-career and 10 established artists/year.

First Contact & Terms Send query letter with brochure, photocopies, photographs, photostats,

résumé, SASE, slides, tearsheets and transparencies. Accepts low-resolution submissions via e-mail. "Please keep e-mail submissions to a maximum of 10 images." Responds in 2 weeks. Company will contact artist for portfolio review if interested. Portfolios may be dropped off every Monday and Tuesday. Portfolio should include color photographs, photostats, roughs, slides, tearsheets, thumbnails and transparencies. Artist should follow up with letter after initial query. Pays royalties of 6-12%; flat fee is optional. Payment is negotiable. Offers advance when appropriate. Negotiates rights purchased. Rights purchased vary according to project. Sometimes requires exclusive representation of artist. Provides advertising, promotion and written contract.
Tips "We are looking for more original art for our distribution."

⊞ ARTEFFECT DESIGNS

Roggenstrasse 28, Weeze 47652 Germany. E-mail: william@arteffectdesigns.de. Web site: www.arteffectdesigns.de. **Manager:** William F. Cupp. Product development, art licensing and representation of European publishers.
Needs Seeking creative, decorative art for the commercial and designer markets. Considers oil, acrylic, mixed media. Interested in all types of design. Artists represented include Nathalie Boucher, James Demmick, Hedy, Henriette Schaeffers, Jasper, Gertrud Schweser, Nancy Flores and Reint Withaar. Editions are created by working from an existing painting.
First Contact & Terms Send brochure, photographs, slides. Responds only if interested. Company will contact artist for portfolio review of transparencies if interested. Pays flat fee or royalties. No advance. Rights purchased vary according to project. Provides advertising and representation at international trade shows.

ARTSOURCE INTERNATIONAL INC.

1237 Pearl St., Boulder CO 80302. (303)444-4079. E-mail: artsource_online@aol.com. **Managing Director:** Ripsime Marashian. Estab. 1997. Publisher of fine art; business management consultant. Handles fine art originals, limited editions. Clients: private upscale clientele, corporate buyers, interior designers, frame shops, distributors and galleries.
● See also listing for Galerie ArtSource in the Galleries section.
Needs Any art of exceptional quality. "We prefer artwork with creative expression—museum-quality landscape, figurative, still life, decorative art." Approached by 50 artists/year. Works with 3-4 emerging and established artists/year.
First Contact & Terms Send query letter, brochure, SASE, digital files, résumé. Accepts e-mail submissions. Prefers JPEGs. Samples are returned by SASE. Responds only if interested. Negotiates rights purchased according to project. Requires exclusive representation of artist. Provides advertising, written contract, promotion and exhibitions. Finds artists through submissions, art exhibits, other galleries.
Tips "Provide a body of work along a certain theme to show a fully developed style that can be built upon. We offer services to artists who are serious about their career, individuals who want to become professional artist representatives, galleries and dealers who want to target new artists."

ARTVISIONS™

Web site: www.artvisions.com. Licensing agency. "Not currently seeking new talent. However, we are always willing to view the work of top-notch established artists. For details and contact information, please see our listing in the Artists' Reps section. If you need advice about marketing your art, please visit: www.artistsconsult.com."

BANKS FINE ART

1231 Dragon St., Dallas TX 75207. (214)352-1811. Fax: (214)352-6360. E-mail: mb@banksfineart
.com. Web site: www.banksfineart.com. **Owner:** Bob Banks. Estab. 1980. Distributor; gallery
of original oil paintings. Clients: galleries, decorators.

Needs Seeking decorative, traditional and impressionistic art for the serious collector and the
commercial market. Considers oil, acrylic. Prefers traditional and impressionistic styles. Artists
represented include Joe Sambataro, Jan Bain and Marcia Banks. Approached by 100 artists/
year. Publishes/distributes the work of 2 emerging artists/year.

First Contact & Terms Send photographs. Samples are returned by SASE. Responds in 1 week.
Offers advance. Rights purchased vary according to project. Provides advertising, in-transit in-
surance, insurance while work is at firm, promotion, shipping from firm, written contract.

Tips Needs Paris and Italy street scenes. Advises artists entering the poster and print market to
attend Artexpo, the industry's largest trade event, held in New York City every spring (and now
also in Las Vegas every fall). Also recommends reading *Art Business News.*

BENTLEY PUBLISHING GROUP

1410 Lesnick Lane, Walnut Creek CA 94597. (925)935-3186. Fax: (925)935-0213. E-mail: harriet
@bentleypublishinggroup.com. Web site: www.bentleypublishinggroup.com. **Product Devel-
opment Coordinator:** Harriet Rinehart. Estab. 1986. Art publisher of open and limited editions of
offset reproductions and canvas replicas; also agency for licensing of artists' images worldwide.
Licenses florals, contemporary, landscapes, wildlife and Christmas images to appear on puzzles,
tapestry products, doormats, stitchery kits, giftbags, greeting cards, mugs, tiles, wall coverings,
resin and porcelain figurines, waterglobes and various other gift items. Clients: framers, galleries,
distributors and framed picture manufacturers.

- Divisions of this company include Bentley House, Rinehart Fine Arts, and Bentley Licensing
 Group. See separate listing for Rinehart Fine Arts in this section.

Needs Seeking decorative fine art for the designer, residential and commercial markets. Consid-
ers oil, watercolor, acrylic, pastel, mixed media and photography. Artists represented include
Sherry Strickland, Lisa Chesaux and Andre Renoux. Editions are created by collaborating with
the artist or by working from an existing painting. Approached by 1,000 artists/year.

First Contact & Terms Submit JPEG images via e-mail or send query letter with brochure show-
ing art style or résumé, advertisements, slides and photographs. Samples are filed or are returned
by SASE if requested by artist. Responds in 6 weeks. Pays royalties of 10% net sales for prints
monthly plus 50 artist proofs of each edition. Pays 40% monies received from licensing. Obtains
all reproduction rights. Usually requires exclusive representation of artist. Provides national
trade magazine promotion, a written contract, worldwide agent representation, 5 annual trade
show presentations, insurance while work is at firm and shipping from firm.

Tips ''Bentley is looking for experienced artists with images of universal appeal.''

BERGQUIST IMPORTS INC.

1412 Hwy. 33 S., Cloquet MN 55720. (218)879-3343. Fax: (218)879-0010. E-mail: bbergqu106@a
ol.com. Web site: www.bergquistimports.com. **President:** Barry Bergquist. Estab. 1948. Distrib-
utor. Distributes unlimited editions. Clients: gift shops.

- See additional listing in the Greeting Cards, Gifts & Products section.

Needs Seeking creative and decorative art for the commercial market. Considers oil, watercolor,
mixed media and acrylic. Prefers Scandinavian or European styles. Artists represented include

Jacky Briggs, Dona Douma and Suzanne Toftey. Editions are created by collaborating with the artist or by working from an existing painting. Approached by 20 artists/year. Publishes the work of 2-3 emerging, 2-3 mid-career and 2 established artists/year. Distributes the work of 2-3 emerging, 2-3 mid-career and 2 established artists/year.

First Contact & Terms Send brochure, résumé and tearsheets. Do not send art attached to e-mail; will not download from unknown sources. Samples are returned, not filed. Responds in 2 months. Artist should follow up. Portfolio should include color thumbnails, final art, photostats, tearsheets and photographs. Pays flat fee of $50-300; royalties of 5%. Offers advance when appropriate. Negotiates rights purchased. Provides advertising, promotion, shipping from firm, and written contract. Finds artists through art fairs.

Tips Suggests artists read *Giftware News Magazine.*

BERKSHIRE ORIGINALS

2 Prospect Hill, Stockbridge MA 01263. (413)298-3691. Fax: (413)298-1356. E-mail: clevesque@ marian.org. Web site: www.marian.org. **Administrator/Senior Designer:** Catherine M. LeVesque. Estab. 1991. Art publisher and distributor of offset reproductions and greeting cards.

Needs Seeking creative art for the commercial market. Considers oil, watercolor, acrylic, pastel and pen & ink. Prefers religious themes, but also considers florals, holiday and nature scenes, line art and border art.

First Contact & Terms Send query letter with brochure showing art style or other art samples. Samples are filed or are returned by SASE if requested by artist. Responds in 1 month. Write for appointment to show portfolio of slides, color tearsheets, transparencies, original/final art and photographs. Pays flat fee: $100-1,000. Buys all rights.

Tips "Good draftsmanship is a must, particularly with figures and faces. Colors must be harmonious and clearly executed."

BERNARD FINE ART

P.O. Box 1528, Manchester Center VT 05255. (802)362-3662. Fax: (802)362-3286. E-mail: publis hing@applejackart.com. Web site: www.applejackart.com. Art publisher. Publishes open edition prints and posters. Clients: picture frame manufacturers, distributors, manufacturers, galleries and frame shops.

- • This company is a division of Applejack Art Partners, along with the high-end poster lines Hope Street Editions and Rose Selavy of Vermont. See separate listings for Hope Street Editions and Rose Selavy of Vermont in this section, and Applejack Art Partners in the Greeting Cards, Gifts Products section.

Needs Seeking creative, fashionable, and decorative art and photography for commercial and designer markets. Considers all media, including oil, watercolor, acrylic, pastel, and mixed media.

First Contact and Terms Send query letter with samples showing art style and/or tearsheets, photocopies, photographs. Samples are returned by SASE only. Pays royalties. Usually requires exclusive representation of artist. Finds artists through submissions, sourcebooks, agents, art shows, galleries and word of mouth.

Tips look for subjects with a universal appeal. Some subjects that would be appropriate are florals, still lifes, wildlife, religious themes, landscapes and contemporary images/abstracts. Please send enough examples of your work so it displays a true representation of your style and technique.

TOM BINDER FINE ARTS

825 Wilshire Blvd. #708, Santa Monica CA 90401. (800)332-4278. Fax: (800)870-3770. E-mail: info@artman.net. Web site: www.artman.net and www.alexanderchen.com. **Owner:** Tom Binder. Wholesaler of hand-pulled originals, limited editions and fine art prints. Clients: galleries and collectors.

● See additional listing in the Galleries section.

Needs Seeking art for the commercial market. Considers acrylic, mixed media, giclée and pop art. Artists represented include Alexander Chen, Ken Shotwell and Elaine Binder. Editions are created by working from an existing painting.

First Contact & Terms Send brochure, photographs, photostats, slides, transparencies and tearsheets. Accepts disk submissions if compatible with Illustrator 5.0. Samples are not filed and are returned by SASE. Does not reply; artist should contact. Offers advance when appropriate. Rights purchased vary according to project. Provides shipping. Finds artists through New York Art Expo and World Wide Web.

THE BLACKMAR COLLECTION

P.O. Box 537, Chester CT 06412. Phone/fax: (860)526-9303. E-mail: carser@mindspring.com. Web site: www.theblackmarcollection.com. Estab. 1992. Art publisher. Publishes offset reproduction and giclée prints. Clients: individual buyers.

Needs "We are not actively recruiting at this time." Artists represented include DeLos Blackmar, Blair Hammond, Gladys Bates and Keith Murphey. Editions are created by working from an existing painting. Approached by 24 artists/year. Publishes the work of 3 established artists/year. Provides advertising, in-transit insurance, insurance while work is at firm. Finds artists through personal contact. All sales have a buy back guarantee.

BON ART™ & ARTIQUE™

Divisions of Art Resources International, Ltd., 129 Glover Ave., Norwalk CT 06850-1311. (203)845-8888. Fax: (203)846-6849. E-mail: sales@bonartique.com. Web site: www.bonartique.com. **Creative Director:** R. Bonnist. Estab. 1980. Art publisher; poster company; licensing and design studio. Publishes/distributes fine art prints, canvas transfers, unlimited editions, offset reproductions and posters. Clients: Internet purveyors of art, picture frame manufacturers, catalog companies, distributors.

Needs Seeking decorative and fashionable art for the commercial and designer markets. Considers oil, acrylic, pastel, watercolor and mixed media. Artists represented include Eric Yang, Tom Butler, Mid Gordon, Martin Wiscombe, Julia Hawkins, Gloria Ericksen, Janet Stever, Louise Montillio, Maxwell Hutchinson, Bennie Diaz and Tina Chaden. Editions are created by collaborating with the artist or by working from an existing painting. Approached by 500 artists/year. Publishes/distributes the work of 30 emerging artists/year.

First Contact & Terms E-mail or send query letter with brochure, samples, photographs, URL. Accepts e-mail submissions with image files or link to Web site. Prefers JPEG or TIFF files. Samples are kept on file or returned by SASE if requested. Responds only if interested. Will contact artist for portfolio review if interested. Portfolio should include b&w, color, finished art, roughs, photographs. Pays flat fee or royalties. Offers advance when appropriate. Rights purchased vary according to project; negotiated. Requires exclusive representation. Provides insurance while work is at firm, shipping from firm, promotion and written contract. Finds artists through agents/reps, submissions, portfolio reviews, art fairs/exhibits, word of mouth, referrals by other artists, magazines, sourcebooks, Internet.

Tips "Bon Art and Artique welcome submissions from a wide range of international artists. As leaders in the field of fine art publishing for the past 30 years, we believe in sharing our knowledge of the trends, categories and styles with our artists. Although interested in working with veterans of our industry, we actively recruit and encourage all accomplished artists to submit their portfolios—preferably by e-mail with links to images."

CLASSIC COLLECTIONS FINE ART

1 Bridge St., Irvington NY 10533. (914)591-4500. Fax: (914)591-4828. E-mail: info@classiccollect ions.com. Web site: www.classiccollections.com. **Acquisition Manager:** Larry Tolchin. Estab. 1990. Art publisher. Publishes unlimited editions and offset reproductions. Clients: galleries, interior designers, hotels. Licenses florals, landscapes, animals for kitchen/bath textiles, rugs, tabletop.

Needs Seeking decorative art for the commercial and designer markets. Considers oil, acrylic, watercolor, mixed media and pastel. Prefers landscapes, still lifes, florals. Artists represented include Harrison Rucker, Roger Duvall, Sid Willis, Martha Collins, Judy Shelby and Henry Peeters. Editions are created by collaborating with the artist and by working from existing painting. Approached by 100 artists/year. Publishes the work of 6 emerging, 6 mid-career and 6 established artists/year.

First Contact & Terms Mail color copies or send JPEGs via e-mail. Samples are filed. Responds in 3 months. Will contact artist for portfolio review if interested. Offers advance when appropriate. Buys first and reprint rights. Provides advertising, insurance while work is at firm, and written contract. Finds artists through art fairs, exhibitions and competitions.

CLAY STREET PRESS, INC.

1312 Clay St., Cincinnati OH 45202. (513)241-3232. E-mail: mpginc@iac.net. Web site: www.pat sfallgraphics.com. **Owner:** Mark Patsfall. Estab. 1981. Art publisher and contract printer. Publishes fine art prints, hand-pulled originals, limited editions. Clients: architects, corporate curators, decorators, galleries and museum print curators.

Needs Seeking serious artists. Prefers conceptual/contemporary. Editions are created by collaborating with the artist. Publishes the work of 2-3 emerging artists/year.

First Contact & Terms Contact only through artist rep. Accepts e-mail submissions with image files. Prefers Mac-compatible JPEG files. Responds in 1 week. Negotiates payment. Negotiates rights purchased. Services provided depend on contract. Finds artists through reps, galleries and word of mouth.

☑ CLEARWATER PUBLISHING

161 MacEwan Ridge Circle NW, Calgary AB T3K 3W3 Canada. (403)295-8885. Fax: (403)295-8981. E-mail: clearwaterpublishing@shaw.ca. Web site: www.clearwater-publishing.com. **Contact:** Laura Skorodenski. Estab. 1989. Fine art publisher. Handles giclées, canvas transfers, fine art prints and offset reproductions. Clients: decorators, frame shops, gift shops, galleries and museum shops.

Needs Seeking artwork for the serious collector and commercial market. Considers acrylic, watercolor, mixed media and oil. Prefers high realism or impressionistic works. Artists represented can be seen on Web site.

First Contact & Terms Accepts e-mail submissions with link to Web site and image file; Windows-compatible. Prefers JPEGs. Samples are not filed or returned. Responds only if interested.

Company will contact artist for portfolio review if interested. Portfolio should include slides. No advance. Requires exclusive representation of artist.

THE COLONIAL ART GALLERY & CO.

1336 NW First St., Oklahoma City OK 73106. (405)232-5233. Fax: (405)232-6607. E-mail: info@c olonialart.com. Web site: www.colonialart.com. **Owner:** Willard Johnson. Estab. 1919. Publisher and distributor of offset reproductions for galleries. Clients: retail and wholesale. Current clients include Osburns, Grayhorse and Burlington.

Needs Prefers realism and expressionism—emotional work. Publishes the work of 2-3 emerging, 2-3 mid-career and 3-4 established artists/year. Distributes the work of 10-20 emerging, 30-40 mid-career and hundreds of established artists/year.

First Contact & Terms Send sample prints. Samples not filed are returned only if requested by artist. Will contact artist for portfolio review if interested. Pays negotiated flat fee, royalties, or on a consignment basis (firm receives 33% commission). Offers an advance when appropriate. Considers buying second rights (reprint rights) to previously published work.

Tips "The current trend in art publishing is an emphasis on quality."

DARE TO MOVE

1117 Broadway, Suite 301, Tacoma WA 98402. (253)284-0975. Fax: (253)284-0977. E-mail: daret omove@aol.com. Web site: www.daretomove.com. **President:** Steve W. Sherman. Estab. 1987. Art publisher, distributor. Publishes/distributes limited editions, unlimited editions, canvas transfers, fine art prints, offset reproductions. Licenses aviation and marine art for puzzles, note cards, bookmarks, coasters, etc. Clients include art galleries, aviation museums, frame shops and interior decorators.

• This company has expanded from aviation-related artwork to work encompassing most civil service areas. Steve Sherman likes to work with artists who have been painting for 10-20 years. He usually starts off distributing self-published prints. If prints sell well, he will work with artist to publish new editions.

Needs Seeking naval, marine, firefighter, civil service and aviation-related art for the serious collector and commercial market. Considers oil and acrylic. Represented artists include John Young, Ross Buckland, Mike Machat, James Dietz, Jack Fellows, William Ryan and Patrick Haskett. Editions are created by collaborating with the artist or working from an existing painting. Approached by 15-20 artists/year. Publishes the work of 1 emerging, 2-3 mid-career and established artists/year. Distributes the work of 9 emerging and 2-3 established artists/year.

First Contact & Terms Send query letter with photographs, slides, tearsheets and transparencies. Samples are filed or sometimes returned by SASE. Artist should follow up with call. Portfolio should include color photographs, transparencies and final art. Pays royalties of 10% commission of wholesale price on limited editions; 5% commission of wholesale price on unlimited editions. Buys one-time or reprint rights. Provides advertising, in-transit insurance, insurance while work is at firm, promotion, shipping from firm, and written contract.

Tips "Present your best work—professionally."

DELJOU ART GROUP, INC.

1616 Huber St., Atlanta GA 30318. (404)350-7190. Fax: (404)350-7195. E-mail: submit@deljouar tgroup.com. Web site: www.deljouartgroup.com. **Contact:** Art Director. Estab. 1980. Art publisher, distributor and gallery of limited editions (maximum 250 prints), hand-pulled originals,

monoprints/monotypes, sculpture, fine art photography, fine art prints and paintings on paper and canvas. Clients: galleries, designers, corporate buyers and architects. Current clients include Coca Cola, Xerox, Exxon, Marriott Hotels, General Electric, Charter Hospitals, AT&T and more than 3,000 galleries worldwide, "forming a strong network throughout the world."

Needs Seeking creative, fine and decorative art for the designer market and serious collectors. Considers oil, acrylic, pastel, sculpture and mixed media and photography. Artists represented include Yunessi, T.L. Lange, Michael Emani, Vincent George, Nela Soloman, Alterra, Ivan Reyes, Mindeli, Sanford Wakeman, Niro Vessali, Lee White, Alexa Kelemen, Bika, Kamy, Craig Alan, Roya Azim, Jian Chang, Elya DeChino, Antonio Dojer, Emanuel Mattini and Mia Stone. Editions are created by collaborating with the artist. Approached by 300 artists/year. Publishes the work of 10 emerging, 20 mid-career and 20 established artists/year.

First Contact & Terms Send query letter with photographs, slides, brochure, photocopies, tearsheets, SASE and transparencies. Prefers contact and samples via e-mail. Samples not filed are returned only by SASE. Responds in 6 months. Will contact artist for portfolio review if interested. Payment method is negotiated. Offers an advance when appropriate. Negotiates rights purchased. Requires exclusive representation. Provides promotion, a written contract and advertising. Finds artists through visiting galleries, art fairs, word of mouth, World Wide Web, art reps, submissions, art competitions and sourcebooks. Pays highest royalties in the industry.

Tips "We need landscape artists, 3D wall art (any media), strong figurative artists, sophisticated abstracts and soft-edge abstracts. We are also beginning to publish sculptures and are interested in seeing slides of such. We also have the largest gallery in the country. We have added a poster division and need images in different categories for our poster catalogue as well."

DODO GRAPHICS, INC.

145 Cornelia St., P.O. Box 585, Plattsburgh NY 12901. (518)561-7294. Fax: (518)561-6720. E-mail: dodographics@aol.com. **Manager:** Frank How. Art publisher of offset reproductions, posters and etchings for galleries and frame shops.

Needs Considers pastel, watercolor, tempera, mixed media, airbrush and photographs. Prefers contemporary themes and styles. Prefers individual works of art, 16×20 maximum. Publishes the work of 5 artists/year.

First Contact & Terms Send query letter with brochure showing art style or photographs, slides or CD-ROM. Samples are filed or are returned by SASE. Responds in 3 months. Write for appointment to show portfolio of original/final art and slides. Payment method is negotiated. Offers an advance when appropriate. Buys all rights. Requires exclusive representation of the artist. Provides written contract.

Tips "Do not send any originals unless agreed upon by publisher."

DOLICE GRAPHICS

649 E. Ninth St., Suite C2, New York NY 10009. (212)529-2025. Fax: (212)260-9217. E-mail: joe@dolice.com. Web site: www.dolice.com. **President:** Joe Dolice. Estab. 1968. Art publisher. Publishes fine art prints, limited editions, offset reproductions, unlimited editions. Clients: architects, corporate curators, decorators, distributors, frame shops, galleries, gift shops and museum shops. Current clients include Bloomingdale's (Federated Dept. Stores).

Needs Seeking decorative, representational, antiquarian "type" art for the commercial and designer markets. Considers acrylic, mixed media, pastel, pen & ink, prints (intaglio, etc.) and watercolor. Prefers traditional, decorative, antiquarian type. Editions are created by collaborat-

ing with the artist and working from an existing painting. Approached by 12-20 artists/year.

First Contact & Terms Send query letter with color photocopies, photographs, résumé, SASE, slides and transparencies. Samples are returned by SASE only. Responds only if interested. Will contact artist for portfolio review if interested. Negotiates payment. Buys all rights on contract work. Rights purchased vary according to project. Provides free Web site space, promotion and written contract. Finds artists through art reps and submissions.

Tips "We publish replicas of antiquarian-type art prints for decorative arts markets and will commission artists to create 'works for hire' in the style of pre-century artists and occasionally to color black & white engravings, etchings, etc. Artists interested should be well schooled and accomplished in traditional painting and printmaking techniques."

FAIRFIELD ART PUBLISHING

87 35th St., 3rd Floor, Brooklyn NY 11232. (800)835-3539. Fax: (718) 832-8432. E-mail: cyclopete @aol.com. **Vice President:** Peter Lowenkron. Estab. 1996. Art publisher. Publishes posters, unlimited editions and offset reproductions. Clients: galleries, frame shops, museum shops, decorators, corporate curators, gift shops, manufacturers and contract framers.

Needs Decorative art for the designer and commercial markets. Considers collage, oil, water-color, pastel, pen & ink, acrylic. Artists represented include Daniel Pollera, Roger Vilarchao, Yves Poinsot.

First Contact & Terms Send query letter with slides and brochure. Samples are returned by SASE if requested by artist. Responds only if interested. Pays flat fee, $400-2,500 maximum, or royalties of 7-15%. Offers advance when appropriate. Rights purchased vary according to project. Interested in buying second rights (reprint rights) to previously published artwork.

FLYING COLORS, INC.

26943 Ruether Ave., Suite S, San Clarita CA 91351. (661)424-0545. Fax: (661)299-5586. E-mail: joe@flying-colors.net. Web site: www.flying-colors.net. **President:** Joe McCormick. Estab. 1993. Poster company and art publisher. Publishes unlimited editions, fine art prints, posters. Clients: galleries, frame shops, distributors, museum shops, gift shops, mail order, end-users, retailers, chains, direct mail.

Needs Seeking decorative art for the commercial market. Considers oil, acrylic, watercolor, mixed media, pastel. Prefers multicultural, religious, inspirational, wildlife, Amish, country, scenics, still life, American culture. Also needs freelancers for design. Prefers designers who own Mac computers. Artists represented include Greg Gorman and Deidre Madsen. Editions are created by collaborating with the artist or by working from an existing painting. Approached by 200 artists/year. Publishes the work of 20 emerging, 5-10 mid-career, 1-2 established artists/year.

First Contact & Terms May contact via e-mail or send photocopies, photographs, SASE, slides, transparencies. Accepts disk submissions if compatible with SyQuest, Dat, Jazzy, ZIP, QuarkX-Press, Illustrator, Photoshop or FreeHand. Samples are filed or returned by SASE. Responds only if interested. Artist should follow-up with call to show portfolio. Portfolio should include color, photographs, roughs, slides, transparencies. Negotiates payment. Offers advance when appropriate. Negotiates rights purchased; all rights preferred. Provides advertising, promotion, written contract. Finds artists through art exhibitions, art fairs, word of mouth, submissions, clients, local advertisements.

Tips "Ethnic and inspirational/religious art is very strong. Watch the furniture industry. Come

up with themes, sketches and series of at least two pieces. Art has to work on 8×10, 16×20, 22×28, 24×36, greeting cards and other possible mediums."

FORTUNE FINE ART

2908 Oregon Court, Suite G3, Torrance CA 90503. (310)618-1231. Fax: (310)618-1232. E-mail: carolv@fortunefa.com. Web site: www.fortunefa.com. **President:** Carol J. Vidic. Licensing: Peter Iwasaki. Publishes fine art prints, hand-pulled serigraphs, originals, limited editions, offset reproductions, posters and unlimited editions. Clients: art galleries, dealers and designers.

Needs Seeking creative art for the serious collector. Considers oil on canvas, acrylic on canvas, mixed media on canvas and paper. Artists represented include John Powell, Daniel Gerhartz, Marilyn Simandle and Don Hatfield. Publishes and distributes the work of a varying number of emerging artists/year.

First Contact & Terms Send query letter with résumé, slides, photographs, transparencies, biography and SASE. Samples are not filed. Responds in 1 month. To show a portfolio, mail appropriate materials. Payment method and advances are negotiated. Prefers exclusive representation of artist. Provides in-transit insurance, insurance while work is at firm, promotion and written contract.

Tips "Establish a unique style, look or concept before looking to be published."

FUNDORA ART STUDIO

100 Bahama Rd., Key Largo FL 33047. (305)852-1516. E-mail: thomasfund@aol.com. **Director:** Thomas Fundora. Estab. 1987. Art publisher/distributor/gallery. Publishes limited edition fine art prints. Clients: galleries, decorators, frame shops. Current clients include Ocean Reef Club, Paul S. Ellison.

Needs Seeking creative and decorative art for the serious collector. Considers oil, watercolor, mixed media. Prefers nautical, maritime, tropical. Artists represented include Thomas Fundora, Gaspel, Juan A. Carballo and Carlos Sierra. Editions created by collaborating with the artist and working from an existing painting. Approached by 15 artists/year. Publishes/distributes the work of 2 emerging, 1 mid-career and 3 established artists/year.

First Contact & Terms Send query letter with brochure, photographs, slides or printed samples. Samples are filed. Will contact artist for portfolio review if interested. Pays royalties. Buys first rights. Requires exclusive representation of artist in U.S. Provides advertising and promotion. Also works with freelance designers.

Tips "Trends to watch: tropical sea and landscapes."

GALAXY OF GRAPHICS, LTD.

20 Murray Hill Pkwy., Suite 160, East Rutherford NJ 07073-2180. (201)806-2100. Fax: (201)806-2050. E-mail: susan.murphy@kapgog.com. Web site: www.galaxyofgraphics.com. **Art Director:** Colleen Buchweitz. Estab. 1983. Art publisher and distributor of unlimited editions. Licensing handled by Christine Gaccione. Clients: galleries, distributors and picture frame manufacturers.

Needs Seeking creative, fashionable and decorative art for the commerical market. Artists represented include Richard Henson, Betsy Brown, Elaine Lane, Charlene Olson, Vivian Flasch, Joyce Combs, Igor Lerashov, Ruane Manning and Carol Robinson. Editions are created by collaborating with the artist or by working from an existing painting. Considers any media. "Any currently popular and generally accepted themes." Art guidelines free for SASE with first-class postage.

Approached by several hundred artists/year. Publishes and distributes the work of 20 emerging and 20 mid-career and established artists/year.

First Contact & Terms Send query letter with résumé, tearsheets, slides, photographs and transparencies. Samples are not filed and are returned by SASE. Responds in 2 weeks. Call for appointment to show portfolio. Pays royalties of 10%. Offers advance. Buys rights only for prints and posters. Provides insurance while material is in-house and while in transit from publisher to artist/photographer. Provides written contract to each artist.

Tips "There is a trend of strong jewel-tone colors and spice-tone colors. African-American art very needed."

ROBERT GALITZ FINE ART & ACCENT ART

166 Hilltop Lane, Sleepy Hollow IL 60118-1816. (847)426-8842. Fax: (847)426-8846. E-mail: robert@galitzfineart.com. Web site: www.galitzfineart.com. **Owner:** Robert Galitz. Estab. 1986. Distributor of fine art prints, handpulled originals, limited editions, monoprints, monotypes and sculpture. Clients: architects and galleries.

• See additional listings in the Galleries and Artists' Reps sections.

Needs Seeking creative, decorative art for the commercial and designer markets. Considers acrylic, mixed media, oil, sculpture and watercolor.

First Contact & Terms Send query letter with brochure, SASE, slides and photographs. Samples are not filed and are returned by SASE. Responds in 1 month. Will contact artist for portfolio review if interested. Pays flat fee. No advance. Rights purchased vary according to project. Finds artists through art fairs and submissions.

N GRAPHIQUE DE FRANCE

9 State St., Woburn MA 01801. (781)935-3405. Fax: (781)935-5145. E-mail: artworksubmissions @graphiquedefrance.com. Web site: www.graphiquedefrance.com. **Contact:** Licensing Department. Estab. 1979. Manufacturer of fine art, photographic and illustrative greeting cards, notecard gift boxes, posters and calendars. Clients: galleries, foreign distributors, museum shops, high-end retailers, book trade, museum shops.

First Contact & Terms Prefers submissions made as JPEGS through Web site. Please do not send original artwork. Please allow 2 months for response. SASE is required for any submitted material to be returned.

Tips "It's best not to insist on speaking with someone at a targeted company prior to submitting work. Let the art speak for itself and follow up a few weeks after submitting."

GUILDHALL, INC.

P.O. Box 136550, Fort Worth TX 76136. (800)211-0305. Fax (817)236-0015. E-mail: westart@guil dhall.com. Web site: www.guildhall.com. **President:** John M. Thompson III. Art publisher/ distributor of limited and unlimited editions, offset reproductions and hand-pulled originals for galleries, decorators, offices and department stores. Current clients include over 500 galleries and collectors nationwide.

Needs Seeking creative art for the serious and commercial collector and designer market. Considers pen & ink, oil, acrylic, watercolor, and bronze and stone sculptures. Prefers historical Native American, Western, equine, wildlife, landscapes and religious themes. Prefers original works of art. Over past 25 years has represented over 50 artists in printing and licensing work. Editions are created by collaborating with the artist and by working from existing art. Approached by 150 artists/year.

First Contact & Terms Send query letter with résumé, tearsheets, photographs, slides and 4×5 transparencies or electronic file, preferably cowboy art in photos or printouts. Samples are not filed and are returned only if requested. Responds in 1 month. Payment options include paying a flat fee for a single use; paying 10-20% royalties for multiple images; paying 35% commission on consignment. Negotiates rights purchased. Requires exclusive representation for contract artists. Provides insurance while work is at firm.

Tips "The new technologies in printing are changing the nature of publishing. Self-publishing artists have flooded the print market. Printing is the easy part. Selling it is another problem. Many artists, in order to sell their work, have to price it very low. In many markets this has caused a glut. Some art would be best served if it was only one of a kind. There is no substitute for scarcity and quality."

◼ HADLEY HOUSE PUBLISHING

4816 Nicollet Ave. S., Minneapolis MN 55419-5511. (886)619-2324. Fax: (952)943-8098. E-mail: borcd@hadleyco.com. Web site: www.hadleylicensing.com or www.hadleyhouse.com. **Vice President—Publishing/Licensing:** Deborah Borchardt. Estab. 1974. Art publisher, distributor. Publishes and distributes canvas transfers, fine art prints, giclées, limited and unlimited editions, offset reproductions and posters. Licenses all types of flat art. Clients: wholesale and retail.

Needs Seeking artwork with creative artistic expression and decorative appeal. Considers oil, watercolor, acrylic, pastel and mixed media. Prefers florals, landscapes, figurative and nostalgic Americana themes and styles. Art guidelines free for SASE with first-class postage. Artists represented include Nancy Howe, Steve Hamrick, Sueellen Ross, Collin Bogle, Lee Bogle and Bruce Miller. Editions are created by collaborating with artist and by working from an existing painting. Approached by 200-300 artists/year. Publishes the work of 3-4 emerging, 15 mid-career and 8 established artists/year. Distributes the work of 1 emerging and 4 mid-career artists/year.

First Contact & Terms Send query letter with brochure showing art style or résumé and tearsheets, slides, photographs and transparencies. Samples are filed or are returned. Responds in 2 months. Call for appointment to show portfolio of slides, original final art and transparencies. Pays royalties. Requires exclusive representation of artist and/or art. Provides insurance while work is at firm, promotion, shipping from firm, a written contract and advertising through dealer showcase.

Tips "Build a market for your originals by affiliating with an art gallery or two. Never give away your copyrights! When you can no longer satisfy the overwhelming demand for your originals, *that* is when you can hope for success in the reproduction market."

IMAGE CONNECTION

456 Penn St., Yeadon PA 19050. (610)626-7770. Fax: (610)626-2778. E-mail: sales@imageconnection.biz. Web site: www.imageconnection.biz. **President:** Michael Markowicz. Estab. 1988. Publishes and distributes limited editions and posters. Represents several European publishers.

Needs Seeking fashionable and decorative art for the commercial market. Considers oil, pen & ink, watercolor, acrylic, pastel and mixed media. Prefers contemporary and popular themes, realistic and abstract art. Editions are created by collaborating with the artist and by working from an existing painting. Approached by 200 artists/year.

First Contact & Terms Send query letter with brochure showing art style or résumé, slides, photocopies, photographs, tearsheets and transparencies. Accepts e-mail submissions with link to Web site or Mac-compatible image file. Samples are not filed and are returned by SASE.

Responds in 2 months. Will contact artist for portfolio review if interested. Portfolio should include b&w and color finished, original art, photographs, slides, tearsheets and transparencies. Payment method is negotiated. Offers advance when appropriate. Negotiates rights purchased. Requires exclusive representation of artist for product. Finds artists through art competitions, exhibits/fairs, reps, submissions, Internet, sourcebooks and word of mouth.

🌐 IMAGE SOURCE INTERNATIONAL

630 Belleville Ave., New Bedford MA 02745. (508)999-0090. Fax: (508)999-9499. E-mail: pdown es@isiposters.com or zbrazdis@isiposters.com. Web site: www.isiposters.com. **Licensing:** Patrick Downes. **Art Editor:** Kevin Miller. **Art Director:** Zach Brazdis. Estab. 1992. Poster company, art publisher/distributor. Publishes/distributes unlimited editions, fine art prints, offset reproductions, posters. Clients: galleries, decorators, frame shops, distributors, architects, corporate curators, museum shops, gift shops, foreign distributors (Germany, Holland, Asia, South America).

● Image Source International is one of America's fastest-growing publishers.

Needs Seeking fashionable, decorative art for the designer market. Considers oil, acrylic, pastel. Artists represented include Brendon Loauglin, William Hartshorn, Adrianna, Michael Rogovsky, Antonia, Dave Marrocco, Mariner's Museum, Baltimore Railroad Museum, Jason Ellis, Ed Martinez, Claire Pavlik Purgus, William Verner, Deborah Chabrian, Vintage prints, and Classic Photography, Juarez Machado, Patrick Downes, Anthony Watkins, Rob Brooks and, Karyn Frances Gray. Editions are created by collaborating with the artist or by working from an existing painting. Approached by hundreds of artists/year. Publishes the work of 6 emerging, 2 mid-career and 2 established artists/year. Distributes the work of 50 emerging, 25 mid-career, 50 established artists/year.

First Contact & Terms Send query letter with brochure, photocopies, photographs, résumé, slides, tearsheets, transparencies, postcards. Samples are filed and are not returned. Responds only if interested. Company will contact artist for portfolio review if interested. Pays flat fee "that depends on artist and work and risk." Buys all rights. Requires exclusive representation of artist.

Tips Notes trends as sports art, neo-classical, nostalgic, oversize editions. "Think marketability. Watch the furniture market." Abstracts and landscapes.

INNOVATIVE ART

(formerly Portal Publications, Ltd.), 100 Smith Ranch Rd., Suite 210, San Rafael CA 94903. (415)884-6200 or (800)227-1720. Fax: (415)382-3377. Web site: www.portalpub.com. **Senior Art Director:** Andrea Smith. Estab. 1954. Publishes greeting cards, calendars, posters, wall decor, framed prints. Art guidelines available for SASE or on Web site.

● See additional listing in the Greeting Cards, Gifts & Products section.

Needs Approached by more than 1,000 freelancers artists/year. Offers up to 400 or more assignments/year. Works on assignment only. Considers any media. Looking for "beautiful, charming, provocative, humorous images of all kinds." 90% of freelance design demands knowledge of the most recent versions of Illustrator, QuarkXPress and Photoshop. Submit seasonal material 1 year in advance.

First Contact & Terms "No submission will be considered without a signed guidelines form, available on our Web site at www.portalpub.com/contact/ArtistSubmissionForm.pdf; or contact Robin O'Conner at (415)526-6362."

Tips "Ours is an increasingly competitive business, so we look for the highest quality and most unique imagery that will appeal to our diverse market of customers."

INSPIRATIONART & SCRIPTURE, INC.

P.O. Box 5550, Cedar Rapids IA 52406. (319)365-4350. Fax: (319)861-2103. E-mail: charles@insp irationart.com. Web site: www.inspirationart.com. **Creative Director:** Charles R. Edwards. Estab. 1993 (incorporated 1996). Produces Christian posters. "We create and produce jumbo-sized (24×36) posters targeted at pre-teens (10-14), teens (15-18) and young adults (18-30). A Christian message appears on every poster. Some are fine art and some are very commercial. We prefer very contemporary images." Art guidelines available on Web site or for SASE with first-class postage.

Needs Approached by 150-200 freelance artists/year. Works with 10-15 freelancers/year. Buys 10-15 designs, photos, illustrations/year. Christian art only. Uses freelance artists for posters. Considers all media. Looking for "something contemporary or unusual that appeals to teens or young adults and communicates a Christian message."

First Contact & Terms Send query letter with SASE, photographs, slides or transparencies. Accepts submissions on disk (call first). Samples are filed or are returned by SASE. Responds in 30 days. Will contact artist for portfolio review if interested. Portfolio should include color roughs, final art, photographs and transparencies. "We need to see the artist's range. It is acceptable to submit 'secular' work, but we also need to see work that is Christian-inspired." Originals are returned at job's completion. Pays by the project, $50-250. Pays royalties of 5% "only if the artist has a body of work that we are interested in purchasing in the future." Rights purchased vary according to project.

Tips "The better the quality of the submission, the better we are able to determine if the work is suitable for our use (slides are best). The more complete the submission (i.e., design, art layout, scripture, copy), the more likely we are to see how it may fit into our poster line. We do accept traditional work but are looking for work that is more commercial and hip (think MTV with values). A poster needs to contain a Christian message that is relevant to teen and young adult issues and beliefs. Understand what we publish before submitting work. Visit our Web site to see what it is that we do. We are not simply looking for beautiful art, but rather we are looking for art that communicates a specific scriptural passage."

INTERCONTINENTAL GREETINGS LTD.

38 West 32nd Street, Suite 910, New York NY 10001. (212)683-5830. Fax: (212)779-8564. Web site: www.intercontinental-ltd.com. **Art Director:** Jerra Parfitt. Estab. 1967. Sells reproduction rights of designs to publishers/manufacturers in 50 countries around the world. Specializes in greeting cards, gift bags, stationery and novelty products, ceramics, textile, bed and bath accessories, and kitchenware.

• See additional listing in the Greeting Cards, Gifts & Products section.

Needs Seeking creative, commercial and decorative art in traditional and computer media and photography. Accepts seasonal and holiday material at any time. Animals, children, babies, fruits/wine, sports, scenics, international cities and Americana themes are highly desirable.

First Contact & Terms Send query letter with brochure, tearsheets, CDs or DVDs. "Please do not send original artwork." Samples are filed or returned by SASE if requested. Artist is paid a percentage once work is published. No credit line given. Sells one-time rights and exclusive product rights. Simultaneous submissions and previously published work okay. "Please state reserved rights, if any."

Tips Recommends the annual New York SURTEX Show. "In addition to having good painting/designing skills, artists should be aware of market needs and trends. We're looking for artists who possess a large collection of designs, and we are interested in series of interrelated images."

⊕ INTERNATIONAL GRAPHICS

Walmsley GmbH, Junkersring 11, Eggenstein DE-76344 Germany. (49)(721)978-0620. Fax: (49)(721)978-0651. E-mail: LW@ig-team.de. Web site: www.international-graphics.com. **President:** Lawrence Walmsley. Publishing Assistant: Anita Cieslar. Estab. 1981. Poster company, art publisher/distributor. Publishes/distributes limited edition monoprints, monotypes, offset reproduction s, posters, original paintings and silkscreens. Clients: galleries, framers, department stores, gift shops, card shops and distributors. Current clients include Art.com, Windsor Art, Intercontinental Art, and Balangier store.

Needs Seeking creative, fashionable and decorative art for the commercial and designer markets. Also seeking Americana art for gallery clients. Considers oil, acrylic, watercolor, mixed media, pastel and photos. Prefers landscapes, florals, still lifes. Art guidelines free for SASE with first-class postage. Artists represented include Christian Choisy, Benevolenza, Ona, Thiry, Magis, Marthe and Mansart. Editions are created by working from an existing painting. Approached by 100-150 artists/year. Publishes the work of 10- 20 emerging artists/year. Distributes the work of 10-20 emerging artists/year.

First Contact & Terms Send query letter with brochure, photocopies, photographs, photostats, résumé, slides, tearsheets. Accepts disc submissions for Mac or Windows. Samples are filed and returned. Responds in 2 months. Will contact artist for portfolio review if interested. Negotiates payment on basis of per-piece-sold arrangement. Offers advance when appropriate. Buys first rights. Provides advertising, promotion, shipping from fir m, and contract. Also works with freelance designers. Prefers local designers. Finds artists through exhibitions, word of mouth, submissions.

Tips "Pastel landscapes and still life pictures are good at the moment. Earthtones are popular—especially lighter shades. At the end of the day, we seek the unusual, that has not yet been published."

⊠ ISLAND ART PUBLISHERS

P.O. Box 22063, Brentwood Bay BC V8M 1R5 Canada. (250)652-5181 or (800)663-7501. Fax: (250)652-2711. E-mail: submissions@islandart.com. Web site: www.islandart.com. **Art Director:** Ryan Grealy. Estab. 1985. Art publisher, distributor and printer. Publishes and distributes art cards, posters, open-edition prints, calenders, bookmarks, giclées and custom products. Clients: galleries, museums, Federal and local governments, major sporting events, department stores, distributors, gift shops, artists and photographers. Art guidelines available for SASE or on Web site.

Needs See Web site for current needs and requirements. Considers oil, watercolor and acrylic. Prefers themes related to the Pacific Northwest. Editions are created by working from an existing painting. Approached by 100 artists/year. Publishes the work of 2-4 emerging artists/year.

First Contact & Terms Send submissions to the attention of Art Director. Submit résumé/CV, tearsheets, slides, photographs, transparencies or digital files on CD-/DVD-ROM (must be TIFF, EPS, PSD or JPEG files compatible with Photoshop). "Please DO NOT send originals." Samples are not filed and are returned only by SASE if requested by artist. Responds in 3-6 months. Will contact artist for portfolio review if interested. Pays royalties of 5-10%. Licenses reproduction

rights. Requires exclusive representation of artist *for selected products only*. Provides promotion, insurance while work is at firm, shipping from firm, written contract, fair trade representation and Internet service. Finds artists through art fairs, submissions and referrals.

Tips "Provide a body of work along a certain theme to show a fully developed style that can be built upon. We are influenced by our market demands. Please review our submission guidelines before sending work on spec."

⊠ LESLIE LEVY FINE ART PUBLISHING

7137 Main St., Scottsdale AZ 85251. (480)947-2925. Fax: (480)945-1518. E-mail: art@leslielevy.com. Web site: www.leslielevy.com. **President:** Leslie Levy. Estab. 1977. Publisher of fine art posters and open editions. Clients: frame shops, galleries, designers, framed art manufacturers, distributors and department stores.

• This company is a division of Bentley Publishing Group (see separate listing in this section).

Needs Seeking creative and decorative art for the residential, hospitality, health care, commercial and designer markets. Artists represented include Steve Hanks, Terry Isaac, Stephen Morath, Kent Wallis, Cyrus Afsary and Raymond Knaub. Considers oil, acrylic, pastel, watercolor, tempera and mixed media. Prefers florals, landscapes, wildlife, semi-abstract, nautical, figurative works and b&w photography. Approached by hundreds of artists/year.

First Contact & Terms We prefer e-mail with link to web site or digital photos.Send query letter with résumé, slides or photos and SASE. Samples are returned by SASE. Please do not send limited editions, transparencies or original works or disks. Pays royalties quarterly based on wholesale price. Insists on acquiring reprint rights for posters. Requires exclusive representation of artist. Provides promotion and written contract. "Please, don't call us. After we review your materials, if we are interested, we will contact you or return materials within one month."

Tips "If you are a beginner, do not go through the time and expense of sending materials."

LOLA LTD./LT'EE

1817 Egret St. SW, Shallotte NC 28470-5433. (910)754-8002. E-mail: lolaltd@yahoo.com. **Owner:** Lola Jackson. Distributor of limited editions, offset reproductions, unlimited editions, hand-pulled originals, antique prints and etchings. Clients: art galleries, architects, picture frame shops, interior designers, major furniture and department stores, industry and antique gallery dealers.

• This distributor also carries antique prints, etchings and original art on paper and is interested in buying/selling to trade.

Needs Seeking creative and decorative art for the commercial and designer markets. "Hand-pulled graphics are our main area." Considers oil, acrylic, pastel, watercolor, tempera or mixed media. Prefers unframed series, up to 30×40 maximum. Artists represented include Buffet, White, Brent, Jackson, Mohn, Baily, Carlson, Coleman. Approached by 100 artists/year. Publishes the work of 5 emerging, 5 mid-career and 5 established artists/year. Distributes the work of 40 emerging, 40 mid-career and 5 established artists/year.

First Contact & Terms Send query letter with samples. Samples are filed or are returned only if requested. Responds in 2 weeks. Payment method is negotiated. "Our standard commission is 50%, less 50% off retail." Offers an advance when appropriate. Provides insurance while work is at firm, shipping from firm and written contract.

Tips "We find we cannot sell black and white only. Leave wide margins on prints. Send all samples before end of May each year as our main sales are targeted for summer. We do a lot of business with birds, botanicals, boats and shells—anything nautical."

⊡ MAPLE LEAF PRODUCTIONS

391 Steelcase Rd. W., Unit 24, Markham ON L3R 3V9 Canada. (905)940-9229.. Fax: (905)940-9761. E-mail: ssillcox@ca.inter.net. Web site: www.mapleleafproductions.com. **President:** Scott Sillcox. Estab. 1993. Art publisher. Publishes sports art (historical), limited editions, posters, unlimited editions. Clients: distributors, frame shops, gift shops and museum shops.

Needs Considers watercolor. See Web site for themes and styles. Artists represented include Tino Paolini, Nola McConnan, Bill Band. Approached by 5 artists/year. Publishes/distributes the work of 1 emerging artist/year.

First Contact & Terms Send e-mail. Accepts e-mail submissions with link to Web site. Prefers TIFF, JPEG, GIF, EPS files. Responds in 1 week. Negotiates payment. Offers advance when appropriate. Buys all rights. Provides written contract. Finds artists through word of mouth.

Tips "We require highly detailed watercolor artists, especially those with an understanding of sports and the human body. Attention to small details is a must."

BRUCE MCGAW GRAPHICS, INC.

389 W. Nyack Rd., West Nyack NY 10994. (845)353-8600. Fax: (845)353-8907. E-mail: acquisitions@bmcgaw.com. Web site: www.bmcgaw.com. **Product Development:** Katy Murphy. Clients: poster shops, galleries, frame shops.

Needs Artists represented include Romero Britto, David Doss, Ray Hendershot, Jacques Lamy, Eve Shpritser, Beverly Jean, Peter Sculthorpe, Bob Timberlake, Robert Bateman, Michael Kahn, Albert Swayhoover and P.G. Gravele. Other important fine art poster licenses include Disney, Andy Warhol, MOMA, New York and others. Publishes the work of 30 emerging and 30 established artists/year; nearly 300 images/year.

First Contact & Terms Send slides, disks (10-15 JPEGs), transparencies or any other visual material that shows the work in the best light. "We review all types of two-dimensional art with no limitation on media or subject. Review period is one month, after which time we will contact you with our decision. If you wish the material to be returned, enclose a SASE. If forwarding material electronically, send easily opened JPEG files for initial review consideration only. Referrals to artists' Web sites will not be addressed. Contractual terms are discussed if work is accepted for publication."

Tips "Simplicity is very important in today's market (yet there still needs to be 'a story' to the image). Form and palette are critical to our decision process. We have a tremendous need for decorative pieces, especially new abstracts, landscapes and florals. Decorative still life images are very popular, whether painted or photographed, and much needed as well. There are a lot of prints and posters being published these days. Market your best material! Review our catalog at your neighborhood gallery or poster shop, or visit our Web site before submitting. Send your best."

MILL POND PRESS COMPANIES

250 Center Court, Venice FL 34285. (800)535-0331. Fax: (941)497-6026. E-mail: ellen@millpond.com. Web site: www.millpond.com. **Public Relations Director:** Ellen Collard. Licensing: Linda Schaner. Estab. 1973. Publishes limited editions, unlimited editions, offset reproductions and giclées on paper and on canvas. Divisions include Mill Pond Press, Visions of Faith, Mill Pond Art Licensing and NextMonet. Clients: galleries, frame shops and specialty shops, Christian book stores, licensees. Licenses various genres on a range of quality products.

Needs Seeking creative, decorative art. Open to all styles, primarily realism. Considers oil,

acrylic, watercolor and mixed media. Prefers wildlife, spiritual, figurative, landscapes and nostalgic. Artists represented include Paul Calle, Kathy Lawrence, Jane Jones, John Seerey-Lester, Robert Bateman, Carl Brenders, Nita Engle, Luke Buck and Maynard Reece. Editions are created by collaborating with the artist or by working from an existing painting. Approached by 250-300 artists/year. Publishes the work of 4-5 established artists/year. The company has a program to assist independent artists who want to self-publish.

First Contact & Terms Send query letter with photographs, résumé, SASE, slides or transparencies, and description of artwork. Samples are not filed and are returned by SASE. Responds in 1 year. Will contact artist for portfolio review if interested. Pays royalties. Rights purchased vary according to project. Requires exclusive representation of artist. Provides promotion, in-transit insurance, insurance while work is at firm, shipping to and from firm, and written contract. Finds artists through art exhibitions, submissions and word of mouth.

Tips "We continue to expand the genre published. Inspirational art has been part of expansion. Realism is our base, but we are open to looking at all art."

MUSEUM MASTERS INTERNATIONAL

185 E. 85th St., Suite 27B, New York NY 10028. (212)360-7100. Fax: (212)360-7102. E-mail: mmimarilyn@aol.com. Web site: www.museummasters.com. **President:** Marilyn Goldberg. Licensing agent for international artists and art estates. Distributor of limited editions, posters, tapestry and sculpture for galleries, museums and gift boutiques. Current clients include the Boutique/Galeria Picasso in Barcelona, Spain, and The Hakone Museum in Japan.

Needs Seeking artwork with decorative appeal for the designer market. Considers oil, acrylic, pastel, watercolor and mixed media. Artists for whom merchandise has been developed include Pablo Picasso, Salvador Dali, Andy Warhol, Keith Haring, Ed Heck, Jacques Tang.

First Contact & Terms E-mail with sample download of artwork offered. Samples are filed or returned. Call or write for appointment to show portfolio or mail slides and transparencies. Payment method is negotiated. Offers advance when appropriate. Negotiates rights purchased. Exclusive representation is not required. Provides insurance while work is at firm, shipping to firm and a written contract.

NEW YORK GRAPHIC SOCIETY

129 Glover Ave., Norwalk CT 06850-1311. (203)847-2000. Fax: (203)846-4869. E-mail: donna@nygs.com. Web site: www.nygs.com. **Contact:** Donna LeVan, vice president of publishing (contact via e-mail only, no phone calls). Estab. 1925. Specializes in fine art reproductions, prints, posters, canvases.

Needs Buys 150 images/year; 125 are supplied by freelancers. "Looking for variety of images."

First Contact & Terms Send query letter with samples to Attn: Artist Submissions. Does not keep samples on file; include SASE for return of material. Responds in 3 months. Payment negotiable. Pays on usage. Credit line given. Buys exclusive product rights. No phone calls.

Tips "Visit Web site to review artist submission guidelines and to see appropriate types of imagery for publication."

OLD GRANGE GRAPHICS

450 Applejack Rd., Manchester Center VT 05255. (800)282-7776. Fax: (802)362-3286. E-mail: jeff@denunzio.com. Web site: www.oldgrangegraphics.com. **Sales Vice President:** Jeff Sands. CEO/President: Jack Appelman. Estab. 1976. Distributor/canvas transfer studio. Publishes/dis-

tributes canvas transfers and posters. Clients: galleries, frame shops, museum shops, publishers, artists.

Needs Seeking decorative art for the commercial and designer markets. Considers lithographs. Prefers prints of artworks that were originally oil paintings. Editions are created by working from an existing painting. Approached by 100 artists/year.

First Contact & Terms Send query letter with brochure. Samples are not filed and are returned. Responds in 1 month. Will contact artist for portfolio review of tearsheets if interested. Negotiates payment. Rights purchased vary according to project. Provides promotion and shipping from firm. Finds artists through art publications.

Tips Recommends Galeria, Artorama and ArtExpo shows in New York, and *Decor*, *Art Trends*, *Art Business News* and *Picture Framing* as tools for learning about the current market.

PENNY LANE PUBLISHING INC.

1791 Dalton Dr., New Carlisle OH 45344. (937)849-1101. Fax: (937)849-9666. E-mail: info@PennyLanePublishing.com. Web site: www.PennyLanePublishing.com. **Art Coordinators:** Kathy Benton and Stacey Hoenie. Licensing: Renee Franck and Sara Elliott. Estab. 1993. Art publisher. Publishes limited editions, unlimited editions, offset reproductions. Clients: galleries, frame shops, distributors, decorators.

Needs Seeking creative, decorative art for the commercial market. Considers oil, acrylic, watercolor, mixed media, pastel. Artists represented include Linda Spivey, Donna Atkins, Lisa Hilliker, Pat Fischer, Annie LaPoint, Fiddlestix and Mary Ann June. Editions are created by collaborating with the artist or working from an existing painting. Approached by 40 artists/year. Publishes the work of 10 emerging, 15 mid-career and 6 established artists/year.

First Contact & Terms Send query letter with brochure, résumé, photographs, slides, tearsheets. Samples are filed or returned by SASE. Responds in 2 months. Will contact artist for portfolio review of color, final art, photographs, slides and tearsheets, if interested. Pays royalties. Buys first rights. Requires exclusive representation of artist. Provides advertising, shipping from firm, promotion, written contract. Finds artists through art fairs and exhibitions, submissions, decorating magazines.

Tips "Be aware of current color trends, and work in a series. Please review our Web site to see the style of artwork we publish."

🌐 PORTER DESIGN—EDITIONS PORTER

Court Farm House, Wello, Bath BA2 8PU United Kingdom. (866)293-2079. E-mail: service@porter-design.com. Web site: www.porter-design.com. **Partners:** Henry Porter and Mary Porter. Estab. 1985. Publishes limited and unlimited editions and offset productions and hand-colored reproductions. Clients: international distributors, interior designers and hotel contract art suppliers. Current clients include Devon Editions, Top Art, Harrods and Bruce McGaw.

Needs Seeking fashionable and decorative art for the designer market. Considers watercolor. Prefers 16th-19th century traditional styles. Artists represented include Victor Postolle, Joseph Hooker and Adrien Chancel. Editions are created by working from an existing painting. Approached by 10 artists/year. Publishes and distributes the work of 10-20 established artists/year.

First Contact & Terms Send query letter with brochure showing art style or résumé and photographs. Accepts disk submissions compatible with QuarkXPress on Mac. Samples are filed or

are returned. Responds only if interested. To show portfolio, mail photographs. Pays flat fee or royalties. Offers an advance when appropriate. Negotiates rights purchased.

PORTFOLIO GRAPHICS, INC.

Art Submissions, New York Graphic Society, 129 Glover Ave., Norwalk CT 06850. E-mail: dawn @nygs.com. Web site: www.nygs.com. **Creative Director:** Kent Barton. Estab. 1986. Publishes and distributes open edition prints, posters and hand-embellished canvas reproductions. Clients: galleries, designers, poster distributors (worldwide) and framers. Licensing: Most artwork is available for license for large variety of products. Portfolio Graphics works with a large licensing firm that represents all of their imagery.

Needs Seeking creative, fashionable and decorative art for commercial and designer markets. Considers oil, watercolor, acrylic, pastel, mixed media and photography. Publishes 100+ new works/year. Editions are created by working from an existing painting, transparency or high-resolution digital file.

First Contact & Terms Send query letter with résumé, bio and the images you are submitting via photos, transparencies, tearsheets or gallery booklets. "Please be sure to label each item. Please do no send original artwork. Make sure to include a SASE for any materials you would like returned." Samples are not filed. Responds in 3 months. Pays royalties of 10%. Provides promotion and a written contract.

Tips "We find artists through galleries, magazines, art exhibits and submissions. We're looking for a variety of artists and styles/subjects."

☒ POSTERS INTERNATIONAL

1180 Caledonia Rd. North York ON M6A 2W5 Canada. (416)789-7156. Fax: (416)789-7159. E-mail: art@postersinternational.net. Web site: www.postersinternational.net. **Art Director**: Dow Marcus Estab. 1976. Poster company, art publisher. Publishes fine art posters and giclee prints. Licenses for gift and stationery markets. Clients: galleries, designers, art consultants, framing, manufacturers, distributors, hotels, restaurants, etc., around the world. Current clients include Starwood Hotels and the Marriott.

Needs Seeking creative, fashionable art for the commercial market. Considers oil, acrylic, watercolor, mixed media, b&w and color photography. Prefers landscapes, florals, abstracts, photography, vintage, collage and tropical imagery. Editions are created by collaborating with the artist or by working from an existing painting. Approached by 100 artists/year.

First Contact & Terms Send query letter or e-mail with attachment, brochure, photographs. Responds in 2 months. Company will contact artist for portfolio review of photographs, tearsheets, thumbnails if interested. Pays flat fee or royalties of 10%. Rights purchased vary according to project. Provides advertising, promotion, shipping from firm, written contract. Finds artists through art fairs, art reps, submissions.

Tips "Be aware of current home décor color trends and always work in a series of two or more per theme/subject. Visit home décor retailers in their wall décor area for inspiration and guidance before submitting artwork."

PRESTIGE ART INC.

3909 W. Howard St., Skokie IL 60076. (847)679-2555. E-mail: unclelouieart@mac.com. Web site: www.prestigeart.com. **President:** Louis Schutz. Estab. 1960. Publisher/distributor/art gallery. Represents a combination of 18th and 19th century work and contemporary material.

Publishes and distributes hand-pulled originals, limited and unlimited editions, canvas transfers, fine art prints, offset reproductions, posters, sculpture. Licenses artwork for note cards, puzzles, album covers and posters. Clients: galleries, decorators, architects, corporate curators.

- Company president Louis Shutz does consultation for new artists on publishing and licensing their art in various media.

Needs Seeking creative and decorative art. Considers oil, acrylic, mixed media, sculpture, glass. Prefers figurative art, impressionism, surrealism/fantasy, photo realism. Artists represented include Jean-Paul Avisse. Editions are created by collaborating with the artist or by working from an existing painting. Approached by 15 artists/year. Publishes the work of 2 emerging artists/year. Distributes the work of 5 emerging artists/year.

First Contact & Terms Send query letter with résumé and tearsheets, photostats, slides, photographs and transparencies. Accepts IBM-compatible disk submissions. Samples are not filed and are returned by SASE. Responds only if interested. Company will contact artist for portfolio review of tearsheets if interested. Pays flat fee. Offers an advance when appropriate. Rights purchased vary according to project. Provides insurance in-transit and while work is at firm, advertising, promotion, shipping from firm and written contract.

Tips "Be professional. People are seeking better quality, lower-sized editions, fewer numbers per edition—1/100 instead of 1/750."

RIGHTS INTERNATIONAL GROUP, LLC

500 Paterson Plank Rd., Union City NJ 07030. (201)239-8118. Fax: (201)222-0694. E-mail: rhazaga@rightsinternational.com. Web site: www.rightsinternational.com. **Contact:** Robert Hazaga. Estab. 1996. Agency for cross licensing. Represents artists for licensing into publishing, stationery, posters, prints, calendars, giftware, home furnishing. Clients: publishers of giftware, stationery, posters, prints, calendars, wallcoverings and home decor.

- See additional listing in the Greeting Cards, Gifts & Products section.

Needs Seeking creative, decorative art for the commercial and designer markets. Also looking for "country/Americana with a fresh interpretation of country with more of a cottage influence. Think Martha Stewart, *Country Living* magazine; globally inspired artwork." Considers all media. Prefers commercial style. Approached by 50 artists/year. See Web site for artists represented.

First Contact & Terms Send brochure, photocopies, photographs, SASE, slides, tearsheets, transparencies, JPEGs, CD-ROM. Accepts disk submissions compatible with PC platform. Samples are not filed and are returned by SASE. Responds in 8 weeks. Will contact artist for portfolio review if interested. Negotiates payment.

Tips "Check our Web site for trend, color and style forecasts!"

RINEHART FINE ARTS

A division of Bentley Publishing Group, 290 West End Ave. #2d, New York NY 10023. (212)595-6862. Fax: (212)595-5837. E-mail: harriet@bentleypublishinggroup.com. Web site: www.bentleypublishinggroup.com. Poster/open edition print publisher and product licensing agent. **President:** Harriet Rinehart. Licenses 2D artwork for posters. Clients include large chain stores and wholesale framers, furniture stores, decorators, frame shops, museum shops, gift shops and substantial overseas distribution.

- See also listing for Bentley Publishing Group in this section.

Needs Seeking creative, fashionable and decorative art. Considers oil, acrylic, watercolor, mixed media, pastel. Images are created by collaborating with the artist or working from an existing

painting. Approached by 200-300 artists/year. Publishes the work of 50 new artists/year.

First Contact & Terms Send query letter with SASE, photographs, slides, tearsheets, transparencies, JPEGs or "whatever the artist has that represents artwork best." Samples are not filed. Responds in 3 months. Portfolio review not required. Pays royalties of 8-10%. Rights purchased vary according to project. Provides advertising, promotion, written contract and substantial overseas exposure.

Tips "Submit work in pairs or groups of four. Work in standard sizes. Visit high-end furniture store chains for color trends."

⊕ FELIX ROSENSTIEL'S WIDOW & SON LTD.

33-35 Markham St., London SW3 3NR United Kingdom. (44)(207)352-3551. Fax: (44)(207)351-5300. E-mail: sales@felixr.com. Web site: www.felixr.com. **Contact:** Ms. Anna Smithson. Licensing: Nicholas Edgar. Estab. 1880. Publishes art prints and posters, both limited and open editions. Licenses all subjects on any quality product. Art guidelines on Web site.

Needs Seeking decorative art for the serious collector and the commercial market. Considers oil, acrylic, watercolor, mixed media and pastel. Prefers art suitable for homes or offices. Editions are created by collaborating with the artist or by working from an existing painting. Approached by 200-500 artists/year.

First Contact & Terms Send query letter with photographs. Samples are not filed and are returned by SASE. Responds in 2 weeks. Company will contact artist for portfolio review of final art and transparencies if interested. Negotiates payment. Offers advance when appropriate. Rights purchased vary according to project.

Tips "We publish decorative, attractive, contemporary art."

SCHIFTAN INC.

1300 Steel Rd. W., Suite 4, Morrisville PA 19067. (215)428-2900 or (800)255-5004. Fax: (215)295-2345. E-mail: schiftan@erols.com. Web site: www.schiftan.com. **President:** Harvey S. Cohen. Estab. 1903. Art publisher/distributor. Publishes/distributes unlimited editions, fine art prints, offset reproductions, posters and hand-colored prints. Distributes unusual ready-made frames. Clients: galleries, decorators, frame shops, architects, wholesale framers to the furniture industry.

Needs Seeking fashionable, decorative art for the commercial market. Considers watercolor, mixed media. Editions are created by collaborating with the artist. Approached by 15-20 artists/year. Also needs freelancers for design.

First Contact & Terms Send query letter with transparencies. Samples are not filed and are returned. Responds in 1 week. Company will contact artist for portfolio review of final art, roughs, transparencies if interested. Pays flat fee or royalties. Offers advance when appropriate. Negotiates rights purchased. Provides advertising and written contract. Finds artists through art exhibitions, art fairs, submissions.

ℕ SCHLUMBERGER GALLERY

P.O. Box 2864, Santa Rosa CA 95405. (707)544-8356. Fax: (707)538-1953. E-mail: sande@schlumberger.org. **Owner:** Sande Schlumberger. Estab. 1986. Private Art Dealer, art publisher, distributor and gallery. Publishes and distributes limited editions, posters, original paintings and sculpture. Specializes in decorative and museum-quality art and photographs. Clients: collectors, designers, distributors, museums, galleries, film and television set designers. Current clients

include: Bank of America Collection, Fairmont Hotel, Editions Ltd., Sonoma Cutter Vineyards, Dr. Robert Jarvis Collection and Tom Sparks Collection.

Needs Seeking decorative art for the serious collector and the designer market. Prefers trompe l'oeil, realist, architectural, figure, portrait. Artists represented include Charles Giulioli, Deborah Deichler, Susan Van Camden, Aurore Carnero, Borislav Satijnac, Robert Hughes, Fletcher Smith, Jacques Henri Lartigue, Ruth Thorn Thompson, Ansel Adams and Tom Palmore. Editions created by collaborating with the artist or by working from an existing painting. Approached by 50 artists/year.

First Contact & Terms Send query letter with tearsheets and photographs. Samples are not filed and are returned by SASE if requested by artist. Publisher/distributor will contact artist for portfolio review if interested. Portfolio should include color photographs and transparencies. Negotiates payment. Offers advance when appropriate. Rights purchased vary according to project. Provides advertising, in-transit insurance, insurance while work is at firm, promotion, shipping to and from firm, written contract and shows. Finds artists through exhibits, referrals, submissions and "pure blind luck."

Tips "Strive for quality, clarity, clean lines and light, even if the style is impressionistic. Bring spirit into your images. It translates!"

SEGAL FINE ART

11955 Teller St., Unit C, Broomfield CO 80020-2823. (800)999-1297 or (303)926-6800. Fax: (303)926-0340. E-mail: carrie@segalfineart.com. Web site: www.segalfineart.com; www.motor cycleart.com. **Art Director:** Carrie Russell. Owner: Ron Segal. Estab. 1986. Art publisher. Publishes limited edition serigraphs, mixed media pieces and posters. Clients: galleries and Harely-Davidson dealerships.

Needs Seeking creative and fashionable art for the serious collector and commercial market. Considers oil, watercolor, mixed media and pastel. Artists represented include David Mann, Scott Jacobs and Motor Marc Lacourciere.

First Contact & Terms Send query letter with slides or résumé, bio and photographs. Samples are not filed and are returned by SASE. Responds in 2 months. To show portfolio, mail slides, color photographs, bio and résumé. Offers advance when appropriate. Negotiates payment method and rights purchased. Requires exclusive representation of artist. Provides promotion.

Tips Advises artists to "remain connected to their source of inspiration."

N ⊕ SJATIN ART B.V.

(formerly Sjatin Publishing & Licensing BV), P.O. Box 7201, Panningen, 5980 AE, The Netherlands. E-mail: art@sjatin.nl. Web site: www.sjatin.nl. **President:** Ton Hanssen. Estab. 1977. Art publisher. Publishes open editions, fine art prints. Licenses decorative art to appear on placemats, calendars, greeting cards, stationery, photo albums, embroidery, posters, canvas, textile, puzzles and gifts. Clients: picture framers, wholesalers, distributors of art print.

● Sjatin actively promotes worldwide distribution for artists they sign.

Needs Seeking decorative art for the commercial market. Considers oil, acrylic, watercolor, pastel. Prefers romantic themes, florals, landscapes/garden scenes, still lifes. Artists represented include Willem Haenraets, Peter Motz, Reint Withaar. Editions created by collaborating with the artist or by working from an existing painting. Approached by 50 artists/year. "We publish a very wide range of art prints and we sell copyrights over the whole world."

First Contact & Terms Send brochure and photographs. Responds only if interested. Company

will contact artist for portfolio review of color photographs (slides) if interested. Negotiates payment. Buys all rights. Provides advertising, promotion, shipping from firm and written contract (if requested).

Tips "Follow the trends in interior decoration; look at the furniture and colors. I receive so many artworks that are beautiful and very artistic, but are not commercial enough for reproduction. I need designs which appeal to many many people, worldwide such as flowers, gardens, interiors and kitchen scenes. I do not wish to receive graphic art."

SOMERSET FINE ART

29366 McKinnon Rd., P.O. Box 869, Fulshear TX 77441. (866)742-2215. Fax: (713)465-6062. E-mail: sallen@somersethouse.com. Web site: www.somersethouse.com. **Executive Vice President**: Stephanie Allen. Licensing: Pat Thomas. Estab. 1972. Art publisher of fine art limited editions: giclees, and repro-ductions on paper/canvas transfers. Clients include independent galleries in U.S. and Canada.

Needs Seeking fine art for the serious collector. Considers oil, acrylic, watercolor, mixed media, pastel. Also has a line of religious art. Artists represented include: Bill Anton, Darrell Bush, Rod Chase, Larry Dyke, Michael Dudash, Nancy Glazier, Ragan Gennusa, Bruce Greene, Martin Grelle, George Hallmark, G. Harvey, Mark Lague, David Mann, Bruce Miller, Robert Peters, Phillip Philbeck, James E. Seward, Kyle Sims, Andy Thomas, Bob Wygant and HongNian Zhang.Editions are created from an existing paintings or by collaborating with the artist. Approached by 1,500 artists/year. Publishes the work of 4 emerging, 4 mid-career and 7 established artists/year.

First Contact & Terms Send query letter accompanied by 10-12 slides or photos representative of work with SASE. Do not send transparencies until requested. Will review art on artist's Web site or submitted digital files in JPEG format. Also include number/size/price of all paintings sold within the last 24 months and list gallery representation. Samples are filed for future projects unless return is requested. Response in 2-3 months. Publisher will contact artist for portfolio review if interested. Pays royalties. Rights purchased vary according to project. Artist retains painting and copyrights. Written contract. Company provides advertising, promotion, in-transit insurance, shipping.

Tips Considers mature, full-time artists. Special consideration given to artists with originals selling above $25,000.

⊕ JACQUES SOUSSANA GRAPHICS

37 Pierre Koenig St., Jerusalem 91041 Israel. E-mail: jsgraphics@soussanart.com. Web site: www.soussanart.com. Estab. 1973. Art publisher. Publishes hand-pulled originals, limited editions, sculpture. Clients: galleries, decorators, frame shops, distributors, architects. Current clients include Royal Beach Hotel, Moriah Gallery, LCA, foreign ministry.

Needs Seeking decorative art for the serious collector and designer market. Considers oil, watercolor and sculpture. Artists represented include Adriana Naveh, Gregory Kohelet, Edwin Salomon, Samy Briss and Calman Shemi. Editions are created by collaborating with the artist. Approached by 20 artists/year. Publishes/distributes the work of 5 emerging artists/year.

First Contact & Terms Send query letter with brochure, slides. To show portfolio, artist should follow up with letter after initial query. Portfolio should include color photographs.

⬚ SUNSET MARKETING

14301 Panama City Beach Pkwy., Panama City Beach FL 32413. (850)233-6261. Fax: (850)233-9169. E-mail: info@sunsetartprints.com. Web site: www.sunsetartprints.com. **Product Development:** Denise Tannery. Estab. 1986. Art publisher and distributor of open edition prints. Clients: galleries, decorators, frame shops, distributors and corporate curators. Current clients include Stylecraft Home Collection, Paragon Picture Gallery, Propac Images, Allposters.com, and Lieberman's Gallery.

Needs Seeking fashionable and decorative art for the commercial and designer market. Considers oil, acrylic and watercolor art and home decor furnishings. Artists represented include Steve Butler, Dianne Krumel, Van Martin, Linda Amundsen, Jane Segrest, Kimberly Hudson, Carol Hallock, Talis Jayme and Barbara Shipman. Editions created by collaborating with the artist.

First Contact & Terms Send query letter with brochure, photocopies and photographs. Samples are filed. Company will contact artist for portfolio review of color final art, roughs and photographs if interested. Requires exclusive representation of artist.

SYRACUSE CULTURAL WORKERS

P.O. Box 6367, Syracuse NY 13217. (315)474-1132. Fax: (877)265-5399. E-mail: karenk@syracusculturalworkers.com. Web site: www.syracuseculturalworkers.com. **Art Director:** Karen Kerney. Produces posters, notecards, postcards, greeting cards, T-shirts and calendars that are feminist, multicultural, lesbian/gay allied, racially inclusive and honoring of elders and children (environmental and social justice themes).

 ● See additional listing in the Greeing Cards, Gifts & Products section.

Needs Art guidelines free for SASE with first-class postage; also available on Web site.

First Contact & Terms Pays flat fee, $85-400; royalties of 6% of gross sales.

Tips "View our Web site to get an idea of appropriate artwork for our company."

⬚ WINN DEVON ART GROUP

110-6311 Westminster Hwy., Richmond BC V7C 4V4 Canada. (604)276-4551. Fax: (604)276-4552. E-mail: artsubmission@encoreartgroup.com. Web site: www.winndevon.com. Art publisher. Publishes open and limited editions, offset reproductions, giclées and serigraphs. Clients: mostly trade, designer, decorators, galleries, retail frame shops. Current clients include Pier 1, Z Gallerie, Intercontinental Art, Chamton International, Bombay Co.

Needs Seeking decorative art for the designer market. Considers oil, watercolor, mixed media, pastel, pen & ink and acrylic. Artists represented include Buffet, Lourenco, Jardine, Hall, Goerschner, Lovelace, Bohne, Romeu and Tomao. Editions are created by working from an existing painting. Approached by 300-400 artists/year. Publishes and distributes the work of 0-3 emerging, 3-8 mid-career and 8-10 established artists/year.

First Contact & Terms Send query letter with brochure, slides, photocopies, résumé, photostats, transparencies, tearsheets or photographs. Samples are returned by SASE if requested by artist. Responds in 4-6 weeks. Publisher will contact artist for portfolio review if interested. Portfolio should include "whatever is appropriate to communicate the artist's talents." Payment is based on royalties. Copyright remains with artist. Provides written contract. Finds artists through art exhibitions, agents, sourcebooks, publications, submissions.

Tips Advises artists to attend WCAF Las Vegas and DECOR Expo Atlanta. "I would advise artists to attend just to see what is selling and being shown, but keep in mind that this is not a good time to approach publishers/exhibitors with your artwork."

Advertising, Design & Related Markets

This section offers a glimpse at one of the most lucrative markets for artists. Because of space constraints, the companies listed are just the tip of the proverbial iceberg. There are thousands of advertising agencies and public relations, design and marketing firms across the country and around the world. All rely on freelancers. Look for additional firms in industry directories such as *The Black Book* and *Workbook*. Find local firms in the yellow pages and your city's business-to-business directory. You can also pick up leads by reading *Adweek*, *HOW*, *PRINT*, *STEP inside design*, *Communication Arts* and other design and marketing publications.

Find your best clients

Read listings carefully to identify firms whose clients and specialties are in line with the type of work you create. (You'll find clients and specialties in the first paragraph of each listing.) For example, if you create charts and graphs, contact firms whose clients include financial institutions. Fashion illustrators should approach firms whose clients include department stores and catalog publishers. Sculptors and modelmakers might find opportunities with firms specializing in exhibition design.

Payment and copyright

You will most likely be paid by the hour for work done on the firm's premises (in-house), and by the project if you take the assignment back to your studio. Most checks are issued 40-60 days after completion of assignments. Fees depend on the client's budget, but most companies are willing to negotiate, taking into consideration the experience of the freelancer, the lead time given, and the complexity of the project. Be prepared to offer an estimate for your services, and ask for a purchase order (P.O.) before you begin an assignment.

Some art directors will ask you to provide a preliminary sketch on speculation or "on spec," which, if approved by the client, can land you a plum assignment. If you are asked to create something "on spec," be aware that you may not receive payment beyond an hourly fee for your time if the project falls through. Be sure to ask upfront about payment policy before you start an assignment.

If you're hoping to retain usage rights to your work, you'll want to discuss this upfront, too. You can generally charge more if the client is requesting a buyout. If research and travel are required, make sure you find out ahead of time who will cover these expenses.

▣ THE AD AGENCY

P.O. Box 470572, San Francisco CA 94147. **Creative Director:** Michael Carden. Estab. 1972. Ad agency; full-service multimedia firm. Specializes in print, collateral, magazine ads. Client list available upon request.

Needs Approached by 120 freelancers/year. Works with 120 freelance illustrators and designers/ year. Uses freelancers mainly for collateral, magazine ads, print ads; also for brochure, catalog and print ad design and illustration, mechanicals, billboards, posters, TV/film graphics, multimedia, lettering and logos. 60% of freelance work is with print ads. 50% of freelance design and 45% of illustration demand computer skills.

First Contact & Terms Send query letter with brochure, photocopies and SASE. Samples are filed or returned by SASE. Responds in 1 month. Portfolio should include color final art, photostats and photographs. Buys first rights or negotiates rights purchased. Finds artists through word of mouth, referrals and submissions.

Tips ''We are an eclectic agency with a variety of artistic needs.''

ADVANCED DESIGNS CORPORATION

1169 W. Second St., Bloomington IN 47403. (812)333-1922. Fax: (812)333-2030. Web site: www. doprad.com. **President:** Matt McGrath. Estab. 1982. AV firm. Specializes in TV news broadcasts. Product specialties are the Doppler Radar and Display Systems.

Needs Prefers freelancers with experience. Works on assignment only. Uses freelancers mainly for TV/film (weather) and cartographic graphics. Needs computer-literate freelancers for production. 100% of freelance work demands skills in ADC Graphics.

First Contact & Terms Send query letter with résumé and SASE. Samples are not filed and are returned by SASE. Pays for design and illustration by the hour, $7 minimum. Will contact artist for portfolio review if interested. Rights purchased vary according to project. Finds artists through classifieds.

ADVERTISING DESIGNERS, INC.

7087 Snyder Ridge Rd., Mariposa CA 95338-9029. (209)742-6704. E-mail: ad@yosemite.net. **President:** Tom Ohmer. Estab. 1947. Number of employees 2. Specializes in annual reports, corporate identity, ad campaigns, package and publication design and signage. Clients: corporations.

First Contact & Terms Send query letter with postcard sample. Samples are filed. Does not reply. Artist should call. Write for appointment to show portfolio.

▣ ▣ AM/PM ADVERTISING, INC.

345 Claremont Ave., Suite 26, Montclair NJ 07402. (973)824-8600. Fax: (973)824-6631. E-mail: mpt4220@aol.com. **President:** Robert Saks. Estab. 1962. Number of employees: 130. Approximate annual billing: $24 million. Ad agency; full-service multimedia firm. Specializes in national TV commercials and print ads. Product specialties are health and beauty aids. Current clients include J&J, Bristol Myers, Colgate Palmolive. Client list available upon request. Professional affiliations: AIGA, Art Directors Club, Illustration Club.

Needs Approached by 35 freelancers/year. Works with 3 freelance illustrators and designers/ month. Prefers to work with local freelancers with experience in animation, computer graphics, film/video production, multimedia, Macintosh. Works only with artists' reps. Works on assign-

ment only. Uses freelancers mainly for illustration and design; also for brochure design and illustration, storyboards, slide illustration, animation, technical illustration, TV/film graphics, lettering and logos. 30% of work is with print ads. 50% of work demands knowledge of Page-Maker, QuarkXPress, FreeHand, Illustrator or Photoshop.

First Contact & Terms Send postcard sample and/or query letter with brochure, résumé and photocopies. Samples are filed or returned. Responds in 10 days. Portfolios may be dropped off every Friday. Artist should follow up after initial query. Portfolio should include b&w and color thumbnails, roughs, final art, tearsheets, photographs and transparencies. Pays by the hour, $35-100; by the project, $300-5,000; or royalties, 25%. Rights purchased vary according to project.

Tips "When showing work, give time it took to do job and costs."

ASHCRAFT DESIGN

821 N. Nash Street, El Segundo CA 90245. (310)640-8330. Fax: (310)640-8333. E-mail: information@ashcraftdesign.com. Web site: www.ashcraftdesign.com. Estab. 1986. Specializes in corporate identity, display and package design and signage. Client list available upon request.

Needs Approached by 2 freelance artists/year. Works with 1 freelance illustrator and 2 freelance designers/year. Works on assignment only. Uses freelance illustrators mainly for technical illustration. Uses freelance designers mainly for packaging and production. Also uses freelance artists for mechanicals and model making.

First Contact & Terms Send query letter with tearsheets, résumé and photographs. Samples are filed and are not returned. Responds only if interested. To show a portfolio, e-mail samples or mail color copies. Pays for design and illustration by the project. Rights purchased vary according to project.

⚡ ASHER AGENCY

535 W. Wayne St., Fort Wayne IN 46802. (260)424-3373. Fax: (260)424-0848. E-mail: webelieve@asheragency.com. Web site: www.asheragency.com. **Creative Director:** Matt Georgi. Estab. 1974. Approximate annual billing: $12 million. Full service ad agency and PR firm. Clients: automotive firms, financial/investment firms, area economic development agencies, health care providers, fast food companies, gaming companies and industrial.

Needs Works with 5-10 freelance artists/year. Assigns 25-50 freelance jobs/year. Prefers local artists. Works on assignment only. Uses freelance artists mainly for illustration; also for design, brochures, catalogs, consumer and trade magazines, retouching, billboards, posters, direct mail packages, logos and advertisements.

First Contact & Terms Send query letter with brochure showing art style or tearsheets and photocopies. Samples are filed or are returned by SASE. Responds only if interested. Will contact artist for portfolio review if interested. Portfolio should include roughs, original/final art, tearsheets and final reproduction/product. Pays for design by the hour, $40 minimum. Pays for illustration by the project, $40 minimum. Finds artists usually through word of mouth.

AURELIO & FRIENDS, INC.

14971 SW 43 Terrace, Miami FL 33185. (305)225-2434. Fax: (305)225-2121. E-mail: aurelio97@aol.com. **President:** Aurelio Sica. Vice President: Nancy Sica. Estab. 1973. Number of employees 3. Specializes in corporate advertising and graphic design. Clients: corporations, retailers, large companies, hotels and resorts.

Needs Approached by 4-5 freelancers/year. Works with 1-2 freelance illustrators and 3-5 design-

ers/year. Uses freelancers for ad design and illustration, brochure, catalog and direct mail design, and mechanicals. 50% of freelance work demands knowledge of Adobe Ilustrator, Photoshop and QuarkXPress.

First Contact & Terms Send brochure and tearsheets. Samples are filed. Will contact artist for portfolio review if interested. Portfolio should include b&w and color final art, photographs, roughs and transparencies. Pays for design and illustration by the project. Buys all rights.

THE BAILEY GROUP, INC.

200 West Germantown Pike, Plymouth Meeting PA 19462. (610)940-9030. Web site: www.bailey gp.com. **Creative Director:** David Fiedler. Estab. 1985. Number of employees: 38. Specializes in package design, brand and corporate identity, sales promotion materials, corporate communications and signage systems. Clients: corporations (food, drug, health and beauty aids). Current clients include Aetna, Johnson & Johnson Consumer Products Co., Wills Eye Hospital and Welch's. Professional affiliations: AIGA, PDC, APP, AMA, ADC.

Needs Approached by 10 freelancers/year. Works with 3-6 freelance illustrators and 3-6 designers/year. Uses illustrators mainly for editorial, technical and medical illustration and final art, charts and airbrushing. Uses designers mainly for freelance production (*not* design), or computer only. Also uses freelancers for mechanicals, brochure and catalog design and illustration, P-O-P illustration and model-making.

First Contact & Terms Send query letter with brochure, résumé, tearsheets and photographs. Samples are filed. Responds only if interested. Will contact for portfolio review if interested. Portfolio should include finished art samples, color tearsheets, transparencies and artist's choice of other materials. May pay for illustration by the hour, $10-15; by the project, $300-3,000. Rights purchased vary according to project.

Tips Finds artists through word of mouth, self-promotions and sourcebooks.

AUGUSTUS BARNETT ADVERTISING/DESIGN

P.O. Box 197, Fox Island WA 98333. (253)549-2396. Fax: (253)549-4707. E-mail: charlieb@augu stusbarnett.com. Web site: www.augustusbarnett.com. **President/Creative Director:** Charlie Barnett. Estab. 1981. Approximate annual billing: $1.2 million. Specializes in food/beverage, financial, agricultural, corporate identity, package design. Clients: corporations, manufacturers. Current clients include Tree Top, Inc.; Nunhems USA; VOLTA. Client list available upon request.

Needs Approached by more than 50 freelancers/year. Works with 2-4 freelance illustrators and 2-3 designers/year. Prefers freelancers with experience. Works as consultant, on assignment and retainer. Uses illustrators and photographers as needed. Also uses freelancers for multimedia projects.

First Contact & Terms Send query letter with samples, résumé and photocopies. Samples are filed. Responds in 1 month. Pays for design by the hour, negotiable. Pays for illustration by project/use and buyouts. Rights purchased vary according to project.

⚉ BARNSTORM VISUAL COMMUNICATIONS, INC.

530 E. Colorado Ave., Colorado Springs CO 80903. (719)630-7200. Fax: (719)630-3280. Web site: www.barnstormcreative.biz. **Owner:** Becky Houston. Estab. 1975. Specializes in corporate identity, brochure design, publications, Web design and Internet marketing. Clients high-tech corporations, nonprofit fundraising, business-to-business and restaurants. Current clients include Liberty Wire and Cable, Colorado Springs Visitors Bureau and Billiard Congress of America.

Needs Works with 2-4 freelance artists/year. Prefers local, experienced (clean, fast and accurate) artists with experience in TV/film graphics and multimedia. Works on assignment only. Uses freelancers mainly for editorial and technical illustration and production. Needs computer-literate freelancers for production. 90% of freelance work demands knowledge of Illustrator, QuarkXPress, Photoshop, Macromedia FreeHand, InDesign and Flash.

First Contact & Terms Send query letter with résumé and samples to be kept on file. Prefers "good originals or reproductions, professionally presented in any form" as samples. Samples not filed are returned by SASE. Responds only if interested. Call or write for appointment to show portfolio. Pays for design by the hour/$15-40. Pays for illustration by the project, $500 minimum for b&w. Considers client's budget, skill and experience of artist, and turnaround time when establishing payment.

Tips "Portfolios should reflect an awareness of current trends. We try to handle as much inhouse as we can, but we recognize our own limitations (particularly in illustration). Do not include too many samples in your portfolio."

BBDO NEW YORK

1285 Avenue of the Americas, New York NY 10019. (212)459-5000. Fax: (212)459-6645. E-mail: mark.goldstein@bbdo.com. Web site: www.bbdo.com. Estab. 1891. Number of employees: 850. Annual billing: $50,000,000. Ad agency; full-service multimedia firm. Specializes in business, consumer advertising, sports marketing and brand development. Clients include Texaco, Frito Lay, Bayer, Campbell Soup, FedEx, Pepsi, Visa and Pizza Hut.

- BBDO Art Director told our editors he is always open to new ideas and maintains an open drop-off policy. If you call and arrange to drop off your portfolio, he'll review it, and you can pick it up in a couple days.

▓ BEDA DESIGN

P.O. Box 16, Lake Villa IL 60046. E-mail: bedadesign@earthlink.net. **President:** Lynn Beda. Estab. 1971. **Design firm:** Specializes in packaging, print material, publishing, film and video documentaries. Current clients include business-to-business accounts, producers to writers, directors and artists. Approximate annual billing: $300,000

Needs Web page builders in Mac platforms. Use skilled Mac freelancers for Retouching, Technical, Illustration, Production, Photoshop, QuarkXPress, Illustrator, Premiere, and Go Live. Use film and editorial writers and photographers.

First Contact & Terms Designers: Send query letter with brochure, photocopies and résumé. Illustrators: Send postcard samples and/or photocopies. Samples are filed and are not returned. Will contact for portfolio review if interested.

BELYEA

1809 Seventh Ave., Suite 1250, Seattle WA 98101. (206)682-4895. Fax: (206)623-8912. Web site: www.belyea.com. Estab. 1988. Design firm. Specializes in brand and corporate identity, marketing collateral, in-store P-O-P, direct mail, packages and publication design. Clients: corporate, manufacturers, retail. Current clients include PEMCO Insurance, Genie Industries, and Weyerhaeuser. Client list available upon request.

Needs Approached by 20-30 freelancers/year. Works with 3 freelance illustrators/photographers and no designers/year. Works on assignment only. Uses illustrators for "any type of project." Also uses freelancers for lettering. 100% of design and 70% of illustration demands skills in Adobe CS.

First Contact & Terms Send postcard sample and résumé. Samples are filed. Responds only if interested. Pays for illustration by the project. Rights purchased vary according to project. Finds artists through submissions by mail and referral by other professionals.

Tips "Designers must be computer-skilled. Illustrators must develop some styles that make them unique in the marketplace. When pursuing potential clients, send something (one or more) distinctive. Follow up. Be persistent (it can take one or two years to get noticed) but not pesky. Always do the best work you can—exceed everyone's expectations."

BERSON, DEAN, STEVENS

P.O. Box 3997, West Lake Village CA 91359. (818)713-0134. Fax: (818)713-0417. E-mail: info@b ersondeanstevens.com. Web site: www.bersondeanstevens.com. **Owner:** Lori Berson. Estab. 1981. Specializes in annual reports, brand and corporate identity, collateral, direct mail, trade show booths, promotions, Web sites, packaging, and publication design. Clients: manufacturers, professional and financial service firms, ad agencies, corporations and movie studios. Professional affiliation L.A. Ad Club.

Needs Approached by 50 freelancers/year. Works with 10-20 illustrators and 10 designers/year. Works on assignment only. Uses illustrators mainly for brochures, packaging, and comps. Also for catalog, P-O-P, ad and poster illustration, mechanicals retouching, airbrushing, lettering, logos and model-making. 90% of freelance work demands skills in Illustrator, QuarkXPress, Photoshop, as well as Web authoring Dreamweaver, Flash/HTML, CGI, Java, etc.

First Contact & Terms Send query letter with tearsheets and photocopies. Samples are filed. Will contact artist for portfolio review if interested. Pays for design and illustration by the project. Rights purchased vary according to project. Considers buying second rights (reprint rights) to previously published work. Finds artists through word of mouth, submissions/self-promotions, sourcebooks and agents.

BFL MARKETING COMMUNICATIONS

2000 Sycamore St., 4th Floor, Cleveland OH 44113. (216)875-8860. Fax: (216)875-8870. E-mail: dpavan@bflcom.com. Web site: www.bflcom.com. **President:** Dennis Pavan. Estab. 1955. Number of employees: 12. Approximate annual billing: $6.5 million. Marketing communications firm; full-service multimedia firm. Specializes in new product marketing, Web site design, interactive media. Product specialty is consumer home products. Client list available upon request. Professional affiliations: North American Advertising Agency Network, BPAA.

Needs Approached by 20 freelancers/year. Works with 5 freelance illustrators and 5 designers/year. Prefers freelancers with experience in advertising design. Uses freelancers mainly for graphic design, illustration; also for brochure and catalog design and illustration, lettering, logos, model making, posters, retouching, TV/film graphics. 80% of work is with print ads. Needs computer-literate freelancers for design, illustration, production and presentation. 50% of freelance work demands knowledge of FreeHand, Photoshop, QuarkXPress, Illustrator.

First Contact & Terms Send postcard-size sample of work or send query letter with brochure, photostats, tearsheets, photocopies, résumé, slides and photographs. Samples are filed or returned by SASE. Responds in 2 weeks. Artist should follow-up with call and/or letter after initial query. Will contact artist for portfolio review if interested. Portfolio should include b&w and color final art, photographs, photostats, roughs, slides and thumbnails. Pays by the project, $200 minimum.

Tips Finds artists through *Creative Black Book, Illustration Annual, Communication Arts*, local interviews. ''Seeking specialist in Internet design, CD-ROM computer presentations and interactive media.''

BIGGS-GILMORE

261 E. Kalamazoo Ave., Suite 300, Kalamazoo MI 49007-3990. (269)349-7711. Fax: (269)349-9657. E-mail: mpuhalj@biggs-gilmore.com. Web site: www.biggs-gilmore.com. **Creative Director:**Marino Puhalj. Estab. 1973. Ad agency; full-service multimedia firm. Specializes in traditional advertising (print, collateral, TV, radio, outdoor), branding, strategic planning, e-business development, and media planning and buying. Product specialties are consumer, business-to-business, marine and healthcare. Clients include Morningstar Farms, Pfizer, Kellogg Company, Zimmer, Beaner's Coffee, United Way.

Needs Approached by 10 artists/month. Works with 1-3 illustrators and designers/month. Works both with artist reps and directly with artist. Prefers artists with experience with client needs. Works on assignment only. Uses freelancers mainly for completion of projects needing specialties; also for brochure, catalog and print ad design and illustration, storyboards, mechanicals, retouching, billboards, posters, TV/film graphics, lettering and logos.

First Contact & Terms Send query letter with brochure, photocopies and résumé. Samples are filed. Responds only if interested. Call for appointment to show portfolio. Portfolio should include all samples the artist considers appropriate. Pays for design and illustration by the hour and by the project. Rights purchased vary according to project.

⛏ SAM BLATE ASSOCIATES LLC

10331 Watkins Mill Dr., Montgomery Village MD 20886-3950. (301)840-2248. Fax: (301)990-0707. E-mail: info@writephotopro.com. Web site: www.writephotopro.com. **President:** Sam Blate. Number of employees: 2. Approximate annual billing: $120,000. AV and editorial services firm. Clients: business/professional, U.S. government, private.

Needs Approached by 6-10 freelancers/year. Works with 1-5 freelance illustrators and 1-2 designers/year. Prefers to work with freelancers in the Washington, DC, metropolitan area. Works on assignment only. Uses freelancers for cartoons (especially for certain types of audiovisual presentations), editorial and technical illustrations (graphs, etc.), 35mm and digital slides, pamphlet and book design. Especially important are ''technical and aesthetic excellence and ability to meet deadlines.'' 80% of freelance work demands knowledge of PageMaker, Photoshop, and/or Powerpoint for Windows.

First Contact & Terms Send query letter with résumé and Web site, tearsheets, brochure, photocopies, slides, transparencies or photographs to be kept on file. Accepts disk submissions compatible with Photoshop and PageMaker; IBM format only. ''No original art.'' Samples are returned only by SASE. Responds only if interested. Pays by the hour, $20-50. Rights purchased vary according to project, ''but we prefer to purchase first rights only. This is sometimes not possible due to client demand, in which case we attempt to negotiate a financial adjustment for the artist.''

Tips ''The demand for technically-oriented artwork has increased.''

BLOCK & DECORSO

3 Clairidge Dr., Verona NJ 07044. (973)857-3900. Fax: (973)857-4041. E-mail: kdeluca@blockde corso.com. Web site: www.blockdecorso.com. **Senior VP/Creative Director:** Karen DeLuca. Senior Art Director: Jay Baumann. Studio Manager: John Murray. Art Director: Jennifer

Schwartz. Estab. 1939. Number of employees: 25. Approximate annual billing: $12 million. Product specialties are food and beverage, education, finance, home fashion, giftware, healthcare and industrial manufacturing. Professional affiliations: Ad Club of North Jersey.

Needs Approached by 100 freelancers/year. Works with 25 freelance illustrators and 25 designers/year. Prefers to work with "freelancers with at least 3-5 years experience as Mac-compatible artists and 'on premises' work as Mac artists." Uses freelancers for "consumer friendly" technical illustration, layout, lettering, mechanicals and retouching for ads, annual reports, billboards, catalogs, letterhead, brochures and corporate identity. Needs computer-literate freelancers for design and presentation. 90% of freelance work demands knowledge of QuarkXPress, Illustrator, Type-Styler and Photoshop.

First Contact & Terms To show portfolio, mail appropriate samples and follow up with a phone call. E-mail résumé and samples of work or mail the same. Responds in 2 weeks. Pays for design by the hour, $20-60. Pays for illustration by the project, $250-5,000 or more.

Tips "We are fortunately busy—we use four to six freelancers daily. Be familiar with the latest versions of QuarkXpress, Illustrator and Photoshop. We like to see sketches of the first round of ideas. Make yourself available occasionally to work on premises. Be flexible in usage rights!"

BOB BOEBERITZ DESIGN

247 Charlotte St., Asheville NC 28801. (828)258-0316. E-mail: bobb@main.nc.us. Web site: www.bobboeberitzdesign.com. **Owner:** Bob Boeberitz. Estab. 1984. Number of employees 1. Approximate annual billing $80,000. Specializes in graphic design, corporate identity and package design. Clients: retail outlets, hotels and restaurants, dot com companies, record companies, publishers, professional services. Majority of clients are business-to-business. Current clients include Para Research Software, SalesVantage.com, AvL Technologies, Southern Appalachian Repertory Theatre, Billy Edd Wheeler (Songwriter/Playwright), Shelby Stephenson (poet), and High Windy Audio. Professional affiliations AAF, NARAS, Asheville Freelance Network, Asheville Creative Services Group, Public Relations Association of WNC.

Needs Approached by 50 freelancers/year. Works with 2 freelance illustrators/year. Works on assignment only. Uses freelancers primarily for technical illustration and comps. Prefers pen & ink, airbrush and acrylic. 50% of freelance work demands knowledge of PageMaker, Illustrator, Photoshop or CorelDraw.

First Contact & Terms Send query letter with résumé, brochure, SASE, photographs, slides and tearsheets. "Anything too large to fit in file" is discarded. Accepts disk submissions compatible with IBM PCs. Send AI-EPS, PDF, JPEG, GIF, HTML and TIFF files. Samples are returned by SASE if requested. Responds only if interested. Will contact artist for portfolio review if interested. Portfolio should include thumbnails, roughs, final art, b&w and color slides and photographs. Sometimes requests work on spec before assigning a job. Pays for design and illustration, by the project, $50 minimum. Rights purchased vary according to project. Will consider buying second rights to previously published artwork. Finds artists through word of mouth, submissions/self-promotions, sourcebooks, agents.

Tips "Show sketches. Sketches help indicate how an artist thinks. The most common mistake freelancers make in presenting samples or portfolios is not showing how the concept was developed, what their role was in it. I always see the final solution, but never what went into it. In illustration, show both the art and how it was used. Portfolios should be neat, clean and flattering to your work. Show only the most memorable work, what you do best. Always have other stuff, but don't show everything. Be brief. Don't just toss a portfolio on my desk; guide me through

it. A 'leave-behind' is helpful, along with a distinctive-looking résumé. Be persistent but polite. Call frequently. I don't recommend cold calls (you rarely ever get to see anyone) but it is an opportunity for a 'leave-behind.' I recommend using the mail. E-mail is okay, but it isn't saved. Asking people to print out your samples to save in a file is asking too much. I like postcards. They get noticed, maybe even kept. They're economical. And they show off your work. And you can do them more frequently. Plus you'll have a better chance to get an appointment. After you've had an appointment, send a thank you note. Say you'll keep in touch and do it!''

BOOKMAKERS LTD.

P.O. Box 1086, Taos NM 87571. (575)776-5435. Fax: (575)776-2762. E-mail: gayle@bookmakersl td.com. Web site: www.bookmakersltd.com. **President:** Gayle McNeil . Estab. 1975. Full-service design and production studio. "We provide design and production services to the publishing industry. We also represent a group of the best children's book illustrators in the business. We welcome authors who are interested in self-publishing."

• This company is also listed in the Artists' Reps section.

First Contact & Terms Send query letter with samples. Include SASE if samples need to be returned. E-mail inquiries preferred.

Tips The most common mistake illustrators make in presenting samples or portfolios is "too much variety, not enough focus."

BOYDEN & YOUNGBLUTT ADVERTISING & MARKETING

120 W. Superior St., Fort Wayne IN 46802. (260)422-4499. Fax: (260)422-4044. E-mail: info@b-y.net. Web site: www.b-y.net. **Vice President:** Jerry Youngblutt. Estab. 1990. Number of employees 24. Ad agency. Full-service, multimedia firm. Specializes in magazine ads, collateral, web, media, television.

Needs Approached by 10 freelancers/year. Works with 3-4 freelance illustrators and 5-6 designers/year. Uses freelancers mainly for collateral layout and Web. Also for annual reports, billboards, brochure design and illustration, logos and model-making. 25% of work is with print ads, 25% web, 25% media, and 25% TV. Needs computer-literate freelancers for design. 100% of freelance work demands knowledge of FreeHand, Photoshop, Adobe Ilustrator, Web Weaver and InDesign.

First Contact & Terms Send query letter with photostats and résumé. Samples are filed. Will contact artist for portfolio review if interested. Portfolio should include b&w and color final art. Pays for design and illustration by the project. Buys all rights.

Tips Finds artists through sourcebooks, word of mouth and artists' submissions. "Send a precise résumé with what you feel are your 'best' samples—less is more."

⊞ BRAGAW PUBLIC RELATIONS SERVICES

800 E. Northwest Hwy., Palatine IL 60074. (847)934-5580. Fax: (847)934-5596. E-mail: info@bra gawpr.com. Web site: www.bragawpr.com. **President:** Richard S. Bragaw. Number of employees: 3. PR firm. Specializes in newsletters and brochures. Clients: professional service firms, associations, public agencies and industry. Current clients available on Web site.

Needs Approached by 12 freelancers/year. Works with 2 freelance illustrators and 2 designers/year. Prefers local freelancers only. Works on assignment only. Uses freelancers for direct mail packages, newsletters, brochures, signage, AV presentations and press releases. 90% of freelance work demands knowledge of PageMaker. Needs editorial and medical illustration.

First Contact & Terms E-mail query with Web site link or mail query. Send query letter with brochure to be kept on file. Responds only if interested. Pays by the hour, $25-75 average. Considers complexity of project, skill and experience of artist and turnaround time when establishing payment. Buys all rights.

Tips "We do not spend much time with portfolios."

BRAINWORKS DESIGN GROUP, INC.

5 Harris Court, Building T, Monterey CA 93940. (831)657-0650. Fax: (831)657-0750. E-mail: mail@brainwks.com. Web site: www.brainwks.com. **President:** Alfred Kahn. Marketing Director: Christina Buckman. Estab. 1970. Number of employees: 8. Specializes in ERC (Emotional Response Communications), graphic design, corporate identity, direct mail and publication. Clients: colleges, universities, nonprofit organizations; majority are colleges and universities. Current clients include City College of New York, Queens College, Manhattan College, Nova University, University of Rochester, Florida Intenational University, Cleveland Chiropractic College, Art Instiute of N.Y., Naval post graduate school.

Needs Approached by 50 freelancers/year. Works with 4 freelance illustrators and 10 designers/year. Prefers freelancers with experience in type, layout, grids, mechanicals, comps and creative visual thinking. Works on assignment only. Uses freelancers mainly for Web Design; also for brochure, direct mail and poster design; lettering; and logos. 100% of design work demands knowledge of QuarkXPress, Illustrator, Photoshop and InDesign.

First Contact & Terms Send brochure or résumé, photocopies, photographs, tearsheets and transparencies. Samples are filed. Artist should follow up with call and/or letter after initial query. Will contact artist for portfolio review if interested. Portfolio should include thumbnails, roughs, final reproduction/product and b&w and color tearsheets, photostats, photographs and transparencies. Pays for design by the project, $100-1,000. Considers complexity of project and client's budget when establishing payment. Rights purchased vary according to project. Finds artists through sourcebooks and self-promotions.

Tips "Creative thinking and a positive attitude are a plus." The most common mistake freelancers make in presenting samples or portfolios is that the "work does not match up to the samples they show." Would like to see more roughs and thumbnails.

N BRAMSON + ASSOCIATES

7400 Beverly Blvd., Los Angeles CA 90036. (323)938-3595. Fax: (323)938-0852. E-mail: gbramson@aol.com. **Principal/Senior Creative Director:** Gene Bramson. Estab. 1970. Number of employees 15. Approximate annual billing more than $4 million. Advertising agency. Specializes in magazine branding ads, collateral, ID, signage, graphic design, imaging, campaigns. Product specialties are healthcare, consumer, business to business. Current clients include Johnson & Johnson, Chiron Vision, Lawry's and Isuzu Motors of America.

Needs Approached by 150 freelancers/year. Works with 10 freelance illustrators, 2 animators and 5 designers/year. Prefers local freelancers. Works on assignment only. Uses freelancers for brochure and print ad design; brochure, technical, medical and print ad illustration, storyboards, mechanicals, retouching, lettering, logos. 30% of work is with print ads. 50% of freelance work "prefers" knowledge of Illustrator, QuarkXPress, Photoshop, Freehand or 3-D Studio. In Design.

First Contact & Terms Send query letter with brochure, photocopies, résumé, photographs, tearsheets, SASE. Samples are filed. Will contact artist for portfolio review if interested. Portfolio should include roughs, color tearsheets. Sometimes requests work on spec before assigning job.

Pays for design by the hour, $20-75. Pays for illustration by the project, $250-2,000. Buys all rights or negotiates rights purchased. Finds artists through sourcebooks.

Tips Looks for "very unique talent only." Price and availability are also important.

BRANDLOGIC

15 River Rd., Wilton CT 06897-4080. (203)834-0087. E-mail: klh@brandlogic.com. Web site: www.brandlogic.com. **Assistant Creative Director:** Karen Lukas-Hardy. Specializes in annual reports, corporate brand identity, Web site design, publications. Current clients include IBM, Siemens, Texaco, Wyeth.

Needs Works with 30 artists/year. Works on assignment only. Uses artists for editorial illustration. Needs computer-literate freelancers for illustration. 30% of freelance work demands knowledge of Illustrator.

First Contact & Terms *"No* phone calls!" Send query letter with tearsheets, slides, photostats or photocopies. Samples not kept on file are returned by SASE only. Responds only if interested. Pays for illustration by the project, $300-3,500 average. Considers client's budget, skill and experience of artist, and how work will be used when establishing payment.

▣ LEO J. BRENNAN, INC.

2359 Livernois, Troy MI 48083-1692. (248)362-3131. Fax: (248)362-2355. E-mail: lbrennan@ljbr ennan.com. Web site: www.ljbrennan.com. **President:** Leo Brennan. Estab. 1969. Number of employees: 3. Ad, PR and marketing firm. Clients: industrial, electronics, robotics, automotive, chemical, tooling, B2B.

Needs Works with 2 illustrators and 2 designers/year. Prefers experienced artists. Uses freelancers for design, technical illustration, brochures, catalogs, retouching, lettering, keylining and typesetting; also for multimedia projects. 50% of work is with print ads. 100% of freelance work demands knowledge of IBM software graphics programs.

First Contact & Terms Send query letter with résumé and samples. Samples not filed are returned only if requested. Responds only if interested. Call for appointment to show portfolio of thumbnails, roughs, original/final art, final reproduction/product, color and b&w tearsheets, photostats and photographs. Payment for design and illustration varies. Buys all rights.

BRIGHT IDEAS

A.W. Peller and Associates, Inc., 116 Washington Ave., Hawthorne NJ 07507. (800)451-7450. Fax: (973)423-5569. E-mail: awpeller@optonline.net. Web site: www.awpeller.com. **Art Director:** Karen Birchak. Estab. 1973. Number of employees: 12. AV producer. Serves clients in education. Produces children's educational materials—videos, sound filmstrips, read-along books, cassettes and CD-ROMs.

Needs Works with 1-2 freelance illustrators/year. "While not a requirement, a freelancer living in the same geographic area is a plus." Works on assignment only, "although if someone had a project already put together, we would consider it." Uses freelancers mainly for illustrating children's books; also for artwork for filmstrips, sketches for books and layout work. 50% of freelance work demands knowledge of QuarkXPress and Photoshop.

First Contact & Terms Send query letter with résumé, tearsheets, SASE, photocopies and photographs. Will contact artist for portfolio review if interested. "Include child-oriented drawings in your portfolio." Requests work on spec before assigning a job. Pays for design and illustration by the project, $20 minimum. Originals not returned. Buys all rights. Finds artists through submissions.

BRIGHT LIGHT PRODUCTIONS, INC.

602 Main St., Suite 810, Cincinnati OH 45202. (513)721-2574. Fax: (513)721-3329. E-mail: info@ brightlightusa.com. Web site: www.brightlightusa.com. **Contact:** Ken Sharp, HR coordinator. Estab. 1976. ''We are a full-service film/video communications firm producing TV commercials and corporate communications.''

Needs Works on assignment only. Uses artists for editorial, technical and medical illustration and brochure and print ad design, storyboards, slide illustration, animatics, animation, TV/ film graphics and logos. Needs computer-literate freelancers for design and production. 50% of freelance work demands knowledge of Photoshop, Illustrator and After Effects.

First Contact & Terms Send query letter with brochure and résumé. Samples not filed are returned by SASE only if requested by artist. Request portfolio review in original query. Portfolio should include roughs and photographs. Pays for design and illustration by the project. Negotiates rights purchased. Finds artists through recommendations.

Tips ''Our need for freelance artists is growing.''

⚜ BROMLEY COMMUNICATIONS

401 E. Houston St., San Antonio TX 78205. (210)244-2000. Fax: (210)244-2442. E-mail: info@bro mcomm.com. Web site: www.bromleyville.com. **Chief Creative Officer:** Cat Lopez. Number of employees: 80. Approximate annual billing: $80 million. Estab. 1986. Full-service, multimedia ad agency and PR firm. Specializes in TV, radio and magazine ads, etc. Specializes in consumer service firms and Hispanic markets. Current clients include BellSouth, Burger King, Circuit City, Continental Airlines, Nestlé, Procter & Gamble.

Needs Approached by 3 artists/month. Prefers local artists only. Works on assignment only. Uses freelancers for storyboards, slide illustration, new business presentations and TV/film graphics and logos. 35% of work is with print ads. 25% of freelance work demands knowledge of PageMaker, QuarkXPress and Illustrator.

First Contact & Terms Send query letter with brochure and résumé. Samples are not filed and are returned by SASE only if requested by artist. Responds only if interested. Write for appointment to show portfolio.

BROWNING ADVERTISING

1 Browning Place, Morgan UT 84050. (801)876-2711. Fax: (801)876-3331. Web site: www.brown ing.com. **Contact:** Senior Art Director. Estab. 1878. Distributor and marketer of outdoor sports products, particularly firearms. Inhouse agency for 3 main clients. Inhouse divisions include non-gun hunting products, firearms and accessories.

Needs Approached by 50 freelancers/year. View Web site for any upcoming freelance opportunites. Prefers freelancers with experience in outdoor sportshunting, shooting, fishing. Works on assignment only. Uses freelancers occasionally for design, illustration and production. Also for advertising and brochure layout, catalogs, product rendering and design, signage, P-O-P displays, and posters.

First Contact & Terms Send query letter with résumé and tearsheets, slides, photographs and transparencies. Samples are not filed and are not returned. Responds only if interested. To show portfolio, mail photostats, slides, tearsheets, transparencies and photographs. Pays for design by the hour, $50-75. Pays for illustration by the project. Buys all rights or reprint rights.

▒ BRYANT, LAHEY & BARNES ADVERTISING & MARKETING

5300 Foxridge Dr., Mission KS 66202. (913)262-7075. Fax: (913)262-2049. E-mail: advertising@blbadv.com. Web site: www.blbadv.com. **Contact:** Art Director. Estab. 1976. Ad agency. Clients: agriculture and veterinary firms.

Needs Local freelancers only. Uses freelancers for illustration and production, via Mac format only; consumer and trade magazines and brochures/flyers.

First Contact & Terms Query by phone. Send business card and résumé to be kept on file for future assignments. Originals not returned. Negotiates payment.

CAHAN & ASSOCIATES

171 Second St., 5th Floor, San Francisco CA 94105. (415)621-0915. Fax: (415)621-7642. E-mail: billc@cahanassociates.com. Web site: www.cahanassociates.com. **President:** Bill Cahan. Estab. 1984. Specializes in annual reports, corporate identity, package design, signage, business and business collateral. Clients: public and private companies (real estate, finance and biotechnology). Client list available upon request.

Needs Approached by 50 freelance artists/year. Works with 5-10 freelance illustrators and 3-5 freelance designers/year. Works on assignment only. Uses freelance illustrators mainly for annual reports. Uses freelance designers mainly for overload cases. Also uses freelance artists for brochure design.

First Contact & Terms Send query letter with brochure, tearsheets, photostats, résumé, photographs, and photocopies. Samples are filed and are not returned. Responds only if interested. To show a portfolio, mail thumbnails, roughs, tearsheets, and transparencies. Pays for design or illustration by the hour or by the project. Negotiates rights purchased.

THE CALIBER GROUP

(formerly Boelts/Stratford Associates), 4007 E. Paradise Falls Dr., Suite 210., Tucson, AZ 85712. (520)794-4500. Fax: (520)792-9720. E-mail: creative@calibergrp.com. Web site: www.calibergrp.com. **Principal/Creative Director:** Kerry Stratford. Estab. 1997. Specializes in annual reports, brand identity, corporate identity, display design, direct mail design, environmental graphics, package design, publication design and signage. Client list available upon request.

● The creative team has won over 500 international, national and local awards.

Needs Approached by 100 freelance artists/year. Works with 10 freelance illustrators and 5-10 freelance designers/year. Works on assignment only. Uses designers and illustrators for brochure, poster, catalog, P-O-P and ad illustration, mechanicals, retouching, airbrushing, charts/graphs and audiovisual materials.

First Contact & Terms Send query letter with PDF samples and résumé. Samples are filed. Responds only if interested. Call to schedule an appointment to show portfolio. Portfolio should include roughs, original/final art. Pays for design by the hour and by the project. Pays for illustration by the project. Negotiates rights purchased.

Tips When presenting samples or portfolios, designers and illustrators "sometimes mistake quantity for quality. Keep it short and show your best work."

CARNASE, INC.

300 East Malino Rd., Palm Springs CA 92262. E-mail: carnase@carnase.com. Web site: www.carnase.com. **President:** Tom Carnase. Estab. 1978. Specializes in annual reports, brand and corporate identity, display, landscape, interior, direct mail, package and publication design, signage

and technical illustration. Clients: agencies, corporations, consultants. Current clients include Brooks Brothers, Fortune Magazine, Calvin Klein, Saks Fifth Avenue.

Needs Approached by 60 freelance artists/year. Works with 2 illustrators and 1 designer/year. Prefers artists with 5 years experience. Works on assignment only. Uses artists for brochure, catalog, book, magazine and direct mail design and brochure and collateral illustration. Needs computer-literate freelancers. 50% of freelance work demands skills in QuarkXPress or Illustrator.

First Contact & Terms Send query letter with brochure, résumé and tearsheets. Samples are filed. Responds in 10 days. Will contact artist for portfolio review if interested. Portfolio should include photostats, slides and color tearsheets. Negotiates payment. Rights purchased vary according to project. Finds artists through word of mouth, magazines, submissions/self-promotions, sourcebooks and agents.

THE CHESTNUT HOUSE GROUP, INC.

2121 St. Johns Ave., Highland Park IL 60035. (847)432-3273. Fax: (847)432-3229. E-mail: chestn uthouse@comcast.net. Web site: www.chestnuthousegroup.com. **President:** Miles Zimmerman. Clients: major educational publishers, small publishers, and selected self-publishers.

Needs Computer-literate freelancers with educational publishing experience. Uses experienced freelancers only. Uses freelancers mainly for illustration, layout and electronic page production. Freelancers should be familiar with QuarkXPress and various drawing and painting programs for illustrators.

First Contact & Terms Submit samples. Pays for production by the hour. Pays for illustration by the project.

CINE DESIGN FILMS

Box 6495, Denver CO 80206. (303)777-4222. E-mail: jghusband@aol.com. Web site: www.cined esignfilms.com. **Producer/Director:** Jon Husband. AV firm. Clients documentary productions.

Needs Works with 3-20 freelancers/year. Works on assignment only. Uses freelancers for layout, titles, animation and still photography. Clear concept ideas that relate to the client in question are important.

First Contact & Terms E-mail query with Web site links or URL's or mail query with sample DVD/CD. "We like to see completed works as samples in DVD/CD form." Responds only if interested. Pays by the project. Considers complexity of project, client's budget and rights purchased when establishing payment. Rights purchased vary according to project.

CLEARVUE & SVE, INC.

1560 Sherman Ave., Evaston IL 60201. E-mail: clearvue_service@discovery.com. Web site: ww w.clearvue.com. **President:** Mark Ventling. Curriculum-oriented multimedia provider.

Needs Works with 1-2 freelance artists/year. Works on assignment only. Uses freelance artists mainly for catalog layout.

First Contact & Terms Send query letter with SASE to be kept on file. Responds in 10 days. Write for appointment to show portfolio.

Tips "Have previous layout skills."

CLIFF & ASSOCIATES

10061 Riverside Dr. #808, Toluca Lake CA 91602. (323)876-1108. Fax: (323)876-5484. E-mail: design@cliffassoc.com. Web site: www.cliffassoc.com. **Owner:** Greg Cliff. Estab. 1984. Number

of employees: 10. Approximate annual billing: $1 million. Specializes in annual reports, corporate identity, direct mail, publication design and signage. Clients: Fortune 500 corporations and performing arts companies. Current clients include BP, IXIA, WSPA, IABC, Capital Research and ING.

Needs Approached by 50 freelancers/year. Works with 30 illustrators and 10 designers/year. Prefers local freelancers and Art Center graduates. Uses freelancers mainly for brochures; also for technical, "fresh" editorial and medical illustration, mechanicals, lettering, logos, catalog/book/magazine design, P-O-P and poster design and illustration, and model making. Needs computer-literate freelancers for design and production. 90% of freelance work demands knowledge of QuarkXPress, FreeHand, Illustrator, Photoshop, etc.

First Contact & Terms Send query letter with résumé and a nonreturnable sample of work. Samples are filed. Will contact artist for portfolio review if interested. Portfolio should include thumbnails, b&w photostats and printed samples. Pays for design by the hour, $25-35. Pays for illustration by the project, $50-3,000. Buys one-time rights. Finds artists through sourcebooks.

COAKLEY HEAGERTY ADVERTISING & PUBLIC RELATIONS

1155 N. First St., Suite 201, San Jose CA 95112-4925. (408)275-9400. Fax: (408)995-0600. E-mail: info@coakley-heagerty.com. Web site: www.coakley-heagerty.com. **Director of Digital Marketing:** Brian Behl. Estab. 1961. Number of employees: 35. Full-service ad agency and PR firm. Clients: real estate, consumer, senior care, banking/financial, insurance, automotive, tel com, public service. Professional affiliation: MAGNET (Marketing and Advertising Global Network).

Needs Approached by 50 freelancers/year. Works with 3 freelance illustrators and 5 designers/year. "We want freelancers with digital and/or Web site experience." Works on assignment only. Uses freelancers for illustration, retouching, animation, lettering, logos and charts/graphs. Freelance work demands skills in InDesign, Illustrator, Photoshop or QuarkXPress.

First Contact & Terms E-mail PDF files showing art style, or e-mail link to Web site. Responds only if interested. Call for an appointment to show portfolio. Pays for design and illustration by the project, $600-5,000.

COMMUNICATIONS ELECTRONICS, INC.

Dept. AM, P.O. Box 1045, Ann Arbor MI 48106-1045. (734)996-8888. E-mail: cei@usascan.com. **Editor:** Ken Ascher. Estab. 1969. Number of employees 38. Approximate annual billing $5 million. Manufacturer, distributor and ad agency (13 company divisions). Specializes in marketing. Clients electronics, computers.

Needs Approached by 500 freelancers/year. Works with 40 freelance illustrators and 40 designers/year. Uses freelancers for brochure and catalog design, illustration and layout, advertising, product design, illustration on product, P-O-P displays, posters and renderings. Needs editorial and technical illustration. Prefers pen & ink, airbrush, charcoal/pencil, watercolor, acrylic, marker and computer illustration. 30% of freelance work demands skills in PageMaker or QuarkXPress.

First Contact & Terms Send query letter with brochure, résumé, business card, samples and tearsheets to be kept on file. Samples not filed are returned by SASE. Responds in 1 month. Will contact artist for portfolio review if interested. Pays for design and illustration by the hour, $10-120; by the project, $10-15,000; by the day, $40-800.

COUSINS DESIGN

330 E. 33rd St., New York NY 10016. (212)685-7190. E-mail: info@cousinsdesign.com. Web site: www.cousinsdesign.com. **President:** Michael Cousins. Number of employees 4. Specializes in packaging and product design. Clients: marketing and manufacturing companies. Professional affiliation: IDSA.

Needs Occassionally works with freelance designers. Prefers local designers. Works on assignment only.

First Contact & Terms Send nonreturnable postcard sample or e-mail Web site link. Samples are filed. Responds in 2 weeks only if interested. Write for appointment to show portfolio of roughs, final reproduction/product and photostats. Pays for design by the hour or flat fee. Considers skill and experience of artist when establishing payment. Buys all rights.

Tips "Send great work that fits our direction."

CREATIVE COMPANY, INC.

726 NE Fourth St., McMinnville OR 97128. Toll-free (866)363-4433. Fax: (503)883-6817. E-mail: jlmorrow@creativeco.com. Web site: www.creativeco.com. **President/Owner:** Jennifer Larsen Morrow. Specializes in branding, marketing-driven corporate identity, collateral, direct mail, packaging and ongoing marketing campaigns. Product specialties are food, financial services, colleges, manufacturing, pharmaceutical, medical, agricultural products.

Needs Works with 6-10 freelance designers and 3-7 illustrators/year. Prefers local artists. Works on assignment only. Uses freelancers for design, illustration, computer production (Mac), retouching and lettering. "Looking for clean, fresh designs!" 100% of design and 60% of illustration demand skills in InDesign, FreeHand, Illustrator and Photoshop.

First Contact & Terms Send query letter with brochure, résumé, business card, photocopies and tearsheets to be kept on file. Samples returned by SASE only if requested. Will contact for portfolio review if interested. "We require a portfolio review. Years of experience not important if portfolio is good. We prefer one-on-one review to discuss individual projects/time/approach." Pays for design by the hour or project, $50-90. Pays for illustration by the project. Considers complexity of project and skill and experience of artist when establishing payment.

Tips Common mistakes freelancers make in presenting samples or portfolios are "1) poor presentation, samples not mounted or organized; 2) not knowing how long it took them to do a job to provide a budget figure; 3) not demonstrating an understanding of the audience, the problem or printing process and how their work will translate into a printed copy; 4) just dropping in without an appointment; 5) not following up periodically to update information or a résumé that might be on file."

CREATIVE CONSULTANTS

2608 W. Dell Dr., Spokane WA 99208-4428. (509)326-3604. Fax: (509)327-3974. E-mail: ebruneau@creativeconsultants.com. Web site: www.creativeconsultants.com. **President:** Edmond A. Bruneau. Estab. 1980. Approximate annual billing $300,000. Ad agency and design firm. Specializes in collateral, logos, ads, annual reports, radio and TV spots. Product specialties are business and consumer. Client list available upon request.

Needs Approached by 20 illustrators and 25 designers/year. Works with 10 illustrators and 15 designers/year. Uses freelancers mainly for animation, brochure, catalog and technical illustration, model-making and TV/film graphics. 36% of work is with print ads. Designs and illustration demands skills in Photoshop and QuarkXPress.

First Contact & Terms Designers: Send query letter. Illustrators: Send postcard sample of work and e-mail. Accepts disk submissions if compatible with Photoshop, QuarkXPress, PageMaker and FreeHand. Samples are filed. Responds only if interested. Pays by the project. Buys all rights. Finds artists through Internet, word of mouth, reference books and agents.

THE CRICKET CONTRAST

29505 N. 146th St., Scottsdale AZ 85262. (602)258-6149. Fax: (602)391-2199. E-mail: cricket@th ecricketcontrast.com. Web site: www.thecricketcontrast.com. **Owner:** Kristie Bo. Estab. 1982. Specializes in providing solutions for branding, corporate identity, Web page design, advertising, package and publication design, and traditional online printing. Clients: corporations. Professional affiliations: AIGA, Scottsdale Chamber of Commerce, Phoenix Society of Communicating Arts, Phoenix Art Museum, Phoenix Zoo.

Needs Approached by 25-50 freelancers/year. Works with 5 freelance illustrators and 5 designers/year. Ues freelancers for ad illustration, brochure design and illustration, lettering and logos. Needs computer-literate freelancers for design and production. 100% of freelance work demands knowledge of Illustrator, Photoshop, InDesign, and QuarkXPress.

First Contact & Terms Send photocopies, photographs and résumé via e-mail. Will contact artist for portfolio review if interested. Pays for design and illustration by the project. Negotiates rights purchased. Finds artists through self-promotions and sourcebooks.

Tips "Beginning freelancers should send all info through e-mail."

⚓ CUTRO ASSOCIATES, INC.

47 Jewett Ave., Tenafly NJ 07670. (201)569-5548. Fax: (201)569-8987. E-mail: cutroassoc@opto nline.net. **Manager:** Ronald Cutro. Estab. 1961. Number of employees: 2. Specializes in annual reports, brochures, corporate identity, direct mail, fashion, package and publication design, technical illustration and signage. Clients: corporations, business-to-business, consumer.

Needs Approached by 5-10 freelancers/year. Works with 2-3 freelance illustrators and 2-3 designers/year. Prefers local artists only. Uses illustrators mainly for wash drawings, fashion, specialty art. Uses designers for comp layout. Also uses freelancers for ad and brochure design and illustration, airbrushing, catalog and P-O-P illustration, direct mail design, lettering, mechanicals, and retouching. Needs computer-literate freelancers for design, illustration and production. 98% of freelance work demands knowledge of Illustrator, QuarkXPress and Photoshop.

First Contact & Terms Send postcard sample of work. Samples are filed. Will contact artist for portfolio review if interested. Portfolio should include final art and photocopies. Pays for design and illustration by the project. Buys all rights.

⚓ DAIGLE DESIGN INC.

921 Hildebrande Lane NE, Suite 230, Bainbridge Island WA 98110. (206)842-5356. Fax: (206)331-4222. E-mail: candace@daigle.com. Web site: www.daigledesign.com. **Creative Director:** Candace Daigle. Estab. 1987. Number of employees 6. Approximate annual billing $450,000. Design firm. Specializes in brochures, catalogs, logos, magazine ads, trade show display and Web sites. Product specialties are telecommunications, furniture, real estate development, aviation, yachts, restaurant equipment and automotive.

Needs Approached by 10 illustrators and 20 designers/year. Works with 5 illustrators and 5 designers/year. Prefers local designers with experience in Photoshop, Illustrator, DreamWeaver, Flash and FreeHand. Uses freelancers mainly for concept and production. Also for airbrushing,

brochure design and illustration, lettering, logos, multimedia projects, signage, technical illustration and Web page design. 50% of work is with print. 50% of design demands skills in Photoshop, Illustrator and FreeHand. 50% of illustration demands skills in Photoshop, Illustrator.

First Contact & Terms Designers: Send query letter with résumé. Illustrators: Send query letter with photocopies. Accepts disk submissions. Send JPEG files. Samples are filed and are not returned. Responds only if interested. Will contact for portfolio review of b&w, color, final art, slides and tearsheets if interested. Pays for design by the hour, $25; pays for illustration by the project, $150-3,000. Buys all rights. Finds artists through submissions, reps, temp agencies and word of mouth.

DEFOREST CREATIVE

300 W. Lake St., Elmhurst IL 60126. (630)834-7200. Fax: (630)279-8410. E-mail: info@deforestgroup.com. Web site: www.deforestgroup.com. **Art Director:** Nick Chapman. Estab. 1965. Number of employees: 15. Marketing solutions, graphic design and digital photography firm.

Needs Approached by 50 freelance artists/year. Works with 3-5 freelance designers/year. Prefers artists with experience in PhotoShop, Illustrator and InDesign.

First Contact & Terms Send query letter with résumé and samples. Samples are filed or returned by SASE if requested by artist. To arrange for portfolio review artist should fax or e-mail. Pays for production by the hour, $25-75. Finds designers through word of mouth and artists' submissions.

Tips "Be hardworking, honest, and good at your craft."

DENTON DESIGN ASSOCIATES

491 Arbor St., Pasadena CA 91105. (626)792-7141. **President:** Margi Denton. Estab. 1975. Specializes in annual reports, corporate identity and publication design. Clients nonprofit organizations and corporations. Recent clients include California Institute of Technology, University of Southern California, Yellowjackets and SETI Institute.

Needs Approached by 12 freelance graphic artists/year. Works with roughly 5 freelance illustrators and 2 freelance designers/year. Prefers local designers only. "We work with illustrators from anywhere." Works with designers and illustrators for brochure design and illustration, lettering, logos and charts/graphs. Demands knowledge of QuarkXPress, Photoshop and Illustrator.

First Contact & Terms Send résumé, tearsheets and samples (illustrators just send samples). Samples are filed and are not returned. Responds only if interested. Art director will contact artist for portfolio review if interested. Pays for design by the hour. Pays for illustration by the project. Rights purchased vary according to project. Finds artists through sourcebooks, AIGA, *PRINT*, *CA*, *Folio Planet* and other Internet sources.

DESIGN ASSOCIATES GROUP, INC.

1828 Asbury Ave., Evanston IL 60201-3504. (847)425-4800. E-mail: info@designassociatesinc.com. Web site: www.designassociatesinc.com. **Contact:** Paul Uhl. Estab. 1986. Number of employees: 5. Specializes in text and trade book design, annual reports, corporate identity, Web site development. Clients corporations, publishers and museums. Client list available upon request.

Needs Approached by 10-20 freelancers/year. Works with 100 freelance illustrators and 2 designers/year. Uses freelancers for design and production. 100% of freelance work demands knowledge of Illustrator, Photoshop and InDesign.

First Contact & Terms Send query letter with samples that best represent work. Accepts disk

submissions. Samples are filed. Will contact artist for portfolio review if interested. Portfolio should include b&w and color samples.

⚏ DESIGN + AXIOM

192 Spadina Ave., Suite101, Toronto ON M5V 3P1. (310)377-0207. E-mail: tom@designaxiom.com. **President:** Thomas Schorer. Estab. 1973. Specializes in graphic, environmental and architectural design, product development and signage.

Needs Approached by 100 freelancers/year. Works with 3 freelance illustrators and 5 designers/year. Works on assignment only. Uses designers for all types of design. Uses illustrators for editorial and technical illustration. 50% of freelance work demands knowledge of PageMaker or QuarkXPress.

First Contact & Terms Send query letter with appropriate samples. Will contact artist for portfolio review if interested. Portfolio should include appropriate samples. Pays for design and illustration by the project. Finds artists through word of mouth, self-promotions, sourcebooks and colleges.

⚏ DESIGN COLLABORATIVE

1617 Lincoln Ave., San Rafael CA 94901-5400. (415)456-0252. Fax: (415)479-2001. E-mail: bford @neteze.com. Web site: www.designco.com. **Creative Director:** Bob Ford. Estab. 1987. Number of employees 7. Approximate annual billing $350,000. Ad agency/design firm. Specializes in publication design, package design, environmental graphics. Product specialty is consumer. Current clients include B of A, Lucas Film Ltd., Broderbund Software. Client list available upon request. Professional affiliations AAGD, PINC, AAD.

Needs Approached by 20 freelance illustrators and 60 designers/year. Works with 15 freelance illustrators and 20 designers/year. Prefers local designers with experience in package design. Uses freelancers mainly for art direction production. Also for brochure design and illustration, mechanicals, multimedia projects, signage, web page design. 25% of work is with print ads. 80% of design and 85% of illustration demand skills in PageMaker, FreeHand, Photoshop, QuarkXPress, Illustrator, PageMill.

First Contact & Terms Designers: Send query letter with photocopies, résumé, color copies. Illustrators: Send postcard sample and/or query letter with photocopies and color copies. After introductory mailing send follow-up postcard samples. Accepts disk submissions. Send EPS files. Samples are filed or returned. Responds in 1 week. Artist should call. Portfolio review required if interested in artist's work. Portfolios of final art and transparencies may be dropped off every Monday. Pays for design by the hour, $40-80. Pays for illustration by the hour, $40-100. Buys first rights. Rights purchased vary according to project. Finds artists through creative sourcebooks.

Tips "Listen carefully and execute well."

DESIGN RESOURCE CENTER

424 Fort Hill Dr., Suite 118, Naperville IL 60540. (630)357-6008. Fax: (630)357-6040. E-mail: info@drcchicago.com. Web site: www.drcchicago.com. **President:** John Norman. Estab. 1990. Number of employees: 14. Approximate annual billing: $1,500,000. Specializes in package design and display, brand and corporate identity. Clients include corporations, manufacturers, private labels.

Needs Approached by 5-10 freelancers/year. Works with 5-10 freelance designers and production artists and 5-10 designers/year. Uses designers mainly for Macintosh or concepts. Also

uses freelancers for P-O-P design and illustration, lettering, logos and package design. Needs computer-literate freelancers for design, illustration and production. 100% of freelance work demands knowledge of Illustrator, QuarkXPress and Photoshop.

First Contact & Terms Send query letter with brochure, photocopies, photographs and résumé. Samples are filed. Artist should follow up. Portfolio review sometimes required. Portfolio should include b&w and color final art, photographs, roughs and thumbnails. Pays for design by the hour, $15-40. Pays for illustration by the project. Buys all rights. Finds artists through word of mouth and referrals.

DEVER DESIGNS

14203 Park Center Dr. Suite 308, Laurel MD 20707. (301)776-2812. Fax: 1-866-665-1196. E-mail: info@deverdesigns.com. Web site: www.deverdesigns.com. **President:** Jeffrey Dever. Marketing Director: Holly Hagen. Estab. 1985. Number of employees 8. Specializes in annual reports, corporate identity and publication design. Clients: associations, nonprofit organizations, educational institutions, museums, government agencies.

Needs Approached by 100 freelance illustrators/year. Works with 20-40 freelance illustrators/year. Prefers artists with experience in editorial illustration. Uses illustrators mainly for publications.

First Contact Terms Send postcard, samples or query letter with photocopies, resume and tearsheets. Accepts PDFs and disk submissions compatible with Photoshop, Illustrator or InDesign, but prefers hard copy samples which are filed. Will contact artist for portfolio review if interested. Portfolio should include b/w and/or color photocopies for files. Pays for illustration by the project. Rights purchased vary according to project. Finds artists through referrals and sourcebooks.

Tips Impressed by and consistent quality.

⚓ ANTHONY DI MARCO

301 Aris Ave., Metairie LA 70005. (504)833-3122. Fax: (504)833-3122. Web site: www.anthonydi marcostudio.com. **Creative Director:** Anthony Di Marco. Estab. 1972. Number of employees: 1. Specializes in illustration, sculpture, costume design, art and photo restoration and retouching. Current clients include Audubon Institute, Louisiana Nature and Science Center, Fair Grounds Race Course. Client list available upon request. Professional affiliations: Art Directors Designers Association, Entergy Arts Council, Louisiana Crafts Council, Louisiana Alliance for Conservation of Arts.

Needs Approached by 50 or more freelancers/year. Works with 5-10 freelance illustrators and 5-10 designers/year. Seeks "local freelancers with ambition. Freelancers should have substantial portfolios and an understanding of business requirements." Uses freelancers mainly for fill-in and finish design, illustration, mechanicals, retouching, airbrushing, posters, model-making, charts/graphs. Prefers highly polished, finished art in pen & ink, airbrush, charcoal/pencil, colored pencil, watercolor, acrylic, oil, pastel, collage and marker. 25% of freelance work demands computer skills.

First Contact & Terms Send query letter with résumé, business card, slides, brochure, photocopies, photographs, transparencies and tearsheets to be kept on file. Samples not filed are returned by SASE. Responds in 1 week if interested. Call or write for appointment to show portfolio. Pays for illustration by the hour or by the project, $100 minimum.

Tips "Keep professionalism in mind at all times. Put forth your best effort. Apologizing for

imperfect work is a common mistake freelancers make when presenting a portfolio. Include prices for completed works (avoid overpricing). Three-dimensional works comprise more of our total commissions than before."

DICCICCO BATTISTA COMMUNICATIONS

655 Business Center Dr., Suite 100, Horsham PA 19044. (215)957-0300 Fax (215) 672-9373. E-mail: ccorbet@dbcommunications.net. Web site: www.dbcommunications.net. **Executive Creative Director:** Carol Corbett. Estab. 1967. Full-service, multimedia, business-to-business ad agency. Specializes in food and business-to-business. Current clients include Hatfield Meats, Primavera, Hallowell and Caulk Dental Supplies.

Needs Works with 10 freelance illustrators and 25 freelance designers/month. Uses freelance artists mainly for paste-up and mechanicals, illustration, photography and copywriting; also for brochure design, slides, print ads, animatics, animation, retouching, TV/film grapics, lettering and logos. 60% of work is with print ads.

First Contact & Terms Send query letter with brochure, résumé, tearsheets, photostats, photocopies, photographs, slides and SASE. Samples are filed or are returned by SASE only if requested by artist. Responds only if interested. Write to schedule an appointment to show a portfolio, which should include roughs, original/final art, tearsheets, final reproduction/product, photographs, slides; include color and b&w samples. Pays for design by the hour, $15-50. Pays for illustration by the project. Rights purchased vary according to project.

NORMAN DIEGNAN & ASSOCIATES

3 Martens Rd., Lebanon NJ 08833. (908)832-7951. Fax: (908)832-9650. Web site: www.diegnan-associates.com. **President:** N. Diegnan. Estab. 1977. Number of employees 5. Approximate annual billing $1 million. PR firm. Specializes in magazine ads. Product specialty is industrial.

Needs Approached by 10 freelancers/year. Works with 20 freelancers illustrators/year. Works on assignment only. Uses freelancers for brochure, catalog and print ad design and illustration, storyboards, slide illustration, animatics, animation, mechanicals, retouching and posters. 50% of work is with print ads. Needs editorial and technical illustration.

First Contact & Terms Send query letter with brochure and tearsheets. Samples are filed and not returned. Responds in 1 week. To show portfolio, mail roughs. Pays for design and illustration by the project. Rights purchased vary according to project.

DLD CREATIVE

620 E. Oregon Rd., Lititz PA 17543. (717)569-6568. E-mail: dave@dldcreative.com. Web site: www.dldcreative.com. **President/Creative Director:** Dave Loose. Estab. 1986. Number of employees 12. Full-service design firm. Specializes in branding and corporate communications. Client list available upon request.

Needs Approached by 4 illustrators and 12 designers/year. Works with 4 illustrators/year. Uses freelancers mainly for illustration. Also for animation, catalog, humorous and technical illustration and TV/film graphics. 10% of work is with print ads. 50% of design demands skills in Photoshop, QuarkXPress, Illustrator.

First Contact & Terms Designers: Send query letter with photocopies, résumé and tearsheets. Illustrators: Send postcard sample of work. Accepts e-mail submissions. Samples are filed. Responds only if interested. No calls, please. Portfolio should include color final art and concept roughs. Pays for design and illustration by the project. Buys all rights. Finds artists through *American Showcase*, postcard mailings, word of mouth.

Tips "Be conscientious of deadlines, willing to work with hectic schedules. Must be top talent and produce highest quality work."

DOWLING & POPE ADVERTISING

311 W. Superior St., Chicago IL 60610. (800)432-8993. E-mail: salesinfo@dowlingadv.com. Web site: www.dowlingadv.com. Estab. 1988. Number of employees: 22. Approximate annual billing: $17 million. Ad agency; full-service multimedia firm. Specializes in magazine ads and collateral. Product specialty is recruitment.

Needs Approached by 6-12 freelance artists/year. Works with 6 freelance illustrators and 72 designers/year. Uses freelancers mainly for collateral; also for annual reports, multimedia, brochure design and illustration, catalog illustration, lettering and posters. 80% of work is with print ads. 80% of design and 50% of illustration demand knowledge of FreeHand, Photoshop and Illustrator.

First Contact & Terms Designers: Send postcard sample with brochure, résumé, photocopies and photographs. Illustrators: Send postcard sample with brochure and résumé. Accepts submissions on disk. Samples are filed. Responds in 2 weeks. Will contact artist for portfolio review if interested. Portfolio should include b&w and color final art. Pays for design and illustration by the project. Negotiates rights purchased. Finds artists through *The Black Book*, *Workbook* and *Chicago Source Book*.

▓ DRAFTFCB

(formerly Foote, Cone & Belding), 633 N St. Clair., Chicago IL 60611. (312)425-5000. Fax: (949)567-9465. Web site: www.draftfcb.com. **Art Buyer:** Karl Gore. Estab. 1950. Ad agency; full-service multimedia firm. Product specialties are package goods, toys, entertainment and retail.

Needs Approached by 15-20 freelance artists/month. Works with 3-4 freelance illustrators and 2-3 freelance designers/month. Prefers local artists with experience in design and sales promotion. Designers must be able to work in-house and have Mac experience. Uses freelance artists for brochure, catalog and print ad design and illustration, storyboards, mechanicals, retouching, lettering, logos and computer (Mac). 30% of work is with print ads.

First Contact & Terms Designers: Send query letter with résumé, photocopies and tearsheets. Illustrators: Send postcard, color photocopies, tearsheets or other nonreturnable samples. Samples are filed. Responds only if interested. Write to schedule an appointment to show a portfolio. Portfolio should include roughs and color. Pays for design based on estimate on project from concept to mechanical supervision. Pays for illustration per project. Rights purchased vary according to project.

▓ DYKEMAN ASSOCIATES INC.

4115 Rawlins, Dallas TX 75219. (214)528-2991. Fax: (214)528-0241. E-mail: adykeman@airmail. net. Web site: www.dykemanassociates.com. **Contact:** Alice Dykeman. PR/marketing firm. Specializes in business, hospitality, sports, environmental, energy, health.

Needs Works with 5 illustrators and designers/year. Local freelancers preferred. Uses freelancers for editorial and technical illustration, brochure design, exhibits, corporate identification, POS, signs, posters, ads and all design and finished artwork for Web sites, and printed materials. PC or Mac.

First Contact & Terms Request portfolio review in original query. Pays by the project, $300-3,000. "Artist makes an estimate; we approve or negotiate."

Tips "Be enthusiastic. Present an organized portfolio with a variety of work. Portfolio should reflect all that an artist can do. Don't include examples of projects for which you only did a small part of the creative work. Have a price structure but be willing to negotiate per project. We prefer to use artists/designers/illustrators who will work with barter (trade) dollars and join one of our trade exchanges. We see steady growth ahead."

EDDINS MADISON CREATIVE

6487 Overlook Dr., Alexandria VA 22312. (703)795-3069. E-mail: steve@em-creative.com. Web site: www.em-creative.com. **President:** Stephen R. Madison. Estab. 1983. Number of employees: 5. Specializes in brand and corporate identity and publication design. Clients: corporations, associations and nonprofit organizations. Current clients include Apex Home Loans, CBS, Library of Congress, Nextel, Sallie Mae. Client list available upon request.

Needs Approached by 20-25 freelancers/year. Works with 4-6 freelance illustrators and 2-4 designers/year. Uses only artists with experience in Macintosh. Uses illustrators mainly for publications and brochures. Uses designers mainly for simple design and Mac production. Also uses freelancers for airbrushing, brochure and poster design and illustration, catalog design, charts/graphs. Needs computer-literate freelancers for design, production and presentation. 100% of freelance work demands knowledge of Illustrator, Photoshop, and QuarkXPress.

First Contact & Terms Send postcard sample of work or send query letter with photocopies and résumé. Samples are filed. Will contact artist for portfolio review if interested. Rights purchased vary according to project. Finds artists through sourcebooks, design/illustration annuals and referrals.

Tips Impressed by "great technical skills, nice cover letter, good/clean résumé and good work samples."

⚇ EJW ASSOCIATES, INC.

Crabapple Village Office Park, 1602 Abbey Court, Alpharetta GA 30004. (770)664-9322. Fax: (770)664-9324. E-mail: advertise@ejwassoc.com. Web site: www.ejwassoc.com. **President:** Emil Walcek. Estab. 1982. Ad agency. Specializes in space ads, corporate ID, brochures, show graphics. Product specialty is business-to-business.

Needs Works with 2 -4 freelance illustrators and designers/year. Prefers local freelancers with experience in Mac computer design /illustration and Photoshop expertise. Works on assignment only. Uses freelancers for brochure, Web site development, catalog and print ad design and illustration, editorial, technical illustration and logos. 50% of work is with print ads. 75% of freelance work demands skills in FreeHand, Photoshop, Web coding, F lash.

First Contact & Terms Send query letter with résumé, photostats, slides and Web site. Samples are filed or are returned by SASE if requested by artist. Responds only if interested. Pays for design by the hour, $40-80; by the day, $300-600; or by the project. Buys all rights.

Tips Looks for "experience in non-consumer, industrial or technology account work. Visit our Web site first, then e-mail or call. Do not send e-mail attachments."

THE EMERY GROUP

1519 Montana Ave., El Paso TX 79902. (888)651-8888. E-mail: emery@emerygroup.com. Web site: www.emerygroup.com. **Contact:** Art Director. Estab. 1977. Number of employees: 18. Ad agency. Specializes in automotive and retail firms, banks and restaurants. Current clients include Texas National Bank and Horizon Company Ltd.

● Second location: 8100 Paseo Del Ocaso, La Jolla CA 92037. (800)770-0099.

Needs Approached by 3-4 freelancers/year. Works with 2-3 freelance illustrators and 4-5 designers/year. Uses freelancers mainly for design, illustration and production. Needs technical illustration and cartoons.

First Contact & Terms Works on assignment only. Send query letter with résumé and samples to be kept on file. Prefers tearsheets as samples. Samples not filed are returned by SASE. Will contact artist for portfolio review if interested. Sometimes requests work on spec before assigning a job. Pays for design by the hour, $15 minimum; by the project, $100 minimum; by the day, $300 minimum. Pays for illustration by the hour, $15 minimum; by the project, $100 minimum. Considers complexity of project, client's budget and turnaround time when establishing payment. Rights purchased vary according to project.

Tips Especially looks for "consistency and dependability; high creativity; familiarity with retail, Southwestern and Southern California look."

ERICKSEN ADVERTISING & DESIGN, INC.

12 W. 37th St., Ninth Floor, New York NY 10018. (212)239-3313. Web site: www.eadcom.com. **Director:** Robert Ericksen. **Art Director:** Magno Parada. Full-service ad agency providing all promotional materials and commercial services for clients. Product specialties are promotional, commercial and advertising material. Current clients include BBC, National Geographic, CBSTV and Prudential.

Needs Works with several freelancers/year. Assigns several jobs/year. Works on assignment only. Uses freelancers mainly for advertising, packaging, brochures, catalogs, trade, P-O-P displays, posters, lettering and logos. Prefers composited and computer-generated artwork.

First Contact & Terms Contact through artist's agent or send query letter with brochure or tearsheets and slides. Samples are filed and are not returned unless requested with SASE; unsolicited samples are not returned. Responds in 1 week if interested or when artist is needed for a project. Does not respond to all unsolicited samples. "Only on request should a portfolio be sent." Pays for illustration by the project, up to $5,000. Buys all rights, and retains ownership of original in some situations. Finds artists through word of mouth, magazines, submissions and sourcebooks.

Tips "Advertising artwork is becoming increasingly 'commercial' in response to very tightly targeted marketing. The artist has to respond to increased creative team input. Must be experienced in computer softwares; Quark, Photoshop, Acrobat, Illustrator, MS Office, Dreamweaver, and other design/web programs."

ERVIN-BELL MARKETING COMMUNICATIONS

2134 Michelson Dr., Irvine CA 92612. (949)251-1166. Fax: (949)417-2239. E-mail: mervin@ervin bell.com. Web site: www.ervinbell.com. **Contact**: Mike Ervin. Estab. 1981. Specializes in annual reports, branding and brand management, corporate identity, retail, direct mail, package and publication design. Clients: corporations, malls, financial firms, industrial firms and software publishers. Current clients include Nutro Pet Foods, The First American Corporation, Toyota. Client list available upon request.

Needs Approached by 100 freelancers/year. Works with 10 freelance illustrators and 6 designers/year. Works on assignment only. Uses illustrators mainly for package designs, annual reports. Uses designers mainly for annual reports, special projects. Also uses freelancers for brochure design and illustration, P-O-P and ad illustration, audiovisual materials, lettering and

charts/graphs. Needs computer-literate freelancers for production. 100% of freelance work demands knowledge of InDesign and Photoshop.

First Contact &Terms Send resume and photocopies. Samples are filed and are not returned. Responds only if interested. Request portfolio review in original query. Portfolio should include tearsheets. Pays for design by the hour, $15-30; by the project (rate varies); by the day, $120-240. Pays for illustration by the project (rate varies). Buys all rights.

Tips Finds artists through Web, Creative Hotlist, submitted résumés.

EVENSON DESIGN GROUP

4445 Overland Ave., Culver City CA 90230. (310)204-1995. Fax: (310)204-4879. E-mail: edgmail @evensondesign.com. Web site: evensondesign.com. **Principal:** Stan Evenson. Estab. 1976. Specializes in annual reports, brand and corporate identity, display design, direct mail, package design, Web site design, and signage. Clients ad agencies, hospitals, corporations, law firms, entertainment companies, record companies, publications, PR firms. Current clients include ActiVistion, Disney, Universal Studios, NSL Properties, Co-Op Network, University of Southern California, Warner Brothers, Yokohama.

Needs Approached by 75-100 freelance artists/year. Works with 10 illustrators and 15 designers/year. Prefers artists with production experience as well as strong design capabilities. Works on assignment only. Uses illustrators mainly for covers for corporate brochures. Uses designers mainly for logo design, page layouts, all overflow work. Also uses freelancers for brochure, catalog, direct mail, ad, P-O-P and poster design and illustration, mechanicals, lettering, logos and charts/graphs. 100% of design work demands skills in InDesign, FreeHand, Photoshop or Illustrator.

First Contact & Terms Send query letter with résumé and samples or send samples via e-mail. Responds only if interested. Portfolio should include b&w and color photostats and tearsheets and 4×5 or larger transparencies.

Tips "Be efficient in the execution of design work, producing quality designs over the quantity of designs. Professionalism, as well as a good sense of humor, will prove you to be a favorable addition to any design team."

EVENTIV

10116 Blue Creek North, Whitehouse OH 43571. E-mail: jan@eventiv.com. Web site: www.even tiv.com. **President/Creative Director:** Janice Robie. Agency specializing in graphics, promotions and tradeshow marketing. Product specialties are industrial, consumer.

Needs Assigns 30 freelance jobs/year. Works with 5 illustrators/year and 20 designers/year. Works on assignment only. Uses freelancers for consumer and trade magazines, brochures, catalogs, P-O-P displays, AV presentations, posters and illustrations (technical and/or creative). 100% of design and 50% of illustration require computer skills. Also needs freelancers experienced in electronic authoring, animation, web design, programming and design.

First Contact & Terms Send query letter with résumé and slides, photographs, photostats or printed samples. Accepts disk submissions compatible with Mac or Windows. Samples returned by SASE if not filed. Responds only if interested. Write for appointment to show portfolio, which should include roughs, finished art, final reproduction/product and tearsheets. Pays by the hour, $25-80 or by the project, $100-2,500. Considers client's budget and skill and experience of artist when establishing payment. Negotiates rights purchased.

Tips "We are interested in knowing your specialty."

F.A.C. MARKETING

P.O. Box 782, Burlington IA 52601. (319)752-9422. Fax: (319)752-7091. E-mail: roger@facmarke ting.com. Web site: www.facmarketing.com. **President:** Roger Sheagren. Estab. 1952. Number of employees 8. Approximate annual billing $500,000. Ad agency. Full-service, multimedia firm. Specializes in newspaper, television, direct mail. Product specialty is funeral home to consumer.

Needs Approached by 30 freelancers/year. Works with 1-2 freelance illustrators and 4-6 designers/year. Prefers freelancers with experience in newspaper and direct mail. Uses freelancers mainly for brochure and direct mail. Also for brochure design and illustration, logos, signage and TV/film graphics. Freelance work demands knowledge of PageMaker, Photoshop, Corel-Draw and QuarkXPress.

First Contact & Terms E-mail Web site links and URL's or mail query letter with brochure, SASE, tearsheets and photocopies. Samples are filed or returned by SASE if requested by artist. Request portfolio review in original query. Portfolio should include b&w photostats, tearsheets and thumbnails. Pays by the project, $100-500. Rights purchased vary according to project.

FLINT COMMUNICATIONS

101 N. 10th St., Suite 300, Fargo ND 58102. (701)237-4850. Fax: (701)234-9680. E-mail: gerri.lien @flintcom.com. Web site: www.flintcom.com. **Creative Director:** Gerri Lien. Art Directors: Dawn Koranda, Jeff Reed, Curt Grant, Frank Stegmaier. Estab. 1947. Number of employees: 60. Approximate annual billing: $14 million. Ad agency; full-service multimedia firm. Product specialties are agriculture, manufacturing, healthcare, insurance, tourism and banking. Professional affiliations: AIGA, MN Ad Fed.

● See also listing for Simmons/Flint Advertising in this section.

Needs Approached by 50 freelancers/year. Works with 6-10 freelance illustrators and 3-4 designers/year. Uses freelancers for annual reports, brochure design and illustration, lettering, logos and TV/film graphics. 40% of work is with print ads. 20% of freelance work demands knowledge of InDesign, Photoshop, QuarkXPress and Illustrator.

First Contact & Terms Send query letter and postcard-size or larger sample of work. Samples are filed. Will contact artist for portfolio review if interested. Pays for illustration by the project, $100-2,000. Rights purchased vary according to project.

FORDESIGN GROUP

5405 South, 550 East, Ogden UT 84405-4771. (801)479-4002. Fax: (801)479-4099. E-mail: steven @fordesign.net. Web site: www.fordesign.net. **Owner:** Steven Ford. Estab. 1990. Specializes in brand and corporate identity, package and Web site design. Clients: corporations. Current clients include Sony, IBM, Cadbury Beverage, Carrs, MasterCard. Professional affiliations: AIGA, PDC.

Needs Approached by 100 freelancers/year. Works with 6-10 freelance illustrators and 4-6 designers/year. Uses illustrators mainly for brochures, ads. Uses designers mainly for corporate identity, packaging, collateral. Also uses freelancers for ad and brochure design and illustration, logos. Needs bright, conceptual designers and illustrators. 90% of freelance work demands skills in Illustrator, Photoshop, FreeHand and Dreamweaver.

First Contact & Terms Send postcard sample of work or send photostats, slides and transparencies. Samples are filed or returned by SASE if requested by artist. Will contact artist for portfolio review if interested. Portfolio should include b&w and color samples. Pays for design by the hour or by the project. Pays for illustration by the project.

Tips "We review *Showcase*, *Workbook*, etc. We are impressed by great work, simply presented. Save money on promotional materials by partnering with printers. Create a joint project or tie-in."

ALAN FRANK & ASSOCIATES INC.

Dept. AM, 1524 South 100 East, Salt Lake City UT 84105. (801)486-7455. Fax: (801)486-7454. **Art Director:** Scott Taylor. Serves clients in travel, fast food chains and retailing. Clients include KFC, A&W, Taco Bell and Tuffy Automotive.

Needs Uses freelancers for illustrations, animation and retouching for annual reports, billboards, ads, letterheads, TV and packaging.

First Contract & Terms Mail art with SASE. Responds in 2 weeks. Minimum payment $500, animation; $100, illustrations; $200, brochure layout.

▣ FREEASSOCIATES

2300 Westwood Blvd., Suite 105, Los Angeles CA 90064. (310)441-9950. Fax: (310)441-9949. E-mail: jfreeman@freeassoc.com. Web site: www.freeassoc.com. **President:** Josh Freeman. Estab. 1974. Number of employees: 4. Design firm. Specializes in marketing materials for corporate clients. Client list available upon request. Professional affiliations: AIGA.

Needs Approached by 60 illustrators and 30 designers/year. Works with 3 illustrators and 3 designers/year. Prefers freelancers with experience in top level design and advertising. Uses freelancers mainly for design, production, illustration; also for airbrushing, brochure design and illustration, catalog design and illustration, lettering, logos, mechanicals, multimedia projects, posters, retouching, signage, storyboards, technical illustration and Web page design. 30% of work is with print ads. 90% of design and 50% of illustration demand skills in Photoshop, InDesign CS, Illustrator.

First Contact & Terms Designers: Send query letter with photocopies, photographs, résumé, tearsheets. Illustrators: Send postcard sample of work and/or photographs and tearsheets. Accepts Mac-compatible disk submissions to view in current version of major software or self-running presentations. CD-ROM OK. Samples are filed or returned by SASE. Will contact for portfolio review if interested. Pays for design and illustration by the project; negotiable. Rights purchased vary according to project. Finds artists through iSpot.com and other online resources, *LA Workbook*, *CA*, *Print*, *Graphis*, submissions and samples.

Tips "Designers should have their own computer and high speed Internet connection. Must have sensitivity to marketing requirements of projects they work on. Deadline commitments are critical."

FULLMOON CREATIONS INC.

100 Mechanic St., Doylestown PA 18901. (215)345-1233. E-mail: info@fullmooncreations.com. Web site: www.fullmooncreations.com. **Contact:** Art Director. Estab. 1986. Number of employees: 10. Specializes in new product ideas, new product concept development, product name generations, brand development, product design, packaging design, packaging structure design, packaging descriptive copy writing. Clients: Fortune 500 corporations. Current clients are top 1,000 manufacturers involved in new product and packaging development.

Needs Approached by 100-120 freelancers/year. Works with 5-15 freelance illustrators and 10-20 designers/year. Uses freelancers for ad, brochure and catalog design and illustration; airbrushing; audiovisual materials; book, direct mail and magazine design; logos; mechanicals;

poster and P-O-P illustration. Needs computer-literate freelancers for design, illustration and production. 50% of freelance work demands knowledge of Illustrator, Photoshop, Adobe CS.

First Contact & Terms Send postcard sample of work, photocopies, résumé and URL. Samples are filed. E-mail links to Web site. Responds in 1 month with SASE. Will contact artist for portfolio review if interested. Portfolio should include b&w and color roughs, thumbnails and transparencies.

Tips "Fullmoon Creations, Inc. is a multi-dimensional creative development team, providing design and marketing services to a growing and diverse group of product and service organizations, and staffed by a team of professionals. Complementing these professionals is a group of talented, motivated (you) copywriters, illustrators, Web designers and programmers who are constantly challenging their creative skills, working together with us as a team. We are, above all, a professional service organization with a total dedication to our clients' marketing needs."

G2 PARTNERS

6 Spring St., Medway MA 02053-2156. (508)533-1223. E-mail: robert@g2partners.com. Web site: www.g2partners.com. **Creative Director:**Robert Greenebaum. Estab. 1975. Ad Agency. Specializes in business to business marketing communications (advertising, direct mail, branding and identity, Internet presence, corporate literature, investor relations) for a variety of regional, national and international clients, large and small.

Needs Uses freelancers mainly for advertising, direct mail and literature; also for brochure and print ad illustration.

First Contact & Terms Samples are filed or are returned by SASE if requested by artist. Responds only if interested. Pays for illustration by the project: $500-3,500. Finds artists through annuals and sourcebooks.

GARRITY COMMUNICATIONS, INC.

391 Lansing Station Rd., Lansing NY 14882-8606. (607)533-4536. Fax: (607)533-4543. E-mail: brandarmor@garrity.com. Web site: www.garrity.com. **Contact:** Art Director. Estab. 1978. Ad agency, AV firm. Specializes in trade ads, newspaper ads, annual reports, video, etc. Product specialties are financial services, food, higher education.

Needs Approached by 8 freelance artists/month. Works with 2 freelance illustrators and 1 freelance designer/month. Works on assignment only. Uses freelance artists mainly for work overflow situations, some logo specialization; also for brochure design and illustration, print ad illustration, TV/film graphics and logos. 40% of work is with print ads. 90% of freelance work demands knowledge of Photoshop, Illustrator, InDesign.

First Contact & Terms Send query letter with brochure and photocopies. Samples are filed and are not returned. Responds only if interested. Will contact artist for portfolio review if interested. Pays for design by the hour, $25-75. Pays for illustration by the project, $150-1,500. Rights purchased vary according to project. Finds artists through sourcebooks, submissions.

KERRY GAVIN STUDIOS

30 Brookwood Rd., Waterford NY 12188. (518)235-5630. E-mail: kerrygavin@kerrygavinstudios .com. Web site: www.kerrygavinsstudio.com. Specializes in publication design. Clients corporations, companies. Client list available upon request.

Needs Approached by 6-10 freelancers/year. Works with 6-8 freelance illustrators and 1-2 designers/year. Uses illustrators mainly for assorted projects. Uses designers mainly for production.

Also uses freelancers for magazine design. Freelancers should be familiar with InDesign, Illustrator and Photoshop.

First Contact & Terms Send postcard sample of work or photocopies and tearsheets. Samples are filed or returned. Responds only if interested. Portfolio review not required. Pays for design by the hour, $20-35. Pays for illustration by the project, $450 minimum. Buys one-time rights. Finds artists through sourcebooks, direct mailing, word of mouth and annuals.

Tips Impressed by "prompt response to query calls, good selection of samples, timely delivery."

GIRVIN STRATEGIC BRANDING AND DESIGN

1601 Second Ave., 5th Floor, Seattle WA 98101-1575. (206)674-7808. Fax: (206)674-7909. Web site: www.girvin.com. Design Firm. Estab. 1977. Number of employees: 34. Specializes in corporate identity and brand strategy, naming, Internet strategy, graphic design, signage, and packaging. Current clients include Warner Bros., Procter & Gamble, Paramount, Wells Fargo, Johnson & Johnson, and Kraft/Nabisco.

Needs Works with several freelance illustrators, production artists and designers/year.

First Contact & Terms Designers: Send query letter with appropriate samples. Illustrators: Send postcard sample or other nonreturnable samples. Will contact for portfolio review if interested. Payment negotiable.

N I GLOBAL FLUENCY

4151 Middlefield Rd., Palo Alto CA 94303. (650)433-4147. Fax: (650)328-5016. Web site: www.globalfluency.com. Estab. 1986. Strategic communications and PR firm. Specializes in promotions, packaging, corporate identity, collateral design, annuals, graphic and ad design. Product specialties are Internet, hi-tech, computer systems and peripherals, medical and consumer packaged goods. Clients include eDiets.com, McAfee, PGP Corporation, TOA Technologies.

Needs Approached by 20 freelance artists/month. Works with 2-3 freelance illustrators and 2-3 freelance designers/month. Prefers local artists with experience in all areas of manual and electronic art capabilities. Works on assignment only. Uses freelance artists mainly for brochure design and illustration, print ad illustration, mechanicals, posters, lettering, logos and cartoons. Needs editorial and technical illustration for cartoons and caricatures. Needs freelancers for design, illustration, production and presentation.

First Contact & Terms Send query letter with "best work samples in area you're best in." Samples are filed. Responds in 2 weeks. To show a portfolio, mail thumbnails, roughs and color slides. Pays for design by the hour. Negotiates rights purchased.

GOLD & ASSOCIATES INC.

6000-C Sawgrass Village Circle, Ponte Vedra Beach FL 32082. (904)285-5669. Fax: (904)285-1579. E-mail: gold@strikegold.com. Web site: www.strikegold.com. **Creative Director/President:** Keith Gold. Incorporated in 1988. Full-service multimedia, marketing and communications firm. Specializes in graphic design and advertising. Product specialties are entertainment, medical, publishing, tourism and sports.

Needs Approached by over 100 freelancers/year. Works with approximately 25 freelance illustrators/year. Works primarily with artist reps. Uses illustrators for annual reports, books, brochures, editorial, technical, print ad illustration; storyboards, animatics, animation, music videos. 65% of work is in print. 50% of freelance work demands knowledge of Illustrator, QuarkXPress, Photoshop or InDesign.

First Contact & Terms Contact through artist rep or send query letter with photocopies or tearsheets. Samples are filed. Responds *only* if interested. Will contact artists for portfolio review if interested. Follow up with letter after initial query. Portfolio should include tearsheets. Pays for illustration by the project, $200-7,500. Buys all rights. Finds artists primarily through source-books and reps. Does not use freelance designers.

TOM GRABOSKI ASSOCIATES, INC.

4649 Ponce De Leon Blvd., Suite 401, Coral Gables FL 33146. (305)669-2550. Fax: (305)669-2539. E-mail: mail@tgadesign.com. Web site: www.tgadesign.com. **President:** Tom Graboski. Estab. 1980. Specializes in exterior/interior signage, environmental graphics, corporate identity, urban design and print graphics. Clients: corporations, cities, museums, a few ad agencies. Current clients include Universal Studios, Florida; Royal Caribbean Cruise Line; The Equity Group; Disney Development; Celebrity Cruises; Baptist Health So. Florida; City of Miami; City of Coral Gables.

Needs Approached by 20-30 freelance artists/year. Works with approximately 4-8 designers/draftspersons/year. Prefers artists with a background in signage and knowledge of architecture and industrial design. Freelance artists used in conjunction with signage projects, occasionally miscellaneous print graphics. 100% of design and 10% of illustration demand knowledge of Illustrator, Photoshop and QuarkXPress.

First Contact & Terms Send query letter with brochure and résumé. "We will contact designer/artist to arrange appointment for portfolio review. Portfolio should be representative of artist's work and skills; presentation should be in a standard portfolio format." Pays by the project. Payment varies by experience and project. Rights purchased vary by project.

Tips "Look at what type of work the firm does. Tailor presentation to that type of work. For this firm, knowledge of environmental graphics and detailing is a plus."

GRETEMAN GROUP

1425 E. Douglas Ave., Wichita KS 67211. (316)263-1004. Fax: (316)263-1060. E-mail: info@grete mangroup.com. Web site: www.gretemangroup.com. **Owner:** Sonia Greteman. Estab. 1989. Number of employees 24. Capitalized billing $20 million. Creative agency. Specializes in corporate identity, advertising, annual reports, signage, Web site design, interactive media, brochures, collateral. Professional affiliations AIGA.

Needs Approached by 20 illustrators and 20 designers/year. Works with 2 illustrators/year. 10% of work is with print ads. 30% of illustration demands computer skills in photoshop and illustrator.

First Contact & Terms Send query letter with brochure and résumé. Accepts disk submissions. Send EPS files. Samples are filed. Will contact for portfolio review of b&w and color final art and photostats if interested. Pays for illustration by the project. Rights purchased vary according to project.

GREY NEW YORK

777 Third Ave., New York NY 10017. (212)546-2000. Fax: (212)546-2255. E-mail: jhorowitz@gre y.com. Web site: www.grey.com. **Vice President/Director of Art Producers:** Jayne Horowitz. Professional affiliations 4A's Art Services Committee.

Needs Approached by hundreds of freelancers/year. Clients include Pantene, DDF, Diagio, and 3m. Works with about 300 freelancers/year. Freelancers are needed mostly for illustration and photography, but also for model-making, fashion styling and lettering.

First Contact & Terms Works on assignment only. E-mail query with Web site link for initial contact. No flollow-up e-mails. Does not respond unless interested and appropriate project arises. Pays by the project. Considers client's budget and rights purchased when establishing fees.

Tips ''Show your work in a neat and organized manner. Have sample leave-behinds or Web site link and do not expect to leave with a job.''

GRIFFIN MARKETING SERVICES, INC.

802 Wabash Ave., Chesterton IN 46304-2250. (219)929-1616. Fax: (219)921-0388. E-mail: rob@g riffinmarketingservices.com. Web site: www.griffinmarketingservices.com. **President:** Michael J. Griffin. Estab. 1974. Number of employees 20. Approximate annual billing $4 million. Integrated marketing firm. Specializes in collateral, direct mail, multimedia. Product specialty is industrial. Current clients include Hyatt, USX, McDonalds.

Needs Works with 20-30 freelance illustrators and 2-30 designers/year. Prefers artists with experience in computer graphics. Uses freelancers mainly for design and illustration. Also uses freelancers for animation, model making and TV/film graphics. 75% of work is with print ads. Needs computer-literate freelancers for design, illustration, production and presentation. 95% of freelance work demands knowledge of PageMaker, FreeHand, Photoshop, QuarkXPress and Illustrator.

First Contact & Terms Send query letter with SASE or e-mail. Samples are not filed and are returned by SASE if requested by artist. Responds in 1 month. Will contact artist for portfolio review if interested. Pays for design and illustration by the hour, $20-150; or by the project.

Tips Finds artists through *Creative Black Book*.

GUERTIN ASSOCIATES

3703 W. Lake Ave., Glenview IL 60025. (847)729-2674, ext. 204. Web site: www.guertincommun ications.com. **Contact:** Russell Guertin. Estab. 1987. Marketing service agency. Specializes in P.O.S. materials, magazine ads, direct mail and business-to-business communications. Product specialties are boating, gasolines, financial and pharmaceuticals. Current clients include Bank of America, GE Capital, Heinz, Kraft Foods, Sprint, Unilever. Client list available upon request.

Needs Approached by 50 freelancers/year. Works with 10 freelance illustrators/year. Prefers freelancers with experience in Mac Quark, Illustrator, Freehand, Photoshop who can work offsite. Uses freelancers mainly for keyline and layout; also for billboards, brochure design, catalog design and illustration, logos, mechanicals, posters and signage. 10% of work is with print ads. Needs computer-literate freelancers for illustration and production. 90% of freelance work demands skills in FreeHand, Photoshop, QuarkXPress and Illustrator.

First Contact & Terms Send query letter with photocopies and résumé. Samples are not returned. Will contact artist for portfolio review if interested. Pays for design by the project, $100-1,000. Pays for illustration by the project. Buys all rights.

HAMMOND DESIGN ASSOCIATES, INC.

824 Euclid Ave., Lexington KY 40505. (859)259-3639. Fax: (859)259-3697. Web site: www.ham monddesign.com. **Vice-President:** Grady Walter. Estab. 1986. Specializes in direct mail, package and publication design and annual reports, brand and corporate identity, display and signage. Clients corporations, universities and medical facilities.

Needs Approached by 35-50 freelance/year. Works with 5-7 illustrators and 5-7 designers/year.

Works on assignment only. Uses freelancers mainly for brochures and ads. Also for editorial, technical and medical illustration, airbrushing, lettering, P-O-P and poster illustration; and charts/graphs. 100% of design and 50% of illustration require computer skills.

First Contact & Terms Send postcard sample or query letter with brochure or résumé. "Sample in query letter a must." Samples are filed or returned by SASE if requested by artist. Responds only if interested. Will contact artist for portfolio review if interested. Pays by the project.

HANSON/DODGE CREATIVE

220 E. Buffalo St., Milwaukee WI 53202-5704. (414)347-1266. Fax: (414)347-0493. E-mail: postm aster@hansondodge.com. Web site: www.hansondodge.com. **CEO:** Ken Hanson. Estab. 1980. Number of employees 78. Approximate annual billing $78 million. Specializes in active lifestyle driven consumer marketing including brand planning, marketing communications, design, public relations, and technology solutions. Clients corporations, agencies. Current clients include Trek Bicycle, Timex, T-Fal, Hushpuppies. Client list available upon request. Professional affiliations AIGA, APDF, ACD.

Needs Approached by 30 freelancers/year. Works with 2-3 freelance illustrators, 2-3 designers and 5-8 production artists/year. Needs computer-literate freelancers for design, illustration and production. 90% of freelance work demands knowledge of Illustrator, Photoshop and InDesign.

First Contact & Terms Send letter of introduction and position sought with résumé and nonreturnable samples to Hanson/Dodge Design, Attn: Claire Chin or e-mail postmaster@hansondodg e.com. Résumés and samples are kept on file for 6 months. Responds in 2 weeks. Artist should follow-up with call. Pays for design and illustration by the hour. Finds artists through word of mouth, submissions.

HARMON GROUP

807 Third Ave. S., Nashville TN 37210. (615)256-3393. Fax: (615)256-3464. E-mail: info@harmo ngrp.com. Web site: www.harmongrp.com. **President:** Rick Arnemann. Estab. 1988. Number of employees 32. Approximate annual billing $7.2 million. Specializes in luxury consumer products, brand identity, display and direct mail design and signage. Clients consumer product companies, corporations, mid-size businesses. Current clients include Best Products, Service Merchandise, WalMart, Hartmann Luggage. Client list available upon request. Professional affiliations Creative Forum.

Needs Approached by 20 freelancers/year. Works with 4-5 freelance illustrators and 5-6 designers/year. Uses illustrators mainly for P-O-P. Uses designers mainly for fliers and catalogs. Also uses freelancers for ad, brochure, catalog, poster and P-O-P design and illustration, logos, magazine design, mechanicals and retouching. 85% of freelance work demands skills in Illustrator, Photoshop and QuarkXPress.

First Contact & Terms Send photographs, resume, slides and transparencies. Samples are filed. Will contact artist for portfolio review if interested. Portfolio should include color final art, roughs, slides and thumbnails. Pays for design and illustration by the project. Rights purchased vary according to project. Finds artists through sourcebooks and portfolio reviews.

HILL AND KNOWLTON, INC.

909 Third Ave., 10th Floor, New York NY 10022. (212)885-0300. Fax: (212)885-0570. E-mail: patrick.baird@hillandknowlton.com. Web site: www.hillandknowlton.com. **Creative Services Manager:** Patrick Baird. Estab. 1927. Number of employees: 1,800 (worldwide). PR firm; full-

service multimedia firm. Specializes in corporate communications, marketing communications, public affairs, health care/pharmaceuticals, technology. Creative services include reports, collateral materials, corporate identity, presentation design, signage and advertisements.

Needs Works with 0-10 freelancers/month. Works on assignment only. Uses freelancers for editorial, technical and medical illustration; also for storyboards, slide illustration, animatics, mechanicals, presentation design, retouching. 10% of work is with print ads. Needs computer-literate freelancers for illustration. Freelancers should be familiar with Adobe Creative Suite: Photoshop, Illustrator, InDesign, and Microsoft PowerPoint.

First Contact & Terms Send query letter with promo and samples. Samples are filed. Does not respond, in which case the artist should "keep in touch by mail—do not call." Call and drop-off only for a portfolio review. Pays freelancers by the project, $250-5,000. Negotiates rights purchased.

Tips Looks for "variety; unique but marketable styles are always appreciated."

THE HITCHINS COMPANY

22756 Hartland St., Canoga Park CA 91307. (818)715-0150. Fax: (775)806-2687. E-mail: whitchins@socal.rr.com. **President:** W.E. Hitchins. Estab. 1985. Advertising agency. Full-service, multimedia firm.

Needs Works with 1-2 illustrators and 3-4 designers/year. Works on assignment only. Uses freelance artists for brochure and print ad design and illustration, storyboards, mechanicals, retouching, TV/film graphics, lettering and logo. Needs editorial and technical illustration and animation. 60% of work is with print ads. 90% of design and 50% of illustration demand knowledge of In Design, PageMaker, Illustrator, or FreeHand.

First Contact & Terms Send postcard sample. Samples are filed if interested and are not returned. Responds only if interested. Call for appointment to show portfolio. Portfolio should include tearsheets. Pays for design and illustration by the project, according to project and client. Rights purchased vary according to project.

BERNARD HODES GROUP

220 East 42nd St., New York NY 10017. (212)999-9687. Web site: www.hodes.com. **Creative Director:** Gregg Petermann. Estab. 1970. Ad agency. Full-service, multimedia firm. Specializes in recruitment advertising and employment communications.

Needs Prefers artists with strong interactive design skills. Heavy emphasis on flash, dreamweaver, and html. Works on assignment only. Uses freelancers for illustration. 50% of work is with print ads. Freelance work demands knowledge of QuarkXPress, Illustrator, Photoshop or InDesign.

First Contact & Terms Send query letter with samples, CD of best work or URL's to the creative director. Write for an appointment to show a portfolio.

HOLLAND ADVERTISING

700 Walnut St., Suite 300, Cincinnati OH 45202-2011. (513)721-1310. Fax: (513)721-1269. E-mail: holland@thinkresponsively. Web site: www.thinkresponsively.com. **Contact:** David Dreisbach. Estab. 1937. Number of employees 17. Approximate annual billing $12 million. Ad agency. Full-service, multimedia firm. Professional affiliation AAAA.

Needs Approached by 6-12 freelancers/year. Works with 5-10 freelance illustrators and 2-3 designers/year. Prefers artists with experience in Macintosh. Uses freelancers for brochure illus-

tration, logos and TV/film graphics. 100% of freelance work demands knowledge of Photoshop, InDesign and Illustrator.

First Contact & Terms Send query letter with photocopies and résumé. Accepts submissions on disk. Samples are filed and are not returned. Will contact artist for portfolio review if interested. Portfolio should include b&w and color final art, photographs, roughs, tearsheets and thumbnails. Pays for design by the hour, by the project and by the day. Pays for illustration by the project. Rights purchased vary according to project.

HORNALL ANDERSON

710 Second Ave., Suite 1300, Seattle WA 98104. (206)467-5800. Fax: (206)467-6411. E-mail: info@hadw.com. Web site: www.hornallanderson.com. Estab. 1982. Number of employees: 100+ Integrated branding firm. Specializes in full-range integrated brand and communications strategy, corporate identity, interactive and digital design, packaging, corporate literature, collateral, retail and environmental graphics. Current clients include Holland America Line, Widmer Brothers Brewery, RedHook Brewery, Tommy Bahama, T-Mobile, CitationShares, Microsoft. Professional affiliations: AIGA, Seattle Design Association, Art Directors Club.

- This firm has received numerous awards and honors, including the International Mobius Awards, London International Advertising Awards, ADDY Awards, Industrial Designers Society of America IDEA Awards, Communication Arts, Brand Design Association Gold Awards, AIGA, Clio Awards, Communicator Awards, Webby Awards, and Graphis Awards.

Needs Interested in all levels, from senior print and interactive design personnel to interns with design experience. Additional illustrators and freelancers are used on an as needed basis in design and online media projects.

First Contact & Terms Designers: Send query letter with photocopies and résumé. Illustrators: Send query letter with brochure and follow-up postcard. Accepts disk submissions compatible with Illustrator or Photoshop, "but the best is something that is platform/software independent (i.e., Director)." Samples are filed. Responds only if interested. Portfolios may be dropped off. Rights purchased vary according to project. Finds designers through word of mouth and submissions; illustrators through sourcebooks, reps and submissions.

HOWARD DESIGN GROUP

20 Nassau St., Suite 250W, Princeton NJ 08542. (609)924-1106. Fax: (609)924-1165. E-mail: diane@howarddesign.com. Web site: www.howarddesign.com. **Vice President:** Diane Savoy. Estab. 1980. Number of employees: 10. Specializes in Web sites, corporate identity, college recruitment materials and publication design. Clients: corporations, schools and colleges.

Needs Approached by 20 freelancers/year. Works with 10 freelance illustrators and 5 designers/ year. Uses freelancers mainly for publication design; also for brochure design and illustration; catalog, direct mail, magazine and poster design; logos. Needs computer-literate freelancers for design and production. 100% of freelance work demands knowlege of Illustrator, Photoshop, FreeHand and QuarkXPress.

First Contact & Terms Send résumé. Samples are filed. Will contact artist for portfolio review if interested. Portfolio should include color final art, roughs and thumbnails. Pays for design and illustration by the project. Buys one-time rights. Finds artists through *Showcase*.

Tips Looks for "innovative design in portfolio."

HOWARD/FROST ADVERTISING COMMUNICATIONS

2100 Westlake Ave N., Suite 201, Seattle, WA 98109. (206)378-1909. Fax: (206)378-1910. E-mail: bruce@hofro.com. Web site: www.hofro.com. **Creative Director:** Bruce Howard. Estab. 1994. Number of full-time employees: 4. Ad agency. Specializes in media advertising, collateral, Web design, Web advertising and direct mail. Client list is available upon request.

Needs Approached by 20-30 illustrators and 10-15 designers/year. Works with 10 illustrators and 2 designers/year. Works only with artist reps. Uses freelancers mainly for illustration, design overload. Also for airbrushing, animation, billboards, brochure, humorous and technical illustration, lettering, logos, multimedia projects, retouching, storyboards, Web page design. 60% of work is with print ads. 60% of freelance design demands knowledge of PageMaker, FreeHand and Photoshop.

First Contact & Terms Designers: Send query letter with photocopies. Illustrators: Send postcard sample. Accepts disk submissions. Send files compatible with Acrobat, InDesign, Illustrator, Dreamweaver, Flash or Photoshop. Samples are filed and not returned. Responds only if interested. Art director will contact artist for portfolio review if interested. Pays for design and illustration by the project. Negotiates rights purchased.

Tips "Be patient."

HOWRY DESIGN ASSOCIATES

354 Pine St., Suite 600, San Francisco CA 94104. (415)433-2035. Fax: (415)433-0816. E-mail: info@howry.com. Web site: www.howry.com. **Principal/Creative Director:** Jill Howry. Estab. 1988. Full service design studio. Number of employees: 10. Specializes in annual reports, corporate identity, print, advertising and multimedia. Clients: startups to Fortune 100 companies. Current clients include Del Monte, Affymetrix, Geron Corporation, McKesson Corp., First Republic Bank. Professional affiliation: AIGA.

Needs Works with 30 freelance illustrators, photographers and Web and print designers/year. Works on assignment only. Uses illustrators for "anything that applies." Uses designers mainly for newsletters, brochures, corporate identity. Also uses freelancers for production, programming, retouching, photography/illustration, logos and charts/graphs. 100% of design work, 10% of illustration work demands knowledge of InDesign, Illustrator or Photoshop.

First Contact & Terms Samples are filed. Responds only if interested. Portfolios may be dropped off every Thursday. Pays for design/production by the hour, or by the job, $25-60. Pays for photography and illustration on a per-job basis. Rights purchased vary according to project.

Tips Finds artists through sourcebooks, samples, representatives.

HUTCHINSON ASSOCIATES, INC.

1147 W. Ohio St., Suite 305, Chicago IL 60622. (312)455-9191. Fax: (312)455-9190. E-mail: hutch@hutchinson.com. Web site: www.hutchinson.com. **President:** Jerry Hutchinson. Estab. 1988. Number of employees: 3. Specializes in annual reports, corporate identity, capability brochures, direct mail, publication design and Web site design and development. Clients: small and large companies, associations and PR firms. Professional affiliations: AIGA.

- Work from Hutchinson Associates has been published in the following design books: *Graphis Design* (Graphis Publications); *Revival of the Fittest: Digital Versions of Classic Typefaces* (North Light Books); *Simpson Paper Show Catalog* (Simpson Paper, San Francisco); *Working with Computer Type*, Vols. 1-3 (Rotovision); *Context One* (Sappi Papers); *Logo Lounge*, Vols. 1-3 (Rockport); *1,000 Invitations* (Rockport); *Publication Design Workbook* (Rockport); *Letterhead and Logo Design 9* (Rockport).

Needs Approached by 5-10 freelancers/year. Works with 3-4 freelance illustrators and 5-15 designers/year.

First Contact & Terms Send postcard sample of work or send query letter with résumé, brochure, photocopies and photographs. Samples are filed. Request portfolio review in original query. Artist should follow up with call. Will contact artist for portfolio review if interested. Pays by the project, $100-10,000. Rights purchased vary according to project. Finds artists through sourcebooks, submissions and Illinois reps.

Tips ''Persistence pays off.''

ICON NICHOLSON, LLC

295 Lafayette St., New York NY 10012. (212)274-0470. Fax: (212)274-0380. E-mail: careers@ico nnicholson.com. Web site: www.iconnicholson.com. **Senior Art Director:** Maya Kopytman. Estab. 1987. Specializes in design of interactive computer programs. Clients: corporations, museums, government agencies and multimedia publishers. Client list available upon request.

Needs Works with 3 freelance illustrators and 12 designers/year. Prefers local freelancers. Uses illustrators mainly for computer illustration and animation. Uses designers mainly for computer screen design and concept development; also for mechanicals, charts/graphs and AV materials. Needs editorial and technical illustration. Especially needs designers with interest (not necessarily experience) in computer screen design plus a strong interest in information design. 80% of freelance work demands computer skills.

First Contact & Terms Send query letter with résumé; include tearsheets and slides if possible. Samples are filed or are returned if requested. Will contact artist for portfolio review if interested. Portfolio should include thumbnails, original/final art and tearsheets. Considers complexity of project, client's budget and skill and experience of artist when establishing payment. Rights purchased vary according to project. Interested in buying second rights (reprint rights) to previously published work. Finds artists through submissions/self-promotions and sourcebooks.

IDEA BANK MARKETING

701 W. Second St., Hastings NE 68902-2117. (402)463-0588. Fax: (402)463-2187. E-mail: sherma @ideabankmarketing.com. Web site: www.ideabankmarketing.com. **Creative Director:** Sherma Jones. Estab. 1982. Number of employees: 7. Approximate annual billing: $1,000,000. Ad agency. Specializes in print materials, direct mail. Product specialty is manufacturers. Client list available upon request. Professional affiliations: Advertising Federation of Lincoln.

Needs Approached by 2 illustrators/year. Works with 2 illustrators and 2 designers/year. Prefers local designers only. Uses freelancers mainly for illustration; also for airbrushing, catalog and humorous illustration, lettering. 30% of work is with print ads. 75% of design demands knowledge of Photoshop, Illustrator, FreeHand. 60% of illustration demands knowledge of FreeHand, Photoshop, Illustrator.

First Contact & Terms Designers/Illustrators: Send query letter with brochure. Send follow-up postcard samples every 6 months. Accepts disk submissions compatible with original illustration files or Photoshop files. Samples are filed or returned by SASE. Responds only if interested. Will contact artist for portfolio review of b&w, color, final art, tearsheets if interested. Pays by the project. Rights purchased vary according to project and are negotiable. Finds artists through word of mouth.

IDENTITY CENTER

1110 Idaho St., Carol Stream IL 60188. E-mail: wk@genericsign.com. Web site: www.genericsign.com. **President:** Wayne Kosterman. Number of employees: 2. Approximate annual billing: $250,000. Specializes in brand and corporate identity, print communications and signage. Clients: corporations, hospitals, manufacturers and banks. Professional affiliations: AIGA, American Center for Design, SEGD.

Needs Approached by 40-50 freelancers/year. Works with 4 freelance illustrators and 4 designers/year. Prefers 3-5 years of experience minimum. Uses freelancers for editorial and technical illustration, retouching and lettering. 50% of freelance work demands knowledge of QuarkXPress, Photoshop, Illustrator and Dreamweaver.

First Contact & Terms Designers: Send resume and photocopies. Illustrators: Send postcard samples, color photocopies or other nonreturnable samples. To show a portfolio, send photocopies or e-mail. Do not send samples you need back without checking with us first. Pays for design by the hour, $20-50. Pays for illustration by the project, $200-5,000. Considers client's budget, skill and experience of artist and how work will be used when establishing payment. Rights purchased vary according to project.

Tips "Not interested in amateurs or part-timers."

IMAGE ASSOCIATES INC.

Keystone Office Park, 615 Davis Dr., Suite 600, Morrisville NC 27560. (919)876-6400. Fax: (919)876-7064. E-mail: carla@imageassociates.com. Web site: www.imageassociates.com. **President:** Carla Davenport. Estab. 1984. Number of employees: 35. Marketing communications group offering advanced Web-based solutions, multimedia and print. Visual communications firm specializing in computer graphics and AV, multi-image, interactive multimedia, Internet development, print and photographic applications.

Needs Approached by 10 freelancers/year. Works with 4 freelance illustrators and 4 designers/year. Prefers freelancers with experience in Web, CD-ROM and print. Works on assignment only. Uses freelancers mainly for Web design and programming. Also for print ad design and illustration and animation. 90% of freelance work demands skills in Flash, HTML, DHTML, ASP, Photoshop and Macromind Director.

First Contact & Terms Send query letter with brochure, résumé and tearsheets. Samples are filed or are returned by SASE if requested by artist. Responds only if interested. To show portfolio, mail roughs, finished art samples, tearsheets, final reproduction/product and slides. Pays for assignments by the project, $100 minimum. Considers complexity of project, client's budget and how work will be used when establishing payment. Rights purchased vary according to project.

☒ IMAGINASIUM, INC.

110 S. Washington St., Green Bay WI 54301-4211. (920)431-7872. Fax: (920)431-7875. E-mail: joe@imaginasium.com. Web site: www.imaginasium.com. **Executive Creative Director:** Joe Bergner. Estab. 1992. Number of employees: 18. Approximate annual billing: $2 million. Strategic marketing communications firm. Specializes in brand development, graphic design, advertising. Product specialties are business to business retail. Current clients include Wisconsin Public Service, Manitowoc Crane, Ansul. Client list available upon request. Professional affiliations: Green Bay Advertising Federation, Second Wind Network.

Needs Approached by 50 illustrators and 25 designers/year. Works with 5 illustrators and 2

designers/year. Prefers local designers. Uses freelancers mainly for overflow; also for brochure illustration and lettering. 15-20% of work is with print ads. 100% of design and 88% of illustration demands skills in Photoshop, QuarkXPress and Illustrator.

First Contact & Terms Designers: Send query letter with brochure, photographs and tearsheets. Illustrators: Send sample of work with follow-up every 6 months. Accepts Macintosh disk submissions of above programs. Samples are filed and are not returned. Will contact for portfolio review of color tearsheets, thumbnails and transparencies if interested. Pays for design by the hour, $50-75. Pays for illustration by the project. Rights purchased vary according to project. Finds artists through submissions, word of mouth, Internet.

IMPACT COMMUNICATIONS GROUP

18627 Brookhurst St., #4200, Fountain Valley CA 92708. (714)963-6760. E-mail: info@impactgroup.com. Web site: www.impactgroup.com. **Creative Director:** Brad Vinikow. Estab. 1983. Number of employees: 15. Marketing communications firm; full-service multimedia firm. Specializes in electronic media, business-to-business and print design. Current clients include Yamaha Corporation, Prudential, Isuzu. Professional affiliations: IICS, NCCC and ITVA.

Needs Approached by 12 freelancers/year. Works with 12 freelance illustrators and 12 designers/year. Uses freelancers mainly for illustration, design and computer production; also for brochure and catalog design and illustration, multimedia and logos. 10% of work is with print ads. 90% of design and 50% of illustration demands knowledge of Photoshop, QuarkXPress, Illustrator and Macro Mind Director.

First Contact & Terms Designers: Send query letter with photocopies, photographs, résumé and tearsheets. Illustrators: Send postcard sample. Samples are filed and are not returned. Will contact artist for portfolio review if interested. Portfolio should include b&w and color final art, photographs, photostats, roughs, slides, tearsheets and thumbnails. Pays for design and illustration by the project, depending on budget. Rights purchased vary according to project. Finds artists through sourcebooks and self-promotion pieces received in mail.

Tips "Be flexible."

▣ INNOVATIVE DESIGN & GRAPHICS

1327 Greenleaf St., Evanston IL 60202-1152. (847)475-7772. Fax: (847)475-7784 E-mail: info@idgevanston.com. Web site: www.idgevanston.com. **Contact:** Tim Sonder. Clients corporate communication and marketing departments.

Needs Works with 1-5 freelance artists/year. Prefers local artists only. Uses artists for editorial and technical illustration and marketing, advertising and spot illustration. Illustrators should be knowledgeable in Adobe Illustrator and Photoshop.

First Contact & Terms Send query letter with résumé or brochure showing art style, tearsheets, photostats, slides and photographs. Will contact artist for portfolio review if interested. Pays for illustration by the project, $200-1,000 average. Considers complexity of project, client's budget and turnaround time when establishing payment. Interested in buying second rights (reprint rights) to previously published work.

Tips "Interested in meeting new illustrators, but have a tight schedule. Looking for people who can grasp complex ideas and turn them into high-quality illustrations. Ability to draw people well is a must. Do not call for an appointment to show your portfolio. Send nonreturnable tearsheets or self-promos, and we will call you when we have an appropriate project for you."

▣ JUDE STUDIOS

8000 Research Forest, Suite 115-266, The Woodlands TX 77382. (281)364-9366. Fax: (281)364-9529. E-mail: jdollar@judestudios.com. Web site: www.judestudios.com. **Creative Director:** Judith Dollar. Estab. 1994. Number of employees: 2. Design firm. Specializes in printed material, brochure, trade show, collateral. Product specialties are industrial, restaurant, homebuilder, financial, high-tech business to business event marketing materials. Professional affiliations: Art Directors of Houston, AAF.

Needs Approached by 20 illustrators and 6 designers/year. Works with 10 illustrators and 2 designers/year. Prefers local designers only. Uses freelancers mainly for newsletter, logo and brochures. Also for airbrushing; brochure design and illustration; humorous, medical, technical illustration; lettering, logos, mechanicals and retouching. 90% of design demands skills in Free-Hand, Photoshop, QuarkXPress. 30% of illustration demands skills in Illustrator and QuarkX-Press.

First Contact & Terms Designers: Send brochure, photocopies, photographs, photostats, résumé, tearsheets. Illustrators: Send query letter with brochure, photocopies, photographs or tearsheets. Accepts disk submissions. Send TIFF, EPS, PDF or JPEG files. Samples are filed and are not returned. Art director will contact artist for portfolio review if interested. Pays by the project; varies. Negotiates rights purchased. Finds artists through *American Show Case*, *Workbook*, *RSVP* and artist's reps.

Tips Wants freelancers with good type usage who contribute to concept ideas. "We are open to designers and illustrators who are just starting out their careers."

▣ KAUFMAN RYAN STRAL INC.

650 N. Dearborn St., Suite 600, Chicago IL 60610. (312)649-9408. Fax: (312)649-9418. E-mail: lkaufman@bworld.com. Web site: www.bworld.com. **President/Creative Director:** Laurence Kaufman. Estab. 1993. Number of employees 7. Ad agency. Specializes in all materials in print and Web site development. Product specialty is business-to-business. Client list available upon request. Professional affiliations: American Israel Chamber of Commerce.

Needs Approached by 30 freelancers/year. Works with 3 designers/year. Prefers local freelancers. Uses freelancers for design, production, illustration and computer work. Also for brochure, catalog and print ad design and illustration, animation, mechanicals, retouching, model-making, posters, lettering and logos. 5% of work is with print ads. 50% of freelance work demands knowledge of QuarkXPress, html programs FrontPage or Page Mill, Photoshop or Illustrator.

First Contact & Terms Send e-mail with with résumé and JPEGs. Responds only if interested. Will contact artist for portfolio review if interested. Portfolio should include b&w and color roughs and final art. Pays for design by the hour, $40-120; or by the project. Pays for illustration by the project, $75-8,000. Buys all rights. Finds artists through sourcebooks, word of mouth, submissions.

KIZER INCORPORATED ADVERTISING & COMMUNICATIONS

4513 Classen Blvd., Oklahoma City OK 73118. (405)858-4906. E-mail: bill@kizerincorporated.com. Web site: www.kizerincorporated.com. **Principal:** William Kizer. Estab. 1998. Number of employees 3. Ad agency. Specializing in magazine ads, print ads, copywriting, design/layout, collateral material. Professional affiliations OKC Ad Club, AMA, AIGA.

Needs Approached by 20 illustrators/year. Works with 3 illustrators and 3 designers/year. 50% of work is with print ads. 100% of design demands knowledge of InDesign, FreeHand, Photoshop. 50% of illustration demands knowledge of FreeHand, Photoshop.

First Contact & Terms Designers: Send or e-mail query letter with samples. Illustrators: Send or e-mail query letter with samples. Accepts disk submissions compatible with FreeHand or Photoshop file. Samples are filed and are not returned. Responds only if interested. To show portfolio, artist should follow up with call. Portfolio should include "your best work." Pays by the project. Rights purchased vary according to project. Finds artists through agents, sourcebooks, online services, magazines, word of mouth, artist's submissions.

LEIMER CROSS DESIGN CORPORATION

12 Auli'i Dr., Makawao HI 96768. E-mail: kerry@leimercross.com. Web site: www.leimercross.com. **Creative Director:** Kerry Leimer. Principal: Dorothy Cross. Estab. 1983. Specializes in annual reports, publication design, marketing brochures. Clients: corporations and service companies. Current clients include Expedia, Gardenburger, Microsoft, U.S. Bancorp.

Needs Approached by 75 freelance artists/year. Works with 4-5 illustrators and 6-8 designers/year. Prefers artists with experience in working for corporations. Uses freelance illustrators mainly for annual reports, lettering and marketing materials. Uses freelance designers mainly for "layout per instructions," production; also for brochure illustration, mechanicals, charts/graphs.

First Contact & Terms Send query letter with résumé, tearsheets and photographs. Samples are filed. Responds only if interested. To show a portfolio, mail thumbnails, roughs, tearsheets and photographs. Pays for design by the hour or by the project. Pays for illustration by the project. Rights purchased vary according to project.

▓ LEKASMILLER

1460 Maria Lane, Suite 260, Walnut Creek CA 94596. (925)934-3971. Fax: (925)934-3978. E-mail: info@lekasmiller.com. Web site: www.lekasmiller.com. **Production Manager:** Denise Fuller. Estab. 1979. Specializes in annual reports, corporate identity, advertising, direct mail and brochure design. Clients: corporate and retail. Current clients include Cost Plus World Market and Interhealth.

Needs Approached by 80 freelance artists/year. Works with 1-3 illustrators and 5-7 designers/year. Prefers local artists only with experience in design and production. Works on assignment only. Uses artists for brochure design and illustration, mechanicals, direct mail design, logos, ad design and illustration. 100% of freelance work demands knowledge of InDesign, Photoshop and Illustrator.

First Contact & Terms Designers/Illustrators: E-mail PDF or résumé and portfolio. Responds only if interested. Considers skill and experience of artist when establishing payment. Negotiates rights purchased.

▣ LIEBER BREWSTER DESIGN, INC.

740 Broadway, Suite 1101, New York NY 10003. (212)614-1221. E-mail: office@lieberbrewster.com. Web site: www.lieberbrewster.com. **Principal:** Anna Lieber. Estab. 1988. Specializes in strategic marketing. Clients: small and midsize businesses, fortune 500s. Client list available upon request. Professional affiliations: Toastmasters, Ad Club-NY.

Needs Approached by more than 100 freelancers/year. Works on assignment only. Uses freelancers for HTML programming, multimedia presentations, Web development, logos, marketing programs, audiovisual materials.

First Contact & Terms Send query letter with résumé, tearsheets and photocopies. Will contact artist for portfolio review if interested.

⏚ LIGGETT-STASHOWER

1228 Euclid Ave., Suite 200, Cleveland OH 44115. (216)348-8500. Fax: (216)736-8118. E-mail: artbuyer@liggett.com. Web site: www.liggett.com. **Art Buyer:** Tom Federico. Estab. 1932. Ad & PR agency. Full-service multimedia firm. Works in all formats. Handles all product categories. Current clients include Forest City Management, Member Health, Crane Performance Siding, Henkel Consumer Adhesives and AkzoNobel.

Needs Approached by 120 freelancers/year. Works with freelance illustrators and designers. Prefers local freelancers. Works on assignment only. Uses freelancers mainly for brochure, catalog and print ad design and illustration, storyboards, slide illustration, animatics, animation, retouching, billboards, posters, TV/film graphics, lettering and logos. Needs computer-literate freelancers for illustration and production. 90% of freelance work demands skills in InDesign, Photoshop or Illustrator.

First Contact & Terms Send query letter. Samples are filed and are not returned. Responds only if interested. To show portfolio, e-mail works best. Pays for design and illustration by the project. Negotiates rights purchased.

Tips "Please consider that art buyers and art directors are very busy and receive numerous inquiries per day from freelancers looking for work opportunities. We might have loved your promo piece, but chances of us remembering it by your name alone when you call are slim. Give us a hint 'it was red and black' or whatever. We'd love to discuss your piece, but it's uncomfortable if we don't know what you're talking about."

LINEAR CYCLE PRODUCTIONS

P.O. Box 2608, North Hills CA 91393-0608. Phone/fax: (818)347-9880. E-mail: lcp@wgn.net. Web site: www.linearproductions.com. **Producer:** Rich Brown. Production Manager: R. Borowy. Estab. 1980. Number of employees 30. Approximate annual billing $200,000. AV firm. Specializes in audiovisual sales and marketing programs and also in teleproduction for CATV. Current clients include Katz, Inc. and McDave and Associates.

Needs Works with 7-10 freelance illustrators and 7-10 designers/year. Prefers freelancers with experience in teleproductions (broadcast/CATV/non-broadcast). Works on assignment only. Uses freelancers for storyboards, animation, TV/film graphics, editorial illustration, lettering and logos. 10% of work is with print ads. 25% of freelance work demands knowledge of FreeHand, Photoshop or Tobis IV.

First Contact & Terms Send query letter with résumé, photocopies, photographs, slides, transparencies, video demo reel and SASE. Samples are filed or are returned by SASE if requested by artist. Responds only if interested. To show portfolio, mail audio/videotapes, photographs and slides; include color and b&w samples. Pays for design and illustration by the project, $100 minimum. Considers skill and experience of artist, how work will be used and rights purchased when establishing payment. Negotiates rights purchased. Finds artists through reviewing portfolios and published material.

Tips "We see a lot of sloppy work and samples, portfolios in fields not requested or wanted, poor photos, photocopies, graphics, etc. Make sure your materials are presentable."

▣ LOHRE & ASSOCIATES

2330 Victory Pkwy., Suite 701, Cincinnati OH 45206. (877)608-1736. E-mail: chuck@lohre.com. Web site: www.lohre.com. **President:** Chuck Lohre. Number of employees: 8. Approximate annual billing: $1 million. Ad agency. Specializes in industrial firms. Professional affiliation: SMPS.

Needs Approached by 24 freelancers/year. Works with 10 freelance illustrators and 10 designers/year. Works on assignment only. Uses freelance artists for trade magazines, direct mail, P-O-P displays, multimedia, brochures and catalogs. 100% of freelance work demands knowledge of PageMaker, FreeHand, Photoshop and Illustrator.

First Contact & Terms Send postcard sample or e-mail. Accepts submissions on disk, any Mac application. Pays for design and illustration by the hour, $10 minimum.

Tips Looks for artists who "have experience in chemical and mining industry, can read blueprints and have worked with metal fabrication." Also needs "Macintosh-literate artists who are willing to work at office, during day or evenings."

▣ LOMANGINO STUDIO INC.

1042 Wisconsin Ave. NW, Washington DC 20007. (202)338-4110. E-mail: info@lomangino.com. Web site: www.lomangino.com. **President:** Donna Lomangino. Estab. 1987. Number of employees: 6. Specializes in annual reports, corporate identity, Web site and publication design. Clients: corporations, nonprofit organizations. Client list available upon request. Professional affiliations: AIGA.

Needs Approached by 25-50 freelancers/year. Works with 1 freelance illustrator/year. Uses illustrators and production designers occasionally for publication; also for multimedia projects. 99% of design work demands skills in Illustrator, Photoshop and QuarkXPress.

First Contact & Terms Send postcard sample of work or URL. Samples are filed. Accepts disk submissions, but not preferable. Will contact artist for portfolio review if interested. Pays for design and illustration by the project. Finds artists through sourcebooks, word of mouth and studio files.

Tips "Please don't call. Send samples or URL for consideration."

▦ LORENC & YOO DESIGN, INC.

109 Vickery St., Roswell GA 30075. (770)645-2828. Fax: (770)998-2452. E-mail: jan@lorencyood esign.com. Web site: www.lorencyoodesign.com. **President:** Mr. Jan Lorenc. Specializes in architectural signage design; environmental, exhibit, furniture and industrial design. Clients: corporate, developers, product manufacturers, architects, real estate and institutions. Current clients include Gerald D. Hines Interests, MCI, Georgia-Pacific, IBM, Simon Property Company, Mayo Clinic. Client list available upon request.

Needs Approached by 25 freelancers/year. Works with 5 illustrators and 10 designers/year. Local senior designers only. Uses freelancers for design, illustration, brochures, catalogs, books, P-O-P displays, mechanicals, retouching, airbrushing, posters, direct mail packages, model-making, charts/graphs, AV materials, lettering and logos. Needs editorial and technical illustration. Especially needs architectural signage and exhibit designers. 95% of freelance work demands knowledge of QuarkXPress, Illustrator or FreeHand.

First Contact & Terms Send brochure, Weblink, or CD, résumé and samples to be kept on file. Prefers digital files as samples. Samples are filed or are returned. Call or write for appointment to show portfolio of thumbnails, roughs, original/final art, final reproduction/product and color photostats and photographs. Pays for design by the hour, $40-100; by the project, $250-20,000; by the day, $80-400. Pays for illustration by the hour, $40-100; by the project, $100-2,000; by the day, $80-400. Considers complexity of project, client's budget, and skill and experience of artist when establishing payment.

Tips "Sometimes it's more cost-effective to use freelancers in this economy, so we have scaled down permanent staff."

▣ JODI LUBY & COMPANY, INC.

808 Broadway, New York NY 10003. (212)473-1922. E-mail: jluby@jodiluby.com. Web site: www.jodiluby.com. **President:** Jodi Luby. Estab. 1983. Specializes in corporate identity, packaging, promotion and direct marketing design. Clients include magazines and corporations.

Needs Approached by 10-20 freelance artists/year. Works with 5-10 illustrators/year. Uses freelancers for production and Web production. 100% of freelance work demands computer skills.

First Contact & Terms Send postcard sample or query letter with résumé and photocopies. Samples are not filed and are not returned. Will contact artist for portfolio review if interested. Portfolio should include thumbnails, roughs, b&w and color printed pieces. Pays for production by the hour, $25 minimum; by the project, $100 minimum. Pays for illustration by the project, $100 minimum. Rights purchased vary according to project. Finds artists through word of mouth.

THE M. GROUP

2512 E. Thomas Rd., Suite 12, Phoenix AZ 85016. (480)998-0600. Fax: (480)998-9833. E-mail: resume@themgroupinc.com. Web site: www.themgroupinc.com. **Contact:** Gary Miller. Estab. 1987. Number of employees: 7. Approximate annual billing: $2.75 million. Strategic visual communications firm. Specializes in annual reports, corporate identity, direct mail, package design, advertising. Clients: corporations and small business. Current clients include American Cancer Society, BankOne, Dole Foods, Giant Industries, Motorola, Subway.

Needs Approached by 50 freelancers/year. Works with 5-10 freelance illustrators/year. Uses freelancers for ad, brochure, poster and P-O-P illustration. 95% of freelance work demands skills in Illustrator, Photoshop and QuarkXPress.

First Contact & Terms Send postcard sample or query letter with samples. Samples are filed or returned by SASE if requested by artist. Responds only if interested. Request portfolio review in original query. Artist should follow-up. Portfolio should include b&w and color final art, photographs and transparencies. Rights purchased vary according to project. Finds artists through publications (trade) and reps.

Tips Impressed by "good work, persistence, professionalism."

TAYLOR MACK ADVERTISING

509 W. Spring #450, Fayetteville AR 72071. (479)444-7770. Fax: (479)444-7977. E-mail: Greg@TaylorMack.com. Web site: www.TaylorMack.com. **Managing Director:** Greg Mack. Estab. 1990. Number of employees 16. Approximate annual billing $3 million. Ad agency. Specializes in collateral. Current clients include Cobb, Jose's, Rheem-Rudd, and Bikes, Blues and BBQ. Client list available upon request.

Needs Approached by 12 illustrators and 20 designers/year. Works with 4 illustrators and 6 designers/year. Uses freelancers mainly for brochure, catalog and technical illustration, TV/film graphics and Web page design. 30% of work is with print ads. 50% of design and illustration demands skills in Photoshop, Illustrator and InDesign.

First Contact & Terms Designers: E-mail Web site links or URL's. Samples are filed or are returned. Responds only if interested. Art director will contact artist for portfolio review of photographs if interested. Pays for design by the project or by the day; pays for illustration by the project, $10,000 maximum. Rights purchased vary according to project.

MICHAEL MAHAN GRAPHICS

P.O. Box 642, Bath ME 04530-0642. (207)443-6110. Fax: (207)443-6085. E-mail: ldelorme@mahangraphics.com. Web site: www.mahangraphics.com. **Contact:** Linda Delorme. Estab. 1986.

Number of employees 5. Approximate annual billing $500,000. Design firm. Specializes in publication design—catalogs and direct mail. Product specialties are furniture, fine art and high tech. Current clients include Bowdoin College, Bath Iron Works and College of the Atlantic. Client list available upon request. Professional affiliations G.A.G., AIGA and Art Director's Club-Portland, ME.

Needs Approached by 5-10 illustrators and 10-20 designers/year. Works with 2 illustrators and 2 designers/year. Uses freelancers mainly for production. Also for brochure, catalog and humorous illustration and lettering. 5% of work is with print ads. 100% of design demands skills in Photoshop and QuarkXPress.

First Contact & Terms Designers: Send query letter with photocopies and résumé. Illustrators: Send query letter with photocopies. Accepts disk submissions. Samples are filed and are not returned. Responds only if interested. Art director will contact artist for portfolio review of final art roughs and thumbnails if interested. Pays for design by the hour, $15-40. Pays for illustration by the hour, $18-60. Rights purchased vary according to project. Finds artists through word of mouth and submissions.

MANGAN HOLCOMB PARTNERS

2300 Cottondale Lane, Suite 300, Little Rock AR 72202. (501)376-0321. Fax: (501)376-6127. E-mail: chip@manganholcomb.com. Web site: www.manganholcomb.com. **Creative Director:** Chip Culpepper. Number of employees: 12. Approximate annual billing: $3 million. Marketing, advertising and PR firm. Clients: recreation, financial, tourism, retail, agriculture. Current clients include Citizens Bank, Farmers Bank & Trust, The Wilcox Group.

Needs Approached by 50 freelancers/year. Works with 8 freelance illustrators and 20 designers/year. Uses freelancers for consumer magazines, stationery design, direct mail, brochures/flyers, trade magazines and newspapers. Needs computer-literate freelancers for production and presentation. 30% of freelance work demands skills in Macintosh page layout and illustration software.

First Contact & Terms Query with samples, flier and business card to be kept on file. Include SASE. Responds in 2 weeks. Call or write for appointment to show portfolio of final reproduction/product. Pays by the project, $250 minimum.

⊞ MARKETAIDE SERVICES, INC.

P.O. Box 500, Salina KS 67402. (785)825-7161. Fax: (785)825-4697. E-mail: our-team@marketaide.com. Web site: www.marketaide.com. **Contact:** Production Manager. Estab. 1975. Full-service ad/marketing/direct mail firm. Clients: financial, industrial and educational.

Needs Prefers artists within one-state distance who possess professional expertise. Works on assignment only. Needs computer-literate freelancers for design, illustration and Web design. 90% of freelance work demands knowledge of QuarkXPress, Illustrator and Photoshop.

First Contact & Terms Send query letter with résumé, business card and samples to be kept on file. Samples not filed are returned by SASE only if requested. Responds only if interested. Write for appointment to show portfolio. Pays for design by the hour, $15-75 average. "Because projects vary in size, we are forced to estimate according to each job's parameters." Pays for illustration by the project.

Tips "Artists interested in working here should be highly polished in technical ability, have a good eye for design, and be able to meet all deadline commitments."

MARKETING BY DESIGN

2012 19th St., Suite 200, Sacramento CA 95818. (916)441-3050. E-mail: creative@mbdstudio.com. Web site: www.mbdstudio.com. **Creative Director:** Joel Stinghen. Estab. 1977. Specializes in corporate identity and brochure design, publications, direct mail, trade shows, signage, display and packaging. Clients: associations and corporations. Client list not available.

Needs Approached by 50 freelance artists/year. Works with 6-7 freelance illustrators and 1-3 freelance designers/year. Works on assignment only. Uses illustrators mainly for editorial; also for brochure and catalog design and illustration, mechanicals, retouching, lettering, ad design and charts/graphs.

First Contact & Terms Send query letter with brochure, résumé, tearsheets. Samples are filed and are not returned. Does not respond. Artist should follow up with call. Call for appointment to show portfolio of roughs, color tearsheets, transparencies and photographs. Pays for design by the hour, $10-30; by the project, $50-5,000. Pays for illustration by the project, $50-4,500. Rights purchased vary according to project. Finds designers through word of mouth; illustrators through sourcebooks.

MARTIN THOMAS, INC.

42 Riverside Dr., Barrington RI 02806-3612. (401)245-8500. Fax: (866)899-2710. E-mail: contact @martinthomas.com. Web site: www.martinthomas.com. **Contact:** Martin K. Pottle. Estab. 1987. Number of employees: 12. Approximate annual billing: $7 million. Ad agency; PR firm. Specializes in industrial, business-to-business. Product specialties are plastics, medical and automotive. Professional affiliations: American Association of Advertising Agencies, Boston Ad Club.

Needs Approached by 10-15 freelancers/year. Works with 6 freelance illustrators and 10-15 designers/year. Prefers freelancers with experience in business-to-business/industrial. Uses freelancers mainly for design of ads, literature and direct mail; also for brochure and catalog design and illustration. 85% of work is print ads. 70% of design and 40% of illustration demands skills in QuarkXPress.

First Contact & Terms Send query letter with brochure and résumé. Samples are filed and are returned. Responds in 3 weeks. Will contact artist for portfolio review if interested. Portfolio should include b&w and color final art. Pays for design and illustration by the hour and by the project. Buys all rights. Finds artists through *Creative Black Book*.

Tips Impress agency by "knowing industries we serve."

MCCAFFERY GOTTLIEB LANE LLC

370 Lexington Ave., New York NY 10017. (212)706-8400. Fax: (212)490-1923. E-mail: jgottlieb@ mglny.com. Web site: www.mglny.com. **Senior Art Director:** Howard Jones. Estab. 1983. Ad agency specializing in advertising and collateral material. Current clients include General Cigar (Macanudo, Cohiba, Partagas, Bolivar, Punch, Excalibur), Bluefly.com, General Electric, Nature's Best.

Needs Works with 6 freelance artists/year. Works on assignment only. Uses artists for brochure and print ad illustration, mechanicals, retouching, billboards, posters, lettering and logos. 80% of work is with print ads.

First Contact & Terms Send query e-mail letter with PDFs. Responds only if interested. To show a portfolio, mail appropriate materials or drop off samples. Portfolio should include original/ final art, tearsheets and photographs; include color and b&w samples. Pays for illustration by the project, $75-5,000. Rights purchased vary according to project.

Tips "Send mailers and drop off portfolio."

MCCLEAREN DESIGN

1201 Gallatin Ave., Nashville TN 37206. (615)226-8089. Fax: (615)226-9237. E-mail: mcclearend esign@comcast.net. **Owner:** Brenda McClearen. Estab. 1987. Number of employees 3. Specializes in display, music, package and publication design, Web sites, photography.

Needs Approached by 5-10 freelancers/year. Works with 5-7 freelance illustrators and designers/year. Uses freelancers for ad design and illustration, model-making and poster design. Needs computer-literate freelancers for design and illustration. 50% of freelance work demands knowledge of QuarkXPress and Macintosh.

First Contact & Terms Samples are filed. Will contact artist for portfolio review if interested. Pays by the project.

SUDI MCCOLLUM DESIGN

3244 Cornwall Dr., Glendale CA 91206. (818)243-1345. Fax: (818)243-2344. E-mail: sudimccollu m@earthlink.net. **Contact:** Sudi McCollum. Specializes in home fashion design and illustration. Majority of clients are medium- to large-size businesses in home fashion industry and graphic design industry.'' Clients: home furnishing and giftware manufacturers, advertising agencies and graphic design studios.

Needs Uses freelance production people either on computer or with painting and product design skills. Potential to develop into fulltime job.

First Contact & Terms Send query letter or whatever you have that's convenient.'' Samples are filed. Responds only if interested.

MCGRATHICS

18 Chestnut St., Marblehead MA 01945. (781)631-7510. E-mail: mcgrathics@aol.com. Web site: www.mcgrathics.com. **Art Director:** Vaughn McGrath. Estab. 1978. Number of employees 4-6. Specializes in corporate identity, annual reports, package and publication and Web design. Clients corporations and universities. Professional affiliations AIGA, VUGB.

Needs Approached by 30 freelancers/year. Works with 8-10 freelance illustrators/year. Uses illustrators mainly for advertising, corporate identity (both conventional and computer). Also for ad, brochure, catalog, poster and P-O-P illustration; charts/graphs. Computer and conventional art purchased.

First Contact & Terms Send postcard sample of work or send brochure, photocopies, photographs, résumé, slides and transparencies. Samples are filed. Responds only if interested. Portfolio review not required. Pays for illustration by the hour or by the project. Rights purchased vary according to project. Finds artists through sourcebooks and mailings.

Tips ''Annually mail us updates for our review.''

MCKENZIE HUBBELL CREATIVE SERVICES

5 Iris Lane, Westport CT 06880. (203)454-2443. Fax: (203)222-8462. E-mail: dmckenzie@mcken ziehubbell.com or nhubbell@mckenziehubbell.com. Web site: www.mckenziehubbell.com. **Principal:** Dona McKenzie. Specializes in business to business communications, annual reports, corporate identity, direct mail and publication design. Expanded services include copywriting and editing, advertising and direct mail, marketing and public relations, Web site design and development, and multimedia and CD-ROM.

Needs Approached by 100 freelance artists/year. Works with 5 freelance designers/year. Uses freelance designers mainly for computer design. Also uses freelance artists for brochure and

catalog design. 100% of design and 50% of illustration demand knowledge of QuarkXPress, Illustrator, InDesign and Photoshop.

First Contact & Terms Send query letter with brochure, résumé, photographs and photocopies. Samples are filed or are returned by SASE if requested by artist. Write to schedule an appointment to show a portfolio. Pays for design by the hour, $25-75. Pays for illustration by the project, $150-3,000. Rights purchased vary according to project.

MEDIA ENTERPRISES

1644 S. Clementine St., Anaheim CA 92802. (714)778-5336. Fax: (714)778-6367. E-mail: john@media-enterprises.com. Web site: www.media-enterprises.com. **Creative Director:** John Lemieux Rose. Estab. 1982. Number of employees 8. Approximate annual billing $2 million. Integrated marketing communications agency. Specializes in interactive multimedia, CD-ROMs, Internet, magazine publishing. Product specialty high tech. Client list available upon request. Professional affiliations Orange County Multimedia Association, Software Council of Southern California, Association of Internet Professionals.

Needs Approached by 30 freelance illustrators and 10 designers/year. Works with 8-10 freelance illustrators and 3 designers/year. Uses freelancers for animation, humorous illustration, lettering, logos, mechanicals, multimedia projects. 30% of work is with print ads. 100% of freelance work demands skills in PageMaker, Photoshop, Adobe InDesign, Illustrator, Director.

First Contact & Terms Send postcard sample and/or query letter with photocopies, photographs or URL. Accepts disk submissions compatible with Mac or PC. Samples are filed. Will contact for portfolio review of color photographs, slides, tearsheets, transparencies and/or disk. Pays by project; negotiated. Buys all rights.

MEDIA GRAPHICS

P.O. Box 820525, Memphis TN 38182-0525. (901)324-1658. Fax: (901)323-7214. E-mail: mediagraphics@devkinney.com. Web site: www.devkinney.com. **CEO:** J. Kinney. Estab. 1973. Integrated marketing communications agency. Specializes in all visual communications. Product specialties are financial, fundraising, retail, business-to-business. Client list available upon request. Professional affiliations: Memphis Area chamber, B.B.B.

• This firm reports they are looking for top illustrators only. When they find illustrators they like, they generally consider them associates and work with them on a continual basis.

First Contact & Terms Send query letter with résumé and tearsheets. Accepts disk submissions compatible with Mac or PC. E-mail 1 sample JPEG, 265K maximum; prefers HTML reference or small PDF file. Samples are filed and are not returned. Will contact artist for portfolio review on Web or via e-mail if interested. Rights purchased vary according to project.

Tips Chooses illustrators based on "portfolio, availability, price, terms and compatibility with project."

MEDIA LOGIC, INC.

One Park Place, Albany NY 12205. (518)456-3015. Fax: (518)456-4279. E-mail: swolff@mlinc.com. Web site: www.mlinc.com. **Recruiter:** Suzanne Wolff. Director of Studio Services: Carol Ainsburg. (All submissions should be directed to Suzanne.) Estab. 1984. Number of employees: 85. Approximate annual billing: $50 million. Integrated marketing communications agency. Specializes in advertising, marketing communications, design. Product specialties are retail, entertainment. Current clients include education, business-to-business, industrial. Professional affiliations: American Marketing Associates, Ad Club of Northeast NY.

Needs Approached by 20-30 freelance illustrators and 20-30 designers/year. Works with 2 freelance illustrators and 2 designers/year. Prefers freelancers with experience in Mac/Photoshop. Uses freelancers for annual reports, brochure design, mechanicals, multimedia projects, retouching, web page design. 30% of work is with print ads. 100% of design and 60% of illustration demand skills in Photoshop, QuarkXPress, Illustrator, Director.

First Contact & Terms Send submission via e-mail to Suzanne Wolff: swolff@mlinc.com. Candidates must be able to work onsite. Compensation via hourly rate.

DONYA MELANSON ASSOCIATES

5 Bisson Lane, Merrimac MA 01860. (978)346-9240. Fax: (978)346-8345. E-mail: dmelanson@d melanson.com. Web site: www.dmelanson.com. **Contact:** Donya Melanson. Advertising agency. Number of employees 1. Clients industries, institutions, education, associations, publishers, financial services and government. Current clients include US Geological Survey, Mannesmann, Cambridge College, American Psychological Association, Ledakka Enterprises and US Dept. of Agriculture. Client list available upon request.

Needs Approached by 30 artists/year. Works with 3-4 illustrators/year. Most work is handled by staff, but may occasionally use freelance illustrators and designers. Uses artists for stationery design, direct mail, brochures/flyers, annual reports, charts/graphs and book illustration. Needs editorial and promotional illustration. 50% of freelance work demands skills in Illustrator, QuarkXPress, InDesign or Photoshop.

First Contact & Terms Query with brochure, résumé, photocopies, tearsheets or CD. Provide materials (no originals) to be kept on file for future assignments. Originals returned to artist after use only when specified in advance. Call or write for appointment to show portfolio or mail thumbnails, roughs, final art, final reproduction/product and color and b&w tearsheets, photostats and photographs. Pays for design and illustration by the project, $100 minimum. Considers complexity of project, client's budget, skill and experience of artist and how work will be used when establishing payment.

Tips ''Be sure your work reflects concept development.''

MILICI VALENTI NG PACK

999 Bishop St., 24th Floor, Honolulu HI 96813. (808)536-0881. Fax: (808)529-6208. E-mail: info@mvnp.com. Web site: www.mvnp.com. **Creative Director:** George Chalekian. Estab. 1946. Number of employees: 74. Approximate annual billing: $40,000,000. Ad agency. Serves clients in travel/tourism, food, finance, utilities, entertainment and public service. Current clients include First Hawaiian Bank, Aloha Airlines, Sheraton Hotels.

Needs Works with 2-3 freelance illustrators/month. Uses freelance artists mainly for illustration, retouching and lettering for newspapers, multimedia kits, magazines, radio, TV and direct mail. Artists must be familiar with advertising demands; used to working long distance through the mail and over the Internet; and familiar with Hawaii.

First Contact & Terms Send brochure, flier and tearsheets or PDFs to be kept on file for future assignments. Pays $200-2,000.

MITCHELL STUDIOS DESIGN CONSULTANTS

1499 Sherwood Drive, East Meadow, NY 11554. (516)832-6230. Fax: (516)832-6232. E-mail: msdcdesign@aol.com. **Principals:** Steven E. Mitchell and E.M. Mitchell. Estab. 1922. Specializes in brand and corporate identity, displays, direct mail and packaging. Clients: major corporations.

Needs Works with 5-10 freelance designers and 20 illustrators/year. "Most work is started in our studio." Uses freelancers for design, illustration, mechanicals, retouching, airbrushing, model-making, lettering and logos. 100% of design and 50% of illustration demands skills in Illustrator 5, Photoshop 5 and QuarkXPress 3.3. Needs technical illustration and illustration of food, people.

First Contact & Terms Send query letter with brochure, résumé, business card, photographs and photocopies to be kept on file. Accepts nonreturnable disk submissions compatible with Illustrator, QuarkXPress, FreeHand and Photoshop. Responds only if interested. Call or write for appointment to show portfolio of roughs, original/final art, final reproduction/product and color photostats and photographs. Pays for design by the hour, $25 minimum; by the project, $250 minimum. Pays for illustration by the project, $250 minimum.

Tips "Call first. Show actual samples, not only printed samples. Don't show student work. Our need has increased—we are very busy."

MNA CREATIVE, INC

(formerly Macey Noyes Associates, Inc.), 93 Lake Ave., 3rd Floor, Danbury CT 06810. (203)791-8856. Fax: (203)791-8876. E-mail: information@mnacreative.com. Web site: www.mnacreative.com. Structural Design Director: Tod Dawson. Estab. 1979. Specializes in corporate and brand identity systems, graphic and structural packaging design, retail merchandising systems, naming and nomenclature systems, Internet and digital media design. Clients corporations (marketing managers, product managers). Current clients include Duracell, Norelco, Motorola, Pitney Bowes, Altec Lansing, Philips. Majority of clients are retail suppliers of consumer goods.

Needs Approached by 25 artists/year. Works with 2-3 illustrators and 5 designers/year. Prefers local and international artists with experience in package comps, Macintosh and type design. Uses technical and product illustrators mainly for ad slick, in-use technical and front panel product. Uses designers for conceptual layouts and product design. Also uses freelancers for mechanicals, retouching, airbrushing, lettering, logos and industrial/structural design. Needs computer-literate freelancers for design, illustration and production. 40% of freelance work demands knowledge of QuarkXPress, Illustrator, Photoshop, Director, Flash and Shockwave.

First Contact & Terms Send query letter with résumé. Samples are filed or are returned by SASE if requested by artist. Responds only if interested. Will contact artist for portfolio review if interested. Portfolio should include thumbnails, roughs and transparencies. Pays for design by the hour, $30-75. Pays for illustration by the project, $100-2,500. Rights purchased vary according to project. Finds new artists through sourcebooks and agents.

MONDERER DESIGN, INC.

2067 Massachusetts Ave., 3rd Floor, Cambridge MA 02140. (617)661-6125. Fax: (617)661-6126. E-mail: stewart@monderer.com. Web site: www.monderer.com. **Creative Director:** Stewart Monderer. Estab. 1982. Specializes in annual reports, corporate identity, corporate communications, datasheets, and interactive solutions. Clients corporations (technology, education, consulting, and life science). Current clients include Tufts University, Spotfire, Iron Mountain, Fluent, Thermo Electron, Northeastern University, Goslings Rum, Thermo Fisher Scientific, Metamatrix. Client list on Web site.

Needs Approached by 40 freelancers/year. Works with 10-12 illustrators and photographers per year. Works on assignment only.

First Contact & Terms Send query letter with brochure, tearsheets, photographs, photocopies or nonreturnable postcards. Will look at links and PDF files. Samples are filed. Will contact

artist for portfolio review if interested. Portfolio should include b&w and color-finished art samples. Pays for design by the hour, $15-25; by the project. Pays for illustration by the project, $250 minimum. Negotiates rights purchased. Finds artists through submissions/self-promotions and sourcebooks.

MRW COMMUNICATIONS

2 Fairfield St., Hingham MA 02043. (781)740-4525. Fax: (781)926-0371. E-mail: jim@mrwinc.c om. Web site: www.mrwinc.com. **President:** Jim Watts. Estab. 2003. Ad agency. Specializes in Branding, advertising, collateral, Direct Marketing, Web site development, online marketing. Product specialties are high tech, healthcare, business to business, financial services, and consumer. Client list available upon request.

Needs Approached by 40-50 freelance illustrators and 40-50 designers/year. Works with 5-10 freelance illustrators and 2-5 designers/year. Prefers freelancers with experience in a variety of techniques brochure, medical and technical illustration, multimedia projects, retouching, storyboards, TV/film graphics and Web page design. 75% of work is with print ads. 90% of design and 90% of illustration demands skills in FreeHand, Photoshop, QuarkXPress, Illustrator.

First Contact & Terms Designers: Send query letter with photocopies, photographs, resume. Illustrators: Send postcard sample and resume, follow-up postcard every 6 months. Accepts disk submissions compatible with QuarkXPress 7.5/version 3.3. Send EPS files. Samples are filed. Will contact for portfolio review of b&w, color final art if interested. Pays by the hour, by the project or by the day depending on experience and ability. Rights purchased vary according to project. Finds artist through sourcebooks and word of mouth.

⚡ 🖥 MSR ADVERTISING, INC.

P.O. Box 10214, Chicago IL 60610-0214. (312)573-0001. Fax: (312)573-1907. E-mail: info@msra dv.com. Web site: www.msradv.com. **Art Director:** Lauren O'Flynn-Redig. Estab. 1983. Number of employees: 6. Approximate annual billing: $2.5 million. Ad agency; full-service multimedia firm. Specializes in medical, food, wines, spirits & beer, automotive, industrial and biotechnology. Current clients include AGCO Parts N.A., American Hospital Association, Illinois Biotechnology Industries Association, General Motors, Fosters Wine Estates, Barenger Wines, and Barton Beers.

• MSR's Tampa, Florida, office (including similar SIC represented industries and professions) has added insurance agencies, law firms and engineering firms to their growing list of clients.

Needs Approached by 6-10 freelancers/year. Works with 5-10 freelance illustrators and 5-10 designers/year. Prefers local artists who are "innovative, resourceful and hungry." Works on assignment only. Uses freelancers mainly for creative thought boards; also for brochure, catalog and print ad design and illustration, multimedia, storyboards, mechanicals, billboards, posters, lettering and logos. 30% of work is with print ads. 75% of design and 25% of illustration demand computer skills.

First Contact & Terms Send query letter with brochure, photographs, photocopies, slides, SASE and résumé. Accepts submissions on disk. Samples are filed or returned. Responds in 2 weeks. Write for appointment to show portfolio or mail appropriate materials thumbnails, roughs, finished samples. Artist should follow up with call. Pays for design by the hour, $45-95. Buys all rights. Finds artists through submissions and agents.

Tips "We maintain a relaxed environment designed to encourage creativity; however, work must be produced in a timely and accurate manner. Normally the best way for a freelancer to

meet with us is through an introductory letter and a follow-up phone call a week later. Repeat contact every 2-4 months. Be persistent and provide outstanding representation of your work.''

■ MYERS, MYERS & ADAMS ADVERTISING, INC.

938 N. Victoria Park Rd., Fort Lauderdale FL 33304. (954)523-6262. Fax: (954)523-3517. E-mail: pete@mmanda.com. Web site: www.mmanda.com. **Creative Director:** Virginia Myers. Estab. 1986. Number of employees 6. Approximate annual billing $2 million. Ad agency. Full-service, multimedia firm. Specializes in magazines and newspaper ads; radio and TV; brochures; and various collateral. Product specialties are consumer and business-to-business. Current clients include Harley-Davidson, Wendy's and Embassy Suites. Professional affiliation Advertising Federation.

Needs Approached by 10-15 freelancers/year. Works with 3-5 freelance illustrators and 3-5 designers/year. Uses freelancers mainly for overflow. Also for animation, brochure and catalog illustration, model-making, posters, retouching and TV/film graphics. 55% of work is with print ads. Needs computer-literate freelancers for illustration and production. 20% of freelance work demands knowledge of PageMaker, Photoshop, QuarkXPress and Illustrator.

First Contact & Terms Send postcard-size sample of work or send query letter with tearsheets. Samples are filed and are returned by SASE if requested by artist. Will contact artist for portfolio review if interested. Portfolio should include b&w and color final art, roughs, tearsheets and thumbnails. Pays for design and illustration by the project, $50-1,500. Buys all rights. Finds artists through *Creative Black Book, Workbook* and artists' submissions.

⚎ NAPOLEON ART STUDIO

420 Lexington Ave., Suite 3020, New York NY 10170. (212)692-9200. Fax: (212)692-0309. E-mail: scott@napny.com. Web site: www.napny.com. **Studio Manager:** Scott Stein. Estab. 1985. Number of employees 40. AV firm. Full-service, multimedia firm. Specializes in storyboards, magazine ads, computer graphic art animatics. Product specialty is consumer. Current clients include "all major New York City ad agencies." Client list not available.

Needs Approached by 20 freelancers/year. Works with 15 freelance illustrators and 5 designers/ year. Prefers local freelancers with experience in animation, computer graphics, film/video production, multimedia, Macintosh. Works on assignment only. Uses freelancers for airbrushing, animation, direct mail, logos and retouching. 10% of work is with print ads. Needs computer-literate freelancers for design, illustration, production and presentation. 80% of freelance work demands skills in Illustrator or Photoshop.

First Contact & Terms Send query letter with photocopies, tearsheets and ¾'' or VHS tape. Samples are filed. Responds only if interested. Will contact artist for portfolio review if interested. Portfolio should include b&w and color thumbnails. Pays for design and illustration by the project. Rights purchased vary acording to project. Finds artists through word of mouth and submissions.

⚎ NEIMAN GROUP

614 N. Front St., Harrisburg PA 17101. (717)232-5554. Fax: (717)232-7998. E-mail: fcoleman@ne imangroup.com. Web site: www.neimangroup.com. **Executive Creative Director**: Jeff Odiorne. Estab. 1978. Full-service ad agency specializing in print collateral and ad campaigns. Product specialties are healthcare, banks, retail and industry.

Needs Works with 5 illustrators and 4 designers/month. Prefers local artists with experience in

comps and roughs. Works on assignment only. Uses freelancers mainly for advertising illustration and comps. Also uses freelancers for brochure design, mechanicals, retouching, lettering and logos. 50% of work is with print ads. 3% of design and 1% of illustration demand knowledge of Illustrator and Photoshop.

First Contact & Terms Designers: Send query letter with résumé. Illustrators: Send postcard sample, query letter or tearsheets. Samples are filed. Will contact artist for portfolio review if interested. Portfolio should include color thumbnails, roughs, original/final art, photographs. Pays for design and illustration by the project, $300 minimum. Finds artists through sourcebooks and workbooks.

Tips "Try to get a potential client's attention with a novel concept. Never, ever, miss a deadline. Enjoy what you do."

LOUIS NELSON DESIGN INC.

P.O. Box 1545, New York NY 10013. (212)620-9191. Fax: (212)620-9194. E-mail: info@louisnelson.com. Web site: www.louisnelson.com. **President:** Louis Nelson. Estab. 1980. Number of employees: 12. Approximate annual billing: $1.2 million. Specializes in environmental, interior and product design and brand and corporate identity, displays, packaging, publications, signage and wayfinding, exhibitions and marketing. Clients: nonprofit organizations, corporations, associations and governments. Current clients include Stargazer Group, Rocky Mountain Productions, Wildflower Records, Port Authority of New York & New Jersey, Richter + Ratner Contracting Corporation, MTA and NYC Transit, Massachusetts Port Authority, Evelyn Hill Inc., Km et cie. Professional affiliations: IDSA, AIGA, SEGD, APDF.

Needs Approached by 30-40 freelancers/year. Works with 30-40 designers/year. Works on assignment only. Uses freelancers mainly for specialty graphics and 3D design; also for design, photo-retouching, model-making and charts/graphs. 100% of design demands knowledge of PageMaker, QuarkXPress, Photoshop, Velum, Autocad, Vectorworks, Alias, Solidworks or Illustrator. Needs editorial illustration. Needs design more than illustration or photography.

First Contact & Terms Send postcard sample or query letter with résumé. Accepts disk submissions compatible with Illustrator 10.0 or Photoshop 7.0. Send EPS/PDF files. Samples are returned only if requested. Responds in 2 weeks. Write for appointment to show portfolio of roughs, color final reproduction/product and photographs. Pays for design by the hour, $15-25; or by the project, negotiable.

Tips "I want to see how the artist responded to the specific design problem and to see documentation of the process—the stages of development. The artist must be versatile and able to communicate a wide range of ideas. Mostly, I want to see the artist's integrity reflected in his/her work."

THE NEXT LEVEL MARKETING & CREATIVE LLC

1607 Pontius Ave., Los Angeles CA 90025. (310)477-2119. Fax: (310)477-2661. E-mail: deborah@tnlmarketing.com. Web site: www.tnlmarketing.com. **Creative Director:** Deborah Rodney. Estab. 2000. Number of employees: 5. Approximate annual billing: $800,000. Ad agency, design/integrated marketing communications firm. Specializes in health care, professional services, software, consumer products, financial services, nonprofits. Current clients include Portable Sound Laboratories, Orange County Federal Teachers Credit Union, QD Technology, Jewish Big Brothers/Big Sisters. Professional affiliations: MENG; Professionals Network Group.

Needs Approached by 100+ illustrators and 20 designers/year. Works with 6-8 illustrators and 2-3 designers/year. Works on assignment only. Prefers designers/illustrators with experience

in animation and computer graphics (Macintosh). Uses freelancers mainly for illustration, photography, flash animation, Web programming; also for animation, brochure illustration, computer needs, direct mail. 35% of work is with print ads. 100% of design work demands skills in Illustrator, Photoshop, QuarkXPress. Illustration work demands knowledge of Illustrator and Photoshop.

First Contact & Terms Call or send samples. Prefers e-mail submissions with image files or link to Web site. Prefers Mac-compatible JPEG files. Samples are kept on file and are not returned. Responds only if interested. Will contact artists for portfolio review if interested. Portfolio should include b&w, color, finished art, photographs. Pays for illustration by the project. Pays for design by the hour or by the project. Rights purchased vary according to project; negotiated. Finds freelancers through agents/reps, submissions, Internet, *Workbook, The Black Book.*

▣ NICOSIA CREATIVE EXPRESSO, LTD.

(NiCE Ltd.), 355 W. 52nd St., 8th Floor, New York NY 10019. (212)515-6600. Fax: (212)265-5422. E-mail: contact@niceltd.com. Web site: www.niceltd.com. **Principal/Creative Director:** Davide Nicosia. Estab. 1993. Number of employees: 20. Full-service multicultural creative agency. Specializes in graphic design, corporate/brand identity, brochures, promotional material, packaging, fragrance bottles and 3D animations. Current clients include Estée Lauder Companies, Procter & Gamble, Dunhill, Gillette, Montblanc, Old Spice and Pantene.

Needs Approached by 70 freelancers/year. Works with 6 illustrators and 8 designers/year. Works by assignment only. Uses illustrators, designers, 3D computer artists and computer artists familiar with Illustrator, Photoshop, After Effects, Premiere, Macromedia Director, Flash and Alias Wavefront.

First Contact & Terms Send query letter and résumé. Responds for portfolio review only if interested. Pays for design by the hour. Pays for illustration by the project. Rights purchased vary according to project.

Tips Looks for "promising talent and the right attitude."

▣ ▣ NOVUS VISUAL COMMUNICATIONS, INC.

121 E. 24th St., 12th Floor, New York NY 10010-2950. (212)473-1377. Fax: (212)505-3300. E-mail: novuscom@aol.com. Web site: www.novuscommunications.com. **President:** Robert Antonik. Vice President/Creative Director: Denis Payne. Estab. 1984. Creative marketing and technology forward communications firm. Specializes in strategic planning, advertising, annual reports, brand and corporate identity, display, direct mail, fashion, package and publication design, technical illustration and signage. Clients include healthcare, telecommunications and consumer products companies.

Needs Approached by 12 freelancers/year. Works with 2-4 freelance illustrators and 2-6 designers/year. Works with artist reps. Prefers local artists only. Uses freelancers for ad, brochure, catalog, poster and P-O-P design and illustration, airbrushing, audiovisual materials, book, direct mail, magazine and newpaper design, charts/graphs, lettering, logos, mechanicals and retouching. 75% of freelance work demands skills in Illustrator, Photoshop, FreeHand, InDesign and QuarkXPress.

First Contact & Terms Contact only through artist rep. Send postcard sample of work. Samples are filed. Responds ASAP. Follow up with call. Pays for design by the hour, $15-75; by the day, $200-300; by the project, $200-1,500. Pays for illustration by the project, $150-1,750. Rights purchased vary according to project. Finds artists through *Creative Illustration, Workbook,* agents and submissions.

Tips "First impressions are important; a portfolio should represent the best, whether it's 4 samples or 12." Advises freelancers entering the field to "always show your best creative. You don't need to overwhelm your interviewer, and it's always a good idea to send a thank-you or follow-up phone call." It works!

THE O'CARROLL GROUP

300 E. McNeese St., Suite 2-B, Lake Charles LA 70605. (337)478-7396. Fax: (337)478-0503. E-mail: pocarroll@ocarroll.com. Web site: www.ocarroll.com. **President:** Peter O'Carroll. Estab. 1978. Ad agency/PR firm. Specializes in newspaper, magazine, outdoor, radio and TV ads. Product specialty is consumer. Client list available upon request.

Needs Approached by 1 freelancer/month. Works with 1 illustrator every 3 months. Prefers freelancers with experience in computer graphics. Works on assignment only. Uses freelancers mainly for time-consuming computer graphics. Also for brochure and print ad illustration and storyboards. Needs Web site developers. 65% of work is with print ads. 50% of freelance work demands skills in Illustrator and Photoshop.

First Contact & Terms Send query e-mail with electronic samples. Responds only if interested. Will contact artist for portfolio review if interested. Pays for design by the project. Pays for illustration by the project. Rights purchased vary according to project. Find artists through viewing portfolios, submissions, word of mouth, American Advertising Federation district conferences and conventions.

☧ OAKLEY DESIGN STUDIOS

519 SW Park Avenue., Portland OR 97205. (503)241-3705. E-mail: oakleyds@oakleydesign.com. Web site: oakleydesign.com. **Creative Director:** Tim Oakley. Estab. 1992. Specializes in brand and corporate identity, display, package, feature film design, along with advertising. Clients: advertising agencies, record companies, motion picture studios, surf apparel manufacturers, mid-size businesses. Current clients include Patrick Lamb Productions, Metro Computerworks, Tiki Nights Entertainment, Oregon State Treasury, Hui Nalu Brand Surf, Stona Winery, Not Dead Yet, Mt Hood Jazz Festival, Think AV, Audient Events, & Kink FM 102. Professional affiliations: GAG, AIGA, PAF, Type Directors Club, Society of Illustrators.

Needs Approached by 3-8 freelancers/year. Works with 3 freelance illustrators and 2 designers/year. Prefers local artists with experience in technical & freehand illustration, airbrush. Uses illustrators mainly for advertising. Uses designers mainly for brand and corporate identity. Also uses freelancers for ad and P-O-P illustration, airbrushing, catalog illustration, lettering and retouching. 60% of design and 30% of illustration demands skills in CS2 Illustrator, CS2 Photoshop and CS2 InDesign.

First Contact & Terms Contact through artist rep or send query letter with brochure, photocopies, photographs, plus resume. Samples are filed or returned by SASE if requested by artist. Request portfolio review in original query. Will contact artist for portfolio review if interested. Portfolio should include b&w and color final art, photocopies, photostats, roughs and/or slides. Pays for design by the project, $200 minimum. Pays for illustration by the project. Rights purchased vary according to project. Finds artists through design workbooks.

Tips: "Just be yourself—and bring coffee."

ORIGIN DESIGN

20 E. Greenway Plaza, Suite 310, Houston TX 77046. (713)520-9544. Fax: (214)341-4682. E-mail: GrowWithUs@origindesign.com. Web site: www.origindesign.com. Design and marketing

firm. Current clients include ExpressJet and Time Warner Cable. Professional affiliations: AIGA, AMA, NIRI, PRSA.

- Recent Origin projects have been recognized in *HOW Magazine*, the national Summit Awards, the Dallas Society of Visual Communicators Annual Show, and the regional Addys.

First Contact & Terms Send query letter with résumé and samples.

OUTSIDE THE BOX INTERACTIVE LLC

150 Bay St., Suite 706, Jersey City NJ 07302-5917. (212)463-7160 or (201)610-0625. Fax: (201)610-0627. E-mail: theoffice@outboxin.com. Web site: www.outboxin.com. **Partner and Director of Multimedia:** Lauren Schwartz. Estab. 1995. Number of employees: 10. Full-service multimedia firm. "Our product mix includes Internet/intranet/extranet development and hosting, corporate presentations, disk-based direct mail, customer/product kiosks, games, interactive press kits, advertising, marketing and sales tools. We also offer Web hosting for product launches, questionnaires and polls. Our talented staff consists of writers, designers and programmers." Current clients include Columbia Pictures, eBay, Lucent Technologies, New York Academy of Sciences, Rolex USA.

Needs Approached by 5-10 illustrators and 5-10 designers/year. Works with 8-10 freelance illustrators and 8-10 designers/year. Prefers freelancers with experience in computer arts. Uses freelancers for airbrushing, animation, brochure and humorous illustration, logos, model-making, multimedia projects, posters, retouching, storyboards, TV/film graphics, Web page design. 90% of design demands skills in Photoshop, QuarkXPress, Illustrator, Director HTML, Java Script and any 3D program. 60% of illustration demands skills in Photoshop, QuarkXPress, Illustrator, any animation and 3D program.

First Contact & Terms Send query letter with brochure, photocopies, photographs, photostats, résumé, SASE, slides, tearsheets, transparencies. Send follow-up postcard every 3 months. Accepts disk submissions compatible with Power PC. Samples are filed and are returned by SASE. Will contact if interested. Pays by the project. Rights purchased vary according to project.

⛏ ▣ OXFORD COMMUNICATIONS, INC.

11 Music Mountain Blvd., Lambertville NJ 08530. (609)397-4242. Fax: (609)397-7594. Web site: www.oxfordcommunications.com. **Creative Director:** Chuck Whitmore. Estab. 1986. Ad agency. Full-service, multimedia firm. Specializes in print advertising and collateral. Product specialties are retail, real estate and destination marketing.

Needs Approached by 6 freelancers/month. Works with 3 designers every 6 months. Prefers local freelancers with experience in Quark, Illustrator, InDesign and Photoshop. Uses freelancers mainly for production and design. 75% of work is with print ads.

First Contact & Terms E-mail résumé and PDF samples to solutions@oxfordcommunications.com. Samples are filed. Responds only if interested. Will contact artist for portfolio review if interested. Portfolio should include b&w and/or color photostats, tearsheets, photographs and slides. Pays for design and illustration by the project, negotiable. Rights purchased vary according to project.

⛏ PACE DESIGN GROUP

379 Day St., San Francisco CA 94131. E-mail: info@pacedesign.com. Web site: www.pacedesign .com. **Creative Director:** Joel Blum. Estab. 1988. Number of employees: 6. Approximate annual billing: $1.2 million. Specializes in branding, advertising and collateral. Product specialties are

financial services, high tech, Internet and computer industries. Current clients include Bank of America, Wells Fargo Bank, Allegiance Telecom, Bio-Rad Laboratories. Client list available upon request. Professional affiliations: AIP (Artists in Print).

Needs Approached by 100 illustrators and 75 designers/year. Works with 3-5 illustrators and 3-5 designers/year. Prefers local designers with experience in QuarkXPress, InDesign, Illustrator and Photoshop. Uses freelancers mainly for illustration and graphics; also for brochure design and illustration, logos, technical illustration and Web page design. 2% of work is with print ads. 100% of design and 85% of illustration demand skills in the latest versions of Photoshop, Illustrator, QuarkXPress and InDesign.

First Contact & Terms Designers: Send query letter with photocopies and résumé. Illustrators: Send query letter with photocopies, tearsheets, follow-up postcard samples every 6 months. Accepts disk submissions. Submit latest version software, System OS X, EPS files. Samples are filed and are not returned. Will contact for portfolio review of color final art and printed pieces if interested. Pays for design by the hour, $35-65. Pays for illustration by the project. Rights purchased vary according to project. Finds artists through sourcebooks, word of mouth, submissions.

PAPAGALOS STRATEGIC COMMUNICATIONS

7330 N. 16th St., Suite B102, Phoenix AZ 85020. (602)279-2933. Fax: (602)277-7448. E-mail: nicholas@papagalos.com. Web site: www.papagalos.com. **Creative Director:** Nicholas Papagalos. Specializes in advertising, brochures, annual corporate identity, displays, packaging, publications and signage. Clients major regional, consumer and business-to-business. Clients include Perini, American Hospice Foundation, Collins College, McMillan Fiberglass Stocks.

Needs Works with 6-20 freelance artists/year. Works on assignment only. Uses artists for illustration, retouching, design and production. Needs computer-literate freelancers, HTML programmers and Web designers for design, illustration and production. 100% of freelance work demands skills in Illustrator, QuarkXPress, InDesign or Photoshop.

First Contact & Terms Mail résumé and appropriate samples. Pays for design by the hour or by the project. Pays for illustration by the project. Considers complexity of project, client's budget, skill and experience of artist, how work will be used, turnaround time and rights purchased when establishing payment. Rights purchased vary according to project.

Tips In presenting samples or portfolios, "two samples of the same type/style are enough."

PERSECHINI AND COMPANY

322 Westgate Dr., Trinidad CA 95570. (310)455-9755. E-mail: sales@persechini.com. Web site: www.persechini.com. Estab. 1979. Multimedia design firm. Specializes in advertising, annual reports, brochures, collateral, corporate identity, events, packaging, publications and Web sites, signage. Current clients include The Bowman Group, Imax, UCLA, Universal Studios.

Needs Approached by 50-100 freelance artists/year. Works with 5-6 illustrators and 1 designer/year. Works on assignment only. Needs computer-literate freelancers for design, illustration, production and presentation. 99% of freelance work demands knowledge of QuarkXPress, FreeHand, Photoshop, FinalCut or Director.

First Contact & Terms Send query letter with brochure, business card and photostats and photocopies. Responds only if interested. Pays for design by the hour, $15-25 average. Pays for illustration by the project, $150-3,000 average.

Tips "Most of our accounts need a sophisticated look for their ads, brochures, etc. Occasionally we have a call for humor."

⚏ PICCIRILLI GROUP

502 Rock Spring Rd., Bel Air MD 21014. (410)879-6780. Fax: (410)879-6602. E-mail: info@picgro up.com. Web site: www.picgroup.com. **Creative Director:** Micah Piccirilli. Estab. 1974. Specializes in design and advertising; also annual reports, advertising campaigns, direct mail, brand and corporate identity, displays, packaging, publications and signage. Clients: recreational sport industries, fleet leasing companies, technical product manufacturers, commercial packaging corporations, direct mail advertising firms, realty companies, banks, publishers and software companies.

Needs Works with 4 freelance designers/year. Works on assignment only. Mainly uses freelancers for layout or production. Prefers local freelancers. 75% of design demands skills in Illustrator and QuarkXPress.

First Contact & Terms Send query letter with brochure, résumé and tearsheets; prefers originals as samples. Samples are returned by SASE. Responds on whether to expect possible future assignments. To show a portfolio, mail roughs and finished art samples or call for an appointment. Pays for design and illustration by the hour, $20-45. Considers complexity of project, client's budget, and skill and experience of artist when establishing payment. Buys one-time or reprint rights; rights purchased vary according to project.

Tips "Portfolios should include work from previous assignments. The most common mistake freelancers make is not being professional with their presentations. Send a cover letter with photocopies of work."

⚏ POSNER ADVERTISING

30 Broad St., 9th floor, New York NY 10004. (212)867-3900. Fax: (212)480-3440. E-mail: pposner @posneradv.com. Web site: www.posneradv.com. **Contact:** VP/Creative Director. Estab. 1959. Number of employees: 85. Full-service multimedia firm. Specializes in ads, collaterals, packaging, outdoor. Product specialties are healthcare, real estate, consumer business to business, corporate.

Needs Approached by 25 freelance artists/month. Works with 1-3 illustrators and 5 designers/month. Prefers local artists only with traditional background and experience in computer design. Uses freelancers mainly for graphic design, production, illustration. 80% of work is with print ads. Needs computer-literate freelancers for design, illustration and production. 90% of freelance work demands knowledge of Illustrator, QuarkXPress, InDesign, Photoshop or FreeHand.

First Contact & Terms Send query letter with photocopies or disk. Samples are filed. Responds only if interested. Write for appointment to show portfolio. Portfolio should include thumbnails, roughs, b&w and color tearsheets, printed pieces. Pays for design by the hour, $15-35 or by the project, $300-2,000. Pays for illustration by the project, $300-2,000. Negotiates rights purchased.

Tips Advises freelancers starting out in advertising field to offer to intern at agencies for minimum wage.

R H POWER AND ASSOCIATES, INC.

9621 Fourth St. NW, Albuquerque NM 87114-2128. (505)761-3150. Fax: (505)761-3153. E-mail: info@rhpower.vom. Web site: www.rhpower.com. **Art Director:** Bruce Yager. Creative Director: Roger L. Vergara. Estab. 1989. Number of employees 12. Ad agency. Full-service, multimedia firm. Specializes in TV, magazine, billboard, direct mail, marriage mail, newspaper, radio. Product specialties are recreational vehicles and automotive. Current clients include Kem Lite Corporation, Albany RV, Ultra-Fab Products, Collier RV, Nichols RV, American RV and Marine. Client list available upon request.

Needs Approached by 10-50 freelancers/year. Works with 5-10 freelance illustrators and 5-10 designers/year. Prefers freelancers with experience in retail automotive layout and design. Uses freelancers mainly for work overload, special projects and illustrations. Also for annual reports, billboards, brochure and catalog design and illustration, logos, mechanicals, posters and TV/film graphics. 50% of work is with print ads. 100% of design demands knowledge of Photoshop 9.0, and Illustrator CS 12.

First Contact & Terms Send query letter with photocopies or photographs and résumé. Accepts disk submissions in PC format compatible with Illustrator 10.0 or Adobe Acrobat (pdf). Send PC EPS files. Samples are filed and are not returned. Will contact artist for portfolio review if interested. Portfolio should include b&w and color final art, roughs and thumbnails. Pays for design and illustration by the hour, $15 minimum; by the project, $100 minimum. Buys all rights.

Tips Impressed by work ethic and quality of finished product. "Deliver on time and within budget. Do it until it's right without charging for your own corrections."

POWERS DESIGN INTERNATIONAL

828 Production Place, Newport Beach CA 92663. (949)645-2265. E-mail: sweepinfo@gmail.com. Web site: www.powersdesign.com. **President:** Ron Powers. Estab. 1974. Specializes in **vehicle** and product design, development; exterior & interior transportation design. Clients large corporations. Current clients include Paccar Inc., McDonnell Douglas, Ford Motor Co. and GM. Client list available upon request.

Needs Works with varying number of freelance illustrators and 5-10 freelance designers/year. Prefers local designers/artists only with experience in transportation design (such as those from Art Center College of Design), or with SYD Mead type abilities. Works on assignment only. Uses freelance designers and illustrators for brochure, ad and catalog design, logos, model making and Alias/Pro-E Computer Cad-Cam capabilities. **Contact & Terms** Call first for permission to submit materials and samples. Pays for design and illustration by the project.

PRO INK

2826 NE 19th Dr., Gainesville FL 32609-3391. (352)377-8973. Fax: (352)373-1175. E-mail: terry@proink.com. Web site: www.proink.com. **President:** Terry Van Nortwick. Estab. 1979. Number of employees: 5. Specializes in publications, marketing, healthcare, engineering, development and ads. Professional affiliations: Public Relations Society of America, Society of Professional Journalists, International Association of Business Communicators, Gainesville Advertising Federation, Florida Public Relations Association.

Needs Works with 3-5 freelancers/year. Works on assignment only. Uses freelancers for brochure/annual report illustration, airbrushing and lettering. 80% of freelance work demands knowledge of Illustrator, InDesign, or Photoshop. Needs editorial, medical and technical illustration.

First Contact & Terms Send résumé, samples, tearsheets, photostats, photocopies, slides and photography. Samples are filed or are returned if accompanied by SASE. Responds only if interested. Call or write for appointment to show portfolio of original/final art. Pays for design and illustration by the project, $50-500. Rights purchased vary according to project.

QUARASAN

405 W. Superior St., Chicago IL 60610-3613. (312)981-2520. Fax: (312)981-2507. E-mail: info@quarasan.com. Web site: www.quarasan.com. **Contact:** John Linder. Estab. 1982. Full-service

product developer. Specializes in educational products. Clients: educational publishers.

Needs Approached by 400 freelancers/year. Works with 700-900 illustrators/year. Prefers freelancers with publishing experience. Uses freelancers for illustration, books, mechanicals, charts/graphs, lettering and production. Needs computer-literate freelancers for illustration. 50% of freelance illustration work demands skills in Illustrator, QuarkXPress, Photoshop or FreeHand. Needs editorial, technical, medical and scientific illustration.

First Contact & Terms Send query letter with brochure or résumé and samples to be circulated and kept on file. Prefers "anything that we can retain for our files—photocopies, color tearsheets, e-mail submissions, disks or dupe slides that do not have to be returned." Responds only if interested. Pays for illustration by the piece/project, $40-750 average. Considers complexity of project, client's budget, how work will be used and turnaround time when establishing payment.

Tips Current job openings posted on Web site.

RIPE CREATIVE

543 W. Apollo Rd., Phoenix AZ 85041. (602)304-0703. Fax: (480)247-5339. E-mail: info@ripecre ative.com. Web site: www.ripecreative.com. **Principal:** Mark Anthony Munoz. Estab. 2005. Number of employees: 5. Approximate annual billing: $500,000. Design firm. Specializes in branding, advertising, strategic marketing, publication design, trade-show environments. Current clients include Swing Development, PetSmart, Aon Consulting, Healthways, Poolsmith Technologies, Phoenix Art Museum. Client list available on request. Professional affiliations: Phoenix Advertising Club, National Organization of Women Business Owners, Arizona Hispanic Chamber of Commerce.

Needs Approached by 100 illustrators and 10 designers/year. Works with 10 illustrators and 3 designers/year. Works on assignment only. Uses freelancers mainly for illustration, graphic design, Web site design. Also for animation, brochure design/illustration, direct mail, industrial/structural design, logos, posters, print ads, storyboards, catalog design and technical illustration. 15% of work is assigned with print ads. 100% of design work demands skills in InDesign, Illustrator, QuarkXPress and Photoshop. 100% of illustration work demands skills in Illustrator, Photoshop and traditional illustration media.

First Contact Terms Designers: Send query letter with contact information, resume, samples, and URL if applicable. Illustrators: Send tearsheets, URL. Samples are returned if requested and SASE is provided. Designers and illustrators should attach PDF files and/or URL. Samples are filed or returned by SASE. Responds in 2 weeks. Company will contact artist for portfolio review if interested. Portfolio should include color finished art, photographs and tearsheets. Pays for illustration. Set rate negotiated and agreed to between RIPE and talent. Pays for design by the hour, $25-100. Rights purchased vary according to project. Finds artists through submissions, word of mouth, *Workbook*, *The Black Book*.

Tips calls are discouraged. When making first contact attempt, the preferred method is via mail or electronically. If interested, RIPE will follow up with talent electronically or by telephone. When providing samples, please ensure talent/rep contact is listed on all samples."

STEVEN SESSIONS INC.

5177 Richmond, Suite 500, Houston TX 77056. (713)850-8450. Fax: (713)850-9324. E-mail: Steve n@Sessionsgroup.com. Web site: www.sessionsgroup.com. **President, Creative Director:** Steven Sessions. Estab. 1981. Number of employees 8. Approximate annual billing $2.5 million. Specializes in annual reports; brand and corporate identity; fashion, package and publication

design. Clients corporations and ad agencies. Current clients are listed on Web site. Professional affiliations AIGA, Art Directors Club, American Ad Federation.

Needs Approached by 50 freelancers/year. Works with 10 illustrators and 2 designers/year. Uses freelancers for brochure, catalog and ad design and illustration; poster illustration; lettering; and logos. 100% of freelance work demands knowledge of Illustrator, InDesign, QuarkXPress, Photoshop. Needs editorial, technical and medical illustration.

First Contact & Terms Designers: Send query letter with brochure, tearsheets, CD's, PDF files and SASE. Illustrators: Send postcard sample or other nonreturnable samples. Samples are filed. Responds only if interested. To show portfolio, mail slides. Payment depends on project, ranging from $1,000-30,000/illustration. Rights purchased vary according to project.

⚇ SILVER FOX ADVERTISING

11 George St., Pawtucket RI 02860. (401)725-2161. Fax: (401)726-8270. E-mail: sfoxstudios@ear thlink.net. Web site: www.silverfoxstudios.com. **President:** Fred Marzocchi, Jr.. Estab. 1979. Number of employees 5. Approximate annual billing $1 million. Specializes in package and publication design, logo design, brand and corporate identity, display, technical illustration and annual reports. Clients corporations, retail. Client list available upon request.

Needs Approached by 16 freelancers/year. Works with 6 freelance illustrators and 12 designers/ year. Works only with artist reps. Prefers local artists only. Uses illustrators mainly for cover designs. Also for multimedia projects. 50% of freelance work demands knowledge of Illustrator, Photoshop, PageMaker and QuarkXPress.

First Contact & Terms Send query letter with résumé and photocopies. Accepts disk submissions compatible with Photoshop 7.0 or Illustrator 8.0. Samples are filed. Does not reply. Artist should follow up with call and/or letter after initial query. Portfolio should include final art, photographs, roughs and slides.

SIMMONS/FLINT ADVERTISING

33 South Third St., Suite D, Grand Forks ND 58201. (701)746-4573. Fax: (701)746-8067. E-mail: YvonneRW@simmonsflint.com. Web site: www.simmonsflint.com. **Contact:** Yvonne Westrum. Estab. 1947. Number of employees 90. Approximate annual billing $5.5 million. Ad agency. Specializes in magazine ads, collateral, documentaries, Web design etc. Product specialties are agriculture, gardening, fast food/restaurants, healthcare. Client list available upon request.

- A division of Flint Communications, Fargo ND, with 5 locations in North Dakota and Minnesota. See listing for Flint Communications in this section.

Needs Approached by 3-6 freelancers/year. Works with 3 freelance illustrators and 2 designer/ year. Works on assignment only. Uses freelancers mainly for illustration. Also for brochure, catalog and print ad design and illustration; storyboards; billboards; and logos. 10% of work is with print ads. 10% of freelance work demands knowledge of QuarkXPress, Photoshop, Illustrator.

First Contact & Terms Send postcard, tearsheets or digital submission. Samples are filed or are returned. Will contact artist for portfolio review if interested. Portfolio should include color thumbnails, roughs, tearsheets, and photographs. Pays for design and illustration by the hour, by the project, or by the day. Rights purchased vary according to project.

SMITH ADVERTISING

321 Arch St., Drawer 2187, Fayetteville NC 28302. (910)222-5071. E-mail: gsmith@smithadv.c om. Web site: www.smithadv.com. **CEO/President:** Gary Smith. Estab. 1974. Ad agency, full-

service multimedia firm. Specializes in newspaper, magazine, broadcast, collateral, PR, custom presentations and Web design. Product specialties are financial, healthcare, manufacturing, business-to-business, real estate, tourism. Client list available upon request.

Needs Approached by 0-5 freelance artists/month. Works with 5-10 freelance illustrators and designers/month. Prefers artists with experience in Macintosh. Works on assignment only. Uses freelance artists mainly for mechanicals and creative; also for brochure, catalog and print ad illustration and animation, mechanicals, retouching, model-making, TV/film graphics and lettering. 50% of work is with print ads. Needs computer-literate freelancers for design, illustration, production and presentation. 95% of freelance work demands knowledge of QuarkXPress, Illustrator or Photoshop.

First Contact & Terms Send query letter with résumé and copies of work. Samples are returned by SASE if requested by artist. Responds in 3 weeks. Will contact artist for portfolio review if interested. Pays for design and illustration by the project, $100. Buys all rights.

SMITH DESIGN

P.O. Box 8278, 205 Thomas St., Glen Ridge NJ 07028. (973)429-2177. Fax: (973)429-7119. E-mail: laraine@smithdesign.com. Web site: www.smithdesign.com. **Vice President:** Laraine Blauvelt. Brand design firm. Specializes in strategy-based visual solutions for leading consumer brands. Clients: grocery, mass market consumer brands, electronics, construction, automotive, toy manufacturers. Current clients include Popsicle, Good Humor, Motts. Client list available upon request.

Needs Approached by more than 100 freelancers/year. Works with 10-20 freelance illustrators and 3-4 designers/year. Requires experience, talent, quality work and reliability. Uses freelancers for package design, concept boards, brochure design, print ads, newsletters illustration, POP display design, retail environments, web programming. 90% of freelance work demands knowledge of Illustrator, QuarkXPress, 3D rendering programs. Design style must be current to trends, particularly when designing for kids and teens. "Our work ranges from classic brands to cutting edge."

First Contact & Terms Send query letter with brochure/samples showing work, style and experience. Include contact information. Samples are filed or are returned only if requested by artist. Responds in 1 week. Call for appointment to show portfolio. Pays for design by the hour, $35-100; or by the project, $175-5,000. Pays for illustration by the project, $175-5,000. Considers complexity of project and client's budget when establishing payment. Buys all rights. (For illustration work, rights may be limited to a particular use TBD). Also buys rights for use of existing non-commissioned art. Finds artists through word of mouth, self-promotions/sourcebooks and agents.

Tips "Know who you're presenting to (visit our Web site to see our needs). Show work which is relevant to our business at the level and quality we require. We use more freelance designers and illustrators for diversity of style and talent."

▣ SMITH & DRESS LTD.

432 W. Main St., Huntington NY 11743. (631)427-9333. Fax: (631)427-9334. E-mail: dress2@att.net. Web site: www.smithanddress.com. **Contact:** Abby Dress. Full-service ad firm. Specializes in annual reports, corporate identity, display, direct mail, packaging, publications, Web sites, trade shows and signage.

Needs Works with 3-4 freelance artists/year. Prefers local artists only. Works on assignment only. Uses artists for illustration, retouching, airbrushing and lettering.

First Contact & Terms Send query letter with brochure showing art style or tearsheets to be kept on file (except for works larger than $8^{1}/_{2} \times 11$). Pays for illustration by the project. Considers client's budget and turnaround time when establishing payment.

SPECTRUM BOSTON CONSULTING, INC.

P.O. Box 689, Westwood MA 02090-0689. (781)320-1361. Fax: (781)320-1315. E-mail: gboesel@ spectrumboston.com. Web site: www.spectrumboston.com. **President:** George Boesel. Estab. 1985. Specializes in brand and corporate identity, display and package design and signage. Clients: consumer, durable manufacturers.

Needs Approached by 30 freelance artists/year. Works with 5 illustrators and 3 designers/year. All artists employed on work-for-hire basis. Works on assignment only. Uses illustrators mainly for package and brochure work; also for brochure design and illustration, logos, P-O-P design and illustration and model-making. 100% of design and 85% of illustration demand knowledge of Illustrator, QuarkXPress, Photoshop. Needs technical and instructional illustration.

First Contact & Terms Designers: Send query letter with résumé and photocopies. Illustrators: Send query letter with tearsheets, photographs and photocopies. Accepts any Mac-formatted disk submissions except for PageMaker. Samples are filed. Responds only if interested. Call or write for appointment to show portfolio of roughs, original/final art and color slides.

SPLANE DESIGN ASSOCIATES

30634 Persimmon Lane, Valley Center CA 90282. (760)749-6018. E-mail: splane@pacificnet.net. Web site: www.splanedesign.com. **President:** Robson Splane. Specializes in product design. Clients: small, medium and large companies. Current clients include Lockheed Aircraft, Western Airlines, Liz Claiborne, Max Factor, Sunkist, Universal studios. Client list available upon request.

Needs Approached by 25-30 freelancers/year. Works with 1-2 freelance illustrators and 6-12 designers/year. Works on assignment only. Uses illustrators mainly for logos, mailings to clients, renderings. Uses designers mainly for sourcing, drawings, prototyping, modeling; also for brochure design and illustration, ad design, mechanicals, retouching, airbrushing, model making, lettering and logos. 75% of freelance work demands skills in FreeHand, Ashlar Vellum, Solidworks and Excel.

First Contact & Terms Send query letter with résumé and photocopies. Samples are filed or are returned. Responds only if interested. Will contact artist for portfolio review if interested. Portfolio should include color roughs, final art, photostats, slides and photographs. Pays for design and illustration by the hour, $7-25. Rights purchased vary according to project. Finds artists through submissions and contacts.

▓ STROMBERG CONSULTING

1285 Avenue of the Americas, 3rd floor, New York NY 10019. (646)935-4388. Fax: (646)935-4368. E-mail: ContactUs@strombergconsulting.com. Web site: www.strombergconsulting.com. **Senior Recruiter:** Lisa Fuhrman. Specializes in direct marketing, internal and corporate communications. Clients: industrial and corporate. Produces multimedia presentations and print materials.

Needs Assigns 25-35 jobs/year. Prefers local designers only (Manhattan and its 5 burroughs) with experience in animation, computer graphics, multimedia and Macintosh. Uses freelancers for animation logos, posters, storyboards, training guides, Web Flash, application development, design catalogs, corporate brochures, presentations, annual reports, slide shows, layouts, me-

chanicals, illustrations, computer graphics and desk-top publishing web development, application development.

First Contact & Terms "Send note on availability and previous work." Responds only if interested. Provide materials to be kept on file for future assignments. Originals are not returned. Pays hourly or by the project.

Tips Finds designers through word of mouth and submissions.

☷ TASTEFUL IDEAS, INC.

7638 Bell Dr., Shawnee KS 66217. (913)722-3769. Fax: (913)722-3967. E-mail: john@tastefuladeas.com. Web site: www.tastefulideas.com. **President:** John Thomsen. Estab. 1986. Number of employees: 4. Approximate annual billing: $500,000. Design firm. Specializes in consumer packaging. Product specialties are largely, but not limited to, food and foodservice.

Needs Approached by 15 illustrators and 15 designers/year. Works with 3 illustrators and 3 designers/year. Prefers local freelancers. Uses freelancers mainly for specialized graphics; also for airbrushing, animation, humorous and technical illustration. 10% of work is with print ads. 75% of design and illustration demand skills in Photoshop and Illustrator.

First Conact & Terms Designers: Send query letter with photocopies. Illustrators: Send non-returnable promotional sample. Accepts submissions compatible with Illustrator, Photoshop (Mac based). Samples are filed. Responds only if interested. Art director will contact artist for portfolio review of final art if interested. Pays by the project. Finds artists through submissions.

TOBOL GROUP, INC.

14 Vanderventer Ave., Port Washington NY 11080. (516)767-8182. Fax: (516)767-8185. E-mail: mt@tobolgroup.com. Web site: www.tobolgroup.com. **President:** Mitch Tobol. Estab. 1981. Ad agency. Product specialties are business to business and business to consumer.

Needs Approached by 2 freelance artists/month. Works with 1 freelance illustrator and 4 designers/month. Works on assignment only. Uses freelancers for brochure, catalog and print ad design and technical illustration, retouching, billboards, posters, TV/film graphics, lettering and logos. 25% of work is with print ads. 75% of freelance work demands knowledge of QuarkXPress, Illustrator, Photoshop, GoLive or Dreamweaver.

First Contact & Terms Send query letter with SASE and tearsheets. Samples are filed or are returned by SASE. Responds in 1 month. Call for appointment to show portfolio or mail thumbnails, roughs, b&w and color tearsheets and transparencies. Pays for design by the hour, $35 minimum; by the project, $200-800; by the day, $200 minimum. Pays for illustration by the project, $300-1,500 ($50 for spot illustrations). Negotiates rights purchased.

☷ TR PRODUCTIONS

209 W. Central St., Suite 108, Natick MA 01760. (508)650-3400. Fax: (508)650-3455. E-mail: info@trprod.com. Web site: www.trprod.com. **Creative Director:** Cary M. Benjamin. Estab. 1947. Number of employees: 12. AV firm; full-service multimedia firm. Specializes in FLASH, collateral, multimedia, Web graphics and video.

Needs Approached by 15 freelancers/year. Works with 5 freelance illustrators and 5 designers/ year. Prefers local freelancers with experience in slides, Web, multimedia, collateral and video graphics. Works on assignment only. Uses freelancers mainly for slides, Web, multimedia, collateral and video graphics; also for brochure and print ad design and illustration, slide illustration, animation and mechanicals. 25% of work is with print ads. Needs computer-literate freelancers

for design, production and presentation. 95% of work demands skills in FreeHand, Photoshop, Premier, After Effects, Powerpoint, QuarkXPress, Illustrator, Flash.

First Contact & Terms Send query letter. Samples are filed. Does not reply. Artist should follow up with call. Will contact artist for portfolio review if interested. Rights purchased vary according to project.

ULTITECH, INC.

Foot of Broad St., Stratford CT 06615. (203)375-7300. Fax: (203)375-6699. E-mail: comcowic@m eds.com. Web site: www.meds.com. **President:** W. J. Comcowich. Estab. 1993. Number of employees 3. Approximate annual billing $1 million. Integrated marketing communications agency. Specializes in interactive multimedia, software, online services. Product specialties are medicine, science, technology. Current clients include large pharmaceutical companies.

Needs Approached by 10-20 freelance illustrators and 10-20 designers/year. Works with 2-3 freelance illustrators and 6-10 designers/year. Prefers freelancers with experience in interactive media design and online design. Uses freelancers mainly for design of Web sites and interactive CD-ROMS/DVDs. Also for animation, brochure design, medical illustration, multimedia projects, TV/film graphics. 10% of work is with print ads. 100% of freelance design demands skills in Photoshop, QuarkXPress, Illustrator, 3D packages.

First Contact & Terms E-mail submission is best. Include links to online portfolio. Responds only if interested. Pays for design by the project or by the day. Pays for illustration by the project. Buys all rights. Finds artists through sourcebooks, word of mouth, submissions.

Tips "Learn design principles for interactive media."

UNICOM

9470 N. Broadmoor Rd., Bayside WI 53217. (414)352-5070. Fax: (414)352-4755. Web site: www.l itteratibooks.com. **Senior Partner:** Ken Eichenbaum. Estab. 1974. Specializes in annual reports, brand and corporate identity, display, direct, package and publication design and signage. Clients: corporations, business-to-business communications, and consumer goods. Client list available upon request.

Needs Approached by 5-10 freelancers/year. Works with 1-2 freelance illustrators/year. Works on assignment only. Uses freelancers for brochure, book and poster illustration, pre-press composition.

First Contact & Terms Send query letter with brochure. Samples not filed or returned. Does not reply; send nonreturnable samples. Write for appointment to show portfolio of thumbnails, photostats, slides and tearsheets. Pays by the project, $200-3,000. Rights purchased vary according to project.

▣ VISUAL HORIZONS

180 Metro Park, Rochester NY 14623. (585)424-5300. Fax: (585)424-5313. E-mail: cs@visualhori zons.com. Web site: www.visualhorizons.com. Estab. 1971. AV firm; full-service multimedia firm. Specializes in presentation products, digital imaging of 35mm slides. Current clients include U.S. government agencies, corporations and universities.

Needs Works on assignment only. Uses freelancers mainly for web design. 5% of work is with print ads. 100% of freelance work demands skills in Photoshop.

First Contact & Terms Send query letter with tearsheets. Samples are not filed and are not returned. Responds if interested. Portfolio review not required. Pays for design and illustration by the hour or project, negotiated. Buys all rights.

◼ WALKER DESIGN GROUP

421 Central Ave., Great Falls MT 59401. (406)727-8115. Fax: (406)791-9655. E-mail: info@walke rdesigngroup.com. Web site: www.walkerdesigngroup.com. **President:** Duane Walker. Number of employees: 6. Design firm. Specializes in annual reports and corporate identity. Professional affiliations: AIGA and Ad Federation.

Needs Uses freelancers for animation, annual reports, brochure, medical and technical illustration, catalog design, lettering, logos and TV/film graphics. 80% of design and 90% of illustration demand skills in PageMaker, Photoshop and Illustrator.

First Contact & Terms Send query letter with brochure, photocopies, post cards, résumé, and/or tearsheets. Accepts digital submissions. Samples are filed and are not returned. Responds only if interested. To arrange portfolio review, artist should follow up with call or letter after initial query. Portfolio should include color photographs, photostats and tearsheets. Pays by the project; negotiable. Finds artists through *Workbook*.

Tips "Stress customer service and be very aware of deadlines."

◪ WARNE MARKETING & COMMUNICATIONS

65 Overlea Blvd, Suite 112, Toronto ON M4H 1P1 Canada. (416)927-0881. Fax: (416)927-1676. E-mail: info@warne.com. Web site: www.warne.com. **Studio Manager:** John Coljee. Number of employees: 9. Approximate annual billing: $2.5 million. Specializes in business-to-business marketing and communications. Current clients include ACTRA Fraternal Benefits Society, 360 Athletics, Johnston Equipment, Leavens Aviation, and Virtek Vision. Professional affiliations: CIM, BMA, INBA.

Needs Works with 1-2 freelance illustrators and 1-3 designers/year. Works on assignment only. Uses freelancers for design and technical illustrations, advertisements, brochures, catalogs, P-O-P displays, posters, direct mail packages, logos and interactive. Artists should have concept thinking.

First Contact & Terms Send query letter with résumé and photocopies. Samples are not returned. Responds only if interested. No e-mails please. Pays for design by the hour, or by the project. Considers complexity of project, client's budget, and skill and experience of artist when establishing payment. Buys all rights.

WAVE DESIGN WORKS

P.O. Box 995, Norfolk MA 02056. (508)541-9171. E-mail: ideas@wavedesignworks.com. Web site: www.wavedesignworks.com. **Principal:** John Buchholz. Estab. 1986. Specializes in corporate identity and display, package and publication design. Clients corporations primarily biotech and software.

Needs Approached by 24 freelance graphic artists/year. Works with 1-5 freelance illustrators and 1-5 freelance designers/year. Works on assignment only. Uses freelancers for brochure, catalog, poster and ad illustration; lettering; and charts/graphs. 100% of design and 50% of illustration demand knowledge of QuarkXPress, Indesign, Illustrator or Photoshop.

First Contact & Terms Designers send query letter with brochure, résumé, photocopies, photographs and tearsheets. Illustrators send postcard promo. Samples are filed. Responds only if interested. Artist should follow up with call and/or letter after initial query. Portfolio should include b&w and color thumbnails and final art. Pays for illustration by the project. Rights purchased vary according to project. Finds artists through submissions and sourcebooks.

WEST CREATIVE, INC.

10780 S. Cedar Niles Circle., Olathe KS 66210-6061. (913)839-2181. Fax: (913)498-8627. E-mail: stan@westcreative.com. Web site: www.westcreative.com. **Creative Director:** Stan Chrzanowski. Estab. 1974. Number of employees 8. Approximate annual billing $600,000. Design firm and agency. Full-service, multimedia firm. Client list available upon request. Professional affiliation AIGA.

Needs Approached by 50 freelancers/year. Works with 4-6 freelance illustrators and 1-2 designers/year. Uses freelancers mainly for illustration. Also for animation, lettering, mechanicals, model-making, retouching and TV/film graphics. 20% of work is with print ads. Needs computer-literate freelancers for design, illustration and production. 95% of freelance work demands knowledge of FreeHand, Photoshop, QuarkXPress and Illustrator. Full service web design capabilities.

First Contact & Terms Send postcard-size sample of work or send query letter with brochure, photocopies, résumé, SASE, slides, tearsheets and transparencies. Samples are filed or returned by SASE if requested by artist. Responds only if interested. Portfolios may be dropped off every Monday-Thursday. Portfolios should include color photographs, roughs, slides and tearsheets. Pays for illustration by the project; pays for design by the hour, $25-60. "Each project is bid." Rights purchased vary according to project. Finds artists through *Creative Black Book* and *Workbook*.

WISNER CREATIVE

18200 NW Sauvie Island Rd., Portland OR 97231-1338. (503)282-3929. Fax: (503)282-0325. E-mail: wizbiz@wisnercreative.com. Web site: www.wisnercreative.com. **Creative Director:** Linda Wisner. Estab. 1979. Number of employees: 1. Specializes in brand and corporate identity, book design, publications and exhibit design. Clients: small businesses, manufacturers, restaurants, service businesses and book publishers.

Needs Works with 3-5 freelance illustrators/year. Prefers experienced freelancers and "fast, accurate work." Works on assignment only. Uses freelancers for technical and fashion illustration and graphic production. Knowledge of QuarkXPress, Photoshop, Illustrator and other software required.

First Contact & Terms Send query letter or e-mail with résumé and samples. Prefers "examples of completed pieces that show the fullest abilities of the artist." Samples not kept on file are returned by SASE, only if requested. Will contact artist for portfolio review if interested. Pays for illustration by the hour, $30-45 average, or by the project, by bid. Pays for computer work by the hour, $25-35.

SPENCER ZAHN & ASSOCIATES

2015 Sansom St., Philadelphia PA 19103. (215)564-5979. Fax: (215)564-6285. E-mail: szahn@erols.com. **President:** Spencer Zahn. Business Manager Brian Zahn. Estab. 1970. Number of employees 5. Specializes in brand and corporate identity, direct mail design, marketing, retail and business to business advertising.P.O.S. Clients: corporations, manufacturers, etc.

Needs Approached by 15 freelancers/year. Works with freelance illustrators and designers. Prefers artists with experience in Macintosh computers. Uses freelancers for design and illustration; direct mail design; and mechanicals. Needs computer-literate freelancers for design, illus-

tration and production. 80% of freelance work demands knowledge of Illustrator, Photoshop, FreeHand and QuarkXPress.

First Contact Terms Send query letter with samples. Samples are not filed and are returned by SASE if requested by artist. Responds only if interested. Artist should follow up with call. Portfolio should include final art and printed samples. Buys all rights.

Stock Illustration & Clip Art Firms

Stock illustration firms market images to book publishers, advertising agencies, magazines, corporations and other businesses through catalogs and Web sites. Art directors flip through stock illustration catalogs or browse the Web for artwork at reduced prices, while firms split fees with illustrators.

There are those who believe stock illustration hurts freelancers. They say it encourages art directors to choose ready-made artwork at reduced rates instead of assigning illustrators for standard industry rates. Others feel the practice gives freelancers a vehicle to resell their work. Marketing your work as stock allows you to sell an illustration again and again instead of filing it away in a drawer. That can mean extra income every time someone chooses the illustration from a stock catalog.

Stock vs. clip art

When most people think of clip art, they think of booklets of copyright-free graphics and cartoons, the kind used in church bulletins, high school newspapers, club newsletters and advertisements for small businesses. But these days, especially with so many digital images available online, perceptions are changing. With the popularity of desktop publishing, newsletters that formerly looked homemade now look more professional.

There is another crucial distinction between stock illustration and clip art. That distinction is copyright. Stock illustration firms do not sell illustrations. They license the right to reprint illustrations, working out a "pay-per-use" agreement. Fees charged depend on how many times and for what length of time their clients want to reproduce the artwork. Stock illustration firms generally split their fees 50-50 with artists and pay the artist every time his/her image is used. Some agencies offer better terms than others, so weigh your options before signing any contracts.

Clip art, on the other hand, generally implies that buyers are granted a license to use the image as many times as they want, and furthermore, they can alter it, crop it or retouch it to fit their purposes. Some clip art firms repackage artwork created many years ago because it is in the public domain, and therefore, they don't have to pay an artist for the use of the work. But in the case of clip art created by living artists, firms either pay the artists an agreed-upon fee for all rights to the work or negotiate a royalty agreement. Keep in mind that if you sell all rights to your work, you will not be compensated each time it is used unless you also negotiate a royalty agreement. Once your work is sold as clip art, the buyer of that clip art can alter your work and resell it without giving you credit or compensation.

How to submit artwork

Companies are identified as either stock illustration or clip art firms in the first paragraph of each listing. Some firms, such as Metro Creative Graphics and Dynamic Graphics, seem to

be hybrids of clip art firms and stock illustration agencies. Read the information under "Needs" to find out what type of artwork each firm wants. Then check "First Contact & Terms" to find out what type of samples you should send. Many firms accept samples in the form of slides, photocopies and tearsheets, but digital submissions are being accepted more frequently.

▨ ARTBANK®

London United Kingdom. E-mail: info@artbank.com. Web site: www.artbank.com. Estab. 1989. Picture library. "Artbank provides a platform where art can be displayed, promoted and sold, and the sellers have the right to protect their anonymity until a buyer wishes to contact them." Clients include advertising agencies, design groups, book publishers, calendar companies, greeting card companies and postcard publishers.

Needs Prefers 4×5 transparencies.

First Contact & Terms Register at www.artistbank.com.

DRAWN & QUARTERED LTD.

Metahqua, Oak Lane, Sewickley PA 15143. E-mail: red@drawnandquartered.com. Web site: www.drawnandquartered.com. **Contact:** Robert Edwards, chief executive.

• See listing in Syndicates & Cartoon Features section.

DREAM MAKER SOFTWARE

P.O. Box 630875, Highlands Ranch CO 80163-0875. (303)350-8557. Fax: (303)683-2646. E-mail: sls@coolclipart.com. Web site: www.coolclipart.com. Estab. 1986. Clip art firm and computer software publisher serving homes, schools and businesses.

Needs Approached by 20-30 freelancers/year. Considers a variety of work, including cartoon-type and realistic illustrations suitable for publication as clip art with a broad market appeal. Also interested in small watercolor illustrations in styles suitable for greeting cards.

First Contact & Terms Send cover letter with 8-12 samples. Samples are not filed and are returned by SASE. Responds in 2 months, only if interested. Considers both traditional and computer-based (Illustrator) artwork. Does not accept initial samples on disk. Pays $10-50 flat fee on completion of contract. Typical contract includes artist doing 50-150 illustrations with full payment made upon completion and acceptance of work. Rights purchased include assignment of copyright from artist.

DYNAMIC GRAPHICS GROUP

A Jupiterimages™ division, 475 Park Ave. S., 4th Floor, New York NY 10016. (309)687-0187 or (800)764-7427. Fax: (703)770-5349. E-mail: photography@jupiterimages.com. Web site: www.d gusa.com. Distributes rights-managed and royalty-free stock images, clip art and animation to thousands of magazines, newspapers, agencies, industries and educational institutions.

• Publisher of *STEP inside design* (www.stepinsidedesign.com), *Dynamic Graphics* magazine (www.dynamicgraphics.com), and *LiquidTreat* (www.liquidtreat.com).

Needs Works with more than 50 freelancers/year. Prefers illustration, symbols and elements; color and b&w; traditional or electronic images. "We are currently seeking to contact established illustrators capable of handling b&w or color stylized and representational illustrations of contemporary subjects and situations."

First Contact & Terms Submit portfolio of at least 15 current samples with SASE. Responds in 2 weeks. **Pays on acceptance.** Negotiates payment. Buys all rights.

Tips ''We are interested in quality, variety and consistency. Illustrators contacting us should have top-notch samples that show consistency of style (repeatability) over a range of subject matter. We often work with artists who are getting started if their portfolios look promising. Because we publish a large volume of artwork monthly, deadlines are extremely important, but we do provide long lead time (4-6 weeks is typical.) We are also interested in working with illustrators who would like an ongoing relationship. Not necessarily a guaranteed volume of work, but the potential exists for a considerable number of pieces each year for marketable styles.''

GETTY IMAGES

601 N. 34th St., Seattle WA 98103. (800)462-4379 or (206)925-5000. Fax: (206)925-5001. Web site: www.gettyimages.com. Leading imagery company, creating and distributing the largest collection of images to communication professionals around the world. Getty Images products are found in newspapers, magazines, advertising, films, television, books and Web sites. Offers royalty-free and rights-managed images.

Needs Approached by 1,500 artists/year. Buys from 100 freelancers/year. Considers illustrations, photos, typefaces and spot drawings.

First Contact & Terms Visit http://contributors.gettyimages.com and click on ''work with us'' link.

INDEX STOCK IMAGERY℠

23 W. 18th St., 3rd Floor, New York NY 10011. (212)929-4644 or (800)690-6979. Fax; (212)633-1914. E-mail: editing@indexstock.com. Web site: www.indexstock.com. Estab. 1992. Specializes in stock imagery for corporations, advertising agencies and design firms. Guidelines available on Web site.

Needs Approached by 300 new artists/year. Themes include animals, business, education, healthcare, holidays, lifestyles, travel locations, technology and computers.

First Contact & Terms ''Ideally we would like to see a sample of 50 or more digital images that cover the range of subjects and styles of your work.'' Visit Web site; click on *For Artists Only* link at bottom of screen; click on *Initial Submission Evaluation* and then *Artists Questionnaire.* As instructed in guidelines, send completed questionnaire with your images for review (e-mail link to Web gallery or portfolio; e-mail low-res samples; or send low-res files on CD/DVD). ''We do not return DVDs or CDs.'' Responds only if interested. Pays royalties of 40%. Negotiates rights purchased. Finds artists through *Workbook, Showcase, Creative Illustration,* magazines, submissions.

Tips ''Index Stock Imagery likes to work with artists to create images specifically for stock. We provide 'Want' lists and concepts to aid in the process. We like to work with illustrators who are motivated to explore an avenue other than just assignment to sell their work.''

INNOVATIVE CLIP ART

4772 Betty Davis Rd., York SC 29745. (803)831-6727. Fax: (704)290-2056. E-mail: info@innovati veclipart.com. Web site: www.innovativeclipart.com. **Owner:** David Dachs. Estab. 1985. Clip art publisher. Specializes in clip art for publishers, ad agencies, designers. Clients include Disney and *Time* Magazine.

Needs Prefers clip art, illustration, line drawing. Themes include animals, business, education, food/cooking, holidays, religion, restaurant, schools. 100% of design work demands knowledge of Illustrator.

First Contact & Terms Send samples and/or Macintosh disks (Illustrator files). Artwork should be saved as EPS files. Samples are filed. Responds only if interested. Pays by the project. Buys all rights.

MONOTYPE IMAGING, INC.

(formerly AGFA Monotype Typography), 500 Unicorn Park Dr., Woburn MA 01801. (781)970-6000. Fax: (781)970-6001. E-mail: info@fonts.com. Web site: www.fonts.com. **Typeface Review Board Chairman:** Allan Haley. Estab. 1897. Font foundry. Specializes in high-quality Postscript and Truetype fonts for graphic design professionals and personal use. Clients include advertising agencies, magazines and desktop publishers. Submission guidelines available on Web site.

- Does not want clip art or illustrations—only fonts.

Needs Approached by 10 designers/year. Works with 5 typeface designers/year. Freelance work demands knowledge of Illustrator, Photoshop, QuarkXPress.

First Contact & Terms E-mail font samples as PDF or EPS files. Samples are not filed. Responds only if interested. Rights purchased vary according to project. Finds designers through word of mouth.

ONE MILE UP, INC.

7011 Evergreen Court, Annandale VA 22003. (703)642-1177. Fax: (703)642-9088. E-mail: info07 @onemileup.com. Web site: www.onemileup.com. **President:** Gene Velazquez. Estab. 1988.

- Gene Velazquez told *AGDM* he is looking for aviation and military graphics. He does NOT use cartoons.

Needs Approached by 10 illustrators and animators/year. Buys from 5 illustrators/year. Prefers illustration.

First Contact & Terms Send 1-5 samples via e-mail with résumé and/or link to your Web site. Pays flat fee: $30-120. **Pays on acceptance.** Negotiates rights purchased.

STOCKART.COM

155 N. College Ave., Suite 225, Fort Collins CO 80524. (970)493-0087 or (800)297-7658. Fax: (970)493-6997. E-mail: art@stockart.com. Web site: www.stockart.com. **Art Manager:** Matthew Lawrence. Estab. 1995. Stock illustration and representative. Specializes in b&w and color illustration for ad agencies, design firms and publishers. Clients include BBDO, Bozell, Pepsi, Chase, Saatchi & Saatchi.

Needs Approached by 250 illustrators/year. Works with 150 illustrators/year. Themes include business, family life, financial, healthcare, holidays, religion and many more.

First Contact & Terms Send at least 10 samples of work. Accepts hard copies, e-mail or disk submissions compatible with TIFF or EPS files less than 600K/image. Pays 50% stock royalty, 70% commission royalty (commissioned work artist retains rights) for illustration. Rights purchased vary according to project. Finds artists through sourcebooks, online, word of mouth. Offers "unprecedented easy-out policy: Not 100% satisfied, will return artwork within 60 days."

Tips "Stockart.com has many artists earning a substantial passive income from work that was otherwise in their file drawers collecting dust."

Syndicates & Cartoon Features

Syndicates are agents who sell comic strips, panels and editorial cartoons to newspapers and magazines. If you want to see your comic strip in the funny papers, you must first get the attention of a syndicate. They promote and distribute comic strips and other features in exchange for a cut of the profits.

The syndicate business is one of the hardest markets to break into. Newspapers are reluctant to drop long-established strips for new ones. Consequently, spaces for new strips do not open up often. When they do, syndicates look for a "sure thing," a feature they'll feel comfortable investing more than $25,000 in for promotion and marketing. Even after syndication, much of your promotion will be up to you.

To crack this market, you have to be more than a fabulous cartoonist—the art won't sell if the idea isn't there in the first place. Work worthy of syndication must be original, salable and timely, and characters must have universal appeal to attract a diverse audience.

Although newspaper syndication is still the most popular and profitable method of getting your comic strip to a wide audience, the Internet has become an exciting new venue for comic strips and political cartoons. With the click of your mouse, you can be introduced to *The Boiling Point* by Mikhaela Reid, *Overboard* by Chip Dunham, and *Strange Brew* by John Deering. (GoComics.com provides a great list of online comics.)

Such sites may not make much money for cartoonists, but it's clear they are a great promotional tool. It is rumored that scouts for the major syndicates have been known to surf the more popular comic strip sites in search of fresh voices.

HOW TO SUBMIT TO SYNDICATES

Each syndicate has a preferred method for submissions, and most have guidelines you can send for or access online. Availability is indicated in the listings.

To submit a strip idea, send a brief cover letter (50 words or less is ideal) summarizing your idea, along with a character sheet (the names and descriptions of your major characters) and photocopies of 24 of your best strip samples on $8\frac{1}{2} \times 11$ paper, six daily strips per page. Sending at least one month of samples shows that you're capable of producing consistent artwork and a long-lasting idea. Never submit originals; always send photocopies of your work. Simultaneous submissions are usually acceptable. It is often possible to query syndicates online, by attaching art files or links to your Web site. Response time can take several months. Syndicates understand it would be impractical for you to wait for replies before submitting your ideas to other syndicates.

Editorial cartoons

If you're an editorial cartoonist, you'll need to start out selling your cartoons to a base newspaper (probably in your hometown) and build up some clips before approaching a syndicate.

Submitting published clips proves to the syndicate that you have a following and are able to produce cartoons on a regular basis. Once you've built up a good collection of clips, submit at least 12 photocopied samples of your published work along with a brief cover letter.

Payment and contracts

If you're one of the lucky few to be picked up by a syndicate, your earnings will depend on the number of publications in which your work appears. It takes a minimum of about 60 interested newspapers to make it profitable for a syndicate to distribute a strip. A top strip such as *Garfield* may be in as many as 2,000 papers worldwide.

Newspapers pay in the area of $10-15 a week for a daily feature. If that doesn't sound like much, multiply that figure by 100 or even 1,000 newspapers. Your payment will be a percentage of gross or net receipts. Contracts usually involve a 50/50 split between the syndicate and cartoonist. Check the listings for more specific payment information.

Before signing a contract, be sure you understand the terms and are comfortable with them.

Self-syndication

Self-syndicated cartoonists retain all rights to their work and keep all profits, but they also have to act as their own salespeople, sending packets to newspapers and other likely outlets. This requires developing a mailing list, promoting the strip (or panel) periodically, and developing a pricing, billing and collections structure. If you have a knack for business and the required time and energy, this might be the route for you. Weekly suburban or alternative newspapers are the best bet here. (Daily newspapers rarely buy from self-syndicated cartoonists.)

<div style="margin-left:2em;">

Helpful Resources

For More Info

You'll get an excellent overview of the field by reading *Your Career in Comics* by Lee Nordling (Andrews McMeel), a comprehensive review of syndication from the viewpoints of the cartoonist, the newspaper editor and the syndicate. *Successful Syndication: A Guide for Writers and Cartoonists*, by Michael H. Sedge (Allworth Press) also offers concrete advice to aspiring cartoonists.

Another great source of information is Stu's Comic Strip Connection at www.stus.com/index2.htm. Here you'll find links to most syndicates and other essential sources, including helpful books, courtesy of Stu Rees.

</div>

ARTIZANS.COM

11149 65th St. NW, Edmonton AB T5W 4K2 Canada. E-mail: submissions@artizans.com. Web site: www.artizans.com. **Submission Editor:** Malcolm Mayes. Estab. 1998. Artist agency and syndicate providing commissioned artwork, stock illustrations, political cartoons, gag cartoons, global caricatures and humorous illustrations to magazines, newspapers, Web sites, corporate and trade publications and ad agencies. Submission guidelines available on Web site. Artists represented include Jan Op De Beeck, Chris Wildt, Aaron Bacall and Dusan Petricic.

Needs Works with 30-40 artists/year. Buys 30-40 features/year. Needs single-panel cartoons, caricatures, illustrations, graphic and stock art. Prefers professional artists with track records who create artwork regularly, and artists who have archived work or a series of existing cartoons, caricatures and/or illustrations.

First Contact & Terms Send cover letter and copies of cartoons or illustrations. Send 10-20 examples if sending via e-mail; 24 if sending via snail mail. "In your cover letter, tell us briefly about your career. This should inform us about your training, what materials you use and where your work has been published." Résumé and samples of published cartoons would be helpful but are not required. E-mail submission should include a link to other online examples of your work. Responds in 2 months. Artist receives 50-75%. Payment varies depending on artist's sales. Artist retains copyright. "Our clients purchase a variety of rights from the artists."

Tips "We are only interested in professional artists with a track record. See our Web site for guidelines."

ASHLEIGH BRILLIANT ENTERPRISES

117 W. Valerio St., Santa Barbara CA 93101. (805)682-0531. **President:** Ashleigh Brilliant. Estab. 1967. Syndicate and publisher. Outlets vary. "We supply a catalog and samples for $2 plus SASE."

● See additional listing in the Greeting Cards, Gifts & Products section.

Needs Considers illustrations and complete word-and-picture designs. Prefers single-panel. Maximum size of artwork: 5½ × 3½, horizontal only.

First Contact & Terms Samples are returned by SASE if requested by artist. Responds in 2 weeks. **Pays on acceptance:** minimum flat fee of $60. Buys all rights. Syndicate owns original art.

Tips "Our product is so unusual that freelancers will be wasting their time and ours unless they first carefully study our catalog."

CITY NEWS SERVICE, LLC

P.O. Box 39, Willow Springs MO 65793. (417)469-4476. E-mail: cns@cnsus.org. Web site: www. cnsus.org. **President:** Richard Weatherington. Estab. 1969. Editorial service providing editorial and graphic packages for magazines.

Needs Buys from 12 or more freelance artists/year. Considers caricatures, editorial cartoons, and tax and business subjects as themes; considers b&w line drawings and shading film.

First Contact & Terms Send query letter with résumé, tearsheets or photocopies. Samples should contain business subjects. "Send 5 or more b&w line drawings, color drawings, shading film or good line-drawing editorial cartoons." Does not want to see comic strips. Samples not filed are returned by SASE. Responds in 4-6 weeks. To show a portfolio, mail tearsheets or photostats. Pays 50% of net proceeds; pays flat fee of $25 minimum. "We may buy art outright or split percentage of sales."

Tips "We have the markets for multiple sales of editorial support art. We need talented artists to supply specific projects. We will work with beginning artists. Be honest about talent and artistic ability. If it isn't there, don't beat your head against the wall."

CONTINENTAL FEATURES/CONTINENTAL NEWS SERVICE

501 W. Broadway, Plaza A, PMB# 265, San Diego CA 92101. (858)492-8696. E-mail: continentaln ewsservice@yahoo.com. Web site: www.continentalnewsservice.com. **Editor-in-Chief:** Gary P. Salamone. Parent firm established 1981. Syndicate serving 3 outlets—house publication, publishing business, and the general public—through the *Continental Newstime* general—interest news magazine. Features include *Portfolio*, a collection of cartoon and caricature art. Guidelines available for #10 SASE with first-class postage.

Needs Approached by up to 200 cartoonists/year. Number of new strips introduced each year varies. Considers comic strips and gag cartoons. Does not consider highly abstract, computer-produced or stick-figure art. Prefers single-panel with gagline. Maximum size of artwork: 8×10; must be reducible to 65% of original size.

First Contact & Terms Sample package should include cover letter and photocopies (10-15 samples). Samples are filed or are returned by SASE if requested by artist. Responds in 1 month, only if interested or if SASE is received. To show portfolio, mail photocopies and cover letter. Pays 70% of gross income on publication. Rights purchased vary according to project. Minimum length of contract is 1 year. The artist owns the original art and the characters.

Tips "We need single-panel cartoons and comic strips appropriate for English-speaking, international audience, including cartoons that communicate feelings or predicaments, without words. Do not send samples reflecting the highs and lows and different stages of your artistic development. CF/CNS wants to see consistency and quality, so you'll need to send your best samples."

CREATORS SYNDICATE, INC.

5777 W. Century Blvd., Suite 700, Los Angeles CA 90045. (310)337-7003. Fax: (310)337-7625. E-mail: info@creators.com. Web site: www.creators.com. **President:** Richard S. Newcombe. Director of Operations: Andrea Fryrear. Estab. 1987. Serves 2,400 daily newspapers, weekly and monthly magazines worldwide. Guidelines on Web site.

Needs Syndicates 100 writers and artists/year. Considers comic strips, caricatures, editorial or political cartoons and "all types of newspaper columns." Recent introductions: *Speedbump* by Dave Coverly; *Strange Brew* by John Deering.

First Contact & Terms Send query letter with brochure showing art style or résumé and "anything but originals." Does not accept e-mail submissions. Samples are not filed and are returned by SASE. Responds in a minimum of 10 weeks. Considers salability of artwork and client's preferences when establishing payment. Negotiates rights purchased.

Tips "If you have a cartoon or comic strip you would like us to consider, we will need to see at least four weeks of samples, but not more than six weeks of dailies and two Sundays. If you are submitting a comic strip, you should include a note about the characters in it and how they relate to each other. As a general rule, drawings are most easily reproduced if clearly drawn in black ink on white paper, with shading executed in ink wash or Benday® or other dot-transfer. However, we welcome any creative approach to a new comic strip or cartoon idea. Your name(s) and the title of the comic or cartoon should appear on every piece of artwork. If you are already syndicated elsewhere, or if someone else owns the copyright to the work, please indicate this."

PLAIN LABEL PRESS

P.O. Box 240331, Ballwin MO 63024. E-mail: mail@plainlabelpress.com. Web site: www.plainla belpress.com. **Submissions Editor:** Laura Meyer. Estab. 1989. Syndicate serving over 100 weekly magazines, newspapers and Internet sites. Guidelines available on Web site.

Needs Approached by 500 cartoonists and 100 illustrators/year. Buys from 2-3 artists/year. Introduces 1-2 new strips/year. Strips introduced include *Barcley & Co.* and *The InterPETS!* by Todd Schowalter. Considers cartoons (single, double and multiple panel), comic strips, editorial/ political cartoons and gag cartoons. Prefers comics with cutting edge humor, NOT mainstream. Maximum size of artwork: $8^{1}/_{2} \times 11$; artwork must be reducible to 25% of original size.

First Contact & Terms Sample package should include cover letter, character descriptions, 3-4 weeks of material (18-24 samples on photocopies or disk, no original art) and SASE if you would like your materials returned. Samples are not filed and are returned by SASE if requested by artist. Pays on publication: 60% of net proceeds. Responds to submissions in 2-4 months. Contract is open and may be cancelled at any time by the creator and/or by Plain Label Press. Artist owns original art and original characters.

Tips "Be FUNNY! Remember that readers *read* the comics as well as look at them. Don't be afraid to take risks. Plain Label Press does not wish to be the biggest syndicate, just the funniest. A large portion of our material is purchased for use online, so a good knowledge of digital color and imaging puts a cartoonist at an advantage. Good luck!"

Record Labels

Record labels hire freelance artists to create packaging, merchandising material, store displays, posters and even T-shirts. But for the most part, you'll be creating work for CD booklets and covers. Your greatest challenge in this market will be working within the size constraints. Most CD covers are $4^{3}/_{4} \times 4^{3}/_{4}$ inches, packaged in a 5×5-inch jewel case. Often there are photographs of the recording artist, illustrations, liner notes, titles, credit lines and lyrics all placed into that relatively small format.

It's not unusual for an art director to work with several freelancers on one project. For example, one freelancer might handle typography, another illustration; a photographer is sometimes used, and a designer can be hired for layout. Labels also turn to outside creatives for display design, promotional materials, collateral pieces or video production.

LANDING THE ASSIGNMENT

Check the listings in this section to see how each label prefers to be approached and what type of samples to send. Disk and e-mail submissions are encouraged by many of the companies. Check also to see what type of music they produce. Assemble a portfolio of your best art and design in case an art director wants to see more of your work.

Be sure your portfolio includes quality samples. It doesn't matter if the work is of a different genre—quality is key. If you don't have any experience in the industry, create your own CD package, featuring one of your favorite recording artists or groups. Send a cover letter with your samples, asking for a portfolio review. If you are not contacted within a couple of months, send a follow-up postcard or sample to the art director or other contact person.

Once you nail down an assignment, get an advance and a contract. Independent labels usually provide an advance and payment in full when a project is done. When negotiating a contract, ask for a credit line on the finished piece and samples for your portfolio.

You don't have to live in one of the recording capitals to land an assignment, but it does help to familiarize yourself with the business. Visit record stores and study the releases of various labels. Read industry publications such as *Billboard*, *Blender*, *Music Connection*, *Rolling Stone* and *Spin*.

ACTIVATE ENTERTAINMENT

PMB 333, 11054 Ventura Blvd., Studio City CA 91604-3546. E-mail: jay@2activate.com. **President:** James Warsinske. Estab. 2000. Produces CDs and cassettes; rock & roll, R&B, soul, dance, rap and pop by solo artists and groups.

Needs Produces 2-6 solo artists and 2-6 groups/year. Uses 4-10 visual artists for CD and album/cassette cover design and illustration; brochure design and illustration; catalog design, layout and illustration; direct mail packages; advertising design and illustration. 50% of freelance work demands knowledge of PageMaker, Illustrator, QuarkXPress and Photoshop.

First Contact & Terms Send query letter with SASE, tearsheets, photographs, photocopies, photostats, slides and transparencies. Samples are filed. Responds in 1 month. To show portfolio, mail roughs, printed samples, b&w and color photostats, tearsheets, photographs, slides and transparencies. Pays by the project, $100-1,000. Buys all rights.

Tips "Get your art used commercially, regardless of compensation. It shows what applications your work has."

ALBATROSS RECORDS; RN'D PRODUCTIONS

P.O. Box 540102, Houston TX 77254-0102. (713)521-2616. Fax: (713)529-4914. E-mail: rpds2405 @aol.com. Web site: www.rnddistribution.com. **Art Director:** Victor Ivey. National Sales Director: Darin Dates. Estab. 1987. Produces CDs, DVDs; country, jazz, R&B, rap, rock and pop by solo artists and groups. Recent releases: *I Love The Bay* by Too Short; *Gangsters and Strippers* by Too Short.

Needs Produces 22 releases/year. Works with 3 freelancers/year. Prefers freelancers with experience in Photoshop. Uses freelancers for cassette cover design and illustration; CD booklet design; CD cover design and illustration; poster design; Web page design; advertising design/illustration. 50% of freelance work demands knowledge of QuarkXPress, FreeHand, Photoshop.

First Contact & Terms Send postcard sample of work. Samples are filed and not returned. Will contact for portfolio review of b&w and color final art if interested. Pays for design by the project, $400 maximum. Pays for illustration by the project, $250 maximum. Buys all rights. Finds freelancers through word of mouth.

ALEAR RECORDS

25 Troubadour Lane, Berkeley Springs WV 25411. (304)258-8314. E-mail: mccoytroubadour@aol.com. Web site: www.troubadourlounge.com. **Owner:** Jim McCoy. Estab. 1973. Produces CDs, cassettes; country/western. Releases: *The Taking Kind* by J.B. Miller; *If I Throw away My Pride* by R.L. Gray; *Portrait of a Fool* by Kevin Wray.

Needs Produces 12 solo artists and 6 groups/year. Works with 3 freelancers/year. Works on assignment only. Uses artists for CD cover design and cassette cover illustration.

First Contact & Terms Send query letter with résumé and SASE. Samples are filed. Responds in 1 month. To show portfolio, mail roughs and b&w samples. Pays by the project, $50-250.

ⓝ AMERICATONE INTERNATIONAL—U.S.A.

1817 Loch Lomond Way, Las Vegas NV 89102-4437. (702)384-0030. Fax: (702)382-1926. E-mail: jjj@americatone.com. Web site: www.americatone.com. **President:** Joe Jan Jaros. Estab. 1983. Produces jazz. Recent releases by Joe Farrell, Bobby Shew, Gabriel Rosati, Carl Saunders, Raoul Romero , Bill Perkins, Dick Shearer, Lee Gibson, Roy Wiegand, Mark Masters and Bobby Morris.

Needs Produces 10 solo artists and 3 groups/year. Uses artists for direct mail packages and posters.

First Contact & Terms Samples are returned by SASE. Responds within 2 months only if interested. To show a portfolio, mail appropriate materials.

▣ ARIANA RECORDS

1312 S. Avenida Polar #A-8, Tucson AZ 85710. (520)790-7324. E-mail: jtiom@aol.com. Web site: www.arianarecords.net. **President:** Mr. Jimmi. Estab. 1980. Produces CDs, low-budget films; rock, funk, strange sounds, soundtracks for films. Recent releases: *Songs 4 Elevators & Answering Machines* by Scubatails; *The Cassette Demos* by Jtiom.

Needs Produces 4-6 music releases/year; 2 films/year. Prefers freelancers with experience in cover design. Uses artwork for CD covers, posters, flyers, T-shirts; design, illustration, multimedia projects. "We are looking to work with new cutting-edge artists."

First Contact & Terms Send postcard sample of work or link to Web site. "Everything is filed. We will contact you if interested." Responds in 2-3 months. Pays by the project.

Tips "Send your best! Simple but kool!"

Ⓝ ARISTA RECORDS

745 Fifth Ave., 6th Floor, New York, NY 10151. (212)489-7400 or (646)840-5600. E-mail: info@arista.com. Web site: www.arista.com. **Senior Art Director**: Sheri G. Lee. Produces CDs and LPs; all styles of music. Recent releases: *Do I Make You Proud?* by Taylor Hicks; *Pearl Jam* by Pearl Jam.

Needs Uses designers and illustrators for music packaging, advertising, broadcast, promotion and P.O.P.

First Contact & Terms Call or write for appointment to show portfolio or drop off portfolio Monday-Friday, 10:30-5:30. Call back after 2 days to arrange pick up of portfolio. Payment varies. Rights purchased vary according to project.

▣ ASTRALWERKS RECORDS

101 Avenue of the Americas, 10th Floor, New York NY 10013-1943. E-mail: sara.reden@astralwerks.com. Web site: www.astralwerks.com. **Contact:** Sara Reden. Estab. 1993. Produces CDs, DVDs, vinyl albums; alternative, progressive, rap, reggae, rock by solo artists and groups. Recent release: *Paper Tigers* by Caesars.

Needs Produces 60-100 releases/year. Works with 2 freelancers/year. Prefers local freelancers. Uses freelancers for CD booklet illustration, CD cover design and illustration. 90% of design work demands knowledge Illustrator, Photoshop, InDesign and QuarkXPress. 10% of illustration work demands knowledge of FreeHand.

First Contact & Terms Send postcard sample or query letter. Samples are filed. Responds only if interested. Request portfolio review in original query. Portfolio should include color finished and original art, photographs and roughs. Pays by the project, $100-500. Rights purchased vary according to project. Finds freelancers through word of mouth.

ATLAN-DEC/GROOVELINE RECORDS

2529 Green Forest Court, Snellville GA 30078-4183. (770)985-1686. E-mail: atlandec@prodigy.net. Web site: www.atlan-dec.com. **Art Director:** Wileta J. Hatcher. Estab. 1994. Produces CDs and cassettes; gospel, jazz, pop, R&B and rap by solo artists and groups. Recent releases: *Stepping Into the Light* by Mark Cocker.

Needs Produces 2-4 releases/year. Works with 1-2 freelancers/year. Prefers freelancers with experience in CD and cassette cover design. Uses freelancers for album cover, cassette cover, CD booklet and poster design. 80% of freelance work demands knowledge of Photoshop.

First Contact & Terms Send postcard sample of work or query letter with brochure, photocopies, photographs and tearsheets. Samples are filed. Will contact for portfolio review of b&w, color, final art if interested. Pays for design by the project, negotiable. Negotiates rights purchased. Finds artists through submissions.

⊕ BIG BEAR RECORDS

P.O. Box 944, Birmingham B16 8UT United Kingdom. (0121)454-7020. Fax (0121)454-9996. E-mail: agency@bigbearmusic.com. Web site: www.bigbearmusic.com. **Managing Director:** Jim Simpson. Produces CDs and cassettes; jazz, R&B. Recent releases: *Hey Puerto Rico!* by King Pleasure and The Biscuit Boys; *The Marbella Jazz Suite* by Alan Barnes All Stars.

Needs Produces 4-6 records/year. Works with 2-3 illustrators/year. Uses freelancers for album cover design and illustration. Needs computer-literate freelancers for illustration.

First Contact & Terms Works on assignment only. Send query letter with photographs or photocopies to be kept on file. Samples not filed are returned only by SAE (include IRC if outside UK). Negotiates payment. Considers complexity of project and how work will be used when establishing payment. Buys all rights. Interested in buying second rights (reprint rights) to previously published work.

BLACK DIAMOND RECORDS INCORPORATED

P.O. Box 222, Pittsburg CA 94565. (510)980-0893. Fax: (925)432-4342 or (510)540-0497. E-mail: blkdiamondrec@aol.com. Web site: www.blackdiamondrecord.com or www.blackdiamondrecords.snn.gr. **President:** Jerry J. Bobelli. Estab. 1988. Produces DVD movies; distributes DVDs, CDs and vinyl 12-inch records.

Needs Produces 2 solo artists and 2 groups/year. Works with 4 freelancers/year. Prefers freelancers with experience in album cover and insert design. Uses freelancers for CD/cassette cover and advertising design and illustration; direct mail packages; and posters. Needs computer-literate freelancers for production. 85% of freelance work demands knowledge of PageMaker and FreeHand.

First Contact & Terms Send query letter with résumé. Samples are filed or returned. Responds in 4 months. Write for appointment to show portfolio of b&w roughs and photographs. Pays for design by the hour, $100; by the project, varies. Rights purchased vary according to project.

Tips "Be unique, simple and patient. Most of the time success comes to those whose artistic design is unique and has endured rejection after rejection. Stay focused, stay humble."

Ⓝ BLASTER BOXX HITS

519 N. Halifax Ave., Daytona Beach FL 32118. (386)252-0381. Fax: (386)252-0381. E-mail: blasterboxxhits@aol.com. Web site: blasterboxxhits.com. **C.O.:** Bobby Lee Cude. Estab. 1978. Produces CDs, tapes and albums rock, R&B. Releases *Blow Blow Stero*, by Zonky-Honky; and *Hootchie-Cootch Girl*.

Needs Approached by 15 designers and 15 illustrators/year. Works with 3 designers and 3 illustrators/year. Produces 6 CDs and tapes/year. Works on assignment only. Uses freelancers for CD cover design and illustration.

First Contact & Terms Send query letter with appropriate samples. Samples are filed. Responds

in 1 week. To show portfolio, mail thumbnails. Sometimes requests work on spec before assigning a job. Pays by the project. Buys all rights.

Ⓝ BLUE NOTE, ANGEL AND MANHATTAN RECORDS

150 5th Aveune, 6th Floor, New York NY 10010. (212)786-8600. Web site: www.bluenote.com and www.angelrecords.com. **Creative Director:** Gordon H. Jee. Creative Assistant: Geri Francis. Estab. 1939. Produces albums, CDs, cassettes, advertising and point-of-purchase materials. Produces classical, jazz, pop and world music by solo artists and groups. Recent releases by Earl Klugh, Al Green and Terrance Blanchard.

Needs Produces approximately 200 releases in US/year. Works with about 10 freelancers/year. Prefers designers with experience in QuarkXPress, Illustrator, Photoshop who own Macs. Uses freelancers for album cover design and illustration; cassette cover design and illustration; CD booklet and cover design and illustration; poster design. Also for advertising. 100% of design demands knowledge of Illustrator, QuarkXPress, Photoshop (most recent versions on all).

First Contact & Terms Send postcard sample of work. Samples are filed. Responds only if interested. Portfolios may be dropped off every Thursday and should include b&w and color final art, photographs and tearsheets. Pays for design by the hour, $12-20; by the project, $1,000-5,000. Pays for illustration by the project, $750-2,500. Rights purchased vary according to project. Finds artists and designers through submissions, portfolio reviews, networking with peers.

BOUQUET-ORCHID ENTERPRISES

P.O. Box 1335, Norcross GA 30091. (770)339-9088. **President:** Bill Bohannon. Estab. 1972. Produces CDs, cassettes; rock, country, pop and contemporary Christian by solo artists and groups. Recent releases: *First Time Feeling* by Adam Day; *Just Another Day* by Bandoleers.

Needs Produces 6 solo artists and 4 groups/year. Works with 5-6 freelancers/year. Works on assignment only. Uses freelancers for CD/cassette cover and brochure design; direct mail packages; advertising illustration, logos, brochures. 60% of design work demands knowledge of PageMaker and QuarkXPress. 40% of illustration work demands knowledge of FreeHand.

First Contact & Terms Send query letter with photocopies and sample CD booklet. "I prefer a brief but concise overview of an artist's background and works showing the range of his/her talents." Include SASE. Samples are not filed and are returned by SASE if requested by artist. Responds in 1 month. Will contact artist for portfolio review if interested. Portfolio should include b&w and color photographs and tearsheets. Pays by the project, in line with industry standards for pay. Rights purchased vary according to project. Finds freelancers through agents, submissions and word of mouth.

Tips "Freelancers should be willing to work within guidelines and deadlines. They should be open to suggested changes and understand budgetary considerations. If we are pleased with an artist's work, we are happy to give repeat business."

CHERRY STREET RECORDS, INC.

P.O. Box 52626, Tulsa OK 74152. (918)742-8087. Fax (918)742-8003. E-mail: ryoung@cherrystreetrecords.com. Web site: www.cherrystreetrecords.com. **President:** Rodney Young. Estab. 1991. Produces CDs and cassettes; rock, R&B, soul, country/western and folk by solo and group artists. Recent releases: *Land of the Living* by Richard Elkerton; *Find You Tonight* by Brad Absher; *RhythmGypsy* by Steve Hardin.

Needs Produces 2 solo artists/year. Approached by 10 designers and 25 illustrators/year. Works

with 2 designers and 2 illustrators/year. Prefers freelancers with experience in CD and cassette design. Works on assignment only. Uses freelancers for CD/album/cassette cover design and illustration; catalog design; multimedia projects and advertising illustration. 100% of design and 50% of illustration demand knowledge of Illustrator and CorelDraw for Windows.

First Contact & Terms Send postcard sample or query letter with photocopies and SASE. Accepts disk submissions compatible with Windows '95 in above programs. Samples are filed or are returned by SASE. Responds only if interested. Write for appointment to show portfolio of printed samples, b&w and color photographs. Pays by the project, up to $1,250. Buys all rights.

Tips "Compact disc covers and cassettes are small; your art must get consumer attention. Be familiar with CD and cassette music layout on computer in either Adobe or Corel. Be familiar with UPC bar code portion of each program. Be under $500 for layout to include buyout of original artwork and photographs. Copyright to remain with Cherry Street; no reprint rights or negatives retained by illustrator, photographer or artist."

▣ DM/BELLMARK/CRITIQUE RECORDS

301 Yamato Rd., Suite 1250, Baco Raton FL 33431. (561)988-1820. Fax: (561)988-1821. Web site: www.dmrecords.com. **Art Director:** Deryck Ragoonan. Estab. 1983. Produces albums, CDs and cassettes country, gospel, urban, pop, R&B, rap, rock. Recent releases *Beautiful Experience,* by Prince; *The Bluegrass Sessions*, by Len Anderson; *Certified Crunk*, by Lil' John and the Eastside Boys. This label recently bought Ichiban Records.

Needs Approached by 6 designers and 12 illustrators/year. Works with 4 illustrators/year. Uses freelancers for album, cassette and CD booklet and cover illustration. 100% of design and 50% of illustration demand knowledge of PageMaker, Illustrator, QuarkXPress, Photoshop, FreeHand.

First Contact & Terms Send postcard sample of work. Samples are filed. Will contact for portfolio review if interested. Pays for illustration by the project, $250-500. Buys all rights. Finds artists through magazines.

Tips "Style really depends on the performing artist we are pushing. I am more interested in illustration than typography when hiring freelancers."

▣ EARACHE RECORDS

43 W. 38th St., New York NY 10018. (212)840-9090. Fax: (212)840-4033. E-mail: usaproduction @earache.com. Web site: www.earache.com. **Product Manager:** Tim McVicker. UK estab. 1986; US estab. 1993. Produces albums, CDs, CD-ROMs, cassettes, 7", 10" and 12" vinyl rock, industrial, heavy metal techno, death metal, grind core. Recent releases *The Haunted Made Me Do It*, by The Haunted; *Gateways to Annihilation*, by Morbid Angel.

Needs Produces 18 releases/year. Works with 4-6 freelancers/year. Prefers designers with experience in music field who own Macs. Uses freelancers for album cover design; cassette cover illustration; CD booklet and cover design and illustration; CD-ROM design. Also for advertising and catalog design. 90% of freelance work demands knowledge of Illustrator 7.0, QuarkXPress 4.0, Photoshop 5.0, FreeHand 7.

First Contact & Terms Send postcard sample of work. Samples are filed and not returned. Does not reply. Artist should follow up with call and/or letter after initial query. Will contact artist for portfolio review of color, final art, photocopies, photographs if interested. Pays by the project. Buys all rights.

Tips "Know the different packaging configurations and what they are called. You must have a background in music production/manufacturing."

FOREFRONT RECORDS

P.O. Box 5085, Brentwood TN 37024-5085. E-mail: info@forefrontrecords.com. Web site: www.f orefrontrecords.com. **Contact:** Creative Services Manager. Estab. 1989. Produces CDs, CD-ROMs, cassettes; Christian alternative rock by solo artists and groups. Recent releases: *Adios* by Audio Adrenaline; *If I Had One Chance to Tell You Something* by Rebecca St. James; *Portable Sounds* by Toby Mac.

Needs Produces 15-20 releases/year. Works with 5-10 freelancers/year. Prefers designers who own Macs and have experience in cutting edge graphics and font styles/layout, have the ability to send art via e-mail, and pay attention to detail and company spec requirements. Uses freelancers for cassette cover design and illustration; CD booklet design and illustration; CD cover design and illustration; CD-ROM design and packaging; poster design. 100% of freelance design and 50% of illustration demands knowledge of Illustrator, QuarkXPress, Photoshop.

First Contact & Terms Send postcard sample or query letter with résumé, photostats, transparencies, photocopies, photographs, slides, SASE, tearsheets. Accepts disk submissions compatible with Mac/Quark, Photoshop or Illustrator, EPS files. Samples are filed or returned by SASE if requested by artist. Responds only if interested. Will contact artist for portfolio review if interested. Payment depends on each project's budgeting allowance. Negotiates rights purchased. Finds artists through submissions, sourcebooks, Internet, reps, word of mouth.

Tips "I look for cutting edge design and typography along with interesting use of color and photography. Illustrations must show individual style and ability to be conceptual."

⃞Ñ⃞ GEFFEN A&M RECORDS

2220 Colorado Ave., Santa Monica CA 90404. (310)865-7606. Web site: www.geffen.com. **Contact:** Nicole Frantz. or Stephanie Hsu. Produces progressive, R&B and rock music. Recent releases *Dilated Peoples*, by The Tipping Point; *The Printz*, by Bumblebeez 81.

● Geffen has a drop-off policy for portfolios. You can drop off your book Monday-Friday, 7 a.m.-7 p.m. and arange for pick-up in 24 hours. They "rarely" use freelance illustrators because most of the covers feature photography.

Tips "The art department and creative services love to see truly original work. Don't be too conservative, but do create a portfolio that's consistent. Don't be afraid to push the limits."

HARD HAT RECORDS AND CASSETTE TAPES

519 N. Halifax Ave., Daytona Beach FL 32118-4017. (386)252-0381. Fax: (386)252-0381. E-mail: hardhatrecords@aol.com. Web site: www.hardhatrecords.com. **CEO:** Bobby Lee Cude. Produces rock, country/western, folk and educational recordings by group and solo artists. Also publishes high school/college marching band arrangements. Recent releases: *Broadway USA* (3-volume CD program of new and original music); *Times-Square Fantasy Theatre* (CD release with 46 tracks of new and original Broadway-style music).

● Also owns Blaster Boxx Hits.

Needs Produces 6-12 records/year. Works with 2 designers and 1 illustrator/year. Works on assignment only. Uses freelancers for album cover design and illustration; advertising design; and sheet music covers. Prefers "modern, up-to-date, on the cutting edge" promotional material and cover designs that fit the music style. 60% of freelance work demands knowledge of Photoshop.

First Contact & Terms Send query letter with brochure to be kept on file for one year. Samples not filed are returned by SASE. Responds in 2 weeks. Write for appointment to show portfolio. Sometimes requests work on spec before assigning a job. Pays by the project. Buys all rights.

▣ HOTTRAX RECORDS

1957 Kilburn Dr., Atlanta GA 30324. (770)662-6661. E-mail: hotwax@hottrax.com. Web site: www.hottrax.com. **Publicity and Promotion:** Teri Blackman. Estab. 1975. Produces CDs and cassettes; rock, R&B, country/western, jazz, pop and blues/novelties by solo and group artists. Recent releases include *Everythang & Mo'* by Sammy Blue; *No Regrets* by Bullitthead.

Needs Produces 2 solo artists and 4 groups/year. Approached by 90-100 designers and 30 illustrators/year. Works with 6 designers and 3 illustrators/year. Prefers freelancers with experience in multimedia and caricatures. Uses freelancers for CD/cassette cover, catalog and advertising design and illustration; posters. 25% of freelance work demands knowledge of PageMaker, Illustrator and Photoshop.

First Contact & Terms Send postcard samples. Accepts disk submissions compatible with Illustrator and CorelDraw. Some samples are filed. If not filed, samples are not returned. Responds only if interested. Pays by the project, $150-1,250 for design; $1,000 maximum for illustration. Buys all rights.

Tips "Digital downloads of single tracks have reduced the demand for CD artwork and graphics. It is our belief that this is only a temporary problem for artists and designers. Hottrax will continue to preserve this medium as an integral part of its album/CD production. We file all samples that interest us even though we may not respond until the right project arises. We like simple designs for blues and jazz, including cartoons/caricatures; abstract for New Age; and fantasy for heavy metal and hard rock."

▣ HULA RECORDS

99-139 Waiua Way, Unit #56, Aiea HI 96701. (808)485-2294. Fax: (808)485-2296. E-mail: hularecords@hawaii.rr.com. Web site: www.hawaiian-music.com. **President:** Donald P. McDiarmid III. Produces educational and Hawaiian records; group and solo artists.

Needs Produces 1-2 soloists and 3-4 groups/year. Works on assignment only. Uses artists for album cover design and illustration, brochure and catalog design, catalog layout, advertising design and posters.

First Contact & Terms Send query letter with tearsheets and photocopies. Samples are filed or are returned only if requested. Responds in 2 weeks. Write for appointment to show portfolio. Pays by the project, $50-350. Considers available budget and rights purchased when establishing payment. Negotiates rights purchased.

▣ IDOL RECORDS

P.O. Box 720043, Dallas TX 75372. (214)321-8890. E-mail: info@idolrecords.com. Web site: www.idolrecords.com. **Contact:** Miles. Estab. 1993. Produces CDs; rock by solo artists and groups. Recent releases: *Movements* by Black Tie Dynasty; *The Man* by Sponge; *The Fifth of July* by Watershed.

Needs Produces 10-20 releases/year. Prefers local designers/illustrators. Uses freelancers for CD booklet illustration; cover design; poster design.

First Contact & Terms Send photocopies, photographs, résumé and sample CD booklet. Samples are filed and not returned. Responds only if interested. Will contact artist for portfolio review if interested. Pays by the project. Buys all rights. Finds freelancers through word of mouth.

IMAGINARY ENTERTAINMENT CORP.

P.O. Box 66, Whites Creek TN 37189. E-mail: jazz@imaginaryrecords.com. Web site: www.imaginaryrecords.com. **Proprietor:** Lloyd Townsend. Estab. 1982. Produces CDs, cassettes and LPs;

rock, jazz, classical, folk and spoken word. Recent releases: *Kaki* by S.P. Somtow;: *Fifth House* by The New York Trio Project;*Triologue* by Stevens, Siegel and Ferguson.

Needs Produces 1-2 solo artists and 1-2 groups/year. Works with 1-2 freelancers/year. Works on assignment only. Uses artists for CD/LP/cassette cover design and illustration.

First Contact & Terms Prefers first contact through e-mail with link to online portfolio; otherwise send query letter with brochure, tearsheets, photographs, and SASE if samples need to be returned. Samples are filed or returned by SASE if requested by artist. Responds in 3 months. To show portfolio, mail thumbnails, roughs and photographs. Pays by the project, $25-500. Negotiates rights purchased.

Tips "I always need one or two dependable artists who can deliver appropriate artwork within a reasonable time frame."

ℕ INTERSCOPE GEFFEN A&M RECORDS

2220 Colorado Ave., Santa Monica CA 90404. (310)865-1000. Web site: www.interscope.com. **Contact:** Director of Creative Services. Produces CDs, cassettes, vinyl, DVD a variety of music by solo artists and groups. Recent releases *Monkey Business*, by the Black Eyed Peas; *Guero*, by Beck; *The Way It Is*, by Keyshia Cole. Art guidelines available with project.

Needs Prefers local designers/illustrators with experience in music. Uses freelancers for cassette illustrations and design; CD booklet and cover illustration and design. 100% of design work demands knowledge of Illustrator, Photoshop and QuarkXpress. 100% of illustration work demands knowledge of FreeHand and Illustrator.

First Contact & Terms Send postcard sample. Samples are filed. Responds only if interested. Portfolio should include b&w and color finished art, original art and photographs. Pays by the project. Rights purchased vary according to project. Finds freelancers through magazines, sourcebooks and word of mouth.

ℕ IRISH MUSIC CORPORATION

P.O. Box 1515 Green Island NY 12183. (518)266-0765. Fax: (518) 833-0277. E-mail: info@irishm usicb2b.com. Web site: www.regorecords.com. **Managing Director:** T. Julian McGrath. Estab. 1916. Produces CDs, DVD—Irish, Celtic, folk.

Needs Produces 12 releases/year. Works with 2 freelancers/year. Prefers local designers. Uses freelancers for CD booklet and cover design; poster design. 100% of illustration demands computer skills.

First Contact & Terms Send query letter with brochure, résumé, tearsheets. Samples are filed if genre compatible. Will contact artist if interested. Pays by the project, $400 maximum. Assumes all rights.

K2B2 RECORDS

1748 Roosevelt Ave., Los Angeles CA 90006-5219. (323)732-1602. Fax: (323)731-2758. E-mail: Marty@k2b2.com. Web site: www.k2b2.com. **Art Director:** Marty Krystall. Estab. 1979. Produces CDs; jazz, classical by solo artists. Recent releases: *Across the Tracks* by Buellgrass; *Thelonious Atmosphere* by Buell Neidlinger Quartet; *Marty Krystall Quartet* by Marty Krystall.

Needs Produces 1 release/year. Approached by 20 designers and 25 illustrators/year. Works with 2 designers and 1 illustrator/year. Uses freelancers for CD cover and catalog design and illustration; brochure and advertising design. Needs computer-literate freelancers for design, illustration. 100% of freelance work demands knowledge of Adobe CS, Quark, Illustrator, Photoshop, FreeHand, Painter.

First Contact & Terms Send query letter with brochure, résumé. Samples are filed and not returned. Responds only if interested. Artist should follow up with letter after initial query. Art Director will contact artist for portfolio review if interested. Portfolio should include color samples. Pays for design and illustration by the project, $500-1,500. Buys all rights.
Tips ''I prefer line drawings and oil painting—real art.''

⬛ KIMBO EDUCATIONAL

P.O. Box 477., Long Branch NJ 07740. E-mail: kimboed@aol.com. Web site: www.kimboed.com. **Production Manager:** Amy Laufer. Educational CD company. Produces 8 CDs/year for schools, teacher-supply stores and parents—primarily early childhood/physical fitness.
Needs Works with 3 freelancers/year. Prefers local artists on assignment only. ''It is very hard to do this type of material via mail.'' Uses artists for CD covers, catalog and flier design, and ads. Helpful if artist has experience in the preparation of CD cover jackets and booklets.
First Contact & Terms Send letter with photographs or actual samples of past work. Responds only if interested. Pays for design and illustration by the project, $ 300-500. Considers complexity of project and budget when establishing payment. Buys all rights.
Tips ''The jobs at Kimbo vary tremendously. We produce material for various levels—infant to senior citizen. Sometimes we need cute 'kid-like' illustrations, and sometimes graphic design will suffice. We are an educational firm, so we cannot pay commercial CD art prices.''

⬛ LAMON RECORDS CORPORATION

P.O. Box 1636, Indian Trail NC 28227. (704)282-9910. E-mail: cody@lamonrecords.com. Web site: www.lamonrecords.com. **Graphic Design Manager:** Cody McSwain. Produces CDs and cassettes; rock, country/western, folk, R&B and religious music by groups. Recent releases: *Play Fiddle* by Dwight Moody; *Western Hits* by Ruth and Ted Reinhart; *Now and Then* by Cathy and Dwight Moody.
Needs Works with 3 designers and 4 illustrators/year. Uses freelancers for album cover design and illustration, brochure and advertising design, and direct mail packages. Works on assignment only. 50% of freelance work demands knowledge of Photoshop.
First Contact & Terms Send brochure and tearsheets. Samples are filed and are not returned. Responds only if interested. Call for appointment to show portfolio or mail appropriate materials. Considers skill and experience of artist and how work will be used when establishing payment. Buys all rights.
Tips ''Include work that has been used on album, CD or cassette covers.''

⬛ PATTY LEE RECORDS

6034½ Graciosa Dr., Hollywood CA 90068. (323)469-5431. Web site: www.PattyLeeRecords.com. **Contact:** Patty Lee. Estab. 1986. Produces CDs and tapes New Orleans rock and roll, jazz and eclectic by solo artists. Recent releases: *Sizzlin'*, by Armand St. Martin; *Magnetic Boots*, by Angelyne; *Return to Be Bop*, by Jim Sharpe; remastered *Alligator Ball*, by Armand St. Martin.
Needs Produces 2 soloists/year. Works with several designers and illustrators/year. Works on assignment only. Uses freelancers for CD/tape cover; sign and brochure design; and posters.
First Contact & Terms Send postcard sample. Samples are filed or are returned by SASE. Responds only if interested. ''Please do not send anything other than an introductory letter or card.'' Pays by the project; $100 minimum. Rights purchased vary according to project. Finds new artists through word of mouth, magazines, submissions/self-promotional material, sourcebooks, agents and reps and design studios.

Tips "The postcard of their style and genre is the best indication to us as to what the artists have and what might fit into our needs. If the artist does not hear from us, it is not due to a negative reflection on their art."

Ⓝ LIVING MUSIC

P.O. Box 72, Litchfield CT 06759. (860)567-8796. Fax (860)567-4276. E-mail: info@livingmusic.com. Web site: www.livingmusic.com. **Director of Communications:** Christina Andersen. Estab. 1980. Produces CDs and cassettes; classical, jazz, folk, progressive, world, New Age. Recent releases include *Celtic Solstice* by Paul Winter & Friends, *Journey with the Sun* by Paul Winter and the Earth Band, *Every Day is a New Life* by Arto Tunchboyaciyan, *Brazilian Days* by Oscar Castro-Neves and Paul Winter, and *Silver Solstice* by Winter & Friends.

Needs Produces 1-3 releases/year. Works with 1-5 freelancers/year. Uses freelancers for CD/cassette cover and brochure design and illustration; direct mail packages; advertising design; catalog design, illustration and layout; and posters. 70% of freelance work demands knowledge of PageMaker, Illustrator, QuarkXPress, Photoshop, FreeHand.

First Contact & Terms Send postcard sample of work or query letter with brochure, transparencies, photographs, slides, SASE, tearsheets. Samples are filed or returned by SASE if requested by artist. Responds only if interested. Art director will contact artist for portfolio review of b&w and color roughs, photographs, slides, transparencies and tearsheets. Pays for design by the project. Rights purchased vary according to project.

Tips "We look for distinct 'earthy' style." Prefers nature themes.

LMNOP

P.O. Box 15749, Chattanooga TN 37415. Web site: www.babysue.com and www.LMNOP.com. **President:** Don W. Seven. Estab. 1983. Produces CDs, cassettes and albums; rock, jazz, classical, country/western, folk and pop. Recent releases: *Bad Sisters*, by The Stereotypes; *The Best and The Rest*, by Lisa Shame.

Needs Produces 6 solo artists and 10 groups/year. Uses 5 freelancers/year for CD/album/cassette cover design and illustration, catalog design, advertising design and illustration, and posters. 20% of design and 50% of illustration demand computer skills.

First Contact & Terms Send postcard sample or query letter with SASE, photographs, photostats and slides. Samples are not filed and are not returned. Responds only if interested. To show portfolio, mail roughs, b&w and color photostats and photographs. Pays by the day, $250-500. Rights purchased vary according to project.

Ⓝ MAGGIE'S MUSIC, INC.

Box 490, Shady Side MD 20764. E-mail: mail@maggiesmusic.com. Web site: www.maggiesmusic.com. **President:** Maggie Sansone. Estab. 1984. Produces CDs and tapes contemporary acoustic, Christmas and Celtic. Recent releases *Acoustic Journey*, by Al Petteway and Amy White; *Mystic Dance*, by Maggie Sansone; *Early American Roots*, by Hesperus; *Scottish Fire*, by Bonnie Rideout.

Needs Produces 3-4 albums/year. Works with freelance graphic designers. Prefers freelancers with experience in CD covers and Celtic designs. Works on assignment only.

First Contact & Terms Send e-mail query only. Company will contact artist if interested.

Tips This company asks that the artist request a catalog first "to see if their product is appropriate for our company."

JIM MCCOY MUSIC

25 Troubadour Lane, Berkeley Springs WV 25411. (304)258-8314. E-mail: mccoytroubadour@ao l.com. Web site: www.troubadourlounge.com. **Owner:** Bertha McCoy. Estab. 1972. Produces CDs, cassettes; country/western. Recent releases: *Mysteries of Life* by Carroll County Ramblers.
Needs Produces 12 solo artists and 10 groups/year. Works on assignment only. Uses artists for CD cover design and illustration; cassette cover illustration.

ⓝ METAL BLADE RECORDS, INC.

2828 Cochran St., Suite 302, Simi Valley CA 93065. (805)522-9111. Fax: (805)522-9380. E-mail: metalblade@metalblade.com. Web site: www.metalblade.com. **Senior Vice President/General Manager:** Tracy Vera. Estab. 1982. Produces CDs and tapes rock by solo artists and groups. Recent releases *Revelation*, by Armored Saint; *Maximum Violence*, by Six Feet Under.
Needs Produces 30-50 releases/year. Approached by 10 designers and 10 illustrators/year. Works with 1 designer and 1 illustrator/year. Prefers freelancers with experience in album cover art. Uses freelancers for CD cover design and illustration. Needs computer-literate freelancers for design and illustration. 80% of freelance work demands knowledge of PageMaker, Illustrator, QuarkXPress, Photoshop.
First Contact & Terms Send postcard sample of work or query letter with brochure, résumé, photostats, photocopies, photographs, SASE, tearsheets. Samples are filed or returned by SASE if requested by artist. Responds only if interested. Art director will contact artist for portfolio review if interested. Portfolio should include b&w and color, final art, photocopies, photographs, photostats, roughs, slides, tearsheets. Pays for design and illustration by the project. Buys all rights. Finds artists through *Black Book*, magazines and artists' submissions.
Tips "Please send samples of work previously done. We are interested in any design."

MIA MIND MUSIC

259 W. 30th St., 12th Floor, New York NY 10001. (212)564-4611. Fax: (212)564-4448. E-mail: mimimus@aol.com. Web site: www.miamindmusic.com. **Contact:** Stevie B. "Mia Mind Music works with bands at the stage in their careers where they need CD artwork and promotional advertisements. The record label Mia Mind signs dozens of artists per year and accepts artwork through the mail; or call for appointment."
Tips "The weirder, the better. 'Extreme' sells in the music market."

ⓝ 🌐 NERVOUS RECORDS

5 Sussex Crescent, Northolt, Middx UB5 4DL United Kingdom. E-mail: nervous@compuserve. com. Web site: www.nervous.co.uk. **Contact:** R. Williams. Produces CDs, rockabilly and psychobilly. Recent releases *Hot 'N Wild Rockabilly Cuts*, by Mystery Gang; *Rockabillies Go Home*, by Blue Flame Combo.
Needs Produces 9 albums/year. Approached by 4 designers and 5 illustrators/year. Works with 3 designers and 3 illustrators/year. Uses freelancers for album cover, brochure, catalog and advertising design and multimedia projects. 50% of design and 75% of illustration demand knowledge of Page Plus II and Microsoft Word 6.0.
First Contact & Terms Send query letter with postcard samples; material may be kept on file. Write for appointment to show portfolio. Accepts disk submissions compatible with PagePlus and Microsoft Word. Samples not filed are returned by SAE (nonresidents include IRC). Responds only if interested. Original art returned at job's completion. Pays for design by the project,

$50-200. Pays for illustration by the project, $10-100. Considers available budget and how work will be used when establishing payment. Buys first rights.

Tips "We have noticed more imagery and caricatures in our field so fewer actual photographs are used." Wants to see "examples of previous album sleeves, keeping with the style of our music. Remember, we're a rockabilly label."

N NEURODISC RECORDS, INC.

3801 N. University Dr., Suite #403, Ft. Lauderdale FL 33351. (954)572-0289. Fax: (954)572-2874. E-mail: info@neurodisc.com. Web site: www.neurodisc.com. **Contact:** John Wai and Tom O'Keefe. Estab. 1990. Produces albums, CDs chillout, dance, electrobass, electronic lounge, New Age, progressive, rap, urban. Recent releases *Drive*, by Peplab; *Beyond the Horizon*, by Tastexperience; *See the Sound*, by Etro Anime; *Bass Crunk*, by Bass Crunk.

Needs Produces 10 releases/year. Works with 5 freelancers/year. Prefers designers with experience in designing covers. Uses freelancers for album cover design and illustration; animation; cassette cover design and illustration; CD booklet design and illustration; CD cover design and illustration; poster design; Web page design. Also for print ads. 100% of freelance work demands computer skills.

First Contact & Terms Send postcard sample or query letter with brochure, photocopies and tearsheets. Samples are not filed and are returned by SASE if requested by artist. Will contact artist for portfolio review if interested. Pays by the project. Buys all rights.

NORTH STAR MUSIC INC.

338 Compass Circle A1, North Kingstown, RI 02852. (401)886-8888. Fax: (401)886-8880. E-mail: info@northstarmusic.com. Web site: www.northstarmusic.com. **President:** Richard Waterman. Estab. 1985. Produces CDs; jazz, classical, folk, traditional, contemporary, world beat and New Age by solo artists and groups. Recent release: *Sundown* by Stewart Dudley.

Needs Produces 4 solo artists and 4 groups/year. Works with 2 freelancers/year. Prefers freelancers with experience in CD cover design. Works on assignment only. Uses artists for CD cover and brochure design and illustration; catalog design, illustration and layout; direct mail packages. 80% of design and 20% of illustration demand knowledge of QuarkXPress 4.0.

First Contact & Terms Send postcard sample or query letter with brochure, photocopies and SASE. Accepts disk submissions compatible with QuarkXPress 4.0. Send EPS or TIFF files. Samples are filed. Responds only if interested. To show portfolio, mail color roughs and final art. Pays for design by the project, $500-1,000. Buys first rights, one-time rights or all rights.

Tips "Learn about our label's style of music/art. Send appropriate samples."

OCP (OREGON CATHOLIC PRESS)

5536 NE Hassalo, Portland OR 97213-3638. E-mail: gust@ocp.org. Web site: www.ocp.org. **Creative Director:** Gus Torres. Estab. 1934. Produces liturgical music CDs, songbooks, missalettes and books.

- OCP (Oregon Catholic Press) is a nonprofit publishing company, producing music and liturgical publications used in parishes throughout the United States, Canada, England and Australia. See additional listings in the Book Publishers and Magazines sections.

Needs Produces 10 collections/year. Works with 5 freelancers/year. Uses freelancers for CD booklet illustration; CD cover design and illustration; also for spot illustration.

First Contact & Terms Send query e-mail with PDF samples only. Responds in 2 weeks. Will

contact artist if interested. Pays for illustration by the project, $35-500. Finds artists through submissions and the Web.

Tips Looks for attention to detail.

ONE STEP TO HAPPINESS MUSIC

Jacobson & Colfin, P.C., 60 Madison Ave., Suite 1026, New York NY 10010-1666. (212)691-5630. Fax: (212)645-5038. E-mail: bruce@thefirm.com. Web site: www.thefirm.com. **Attorney:** Bruce E. Colfin. Produces CDs, cassettes and albums; reggae by solo artists and groups. Recent release: *Make Place for the Youth* by Andrew Tosh.

Needs Produces 1-2 solo artists and 1-2 groups/year. Works with 1-2 freelancers/year on assignment only. Uses artists for CD/album/cassette cover design and illustration.

First Contact & Terms Send query letter with brochure, résumé and SASE. Samples are filed or returned by SASE if requested by artist. Responds in 2 months. Call or write for appointment to show portfolio of tearsheets. Pays by the project. Rights purchased vary according to project.

ⓃPALM PICTURES

76 Ninth Avenue, Suite 1110, New York NY 10001. (212)320-3600. Fax: (212)320-3609. E-mail: art@palmpictures.com. Web site: www.palmpictures.com. **Studio/Creative Director:** Yuan Wu. Estab. 1959. Produces films, albums, CDs, CD-ROMs, cassettes, LPs folk, gospel, pop, progressive, R&B, rap and rock by solo artists and groups.

Needs Works with 15 freelancers/year. Prefers designers who own Mac computers. Uses freelancers for album, cassette, CD, DVD and VHS cover design and illustration; CD booklet design and illustration; and poster design; advertising; merchandising. 99% of design and 20% of illustration demand knowledge of Illustrator, QuarkXPress, Photoshop and FreeHand.

First Contact & Terms Send postcard sample and or query letter with tearsheets. Accepts disk submissions. Samples are filed. Portfolios of b&w and color final art and tearsheets may be dropped off Monday through Friday. Pays for design by the project, $50-5,000; pays for illustration by the project, $500-5,000. Rights purchased vary according to project. Finds artists through submissions, word of mouth and sourcebooks.

Tips "Have a diverse portfolio."

PANDISC MUSIC CORP.

247 SW 8th Street, Suite 349., Miami FL 33131. (305)557-1914. Fax: (888)493-7778. E-mail: beth@pandisc.com. Web site: www.pandisc.com. **Director of Production:** Beth Sereni. Estab. 1982. Produces CDs and vinyl; dance, underground/club, electronica, bass and rap.

Needs Produces 35-50 releases/year as well as some print ads and miscellaneous jobs. Works with a few freelancers and design firms. Prefers freelancers with experience in record industry. Uses freelancers for CD/album jacket design, posters, direct mail packages as well as print ads, promotional materials, etc. Needs computer-literate freelancers for design and production. 100% of freelance work demands computer knowledge, specifically QuarkXpress and the Adobe suites.

First Contact & Terms Send query letter with samples of work. Samples are filed if found to have potential. Art director will contact artist if interested. "Call for per-job rates." Buys all rights.

Tips "Must be deadline conscious and versatile."

PPL ENTERTAINMENT GROUP

468 North Camden Drive, Suite 200, Beverly Hills, CA 90210. (310)860-7499. Fax: (310)860-7400. E-mail: pplzmi@aol.com. Web site: www.pplzmi.com. **Art Director:** Kaitland Diamond. Estab. 1979. Produces albums, CDs, cassettes; country, pop, R&B, rap, rock and soul by solo artists and groups. Recent releases: *Return of the Playazz* by JuzCuz; *American Dream* by Riki Hendrix.

Needs Produces 12 releases/year. Works with 2 freelancers/year. Prefers designers who own Mac or IBM computers. Uses freelancers for CD booklet design and illustration; CD/album/cassette cover design and illustration; CD-ROM design and packaging; poster design; Web page design. Freelance work demands knowledge of PageMaker, Illustrator, Photoshop, QuarkXPress.

First Contact & Terms Send query letter with brochure, photocopies, tearsheets, résumé, photographs, photostats, slides, transparencies and SASE. Accepts disc submissions. Samples are filed or returned by SASE if requested by artist. Responds in 2 months. Request portfolio review in original query. Pays by the project, monthly.

PRAVDA RECORDS

PO Box 268043 , Chicago IL 60626. (773)763-7509. Fax: (773)763-3252. E-mail: pravdausa@aol.com. Web site: www.pravdamusic.com. **Contact:** Kenn Goodman. Estab. 1986. Produces CDs, tapes and posters rock, progressive by solo artists and groups. Recent releases *Vodka and Peroxide*, by Civiltones; *Dumb Ask*, by Cheer Accident.

Needs Produce 1 solo artist and 3-6 groups/year. Works with 1-2 freelancers/year. Works on assignment only. Uses freelancers for CD/tape covers and advertising design and illustration; catalog design and layout; posters. Needs computer-literate freelancers for design and production. 100% of freelance work demands knowledge of Illustrator, QuarkXPress and Photoshop.

First Contact & Terms Send query letter with résumé, photocopies, SASE. Samples are not filed and are returned by SASE if requested by artist. Responds in 2 months. Portfolio should include roughs, tearsheets, slides, photostats, photographs. Pays for design by the project, $250-1,000. Rights purchased vary according to project.

N RHINO ENTERTAINMENT/WARNER STRATEGIC MARKETING

(formerly Rhino Entertainment Company), 3400 W. Olive Ave., Burbank CA 91505. (818)238-6187. Fax: (818)562-9241. Web site: www.rhino.com. **Creative Services:** Hugh Brown. Director, Creative Services: Lori Carfora. Estab. 1977. Produces albums, CDs, CD-ROMs, cassettes country, folk, gospel, jazz, pop, progressive, R&B, rap, rock, soul. Recent releases *Like Omigod! The 80's Pop Culture Box (Totally)*; *Dwight Yoakum, Reprise Please Baby The Warner Bros. Years*; *Ed Sullivan's Rock 'N' Roll Classics Video Compilation*.

Needs Produces 200 releases/year. Works with 10 freelancers/year. Prefers local designers and illustrators who own Mac computers. Uses freelancers for album, cassette and CD cover design and illustration; CD booklet design and illustration; and CD-ROM design and packaging. 100% of design demands knowledge of Illustrator, QuarkXPress, Photoshop, FreeHand.

First Contact & Terms Send postcard sample. Accepts disk submissions compatible with Mac. Samples are filed. Artist should "keep us updated." Portfolios of tearsheets may be dropped off every Tuesday. Buys one-time rights. Rights purchased vary according to project. Finds artists through word of mouth, sourcebooks.

▨ ROTTEN RECORDS

P.O. Box 56, Upland CA 91786. (909)920-4567. Fax (909)920-4577. E-mail: rotten@rottenrecords .com. Web site: www.rottenrecords.com. **President:** Ron Peterson. Estab. 1988. Produces CDs and tapes rock by groups. Recent releases *When the Kite String Pops*, by Acid Bath; *Do Not Spit*, by Damaged.

Needs Produces 4-5 releases/year. Works with 3-4 freelancers/year. Uses freelancers for CD/ tape cover design; and posters. Needs computer-literate freelancers for desigin, illustration, production.

First Contact & Terms Send postcard sample of work or query letter with photocopies, tearsheets (any color copies samples). Samples are filed and not returned. Responds only if interested. Artist should follow up with call. Portfolio should include color photocopies. Pays for design and illustration by the project.

SAHARA RECORDS AND FILMWORKS ENTERTAINMENT

10573 W. Pico Blvd. #352, Los Angeles CA 90064. (310)948-9652. E-mail: info@edmsahara.com. Web site: www.edmsahara.com. **Marketing Director:** Dwayne Woolridge. Estab. 1981. Produces CDs, cassettes; jazz, pop, R&B, rap, rock, soul, TV-film music by solo artists and groups. Recent releases: *Pay the Price* and *Rice Girl* film soundtracks; *Dance Wit Me* by Steve Lynn.

Needs Produces 25 releases/year. Works with 2 freelancers/year. Uses freelancers for CD booklet design and illustration; CD cover design and illustration; poster design and animation.

First Contact & Terms Contact only through artist rep. Samples are filed. Responds only if interested. Payment negotiable. Buys all rights. Finds artists through agents, submissions, *The Black Book* and *Directory of Illustration*.

▨ SCOTDISC B.G.S. PRODUCTIONS LTD.

Newtown St., Kilsyth, Glasgow G65 0JX United Kingdom. 44(0)1236-821081. Fax: 44(0)1236- 826900. E-mail: nscott@scotdisc.co.uk. Web site: www.scotdisc.co.uk. **Director:** Dougie Stevenson. Produces country and folk; solo artists. Recent releases *Black Watch Pipe Band*; *In the Garden*.

Needs Produces 15-20 records/videos per year. Approached by 3 designers and 2 illustrators/ year. Works with 1 designer and 2 illustrators/year for album cover design and illustration; brochure design, illustration and layout; catalog design, illustration and layout; advertising design, illustration and layout; posters.

First Contact & Terms Send postcard sample or brochure, résumé, photocopies and photographs to be kept on file. Call or write for appointment to show portfolio. Accepts disk submissions compatible with Illustrator 3.2 or FreeHand 3.0. Send Mac-formatted EPS files. Samples not filed are returned only if requested. Responds only if interested. Pays by the hour, $30 average. Considers available budget when establishing payment. Buys all rights.

▨ SHAOLIN COMMUNICATIONS

P.O. Box 900457, San Diego CA 92190. (801)595-1123. E-mail: taichiyouth@worldnet.att.net. **Vice President of A&R:** Don DeLaVega. Estab. 1984. Produces albums, CDs, CD-ROMs, cassettes, books and videos folk, pop, progressive, rock, Chinese meditation music by solo artists and groups. Recent releases: *Levell*, by American Zen; *Tai Chi Magic*, by Master Zhen.

Needs Produces 14 releases/year. Works with 4 freelancers/year. Prefers local freelancers who own Macs. Uses freelancers for album cover design and illustration; animation; cassette cover

design and illustration; CD booklet design and illustration; CD cover design and illustration; CD-ROM design and packaging; poster design; Web page design. Also for multimedia, brochures and newsletter *Shaolin Zen*. 80% of design and 20% of illustration demands knowledge of Dreamweaver, Canvas and Photoshop.

First Contact & Terms Send query letter with brochure, résumé, SASE. Samples are filed or returned by SASE if requested by artist. Responds in 6 weeks if interested. Will contact for portfolio review if interested. Pays for design and illustration by the hour, $15-25; by the project, $250-500. Buys all rights. Finds artists through submissions and social contacts.

Tips "Find projects to do for friends, family . . . to build your portfolio and experience. A good designer must have some illustration ability and a good illustrator needs to have design awareness—so usually our designer is creating a lot of artwork short of a photograph or piece of cover art."

SILVER WAVE RECORDS

P.O. Box 7943 , Boulder CO 80306. (303)443-5617. Fax: (303)443-0877. E-mail: valerie@silverwave.com. Web site: www.silverwave.com. **Art Director:** Valerie Sanford. Estab. 1986. Produces CDs and cassettes; Native American, New Age and World music. Recent releases: *Out of the Ashes* by Shelley Morningsong; *10 Questions for the Dalai Lama* by Peter Kater; Grammy winner *Dance With the Wind* by Mary Youngblood; *Johnny Whitehorse* by Johnny Whitehorse.

Needs Produces 4 releases/year. Works with 4-6 illustrators, artists, photographers/year. Uses illustrators for CD cover illustration.

First Contact & Terms Send postcard sample or query letter with 2 or 3 samples. Samples are filed. Will contact for portfolio review if interested. Pays by the project. Rights purchased vary according to project.

Tips "Develop some good samples and experience. I look in galleries, art magazines, *Workbook*, *The Black Book* and other trade publications. I visit artists' booths at Native American 'trade shows.' Word of mouth is effective. We will call if we like work or need someone." When hiring freelance illustrators, this company looks for a specific style for a particular project. "Currently we are producing contemporary Native American music and look for art that expresses that."

N ◩ SOMERSET ENTERTAINMENT

20 York Mills Rd., Suite 600., Toronto ON M2P 2C2 Canada. (416)510-2800. Fax: (416)510-3070. E-mail: elahman@somersetent.com. Web site: www.somersetent.com. **Art Director:** Elliot Lahman. Estab. 1994. Produces CDs, cassettes and enhanced CDs classical, country, folk, jazz, soul, children's music, solo artists and groupssome enhanced by nature sounds. Recent releases *Jazz by Twilight*; *Shorelines-Classical Guitar*; *Spring Awakening*, by Dan Gibson and Joan Jerberman.

N SOMNIMAGE CORPORATION

P.O. Box 24, Bradley IL 60915. (815)932-8547. E-mail: somnimage@aol.com. Web site: www.somnimage.com. **Contact:** Mykel Boyd. Estab. 1998. Produces albums, CDs, CD-ROMs, cassettes and vinyl classical, folk, jazz, pop, progressive, rap, rock, experimental and electronic music by solo artists and groups. Recent releases *Wolf Sheep Cabbage*, by The Hafler Trio; Kafka tribute CD compilation.

Needs Produces 10 releases/year. Works with 10 freelancers/year. Looking for creative art. Uses freelancers for cover design and illustration; cassette cover design and illustration; CD booklet design and illustration; CD cover design and illustration; CD-ROM design and packaging and

poster design. Freelancers should be familiar with PageMaker, Illustrator, QuarkXPress, Photoshop, FreeHand.

First Contact & Terms Send query letter with brochure, résumé, photostats, transparencies, photocopies, photographs, slides, SASE, tearsheets. Accepts disk submissions. Samples are filed or returned by SASE if requested by artist. Responds in 3 months. Will contact artist for portfolio review of b&w and color final art, photocopies, photographs, photostats, roughs, slides, tearsheets, thumbnails and transparencies, if interested. Pays by the project. Negotiates rights purchased. Finds artists through word of mouth.

Tips "We are interested in surreal art, dada art, dark themed photography too."

Ⓝ SUGAR BEATS ENTERTAINMENT

12129 Maxwellton Ave, Studio City CA 91604.(818)358-2408. Fax: (818)358-2407. Web site: www.sugarbeats.com. **Vice President Marketing:** Bonnie Gallanter. Estab. 1993. Produces CDs, cassettes children's music by groups. Recent releases "A Sugar Beats Christmas."

Needs Produces 1 release/year. Works with 1-2 freelancers/year. Prefers local freelancers who own Macs with experience in QuarkXPress, Photoshop, Illustrator and web graphics. Uses freelancers for album cover design; cassette cover design and illustration; CD booklet design and illustration; CD cover design and illustration; poster design; Web page design. Also for ads, sell sheets and postcards. 100% of freelance design demands knowledge of Illustrator, QuarkXPress, Photoshop, FreeHand.

First Contact & Terms Send postcard sample or query letter with brochure, tearsheets, résumé and photographs. Accepts Mac-compatible disk submissions. Will contact artist for portfolio review of b&w and color art. Pays by the project. Rights purchased vary according to project. Finds freelancers through referrals.

Ⓣ Ⓔ TANGENT RECORDS

P.O. Box 383, Reynoldsburg OH 43068-0383. (614)751-1962. Fax: (614)751-6414. E-mail: info@tangentrecords.com. Web site: www.tangentrecords.com. **President:** Andrew J. Batchelor. Estab. 1986. Produces CDs, DVDs, CD-ROMs, cassettes, videos; contemporary, classical, jazz, progressive, rock, electronic, world beat and New Age fusion. Recent releases: *Moments Edge* by Andrew Batchelor.

Needs Produces 20 releases/year. Works with 5 freelancers/year. Prefers local illustrators and designers who own computers. Uses freelancers for CD booklet design and illustration; CD cover design and illustration; CD-ROM design and packaging; poster design; Web page design; advertising and brochure design/illustration and multimedia projects. Most freelance work demands knowledge of Illustrator, QuarkXPress, Photoshop, FreeHand and PageMaker.

First Contact & Terms Send postcard sample or query letter with résumé, brochure, one-sheets, photocopies, tearsheets, photographs. Accepts both Mac- and IBM-compatible digital submissions. Send JPEG files on 3.5" diskette, CD-ROM or Superdisk 120MB. Samples are filed and not returned. Will contact artist for portfolio review if interested. Portfolio should include b&w, color, final art, photocopies, photographs, photostats, slides, tearsheets, thumbnails, transparencies. Pays by the project. "Amount varies by the scope of the project." Negotiates rights purchased. Finds artists through college art programs and referrals.

Tips Looks for "creativity and innovation."

⊕ TOP RECORDS
4 Galleria del Corso, 20122 Milano Italy. E-mail: topdingo@toprecords.it. Web site: www.toprecords.it. **Managing Director:** Guido Palma. Estab. 1975. Produces CDs, albums; rock, rap, R&B, soul, pop, folk, country/western, disco by solo artists and groups.
Needs Produces 5 solo artists and 5 groups/year. Works with 2 freelancers/year on assignment only.
First Contact & Terms Send query letter with brochure. Samples are filed but not returned, unless requested and paid for by the artist. Responds in 1 month. Call for appointment to show portfolio or mail appropriate materials. Portfolio should include original/final art and photographs. Buys all rights.
Tips "Have a new and original idea."

VARESE SARABANDE RECORDS
11846 Ventura Blvd., Suite 130, Studio City CA 91604. (818)753-4143. Fax: (818)753-7596. E-mail: publicity@varesesarabande.com. Web site: www.varesesarabande.com. **Vice President:** Robert Townson. Estab. 1978. Produces CDs; film music soundtracks. Recent releases: *Shrek The Third* by Harry Gregson-Williams; *Evan Almighty* by John Debney; *Blood Diamond* by James Newton Howard; *Live Free or Die Hard* by Marco Beltrami; *Rush Hour 3* by Lalo Schifrin; *Grindhouse: Planet Terror* by Robert Rodriguez.
Needs Works on assignment only. Uses artists for CD cover illustration and promotional material.
First Contact & Terms Send query letter with photostats, slides and transparencies. Samples are filed. Responds only if interested. Pays by the project.
Tips "Be familiar with the label's output before approaching us."

ℕ VERVE MUSIC GROUP
1755 Broadway, 3rd Floor, New York NY 10019. (212)331-2000. Fax: (212)331-2065. E-mail: contact@vervemusicgroup.com. Web site: www.vervemusicgroup.com. **Associate Director:** Sherniece Johnson-Smith. Produces albums and CDs; jazz, progressive by solo artists and groups. Recent release: *The Girl in the Other Room* by Diana Krall.
● Verve Music Group houses the Verve, GRP, Impulse! and Verve Forecast record labels.
Needs Produces 120 releases/year. Works with 20 freelancers/year. Prefers designers with experience in CD cover design who own Macs. Uses freelancers for album cover design and illustration; CD booklet design and illustration; CD cover design and illustration. 100% of freelance design demands computer skills.
First Contact & Terms Send nonreturnable postcard sample of work. Samples are filed. Does not reply. Portfolios may be dropped off Monday through Friday. Will contact artist for portfolio review if interested. Pays for design by the project, $1,500 minimum; pays for illustation by the project, $2,000 minimum.

ℕ VIRGIN RECORDS
150 Fifth Ave., New York NY 10011. (212)786-8300. Web site: www.virginrecords.com. **Contact:** Creative Dept. Recent releases include *Out of State Plates* by Fountains of Wayne, *Baptism* by Lenny Kravitz, *There Will Be A Light* by Ben Harper and the Blind Boys of Alabama. Uses freelancers for CD and album cover design and illustration. Send query letter with samples. Portfolios may be dropped off on Wednesdays between 10 a.m. and 5 p.m. Samples are filed. Responds only if interested.

Ⓝ WARNER BROS. RECORDS

3300 Warner Blvd., Burbank CA 91505. (818)846-9090. Fax: (818)953-3232. Web site: www.warnerbros.com. **Art Dept. Assistant:** Michelle Barish. Produces artwork for CDs, cassettes and sometimes albums; rock, jazz, hip-hop, alternative, rap, R&B, soul, pop, folk, country/western by solo and group artists. Releases include *Greatest Hits and Videos* by Red Hot Chili Peppers; *Closer* by Josh Groban; *In Time, Best of R.E.M. 1988-2003* by R.E.M. Releases approximately 200 total packages/year.

Needs Works with freelance art directors, designers, photographers and illustrators on assignment only. Uses freelancers for CD cover design and illustration; brochure design and illustration; catalog design, illustration and layout; advertising design and illustration; and posters. 100% of freelance work demands knowledge of QuarkXPress, FreeHand, Illustrator or Photoshop.

First Contact & Terms Send query letter with résumé, brochure, tearsheets, slides and photographs. Samples are filed or are returned by SASE if requested by artist. Responds only if interested. Will contact artist for portfolio review if interested. Portfolio should include roughs, printed samples and b&w and color tearsheets, photographs, slides and transparencies. "Any of these are acceptable. Do not submit original artwork." Pays by the project.

Tips "We tend to use artists or illustrators with distinct/stylized work. Rarely do we call on the illustrators to render likenesses; more often we are looking for someone with a conceptual or humorous approach."

Ⓝ WELK MUSIC GROUP

2700 Pennsylvania Ave., Santa Monica CA 90404. (805)498-0197. Fax: (805)498-4297. E-mail: gcartwright@e-znet.com. Web site: www.welkmusicgroup.com. **Contact:** Georgette Cartwright, creative services manager or Amy Von, director of new artist development. Estab. 1987. Produces CDs, tapes and albums; R&B, jazz, soul, folk, country/western, solo artists. Recent release: *RedLuck* by Patty Larkin.

- Contact information for Georgette Cartwright listed above; contact information for Amy Von is (310)829-9355; fax (310)315-3006. This label acquired Sugar Hill Records. Sugar Hill will maintain its Durham, North Carolina, headquarters. Welk Music Group, a division of The Welk Group, encompasses Vanguard Records and Ranwood Records.

Needs Produces almost 2 new artists and 2 catalog releases/month. Works with 4 designers/year. Prefers artists with experience in the music industry. Uses artists for CD cover design and illustration; album/tape cover design and illustration; catalog design, illustration and layout; direct mail packages; advertising design. 100% of freelance work demands knowledge of QuarkXPress, Illustrator and Photoshop.

First Contact & Terms Send postcard sample with brochure, photocopies, photographs and tearsheets. Samples are filed. Responds only if interested. To show a portfolio, mail tearsheets and printed samples. Pays for design by the hour, $25-45; by the project, $800-2,000. Pays for illustration by the project, $200-500. Buys all rights.

Tips "We need to have artwork for cover combined with CD booklet format."

Artists' Reps

Many artists find leaving promotion to a rep allows them more time for the creative process. In exchange for actively promoting an artist's career, the representative receives a percentage of sales (usually 25-30%). Reps generally focus on either the fine art market or commercial market, rarely both.

Fine art reps promote the work of fine artists, sculptors, craftspeople and fine art photographers to galleries, museums, corporate art collectors, interior designers and art publishers. Commercial reps help illustrators and graphic designers obtain assignments from advertising agencies, publishers, magazines and other art buyers. Some reps also act as licensing agents.

What reps do

Reps work with artists to bring their portfolios up to speed and actively promote their work to clients. Usually a rep will recommend advertising in one of the many creative directories such as *Showcase* (www.showcase.com) or *Workbook* (www.workbook.com) so that your work will be seen by hundreds of art directors. (Expect to make an initial investment in costs for duplicate portfolios and mailings.) Reps also negotiate contracts, handle billing and collect payments.

Getting representation isn't as easy as you might think. Reps are choosy about who they represent—not just in terms of talent but also in terms of marketability and professionalism—reps will only take on talent they know will sell.

What to send

Once you've gone through the listings in this section and compiled a list of art reps who handle your type and style of work, contact them with a brief query letter and nonreturnable copies of your work. Check each listing for specific guidelines and requirements.

Learn About Reps

For More Info

The Society of Photographers and Artists Representatives (SPAR) is an organization for professional representatives. SPAR members are required to maintain certain standards and follow a code of ethics. For more information, write to SPAR, 60 E. 42nd St., Suite 1166, New York NY 10165, or visit www.spar.org.

FRANCE ALINE, INC.

E-mail: france@francealine.com. Web site: www.francealine.com. **Owner:** France Aline. Commercial illustration, photography and digital art representative. Estab. 1979. Specializes in logo design and advertising. Markets include advertising, corporations, design firms, movie studios, record companies. Artists include Jill Sabella, Craig Mullins, Ezra Tucker, Elisa Cohen, Justin Brandstater, Nora Feller, Peter Greco, Erica Lennand and Thomas Blacksedir.

Handles Illustration, photography.

Terms Rep receives 25% commission. Exclusive area representation is required. Advertises in *American Showcase*, *Workbook* and *The Black Book*.

How to Contact For first contact, send e-mail query. Responds in a few days.

AMERICAN ARTISTS REP., INC.

380 Lexington Ave., 17th floor, New York NY 10168. (212)682-2462. Fax: (212)582-0090. Web site: www.aareps.com. Commercial illustration representative. Estab. 1930. Member of SPAR. Represents 40 illustrators. Markets include advertising agencies, corporations/client direct, design firms, editorial/magazines, paper products/greeting cards, publishing/books, sales/promotion firms.

Handles Illustration, design.

Terms Rep receives 30% commission. "All portfolio expenses billed to artist." Advertising costs are split: 70% paid by talent; 30% paid by representative. "Promotion is encouraged; portfolio must be presented in a professional manner—8×10, 4×5, tearsheets, etc." Advertises in *American Showcase*, *The Black Book*, *RSVP*, *Workbook*, medical and Graphic Artist Guild publications.

How to Contact Send query letter, direct mail flier/brochure, tearsheets. Responds in 1 week if interested. After initial contact, drop off or mail appropriate materials for review. Portfolio should include tearsheets, slides. Obtains new talent through recommendations from others, solicitation, conferences.

ART LICENSING INTERNATIONAL INC.

711 S Osprey Ave, Ste 1, Sarasota FL 34236. (941)966-4042. Fax: (941)296-7345. E-mail: artlicensing@comcast.net. Web site: www.out-of-the-blue.us. **President:** Michael Woodward, author of *Licensing Art 101*. Licensing agent. Estab. 1986. Represents fine artists, designers, photographers and concept designers. Handles collections of work submitted by artists for licensing across a range of product categories, such as fine art for interior design market, wall decor, greeting cards, stationery and gift products.

 ● See additional listings for this company in the Greeting Cards, Gifts & Products and Posters & Prints sections. See also listing for Out of the Blue in the Greeting Cards, Gifts & Products section.

Handles Prefers collections of art, illustrations or photography that have good consumer appeal.

Terms Send samples on CD (JPEG files) or color photocopies with SASE. Fine artists should send short bio. "Terms are 50/50 with no expenses to artist as long as artist can provide high-res scans if we agree on representation. Our agency specializes in aiming to create a full licensing program so we can license art across a varied product range. We are therefore only interested in collections, or groups of artworks or concepts that have commercial appeal."

Tips "Artists need to consider actual products when creating new art. Look at products in retail outlets and get a feel for what is selling well. Get to know the markets you are trying to sell your work to."

ART IN FORMS (A Division of Martha Productions)

7550 W. 82nd St., Playa Del Rey CA 90293. (310)670-5300. Fax: (310)670-3644. E-mail: contact@artinforms.com. Web site: www.artinforms.com. **President:** Martha Spelman. Commercial illustration representative. Estab. 2000. Represents 9 illustrators. Specializes in illustrators who create informational graphics and technical drawings, including maps, charts, diagrams, cutaways, flow charts and more.

● See listing for Martha Productions in this section.

ARTISAN CREATIVE, INC.

1950 S. Sawtelle Blvd., Suite 320, Los Angeles CA 90025. (310)312-2062. Fax: (310)312-0670. E-mail: info@artisancreative.com. Web site: www.artisancreative.com. **Creative Contact:** Jamie Grossman. Estab. 1996. Represents creative directors, art directors, graphic designers, illustrators, animators (3D and 2D), storyboarders, packaging designers, photographers, Web designers, broadcast designers and flash developers. Markets include advertising agencies, corporations/client direct, design firms, entertainment industry.

● Artisan Creative has another location at 850 Montgomery St., C-50, San Francisco CA 94133. (415)362-2699. **Contact:** Wayne Brown.

Handles Web design, multimedia, illustration, photography and production. Looking for Web, packaging, traditional and multimedia-based graphic designers.

Terms 100% of advertising costs paid by the representative. For promotional purposes, talent must provide PDFs of work. Advertises in magazines for the trade, direct mail and the Internet.

How to Contact For first contact, e-mail résumé to Creative Staffing Department. "You will then be contacted if a portfolio review is needed." Portfolio should include roughs, tearsheets, photographs, or color photos of your best work.

Tips "Have at least two years' working experience and a great portfolio."

ARTREPS

22287 Mulholland Hwy., Suite 133, Calabasas CA 91302-5157. (818)888-0825 or (800)959-6040. E-mail: info@artrepsart.com. Web site: www.artrepsart.com. **Art Director:** Phoebe Batoni. Fine art representative, art consultant, publisher. Estab. 1993. Represents fine artists. Specializes in working with royalty publishers for posters, open editions, limited edition giclées; and galleries, interior designers and licensing agents. Markets include art publishers, corporate collections, galleries, interior decorators. Represents Barbara Cleary, Lili Maglione, Peter Colvine, Ann Christensen, Peter Wilkinson and Ron Peters.

● This agency attends Artexpo and DECOR Expo to promote its clients.

Handles Fine art: works on paper, canvas and mixed media; no sculpture.

Terms Negotiated on an individual basis. For promotional purposes, talent must provide "adequate materials."

How to Contact Send query letter with résumé, bio, direct mail flier/brochure, tearsheets, slides, photographs, photocopies or photostats and SASE (for return of materials). Will look at CD or Web site but prefers to review artwork in a tangible form. Responds in 2 weeks.

Tips "We're interested in fine art with universal mainstream appeal. Check out the kind of art that's selling at your local frame shop and fine art galleries or at retailers like Pier One Imports and Bed Bath & Beyond. Presentation counts, so make sure your submission looks professional."

ARTVISIONS™

Bellevue WA. Web site: www.artvisions.com. Estab. 1993. Licenses fine art and professional photography.

Handles Fine art and professional photography licensing only.

Terms Royalties are split 50/50. Exclusive worldwide representation for licensing is required (the artist is free to market original art). Written contract provided.

How to Contact Review guidelines on Web site. "Not currently seeking new talent. However, we are always willing to view the work of top-notch established artists. If you fit this category, please contact ArtVisions via e-mail (from our Web site) and include a link to a Web site where your art can be seen. Or, you may include a few small samples attached to your e-mail as JPEG files."

Tips "To gain an idea of the type of art we license, please view our Web site. Artist MUST be able to provide high-resolution, professionally made scans of artwork on CD. We are firmly entrenched in the digital world, if you are not, then we cannot represent you. If you need advice about marketing your art, please visit: www.artistsconsult.com."

ARTWORKS ILLUSTRATION

325 W. 38th St., New York NY 10018. (212)239-4946. Fax: (212)239-6106. E-mail: artworksillustration@earthlink.net. Web site: www.artworksillustration.com. **Owner:** Betty Krichman. Commercial illustration representative. Estab. 1990. Member of Society of Illustrators. Represents 30 illustrators. Specializes in publishing. Markets include advertising agencies, design firms, paper products/greeting cards, movie studios, publishing/books, sales/promotion firms, corporations/client direct, editorial/magazines, video games. Artists include Dan Brown, Dennis Lyall, Jerry Vanderstelt and Chris Cocozza.

Handles Illustration. Looking for interesting juvenile, digital sci-fi/fantasy & romance images.

Terms Rep receives 30% commission. Exclusive area representation required. Advertising costs are split: 75% paid by artist; 25% paid by rep. Advertises in *American Showcase* and on www.theispot.com.

How to Contact For first contact, send e-mail samples. Responds only if interested.

ASCIUTTO ART REPS., INC.

1712 E. Butler Circle, Chandler AZ 85225. (480)899-0600. Fax: (480)899-3636. E-mail: aartreps@cox.net. Web site: www.Aartreps.com. **Contact:** Mary Anne Asciutto. Children's illustration representative. Estab. 1980. Specializes in children's illustration for books, magazines, posters, packaging, etc. Markets include publishing/packaging/advertising.

Handles Illustration only.

Terms Rep receives 25% commission. Advertising costs are split: 75% paid by talent; 25% paid by representative. For promotional purposes, talent should provide color prints or originals in an 8.5×11 size format. Electronic samples via e-mail or CD-ROM.

How to Contact E-mail or send sample work with an SASE.

Tips "Be sure to connect with an agent who handles the kind of accounts you *want*."

CAROL BANCROFT & FRIENDS

P.O. Box 2030, Danbury CT 06813. (203)730-8270. Fax: (203)730-8275. E-mail: artists@carolbancroft.com. Web site: www.carolbancroft.com. **Owner:** Joy Elton Tricarico. Founder: Carol Bancroft. Illustration representative for children's publishing. Estab. 1972. Member of Society of

Illustrators, Graphic Artists Guild, SCBWI and National Art Education Association. Represents over 30 illustrators. Specializes in, but not limited to, representing artists who illustrate for children's publishing—text, trade and any children's-related material. Clients include Scholastic, Harcourt, HarperCollins, Random House, Penguin USA, Simon & Schuster. Artist list available upon request.

Handles Illustration for children of all ages.

Terms Rep receives 25% commission. Advertising costs are split: 75% paid by talent; 25% paid by representative. For promotional purposes, artist should provide "Web address in an e-mail or samples via mail (laser copies, not slides; tearsheets, promo pieces, books, good color photocopies, etc.); 6 pieces or more; narrative scenes with children and/or animals interacting." Advertises in *Picture Book and Directory of Illustration*.

How to Contact Send samples and SASE. "Artists may call no sooner than one month after sending samples."

Tips "We look for artists who can draw animals and people with imagination and energy, depicting engaging characters with action in situational settings."

BERNSTEIN & ANDRIULLI

58 W. 40th St., New York NY 10018. (212)682-1490. Fax: (212)286-1890. E-mail: artinfo@ba-reps.com. Web site: www.ba-reps.com. **Contact:** Louisa St. Pierre.

Commercial illustration and photography representative. Estab. 1975. Member of SPAR. Represents 100 illustrators, 40 photographers. Markets include advertising agencies, corporations/client direct, design firms, editorial/magazines, paper products/greeting cards, publishing/books, sales/promotion firms.

Handles Illustration, New Media and Photography.

Terms Rep receives a commission. Exclusive career representation is required. No geographic restrictions. Advertises in *The Black Book*, *Workbook*, *Bernstein Andriulli International Illustration*, *CA Magazine*, *Archive*, American Illustration/Photography.

How to Contact Send query e-mail with Web site or digital files. Call to schedule an appointment before dropping off portfolio.

JOANIE BERNSTEIN, ART REP

756 8th Ave., Naples FL 34102. (239)403-4393. Fax: (239)403-0066. E-mail: joanie@joaniebrep.com. Web site: www.joaniebrep.com. **Contact:** Joanie. Commercial illustration representative. Estab. 1984.

Handles Illustration. Looking for an unusual, problem-solving style. Clients include advertising, design, books, music, product merchandising, developers, movie studios, films, private collectors.

Terms Rep receives 25% commission. Exclusive representation required.

How to Contact E-mail samples.

Tips "Web sites are a necessity."

BOOKMAKERS LTD.

P.O. Box 1086, Taos NM 87571. (575)776-5435. Fax: (575)776-2762. E-mail: gayle@bookmakersltd.com. Web site: www.bookmakersltd.com. **President:** Gayle McNeil. Estab. 1975. "We represent professional, experienced children's book illustrators. We welcome authors who are interested in self-publishing."

● See additional listing in the Advertising, Design & Related Markets section.

BROWN INK ASSOCIATES

222 E. Brinkerhoff Ave., Palisades Park NJ 07650. (201)313-6081. Fax: (201)461-6571. E-mail: robert229artist@juno.com@juno.com. Web site: www.browninkonline.com. **President/Owner:** Bob Brown. Digital fine art publisher and distributor. Estab. 1979. Represents 5 fine artists, 2 illustrators. Specializes in advertising, magazine editorials and book publishing, fine art. Markets include advertising agencies, corporations/client direct, design firms, editorial/magazines, galleries, movie studios, paper products/greeting cards, publishing/books, record companies, sales/promotion firms.

Handles Fine art, illustration, digital fine art, digital fine art printing, licensing material. Looking for professional artists who are interested in making a living with their art. Art samples and portfolio required.

Terms Rep receives 25% commission on illustration assignment; 50% on publishing (digital publishing) after expenses. "The only fee we charge is for services rendered (scanning, proofing, printing, etc.). We pay for postage, labels and envelopes." Exclusive area representation required (only in the NY, NJ, CT region of the country). Advertising costs are paid by artist or split: 75% paid by artist; 25% paid by rep. Artists must pay for their own promotional material. For promotional purposes, talent must provide a full-color direct mail piece, an 11×14 flexible portfolio, digital files and CD. Advertises in *Workbook*.

How to Contact For first contact, send bio, direct mail flier/brochure, photocopies, photographs, résumé, SASE, tearsheets, slides, digital images/CD, query letter (optional). Responds only if interested. After initial contact, call to schedule an appointment, drop off or mail portfolio, or e-mail. Portfolio should include b&w and color finished art, original art, photographs, slides, tearsheets, transparencies (35mm, 4×5 and 8×10).

Tips "Be as professional as possible! Your presentation is paramount. The competition is fierce, therefore your presentation (portfolio) and art samples need to match or exceed that of the competition."

WOODY COLEMAN PRESENTS, INC.

490 Rockside Rd., Cleveland OH 44131. (216)661-4222. Fax: (216)661-2879. E-mail: woody@portsort.com. Web site: www.portsort.com. **CEO:** Laura Ray. Estab. 1978. Member of Graphic Artists Guild. Specializes in illustration and artist services. Markets include advertising agencies, corporations/client direct, design firms, editorial/magazines, paper products/greeting cards, publishing/books, sales/promotion firms, public relations firms. Also provides referral to legal reference resources and materials.

Handles Illustration.

Terms Negotiates and invoices projects and receives 25% commission.

How to Contact Write, e-mail or call

⚡ CONTACT JUPITER

5 Laurier St., St. Eustache QC J7R 2E5 Canada. Phone/fax: (450)491-3883. E-mail: info@contactjupiter.com. Web site: www.contactjupiter.com. **President:** Oliver Mielenz. Commercial illustration representative. Estab. 1996. Represents 12 illustrators, 6 photographers. Specializes in publishing, children's books, magazines, advertising. Licenses illustrators, photographers. Markets include advertising agencies, paper products/greeting cards, record companies, publishing/books, corporations/client direct, editorial/magazines.

Handles Illustration, multimedia, music, photography, design.

Terms Rep receives 15-25% and rep fee. Advertising costs are split: 50% paid by artist; 50% paid by rep. Exclusive representation required. For promotional purposes, talent must provide portfolio pieces (8×10) and electronic art samples. Advertises in *Directory of Illustration*.

How to Contact Send query by e-mail with a few JPEG samples. Responds only if interested. After initial contact, e-mail to set up an interview or portfolio review. Portfolio should include b&w and color tearsheets.

Tips "One specific style is easier to sell. Focus, focus, focus. Initiative, I find, is very important in an artist."

CORNELL & MCCARTHY, LLC

2-D Cross Hwy., Westport CT 06880. (203)454-4210. Fax: (203)454-4258. E-mail: contact@cmart reps.com. Web site: www.cmartreps.com. **Contact:** Merial Cornell. Children's book illustration representative. Estab. 1989. Member of SCBWI and Graphic Artists Guild. Represents 30 illustrators. Specializes in children's books—trade, mass market, educational.

Handles Illustration.

Terms Agent receives 25% commission. Advertising costs are split: 75% paid by talent; 25% paid by representative. For promotional purposes, talent must provide 10-12 strong portfolio pieces relating to children's publishing.

How to Contact For first contact, send query letter, direct mail flier/brochure, tearsheets, photocopies and SASE. Responds in 1 month. Obtains new talent through recommendations, solicitation, conferences.

Tips "Work hard on your portfolio."

CWC INTERNATIONAL, INC.

611 Broadway, Suite 730, New York NY 10012-2649. (646)486-6586. Fax: (646)486-7622. E-mail: agent@cwc-i.com. Web site: www.cwc-i.com. **VP/Executive Creative Agent:** Koko Nakano. Estab. 1999. Commercial ilustration representative. Represents 23 illustrators. Specializes in advertising, fashion. Markets include advertising agencies, corporations/client direct, design firms, editorial/magazines, galleries, paper products/greeting cards, publishing/books, record companies. Artists include Jeffrey Fulvimari, Stina Persson, Chris Long and Kenzo Minami.

Handles Fine art, illustration.

Terms Exclusive area representation required.

How to Contact Send query letter with direct mail flier/brochure, photocopies (3-4 images) and résumé via postal mail or e-mail. Please put "rep query" as the subject of the e-mail. Responds only if interested.

Tips "Please do not call. When sending any image samples by e-mail, be sure the entire file will not exceed 300K."

LINDA DE MORETA REPRESENTS

1511 Union St., Alameda CA 94501. (510)769-1421. Fax: (510)892-2955. E-mail: linda@lindarep s.com. Web site: www.lindareps.com. **Contact:** Linda de Moreta. Commercial illustration, calligraphy/handlettering and photography representative. Estab. 1988. Represents 10 illustrators, 2 photographers. Markets include advertising agencies; design firms; corporations/client direct; editorial/magazines; paper products/greeting cards; publishing/books. Represents Chuck Pyle, Pete McDonnell, Tina Rachelle, Monica Dengo, John Howell, Shannon Abbey, Craig Hannah, Shan O'Neill, Ron Miler, and Doves.

Handles Photography, illustration, lettering/title design, storyboards/comps.

Terms Commission, exclusive representation requirements and advertising costs are according to individual agreements. Materials for promotional purposes vary with each artist. Advertises in *Workbook*, *Directory of Illustration*, and on www.theispot.com.

How to Contact For first contact, e-mail samples or link to Web site; or send direct mail flier/brochure. ''Please do *not* send original art. Include SASE for any items you wish returned.'' Responds to any inquiry in which there is an interest. Portfolios are individually developed for each artist.

Tips Obtains new talent through client and artist referrals primarily, some solicitation. ''I look for great creativity, a personal vision and style combined with professionalism, and passion.''

THE DESKTOP GROUP

420 Lexington Ave., Suite 2100, New York NY 10170. (212)916-0824. Fax: (212)867-1759. E-mail: jobs@thedesktopgroup.com. Web site: www.thedesktopgroup.com. Estab. 1991. Specializes in recruiting and placing creative talent on a freelance basis. Markets include advertising agencies, design firms, publishers (book and magazine), corporations, and banking/financial firms.

Handles Artists with Macintosh (and Windows) software and multimedia expertise—graphic designers, production artists, pre-press technicians, presentation specialists, traffickers, art directors, Web designers, content developers, project managers, copywriters, and proofreaders.

How to Contact For first contact, e-mail résumé, cover letter and work samples.

Tips ''Our clients prefer working with talented artists who have flexible, easy-going personalities and who are very professional.''

ROBERT GALITZ FINE ART & ACCENT ART

166 Hilltop Court, Sleepy Hollow IL 60118. (847)426-8842. Fax: (847)426-8846. E-mail: robert@galitzfineart.com. Web site: www.galitzfineart.com. **Owner:** Robert Galitz. Fine art representative. Estab. 1985. Represents 100 fine artists (including 2 sculptors). Specializes in contemporary/abstract corporate art. Markets include architects, corporate collections, galleries, interior decorators, private collections. Represents Roland Poska, Jan Pozzi, Diane Bartz and Louis De Mayo.

• See additional listings in the Galleries and Posters & Prints sections.

Handles Fine art.

Terms Agent receives 25-40% commission. No geographic restrictions; sells mainly in Chicago, Illinois, Wisconsin, Indiana and Kentucky. For promotional purposes, talent must provide ''good photos and slides.'' Advertises in monthly art publications and guides.

How to Contact Send query letter, slides, photographs. Responds in 2 weeks. After initial contact, call for appointment to show portfolio of original art. Obtains new talent through recommendations from others, solicitation, conferences.

Tips ''Be confident and persistent. Never give up or quit.''

ANITA GRIEN REPRESENTING ARTISTS

155 E. 38th St., New York NY 10016. E-mail: anita@anitagrien.com. Web site: www.anitagrien.com. Representative not currently seeking new talent.

▣ CAROL GUENZI AGENTS, INC.

(DBA ArtAgent.com), 865 Delaware St., Denver CO 80204. (303)820-2599. E-mail: art@artagent. com. Web site: www.artagent.com. **President:** Carol Guenzi. Commercial illustration, photography, new media and film/animation representative. Estab. 1984. Represents 25 illustrators, 6 photographers, 4 film/animation developers, and 3 multimedia developers. Specializes in a "worldwide selection of talent in all areas of visual communications." Markets include advertising agencies, corporations/client direct, design firms, editorial/magazines, paper products/ greeting cards, sales/promotions firms. Clients include Integer, BBDO, DDB Needham, TLP. Partial client list available upon request. Represents Christer Eriksson, Juan Alvarez, Michael Fisher, Kelly Hume, Capstone Studios and more.

Handles Illustration, photography. Looking for "unique style application."

Terms Rep receives 25-30% commission. Exclusive area representation is required. Advertising costs are split: 70-75% paid by talent; 25-30% paid by rep. For promotional purposes, talent must provide "promotional material; some restrictions on portfolios." Advertises in *The Black Book*, *Directory of Illustration*, *Workbook*.

How to Contact For first contact, e-mail PDFs or JPEGs with link to URL, or send direct mail flier/brochure. Responds only if interested. E-mail or call for appointment to drop off or mail in appropriate materials for review, depending on artist's location. Portfolio should include tearsheets, CD/DVD, photographs. Obtains new talent through solicitation, art directors' referrals, and active pursuit by individual artists.

Tips "Show your strongest style and have at least 12 samples of that style before introducing all your capabilities. Be prepared to add additional work to your portfolio to help round out your style. Have a digital background."

GUIDED IMAGERY DESIGN & PRODUCTIONS

2995 Woodside Rd., Suite 400, Woodside CA 94062. (650)324-0323. Fax: (650)324-9962. Web site: www.guided-imagery.com. **Owner/Director:** Linda Hoffman. Fine art representative. Estab. 1978. Member of Hospitality Industry Association. Represents 3 illustrators, 12 fine artists. Specializes in large art production; perspective murals (trompe l'oiel); unusual painted furniture/screens. Markets include design firms; interior decorators; hospitality industry.

Handles Looking for "mural artists (realistic or trompe l'oiel) with good understanding of perspectives."

Terms Rep receives 33-50% commission. 100% of advertising costs paid by representative. For promotional purposes, talent must provide a direct mail piece to preview work, along with color copies of work, and SASE. Advertises in *Hospitality Design*, *Traditional Building Magazine* and *Design Journal*.

How to Contact For first contact, send query letter, résumé, photographs, photocopies and SASE. Responds in 1 month. After initial contact, mail appropriate materials. Portfolio should include photographs.

Tips Wants artists with talent, references and follow-through. "Send color copies of original work that show your artistic style. Never send one-of-a-kind artwork. My focus is 3D murals. References from previous clients very helpful. Please, no cold calls."

PAT HACKETT, ARTIST REPRESENTATIVE

7014 N. Mercer Way, Mercer Island WA 98040. (206)447-1600. Fax: (206)447-0739. E-mail: pat@pathackett.com. Web site: www.pathackett.com. **Contact:** Pat Hackett. Commercial illus-

tration and photography representative. Estab. 1979. Represents 12 illustrators, 1 photographer. Markets include advertising agencies; corporations/client direct; design firms; editorial/magazines.

Handles Illustration and photography.

Terms Rep receives 25-33% commission. Advertising costs are split: 75% paid by talent; 25% paid by representative. For promotional purposes, talent must provide "standardized portfolio, i.e., all pieces within the book are the same format. Reprints are nice, but not absolutely required." Advertises in *Showcase*, *Workbook*, and on www.theispot.com and www.portfolios.com.

How to Contact For first contact, send direct mail flier/brochure. Responds in 1 week, only if interested. After initial contact, drop off or mail in appropriate materials—tearsheets, slides, photographs, photostats, photocopies. Obtains new talent through "recommendations and calls/letters."

Tips Looks for "experience in the *commercial* art world, professional presentation in both portfolio and person, cooperative attitude and enthusiasm."

HOLLY HAHN & CO.

837 W. Grand Ave., Chicago IL 60622. (312)633-0500. Fax: (312)633-0484. E-mail: holly@hollyh ahn.com. Web site: www.hollyhahn.com. Commercial illustration and photography representative. Estab. 1988.

Handles Illustration, photography.

How to Contact Send direct mail flier/brochure and tearsheets.

BARB HAUSER, ANOTHER GIRL REP

P.O. Box 421443, San Francisco CA 94142-1443. (415)647-5660. E-mail: barb@girlrep.com. Web site: www.girlrep.com. Estab. 1980. Represents 8 illustrators. Markets include primarily advertising agencies and design firms; corporations/client direct.

Handles Illustration.

Terms Rep receives 25-30% commission. Exclusive representation in the San Francisco area is required.

How to Contact For first contact, "please e-mail. If you wish to send samples, please send no more than three very small JPEGs; but please note, I am not presently accepting new talent."

JOANNE HEDGE/ARTIST REPRESENTATIVE

1415 Garden St., Glendale CA 91201. (818) 244-0110. E-mail: hedgegraphics@earthlink.com. Web site: www.hedgereps.com. **Contact:** J. Hedge. Commercial illustration representative. Estab. 1975. Represents 10 illustrators. Specializes in quality painterly and realistic illustration, digital art and lettering, icons; also vintage and period styles. Markets include packaging, especially food and beverage, advertising agencies, design firms, package design firms, display companies, and interactive clients.

Handles Illustration. Seeks established artists compatible with Hedge Graphics group.

Terms Rep receives 30% commission. Handles all negotiations and billing. Artist expected to appear on hedgereps.com and link Hedge as agent in his or her own site. Advertising costs are split: 75% paid by talent; 25% paid by representative. For promotional purposes, talent should provide reprint flyers, produce a new one on Hedge template, and CDs. Advertises in Workbook and at workbook.com.

How to Contact E-mail with samples attached or Web site address to view your work. Responds if interested.

Tips Obtains new talent after talent sees Workbook directory ad, or through referrals from art directors or other talent. As much experience as possible and zero or one other rep.

HERMAN AGENCY

350 Central Park West, New York NY 10025. (212)749-4907. Fax: (212)663-5151. E-mail: herman agen@aol.com. Web site: www.HermanAgencyInc.com. **Owner/President:** Ronnie Ann Herman. Illustration representative for children's market. Estab. 1999. Member of SCBWI, Graphic Artists' Guild. Represents 33 illustrators. Artists include Seymour Chwast, Alexi Natchev, Joy Allen, and Jago.

Handles Illustration. Looking for artists with strong history of publishing in the children's market.

Terms Rep receives 25% commission. Exclusive representation required. Advertising costs are split: 75% paid by the artist; 25% paid by rep. Advertises in direct mailing.

How to Contact For first contact, send bio, photocopies, SASE, tearsheets, list of published books or email and direct me to you web site. Responds in 4 weeks. Portfolio should include b&w and color tearsheets, copies of published books.

Tips " Check our Web site to see if you belong with our agency."

SCOTT HULL ASSOCIATES

4 West Franklin St., Suite 200, Dayton OH 45459. (937)433-8383. Fax: (937)433-0434. E-mail: scott@scotthull.com. Web site: www.scotthull.com. **Contact:** Scott Hull. Specialized illustration representative. Estab. 1981. Represents 25+ illustrators.

How to Contact Send e-mail samples or appropriate materials for review. No original art. Follow up with e-mail. Responds in one week.

Tips Looks for interesting talent with a passion to grow, as well as strong in-depth portfolio.

ICON ART REPS (A Division of Martha Productions)

7550 W. 82nd St., Playa Del Rey CA 90293. (310)670-5300. Fax: (310)670-3644. E-mail: contact@ marthaproductions.com. Web site: www.iconartreps.com. **President:** Martha Spelman. Commercial illustration representative. Estab. 1998. Represents 14 illustrators. Specializes in artists doing character design and development for advertising, promotion, publishing and licensed products.

• See listing for Martha Productions in this section.

KIRCHOFF/WOHLBERG, ARTISTS REPRESENTATION DIVISION

866 United Nations Plaza, #525, New York NY 10017. (212)644-2020. Fax: (212)223-4387. Web site: www.kirchoffwohlberg-artistrep.com. **Contact:** Libby Ford. Estab. 1930. Member of SPAR, Society of Illustrators, AIGA, Associaton of American Publishers, Bookbuilders of Boston, New York Bookbinders' Guild. Represents over 45 illustrators. Specializes in juvenile and young adult trade books and textbooks. Markets include publishing/books/editorial

Handles Illustration (juvenile and young adult).

Terms Advertises in *Art Directors' Index*, *Society of Illustrators Annual*, children's book issues of *Publishers Weekly*.

How to Contact Please send all correspondence to lford@kirchoffwohlberg.com. Portfolios should be sent electronically. Will contact you for additional materials.

CLIFF KNECHT—ARTIST REPRESENTATIVE

309 Walnut Rd., Pittsburgh PA 15202. (412)761-5666. Fax: (412)894-8175. E-mail: mail@artrep1 .com. Web site: www.artrep1.com. **Contact:** Cliff Knecht. Commercial illustration representative. Estab. 1972. Represents more than 20 illustrators. Markets include advertising agencies, corporations/client direct, design firms, editorial/magazines, paper products/greeting cards, publishing/books, sales/promotion firms.

Handles Illustration.

Terms Rep receives 25% commission. No geographic restrictions. Advertising costs are split: 75% paid by the talent; 25% paid by representative. For promotional purposes, talent must provide a direct mail piece. Advertises in *Graphic Artists Guild Directory of Illustration.*

How to Contact Send résumé, direct mail flier/brochure, tearsheets, and send jpegs samples by e-mail. Responds in 1 week. After initial contact, call for appointment to show portfolio of original art, tearsheets, slides, photographs. Obtains new talent directly or through recommendations from others.

ANN KOEFFLER ARTIST REPRESENTATION

4636 Cahuenga Blvd. Suite #204, Toluca Lake CA 91602. (818)260-8980. Fax: (818)260-8990. E-mail: annartrep@aol.com. Web site: www.annkoeffler.com. **Owner/Operator:** Ann Koeffler. Commercial illustration representative. Estab. 1984. Represents 20 illustrators. Markets include advertising agencies, corporations/client direct, design firms, editorial/magazines, paper products/greeting cards, publishing/books, individual small business owners.

Will Handle Interested in reviewing illustration. Looking for artists who are digitally adept.

Terms Rep receives 25-30% commission. Advertising costs 100% paid by talent. For promotional purposes, talent must provide an initial supply of promotional pieces and a committment to advertise regularly. Advertises in *Workbook* and *Folio Planet.*

How to Contact For first contact, send tearsheets or send images digitally. Responds in 1 week. Portfolio should include photocopies, 4×5 chromes.

Tips "I only carry artists who are able to communicate clearly and in an upbeat and professional manner."

SHARON KURLANSKY ASSOCIATES

192 Southville Rd., Southborough MA 01772. (508)460-0037. Fax: (508)480-9221. E-mail: lstock @charter.net. Web site: www.laughing-stock.com. **Contact:** Sharon Kurlansky. Commercial illustration representative. Estab. 1978. Represents illustrators. Markets include advertising agencies; corporations/client direct; design firms; editorial/magazines; paper products/greeting cards; publishing/books; sales/promotion firms. Client list available upon request. Represents Tim Lewis, Bruce Hutchison and Blair Thornley. Licenses stock illustration for 150 illustrators at www.laughing-stock.com in all markets.

Handles Illustration.

Terms Rep receives 25% commission. Exclusive area representation is required. Advertising costs are split: 75% paid by talent; 25% paid by representative. "Will develop promotional materials with talent. Portfolio presentation formated and developed with talent also."

How to Contact For first contact, send direct mail flier/brochure, tearsheets, slides and SASE or e-mail with Web site address/online portfolio. Responds in 1 month if interested. After initial contact, call for appointment to show portfolio of tearsheets, photocopies.

LANGLEY CREATIVE

333 N. Michigan Ave., Suite 1322, Chicago IL 60601. (312)782-0244. Fax: (312)782-1535. E-mail: s.langley@langleycreative.com or j.blasco@langleycreative.com. Web site: www.langleycreative.com. **Contact:** Sharon Langley or Jean Blasco. Commercial illustration representative. Estab. 1988. Represents 44 internationally acclaimed illustrators. Markets include advertising agencies; corporations; design firms; editorial/magazines; publishing/books; promotion. Clients include "every major player in the United States."

Handles Illustration. "We are receptive to reviewing samples by enthusiastic up-and-coming artists. E-mail samples and/or your Web site address."

Terms Rep receives 25% commission. Exclusive area representation is preferred. For promotional purposes, talent must provide printed promotional pieces and a well organized, creative portfolio. "If your book is not ready to show, be willing to invest in a new one." Advertises in *Workbook*, Directory of Illustration, Folio Planet, Theispot.

How to Contact For first contact, send samples via e-mail, or printed materials that do not have to be returned. Responds only if interested. Obtains new talent through recommendations from art directors, referrals and submissions.

Tips "You need to be focused in your direction and style. Be willing to create new samples. Be a 'team player.' The agent and artist form a bond, and the goal is success. Don't let your ego get in the way. Be open to constructive criticism. If one agent turns you down, quickly move to the next name on your list."

MARLENA AGENCY

322 Ewing St., Princeton NJ 08540. (609)252-9405. Fax: (609)252-1949. E-mail: marlena@marlenaagency.com. Web site: www.marlenaagency.com. Commercial illustration representative. Estab. 1990. Member of Art Directors Club of New York, Society of Illustrators. Represents 28 illustrators from France, Poland, Germany, Hungary, Italy, Spain, Canada and U.S. "We speak English, French, Spanish, German, Flemish, Polish and Russian." Specializes in conceptual illustration. Markets include advertising agencies, corporations/client direct, design firms, editorial/magazines, publishing/books, theaters.

● See also listing for MarlenaStock in the Stock Illustration & Clip Art Firms section.

Handles Illustration, fine art and prints.

Terms Rep receives 30% commission; 35% if translation needed. Costs are shared by all artists. Exclusive area representation is required. Advertising costs are split: 70% paid by talent; 30% paid by representative. For promotional purposes, talent must provide slides (preferably 8×10 framed), direct mail pieces, 3-4 portfolios. Advertises in *The Black Book*, *Workbook*. Many of the artists are regularly featured in *CA* Annuals, The Society of Illustrators Annuals, and American Illustration Annuals. Agency produces promotional materials for artists, such as wrapping paper, calendars, brochures.

How to Contact Send tearsheets or e-mail low-resolution images. Responds in 1 week, only if interested. After initial contact, drop off or mail appropriate materials. Portfolio should include tearsheets.

Tips Wants artists with "talent, good concepts-intelligent illustration, promptness in keeping up with projects, deadlines, etc."

MB ARTISTS

(Previously known as HK Portfolio), 10 E. 29th St., Suite 40G, New York NY 10016. (212)689-7830. Fax: (212)689-7829. E-mail: mela@mbartists.com. Web site: www.mbartists.com. **Con-**

tact: Mela Bolinao. Juvenile illustration representative. Estab. 1986. Member of SPAR, Society of Illustrators and SCBWI. Represents over 45 illustrators. Specializes in illustration for juvenile markets. Markets include advertising agencies; editorial/magazines; publishing/books; toys/games.

Handles Illustration.

Terms Exclusive representation required. Rep receives 25% commission. No geographic restrictions. Advertising costs are split: 75% paid by talent; 25% paid by representative. Advertises in Picture Book, Directory of Illustration, Play Directory, Workbook, folioplanet.com, and theIspot.com.

How to Contact E-mail query letter with Web site address or send portfolio with flier/brochure, tear sheets, published books if available, and SASE. Responds in 1 week. Portfolio should include at least 10-15 images exhibiting a consistent style.

Tips Leans toward "highly individual personal styles."

MORGAN GAYNIN INC.

194 Third Ave., New York NY 10003. (212)475-0440. Fax: (212)353-8538. E-mail: submissions@morgangaynin.com. Web site: www.morgangaynin.com. **Partners:** Vicki Morgan and Gail Gaynin. Illustration representatives. Estab. 1974. Markets include advertising agencies; corporations/client direct; design firms; magazines; books; sales/promotion firms.

Handles Illustration.

Terms Rep receives 30% commission. Exclusive area representation is required. No geographic restrictions. Advertising costs are split: 70% paid by talent; 30% paid by representative. Advertises in directories, on the Web, direct mail.

How to Contact Check Web site and click.

THE NEWBORN GROUP, INC.

115 W. 23rd St., Suite 43A, New York NY 10011. (212)989-4600. Fax: (212)989-8998. Web site: www.newborngroup.com. **Owner:** Joan Sigman. Commercial illustration representative. Estab. 1964. Member of Society of Illustrators; Graphic Artists Guild. Represents 12 illustrators. Markets include advertising agencies, design firms, editorial/magazines, publishing/books. Clients include Leo Burnett, Penguin Putnam, Time Inc., Weschler Inc.

Handles Illustration.

Terms Rep receives 30% commission. Exclusive area representation is required. Advertising costs are split: 70% paid by talent; 30% paid by representative. Advertises in *Workbook* and *Directory of Illustration*.

How to Contact "Not reviewing new talent."

Tips Obtains new talent through recommendations from other talent or art directors.

CHRISTINE PRAPAS/ARTIST REPRESENTATIVE

8402 SW Woods Creek Court, Portland OR 97219. E-mail: christine@christineprapas.com. Web site: www.christineprapas.com. **Contact:** Christine Prapas. Commercial illustration and photography representative. Estab. 1978. Member of AIGA and Graphic Artists Guild. "Promotional material welcome."

GERALD & CULLEN RAPP—ARTIST REPRESENTATIVES

420 Lexington Ave., Penthouse, New York NY 10170. (212)889-3337. Fax: (212)889-3341. E-mail: info@rappart.com. Web site: www.rappart.com. Commercial illustration representative.

Estab. 1944. Member of The Society of Illustrators and Graphic Artists Guild. Represents 60 illustrators. Markets include advertising agencies, corporations/client direct, design firms, editorial/magazines, paper products/greeting cards, publishing/books, sales/promotion firms.
Handles Illustration.

Terms Exclusive area representation is required. No geographic restrictions. Split of advertising costs is negotiated. Advertises in Workbook, The Graphic Artists Guild Directory of Illustration and CA and PRINT magazines. Conducts active direct mail program and advertises on the Internet.

How to Contact Send e-mail with a website link. Responds within 1 week if interested. Obtains new talent through recommendations from others, solicitations.

REMEN-WILLIS DESIGN GROUP

2964 Colton Rd., Pebble Beach CA 93953. (831)655-1407. Fax: (831)655-1408. E-mail: remenwillis@comcast.net. Web site: www.annremenwillis.com. **Art Rep:** Ann Remen-Willis. Children's book illustration representative. Estab. 1984. Member of SCBWI. Represents 15 illustrators. Specializes in children's books trade and text. Markets include design firms, editorial/magazines, paper products/greeting cards, publishing/books.

Handles Illustration—children's books only; no advertising.

Terms Rep receives 25% commission. Advertising costs are split: 50% paid by artist; 50% paid by rep. Advertises in *Picturebook* and postcard mailings.

How to Contact For first contact, send query letter with tearsheets. Responds in one week. After initial contact, call to schedule an appointment. Portfolio should include b&w and color tearsheets.

Tips ''Fill portfolio with samples of art you want to continue receiving as commissions. Do not include that which is not a true representation of your style and capability.''

ROSENTHAL REPRESENTS

3850 Eddingham Ave., Calabasas CA 91302. (818)222-5445. Fax: (818)222-5650. E-mail: elise@rosenthalrepresents.com. Web site: www.rosenthalrepresents.com. **Contact**: Elise Rosenthal or Neil Sandler, neilsandler72@hotmail.com. Primarily licensing agents. Estab. 1979. Previously member of Society of Illustrators, Graphic Artists Guild. Presently member of Women in Design and LIMA, a licensing organization. Represents 25 artists and designers geared for creating products, such as dinnerware, rugs, placemats, rugs, cutting boards, coasters, kitchen and bath textiles, bedding, wall hangings, children's and baby products,stationary, and more. Specializes in licensing, merchandising art. Markets include manufacturers of tabletop products, rugs, kitchen and bath textiles, paper products/greeting cards, and more. Handles product designers and artists. Must know adobe photoshop and other computer programs to help artist adapt art into product mockups.

Terms Rep receives 50% as a licensing agent. Exclusive licensing representation is required. No geographic restrictions. Artist contributes $800 once a year to exhibit with RR at our two all important trade shows, Surtex and Licensing Shows. For promotional purposes, talent must provide CD of artwork designs and website link if available. We advertise in Total Art Licensing. Only contact us if you have done product design and if you are willing to work hard, give the agent lots of new work all the time. Must be willing to accept critiques and are willing to make corrections.

How to Contact Send email, and computer link, or direct mail flier/brochure, tearsheets, photo-

copies, and SASE. Responds in 1 week. After initial contact, call for appointment to show portfolio of tearsheets, photographs, photocopies. Obtains new talent through seeing their work in trade shows, in magazines and through referrels.

THE SCHUNA GROUP

1503 Briarknoll Dr., Arden Hills MN 55112. (651)631-8480. Fax: (651)631-8426. E-mail: joanne@ schunagroup.com. Web site: www.schunagroup.com. **Contact:** JoAnne Schuna. Commercial illustration representative. Represents 15 illustrators. Specializes in illustration. Markets include advertising agencies, corporations/client direct, design firms, editorial/magazines, paper products/greeting cards, publishing/books, record companies, sales/promotion firms. Represented artists include Cathy Gendron and Jim Dryden.

Handles Interested in reviewing illustration samples.

Terms Rep receives 25% commission. Exclusive representation required. Advertising costs are split: 75% paid by artist; 25% paid by rep. Advertises in various mediums.

How to Contact For first contact, send 2-3 digital samples via e-mail. "I will respond via e-mail within a few weeks at most if interested."

Tips "Listing your Web site in your e-mail is helpful, so I can see more if interested."

THOSE 3 REPS

501 S. 2nd Ave., Suite A600, Dallas TX 75226. (214)871-1316. Fax: (214)880-0337. E-mail: morei nfo@those3reps.com. Web site: www.those3reps.com. **Contact:** Debbie Bozeman, Carol Considine. Artist representative. Estab. 1989. Member of Dallas Society of Visual Community, ASMP, SPAR and Dallas Society of Illustrators. Represents 15 illustrators, 8 photographers. Specializes in commercial art. Markets include advertising agencies; corporations/client direct; design firms; editorial/magazines.

Handles Illustration, photography (including digital).

Terms Rep receives 30% commission; 30% for out-of-town jobs. Exclusive area representation is required. Advertising costs are split 70% paid by talent; 30% paid by representative. For promotional purposes, talent must provide 2 new pieces every 2 months, national advertising in sourcebooks and at least 1 mailer. Advertises in *Workbook*, own book.

How to Contact For first contact, send query letter and tearsheets. Responds in days or weeks only if interested. After initial contact, call to schedule an appointment, drop off or mail in appropriate materials. Portfolio should include tearsheets, photostats, transparencies, digital prints.

Tips Wants artists with "strong unique consistent style."

THREE IN A BOX INC.

67 Mowat Ave., Ste. 236 Toronto, ON Canada. (416)367-2446. Fax: (416)367-3362. E-mail: info@ threeinabox.com. Web site: www.threeinabox.com. **Managing Director:** Holly Venable. Commercial illustration representative. Estab. 1990. Member of Graphic Artists Guild. Represents 53 illustrators, 2 photographers. Specializes in illustration. Licenses illustrators and photographers. Markets include advertising agencies, corporations/client direct, design firms, editorial/magazines, paper products/greeting cards, publishing/books, record companies, sales/promotion firms.

How to Contact For first contact, send query letter and URL to info@threeinabox.com. Responds in 1 week. After initial contact, rep will call if interested. Send only links to website.

GWEN WALTERS

1801 S. Flagler Dr. #1202, West Palm Beach FL 33401. (561)805-7739. Fax: (561)805-5931. E-mail: artincgw@aol.com. Web site: www.gwenwaltersartrep.com. Commercial illustration representative. Estab. 1976. Represents 19 illustrators. Markets include advertising agencies; corporations/client direct; editorial/magazines; paper products/greeting cards; publishing/books; sales/promotion firms. "I lean more toward book publishing." Represents Gerardo Suzan, Fabricio Vanden Broeck, Resario Valderrama, Lave Gregory, Susan Spellman, Judith Pfeiffer, Yvonne Gilbert, Gary Torrisi, Larry Johnson, Pat Daris, Scott Wakefield, Tom Barrett and Linda Pierce.

Handles Illustration.

Terms Rep receives 30% commission. Charges for color photocopies. Advertising costs are split: 50% paid by talent; 50% paid by representative. For promotional purposes, talent must provide direct mail pieces. Advertises in *RSVP, Directory of Illustration.*

How to Contact For first contact, send résumé, bio, direct mail flier/brochure. After initial contact, representative will call. Portfolio should include "as much as possible."

Tips "You need to pound the pavement for a couple of years to get some experience under your belt. Don't forget to sign all artwork. So many artists forget to stamp their samples."

THE WILEY GROUP

1535 Green St., Suite #301, San Francisco CA 94123. (415)441-3055. Fax: (415)520-0999. E-mail: office@thewileygroup.com. Web site: www.thewileygroup.com. **Owner:** David Wiley. Commercial artist and fine art illustration and photography representative. Estab. in 1984 as an artist agency that promotes and sells the work of illustrators for commercial use worldwide. He has over 24 years of experience in the industry, and an extensive knowledge about the usage, pricing and m marketing of commercial art. Currently, David represents 13 illustrators. The artist's work is all digital. The artist agency services accounts in advertising, design and publishing as well as corporate accounts. **Partial client list:** Disney, Coca Cola, Smithsonian, Microsoft, Nike, Oracle, Google, Random house, Eli Lilly Pharmaceuticals, National Geographic, Kraft Foods, FedEx, Nestle Corp., Apple Computers.

Terms Rep receives 25% commission with a bonus structure. No geographical restriction. Artist is responsible for all portfolio costs. Artist pays 75% of sourcebook ads, postcard/tearsheet mailings. Agent will reimburse artist for 25% of costs. Each year the artists are promoted using online agencies, bimonthly postcard mailings, and monthly e-cards (e-mail postcards).

How to Contact For first contact, e-mail Web site URL and one visual image representing your style. If interested, agent will e-mail or call back to discuss representation.

Tips "The bottom line is that a good agent will get you *more* work at *better rates* of pay."

DEBORAH WOLFE LTD.

731 N. 24th St., Philadelphia PA 19130. (215)232-6666. Fax: (215)232-6585. E-mail: info@illustrationOnLine.com. Web site: www.illustrationOnLine.com. **Contact:** Deborah Wolfe. Commercial illustration representative. Estab. 1978. Represents 30 illustrators. Markets include advertising agencies, corporations/client direct, design firms, editorial/magazines, publishing/books.

Handles Illustration.

Terms Rep receives 25% commission. Advertises in Workbook, Directory of Illustration, Picturebook and The Medical Sourcebook.

How to Contact For first contact, send an e-mail with samples or a Web address. Responds in 3 weeks.

Art Fairs

How would you like to sell your art from New York to California, showcasing it to thousands of eager art collectors? Art fairs (also called art festivals or art shows) are not only a good source of income for artists but an opportunity to see how people react to their work. If you like to travel, enjoy meeting people, and can do your own matting and framing, this could be a great market for you.

Many outdoor fairs occur during the spring, summer and fall months to take advantage of warmer temperatures. However, depending on the region, temperatures could be hot and humid, and not all that pleasant! And, of course, there is always the chance of rain. Indoor art fairs held in November and December are popular because they capitalize on the holiday shopping season.

To start selling at art fairs, you will need an inventory of work—some framed, some unframed. Even if customers do not buy the framed paintings or prints, having some framed work displayed in your booth will give buyers an idea of how your work looks framed, which could spur sales of your unframed prints. The most successful art fair exhibitors try to show a range of sizes and prices for customers to choose from.

When looking at the art fairs listed in this section, first consider local shows and shows in your neighboring cities and states. Once you find a show you'd like to enter, visit its Web site or contact the appropriate person for a more detailed prospectus. A prospectus is an application that will offer additional information not provided in the art fair's listing.

Ideally, most of your prints should be matted and stored in protective wraps or bags so that customers can look through your inventory without damaging prints and mats. You will also need a canopy or tent to protect yourself and your wares from the elements as well as some bins in which to store the prints. A display wall will allow you to show off your best framed prints. Generally, artists will have 100 square feet of space in which to set up their tents and canopies. Most listings will specify the dimensions of the exhibition space for each artist.

If you see the ⚑ icon before a listing in this section, it means that the art fair is a juried event. In other words, there is a selection process artists must go through to be admitted into the fair. Many art fairs have quotas for the categories of exhibitors. For example, one art fair may accept the mediums of photography, sculpture, painting, metal work and jewelry. Once each category fills with qualified exhibitors, no more will be admitted to the show that year. The jurying process also ensures that the artists who sell their work at the fair meet the sponsor's criteria for quality. So, overall, a juried art fair is good for artists because it means they will be exhibiting their work along with other artists of equal caliber.

Be aware there are fees associated with entering art fairs. Most fairs have an application

fee or a space fee, or sometimes both. The space fee is essentially a rental fee for the space your booth will occupy for the art fair's duration. These fees can vary greatly from show to show, so be sure to check this information in each listing before you apply to any art fair.

Most art fair sponsors want to exhibit only work that is handmade by the artist, no matter what medium. Unfortunately, some people try to sell work that they purchased elsewhere as their own original artwork. In the art fair trade, this is known as "buy/sell." It is an undesirable situation because it tends to bring down the quality of the whole show. Some listings will make a point to say "no buy/sell" or "no manufactured work."

For more information on art fairs, pick up a copy of *Sunshine Artist* or *Art Calendar*, and consult online sources such as www.artfairsource.com, www.artcalendar.com and www.festival.net.

NORTHEAST & MIDATLANTIC

☑ ALLENTOWN ART FESTIVAL

P.O. Box 1566, Ellicott Station, Buffalo NY 14205-1566. (716)881-4269. E-mail: allentownartfesti val@verizon.net. Web site: www.allentownartfestival.com. **Contact:** Mary Myszkiewicz, president. Estab. 1958. Fine arts & crafts show held annually 2nd full weekend in June. Outdoors. Accepts photography, painting, watercolor, drawing, graphics, sculpture, mixed media, clay, glass, acrylic, jewelry, creative craft (hard/soft). Slides juried by hired professionals that change yearly. Awards/prizes: $17,925 in 40 cash prizes; Best of Show. Number of exhibitors: 450. Public attendance: 300,000. Free to public. Artists should apply by downloading application from Web site. Deadline for entry: January 31. Application fee: $15. Space fee: $250. Exhibition space: 13 × 10 ft. For more information, artists should e-mail, visit Web site, call or send SASE. **Tips** "Artists must have attractive booth and interact with the public."

☑ ART IN THE HEART OF THE CITY

171 E. State St., Ithaca NY 14850. (607)277-8679. Fax: (607)277-8691. E-mail: phil@downtownit haca.com. Web site: www.downtownithaca.com. **Contact:** Phil White, office manager/event coordinator. Estab. 1999. Sculpture exhibition held annually in early June. Primarily outdoors; limited indoor pieces. Accepts photography, wood, ceramic, metal, stone. Juried by Public Arts Commission. Number of exhibitors: 28-35. Public attendance: 100,000 +. Free to public. Artists should apply by submitting application, artist statement, slides/photos. Deadline for entry: May. Exhibition space depends on placement. For more information, artists should e-mail. This year we are having a "Green Exhibition, a pioneering step for public art across the country. We will focus on only (3) artists, and publicize their work broadly. The stipend has been increased to $1,500 per artist. We're creating a new online gallery and we're collaborating with area arts, sustainability and education groups for public programs. Art in the Heart '09 is asking for you to use the 'Green' interpretation as a starting point—and, through your submissions, help us."- **Tips** "Be sure there is a market and interest for your work, and advertise early."

☑ ART IN THE PARK FALL FOLIAGE FESTIVAL

(formerly Art in the Park Fall Foliage Festival), sponsored by the Chaffee Center for the Visual Arts. 16 S. Main St., Rutland VT 05701. (802)775-0356. Fax: (802)773-4401. E-mail: beyondmark eting@yahoo.com. Web site: www.chaffeeartcenter.org. **Contact:** Sherri Birkheimer Rooker, event coordinator. Estab. 1961. Fine arts & crafts show held annually Columbus weekend. Outdoors. Accepts photography, clay, fiber, floral, glass, wood, jewelry, soaps and baskets. Juried

by a panel of 10-15 judges. Submit 3 slides (2 of artwork and 1 of booth display). Number of exhibitors: 130. Public attendance: 7,000-9,000. Public admission: voluntary donation. Artists should apply by submitting three slides of work and one of booth (photos upon preapproval). Deadline for entry: "Ongoing jurying, but to receive discount for doing both shows, March 31." Space fee: $180-330. Exhibition space: 10×12 ft. and 20×12 ft. For more information, artists should e-mail, visit Web site or call.

Tips "Have a good presentation and variety, if possible (in pricing also), to appeal to a large group of people."

ART IN THE PARK SUMMER FESTIVAL

16 South Main St., Rutland VT 05701. (802)775-0356. Fax: (802)773-4401. E-mail: beyondmarket ing@yahoo.com. Web site: chaffeartcenter.org. Sherri Birkheimer Rooker, event coordinator. Estab. 1961. Fine arts and crafts show held outdoors annually in August. 2008 dates: August 9 and 10. Accepts photography, clay, fiber, floral, glass, art, specialty foods, wood, jewelry, hand-made soaps, lampshades, baskets, etc. Juried by a panel of 10-15 judges who perform a blind review of slide submissions. Number of exhibitors: 130. Public attendance: 8,000. Public admission: voluntary donation. Artists should submit three slides of work and one of booth (photos upon pre-approval). Deadline for entry: on-going but to receive discount for doing both shows, must apply by March 31; $25 late fee after that date. Space fee: $180-$330. For more information, artists should e-mail, visit Web site, or call.

Tips "Have a good presentation, variety if possible (in price ranges, too) to appeal to a large group of people."

ART'S ALIVE

200-125th St. & the Bay, Ocean City MD 21842-2247. (410)250-0125. Fax: (410)250-5409. E-mail: Bmoore@ococean.com. Web site: www.ococean.com. **Contact:** Brenda Moore, event coordinator. Estab. 2000. Fine art show held annually in mid-June. Outdoors. Accepts photography, ceramics, drawing, fiber, furniture, glass, printmaking, jewelry, mixed media, painting, sculpture, fine wood. Juried. Awards/prizes: $5,000 in cash prizes. Number of exhibitors: 110. Public attendance: 10,000. Free to pubic. Artists should apply by downloading application from Web site or call. Deadline for entry: February 28. Space fee: $75. Jury Fee: $25. Exhibition space: 10×10 ft. For more information, artists should e-mail, visit Web site, call or send SASE.

Tips "Apply early."

ARTS ON FOOT

Downtown DC BID, 1250 H St., NW, Suite 1000, Washington DC 20005. (202)661-7592. E-mail: ashley@downtowndc.org. Web site: www.artsonfoot.org. **Contact:** Ashley Neeley. Fine arts & crafts show held annually in September. Outdoors. Accepts photography, painting, sculpture, fiber art, furniture, glass, jewelry, leather. Juried by 5 color images of the artwork. Send images as 35mm slides, TIFF or JPEG files on CD or DVD. Also include artist's résumé and SASE for return of materials. Free to the public. Deadline for entry: July. Exhibition space: 10×10 ft. "Arts on Foot will pay participating artists a $25 gratuity to help cover out-of-pocket expenses (such as transportation and food) each artist may incur during Arts on Foot." For more information, artists should call, e-mail, visit Web site.

✔ CHATSWORTH CRANBERRY FESTIVAL

P.O. Box 286, Chatsworth NJ 08019-0286. (609)726-9237. Fax: (609)726-1459. E-mail: lgiamalis @aol.com. Web site: www.cranfest.org. **Contact:** Lynn Giamalis, chairperson. Estab. 1983. Arts & crafts show held annually in October. Outdoors. Accepts photography. Juried. Number of exhibitors: 200. Public attendance: 75,000-100,000. Free to public. Artists should apply by sending SASE to above address. Deadline for entry: September 1. Space fee: $200. Exhibition space: 15×15 ft. For more information, artists should visit Web site.

✔ CHRISTMAS CRAFTS EXPOS I & II

P.O Box 227, North Granby CT 06060. (860)653-6671. Fax: (860)653-6858. E-mail: acf@handma deinamerica.com. Web site: www.handmadeinamerica.com. **Contact:** Joanne McAulay, president. Estab. 1971. Fine arts & crafts holiday show held annually 1st 2 weekends in December. Indoors. Accepts photography, metal, fiber, pottery, glass, wood, jewelry, pen & ink. Juried by 6 product slides or photos, 1 booth photo, and 1 studio or shop photo (where the art is made). Number of exhibitors: 200. Public attendance: 10,000. Public admission: $7. Artists should apply by calling for an application or by downloading one from Web site. Deadline for entry: Applications are juried and space sold until sold out. Space fee: $420-$650. Exhibition space: 10×10 ft.; 10×15 ft.; 10×20 ft. For more information, artists should e-mail, visit Web site, send SASE. **Tips:** "Look at current market trends and economics. Have a unique and presentable booth. Be personable and friendly to customers."

✔ COLORSCAPE CHENANGO ARTS FESTIVAL

P.O. Box 624, Norwich NY 13815. (607)336-3378. E-mail: info@colorscape.org. Web site: www. colorscape.org. **Contact:** Peggy Finnegan, festival director. Estab. 1995. Fine arts & crafts show held annually the weekend after Labor Day. Outdoors. Accepts photography and all types of mediums. Juried. Awards/prizes: $5,000. Number of exhibitors: 80-85. Public attendance: 14,000-16,000. Free to public. Deadline for entry: March. Application fee: $15/jury fee. Space fee: $150. Exhibition space: 12×12 ft. For more information, artists should e-mail, visit Web site, call or send SASE.

Tips "Interact with your audience. Talk to them about your work and how it is created. Don't sit grumpily at the rear of your booth reading a book. People like to be involved in the art they buy and are more likely to buy if you involve them."

⚝ ✔ CRAFT FAIR AT THE BAY

Castleberry Fairs & Festivals, 38 Charles St., Rochester NH 03867. (603)332-2616. E-mail: info@c astleberryfairs.com. Web site: www.castleberryfairs.com. **Contact:** Terry Mullen, event coordinator. Estab. 1988. Arts & crafts show held annually in July in Alton Bay, New Hampshire. Outdoors. Accepts photography and all other mediums. Juried by photo, slide or sample. Number of exhibitors: 85. Public attendance: 7,500. Free to the public. Artists should apply by downloading application from Web site. Deadline for entry: until full. Space fee: $250. Exhibition space: 100 sq. ft. Average gross sales/exhibitor: "Generally, this is considered an 'excellent' show, so I would guess most exhibitors sell ten times their booth fee, or in this case, at least $2,500 in sales." For more information, artists should visit Web site.

Tips "Do not bring a book; do not bring a chair. Smile and make eye contact with everyone who enters your booth. Have them sign your guest book; get their e-mail address so you can let them know when you are in the area again. And, finally, make the sale—they are at the fair to shop, after all."

☑ CRAFTS AT RHINEBECK

6550 Springbrook Ave., Rhinebeck NY 12572. (845)876-4001. Fax: (845)876-4003. E-mail: vimpe rati@dutchessfair.com. Web site: www.craftsatrhinebeck.com. **Contact:** Vicki Imperati, event coordinator. Estab. 1981. Fine arts & crafts show held biannually in late June and early October. Indoors and outdoors. Accepts photography, fine art, ceramics, wood, mixed media, leather, glass, metal, fiber, jewelry. Juried by 3 slides of work and 1 of booth display. Number of exhibitors: 350. Public attendance: 25,000. Public admission: $7. Artists should apply by calling for application or downloading application from Web site. Deadline for entry: February 1. Application fee: $20. Space fee: $300-730. Exhibition space: inside: 10×10 ft. and 10×20 ft.; outside: 15×15 ft. For more information, artists should e-mail, visit Web site or call.

Tips "Presentation of work within your booth is very important. Be approachable and inviting."

☒ ☑ ELMWOOD AVENUE FESTIVAL OF THE ARTS, INC.

P.O. Box 786, Buffalo NY 14213. (716)830-2484. E-mail: directoreafa@aol.com. Web site: www. elmwoodartfest.org. **Contact:** Joe DiPasquale. Estab. 2000. Arts & crafts show held annually in late-August, the weekend before Labor Day weekend. Outdoors. Accepts photography, metal, fiber, ceramics, glass, wood, jewelry, basketry, 2D media. Juried. Awards/prizes: to be determined. Number of exhibitors: 170. Public attendance: 80,000-120,000. Free to the public. Artists should apply by e-mailing their contact information or by downloading application from Web site. Deadline for entry: April. Application fee: $20. Space fee: $200. Exhibition space: 150 sq. ft. Average gross sales/exhibitor: $3,000. For more information, artists should e-mail, visit Web site, call, send SASE.

Tips: "Make sure your display is well designed, with clean lines that highlight your work. Have a variety of price points—even wealthy people don't always want to spend $500 at a booth where they may like the work."

☑ A FAIR IN THE PARK

1005 Oglethorpe St., Pittsburgh PA 15201. (212)655-5796. Fax: (347)220-1181. E-mail: info@craf tsmensguild.org. Web site: www.craftsmensguild.org. **Contact:** Leah Shannon, director. Estab. 1969. Contemporary fine arts & crafts show held annually the weekend after Labor Day outdoors. Accepts photography, clay, fiber, jewelry, metal, mixed media, wood, glass, 2D visual arts. Juried. Awards/prizes: 1 Best of Show and 4 Craftsmen's Guild Awards. Number of exhibitors: 115. Public attendance: 25,000+. Free to public. Artists should apply by sending application with jury fee, booth fee and 5 digital images. Deadline for entry: May 1. Application fee: $25. Space fee: $250-300. Exhibition space: 11×12 ft. Average gross sales/exhibitor: $1,000 and up. For more information artists should e-mail, visit Web site or call.

Tips "It is very important for artists to present their work to the public, to concentrate on the business aspect of their artist career. They will find that they can build a strong customer/ collector base by exhibiting their work and by educating the public about their artistic process and passion for creativity."

☑ FALL CRAFTS AT LYNDHURST

P.O. Box 28, Woodstock NY 12498. (845)331-7900. Fax: (845)331-7484. E-mail: crafts@artrider.c om. Web site: www.artrider.com. **Contact:** Laura Kandel. Estab. 1984. Fine arts & crafts show held annually in mid-September. Outdoors. Accepts photography, wearable and nonwearable fiber, metal and nonmetal jewelry, clay, leather, wood, glass, painting, drawing, prints mixed

media. Juried by 5 images of work and 1 of booth, viewed sequentially. Number of exhibitors: 325. Public attendance: 14,000. Public admission: $10. Artists should apply by downloading application from www.artrider.com or can apply online at www.zapplication.org. Deadline for entry: January 14. Application fee: $35. Space fee: $775. Exhibition space: 10×10. For more information, artists should e-mail, visit Web site, call.

☑ FALL FINE ART & CRAFTS AT BROOKDALE PARK

Watchung Ave., Montclair NJ. (908)874-5247. Fax: (908)874-7098. E-mail: rosesquared@patme dia.com. Web site: www.rosesquared.com. **Contact:** Janet Rose, president. Estab.1997. Fine arts & craft show held annually in mid-October. Outdoors. Accepts photography and all other mediums. Juried. Number of exhibitors: 180. Public attendance: 14,000. Free to the public. Artists should apply by downloading application from Web site or call for application. Deadline: 1 month before show date. Application fee: $15. Space fee: $310. Exhibition space: 120 sq. ft. For more information, artists should e-mail, visit Web site, call.

Tips "Create a professional booth that is comfortable for the customer to enter. Be informative, friendly and outgoing. People come to meet the artist."

☑ FALL FINE ART & CRAFTS AT NOMAHEGAN PARK

Springfield Ave, Cranford NJ. (908)874-5247. Fax: (908)874-7098. E-mail: rosesquared@patmed ia.com. Web site: www.rosesquared.com. **Contact:** Janet Rose, president. Estab.1986. Fine arts & craft show held annually in October. Outdoors. Accepts photography and all other mediums. Juried. Number of exhibitors: 100. Public attendance: 14,000. Free to the public. Artists should apply by downloading application from Web site or call for application. Deadline: 1 month before show date. Application fee: $20. Space fee: $325. Exhibition space: 120 sq. ft. For more information, artists should e-mail, visit Web site, call.

Tips "Create a professional booth that is comfortable for the customer to enter. Be informative, friendly and outgoing. People come to meet the artist."

☑ FINE ART & CRAFTS AT ANDERSON PARK

N. Mountain Ave., Upper Montclair NJ. (908)874-5247. Fax: (908)874-7098. E-mail: rosesquared @patmedia.net. Web site: www.rosesquared.com. **Contact:** Janet Rose, president. Estab.1984. Fine arts & craft show held annually in mid-September. Outdoors. Accepts photography and all other mediums. Juried. Number of exhibitors: 190. Public attendance: 16,000. Free to the public. Artists should apply by downloading application from Web site or call for application. Deadline: 1 month before show date. Application fee: $15. Space fee: $310. Exhibition space: 120 sq. ft. For more information, artists should e-mail, visit Web site, call.

Tips "Create a professional booth that is comfortable for the customer to enter. Be informative, friendly and outgoing. People come to meet the artist."

☑ FINE ART & CRAFTS AT NOMAHEGAN PARK

Springfield Ave., Cranford NJ. (908)874-5247. Fax: (908)874-7098. E-mail: rosesquared@pat media.com. Web site: www.rosesquared.com. **Contact:** Janet Rose, president. Estab. 1987. (908)874-5247. Fax: (908)874-7098. Fine arts & craft show held annually in early June. Outdoors. Accepts photography and all other mediums. Juried. Number of exhibitors: 110. Public attendance: 12,000. Free to the public. Artists should apply by downloading application from Web site or call for application. Deadline: 1 month before show date. Application fee: $15.

Space fee: $310. Exhibition space: 120 sq. ft. For more information, artists should e-mail, visit Web site, call.

Tips "Create a professional booth that is comfortable for the customer to enter. Be informative, friendly and outgoing. People come to meet the artist."

FINE ART & CRAFTS FAIR AT VERONA PARK

Verona Park NJ. (908)874-5247. Fax: (908)874-7098. E-mail: rosesquared@patmedia.net. Web site: www.rosesquared.com. **Contact:** Janet Rose, president. Estab.1986. Fine arts & craft show held annually in May. Outdoors. Accepts photography and all other mediums. Juried. Number of exhibitors: 140. Public attendance: 14,000. Free to the public. Artists should apply by downloading application from Web site or call for application. Deadline: 1 month before show date. Application fee: $15. Space fee: $310. Exhibition space: 120 sq. ft. For more information, artists should e-mail, visit Web site, call.

Tips "Create a professional booth that is comfortable for the customer to enter. Be informative, friendly and outgoing. People come to meet the artist."

FORD CITY HERITAGE DAYS

P.O. Box 205, Ford City PA 16226-0205. (724)763-1617. Fax: (724)763-1763. E-mail: pendletonhomer@hotmail.com. Estab. 1980. Arts & crafts show held annually on the Fourth of July. Outdoors. Accepts photography, any handmade craft. Juried by state. Awards/prizes: 1st & 2nd place plaques for best entries. Public attendance: 35,000-50,000. Free to public. Artists should apply by requesting an application by e-mail or telephone. Deadline for entry: April 15. Application fee: $200. Space fee included with application fee. Exhibition space: 12×17 ft. For more information, artists should e-mail, call or send SASE.

Tips "Show runs for six days. Have quality product, be able to stay for length of show, and have enough product."

GARRISON ART CENTER FINE ART & CRAFT FAIR

P.O. Box 4, 23 Camison's Landing, Garrison NY 10524. (845)424-3960. Fax: (845)424-3960. E-mail: gac@highlands.com. Web site: www.garrisonartcenter.org. Estab. 1969. **Contact:** Libby Turnock, executive director. Fine arts & crafts show held annually 3rd weekend in August. Outdoors. Accepts all mediums. Juried by a committee of artists and community members. Number of exhibitors: 75. Public attendance: 10,000. Public admission: suggested donation of $5. Artists should call for application form or download from Web site. Deadline for entry: April. Application fee: $15. Space fee: $245; covered corner booth: $265. Exhibition space: 10×10 ft. For more information, artists should e-mail, visit Web site, call, send SASE.

Tips "Have an inviting booth and be pleasant and accessible. Don't hide behind your product—engage the audience."

GLOUCESTER WATERFRONT FESTIVAL

Castleberry Fairs & Festivals, 38 Charles St., Rochester NH 03867. (603)332-2616. E-mail: info@castelberryfairs.com. Web site: www.castleberryfairs.com. **Contact:** Terry Mullen, events coordinator. Estab. 1971. Arts & crafts show held 3rd weekend in August in Gloucester, Massachusettes. Outdoors. Accepts photography and all other mediums. Juried by photo, slide or sample. Number of exhibitors: 300. Public attendance: 50,000. Free to the public. Artists should apply by downloading application from Web site. Deadline for entry: until full. Space fee: $350. Exhibition

space: 100 sq. ft. Average gross sales/exhibitor: "Generally, this is considered an 'excellent' show, so I would guess most exhibitors sell ten times their booth fee, or in this case, at least $3,500 in sales." For more information, artists should visit Web site.

Tips "Do not bring a book; do not bring a chair. Smile and make eye contact with everyone who enters your booth. Have them sign your guest book; get their e-mail address so you can let them know when you are in the area again. And, finally, make the sale—they are at the fair to shop, after all."

🅽 🆈 GREAT NECK STREET FAIR

P.O. Box 477, Smithtown NY 11787-0477.(631)724-5966. Fax: (631)724-5967. E-mail: showtique s@aol.com. Web site: www.showtiques.com. **Contact:** Eileen. Estab. 1978. Fine arts & crafts show held annually in May. Outdoors. Accepts photography, all arts & crafts made by the exhibitor. Juried. Number of exhibitors: 250. Public attendance: 50,000. Free to public. Deadline for entry: until full. Space fee: $150-175. Exhibition space: 10 × 10 ft. For more information, artists should e-mail, visit Web site or call.

🅽 🆈 GUNSTOCK SUMMER FESTIVAL

Castleberry Fairs & Festivals, 38 Charles St., Rochester NH 03867. (603)332-2616. E-mail: info@c astelberryfairs.com. Web site: www.castleberryfairs.com. **Contact:** Terry Mullen, events coordinator. Estab. 1971. Arts & crafts show held annually in July in Gilford, New Hampshire. Indoors and outdoors. Accepts photography and all other mediums. Juried by photo, slide or sample. Number of exhibitors: 100. Public attendance: 10,000. Free to the public. Artists should apply by downloading application from Web site. Deadline for entry: until full. Space fee: $200. Exhibition space: 100 sq. ft. For more information, artists should visit Web site.

Tips "Do not bring a book; do not bring a chair. Smile and make eye contact with everyone who enters your booth. Have them sign your guest book; get their e-mail address so you can let them know when you are in the area again. And, finally, make the sale—they are at the fair to shop, after all."

🆈 HOLIDAY CRAFTS AT MORRISTOWN

P.O. Box 28, Woodstock NY 12498. (845)331-7900. Fax: (845)331-7484. E-mail: crafts@artrider.c om. Web site: www.craftsatmorristown.com; www.artrider.com. **Contact:** Laura Kandel. Estab. 1990. Fine arts & crafts show held annually in early December. Indoors. Accepts photography, wearable and nonwearable fiber, metal and nonmetal jewelry, clay, leather, wood, glass, painting, drawing, prints, mixed media. Juried by 5 images of work and 1 of booth, viewed sequentially. Number of exhibitors: 165. Public attendance: 5,000. Public admission: $7. Artists should apply by downloading application from www.artrider.com or can apply online at www.zapplicat ion.org. Deadline for entry: August 1. Application fee: $35. Space fee: $475. Exhibition space: 10 × 10. For more information, artists should e-mail, visit Web site, call.

HOME, CONDO AND GARDEN ART & CRAFT FAIR

P.O. Box 486, Ocean City MD 21843. (410)524-7020. Fax: (410)524-0051. E-mail: oceanpromotio ns@beachin.net. Web site: www.oceanpromotions.info. **Contact:** Mike, promoter; Starr, assistant. Estab. 1984. Fine arts & crafts show held annually in March. Indoors. Accepts photography, carvings, pottery, ceramics, glass work, floral, watercolor, sculpture, prints, oils, pen & ink. Number of exhibitors: 125. Public attendance: 18,000. Public admission: $7/adults; $6/seniors

& students; 13 and under free. Artists should apply by e-mailing request for info and aplication. Deadline for entry: Until full. Space fee: $250. Exhibition space: 10 × 8 ft. For more information, artists should e-mail, visit Web site or call.

N Y JOHNS HOPKINS UNIVERSITY SPRING FAIR

3400 N Charles Street, Mattin Suite 210, Baltimore MD 21218. (410)513-7692. Fax: (410)516-6185. E-mail: springfair@gmail.com. Web site: www.jhuspringfair.com. **Contact:** Catalina Mc-Callum, arts & crafts chair. Estab. 1972. Fine arts & crafts, campus-wide, festival held annually in April. Outdoors. Accepts photography and all mediums. Juried. Number of exhibitors: 80. Public attendance: 20,000 + . Free to public. Artists should apply via Web site. Deadline for entry: March 1. Application fee: $200. Space fee: $200. Exhibition space: 10 × 10 ft. For more information, artists should e-mail, visit Web site or call.

Tips "Artists should have fun displays, good prices, good variety and quality pieces."

N Y LILAC FESTIVAL ARTS & CRAFTS SHOW

171 Reservoir Ave., Rochester NY 14620. (585)256-4960. Fax: (585)256-4968. E-mail: info@lilacf estival.com. Web site: www.lilacfestival.com. **Contact:** Sue LeBeau, art show coordinator. Estab. 1985. Arts & crafts show held annually in May. Outdoors. Accepts photography, painting, ceramics, woodworking, metal sculpture, fiber. Juried by a panel. Number of exhibitors: 150. Public attendance: 25,000. Free to public. Deadline for entry: March 1. Application fee: $190. Space fee: $190. Exhibition space: 10 × 10 ft. For more information, artists should visit Web site or send SASE.

N Y MEMORIAL WEEKEND ARTS & CRAFTS FESTIVAL

Castleberry Fairs & Festivals. 38 Charles St., Rochester NH 03867. (603)332-2616. E-mail: info@c astleberryfairs.com. Web site: www.castleberryfairs.com. **Contact:** Terry Mullen, event coordinator. Estab. 1989. Arts & crafts show held annually on Memorial Day weekend in Meredith, New Hampshire. Outdoors. Accepts photography and all other mediums. Juried by photo, slide or sample. Number of exhibitors: 85. Public attendance: 7,500. Free to the public. Artists should apply by downloading application from Web site. Deadline for entry: until full. Space fee: $300. Exhibition space: 100 sq. ft. Average gross sales/exhibitor: "Generally, this is considered an 'excellent' show, so I would guess most exhibitors sell ten times their booth fee, or in this case, at least $3,000 in sales." For more information, artists should visit Web site.

Tips "Do not bring a book; do not bring a chair. Smile and make eye contact with everyone who enters your booth. Have them sign your guest book; get their e-mail address so you can let them know when you are in the area again. And, finally, make the sale—they are at the fair to shop, after all."

Y MOUNT GRETNA OUTDOOR ART SHOW

P.O. Box 637, Mount Gretna PA 17064. (717)964-3270. Fax: (717)964-3054. E-mail: mtgretnaart @comcast.net. Web site: www.mtgretnaarts.com. **Contact:** Linda Bell, show committee chairperson. Estab. 1974. Fine arts & crafts show held annually 3rd full weekend in August. Outdoors. Accepts photography, oils, acrylics, watercolors, mixed media, jewelry, wood, paper, graphics, sculpture, leather, clay/porcelain. Juried by 4 professional artists who assign each applicant a numeric score. The highest scores in each medium are accepted. Awards/prizes: Judges' Choice Awards: 30 artists are invited to return the following year, jury exempt; the top 10 are given a

monetary award of $250. Number of exhibitors: 275. Public attendance: 15,000-19,000. Public admission: $7; children under 12: free. Artists should apply via www.zapplication.org. Deadline for entry: April 1. Application fee: $20 jury fee. Space fee: $300. Exhibition space: 10×10 ft. For more information, artists should e-mail, visit Web site, call.

N ☑ NEW ENGLAND CRAFT & SPECIALTY FOOD FAIR

Castleberry Fairs & Festivals, 38 Charles Rd., Rochester NH 03867. (603)332-2616. E-mail: info@ castleberryfairs.com. Web site: www.castleberryfairs.com. **Contact:** Terry Mullen, event coordinator. Estab. 1995. Arts & crafts show held annually on Veteran's Day weekend in Salem, New Hampshire. Indoors. Accepts photography and all other mediums. Juried by photo, slide or sample. Number of exhibitors: 200. Public attendance: 15,000. Admissions: $6. Artists should apply by downloading application from Web site. Deadline for entry: until full. Space fee: $300. Exhibition space: 100 sq. ft. Average gross sales/exhibitor: "Generally, this is considered an 'excellent' show, so I would guess most exhibitors sell ten times their booth fee, or in this case, at least $3,000 in sales." For more information, artists should visit Web site.

Tips "Do not bring a book; do not bring a chair. Smile and make eye contact with everyone who enters your booth. Have them sign your guest book; get their e-mail address so you can let them know when you are in the area again. And, finally, make the sale—they are at the fair to shop, after all."

N ☑ PARADISE CITY ARTS FESTIVALS

30 Industrial Dr. E., Northampton MA 01060-2351. (800)511-9725. Fax: (413)587-0966. E-mail: artist@paradisecityarts.com. Web site: www.paradisecityarts.com. **Contact:** Katherine Sanderson. Estab. 1995. Five fine arts & crafts shows held annually in March, April, May, October and November. Indoors. Accepts photography, all original art and fine craft media. Juried by 5 slides or digital images of work and an independent board of jury advisors. Number of exhibitors: 150-275. Public attendance: 5,000-20,000. Public admission: $12. Artists should apply by submitting name and address to be added to mailing list or print application from Web site. Deadline for entry: August 25 and April 1. Application fee: $30. Space fee: $650-1,500. Exhibition space:8' to 10' deep; 10; to 20' wide. For more information, artists should e-mail, visit Web site or call.

☑ PETERS VALLEY ANNUAL CRAFT FAIR

19 Kuhn Rd., Layton NJ 07851. (973)948-5200. Fax: (973)948-0011. E-mail: info@petersvalley.o rg. Web site: www.petersvalley.org. **Contact:** Mikal Brutzman, craft fair coordinator. Estab. 1970. Arts & crafts show held annually in late September at the Sussex County Fair Grounds in Augusta, New Jersey. Indoors. Accepts photography, ceramics, fiber, glass, basketry, metal, jewelry, sculpture, printmaking, paper book art, drawing, painting. Juried. Awards/prizes: cash awards. Number of exhibitors: 180. Public attendance: 8,000-10,000. Public admission: $7. Artists should apply by downloading application from Web site. Deadline for entry: May 15. Jury fee: $25. Space fee: $375. Exhibition space: 10×10 ft. Average gross sales/exhibitor: $2,000-5,000. For more information artists should e-mail, visit Web site, call or send SASE.

Tips "Have fun, have an attractive booth design and a diverse price range."

☑ QUAKER ARTS FESTIVAL

P.O. Box 202, Orchard Park NY 14127. (716)677-2787. **Contact:** Randy Kroll, chairman. Estab. 1961. Fine arts & crafts show held annually in September. Outdoors. Accepts photography,

painting, graphics, sculpture, crafts. Juried by 4 panelists during event. Awards/prizes: over $10,000 total cash prizes. Number of exhibitors: 330. Public attendance: 75,000. Free to the public. Artists should apply by sending SASE. Deadline for entry: August. Space fee: $175. Exhibition space: 10×12 ft. For more information, artists should call, send SASE.

Tips "Have an inviting booth and be pleasant and accessible. Don't hide behind your product—engage the audience."

ℕ ☑ SACO SIDEWALK ART FESTIVAL

P.O. Box 336, 146 Main St., Saco ME 04072. (207)286-3546. E-mail: sacospirit@hotmail.com. Web site: www.sacospirit.com. **Contact:** Ann-Marie Mariner, downtown director. Estab. 1970. Fine arts/crafts show held annually the last Saturday in June. Outdoors. Accepts photography, sculpture, mixed media, painting, silk screening, graphics. Juried by a committee of judges with an art/media background. Awards/prizes: Best of Show, First Runner-up, Merit Awards, People's Choice Award, Purchase Prizes. Number of exhibitors: 115-125. Public attendance: 5,000. Free to the public. Space fee: $50. Exhibition space: 10×10 ft. Artists should e-mail, call for more information.

Tips "Offer a variety of pieces priced at various levels."

☑ SPRING CRAFTS AT LYNDHURST

P.O. Box 28, Woodstock NY 12498. (845)331-7900. Fax: (845)331-7484. E-mail: crafts@artrider.com. Web site: www.craftsatlyndhurst.com; www.artrider.com. **Contact:** Laura Kandel. Estab. 1984. Fine arts & crafts show held annually in early May. Outdoors. Accepts photography, wearable and nonwearable fiber, metal and nonmetal jewelry, clay, leather, wood, glass, painting, drawing, prints, mixed media. Juried by 5 images of work and 1 of booth, viewed sequentially. Number of exhibitors: 300. Public attendance: 14,000. Public admission: $10. Artists should apply by downloading application from www.artrider.com or can apply online at www.zapplication.org. Deadline for entry: January 14. Application fee: $35. Space fee: $750. Exhibition space: 10×10. For more information, artists should e-mail, visit Web site, call.

☑ SPRING CRAFTS AT MORRISTOWN

P.O. Box 28, Woodstock NY 12498. (845)331-7900. Fax: (845)331-7484. E-mail: crafts@artrider.com. Web site: www.craftsatmorristown.com; www.artrider.com. **Contact:** Laura Kandel. Estab. 1990. Fine arts & crafts show held annually end of March. Indoors. Accepts photography, wearable and nonwearable fiber, metal and nonmetal jewelry, clay, leather, wood, glass, painting, drawing, prints, mixed media. Juried by 5 images of work and 1 of booth, viewed sequentially. Number of exhibitors: 165. Public attendance: 5,000. Public admission: $7. Artists should apply by downloading application from www.artrider.com or apply online at www.zapplication.org. Deadline for entry: January 14. Application fee: $35. Space fee: $475. Exhibition space: 10×10 ft. For more information, artists should e-mail, visit Web site, call.

☑ SPRING FINE ART & CRAFTS AT BROOKDALE PARK

Watchung Ave., Montclair NJ. (908)874-5247. Fax: (908)874-7098. E-mail: rosesquared@patmedia.net. Web site: www.rosesquared.com. **Contact:** Janet Rose, president. **Contact:** Estab.1988. Fine arts & craft show held annually in mid-June. Outdoors. Accepts photography and all other mediums. Juried. Number of exhibitors: 180. Public attendance: 16,000. Free to the public. Artists should apply by downloading application from Web site or call for application. Deadline:

1 month before show date. Application fee: $15. Space fee: $310. Exhibition space: 120 sq. ft. For more information, artists should e-mail, visit Web site, call.

Tips "Create a professional booth that is comfortable for the customer to enter. Be informative, friendly and outgoing. People come to meet the artist."

SPRINGFEST AND SEPTEMBERFEST

PO Box 677, Nyack NY 10960-0677. (845)353-2221. Fax: (845)353-4204. Web site: www.nyack-ny.com. **Contact:** Lorie Reynolds, executive director. Estab. 1980. Arts & crafts show held annually in April and September. Outdoors. Accepts photography, pottery, jewelry, leather, clothing. Number of exhibitors: 220. Public attendance: 30,000. Free to public. Artists should apply by submitting application, fees, permits, photos of product and display. Deadline for entry: 15 days before show. Space fee: $175. Exhibition space: 10×10 ft. For more information, artists should visit Web site, call or send SASE.

N ☑ SUMMER ARTS & CRAFTS FESTIVAL

Castleberry Fairs & Festivals, 38 Charles St., Rochester NH 03867. (603)332-2616. E-mail: info@castleberryfairs.com. Web site: www.castleberryfairs.com. **Contact:** Terry Mullen, events coordinator. Estab. 1992. Arts & crafts show held annually 2nd weekend in August in Lincoln, New Hampshire. Outdoors. Accepts photography and all other mediums. Juried by photo, slide or sample. Number of exhibitors: 100. Public attendance: 7,500. Free to the public. Artists should apply by downloading application from Web site. Deadline for entry: until full. Space fee: $200. Exhibition space: 100 sq. ft. For more information, artists should visit Web site.

Tips "Do not bring a book; do not bring a chair. Smile and make eye contact with everyone who enters your booth. Have them sign your guest book; get their e-mail address so you can let them know when you are in the area again. And, finally, make the sale—they are at the fair to shop, after all."

☑ WASHINGTON SQUARE OUTDOOR ART EXHIBIT

115 East 9th St., #7C, New York NY 10003. (212)982-6255. Fax: (212)982-6256. Web site: www.washingtonsquareoutdoorartexhibit.org. **Contact:** Margot J. Lufitg, executive director. Estab. 1931. Fine arts & crafts show held semiannually Memorial Day weekend and the following weekend in May/early June and Labor Day weekend and following weekend in September. Outdoors. Accepts photography, oil, watercolor, graphics, mixed media, sculpture, crafts. Juried by submitting 5 slides of work and 1 of booth. Awards/prizes: certificates, ribbons and cash prizes. Number of exhibitors: 200. Public attendance: 200,000. Free to public. Artists should apply by sending a SASE or downloading application from Web site. Deadline for entry: March, Spring Show; July, Fall Show. Application fee: $20. Exhibition space: 10×5 ft. For more information, artists should call or send SASE.

Tips "Price work sensibly."

☑ WESTMORELAND ART NATIONALS

252 Twin Lakes Rd., Latrobe PA 15650-3554. (724)834-7474. E-mail: info@artsandheritage.com. Web site: www.artsandheritage.com. **Contact:** Donnie Gutherie, executive director. Estab. 1975. Fine arts & crafts show held annually in July. Photography displays are indoors. Accepts photography, all mediums. Juried: 2 jurors review slides. Awards/prizes: $5,000+ in prizes. Number of exhibitors: 200. Public attendance: 100,000. Free to public. Artists should apply by downloading

application from Web site. Application fee: $35/craft show vendors; $25/fine art/photography exhibitors. Space fee: $325. Vendor/exhibition space: 10×10 ft. For more information, artists should visit Web site.

☑ WILD WIND FOLK ART & CRAFT FESTIVAL

719 Long Lake, New York NY 12847. (814)723-0707 or (518)624-6404. E-mail: wildwindcraftsho w@yahoo.com. Web site: www.wildwindfestival.com. **Contact:** Liz Allen or Carol Jilk, promoters. Estab. 1979. Fine arts & traditional crafts show held annually the weekend after Labor Day at the Warren County Fairgrounds in Pittsfield, Pennsylvania. Barn locations and outdoors. Accepts photography, paintings, pottery, jewelry, traditional crafts, prints, stained glass. Juried by promoters. Three photos or slides of work plus one of booth, if available. Number of exhibitors: 140. Public attendance: 8,000. Public admission: $6/adult; $4/seniors; 12 & under free. Artists should apply by visiting Web site and filling out application request, calling or sending a written request.

MIDSOUTH & SOUTHEAST

Ⓝ ☑ ANNUAL VOLVO MAYFAIRE-BY-THE-LAKE

Polk Museum of Art, 800 E. Palmetto St., Lakeland FL 33801. (863)688-7743, ext. 237. Fax: (863)688-2611. E-mail: mayfaire@polkmuseumofart.org. Web site: www.PolkMuseumOfArt.o rg. Estab. 1971. Fine arts & crafts show held annually in May on Mother's Day weekend. Outdoors. Accepts photography, oil, acrylic, watercolor, drawing & graphics, sculpture, clay, jewelry, glass, wood, fiber, mixed media. Juried by a panel of jurors who will rank the artist's body of work based on 3 slides of works and 1 slide of booth setup. Awards/prizes: 2 Best of Show, 3 Awards of Excellence, 8 Merit awards, 10 Honorable Mentions, Museum Purchase Awards, Collectors Club Purchase Awards, which equal over $25,000. Number of exhibitors: 185. Public attendance: 65,000. Free to public. Artists should download application from Web site to apply. Deadline for entry: March 1. Application fee: $25. Space fee: $145. Exhibition space: 10×10 ft. For more information, artists should visit Web site or call.

☑ APPLE ANNIE CRAFTS & ARTS SHOW

4905 Roswell Rd. NE, Marietta GA 30062. (770)552-6400, ext. 6110. Fax: (770)552-6420. E-mail: appleannie@st-ann.org. Web site: www.st-ann.org/appleannie. **Contact:** Show Manager. Estab.1981. Arts & crafts show held annually the 1st weekend in December. Indoors. Accepts photography, woodworking, ceramics, pottery, painting, fabrics, glass. Juried. Number of exhibitors: 135. Public attendance: 5,000. Public admission: $3. Artists should apply by visiting Web site to print an application form, or call to have one sent to them. Deadline: March 31. Application fee: $10 nonrefundable. Space fee: $120. Exhibition space: 72 sq. ft. For more information, artists should e-mail, visit Web site, call.
Tips "Have an open, welcoming booth and be accessible and friendly to customers."

☑ APPLE CHILL & FESTIFALL

200 Plant Rd., Chapel Hill NC 27514. (919)968-2784. Fax: (919)932-2923. E-mail: lradson@town ofchapelhill.org. Web site: www.applechill.com and www.festifall.com. **Contact:** Lauren Rodson, lead event coordinator. Estab. 1972. Apple Chill street fair held annually 3rd full weekend in April; Festifall street fair held annually 1st weekend in October. Estab. 1972. Outdoors. Accepts

photography, pottery, painting, fabric, woodwork, glass, jewelry, leather, sculpture, tile. Juried by application process; actual event is not juried.

⚅ ART IN THE PARK

P.O. Box 1540, Thomasville GA 31799. (229)227-7020. Fax: (229)227-3320. E-mail: roseshowfest @rose.net. Web site: www.downtownthomasville.com. **Contact:** Felicia Brannen, festival coordinator. Estab. 1998-1999. Arts in the park (an event of Thomasville's rose show and festival) is a 1 day arts & crafts show held annually in April. Outdoors. Accepts photography, handcrafted items, oils, acrylics, woodworking, stained glass, other varieties. Juried by a selection committee. Number of exhibitors: 60. Public attendance: 2,500. Free to public. Artists should apply by application. Deadline for entry: February 1. Space fee: $75, varies by year. Exhibition space: 20×20 ft. For more information, artists should e-mail or call.

Tips "Most important, be friendly to the public and have an attractive booth display."

⚅ CHERRY BLOSSOM FESTIVAL OF CONYERS

1996 Centennial Olympic Parkway, Conyers GA 30013. (770)860-4190. Fax: (770)602-2500. E-mail: rebecca.hill@conyersga.com. Web site: http://www.conyerscherryblossom.com. **Contact:** Rebecca Hill, event manager. Estab. 1981. Arts & crafts show held annually in late March. Outdoors. Accepts photography, paintings. Juried. Number of exhibitors: 300. Public attendance: 40,000. Free to public; $5 parking fee. Deadline for entry: January. Space fee: $125/booth. Exhibition space: 10×10 ft. For more information, artists should e-mail, visit Web site or call.

⚅ CHURCH STREET ART & CRAFT SHOW

P.O. Box 1409, Waynesville NC 28786. (828)456-3517. Fax: (828)456-2001. E-mail: downtownw aynesville@charter.net. Web site: www.downtownwaynesville.com. **Contact:** Ronald Huelster, executive director. Estab. 1983. Fine arts & crafts show held annually 2nd Saturday in October. Outdoors. Accepts photography, paintings, fiber, pottery, wood, jewelry. Juried by committee: submit 4 slides or photos of work and 1 of booth display. Awards/prizes: $1,000 cash prizes in 1st, 2nd, 3rd and Honorable Mentions. Number of exhibitors: 100. Public attendance: 15,000-18,000. Free to public. Deadline for entry: August 15. Application/space fee: $95-165. Exhibition space: 10×12 ft.-12×20 ft. For more information artists should e-mail, call or send SASE.

Tips Recommends "quality in work and display."

⚆ ⚅ CITY OF FAIRFAX FALL FESTIVAL

4401 Sideburn Rd., Fairfax VA 22030. (703)385-7949. Fax: (703)246-6321. E-mail: klewis@fairfa xva.gov. Web site: http://www.fairfaxva.gov/SpecialEvents/FallFestival/FallFestival.asp. **Contact:** Kathy Lewis, special events coordinator. Estab. 1975. Arts & crafts show held annually 2nd Saturday in October. Outdoors. Accepts photography, jewelry, glass, pottery, clay, wood, mixed media. Juried by a panel of 5 independent jurors. Number of exhibitors: 400. Public attendance: 25,000. Public admission: $5 for age 18 and older. Artists should apply by contacting Leslie Herman for an application. Deadline for entry: March. Application fee: $10. Space fee: $150. Exhibition space: 10×10 ft. For more information, artists should e-mail.

Tips "Be on-site during the event. Smile. Price according to what the market will bear."

⚆ ⚅ CITY OF FAIRFAX HOLIDAY CRAFT SHOW

4401 Sideburn Rd., Fairfax VA 22030. (703)385-7949. Fax: (703)246-6321. E-mail: klewis@fairfa xva.gov. Web site: www.fairfaxva.gov. **Contact:** Leslie Herman, special events coordinator.

Estab. 1985. Arts & crafts show held annually 3rd weekend in November. Indoors. Accepts photography, jewelry, glass, pottery, clay, wood, mixed media. Juried by a panel of 5 independent jurors. Number of exhibitors: 247. Public attendance: 10,000. Public admission: $5 for age 18 an older. Artists should apply by contacting Leslie Herman for an application. Deadline for entry: March. Application fee: $10. Space fee: 10×6 ft.: $175; 11×9 ft.: $250; 10×10 ft.: $250. For more information, artists should e-mail. Currently full.

Tips "Be on-site during the event. Smile. Price according to what the market will bear."

N DOWNTOWN FESTIVAL & ART SHOW

P.O. Box 490, Gainesville FL 32602. (352)334-5064. Fax: (352)334-2249. E-mail: piperlr@cityofg ainesville.org. Web site: www.gvlculturalaffairs.org. **Contact:** Linda Piper, festival director. Estab. 1981. Fine arts & crafts show held annually in November. Outdoors. Accepts photography, wood, ceramic, fiber, glass, and all mediums. Juried by 3 slides of artwork and 1 slide of booth. Awards/prizes: $14,000 in Cash Awards; $5,000 in Purchase Awards. Number of exhibitors: 250. Public attendance: 115,000. Free to the public. Artists should apply by mailing 4 slides. Deadline for entry: May. Space fee: $185. Exhibition space: 12 ft.×12 ft. Average gross sales/ exhibitor: $6,000. For more information, artists should e-mail, visit Web site, call, send SASE.

Tips "Submit the highest-quality slides possible. A proper booth slide is so important."

N ☟ ELIZABETHTOWN FESTIVAL

818 Jefferson, Moundsville WV 26041. (304)843-1170. Fax: (304)845-2355. E-mail: jvhblake@ao l.com. Web site: www.wvpentours.com. **Contact:** Sue Riggs at (304)843-1170 or Hilda Blake at (304)845-2552, co-chairs. Estab. 1999. Arts & crafts show held annually the 3rd weekend in May (Saturday and Sunday). Sponsored by the Moundsville Economic Development Council. Also includes heritage exhibits of 1800s-era food and entertainment. Indoors and outdoors within the walls of the former West Virginia Penitentiary. Accepts photography, crafts, wood, pottery, quilts, jewelry. "All items must be made by the craftspeople selling them; no commercial items." Juried based on design, craftsmanship and creativity. Submit 5 photos: 3 of your medium; 2 of your booth set-up. Jury fee: $10. Number of exhibitors: 70-75. Public attendance: 3,000-5,000. Public admission: $3. Artists should apply by requesting an application form by phone. Space fee: $50. Exhibition space: 100 sq. ft. For more information, artists should e-mail, visit Web site, call, send SASE.

Tips "Be courteous. Strike up conversations—do not sit in your booth and read! Have an attractive display of wares."

☟ FESTIVAL IN THE PARK

1409 East Blvd., Charlotte NC 28203. (704)338-1060. Fax: (704)338-1061. E-mail: festival@festiv alinthepark.org. Web site: www.festivalinthepark.org. **Contact:** Julie Whitney Austin, executive director. Estab. 1964. Fine arts & crafts/arts & crafts show held annually 3rd Thursday after Labor Day. Outdoors. Accepts photography, decorative and wearable crafts, drawing and graphics, fiber and leather, jewelry, mixed media, painting, metal, sculpture, wood. Juried by slides or photographs. Awards/prizes: $4,000 in cash awards. Number of exhibitors: 150. Public attendance: 85,000. Free to the public. Artists should apply by visiting Web site for application. Application fee: $25. Space fee: $345. Exhibition space: 10×10 ft. For more information, artists should e-mail, visit Web site, call.

ℕ ☑ FOOTHILLS CRAFTS FAIR

2753 Lynn Rd. #A, Tryon NC 28782-7870. (828)859-7427. E-mail: bbqfestival@azztez.net. Web site: www.BlueRidgeBBQFestival.com. **Contact:** Julie McIntyre. Estab. 1994. Fine arts & crafts show and Blue Ridge BBQ Festival/Championship held annually 2nd Friday and Saturday in June. Outdoors. Accepts photography, arts and handcrafts by artist only; nothing manufactured or imported. Juried. Number of exhibitors: 50. Public attendance: 25,000 +. Public admission: $8; 12 and under free. Artists should apply by downloading application from Web site or sending personal information to e-mail or mailing address. Deadline for entry: March 30. Jury fee: $25 nonrefundable. Space fee: $150. Exhibition space: 10 × 10 ft. For more information, artists should visit Web site.

Tips "Have an attractive booth, unique items, and reasonable prices."

GERMANTOWN FESTIVAL

P.O. Box 381741, Germantown TN 38183. (901)757-9212. E-mail: gtownfestival@aol.com. **Contact:** Melba Fristick, coordinator. Estab. 1971. Arts and crafts show held annually the weekend after Labor Day. Outdoors. Accepts photography, all arts & crafts mediums. Number of exhibitors: 400 +. Public attendance: 65,000. Free to public. Artists should apply by sending applications by mail. Deadline for entry: until filled. Application/space fee: $190-240. Exhibition space: 10 × 10 ft. For more information, artists should e-mail, call or send SASE.

Tips "Display and promote to the public. Price attractively."

ℕ GOLD RUSH DAYS

P.O. Box 774, Dahlonega GA 30533. (706)864-7247. Web site: www.dahlonegajaycees.com. **Contact:** Gold Rush Chairman. Arts & crafts show held annually the 3rd full week in October. Accepts photography, paintings and homemade, handcrafted items. No digitally originated art work. Outdoors. Number of exhibitors: 300. Public attendance: 200,000. Free to the public. Artists should apply online at www.dahlonegajaycees.com under "Gold Rush," or send SASE to request application. Deadline: March. Space fee: $225, "but we reserve the right to raise the fee to cover costs." Exhibition space: 10 × 10 ft. Artists should e-mail, visit Web site for more information.

Tips "Talk to other artists who have done other shows and festivals. Get tips and advice from those in the same line of work."

ℕ ☑ HIGHLAND MAPLE FESTIVAL

P.O. Box 223, Monterey VA 24465-0223. (540)468-2550. Fax:(540)468-2551. E-mail: highcc@cfw.co. Web site: www.highlandcounty.org. **Contact:** Carolyn Pottowsky, executive director. Estab. 1958. Fine arts & crafts show held annually the 2nd and 3rd weekends in March. Indoors and outdoors. Accepts photography, pottery, weaving, jewelry, painting, wood crafts, furniture. Juried by 3 photos or slides. Number of exhibitors: 150. Public attendance: 35,000-50,000. Public admission: $2. Vendors accepted until show is full." Space fee: $125-$150. Exhibition space: 10 × 10 ft. For more information, artists should e-mail, visit Web site, call.

Tips "Have quality work and good salesmanship."

☑ HOLIDAY ARTS & CRAFTS SHOW

60 Ida Lee Dr., Leesburg VA 20176. (703)777-1368. Fax: (703)737-7165. E-mail: lfountain@leesburgva.gov. Web site: www.idalee.org. **Contact:** Linda Fountain, program supervisor. Estab.

1990. Arts & crafts show held annually 1st weekend in December. Indoors. Accepts photography, jewelry, pottery, baskets, clothing, accessories. Juried. Number of exhibitors: 100. Public attendance: 4,000. Free to public. Artists should apply by downloading application from Web site. Deadline for entry: August 31. Space fee: $100-150. Exhibition space: 10×7 ft. For more information, artists should e-mail or visit Web site.

HOLLY ARTS & CRAFTS FESTIVAL

P.O. Box 2122, Pinehurst NC 28370. (910)295-7462. E-mail: sbharrison@earthlink.net, pbguild @pinehurst.net. Web site: www.pinehurstbusinessguild.com. **Contact:** Susan Harrison, Holly Arts & Crafts committee. Estab. 1978. Arts & crafts show held annually 3rd Saturday in October. Outdoors. Accepts quality photography, arts, and crafts. Juried based on uniqueness, quality of product, and overall display. Awards/prizes: plaque given to Best in Show; 2 Honorable Mentions receive ribbons. Number of exhibitors: 200. Public attendance: 7,000. Free to the public. Artists should apply by filling out application form. Space fee: $75. Exhibition space: 10×10 ft. For more information, artists should e-mail, visit Web site, call, send SASE. Applications accepted after deadline if available space.

INTERNATIONAL FOLK FESTIVAL

P.O. Box 318, Fayetteville NC 28302-0318. (910)323-1776. Fax: (910)323-1727. E-mail: kelvinc@ theartscouncil.com. Web site: www.theartscouncil.com. **Contact:** Kelvin Culbreth, director of special events. Estab. 1978. Fine arts & crafts show held annually in late September. Outdoors. Accepts photography, painting of all mediums, pottery, woodworking, sculptures of all mediums. "Work must be original." Juried. Awards/prizes: $2,000 in cash prizes in several categories. Number of exhibitors: 120 + . Public attendance: 70,000. Free to public. Artists should apply on the Web site. Deadline for entry: September 1. Application fee: $60; includes space fee. Exhibition space: 10×10 ft. Average gross sales/exhibitor: $500. For more information, artists should e-mail or visit Web site.

Tips "Have reasonable prices."

ISLE OF EIGHT FLAGS SHRIMP FESTIVAL

18 N. Second St., Ferninda Beach FL 32034. (904)271-7020. Fax: (904)261-1074. E-mail: islandart @net-magic.net. Web site: www.islandart.org. **Contact:** Shrimp Festival Committee Chairperson. Estab. 1963. Fine arts & crafts show and community celebration held annually the 1st weekend in May. Outdoors. Accepts photography and all mediums. Juried. Awards/prizes: $9,700 in cash prizes. Number of exhibitors: 425. Public attendance: 150,000. Free to public. Artists should apply by downloading application from Web site. Deadline for entry: January 1. Application fee: $30. Space fee: $200. Exhibition space: 10×12 ft. Average gross sales/exhibitor: $1,500 + . For more information, artists should visit Web site.

Tips "Quality product and attractive display."

JUBILEE FESTIVAL

P.O. Drawer 310, Daphne AL 36526. (251)621-8222. Fax: (251)621. E-mail: office@eschamber.c om. Web site: www.eschamber.com. **Contact:** Angela Kimsey, event coordinator. Estab. 1952. Fine arts & crafts show held in September in Olde Towne of Daphne, Alabama. Outdoors. Accepts photography and fine arts and crafts. Juried. Awards/prizes: ribbons and cash prizes. Number

of exhibitors: 258. Public attendance: 200,000. Free to the public. Application fee: $25. Space fee: $265. Exhibition space: 10 ft. × 10 ft. For more information, artists should e-mail, call, see Web site.

[N] [Z] KETNER'S MILL COUNTY ARTS FAIR

P.O. Box 322, Lookout Mountain TN 37350. (243)267-5702. Fax: (423)757-1343. **Contact:** Sally McDonald. Estab. 1977. Arts & crafts show held annually the 3rd weekend in October. Outdoors. Accepts photography, painting, prints, dolls, fiber arts, baskets, folk art, wood crafts, jewelry, musical instruments, sculpture, pottery, glass. Juried. Prizes: 1st: $75 and free booth for following year; 2nd: $50 and free booth for following year; 3rd: free booth for following year; People's Choice Award. Number of exhibitors: 150. Number of attendees: 10,000/day, depending on weather. Public admission: $5.00. Artists should call or send SASE to request a prospectus/application. Space fee: $125. Exhibition space: 15 × 15 ft. Average gross sales/exhibitor: $1,500. **Tips** "Display your best and most expensive work, framed. But also have smaller unframed items to sell. Never underestimate a show: Someone may come forward and buy a large item."

NEW SMYRNA BEACH ART FIESTA

210 Sams Ave., New Smyrna Beach FL 32168. (386)424-2175. Fax: (386)424-2177. Web site: www.cityofnsb.com. **Contact:** Kimla Shelton, program coordinator. Estab. 1952. Arts & crafts show held annually the last full weekend in February. Outdoors. Accepts photography, oil, acrylics, pastel, drawings, graphics, sculpture, crafts, watercolor. Awards/prizes: $14,000 prize money; $1,500/category; Best of Show. Number of exhibitors: 250. Public attendance: 14,000. Free to public. Artists should apply by calling to get on mailing list. Applications are always mailed out the day before Thanksgiving. Deadline for entry: until full. Application/space fee: $135 plus tax. Exhibition space: 10 × 10 ft. For more information, artists should call.

[N] NEW WORLD FESTIVAL OF THE ARTS

PO Box 994, Manteo NC 27954. (252)473-2838. Fax: (252)473-6044. E-mail: Edward@outerbank schristmas.co. **Contact**: Owen Holleran, event registrar. Estab. 1963. Fine arts &crafts show held annually in August. Outdoors. Juried. Accepts photography, watercolor, oil, mixed media, drawing printmaking, graphics, pastel, ceramic, sculpture, fiber, handwoven wearable art, wood, glass, hand-crafted jewelry, metalsmithing, leather. "No commercial molds or kids will be accepted. All work must be signed by the artist." Juror reviews slides to select participants; then selects winners on the 1st day of exhibit. Awards/prizes: cash awards totaling $3,000. Number of exhibitors: 80. Public attendance: 4,500-5000. Free to pubic. Artists should apply by sending for application. Deadline for entry: June 10. Application fee: $10 jury fee. Space fee: $80. Exhibition space: 10 × 10 ft. For more information, artists should e-mail or call.

[Z] PANOPLY ARTS FESTIVAL, PRESENTED BY THE ARTS COUNCIL, INC.

700 Monroe St. SW, Suite 2, Huntsville AL 35801. (256)519-2787. Fax: (256)533-3811. E-mail: tac@panoply.org. Web site: www.panoply.org; www.artshuntsville.org. Estab. 1982. Fine arts show held annually the last weekend in April. Also features music and dance. Outdoors. Accepts photography, painting, sculpture, drawing, printmaking, mixed media, glass, fiber. Juried by a panel of judges chosen for their in-depth knowledge and experience in multiple mediums, and who jury from slides or disks in January. During the festival 1 judge awards the various prizes. Awards/prizes: Best of Show: $1,000; Award of Distinction: $500; Merit Awards: 5 awards, $200

each. Number of exhibitors: 60-80. Public attendance: 140,000 +. Public admission: weekend pass: $10; 1-day pass: $5; children 12 and under: free. Artists should e-mail, call or write for an application form, or check online through November 1. Deadline for entry: January 2008. Application fee: $30. Space fee: $175 for space only; $375 including tent rental. Exhibition space: 10×10 ft. Average gross sales/exhibitor: $2,500. For more information, artists should e-mail.

PUNGO STRAWBERRY FESTIVAL

P.O. Box 6158, Virginia Beach VA 23456. (757)721-6001. Fax: (757)721-9335. E-mail: pungofesti val@aol.com. Web site: www.PungoStrawberryFestival.info. **Contact:** Janet Dowdy, secretary of board. Estab. 1983. Arts & crafts show held annually on Memorial Day Weekend. Outdoors. Accepts photography and all media. Number of exhibitors: 60. Public attendance: 120,000. Free to Public; $5 parking fee. Artists should apply by calling for application or downloading a copy from the Web site and mail in. Deadline for entry: March 1; applications accepted from that point until all spaces are full. Application fee: $50 refundable deposit. Space fee: $175. Exhibition space: 10×10 ft. For more information, artists should e-mail, visit Web site or call.

N RIVERFRONT MARKET

P.O. Box 565, Selma AL 36702-0565.(334)874-6683. **Contact:** Ed Greene, chairman. Estab. 1972. Arts & crafts show held annually the 2nd Saturday in October. Outdoors. Accepts photography, painting, sculpture. Number of exhibitors: 200. Public attendance: 8,000. Public admission: $2. Artists should apply by calling or mailing to request application. Deadline for entry: September 1. Space fee: $40; limited covered space available at $60. Exhibition space: 10×10 ft. For more information, artists should call.

RIVERSIDE ART FESTIVAL

2623 Herschel St., Jacksonville FL 32204. (904)389-2449. Fax: (904)389-0431. E-mail: info@river sideavondale.org. Web site: www.Riverside-Avondale.com. **Contact:** Bonnie Grissett, executive director. Estab. 1972. Fine arts & crafts show held annually the weekend after Labor Day. Outdoors. Accepts photography and all fine art. Juried. Awards/prizes: $10,000/cash. Number of exhibitors: 150. Public attendance: 25,000. Free to public. Artists should apply by sending name and address or by e-mailing for an application. Deadline for entry: June 15. Jury fee: $25 (nonrefundable). Space fee: $175. Exhibition space: 10×10 ft. For more information, artists should call or e-mail.

SANDY SPRINGS FESTIVAL

135 Hilderbrand Dr., Sandy Springs GA 30328-3805. (404)851-9111. Fax: (404)851-9807. E-mail: info@sandyspringsfestival.com. Web site: www.sandyspringsfestival.com. **Contact:** Christy Nickles, special events director. Estab. 1985. Fine arts & crafts show held annually in mid-September. Outdoors. Accepts photography, painting, sculpture, jewelry, furniture, clothing. Juried by area professionals and nonprofessionals who are passionate about art. Awards/prizes: change annually; usually cash with additional prizes. Number of exhibitors: 100 +. Public attendance: 20,000. Public admission: $5. Artists should apply via application on Web site. Application fee: $10 ($35 for late registration). Space fee: $150. Exhibition space: 10×10 ft. Average gross sales/exhibitor: $1,000. For more information, artists should visit Web site.
Tips ''Most of the purchases made at Sandy Springs Festival are priced under $100. The look of the booth and its general attractiveness are very important, especially to those who might not 'know' art.''

▨ SIDEWALK ART SHOW

One Market Square, Roanoke VA 24011-143. (540)342-5760. E-mail: info@artmuseumroanoke.org. Web site: www.artmuseumroanoke.org. **Contact:** Mickie Kagey, registration chair. Estab. 1958. Fine arts show held annually in early June. Outdoors. Accepts photography, watercolor, oils, acrylic, sculpture, prints. Awards/prizes: $6,500 total cash awards. Number of exhibitors: 175-200. Public attendance: 10,000. Free to public. Deadline for entry: April 15. Application fee: $25. Space fee: $90-175. Exhibition space: 10×10 ft./tent; 8 ft./fence. For more information, artists should e-mail or visit Web site.

SPRINGFEST

P.O. Box 831, Southern Pines NC 28388. (910)315-6508. E-mail: spba@earthlink.net. Web site: www.southernpines.biz. **Contact:** Susan Harrison, booth coordinator. Estab. 1979. Arts & crafts show held annually last Saturday in April. Outdoors. Accepts photography and crafts. Number of exhibitors: 200. Public attendance: 8,000. Free to the public. Artists should apply by filling out application form. Deadline for entry: March 15, 2009. Space fee: $60. Exhibition space: 10×12 ft. For more information, artists should e-mail, visit Web site, call, send SASE. Application online in fall 2008.

▨ STEPPIN' OUT

P.O. Box 233, Blacksburg VA 24063. (540)951-0454. E-mail: dmob@downtownblacksburg.com. Web site: www.downtownblacksburg.com. **Contact:** Laureen Blakemore, director. Estab. 1981. Arts & crafts show held annually 1st Friday and Saturday in August. Outdoors. Accepts photography, pottery, painting, drawing, fiber arts, jewelry, general crafts. Number of exhibitors: 170. Public attendance: 45,000. Free to public. Artists should apply by e-mailing, calling or by downloading application on Web site. Space fee: $150. For more information, artists should e-mail, visit Web site or call.

Tips "Visit shows and consider the booth aesthetic—what appeals to you. Put the time, thought, energy and money into your booth to draw people in to see your work."

▧ STOCKLEY GARDENS FALL ARTS FESTIVAL

801 Boush St., Norfolk VA 23510. (757)625-6161. Fax: (757)625-7775. E-mail: jlong@hope-house.org. Web site: www.hope-house.org. **Contact:** Jenny Long, development coordinator. Estab. 1984. Fine arts & crafts show held annually 3rd weekend in October. Outdoors. Accepts photography and all major fine art mediums. Juried. Number of exhibitors: 150. Public attendance: 30,000. Free to the public. Artists should apply by submitting application, jury and booth fees, 5 slides. Deadline for entry: July. Application fee: $15. Space fee: $225. Exhibition space: 10×10 ft. For more information, artists should e-mail, visit Web site, call.

▨ ▧ THREEFOOT ART FESTIVAL & CHILI COOKOFF

P.O. Box 1405, Meridian MS 39302. (601)693-ARTS. E-mail: debbie0708@comcast.net. Web site: www.meridianarts.org. **Contact:** Debbie Martin, president. Estab. 2002. Fine arts & crafst show held annually the 2nd Saturday in October. Outdoors. Accepts photography and all mediums. Juried by a panel of prominent members of the arts community on day of show. Awards/prizes: $1,000, Best in Show; $500, 2 Awards of Distinction; up to 10 Merit Awards. Number of exhibitors: 50-75. Public attendance: 5,000. Free to public. Artists should apply by downloading application from Web site or request to be added to mailing list. Deadline

for entry: August 1, 2008. Application fee: $10. Space fee: $85. Exhibition space: 10 × 10 ft. Average gross sales/exhibitors: $1,000. For more information, artists should visit Web site or send SASE.

Tips "Price points are relative to the market. Booth should be attractive."

⬛ ⬛ VIRGINIA CHRISTMAS SHOW

P.O. Box 305, Chase City VA 23924. (434)372-3996. Fax: (434)372-3410. E-mail: vashowsinc@aol.com. **Contact:** Patricia Wagstaff, coordinator. Estab. 1986. Holiday arts & crafts show held annually 1st week in November in Richmond, Virginia. Indoors at the showplace. Accepts photography and other arts and crafts. Juried by 3 slides of artwork and 1 of display. Awards/prizes: Best Display. Number of exhibitors: 350. Public attendance: 25,000. Public admission: $7. Artists should apply by writing or e-mailing for an application. Space fee: $400. Exhibition space: 10 × 10 ft. For more information, artists should e-mail, send SASE.

Tips "If possible, attend the show before you apply. 21st Virginia Spring show March 13-15, 2009 is held at the same facility. Fee is $300. Requirements same as above."

⬛ ⬛ WELCOME TO MY WORLD PHOTOGRAPHY COMPETITION

319 Mallery St., St. Simons Island GA 31522.(912)638-8770. E-mail: glynnart@bellsouth.net. Web site: www.glynnart.org. **Contact:** Ann Marie Dalis, executive director. Estab. 1991. Seasonal photography competition annually held in July. Indoors. Accepts only photography. Juried. Awards/prizes: 1st, 2nd, 3rd in each category. Number of exhibitors: 50. Artists should apply by visiting Web site. Deadline for entry: June. Application fee: $35. For more information, artists should e-mail, visit Web site or call.

⬛ WHITE OAK CRAFTS FAIR

The Arts Center, 1424 John Bragg, Woodbury TN. (625)563-2787. Fax: (615)563-2788. E-mail: carol@artcenterofcc.com. Web site: www.artscenterofcc.com. **Contact:** Carol Reed, publicity. Estab. 1985. Arts & crafts show held annually in September. Outdoors. Accepts photography; all handmade crafts, traditional and contemporary. Must be handcrafted displaying "excellence in concept and technique." Juried by committee. Send 3 slides or photos. Awards/prizes: more than $1,000. Number of exhibitors: 80. Public attendance: 6,000. Free to public, $2 parking fee. Applications can be downloaded from Web site. Deadline for entry: June 1. Space fee: $60. Exhibition space: 15 ft. For more information, artists should e-mail mary@artscenterofcc.com.

MIDWEST & NORTH CENTRAL

⬛ AKRON ARTS EXPO

220 S. Balch St., Akron OH 44302. (330)375-2835. Fax: (330)375-2883. E-mail: recreation@ci.akron.oh.us. Web site: www.akronperforms.com. **Contact:** Yvette Davidson, community events coordinator. Estab. 1979. Fine art & craft show held annually in late July. Outdoors. Accepts photography, 2D art, functional craft, ornamental. Juried by 4 slides of work and 1 slide of display. Awards/prizes: $1,600 in cash awards and ribbons. Number of exhibitors: 165. Public attendance: 3,000 + . Free to public. Deadline for entry: March 31. Space fee: $150-180. Exhibition space: 15 × 15 ft. For more information, artists should e-mail or call.

☑ AMISH ACRES ARTS & CRAFTS FESTIVAL

1600 W Market St., Nappanee IN 46550. (574)773-4188. Fax: (574)773-4180. E-mail: jenniwyson g@amishacres.com. Web site: www.amishacres.com. **Contact:** Jenni Wysong, marketplace coordinator. Estab. 1962. Arts & crafts show held annually 1st full weekend in August. Outdoors. Accepts photography, crafts, floral, folk, jewelry, oil, acrylic, sculpture, textiles, watercolors, wearable, wood. Juried by 5 images, either 35mm slides or digital images e-mailed. Awards/ prizes: $10,000 cash including Best of Show and $1,500 Purchase Prizes. Number of exhibitors: 350. Public attendance: 60,000. Public admission: $6; children under 12 free. Artists should apply by sending SASE or printing application from Web site. Deadline for entry: April 1. Space fee: 10×10 ft.: $475; 15×12 ft.: $675; 20×12 ft.: $1,095; 30×12 ft.: $1,595. Exhibition space: from 120-300 sq. ft. Average gross sales/exhibitor: $7,000. For more information, artists should e-mail, visit Web site, call or send SASE.

Tips "Create a vibrant, open display that beckons to passing customers. Interact with potential buyers. Sell the romance of the purchase."

Ⓝ ☑ ANN ARBOR STREET ART FAIR

P.O. Box 1352, Ann Arbor MI 48106. (734)994-5260. Fax: (734)994-0504. E-mail: production@ar tfair.org. Web site: www.artfair.org. **Contact:** Jeannie Uh, production coordinator. Estab. 1958. Fine arts & crafts show held annually 3rd Saturday in July. Outdoors. Accepts photography, fiber, glass, digital art, jewelry, metals, 2D and 3D mixed media, sculpture, clay, painting, drawing, printmaking, pastels, wood. Juried based on originality, creativity, technique, craftsmanship and production. Awards/prizes: cash prizes for outstanding work in any media. Number of exhibitors: 175. Public attendance: 500,000. Free to the public. Artists should apply through www.zapplication.org. Deadline for entry: January. Application fee: $30. Space fee: $595. Exhibition space: 10×20 ft. or 10×12 ft. Average gross sales/exhibitor: $7,000. For more information, artists should e-mail, visit Web site, call.

ANN ARBOR'S SOUTH UNIVERSITY ART FAIR

P.O. Box 4525, Ann Arbor MI 48106. (734)663-5300. Fax: (734)663-5303. Web site: www.a2sout hu.com. **Contact:** Maggie Ladd, director. Estab. 1960. Fine arts & crafts show held annually 3rd Wednesday through Saturday in July. Outdoors. Accepts photography, clay, drawing, digital, fiber, jewelry, metal, painting, sculpture, wood. Juried. Awards/prizes: $3,000. Number of exhibitors: 190. Public attendance: 750,000. Free to public. Deadline for entry: January. Application fee: $25. Space fee: $700-1500. Exhibition space: 10×10 to 20×10 ft. Average gross sales/ exhibitor: $7,000. For more information artists should e-mail, visit Web site or call.

Tips "Research the market, use a mailing list, advertise in *Art Fair Guide* (150,000 circulation)."

☑ ANNUAL ARTS & CRAFTS ADVENTURE AND ANNUAL ARTS & CRAFTS ADVENTURE II

P.O. Box 1326, Palatine IL 60078. (847)991-4748 or (312)751-2500. E-mail: asoa@webtv.net. Web site: www.americansocietyofartists.org. **Contact:** American Society of Artists—"anyone in the office can help." Estab. 1991. Fine arts & crafts show held biannually in May and September. Outdoors. Accepts photography, pottery, paintings, sculpture, glass, wood, woodcarving. Juried by 4 slides or photos of work and 1 slide or photo of display; SASE (No. 10); a résumé or show listing is helpful. See our Web site for on-line jury. Number of exhibitors: 75. Free to the public. Artists should apply by submitting jury materials. If juried in, you will receive a jury/approval

number. Deadline for entry: 2 months prior to show or earlier if spaces fill. Space fee: $80. Exhibition space: approximately 100 sq. ft. for single space; other sizes available. For more information, artists should send SASE, submit jury material.

- Event held in Park Ridge, Illinois.

Tips "Remember that when you are at work in your studio, you are an artist. But when you are at a show, you are a business person selling your work."

⚑ ANNUAL ARTS & CRAFTS EXPRESSIONS

P.O. Box 1326, Palatine IL 60078. (847)991-4748 or (312)751-2500. E-mail: asoa@webtv.net. Web site: www.americansocietyofartists.org. **Contact:** American Society of Artists—"anyone in the office can help." Estab. 1998. Fine arts & crafts show held annually in late July. Outdoors. Accepts photography, sculpture, jewelry, glass works, woodworking and more. Juried by 4 slides or photos of your work and 1 slide or photo of your display; SASE (No. 10); a resume or show listing is helpful. Number of exhibitors: 50. Free to the public. Artists should apply by submitting jury materials. If you want to jury via internet see our Web site and follow directions given there. If juried in, you will receive a jury/approval number. Deadline for entry: 2 months prior to show or earlier if spaces fill. Space fee: $155. Exhibition space: approximately 100 sq. ft for single space; other sizes available. For more information, artsits should send SASE, submit jury material.

- Event held in Chicago, Illinois.

Tips "Remember that when you are at work in your studio, you are an artist. But when you are at a show, you are a business person selling your work."

⚑ ANNUAL ARTS ADVENTURE

P.O. Box 1326, Palatine IL 60078. (847)991-4748 or (312)571-2500. E-mail: asoa@webtv.net. Web site: www.americansocietyofartists.org. **Contact:** American Society of Artists—"anyone in the office can help." Estab. 2001. Fine arts & crafts show held annually the end of July. Event held in Chicago, Illinois. Outdoors. Accepts photography, paintings, pottery, sculpture, jewelry and more. Juried. Send 4 slides or photos of your work and 1 slide or photo of your display; SASE (No. 10); a resume or show listing is helpful. See our Web site for on-line jury. Number of exhibitors: 50. Free to the public. Artists should apply by submitting jury materials. If juried in, you will receive a jury/approval number. Deadline for entry: 2 months prior to show or earlier if spaces fill. Space fee: $125. Exhibition space: approximately 100 sq. ft. for single space; other sizes available. For more information, artsits should send SASE, submit jury material.

- Event held in Chicago, Illinois.

Tips "Remember that when you are at work in your studio, you are an artist. But when you are at a show, you are a business person selling your work."

⚑ ANNUAL EDENS ART FAIR

P.O. Box 1326, Palatine IL 60078. (847)991-4748 or (312)2500. E-mail: asoa@webtv.net. Web site: www.americansocietyofartists.org. **Contact:** American Society of Artists—"anyone in the office can help." Estab. 1995 (after renovation of location; held many years prior to renovation). Fine arts & fine selected crafts show held annually in mid-July. Outdoors. Accepts photography, paintings, sculpture, glass works, jewelry. Juried. Send 4 slides or photos of your work and 1 slide or photo of your display; SASE (No. 10); a resume or show listing is helpful. Number of exhibitors: 50. Free to the public. Artists should apply by submitting jury materials. If you wish

to jury online please see our Web site and follow directions given there. If juried in, you will receive a jury/approval number. Deadline for entry: 2 months prior to show or earlier if spaces fill. Space fee: $140. Exhibition space: approximately 100 sq. ft. for single space; other sizes available. For more information, artists should send SASE, submit jury material.

● Event held in Willamette, Illinois.

Tips "Remember that when you are at work in your studio, you are an artist. But when you are at a show, you are a business person selling your work."

✉ ANNUAL HYDE PARK ARTS & CRAFTS ADVENTURE

P.O. Box 1326, Palatine IL 60078. (847)991-4748 or (312)751-2500. E-mail: asoa@webtv.net. Web site: www.americansocietyofartists.org. **Contact:** American Society of Artists—"anyone in the office can help." Estab. 2001. Arts & crafts show held twice a year in late May/early June and September. Outdoors. Accepts photography, paintings, glass, wood, fiber arts, hand-crafted candles, quilts, sculpture and more. Juried by 4 slides or photos of work and 1 slide or photo of display; SASE (No. 10); a résumé or show listing is helpful. Number of exhibitors: 50. Free to the public. Artists should apply by submitting jury materials. If juried in, you will receive a jury/approval number. See Web site for jurying on-line. Deadline for entry: 2 months prior to show or earlier if spaces fill. Space fee: $135. Exhibition space: approximately 100 sq. ft. for single space; other sizes are available. For more information, artists should send SASE, submit jury material.

● Event held in Chicago, Illinois.

Tips "Remember that when you are at work in your studio, you are an artist. But when you are at a show, you are a business person selling your work."

✉ ANNUAL OAK PARK AVENUE-LAKE ARTS & CRAFTS SHOW

P.O. Box 1326, Palatine IL 60078. (847)991-4748 or (312)751-2500. E-mail: asoa@webtv.net. Web site: www.americansocietyofartists.org. **Contact:** American Society of Artists—"anyone in the office can help." Estab. 1974. Fine arts & crafts show held annually in mid-August. Outdoors. Accepts photography, paintings, graphics, sculpture, glass, wood, paper, fiber arts, mosaics and more. Juried by 4 slides or photos of work and 1 slide or photo of display; SASE (No. 10); a resume or show listing is helpful. Number of exhibitors: 150. Free to the public. Artists should apply by submitting jury materials. If you want to jury online please see our Web site and follow directions given there. If juried in, you will receive a jury/approval number. Deadline for entry: 2 months prior to show or earlier if spaces fill. Space fee: $160. Exhibition space: approximately 100 sq. ft. for single space; other sizes available. For more information, artists should send SASE, submit jury material.

● Event held in Oak Park, Illinois.

Tips "Remember that when you are at work in your studio, you are an artist. But when you are at a show, you are a business person selling your work."

✉ ART IN THE PARK

8707 Forest Ct., Warren MI 48093. (586)795-5471. E-mail: wildart@wowway.com. Web site: www.warrenfinearts.org. **Contact:** Paula Wild, chairperson. Estab. 1990. Fine arts & crafts show held annually 2nd weekend in July. Indoors and outdoors. Accepts photography, sculpture, basketry, pottery, stained glass. Juried. Awards/prizes: 2D & 3D monetary awards. Number of exhibitors: 115. Public attendance: 7,500. Free to public. Deadline for entry: May 16. Jury fee:

$20. Space fee: $125/outdoor; $175/indoor. Exhibition space: 12 × 12 ft./tent; 12 × 10 ft./atrium. For more information, artists should e-mail, visit Web site or send SASE.

AN ARTS & CRAFTS AFFAIR, AUTUMN & SPRING TOURS

P.O. Box 184, Boys Town NE 68010. (402)331-2889. Fax: (402)445-9177. E-mail: hpifestivals@co x.net. Web site: www.hpifestivals.com. **Contact:** Huffman Productions. Estab. 1983. An arts & crafts show that tours different cities and states. The Autumn Festival tours annually October-November; Spring Festival tours annually in April. Artists should visit Web site to see list of states and schedule. Indoors. Accepts photography, pottery, stained glass, jewelry, clothing, wood, baskets. All artwork must be handcrafted by the actual artist exhibiting at the show. Juried by sending in 2 photos of work and 1 of display. Awards/prizes: 4 $30 show gift certificates; $50, $100 and $150 certificates off future booth fees. Number of exhibitors: 300-500 depending on location. Public attendance: 15,000-40,000. Public admission: $6-8/adults; $5-7/seniors; 10 & under, free. Artists should apply by calling to request an application. Deadline for entry: varies for date and location. Space fee: $350-550. Exhibition space: 8 × 11 ft. up to 8 × 22 ft. For more information, artists should e-mail, visit Web site, call or send SASE.

Tips "Have a nice display, make sure business name is visible, dress professionally, have different price points, and be willing to talk to your customers."

ARTS ON THE GREEN

P.O. Box 752, LaGrange KY 40031. 502-222-3822. Fax: 502-222-3823. E-mail: info@oldhamcount yarts.org. Web site: www.oldhamcountyarts.org. **Contact:** Marion Gibson, show coordinator. Estab. 2001. Fine arts & crafts show held annually 1st weekend in June. Outdoors. Accepts photography, painting, clay, sculpture, metal, wood, fabric, glass, jewelry. Juried by a panel. Awards/prizes: cash prizes for Best of Show and category awards. Number of exhibitors: 100. Public attendance: 7,500. Free to the public. Artists should apply online or call. Jury fee: $15. Space fee: $125. Electricity fee: $15. Exhibition space: 12 × 12 ft. For more information, artists should e-mail, visit Web site, call.

Tips "Make potential customers feel welcome in your space. Don't overcrowd your work. Smile!"

AUTUMN FESTIVAL, AN ARTS & CRAFTS AFFAIR

P.O. Box 184, Boys Town NE 68010.(402)331-2889. Fax: (402)445-9177. E-mail: hpifestivals@co x.net. Web site: www.hpifestivals.com. **Contact:** Huffman Productions. Estab. 1986. Fine arts & craft show held annually in October. Indoors. Accepts photography, pottery, jewelry, wood. All must be handcrafted by the exhibitor. Juried by 2 photos of work and 1 of display. Awards/ prizes: $420 total cash awards. Number of exhibitors: 300. Public attendance: 18,000. Public admission: $6. Artists should apply by calling for an application. Deadline: when full or by the end of September. Space fee: $400. Exhibition space: 8 × 11 ft. ("We provide pipe and drape plus 500 watts of power." For more information, artists should e-mail, visit Web site, call, send SASE.

Tips "Have a nice display; dress professionally; have various price points; be willing to talk to your customers; display your business name."

BLACK SWAMP ARTS FESTIVAL

P.O. Box 532, Bowling Green OH 43402. (419)354-2723. E-mail: info@blackswamparts.org. Web site: www.blackswamparts.org. **Contact:** Tim White, visual arts committee. Estab. 1993. Fine

arts & crafts show held annually the weekend after Labor Day. Outdoors. Accepts photography, ceramics, drawing, enamel, fiber, glass, jewelry, leather, metal, mixed media, painting, paper, prints, sculpture, wood. Juried by unaffiliated, hired jurors. Awards/prizes: Best in Show, 2nd Place, 3rd Place, Honorable Mention, Painting Prize. Number of exhibitors: Juried: 110. Invitational: 40. Public attendance: 60,000. Free to the public. Artists should apply by visiting Web site. Deadline for entry: Juried: April; Invitational: June or until filled. Application fee: Juried: $225; Invitational: $120. Exhibition space: 10×10 ft. For more information, artists should visit Web site, call (voice mail only) or e-mail.

Tips "Offer a range of prices, from $5 to $500."

☑ CAIN PARK ARTS FESTIVAL

40 Severance Circle, Cleveland Heights OH 44118-9988. (216)291-3669. Fax: (216)3705. E-mail: jhoffman@clvhts.com. Web site: www.cainpark.com. **Contact:** Janet Hoffman, administrative assistant. Estab. 1976. Fine arts & crafts show held annually 2nd full week in July. Outdoors. Accepts photography, painting, clay, sculpture, wood, jewelry, leather, glass, ceramics, clothes and other fiber, paper, block printing. Juried by a panel of professional artists; submit 5 slides. Awards/prizes: cash prizes of $750, $500 and $250; also Judges' Selection, Director's Choice and Artists' Award. Number of exhibitors: 155. Public attendance: 60,000. Free to the public. Artists should apply by requesting an application by mail, visiting Web site to download application or by calling. **Deadline for entry**: March 1. Application fee: $25. Space fee: $350. Exhibition space: 10×10 ft. Average gross sales/exhibitor: $4,000. For more information, artists should e-mail, visit Web site, or call.

Tips "Have an attractive booth to display your work. Have a variety of prices. Be available to answer questions about your work."

Ⓝ ☑ CEDARHURST CRAFT FAIR

P.O. Box 923, Mt. Vernon IL 62864. (618)242-1236. Fax: (618)242-9530. E-mail: linda@cedarhur st.org. Web site: www.cedarhurst.org. **Contact:** Linda Wheeler, coordinator. Estab. 1977. Arts & crafts show held annually in September. Outdoors. Accepts photography, paper, glass, metal, clay, wood, leather, jewelry, fiber, baskets, 2D art. Juried. Awards/prizes: Best of each category. Number of exhibitors: 125. Public attendance: 14,000. Public admission: $3. Artists should apply by filling out application form. Deadline for entry: March. Application fee: $25. Space fee: $275. Exhibition space: 10×15 ft. For more information, artists should e-mail, visit Web site.

CENTERVILLE/WASHINGTON TOWNSHIP AMERICANA FESTIVAL

P.O. Box 41794, Centerville OH 45441-0794. (937)433-5898. Fax: (937)433-5898. E-mail: america nafestival@sbcglobal.net. Web site: www.americanafestival.org. **Contact:** Patricia Fleissner, arts & crafts chair. Estab. 1972. Arts & crafts show held annually on the Fourth of July. Festival includes entertainment, parade, food, car show and other activities. Accepts photography and all mediums. "No factory-made items accepted." Awards/prizes: 1st Place; 2nd Place; 3rd Place; certificates and ribbons for most attractive displays. Number of exhibitors: 275-300. Public attendance: 70,000. Free to the public. Artists should send SASE for application form or apply online. "Main Street is usually full by early June." Space fee: $45. Exhibition space: 12×10 ft. For more information, artists should e-mail, visit Web site, call.

Tips "Artists should have moderately priced items; bring business cards; and have an eye-catching display."

COUNTRY ARTS & CRAFTS FAIR

N104 W14181 Donges Bay Rd., Germantown WI 53022. (262)251-0604. E-mail: stjohnucc53022 @sbcglobal.net. **Contact:** Mary Ann Toth, booth chairperson. Estab. 1975. Arts & crafts show held annually in September. Indoors and outdoors. Limited indoor space; unlimited outdoor booths. Accepts photography, jewelry, clothing, country crafts. Number of exhibitors: 70. Public attendance: 500-600. Free to the public. Artists should e-mail for an application and state permit. Space fee: $10 for youth; $30 for outdoor. Exhibition space: 10×10 ft. and 15×15 ft. For more information, artists should e-mail or call Mary Ann Toth or church secretary, or send SASE.

⊠ CUNEO GARDENS ART FESTIVAL

3417 R.F.D., Long Grove IL 60047. Phone/Fax: (847)726-8669. E-mail: dwevents@comcast.net. Web site: www.dwevents.org. **Contact:** D & W Events, Inc. Estab. 2005. Fine arts & crafts show. Outdoors. Accepts photography, fiber, oil, acrylic, watercolor, mixed media, jewelry, sculpture, metal, paper, painting. Juried by 3 jurors. Awards/prizes: Best of Show; First Place and awards of excellence. Number of exhibitors: 75. Public attendance: 10,000. Free to public. Artists should apply by downloading application from Web site, e-mail or call. Deadline for entry: March 1. Application fee: $25. Space fee: $275. Exhibition space: 100 sq. ft. For more information, artists should e-mail, visit Web site, call.

Tips "Artists should display professionally and attractively, and interact positively with everyone."

⊠ DEERFIELD FINE ARTS FESTIVAL

3417 R.F.D., Long Grove IL 60047. Phone/Fax: (847)726-8669. E-mail: dwevents@comcast.net. Web site: www.dwevents.org. **Contact:** D & W Events, Inc. Estab. 2000. Fine arts & crafts show held annually in early June. Outdoors. Accepts photography, fiber, oil, acrylic, watercolor, mixed media, jewelry, sculpture, metal, paper, painting. Juried by 3 jurors. Awards/prizes: Best of Show; First Place, awards of excellence. Number of exhibitors: 150. Public attendance: 35,000. Free to public. Artists should apply by downloading application from Web site, e-mail or call. Deadline for entry: March 1. Application fee: $25. Space fee: $275. Exhibition space: 100 sq. ft. For more information artists should e-mail, visit Web site, call.

Tips "Artists should display professionally and attractively, and interact positively with everyone."

⊠ DELAWARE ARTS FESTIVAL

P.O. Box 589, Delaware OH 43015. (740-)363-2695. E-mail: info@delawareartsfestival.org. Web site: www.delawareartsfestival.org. **Contact:** Tom King. Estab. 1973. Fine arts & crafts show held annually the Saturday and Sunday after Mother's Day. Outdoors. Accepts photography; all mediums, but no buy/sell. Juried by committee members who are also artists. Awards/prizes: Ribbons, cash awards, free booth for the following year. Number of exhibitors: 160. Public attendance: 25,000. Free to the public. Artists should apply by visiting Web site for application. Application fee: $10. Space fee: $125. Exhibition fee: 120 sq. ft. For more information, artists should e-mail or visit Web site.

Tips: "Have high-quality stuff. Engage the public. Set up a good booth."

Ⓝ ⊠ FARGO'S DOWNTOWN STREET FAIR

203 4th St., Fargo ND 58102. (701)241-1570. Fax: (701)241-8275. E-mail: steph@fmdowntown.c om. Web site: www.fmdowntown.com. **Contact:** Stephanie, events & membership. Estab. 1975.

Fine arts & crafts show held annually in July. Outdoors. Accepts photography, ceramics, glass, fiber, textile, jewelry, metal, paint, print/drawing, sculpture, 3D mixed media, wood. Juried by a team of artists from the Fargo-Moorehead area. Awards/prizes: Best of Show and best in each medium. Number of exhibitors: 300. Public attendance: 130,000-150,000. Free to pubic. Artists should apply online or by mail. Deadline for entry: February 18. Space fee: $275/booth; $50/corner. Exhibition space: 10×10 ft. For more information, artists should e-mail, visit Web site or call.

☙ FERNDALE ART SHOW

Integrity Shows, 2102 Roosevelt, Ypsilanti MI 48197. (734)216-3958. Fax: (734)482-2070. E-mail: mark@integrityshows.com. Web site: www.downtownferndale.com. **Contact:** Mark Loeb, president. Estab. 2004. Fine arts & crafts show held annually in September. Outdoors. Accepts photography and all fine art and craft mediums; emphasis on fun, funky work. Juried by 3 independent jurors. Awards/prizes: Purchase Awards and Merit Awards. Number of exhibitors: 90. Public attendance: 30,000. Free to the public. Application is available in March. Deadline for entry: July. Application fee: $15. Space fee: $250. Exhibition space: 10×12 ft. For more information, artists should e-mail or call.

Tips: "Enthusiasm. Keep a mailing list. Develop collectors."

Ⓝ ☙ 49TH ARTS EXPERIENCE

P.O. Box 1326, Palatine IL 60078. (847)991-4748 or (312)751-2500. E-mail: asoa@webtv.net. Web site: www.americansocietyofartists.org. Estab. 1979. Fine arts & crafts show held in summer. Outdoors. Accepts photography, paintings, graphics, sculpture, quilting, woodworking, fiber art, hand-crafted candles, glass works, jewelry, etc. Juried by 4 slides/photo representative of work being exhibited; 1 photo of display set-up, #10 SASE, résumé with 7 show listings helpful. Number of exhibitors: 50. Free to public. Artists should apply by submitting jury material and indicate you are interested in this particular show. If you wish to jury online please see our Web site and follow directions given there. When you pass the jury, you will receive jury approval number and application you requested. Deadline for entry: 2 months prior to show or earlier if space is filled. Space fee: to be announced. Exhibition space: 100 sq. ft. for single space; other sizes are available. For more information, artists should send SASE to submit jury material.

● Event held in Chicago, Illinois.

Tips "Remember that at work in your studio, you are an artist. When you are at a show, you are a business person selling your work."

☙ FOUR RIVERS ARTS & CRAFTS HARVEST HOME FESTIVAL

112 S. Lakeview Dr., Petersburg IN 47567. (812)354-6808, ext. 112. Fax: (812)354-2785. E-mail: rivers4@sigecom.net. Web site: http://www.fourriversrcd.org/gpage.html4.html. **Contact:** Denise Tuggle, program assistant. Estab. 1976. Arts & crafts show held annually the 3rd weekend in October. Indoors. Juried. Board of Directors are assigned certain buildings to check for any manufactured items. Crafts are not judged. Awards/prizes: $30-50; 3 display awards based on display uniqueness and the correlation of the harvest theme. Number of exhibitors: 200. Public attendance: 5,000. Free to public; $2 parking fee. Artists should apply by calling with information. Application will be mailed along with additional information. Deadline for entry: July 30. Space fee: $55, 2 per applicant. Exhibition space: 10×10 ft. For more information, artists should call.

ℕ ⬇ FOURTH STREET FESTIVAL FOR THE ARTS & CRAFTS

P.O. Box 1257, Bloomington IN 47402. (812)335-3814. Web site: www.4thstreet.org. Estab. 1976. Fine arts & crafts show held annually Labor Day weekend. Outdoors. Accepts photography, clay, glass, fiber, jewelry, painting, graphic, mixed media, wood. Juried by a 4-member panel. Awards/prizes: Best of Show, 1st, 2nd, 3rd in 2D and 3D. Number of exhibitors: 105. Public attendance: 25,000. Free to public. Artists should apply by sending requests by snail mail, e-mail or download application from Web site. Deadline for entry: April 1. Application fee: $15. Space fee: $175. Exhibition space: 10×10 ft. Average gross sales/exhibitor: $2,700. For more information, artists should e-mail, visit Web site, call or send for information with SASE.
Tips ''Be professional.''

ℕ ⬇ FRANKFORT ART FAIR

P.O. Box 566, Frankfort MI 49635.(231)352-7251. Fax: (231)352-6750. E-mail: fcofc@frankfort-elberta.com. Web site: www.frankfort-elberta.com. Estab. 1976. **Contact:** Joanne Bartley, art fair director. Fine Art Fair held annually in August. Outdoors. Accepts photography, clay, glass, jewelry, textiles, wood, drawing/graphic arts, painting, sculpture, baskets, mixed media. Juried by 3 photos of work, one photo of booth display and one photo of work in progress. Prior exhibitors are not automatically accepted. No buy/sell allowed. Artists should apply by downloading application from Web site, e-mailing or calling. Deadline for entry: May 1. Jury fee: $15. Space fee: $105 for Friday and Saturday. Exhibition space: 12×12 ft. For more information, artists should e-mail, see Web site.

⬇ GOOD OLD SUMMERTIME ART FAIR

P.O. Box 1753, Kenosha WI 53141-1753. (262)654-0065. E-mail: kaaartfairs@yahoo.com. Web site: www.KenoshaArtAssoc.org. **Contact:** Karen Gulbransen, art fair coordinator. Estab. 1975. Fine arts show held annually the 1st Sunday in June. Outdoors. Accepts photography, paintings, drawings, mosaics, ceramics, pottery, sculpture, wood, stained glass. Juried by a panel. Photos or slides required with application. Awards/prizes: Best of Show, 1st, 2nd and 3rd Places, plus Purchase Awards. Number of exhibitors: 100. Public attendance: 3,000. Free to public. Artists should apply by completing application form, and including fees and SASE. Deadline for entry: April 1. Application/space fee: $60-65. Exhibition space: 12×12 ft. For more information, artists should e-mail, visit Web site or send SASE.
Tips ''Have a professional display, and be friendly.''

ℕ GRADD ARTS & CRAFTS FESTIVAL

3860 US Hwy 60 W., Owensboro KY 42301. (270)926-4433. Fax: (270)684-0714. E-mail: bethgoetz@gradd.com. Web site: www.gradd.com. **Contact:** Beth Goetz, festival coordinator. Estab. 1972. Arts & crafts show held annually 1st full weekend in October. Outdoors. Accepts photography taken by crafter only. Number of exhibitors: 180-200. Public attendance: 15,000+. Free to public; $3 parking fee. Artists should apply by calling to be put on mailing list. Space fee: $100-150. Exhibition space: 10×12 ft. For more information, artists should e-mail, visit Web site or call.
Tips ''Be sure that only hand-crafted items are sold. No buy/sell items will be allowed.''

⬇ HINSDALE FINE ARTS FESTIVAL

22 E. First St., Hinsdale IL 60521. (630)323-3952. Fax: (630)323-3953. E-mail: janet@hindsdalechamber.com. Web site: www.hinsdalechamber.com. **Contact:** Jan Anderson, executive director.

Fine arts show held annually in mid-June. Outdoors. Accepts photography, ceramics, painting, sculpture, fiber arts, mixed media, jewelry. Juried by 3 slides. Awards/prizes: Best in Show, Presidents Award and 1st, 2nd and 3rd Place in 7 categories. Number of exhibitors: 150. Public attendance: 2,000-3,000. Free to public. Artists should apply by mailing or downloading application from Web site. Deadline for entry: March 2. Application fee: $25. Space fee: $250. Exhibition space: 10×10 ft. For more information, artists should e-mail or visit Web site.

Tips "Original artwork sold by artist. Artwork should be appropriately and reasonably priced."

N ✓ STAN HYWET HALL & GARDENS WONDERFUL WORLD OF OHIO MART

714 N. Portage Path, Akron OH 44303-1399. (330)836-5533. Web site: www.stanhywet.org. **Contact:** Lynda Grieves, exhibitor chair. Estab. 1966. Arts & crafts show held annually 1st full weekend in October. Outdoors. Accepts photography and all mediums. Juried 2 Saturdays in January and via mail application. Awards/prizes: Best Booth Display. Number of exhibitors: 115. Public attendance: 15,000-20,000. Public admission: $7. Deadline for entry: Mid-February. Space fee: $450. Exhibition space: 10×10 ft. For more information, artists should visit Web site or call.

✓ KIA ART FAIR (KALAMAZOO INSTITUTE OF ARTS)

314 S. Park St., Kalamazoo MI 49007-5102. (269)349-7775. Fax: (269)349-9313. E-mail: sjrodia@yahoo.com. Web site: www.kiarts.org. **Contact:** Steve Rodia, artist coordinator. Estab. 1951. Fine arts & crafts show held annually the 1st Friday and Saturday in June. Outdoors. Accepts photography, prints, pastels, drawings, paintings, mixed media, ceramics (functional and non-functional), sculpture/metalsmithing, wood, fiber, jewelry, glass, leather. Juried by no fewer than 3 and no more than 5 art professionals chosen for their experience and expertise. See prospectus for more details. Awards/prizes: 1st prize: $500; 2nd prize: 2 at $300 each; 3rd prize: 3 at $200 each. 10 category prizes at $100 each. Number of exhibitors: 200. Public attendance: 40,000-50,000. Free to the public. Artists should apply by filling out application form and submitting 3 digital images of their art and 1 digital image of their booth display. Deadline for entry: March 1. Application fee: $25, nonrefundable. Space fee: $110. Exhibition space: 10×12 ft. Height should not exceed 10 ft. in order to clear the trees in the park. For more information, artists should e-mail, visit Web site, call.

N ✓ LES CHENEAUX FESTIVAL OF ARTS

P.O. Box 30, Cedarville MI 49719. (906)484-2821. Fax: (906)484-6107. E-mail: lcha@cedarville.net. Contact: A. Goehring, curator. Estab. 1976. Fine arts & crafts show held annually 2nd Saturday in August. Outdoors. Accepts photography and all other media; original work and design only; no kits or commercially manufactured goods. Juried by a committee of 10. Submit 4 slides (3 of the artwork; 1 of booth display). Awards/prizes: monetary prizes for excellent and original work. Number of exhibitors: 70. Public attendance: 8,000. Public admission: $7. Artists should fill out application form to apply. Deadline for entry: April 1. Application fee: $65. Exhibition space: 10×10 ft. Average gross sales/exhibitor: $5-$500. For more information, artists should call, send SASE.

✓ MASON ARTS FESTIVAL

P.O. Box 381, Mason OH 45040. ((513)573-9376. E-mail: pgast@cinci.rr.com for Inside City Gallery; mraffel@cinci.rr.com. for outdoor art festival. Web site: www.masonarts.org. **Contact:**

Pat Gastreich, City Gallery Chairperson. Fine arts and crafts show held annually in September. Indoors and outdoors. Accepts photography, graphics, printmaking, mixed media; painting and drawing; ceramics, metal sculpture; fiber, glass, jewelry, wood, leather. Juried. Awards/prizes: $3,000+. Number of exhibitors: 75-100. Public attendance: 3,000-5,000. Free to the public. Artists should apply by visiting Web site for application, e-mailing mraffel@cinci.rr.com, or calling (513)573-0007. Deadline for entry: June. Application fee: $25. Space fee: $75 for single space; $135 for adjoining spaces. Exhibition space: 12×12 ft.; artist must provide 10×10 ft. pop-up tent.

- City Gallery show is held indoors; these artists are not permitted to participate outdoors and vice versa. City Gallery is a juried show featuring approximately 30-50 artists who may show up to 2 pieces.

Tips "Photographers are required to disclose both their creative and printing processes. If digital manipulation is part of the composition, please indicate."

⬛ MICHIGAN STATE UNIVERSITY SPRING ARTS & CRAFTS SHOW

322 MSU Union, East Lansing MI 48824. (517)355-3354. E-mail: artsandcrafts@uabevents.com. Web site: www.uabevents.com. Contact: Kate Lake, assistant manager. Estab. 1963. Arts & crafts show held annually in mid-May. Outdoors. Accepts photography, basketry, candles, ceramics, clothing, sculpture, soaps, drawings, floral, fibers, glass, jewelry, metals, painting, graphics, pottery, wood. Juried by a panel of judges using the photographs submitted by each vendor to eliminate commercial products. They will evaluate on quality, creativity and crowd appeal. Number of exhibitors: 329. Public attendance: 60,000. Free to public. Artists can apply online beginning in February. Online applications will be accepted until show is filled. Application fee: $240. Exhibition space: 10×10 ft. For more information, artists should visit Web site or call.

⬛ ⬛ NEW ENGLAND ARTS & CRAFTS FESTIVAL

Castleberry Fairs & Festivals, 38 Charles St., Rochester NE 03867. (603)322-2616. E-mail: info@c astleberryfairs.com. Web site: www.castleberryfairs.com. **Contact:** Terry Mullen, event coordinator. Estab. 1988. Arts & crafts show held annually on Labor Day weekend in Topsfield, Massachusettes. Indoors and outdoors. Accepts photography and all other mediums. Juried by photo, slide or sample. Number of exhibitors: 250. Public attendance: 25,000. Public admission: $6.00 for adults: free for 13 and under. Artists should apply by downloading application from Web site. Deadline for entry: until full. Space fee: $350. Exhibition space: 100 sq. ft. Average gross sales/exhibitor: "Generally, this is considered an 'excellent' show, so I would guess most exhibitors sell ten times their booth fee, or in this case, at least $3,500 in sales." For more information, artists should visit Web site.

Tips "Do not bring a book; do not bring a chair. Smile and make eye contact with everyone who enters your booth. Have them sign your guest book; get their e-mail address so you can let them know when you are in the area again. And, finally, make the sale—they are at the fair to shop, after all."

⬛ ORCHARD LAKE FINE ART SHOW

P.O. Box 79, Milford MI 48381-0079. (248)684-2613. Fax: (248)684-0195. E-mail: patty@hotwork s.org. Web site: www.hotworks.org. **Contact:** Patty Narozny, show director. Estab. 2002. Fine arts & crafts show held annually late July/early August. Outdoors. Accepts photography, clay, glass, fiber, wood, jewelry, painting, prints, drawing, sculpture, metal, multimedia. Juried by 3

art professionals who view 3 slides of work and 1 of booth. Awards/prizes: $2,500 in awards: 1 Best of Show: $1,000; 2 Purchase Awards: $500 each; 5 Awards of Excellence: $100 each. Free to the public; parking: $5. Artists can obtain an application on the Web site, or they can call the show director who will mail them an application. Deadline for entry: March. Application fee: $25. Space fee: starts at $300. Exhibition space: 12×3 ft. "We allow room on either side of the tent, and some space behind the tent." For more information, artists should e-mail, visit Web site, call, send SASE.

Tips: "Be attentive to your customers. Do not ignore anyone."

RILEY FESTIVAL

312 E. Main St. #C, Greenfield IN 46140. (317)462-2141. Fax: (317)467-1449. E-mail: info@rileyf estival.com. Web site: www.rileyfestival.com. **Contact:** Sarah Kesterson, office manager. Estab. 1970. Fine arts & crafts show held October 2-5, 2008. Outdoors. Accepts photography, fine arts, home arts, quilts. Juried. Awards/prizes: small monetary awards and ribbons. Number of exhibitors: 450. Public attendance: 75,000. Free to public. Artists should apply by downloading application on Web site. Deadline for entry: September 15. Space fee: $165. Exhibition space: 10×10 ft. For more information, artists should visit Web site.

Tips "Keep arts priced for middle-class viewers."

ROYAL OAK OUTDOOR ART FAIR

PO Box 64, Royal Oak MI 48068-0064. (248)246-3180. Fax: (248)246-3007. E-mail: artfaire@ci.ro yal-oak.mi.us. Web site: www.ci.royal-oak.mi.us/rec/r7.html. **Contact:** Recreation Office Staff. Events & Membership. Estab. 1970. Fine arts & crafts show held annually in July. Outdoors. Accepts photography, collage, jewelry, clay, drawing, painting, glass, wood, metal, leather, soft sculpture. Juried. Number of exhibitors: 110. Public attendance: 25,000. Free to pubic. Artists should apply with application form and 3 slides of current work. Deadline for entry: March 1. Application fee: $20. Space fee: $300. Exhibition space: 15×15 ft. For more information, artists should e-mail or call.

Tips: "Be sure to label your slides on the front with name, size of work and 'top'."

ST. CHARLES FINE ART SHOW

213 Walnut St., St. Charles IL 60174. (630)513-5386. Fax: (630)513-6310. E-mail: bethany@dtow n.org. Web site: www.stcharlesfineartshow.com. **Contact:** Bethany McFarland, marketing coordinator. Estab. 1999. Fine art fair held annually in late May. Outdoors. Accepts photography, painting, sculpture, glass, ceramics, jewelry, nonwearable fiber art. Juried by committee: submit 4 slides of art and 1 slide of booth/display. Awards/prizes: Cash awards of $2,500+ awarded in several categories. Purchase Award Program: $14,000 of art has been purchased through this program since its inception in 2005. Number of exhibitors: 100. Free to the public. Artists should apply by downloading application from Web site or call for application. Deadline for entry: February. Jury fee: $25. Space fee: $200. Exhibition space: 12×12 ft. For more information, artists should e-mail, visit Web site, call.

ST. JAMES COURT ART SHOW

P.O. Box 3804, Louisville KY 40201. (502)635-1842. Fax: (502)635-1296. E-mail: mesrock@stjam escourtartshow.com. Web site: www.stjamescourtartshow.com. **Contact:** Marguerite Esrock, executive director. Estab. 1957. Annual fine arts & crafts show held the first full weekend in

October. Accepts photography; has 16 medium categories. Juried in March; there is also a street jury held during the art show. Awards/prizes: Best of Show—3 places; $7,500 total prize money. Number of exhibitors: 340. Public attendance: 275,000. Free to the public. Artists should apply by visiting Web site and printing out an application or via www.zapplication.org. Deadline for entry in 2009 show: March 1, 2009. Application fee: $30. Space fee: $500. Exhibition space: 10 × 12 ft. For more information, artists should e-mail or visit Web site.

Tips "Have a variety of price points. Don't sit in the back of the booth and expect sales."

ⓃⓋ STONE ARCH FESTIVAL OF THE ARTS

219 Main St. SE, Suite 304, Minneapolis MN 55414. (612)378-1226. E-mail: mplsriverfront@msn. com. Web site: www.stonearchfestival.com. **Contact:** Sara Collins, manager. Estab. 1994. Fine arts & crafts show and culinary arts show held annually Father's Day weekend. Outdoors. Accepts photography, painting, ceramics, jewelry, fiber, printmaking, wood, metal. Juried by committee. Awards/prizes: free booth the following year; $100 cash prize. Number of exhibitors: 230. Public attendance: 80,000. Free to public. Artists should apply by application found on Web site or through www.zapplication.org. Deadline for entry: March 15. Application fee: $20 jury. Space fee: $250-300. Exhibition space: 10 × 10 ft. For more information, artists should e-mail, visit Web site, call or send SASE.

Tips "Have an attractive display and variety of prices."

Ⓥ STREET FAIRE AT THE LAKES

PO Box 348, Detroit Lakes MN 56502. (800)542-3992. Fax: (218)847-9082. E-mail: dlchamber@v isitdetroitlakes.com. Web site: www.visitdetroitlakes.com. **Contact:** Sue Braun, artist coordinator. Estab. 2001. Fine arts & crafts show held annually 1st weekend after Memorial Day. Outdoors. Accepts photography, handmade/original artwork, wood, metal, glass, painting, fiber. Juried by anonymous scoring. Submit 5 slides, 4 of work and 1 of booth display. Top scores are accepted. Number of exhibitors: 125. Public attendance: 15,000. Free to public. Artists should apply by downloading application from Web site. Deadline for entry: January 15. Application fee: $150-175. Exhibition space: 11 × 11 ft. For more information, artists should e-mail or call.

SUMMER ARTS AND CRAFTS FESTIVAL

UW-Parkside, 900 Wood Rd., Box 2000, Kenosha WI 53141. (262)595-2457. E-mail: eichner@uw p.edu. **Contact:** Mark Eichner, coordinator. Estab. 1990. Arts & crafts show held annually 3rd week in June. Outdoors. Accepts photography, painting, glass, sculpture, woodwork, metal, jewelry, leather, quilts. Number of exhibitors: 200. Public attendance: 4,000. Free to the public. Artists should apply by calling or e-mailing for an application form. Deadline for entry: May. Space fee: $100. Exhibition space: 10 × 10 ft. For more information, artists should e-mail, call.

Tips "Items priced less than $100 are excellent sellers."

Ⓥ SUMMERFAIR

7850 Five Mile Road, Cincinnati, OH 45230. (513)531-0050. Fax: (513)531-0377. E-mail: exhibitor s@summerfair.org. Web site: www.summerfair.org. **Contact:** Sharon Strubbe. Estab. 1968. Fine arts & crafts show held annually the weekend after Memorial Day. Outdoors. Accepts photography, ceramics, drawing/printmaking, fiber/leather, glass, jewelry, painting, sculpture/metal, wood. Juried by a panel of judges selected by Summerfair, including artists and art educators with expertise in the categories offered at Summerfair. Submit 5 slides of artwork, including

artist's name, dimensions of work, and arrow indicating top of work. "Do not submit a booth slide." Awards/prizes: $10,000 in cash awards. Number of exhibitors: 300. Public attendance: 25,000. Public admission: $10. Artists should apply by downloading application from Web site (available in December) or by e-mailing for an application. Deadline: February. Application fee: $30. Space fee: $375, single single; $750, double space; $75 canopy fee (optional—exhibitors can rent a canopy for all days of the fair). Exhibition space: 10×10 ft. for single space; 10×20 for double space. For more information, artists should e-mail, visit Web site, call.

☑ UPTOWN ART FAIR

1406 West Lake St., Suite 202, Minneapolis MN 55408. (612)823-4581. Fax: (612)823-3158. E-mail: info@uptownminneapolis.com. Web site: www.uptownminneapolis.com. **Contact:** Cindy Fitzpatrick. Estab. 1963. Fine arts & crafts show held annually 1st full weekend in August. Outdoors. Accepts photography, painting, printmaking, drawing, 2D and 3D mixed media, ceramics, fiber, sculpture, jewelry, wood. Juried by 4 images of artwork and 1 of booth display. Awards/prizes: Best in Show in each category; Best Artist. Number of exhibitors: 350. Public attendance: 350,000. Free to the public. Artists should apply by visiting www.zapplication.com. Deadline for entry: March. Application fee: $30. Space fee: $450 for 10×10 space; $900 for 10×20 space. For more information, artists should call or visit Web site.

Ⓝ ☑ A VICTORIAN CHAUTAUQUA

1101 E Market St., P.O. Box 606, Jeffersonville IN 47131-0606. (812) 283-3728. Fax: (812)283-6049. E-mail: hsmsteam@aol.com. Web site: www.steamboatmuseum.org. **Contact:** Yvonne Knight, administrator. Estab. 1993. Fine arts & crafts show held annually 3rd weekend in May. Outdoors. Accepts photography, all mediums. Juried by a committee of 5. Awards/prizes: $100, 1st Place; $75, 2nd Place; $50, 3rd Place. Number of exhibitors: 80. Public attendance: 3,000. Public admission: $3. Deadline for entry: March 31. Space fee: $40-60. Exhibition space: 12×12 ft. For more information, artists should e-mail or call.

Ⓝ ☑ WILMETTE FESTIVAL OF FINE ARTS

P.O. Box 902, Wilmette IL 60091-0902. Phone/fax: (847)256-2080. E-mail: wilmetteartsguild@aol.com. Web site: www.wilmetteartsguild.org. **Contact:** Julie Ressler, president. Estab. 1992. Fine arts & crafts show held annually in September. Outdoors. Accepts photography, paintings, prints, jewelry, sculpture, ceramics, and any other appropriate media; no wearable. Juried by a committee of 6-8 artists and art teachers. Awards/prizes: 1st Place: $1,000; 2nd Place: $750; 3rd Place: $500; People's Choice: $50; local merchants offer purchase awards. Number of exhibitors: 100. Public attendance: 4,000. Free to the public. Deadline for entry: April. Application fee: $120. Space fee: $195. Exhibition space: 12×12 ft. For more information, artists should e-mail, visit Web site, call, send SASE.
Tips "Maintain a well-planned, professional appearance in booth and person. Greet viewers when they visit the booth. Offer printed bio with photos of your work. Invite family, friends and acquaintances."

☑ WINNEBAGOLAND ART FAIR

South Park Avenue/South Park, Oshkosh WI 54902. (920)303-1503. E-mail: shelling1230@charter.net. Estab. 1957. Fine arts show held annually. Outdoors. Accepts photography, watercolor, oils & acrylics, 3D large, 3D small, drawing, pastels. Juried. Applicants send in slides to be

reviewed. Awards/prizes: monetary awards, Purchase, Merit and Best of Show awards. Number of exhibitors: 125-160. Public attendance: 5,000-7,000. Free to public. Deadline for entry: April 30. Application fee: $60, but may increase next year. Exhibition space: 20×20 ft. For more information, artists should e-mail or call.

Tips "Have a nice-looking exhibit booth."

☑ WYANDOTTE STREET ART FAIR

3131 Biddle Ave., Wyandotte MI 48192. (734)324-4505. Fax: (734)324-4505. E-mail: info@wyan. org. Web site: www.wyandottestreetartfair.net. **Contact:** Lisa Hooper, executive director, Wyandotte Downtown Development Authority. Estab. 1961. Fine arts & crafts show held annually 2nd week in July. Outdoors. Accepts photography, 2D mixed media, 3D mixed media, painting, pottery, basketry, sculpture, fiber, leather, digital cartoons, clothing, stitchery, metal, glass, wood, toys, prints, drawing. Juried. Awards/prizes: Best New Artist: $500; Best Booth Design Award: $500; Best of Show: $1,200. Number of exhibitors: 300. Public attendance: 200,000. Free to the public. Artists may apply online or request application. Deadline for entry: February. Application fee: $20 jury fee. Space fee: $225/single space; $450/double space. Exhibition space: 10×10 ft. Average gross sales/exhibitor: $2,000-$4,000. For more information, artists should e-mail, visit Web site, call, send SASE.

SOUTH CENTRAL & WEST

☑ AFFAIRE IN THE GARDENS ART SHOW

Greystone Park, 501 Doheny Rd., Beverly Hills CA 90210-2921. (310)550-4796. Fax: (310)858-9238. E-mail: kmclean@beverlyhills.org. Web site: www.beverlyhills.org. **Contact:** Karen Fitch McLean, art show coordinator. Estab. 1973. Fine arts & crafts show held biannulay 3rd weekend in May and 3rd weekend in October. Outdoors. Accepts photography, painting, sculpture, ceramics, jewelry, digital media. Juried. Awards/prizes: 1st Place in category, cash awards, Best in Show cash award; Mayor's Purchase Award in October show. Number of exhibitors: 225. Public attendance: 30,000-40,000. Free to public. Deadline for entry: end of February, May show; end of July, October show. Application fee: $30. Space fee: $300. Exhibition space: 10×12 ft. For more information, artists should e-mail, visit Web site, call or send SASE.

Tips "Art fairs tend to be commercially oriented. It usually pays off to think in somewhat commercial terms—what does the public usually buy? Personally, I like risky and unusual art, but the artists who produce esoteric art sometimes go hungry! Be nice and have a clean presentation."

☑ ART IN THE PARK

P.O. Box 748, Sierra Vista AZ 85636-0247. (520)803-8981. E-mail: artinthepark@msm.com. Web site: www.huachuca-art.com. **Contact:** Vendor Committee. Estab. 1972. Fine arts & crafts show held annually 1st full weekend in October. Outdoors. Accepts photography, all fine arts and crafts created by vendor. Juried by 3-6 typical customers. Artists submit 6 photos. Number of exhibitors: 240. Public attendance: 20,000. Free to public. Artists should apply by calling, e-mailing or sending SASE between February and May; application package available online at HAA Web site. Deadline for entry: postmarked by June 27. Application fee: $10 included in space fee. Space fee: $175, includes jury fee. Exhibition space: 15×35 ft. For more information, artists should e-mail, call or send SASE.

☒ AVON FINE ART & WINE AFFAIRE

15648 N. Eagles Nest Dr., Fountain Hills AZ 85268-1418. (480)837-5637. Fax: (480)837-2355. E-mail: info@thunderbirdartists.com. Web site: www.thunderbirdartists.com. **Contact:** Denise Colter, vice president. Estab. 1993. Fine arts & crafts show and wine tasting held annually in mid-July. Outdoors. Accepts photography, painting, mixed media, bronze, metal, copper, stone, stained glass, clay, wood, paper, baskets, jewelry, scratchboard. Juried by 4 slides of work and 1 slide of booth. Number of exhibitors: 150. Public attendance: 3,000-6,000. Free to public. Artists should apply by sending application, fees, 4 slides of work, 1 slide of booth and 2 SASEs. Deadline for entry: March 27. Application fee: $20. Space fee: $360-1,080. Exhibition space: 10×10 ft.-10×30 ft. For more information, artists should visit Web site.

CALABASAS FINE ARTS FESTIVAL

26135 Mureau Rd., Calabasas CA 91302. (818)878-4225, ext. 270. E-mail: artcouncil@cityofcalab asas.com. Web site: www.calabasasartscouncil.com. Estab. 1997. Fine arts & crafts show held annually in late April/early May. Outdoors. Accepts photography, painting, sculpture, jewelry, mixed media. Juried. Number of exhibitors: 250. Public attendance: 10,000+. Free to public; parking: $5. For more information, artists should visit Web site or e-mail.

☒ CHUN CAPITOL HILL PEOPLE'S FAIR

1290 Williams St., Denver CO 80218. (303)830-1651. Fax: (303)830-1782. E-mail: chun@chunde nver.org. Web site: www.peoplesfair.com; www.chundenver.org. Estab. 1971. Arts & crafts show held annually 1st weekend in June. Outdoors. Accepts photography, ceramics, jewelry, paintings, wearable art, glass, sculpture, wood, paper, fiber. Juried by professional artisans representing a variety of mediums and selected members of fair management. The jury process is based on originality, quality and expression. Awards/prizes: Best of Show. Number of exhibitors: 300. Public attendance: 250,000. Free to public. Artists should apply by downloading application from Web site. Deadline for entry: March. Application fee: $35. Space fee: $300. Exhibition space: 10×10 ft. For more information, artists should e-mail, visit Web site or call.

☒ EDWARDS FINE ART & SCULPTURE FESTIVAL

15648 N. Eagles Nest Dr., Fountain Hills AZ 85268-1418. (480)837-5637. Fax: (480)837-2355. E-mail: info@thunderbirdartists.com. Web site: www.thunderbirdartists.com. **Contact:** Denise Colter, vice president. Estab. 1999. Fine arts & sculpture show held annually in late July. Outdoors. Accepts photography, painting, drawing, graphics, fiber sculpture, mixed media, bronze, metal, copper, stone, stained glass, clay, wood, baskets, jewelry. Juried by 4 slides of work and 1 slide of booth presentation. Number of exhibitors: 115. Public attendance: 3,000-6,000. Free to public. Artists should apply by sending application, fees, 4 slides of work, 1 slide of booth labeled and 2 SASE. Deadline for entry: March 29. Application fee: $20. Space fee: $360-1,080. Exhibition space: 10×10 ft.-10×30 ft. For more information, artists should visit Web site.

☒ FAIRE ON THE SQUARE

117 W. Goodwin St., Prescott AZ 86301-1147. (928)445-2000, ext. 12. Fax: (928)445-0068. E-mail: scott@prescott.org. Web site: www.prescott.org. **Contact:** Scott or Jill Currey (Special Events—Prescott Chamber of Commerce) Estab. 1985. Arts & crafts show held annually in Labor Day weekend. Outdoors. Accepts photography, ceramics, painting, sculpture, clothing, woodworking, metal art, glass, floral, home décor. "No resale." Juried. "Photos of work and artist

creating work are required." Number of exhibitors: 170. Public attendance: 10,000-12,000. Free to public. Application can be printed from Web site or obtained by phone request. Deadline: spaces are sold until show is full. Application fee: $50 deposit. Space fee: $400. Exhibition space; 10×15 ft. For more information, artist should e-mail, visit Web site or call.

Ⓝ FALL FEST IN THE PARK

117 W. Goodwin St., Prescott AZ 86301-1147. (928)445-2000 ext 12. Fax: (928)445-0068. E-mail: scott@prescott.org. Web site: www.prescott.org. **Contact:** Scott or Jill Currey (Special Events—Prescott Chamber of Commerce) Estab. 1981. Arts & crafts show held annually in mid-October. Outdoors. Accepts photography, ceramics, painting, sculpture, clothing, woodworking, metal art, glass, floral, home décor. "No resale." Juried. "Photos of work and artist creating work are required." Number of exhibitors: 150. Public attendance: 6,000-7,000. Free to public. Application can be printed from Web site or obtained by phone request. Deadline: Spaces are sold until show is full. Application fee: $50 deposit. Space fee: $225. Exhibition space; 10×15 ft. For more information, artists should e-mail, visit Web site or call.

Ⓝ ☑ FAUST FINE ARTS & FOLK FESTIVAL

15185 Olive St., St. Louis MO 63017. (636)391-0900, ext.27. Fax: (636)527-2259. E-mail: toconnell@stlouisco.com. Web site: www.stlouisco.com/parks. **Contact:** Tonya O'Connell, recreation supervisor. Fine arts & crafts show held biannually in May and September. Outdoors. Accepts photography, oil, acrylic, clay, fiber, sculpture, watercolor, jewelry, wood, floral, baskets, prints, drawing, mixed media, folk art. Juried by a committee. Awards/prizes: $100. Number of exhibitors: 90-100. Public attendance: 5,000. Public admission: $5. Deadline for entry: March, spring show; July, fall show. Application fee: $15. Space fee: $75. Exhibition space: 10×10 ft. For more information, artists should call.

Ⓝ ☑ FILLMORE JAZZ FESTIVAL

P.O. Box 15107, San Rafael CA 94915. (800)310-6563. Fax: (414)456-6436. E-mail: art@fillmorejazzfestival.com. Web site: www.fillmorejazzfestival.com. Estab. 1984. Fine arts & crafts show and jazz festival held annually 1st weekend of July in San Franciso, between Jackson & Eddy Streets. Outdoors. Accepts photography, ceramics, glass, jewelry, paintings, sculpture, metal clay, wood, clothing. Juried by prescreened panel. Number of exhibitors: 250. Public attendance: 90,000. Free to public. Deadline for entry: ongoing. Space fee: $350-600. Exhibition space: 8×10 ft. or 10×10 ft. Average gross sales/exhibitor: $800-11,000. For more information, artists should e-mail, visit Web site or call.

☑ FOURTH AVENUE SPRING STREET FAIR

329 E. 7th St., Tucson AZ 85705. (520)624-5004. Fax: (520)624-5933. E-mail: kurt@fourthavenue.org. Web site: www.fourthavenue.org. **Contact:** Kurt Tallis, event director. Estab. 1970. Arts & crafts fair held annually in March. 2009 dates: March 20-22. Outdoors. Accepts photography, drawing, painting, sculpture, arts and crafts. Juried by 5 jurors. Awards/prizes: Best of Show. Number of exhibitors: 400. Public attendance: 300,000. Free to the public. Artists should apply by completing the online application. Application fee: $35. Space fee: $470. Exhibition space: 10×10 ft. Average gross sales/exhibitor: $3,000. For more information, artists should e-mail, visit Web site, call, send SASE.

🎨 FOURTH AVENUE WINTER STREET FAIR

329 E. 7th St., Tucson AZ 85705. (520)624-5004. Fax: (520)624-5933. E-mail: kurt@fourthave nue.org. Web site: www.fourthavenue.com. **Contact:** Kurt Tallis, event director. Estab. 1970. Arts & crafts fair held annually in December. Outdoors. Accepts photography, drawing, painting, sculpture, arts and crafts. Juried by 5 jurors. Awards/prizes: Best of Show. Number of exhibitors: 400. Public attendance: 300,000. Free to the public. Artists should apply by completing the online application. Deadline for entry: September. Application fee: $35. Space fee: $470. Exhibition space: 10 × 10 ft. Average gross sales/exhibitor: $3,000. For more information, artists should e-mail, visit Web site, call, send SASE.

🅽 🎨 FOURTH OF JULY STREET FAIR, AUTUMN FEST IN THE PARK AND HOLIDAY STREET FESTIVAL

501 Poli St. #226, Ventura CA 93002. (805)654-7830. Fax: (805)648-1030. E-mail: mgoody@ci.ve ntura.ca.us. Web site: www.venturastreetfair.com. **Contact:** Michelle Goody, cultural affairs coordinator. Estab. 1976. Fine arts & crafts show held annually in July, September and December. Outdoors. Accepts photography. Juried by a panel of 3 artists who specialize in various mediums; photos of work required. Number of exhibitors: 75-300. Public attendance: 1,000-50,000. Free to public. Artists should apply by downloading application from Web site or call to request application. Space fee: $100-175. Exhibition space: 10 × 10 ft. For more information, artists should e-mail, visit Web site or call.

Tips "Be friendly, outgoing; know the area for pricing."

🅽 🎨 GRAND FESTIVAL OF THE ARTS & CRAFTS

P.O. Box 429, Grand Lake CO 80447-0429. (970)627-3372. Fax: (970)627-8007. E-mail: glinfo@gr andlakechamber.com. Web site: www.grandlakechamber.com. **Contact:** Cindy Cunningham, events coordinator; Elaine Arguien, office chamber. Fine arts & crafts show held annually 1st weekend in June. Outdoors. Accepts photography, jewelry, leather, mixed media, painting, paper, sculpture, wearable art. Juried by chamber committee. Awards/prizes: Best in Show and People's Choice. Number of exhibitors: 50-55. Public attendance: 1,000 + . Free to public. Artists should apply by submitting slides or photos. Deadline for entry: May 1. Application fee: $125, includes space fee, security deposit and business license. Exhibition space: 10 × 10 ft. For more information, artists should e-mail or call.

HOME DECORATING & REMODELING SHOW

P.O. Box 230699, Las Vegas NV 89105-0699. (702)450-7984 or (800)343-8344. Fax: (702)451- 7305. E-mail: spvandy@cox.net. Web site: www.nashvillehomeshow.com. **Contact:** Vandy Richards, manager member. Estab. 1983. Home show held annually in September. Indoors. Accepts photography, sculpture, watercolor, oils, mixed media, pottery. Awards/prizes: Outstanding Booth Award. Number of exhibitors: 300-350. Public attendance: 25,000. Public admission: $8. Artists should apply by calling. Marketing is directed to middle and above income brackets. Deadline for entry: open until filled. Space fee: $850 + . Exhibition space: 9 × 10 ft. or complement of 9 × 10 ft. For more information, artists should call.

🎨 KINGS MOUNTAIN ART FAIR

13106 Skyline Blvd., Woodside CA 94062. (650)851-2710. E-mail: kmafsecty@aol.com. **Contact:** Carrie German, administrative assistant. Web site: www.kingsmountainartfair.org. Es-

tab. 1963. Fine arts & crafts show held annually Labor Day weekend. Fundraiser for volunteer fire dept. Accepts photography, ceramics, clothing, 2D, painting, glass, jewelry, leather, sculpture, textile/fiber, wood. Juried. Number of exhibitors: 135. Public attendance: 10,000. Free to public. Deadline for entry: January 30. Application fee: $10. Space fee: $100 plus 15%. Exhibition space: 10×10 ft. Average gross sales/exhibitor: $3,000. For more information, artists should e-mail, visit Web site, call or send SASE.

LAKE CITY ARTS & CRAFTS FESTIVAL

P.O.Box 1147, Lake City CO 81235. (970)944-2706. E-mail: jlsharpe@centurytel.net. Web site: www.lakecityarts.org. **Contact:** Laura Sharpe, festival director. Estab. 1975. Fine arts/arts & craft show held annually 3rd Tuesday in July. One-day event. Outdoors. Accepts photography, jewelry, metal work, woodworking, painting, handmade items. Juried by 3-5 undisclosed jurors. Prize: Winners are entered in a drawing for a free both space in the following year's show. Number of Exhibitors: 85. Public Attendance: 500. Free to the public. Deadline for entry: entries must be postmarked April 25. Application fee: $75; nonrefundable jury fee: $10. Exhibition space: 12×12 ft. Average gross sales/exhibitor: $500-$1,000. For more information, artists should visit Web site .

Tips "Repeat vendors draw repeat customers. People like to see their favorite vendors each year or every other year. If you come every year, have new things as well as your best-selling products."

LITCHFIELD LIBRARY ARTS & CRAFTS FESTIVAL

101 W Wigwam Blvd., Litchfield Park AZ 85340. (623)393-7820. E-mail: cvermill@apsc.com. **Contact:** Candy Vermillion, promoter. Estab. 1970. Fine arts and select crafts show held annually 1st weekend in November. Outdoors. Accepts photography and all mediums. Juried. Number of exhibitors: 300. Public attendance: 90,000. Free to public. Artists should apply by calling for application. Space fee: $300. Exhibition space: 10×15 ft. For more information, artists should call.

Tips "Professional display and original art."

LOMPOC FLOWER FESTIVAL

P.O. Box 723, Lompoc CA 93438. (805)735-9501. Web site: www.lompocvalleyartassociation.com. **Contact:** Marie Naar, chairman. Estab. 1942. Fine arts & crafts show held annually last week in June. Event includes a parade, food booths, entertainment, beer garden and commercial center, which is not located near arts & crafts. Outdoors. Accepts photography, fine art, woodworking, pottery, stained glass, fine jewelry. Juried by 5 members of the Lompoc Valley Art Association. Vendor must submit 5 photos of their craft and a description on how to make the craft. Number of exhibitors: 95. Public attendance: 95,000+. Free to public. Artists should apply by calling the contact person for application or download application from Web site. Deadline for entry: April 1. Application fee: $173 plus insurance. Exhibition space: 16×16 ft. For more information, artists should visit Web site, call or send SASE.

Tips "Artists should have prices that are under $100 to succeed."

MID-MISSOURI ARTISTS CHRISTMAS ARTS & CRAFTS SALE

P.O. Box 116, Warrensburg MO 64093. (660)747-6092. E-mail: bjsmith@iland.net or rlimback@iland.net. **Contact:** Beverly Smith. Estab. 1970. Holiday arts & crafts show held annually in

November. Indoors. Accepts photography and all original arts and crafts. Juried by 3 good-quality color photos (2 of the artwork, 1 of the display). Number of exhibitors: 50. Public attendance: 1,200. Free to the public. Artists should apply by e-mailing or calling for an application form. Deadline for entry: November 1. Space fee: $50. Exhibition space: 10×10 ft. For more information, artists should e-mail or call.

Tips "Items under $100 are most popular."

NAPA WINE & CRAFTS FAIRE

1556 First St., Suite 102, Napa CA 94559. (707)257-0322. Fax: (707)257-1821. E-mail: info@napa downtown.com. Web site: www.napadowntown.com. **Contact:** Craig Smith, executive director. Wine and crafts show held annually in September. Outdoors. Accepts photography, jewelry, clothing, woodworking, glass, dolls, candles and soaps, garden art. Juried based on quality, uniqueness, and overall craft mix of applicants. Number of exhibitors: over 200. Public attendance: 20,000-30,000. Artists should apply by contacting the event coordinator, Marla Bird, at (707)299-0712 to obtain an application form. Application forms are also available on Web site. Application fee: $15. Space fee: $200. Exhibition space: 10×10 ft. For more information, artists should e-mail, visit Web site or call.

Tips "Electricity is available, but limited. There is a $40 processing fee for cancellations."

NEW MEXICO ARTS & CRAFTS FAIR

P.O. Box 7279, Albuquerque NM 87194. (505)884-9043. Fax: (505)247-0608. E-mail: info@nmart sandcraftsfair.org. Web site: www.nmartsandcraftsfair.org. **Contact:** Corey Dzenko, office manager. Estab. 1962. Fine arts & craft show held annually in June. Indoors and outdoors. Accepts photography, ceramics, fiber, digital art, drawing, jewelry—precious and nonprecious, printmaking, sculpture, wood, mixed media. **Only New Mexico residents 18 years and older are eligible.** Juried by submitting 5 slides; 5 New Mexico artists are chosen each year to jury. Awards/prizes: Total cash awards exceed $4,500. Best of Show: $1,500; First Lady's Choice; Jury Awards; Artist's Choice Award; Creativity Award; First-Time Exhibitor Award. Number of exhibitors: 220. Public admission: $10 for 3-day adult & senior pass; $5 for adult & senior daily admission; free to youth 12 and under. Artists should apply by downloading application from Web site or e-mail for application. Deadline: January. Application fee: Jury fee of $25 per category entered. Space fee: 10×10 ft. (outdoor-1 exhibitor): $350; 10×10 ft. (indoor-1 exhibitor): $400; 10×10 ft. (outdoor, 2 exhibitors): $425; 10×10 ft. (indoor, 2 exhibitors): $450; corner booth fee: $60. For more information, artists should e-mail, visit Web site, call.

OFFICIAL TEXAS STATE ARTS & CRAFTS FAIR

4000 Riverside Dr., Kerrville TX 78028. (830)896-5711. Fax: (830)896-5569. E-mail: fair@tacef.o rg. Web site: www.tacef.org. **Contact:** Penni Carr. Estab.1972. Fine arts & crafts show held annually on Memorial Day weekend. Outdoors. Accepts photography, ceramics, fiber, glass, graphics/drawing, jewelry, leather, metal, mixed media, painting, sculpture, wood. Juried by a panel of professional artists and college art professors. Number of exhibitors: 160 + . Public attendance: 16,000. Public admission: $10 for a 4-day pass. Artists should apply by downloading application from Web site. Deadline: December. Application fee: $20. Space fee: $300-600. Exhibition space: 10×10. ft. and 10×20 ft. For more information, artists should visit Web site.

Tips "Market and advertise."

☑ PASEO ARTS FESTIVAL

3022 Paseo, Oklahoma City OK 73103. (405)525-2688. Web site: www.ThePaseo.com. **Contact:** Lori Oden, executive director. Estab. 1976. Fine arts & crafts show held annually Memorial Day weekend. Outdoors. Accepts photography and all fine art mediums. Juried by submitting 3 slides or CD. Awards/prizes: $1,000, Best of Show; $350, 2D; $350, 3D; $350, Best New Artist. Number of exhibitors: 75. Public attendance: 50,000-60,000. Free to public. Artists should apply by calling for application form. Deadline for entry: March 1. Application fee: $25. Space fee: $250. Exhibition space: 10×10 ft. For more information, artists should visit Web site, call or send SASE.

Ⓝ ☑ PATTERSON APRICOT FIESTA

P.O. Box 442, Patterson CA 95363. (209)892-3118. Fax: (209)892-3388. E-mail: patterson-apricot-fiesta@hotmail.com. Web site: www.patterson-ca.com. **Contact:** Chris Rodriguez, chairperson. Estab. 1984. Arts & crafts show held annually in May/June. Outdoors. Accepts photography, oils, leather, various handcrafts. Juried by type of product; number of artists already accepted; returning artists get priority. Number of exhibitors: 140-150. Public attendance: 25,000. Free to the public. Deadline for entry: approximately April 15. Application fee/space fee: $130. Exhibition space: 12×12 ft. For more information, artists should call, send SASE.

Tips ''Please get your applications in early!''

Ⓝ ☑ RIVERBANK CHEESE & WINE EXPOSITION

3429 Harpers Ferry Dr., Stockton CA 95219. (209)955-1310. Fax: (209)955-1028. E-mail: info@riverbankcheeseandwine.org. Web site: www.riverbankcheeseandwine.org. **Contact:** Suzi De-Silva. Estab. 1977. Arts & crafts show and food show held annually 2nd weekend in October. Outdoors. Accepts photography, other mediums depends on the product. Juried by pictures and information about the artists. Number of exhibitors: 400. Public attendance: 70,000-80,000. Free to public. Artists should apply by calling and requesting an application. Deadline for entry: June 30. Space fee: $260/arts & crafts; $380/commercial. Exhibition space: 10×12 ft. For more information, artists should e-mail, visit Web site, call or send SASE.

Tips ''Make sure your display is pleasing to the eye.''

☑ SANTA CALI GON DAYS FESTIVAL

P.O. Box 1077, Independence MO 64051. (816)252-4745. Fax: (816)252-4917. E-mail: tfreeland@independencechamber.org. Web site: www.santacaligon.com. **Contact:** Teresa Freeland, special projects assistant. Estab. 1973. Market vendors show held annually Labor Day weekend. Outdoors. Accepts photography, all other mediums. Juried by committee. Number of exhibitors: 240. Public attendance: 225,000. Free to public. Artists should apply by requesting application. Application requirements include completed application, application fee, 4 photos of product/art and 1 photo of display. Deadline for entry: March 6-April 7. Application fee: $20. Space fee: $330-430. Exhibition space: 8×8 ft.-10×10 ft. For more information, artists should e-mail, visit Web site or call.

☑ SAUSALITO ART FESTIVAL

P.O. Box 10, Sausalito CA 94966. (415)332-3555. Fax: (415)331-1340. E-mail: info@sausalitoartfestival.org. Web site: www.sausalitoartfestival.org. **Contact:** Tracy Bell Redig, festival coordinator. Estab. 1952. Fine arts & crafts show held annually Labor Day weekend. Outdoors. Accepts painting, photography, 2D and 3D mixed media, ceramics, drawing, fiber, functional art, glass,

jewelry, printmaking, sculpture, watercolor, woodwork. Juried. Jurors are elected by their peers from the previous year's show (1 from each category). They meet for a weekend at the end of March and give scores of 1, 2, 3, 4 or 5 to each applicant (5 being the highest). Awards/prizes: $500 for each 1st and 2nd Place in each category; optional $1,000 for Best in Show. Number of exhibitors: 270. Public attendance: 40,000. Public admission: $20; seniors (age 62 +): $10; children (under 6): $5. Artists should apply by visiting Web site for instructions and application (http://www.sausalitoartfestival.org/artists.html). Applications are through Juried Art Services. Deadline for entry: March. Application fee: $50. Space fee: $1050-2,800. Exhibition space: 100 or 200 sq. ft. Average gross sales/exhibitor: $14,000. For more information, artists should visit Web site.

⊠ ⊠ SCOTTSDALE ARTS FESTIVAL

7380 E. 2nd St., Scottsdale AZ 85251. (480)874-4686. Fax: (480)874-4699. E-mail: festival@sccar ts.org. Web site: www.scottsdaleartsfestival.org. **Contact:** Debbie Rauch, artist coordinator. Estab. 1970. Fine arts & crafts show held annually in March. Outdoors. Accepts photography, jewelry, ceramics, sculpture, metal, glass, drawings, fiber, paintings, printmaking, mixed media, wood. Juried. Awards/prizes: 1st, 2nd, 3rd Places in each category and Best of Show. Number of exhibitors: 200. Public attendance: 40,000. Public admission: $7. Artists should apply through www.zapplication.org. Deadline for entry: October. Application fee: $25. Space fee: $415. Exhibition space: 100 sq. ft. For more information, artists should visit Web site.

⊠ SIERRA MADRE WISTARIA FESTIVAL

37 Auburn Ave., Suite 1, Sierra Madre CA 91024.(626)355-5111. Fax: (626)306-1150. E-mail: info@sierramadrechamber.com. Web site: www.SierraMadrechamber.com. Estab. 100 years ago. Fine arts, crafts and garden show held annually in March. Outdoors. Accepts photography, anything handcrafted. Juried. Craft vendors send in application and photos to be juried. Most appropriate are selected. Awards/prizes: Number of exhibitors: 175. Public attendance: 12,000. Free to public. Artists should apply by sending completed and signed application, 3-5 photographs of their work, application fee, license application, space fee and 2 SASEs. Deadline for entry: December 20. Application fee: $25. Space fee: $175 and a city license fee of $29. Exhibition space: 10×10 ft. For more information, artists should e-mail, visit Web site or call.
Tips "Have a clear and simple application. Be nice."

⊠ SOLANO AVENUE STROLL

1563 Solano Ave. #PMB 101, Berkeley CA 94707. (510)527-5358. E-mail: saa@solanoave.org. Web site: www.solanoave.org. **Contact:** Allen Cain, executive director. Estab. 1974. Fine arts & crafts show held annually 2nd Sunday in September. Outdoors. Accepts photography and all other mediums. Juried by board of directors. Jury fee: $10. Number of exhibitors: 140 spaces for crafts; 600 spaces total. Public attendance: 300,000. Free to the public. Artists should apply online after April 1, or send SASE. Deadline for entry: June 1. Space fee: $10. Exhibition space: 10×10 ft. For more information, artists should e-mail, visit Web site, send SASE.
Tips "Artists should have a clean presentation; small-ticket items as well as large-ticket items; great customer service; enjoy themselves."

⊠ ST. GEORGE ART FESTIVAL

86 S. Main St., St. George UT 84770. (435)634-5850. Fax: (435)634-0709. E-mail: leisure@sgcity. org. Web site: www.sgcity.org. **Contact:** Carlene Garrick, administrator assistant. Estab. 1979.

Fine arts & crafts show held annually Easter weekend in either March or April. Outdoors. Accepts photography, painting, wood, jewelry, ceramics, sculpture, drawing, 3D mixed media, glass. Juried from slides. Awards/prizes: $5,000 Purchase Awards. Art pieces selected will be placed in the city's permanent collections. Number of exhibitors: 110. Public attendance: 20,000/day. Free to public. Artists should apply by completing application form, nonrefundable application fee, slides or digital format of 4 current works in each category and 1 of booth, and SASE. Deadline for entry: January 6. Application fee $20. Space fee: $125. Exhibition space: 10×11 ft. For more information, artists should e-mail.

Tips "Artists should have more than 50% originals. Have quality booths and set-up to display art in best possible manner. Be outgoing and friendly with buyers."

⚑ TUBAC FESTIVAL OF THE ARTS

P.O. Box 1866, Tubac AZ 85646. (520)398-2704. Fax: (520)398-1704. E-mail: artfestival@tubacaz.com. Web site: www.tubacaz.com. Estab. 1959. Fine arts & crafts show held annually in early February. Outdoors. Accepts photography and considers all fine arts and crafts. Juried. A 7-member panel reviews digital images and artist statement. Jury process is blind—applicants' names are withheld from the jurists. Number of exhibitors: 170. Public attendance: 80,000. Free to the public; parking: $6. Applications for the 2009 festival will be available and posted on Web site mid-summer 2008. Deadline for entry: October 31. Application fee: $25. Space fee: $575 for 10×10 ft. space. For more information, artists should e-mail, visit Web site, call, send SASE.

⚑ TULSA INTERNATIONAL MAYFEST

321 S. Boston #101, Tulsa OK 74103. (918)582-6435. Fax: (918)587-7721. E-mail: comments@tulsamayfest.org. Web site: www.tulsamayfest.org. Estab. 1972. Fine arts & crafts show annually held in May. Outdoors. Accepts photography, clay, leather/fiber, mixed media, drawing, pastels, graphics, printmaking, jewelry, glass, metal, wood, painting. Juried by a blind jurying process. Artists should apply online at www.zapplication.org and submit 4 photos of work and 1 of booth set-up. Awards/prizes: Best in Category and Best in Show. Number of exhibitors: 120. Public attendance: 350,000. Free to public. Artists should apply by downloading application in late November. Deadline for entry: January 16. Application fee: $35. Space fee: $300. Exhibition space: 10×10 ft. For more information, artists should e-mail or visit Web site.

NORTHWEST & CANADA

⚑ ANACORTES ARTS FESTIVAL

505 O Ave., Anacortes WA 98221. (360)293-6211. Fax: 360-299-0722 . E-mail: info@anacortesartsfestival.com. Web site: www.anacortesartsfestival.com. **Contact:** Mary Leone. Fine arts & crafts show held annually 1st full weekend in August. Accepts photography, painting, drawings, prints, ceramics, fiber art, paper art, glass, jewelry, sculpture, yard art, woodworking. Juried by projecting 3 images on a large screen. Works are evaluated on originality, quality and marketability. Each applicant must provide 3 high-quality digital images or slides—2 of the product and 1 of the booth display. Awards/prizes: over $4,000 in prizes. Number of exhibitors: 250. Artists should apply by visiting Web site for online submission or by mail (there is a $25 processing fee for application by mail). Deadline for entry: early March. Booth fee: $300. For more information, artists should see Web site.

✍ ANNUAL ARTS & CRAFTS FAIR

Pend Oreille Arts Council, P.O. Box 1694, Sandpoint ID 83864. (208)263-6139. E-mail: art@sand point.net. Web site: www.ArtinSandpoint.org. Estab. 1962. Arts & crafts show held annually in August. Outdoors. Accepts photography and all handmade, noncommercial works. Juried by 8-member jury. Number of exhibitors: 100. Public attendance: 5,000. Free to public. Artists should apply by sending in application. Deadline for entry: May 1. Application fee: $15. Space fee: $150-230, no commission. Exhibition space: 10×10 ft. or 10×15 ft. For more information, artists should e-mail, visit Web site, call or send SASE.

✍ ART & JAZZ ON BROADWAY

P.O. Box 583, Philipsburg MT 59858. **Contact:** Sherry Armstrong at hitchinpost@blackfoot.net or (406)859-0366, or Connie Donlan at coppersok2@aol.com or (406)859-0165. Estab. 2000. Fine arts/jazz show held annually in August. Outdoors. Accepts photography and handcrafted, original, gallery-quality fine arts and crafts made by selling artist. Juried by Flint Creek Valley Arts Council. Number of exhibitors: 75. Public attendance: 1,500-2,000. Admission fee: donation to Flint Creek Valley Arts Council. Artists should visit www.artinphilipsburg.com, e-mail, or call for more information. Application fee: $45. Exhibtion space: 10×10 ft. For more information, artists should e-mail or call for more information.

Tips "Be prepared for temperatures of 100 degrees or rain. Display in a professional manner. Friendliness is crucial; fair pricing is essential."

N ✍ ARTS IN THE PARK

302 2nd Ave. East, Kalispell MT 59901. (406)755-5268. Fax: (405)755-2023. E-mail: information @hackadaymuseum.org. Web site: www.hockadaymuseum.org/artpark.htm. Estab. 1968. Fine arts & crafts show held annually 4th weekend in July. Outdoors. Accepts photography, jewelry, clothing, paintings, pottery, glass, wood, furniture, baskets. Juried by a panel of 5 members. Artwork is evaluated for quality, creativity and originality. Jurors attempt to achieve a balance of mediums in the show. Awards/prizes: $100, Best Booth Award. Number of exhibitors: 100. Public attendance: 10,000. Public admission: $5/weekend pass; $3/day pass; under 12, free. Artists should apply by completing the application form, entry fee, a SASE and a CD containing 5 images in JPEG format; 4 images of work and 1 of booth. Deadline for entry: May 1. Application fee: $25. Space fee: $160-425 per location. Exhibition space: 10×10 ft-10×20 ft. For more information artists should e-mail, visit Web site or call.

N ✍ THE BIG ONE ARTS & CRAFTS SHOW

P.O. Box 494, Black Eagle MT 59414. (406)453-3120. Fax: (406)788-7227. E-mail: giskaasent@br esnan.net. **Contact:** Sue Giskaas, owner/promoter. Estab. 1990. Arts & crafts show held annually in mid- September. Indoors. Accepts photography, anything handmade, no resale. Juried by management selects. Number of exhibitors: 141. Public attendance: 5,000. Public admission: $2. Artists should apply by sending SASE to above address. Deadline for entry: August 15. Space fee: $125-195. Exhibition space: 10×10 ft-10×15 ft. For more information artists should e-mail, call or send SASE.

✍ STRAWBERRY FESTIVAL

2815 2nd Ave. N., Billings MT 59101. (406)259-5454. Fax: (406)294-5061. E-mail: lisaw@downt ownbillings.com. Web site: www.strawberryfun.com. **Contact:** Lisa Woods, executive director.

Estab. 1991. Fine arts & crafts show held annually 2nd Saturday in June. Outdoors. Accepts photography. Juried. Number of exhibitors: 76. Public attendance: 15,000. Free to public. Artists should apply by application available on the Web site. Deadline for entry: April 14. Exhibition space: 12×12 ft. For more information, artists should visit Web site.

TULIP FESTIVAL STREET FAIR

P.O. Box 1801, Mt. Vernon WA 98273. (360)226-9277. E-mail: dwntwnmv@cnw.com. Web site: www.downtownmountvernon.com. **Contact:** Executive Director. Estab. 1984. Arts & crafts show held annually 3rd weekend in April. Outdoors. Accepts photography and original artists' work only. No manufactured work. Juried by a board. Jury fee: $10 with application and prospectus. Number of exhibitors: 215-220. Public attendance: 20,000-25,000. Free to public. Artists should apply by calling or e-mailing. Deadline for entry: January 30. Application fee: $10. Flat fee: $300. Exhibition space: 10×10 ft. Average gross sales/exhibitor: $2,500-4,000. For more information, artists should e-mail, visit Web site, call or send SASE.

Tips "Keep records of your street fair attendance and sales for your résumé. Network with other artists about which street fairs are better to return to or apply for."

WHITEFISH ARTS FESTIVAL

P.O. Box 131, Whitefish MT 59937. (406)862-5875. Fax: (406)862-3515. Web site: www.whitefis hartsfestival.org. **Contact:** Rachael Knox, coordinator. Estab. 1979. Fine arts & crafts show held annually 1st full weekend in July. Outdoors. Accepts photography, pottery, jewelry, sculpture, paintings, woodworking. Juried. Art must be original and handcrafted. Work is evaluated for creativity, quality and originality. Awards/prizes: Best of Show awarded half-price booth fee for following year with no application fee. Number of exhibitors: 100. Public attendance: 3,000. Free to public. Deadline for entry: April 14. Application fee: $20. Space fee: $195. Exhibition space: 10×10 ft. For more information, artists should e-mail, visit Web site or call.

Tips Recommends "variety of price range, professional display, early application for special requests."

Grants

State, Provincial & Regional

Arts councils in the United States and Canada provide assistance to artists in the form of fellowships or grants. These grants can be substantial and confer prestige upon recipients; however, **only state or province residents are eligible**. Because deadlines and available support vary annually, query first (with a SASE) or check Web sites for guidelines.

UNITED STATES ARTS AGENCIES

Alabama State Council on the Arts, 201 Monroe St., Montgomery AL 36130-1800. (334)242-4076. E-mail: staff@arts.alabama.gov. Web site: www.arts.state.al.us.

Alaska State Council on the Arts, 411 W. Fourth Ave., Suite 1-E, Anchorage AK 99501-2343. (907)269-6610 or (888)278-7424. E-mail: aksca_info@eed.state.ak.us. Web site: www.eed. state.ak.us/aksca.

Arizona Commission on the Arts, 417 W. Roosevelt St., Phoenix AZ 85003-1326. (602)771-6501. E-mail: info@azarts.gov. Web site: www.azarts.gov.

Arkansas Arts Council, 1500 Tower Bldg., 323 Center St., Little Rock AR 72201. (501)324-9766. E-mail: info@arkansasarts.com. Web site: www.arkansasarts.com.

California Arts Council, 1300 I St., Suite 930, Sacramento CA 95814. (916)322-6555. E-mail: info@caartscouncil.com. Web site: www.cac.ca.gov.

Colorado Council on the Arts, 1625 Broadway, Suite 2700, Denver CO 80202. (303)892-3802. E-mail: online form. Web site: www.coloarts.state.co.us.

Connecticut Commission on Culture & Tourism, Arts Division, One Financial Plaza, 755 Main St., Hartford CT 06103. (860)256-2800. Web site: www.cultureandtourism.org.

Delaware Division of the Arts, Carvel State Office Bldg., 4th Floor, 820 N. French St., Wilmington DE 19801. (302)577-8278 (New Castle County) or (302)739-5304 (Kent or Sussex Counties). E-mail: delarts@state.de.us. Web site: www.artsdel.org.

District of Columbia Commission on the Arts & Humanities, 2901 14th St. NW, 1st Floor, Washington DC 20010. (202)724-5613. E-mail: cah@dc.gov. Web site: www.dca rts.dc.gov.

Florida Division of Cultural Affairs, R.A. Gray Building, 3rd Floor, 500 S. Bronough St., Tallahassee FL 32399-0250. (850)245-6470. E-mail: info@florida-arts.org. Web site: www. florida-arts.org.

Georgia Council for the Arts, 260 14th St. NW, Suite 401, Atlanta GA 30318. (404)685-2787. E-mail: gaarts@gaarts.org. Web site: www.gaarts.org.

Guam Council on the Arts & Humanities, P.O. Box 2950, Tiyan GU 96932. (671)475-2242. E-mail: arts@ns.gov.nu. Web site: www.guam.net.

Hawai'i State Foundation on Culture & the Arts, 250 S. Hotel St., 2nd Floor, Honolulu HI 96813. (808)586-0300. E-mail: ken.hamilton@hawaii.gov. Web site: www.state.hi.us/sfca.

Idaho Commission on the Arts, P.O. Box 83720, Boise ID 83720-0008. (208)334-2119 or (800)278-3863. E-mail: info@arts.idaho.gov. Web site: www.arts.idaho.gov.

Illinois Arts Council, James R. Thompson Center, 100 W. Randolph, Suite 10-500, Chicago IL 60601. (312)814-6750. E-mail: iac.info@illinois.gov. Web site: www.state.il.us/agency/iac.

Indiana Arts Commission, 150 W. Market St., Suite 618, Indianapolis IN 46204. (317)232-1268. E-mail: IndianaArtsCommission@iac.in.gov. Web site: www.in.gov/arts.

Iowa Arts Council, 600 E. Locust, Des Moines IA 50319-0290. (515)281-6412. Web site: www.iowaartscouncil.org.

Kansas Arts Commission, 700 SW Jackson, Suite 1004, Topeka KS 66603-3761. (785)296-3335. E-mail: kac@arts.ks.gov. Web site: http://arts.state.ks.us.

Kentucky Arts Council, 21st Floor, Capital Plaza Tower, 500 Mero St., Frankfort KY 40601-1987. (502)564-3757 or (888)833-2787. E-mail: kyarts@ky.gov. Web site: www.artscouncil.ky.gov.

Louisiana Division of the Arts, P.O. Box 44247, Baton Rouge LA 70804. (225)342-6083. E-mail: arts@crt.state.la.us. Web site: www.crt.state.la.us/arts.

Maine Arts Commission, 193 State St., 25 State House Station, Augusta ME 04333-0025. (207)287-2724. E-mail: MaineArts.info@maine.gov. Web site: http://mainearts.maine.gov.

Maryland State Arts Council, 175 W. Ostend St., Suite E, Baltimore MD 21230. (410)767-6555. E-mail: msac@msac.org. Web site: www.msac.org.

Massachusetts Cultural Council, 10 St. James Ave., 3rd Floor, Boston MA 02116-3803. (617)727-3668. E-mail: mcc@art.state.ma.us. Web site: www.massculturalcouncil.org.

Michigan Council for Arts & Cultural Affairs, 702 W. Kalamazoo St., P.O. Box 30705, Lansing MI 48909-8205. (517)241-4011. E-mail: artsinfo@michigan.gov. Web site: www.michigan.gov/hal/0,1607,7-160-17445_19272---,00.html.

Minnesota State Arts Board, Park Square Court, Suite 200, 400 Sibley St., St. Paul MN 55101-1928. (651)215-1600 or (800)866-2787. E-mail: msab@arts.state.mn.us. Web site: www.arts.state.mn.us.

Mississippi Arts Commission, 501 N. West St., Suite 701B, Woolfolk Bldg., Jackson MS 39201. (601)359-6030. Web site: www.arts.state.ms.us.

Missouri Arts Council, 815 Olive St., Suite 16, St. Louis MO 63101-1503. (314)340-6845 or (866)407-4752. E-mail: moarts@ded.mo.gov. Web site: www.missouriartscouncil.org.

Montana Arts Council, 316 N. Park Ave., Suite 252, Helena MT 59620-2201. (406)444-6430. E-mail: mac@mt.gov. Web site: http://art.mt.gov.

Resources

National Assembly of State Arts Agencies, 1029 Vermont Ave. NW, 2nd Floor, Washington DC 20005. (202)347-6352. E-mail: nasaa@nasaa-arts.org. Web site: www.nasaa-arts.org.

Nebraska Arts Council, 1004 Farnam St., Plaza Level, Omaha NE 68102. (402)595-2122 or (800)341-4067. Web site: www.nebraskaartscouncil.org.

Nevada Arts Council, 716 N. Carson St., Suite A, Carson City NV 89701. (775)687-6680. E-mail: online form. Web site: http://dmla.clan.lib.nv.us/docs/arts.

New Hampshire State Council on the Arts, 2½ Beacon St., 2nd Floor, Concord NH 03301-4974. (800)735-2964. Web site: www.nh.gov/nharts.

New Jersey State Council on the Arts, 225 W. State St., P.O. Box 306, Trenton NJ 08625. (609)292-6130. Web site: www.njartscouncil.org.

New Mexico Arts, Dept. of Cultural Affairs, P.O. Box 1450, Santa Fe NM 87504-1450. (505)827-6490 or (800)879-4278. Web site: www.nmarts.org.

New York State Council on the Arts, 175 Varick St., New York NY 10014. (212)627-4455. Web site: www.nysca.org.

North Carolina Arts Council, 109 East Jones St., Cultural Resources Building, Raleigh NC 27601. (919)807-6500. E-mail: ncarts@ncmail.net. Web site: www.ncarts.org.

North Dakota Council on the Arts, 1600 E. Century Ave., Suite 6, Bismarck ND 58503. (701)328-7590. E-mail: comserv@state.nd.us. Web site: www.state.nd.us/arts.

Commonwealth Council for Arts and Culture (Northern Mariana Islands), P.O. Box 5553, CHRB, Saipan MP 96950. (670)322-9982 or (670)322-9983. E-mail: galaidi@vzpacifica.net. Web site: www.geocities.com/ccacarts/ccacwebsite.html.

Ohio Arts Council, 727 E. Main St., Columbus OH 43205-1796. (614)466-2613. Web site: www.oac.state.oh.us.

Oklahoma Arts Council, Jim Thorpe Building, 2101 N. Lincoln Blvd., Suite 640, Oklahoma City OK 73105. (405)521-2931. E-mail: okarts@arts.ok.gov. Web site: www.arts.state.ok.us.

Oregon Arts Commission, 775 Summer St. NE, Suite 200, Salem OR 97301-1280. (503)986-0082. E-mail: oregon.artscomm@state.or.us. Web site: www.oregonartscommission.org.

Pennsylvania Council on the Arts, 216 Finance Bldg., Harrisburg PA 17120. (717)787-6883. Web site: www.pacouncilonthearts.org.

Institute of Puerto Rican Culture, P.O. Box 9024184, San Juan PR 00902-4184. (787)724-0700. E-mail: www@icp.gobierno.pr. Web site: www.icp.gobierno.pr.

Rhode Island State Council on the Arts, One Capitol Hill, Third Floor, Providence RI 02908. (401)222-3880. E-mail: info@arts.ri.gov. Web site: www.arts.ri.gov.

American Samoa Council on Culture, Arts and Humanities, P.O. Box 1540, Office of the Governor, Pago Pago AS 96799. (684)633-4347. Web site: www.prel.org/programs/pcahe/PTG/terr-asamoa1.html.

South Carolina Arts Commission, 1800 Gervais St., Columbia SC 29201. (803)734-8696. E-mail: info@arts.state.sc.us. Web site: www.southcarolinaarts.com.

South Dakota Arts Council, 711 E. Wells Ave., Pierre SD 57501-3369. (605)773-3301. E-mail: sdac@state.sd.us. Web site: www.artscouncil.sd.gov.

Resources

Tennessee Arts Commission, 401 Charlotte Ave., Nashville TN 37243-0780. (615)741-1701. Web site: www.arts.state.tn.us.

Texas Commission on the Arts, E.O. Thompson Office Building, 920 Colorado, Suite 501, Austin TX 78701. (512)463-5535. E-mail: front.desk@arts.state.tx.us. Web site: www.arts. state.tx.us.

Utah Arts Council, 617 E. South Temple, Salt Lake City UT 84102-1177. (801)236-7555. Web site: http://arts.utah.gov.

Vermont Arts Council, 136 State St., Drawer 33, Montpelier VT 05633-6001. (802)828-3291. E-mail: online form. Web site: www.vermontartscouncil.org.

Virgin Islands Council on the Arts, 5070 Norre Gade, St. Thomas VI 00802-6872. (340)774-5984. Web site: http://vicouncilonarts.org.

Virginia Commission for the Arts, Lewis House, 223 Governor St., 2nd Floor, Richmond VA 23219. (804)225-3132. E-mail: arts@arts.virginia.gov. Web site: www.arts.state.va.us.

Washington State Arts Commission, 711 Capitol Way S., Suite 600, P.O. Box 42675, Olympia WA 98504-2675. (360)753-3860. E-mail: info@arts.wa.gov. Web site: www.arts.wa.gov.

West Virginia Commission on the Arts, The Cultural Center, Capitol Complex, 1900 Kanawha Blvd. E., Charleston WV 25305-0300. (304)558-0220. Web site: www.wvculture. org/arts.

Wisconsin Arts Board, 101 E. Wilson St., 1st Floor, Madison WI 53702. (608)266-0190. E-mail: artsboard@arts.state.wi.us. Web site: www.arts.state.wi.us.

Wyoming Arts Council, 2320 Capitol Ave., Cheyenne WY 82002. (307)777-7742. E-mail: ebratt@state.wy.us. Web site: http://wyoarts.state.wy.us.

CANADIAN PROVINCES ARTS AGENCIES

Alberta Foundation for the Arts, 10708 - 105 Ave., Edmonton AB T5H 0A1. (780)427-9968. Web site: www.cd.gov.ab.ca/all_about_us/commissions/arts.

British Columbia Arts Council, P.O. Box 9819, Stn. Prov. Govt., Victoria BC V8W 9W3. (250)356-1718. E-mail: BCArtsCouncil@gov.bc.ca. Web site: www.bcartscouncil.ca.

The Canada Council for the Arts, 350 Albert St., P.O. Box 1047, Ottawa ON K1P 5V8. (613)566-4414 or (800)263-5588 (within Canada). Web site: www.canadacouncil.ca.

Manitoba Arts Council, 525-93 Lombard Ave., Winnipeg MB R3B 3B1. (204)945-2237 or (866)994-2787 (in Manitoba). E-mail: info@artscouncil.mb.ca. Web site: www.artscouncil.mb.ca.

New Brunswick Arts Board (NBAB), 634 Queen St., Suite 300, Fredericton NB E3B 1C2. (506)444-4444 or (866)460-2787. Web site: www.artsnb.ca.

Newfoundland & Labrador Arts Council, P.O. Box 98, St. John's NL A1C 5H5. (709)726-2212 or (866)726-2212. E-mail: nlacmail@nfld.net. Web site: www.nlac.nf.ca.

Nova Scotia Department of Tourism, Culture, and Heritage, Culture Division, 1800 Argyle St., Suite 601, P.O. Box 456, Halifax NS B3J 2R5. (902)424-4510. E-mail: cultaffs@gov.ns. ca. Web site: www.gov.ns.ca/dtc/culture.

Ontario Arts Council, 151 Bloor St. W., 5th Floor, Toronto ON M5S 1T6. (416)961-1660 or (800)387-0058 (in Ontario). E-mail: info@arts.on.ca. Web site: www.arts.on.ca.

Prince Edward Island Council of the Arts, 115 Richmond St., Charlottetown PE C1A 1H7. (902)368-4410 or (888)734-2784. E-mail: info@peiartscouncil.com. Web site: www.peiart scouncil.com.

Québec Council for Arts & Literature, 79 boul. René-Lévesque Est, 3e étage, Québec QC G1R 5N5. (418)643-1707 or (800)897-1707. E-mail: info@calq.gouv.qc.ca. Web site: www.calq. gouv.qc.ca.

The Saskatchewan Arts Board, 2135 Broad St., Regina SK S4P 1Y6. (306)787-4056 or (800)667-7526 (Saskatchewan only). E-mail: sab@artsboard.sk.ca. Web site: www.artsbo ard.sk.ca.

Yukon Arts Section, Cultural Services Branch, Dept. of Tourism & Culture, Government of Yukon, Box 2703 (L-3), Whitehorse YT Y1A 2C6. (867)667-8589 or (800)661-0408 (in Yukon). E-mail: arts@gov.yk.ca. Web site: www.btc.gov.yk.ca/cultural/arts.

REGIONAL GRANTS AND AWARDS

The following opportunities are arranged by state since most of them grant money to artists in a particular geographic region. Because deadlines vary annually, check Web sites or call for the most up-to-date information.

California

Flintridge Foundation Awards for Visual Artists, 1040 Lincoln Ave., Suite 100, Pasadena CA 91103. (626)449-0839 or (800)303-2139. Fax: (626)585-0011. Web site: www.flintridge foundation.org. *For artists in California, Oregon and Washington only.*

James D. Phelan Award in Photography, Kala Art Institute, Don Porcella, 1060 Heinz Ave., Berkeley CA 94710. (510)549-6914. Web site: www.kala.org. *For artists born in California only.*

Connecticut

Martha Boschen Porter Fund, Inc., 145 White Hallow Rd., Sharon CT 06064. *For artists in northwestern Connecticut, western Massachusetts and adjacent areas of New York (except New York City).*

Idaho

Betty Bowen Memorial Award, % Seattle Art Museum, 100 University St., Seattle WA 98101. (206)654-3131. Web site: www.seattleartmuseum.org/bettybowen/. *For artists in Washington, Oregon and Idaho only.*

Illinois

Illinois Arts Council, Artists Fellowship Program, James R. Thompson Center, 100 W. Randolph, Suite 10-500, Chicago IL 60601. (312)814-6750. Web site: www.state.il.us/agency/ iac/Guidelines/guidelines.htm. *For Illinois artists only.*

Kentucky

Kentucky Foundation for Women Grants Program, 1215 Heyburn Bldg., 332 W. Broadway, Louisville KY 40202. (502)562-0045. Web site: www.kfw.org/grants.html. *For female artists living in Kentucky only.*

Massachusetts

See Martha Boschen Porter Fund, Inc., under Connecticut.

Minnesota

McKnight Photography Fellowships Program, University of Minnesota Dept. of Art, Regis Center for Art, E-201, 405 21st Ave. S., Minneapolis MN 55455. (612)626-9640. Web site: www.mcknightphoto.umn.edu. *For Minnesota artists only.*

New York

A.I.R. Gallery Fellowship Program, 511 W. 25th St., Suite 301, New York NY 10001. (212)255-6651. E-mail: info@airnyc.org. Web site: www.airnyc.org. *For female artists from New York City metro area only.*

Arts & Cultural Council for Greater Rochester, 277 N. Goodman St., Rochester NY 14607. (585)473-4000. Web site: www.artsrochester.org.

Constance Saltonstall Foundation for the Arts Grants and Fellowships, P.O. Box 6607, Ithaca NY 14851 (include SASE). (607)277-4933. E-mail: info@saltonstall.org. Web site: www.saltonstall.org. *For artists in the central and western counties of New York.*

New York Foundation for the Arts: Artists' Fellowships, 155 Avenue of the Americas, 14th Floor, New York NY 10013-1507. (212)366-6900, ext. 217. E-mail: nyfaafp@nyfa.org. Web site: www.nyfa.org. *For New York artists only.*

Oregon

See Flintridge Foundation Awards for Visual Artists, under California.

Pennsylvania

Leeway Foundation—Philadelphia, Pennsylvania Region, 123 S. Broad St., Suite 2040, Philadelphia PA 19109. (215)545-4078. E-mail: info@leeway.org. Web site: www.leeway.org. *For female artists in Philadelphia only.*

Texas

Individual Artist Grant Program—Houston, Texas, Cultural Arts Council of Houston and Harris County, 3201 Allen Pkwy., Suite 250, Houston TX 77019-1800. (713)527-9330. E-mail: info@cachh.org. Web site: www.cachh.org. *For Houston artists only.*

Washington

See Flintridge Foundation Awards for Visual Artists, under California.

Residencies & Organizations

RESIDENCIES

Artists' residencies (also known as communities, colonies or retreats) are programs that support artists by providing time and space for the creation of new work. There are over 250 residency programs in the United States, and approximately 200 in at least 40 other countries. These programs provide an estimated $36 million in support to independent artists each year.

Many offer not only the resources to *do* artwork, but also to have it *seen* by the public. While some communities are isolated in rural areas, others are located near urban centers and may provide public programming such as workshops and exhibitions. Spending time as a resident at an artists' community is a great way to network and cultivate relationships with other artists.

Alliance of Artists Communities: www.artistcommunities.org
Offers an extensive list of international artists' communities and residencies.

Anderson Ranch Arts Center: www.andersonranch.org
Nonprofit visual arts community located in Snowmass Village, Colorado.

Arrowmont School of Arts & Crafts: www.arrowmont.org
Nationally renowned center of contemporary arts and crafts education located in Gatlinburg, Tennessee.

The Bogliasco Foundation/Liguria Study Center for the Arts & Humanities:
www.liguriastudycenter.org
Located on the Italian Riviera in the village of Bogliasco, the Liguria Study Center provides residential fellowships for creative or scholarly projects in the arts and humanities.

Fine Arts Work Center: www.fawc.org
Nonprofit institution devoted to encouraging and supporting young artists, located in Provincetown, Massachusetts.

Hall Farm Center: www.hallfarm.org
A 221-acre retreat in Townshend, Vermont, that offers residencies, workshops and other resources for emerging and established artists.

Kala Art Institute: www.kala.org
Located in the former Heinz ketchup factory in Berkeley, California, Kala provides exceptional facilities to professional artists working in all forms of printmaking, photography, digital media and book arts.

Lower Manhattan Cultural Council: www.lmcc.net

Creative hub for connecting residents, tourists and workers to Lower Manhattan's vast and vibrant arts community. Provides residencies, studio space, grants and professional development programming to artists.

The MacDowell Colony: www.macdowellcolony.org

A 100-year-old artists' community consisting of 32 studios located on a 450-acre farm in Peterborough, New Hampshire.

Pouch Cove Foundation: www.pouchcove.org

Not-for-profit organization in Newfoundland, Canada, providing retreat for artists from around the world.

Santa Fe Art Institute: www.sfai.org

Located on the College of Santa Fe campus in Santa Fe, New Mexico, SFAI is a nonprofit organization offering a wide range of programs to serve artists at various stages of their careers.

Vermont Studio Center: www.vermontstudiocenter.org

The largest international artists' and writers' residency program in the United States, located in Johnson, Vermont.

Women's Studio Workshop: www.wsworkshop.org

Visual arts organization in Rosendale, New York, with specialized studios in printmaking, hand papermaking, ceramics, letterpress printing, photography and book arts.

Yaddo: www.yaddo.org

Artists' community located on a 400-acre estate in Saratoga Springs, New York, offering residencies to professional creative artists from all nations and backgrounds

ORGANIZATIONS

There are numerous organizations for artists that provide resources and information about everything from industry standards and marketing tips to contest announcements and legal advice. Included here are just a handful of groups that we at *Artist's & Graphic Designer's Market* have found useful.

American Association of Editorial Cartoonists: http://editorialcartoonists.com

Professional association concerned with promoting the interests of staff, freelance and student editorial cartoonists in the United States.

American Institute of Graphic Arts: www.aiga.org

AIGA is the oldest and largest membership association for professionals engaged in the discipline, practice and culture of designing.

Art Dealers Association of America: www.artdealers.org

Nonprofit membership organization of the nation's leading galleries in the fine arts.

The Art Directors Club: www.adcglobal.org

The ADC is the premier organization for integrated media and the first international creative collective of its kind. Founded in New York in 1920, the ADC is a self-funding, not-for-profit membership organization that celebrates and inspires creative excellence by connecting visual communications professionals from around the world.

Artists Unite: www.artistsunite-ny.org

Nonprofit organization dedicated to providing quality arts programming and to helping artists of all genres collaborate on projects.

The Association of Medical Illustrators: www.ami.org
International organization for anyone interested in the highly specialized niche of medical illustration.

The Association of Science Fiction and Fantasy Artists: www.asfa-art.org
Nonprofit association organized for artistic, literary, educational and charitable purposes concerning the visual arts of science fiction, fantasy, mythology and related topics.

Association International du Film d'Animation (International Animated Film Association): www.asifa.net
International organization dedicated to the art of animation, providing worldwide news and information on chapters of the group, as well as conferences, contests and workshops.

Association Typographique Internationale: www.atypi.org
Not-for-profit organization run by an elected board of type designers, type publishers, graphic and typographic designers.

Canadian Association of Photographers and Illustrators in Communications: www.capic.org
Not-for-profit association dedicated to safeguarding and promoting the rights and interests of photographers, illustrators and digital artists working in the communications industry.

Canadian Society of Children's Authors, Illustrators and Performers: www.canscaip.org
This organization supports and promotes all aspects of children's literature, illustration and performance.

College Art Association: www.collegeart.org
CAA promotes excellence in scholarship and teaching in the history and criticism of the visual arts and in creativity and technical skill in the teaching and practices of art. Membership is open to all individuals with an interest in art, art history or a related discipline.

The Comic Book Legal Defense Fund: www.cbldf.org
Nonprofit organization dedicated to the preservation of First Amendment rights for members of the comics community.

Friends of Lulu: www.friends-lulu.org
National organization whose main purpose is to promote and encourage female readership and participation in the comic book industry.

Graphic Artists Guild: www.gag.org
National union of illustrators, designers, production artists and other creatives who have come together to pursue common goals, share experiences and raise industry standards.

Greeting Card Association: www.greetingcard.org
Trade organization representing greeting card and stationery publishers, and allied members of the industry.

International Comic Arts Association: www.comicarts.org
Member-driven organization open to anyone with a love and appreciation of the comics art form and a desire to help support and further promote the industry.

National Cartoonists Society: www.reuben.org
Home of the famed Reuben Awards, this organization offers news and resources for cartoonists interested in everything from caricature to animation.

New York Foundation for the Arts: www.nyfa.org
NYFA offers information and financial assistance to artists and organizations that directly

Resources

serve artists, by supporting arts programming in the community, and by building collaborative relationships with others who advocate for the arts in New York State and throughout the country.

Society of Children's Book Writers and Illustrators: www.scbwi.org
With chapters all over the world, SCBWI is the premier organization for professionals in children's publishing.

Society of Graphic Designers of Canada: www.gdc.net
Member-based organization of design professionals, educators, administrators, students and associates in communications, marketing, media and design-related fields.

The Society of Illustrators: www.societyillustrators.org
Since 1901, this nonprofit organization has been working to promote the interests of professional illustrators through exhibitions, lectures, education, and by fostering a sense of community and open discussion.

Type Directors Club: www.tdc.org
Organization dedicated to raising the standards of typography and related fields of the graphic arts through research, education, competitions and publications.

United States Artists: www.unitedstatesartists.org
Provides direct financial support to artists across all disciplines. Currently offers one grant program: USA Fellows.

US Regional Arts Organizations: www.usregionalarts.org
Six nonprofit entities created to encourage development of the arts and to support arts programs on a regional basis. Funded by the NEA, these organizations—Arts Midwest, Mid-America Arts Alliance, Mid Atlantic Arts Foundation, New England Foundation for the Arts, Southern Arts Federation, and Western States Arts Federation—provide technical assistance to their member state arts agencies, support and promote artists and arts organizations, and develop and manage arts initiatives on local, regional, national and international levels.

Resources

Publications, Web Sites & Blogs

I n addition to the thousands of trade publications written for visual artists, there are now countless Web sites, blogs and online artists' communities intended to connect, inspire and support artists in their careers. Listed here are just a handful of books, magazines and online resources to get you started; most will lead to additional sources, especially Web sites that provide links to other sites.

BOOKS

AIGA Professional Practices in Graphic Design: The American Institute of Graphic Arts, edited by Tad Crawford (Allworth Press)

Art Marketing 101: A Handbook for the Fine Artist by Constance Smith (ArtNetwork)

Business and Legal Forms for Fine Artists by Tad Crawford (Allworth Press)

Business and Legal Forms for Graphic Designers by Tad Crawford and Eva Doman Bruck (Allworth Press)

Business and Legal Forms for Illustrators by Tad Crawford (Allworth Press)

The Business of Being an Artist by Daniel Grant (Allworth Press)

Career Solutions for Creative People: How to Balance Artistic Goals with Career Security by Dr. Ronda Ormont (Allworth Press)

Children's Writer's & Illustrator's Market, edited by Alice Pope (Writer's Digest Books, F + W Media, Inc.)

Comics and Sequential Art by Will Eisner (Poorhouse Press)

Creativity for Graphic Designers: A Real-World Guide to Idea Generation—From Defining Your Message to Selecting the Best Idea for Your Printed Piece by Mark Oldach (North Light Books, F + W Media, Inc.)

Design Basics for Creative Results by Bryan L. Peterson (HOW Books, F + W Media, Inc.)

The Fine Artist's Guide to Marketing and Self-Promotion by Julius Vitali (Allworth Press)

Fingerprint: The Art of Using Handmade Elements in Graphic Design by Chen Design Associates (HOW Books, F + W Media, Inc.)

A Gallery Without Walls: Selling Art in Alternative Venues by Margaret Danielak (ArtNetwork)

Graphic Artists Guild Handbook: Pricing & Ethical Guidelines (Graphic Artists Guild)

The Graphic Designer's and Illustrator's Guide to Marketing and Promotion by Maria Piscopo (Allworth Press)

The Graphic Designer's Guide to Clients: How to Make Clients Happy and Do Great Work by Ellen Shapiro (Allworth Press)

Graphic Storytelling & Visual Narrative by Will Eisner (Poorhouse Press)

Guide to Getting Arts Grants by Ellen Liberatori (Allworth Press)

How to Draw and Sell Comics by Alan McKenzie (IMPACT Books, F + W Media, Inc.)

How to Survive and Prosper as an Artist: Selling Yourself Without Selling Your Soul by Caroll Michels (Owl Books)

Inside the Business of Illustration by Steven Heller and Marshall Arisman (Allworth Press)

Legal Guide for the Visual Artist by Tad Crawford (Allworth Press)

Licensing Art 101: Publishing and Licensing Artwork for Profit by Michael Woodward (ArtNetwork)

Licensing Art & Design: A Professional's Guide to Licensing and Royalty Agreements by Caryn R. Leland (Allworth Press)

Logo, Font & Lettering Bible: A Comprehensive Guide to the Design, Construction and Usage of Alphabets and Symbols by Leslie Cabarga (HOW Books, F + W Media, Inc.)

Making Comics: Storytelling Secrets of Comics, Manga and Graphic Novels by Scott McCloud (HarperCollins)

Starting Your Career as a Freelance Illustrator or Graphic Designer by Michael Fleishman (Allworth Press)

Successful Syndication: A Guide for Writers and Cartoonists by Michael Sedge (Allworth Press)

The Word It Book: Speak Up Presents a Gallery of Interpreted Words, edited by Bryony Gomez-Palacio and Armin Vit (HOW Books, F + W Media, Inc.)

MAGAZINES

Advertising Age: www.adage.com
Weekly print magazine delivering news, analysis and data on marketing and media. Web site provides a database of advertising agencies as well as daily e-mail newsletters: *Ad Age Daily*, *Ad Age's Mediaworks* and *Ad Age Digital*.

Art Business News: www.artbusinessnews.com
Monthly magazine that reports on art trends, news and retailing issues. Offers profiles on emerging and established artists, as well as in-depth articles on merchandising and marketing issues.

Art Calendar: www.artcalendar.com
Business magazine devoted to connecting artists with income-generating opportunities and resources for a successful art career.

Art in America: www.artinamericamagazine.com

"The World's Premier Art Magazine," covering the visual art world both in the U.S. and abroad, but concentrating on New York City. Provides news and criticism of painting, sculpture, photography, installation art, performance art, video and architecture in exhibition reviews, artist profiles, and feature articles. Every August issue is the *Annual Guide to Museums, Galleries and Artists*.

ART PAPERS: www.artpapers.org

Dedicated to the examination, development and definition of art and culture in the world today.

ARTFORUM: www.artforum.com

International magazine widely known as a decisive voice in its field. Features in-depth articles and reviews of contemporary art, as well as book reviews and columns on cinema and popular culture.

The Artist's Magazine: www.artistsmagazine.com

Features color reproductions, interviews with artists, practical lessons in craft, and news of exhibitions and events.

ARTnews: www.artnews.com

Oldest and most widely circulated art magazine in the world. Reports on the art, personalities, issues, trends and events shaping the international art world.

Artweek: www.artweek.com

Offers critical reviews of West Coast exhibitions, as well as news, feature articles, interviews and opinion pieces focusing on contemporary art. Includes a comprehensive listing of regional, national and international competitions; classified ads for job opportunities, studio space, artists' services, supplies and equipment; exhibition listings of over 200 gallery and museum spaces.

Communication Arts Magazine: www.commarts.com

Leading trade journal for visual communications. Showcases the top work in graphic design, advertising, illustration, photography and interactive design.

Create Magazine: www.createmagazine.com

Quarterly publication offering creative professionals an insider's perspective on the people, news, trends and events that influence the advertising and creative production industries.

Creativity: http://creativity-online.com

Monthly magazine about the creative process. Web site features what its editors believe to be the best video, print and interactive ads.

Eye: The International Review of Graphic Design: www.eyemagazine.com

Published in the United Kingdom, this quarterly print magazine is for anyone involved in graphic design and visual culture.

Grafik: www.grafikmagazine.co.uk

Based in London, this monthly magazine serves the international design community with essential information, independent-minded editorial, unflinching reviews and outspoken opinion from industry personalities.

Graphic Design USA: www.gdusa.com

News magazine for graphic designers and other creative professionals.

Greetings etc.: www.greetingsmagazine.com

Official publication of the Greeting Card Association, featuring timely information for everyone doing business in the greeting card, stationery, and party goods markets.

HOW: www.howdesign.com

Provides graphic design professionals with essential business information; covers new technology and processes; profiles renowned and up-and-coming designers; details noteworthy projects; provides creative inspiration; and publishes special issues featuring the winners of its annual competitions. Web site is a trusted source for business advice, creative inspiration and tools of the trade.

I.D.: www.idonline.com

America's leading critical magazine covering the art, business and culture of design. Published seven times/year, including the Annual Design Review (America's oldest and most prestigious juried design-recognition program).

JUXTAPOZ: www.juxtapoz.com

Monthly art and culture magazine based in San Francisco, California. Features profiles and exhibition announcements of "lowbrow" or "underground" artists—art establishment conventions do not apply here.

PRINT: www.printmag.com

Bimonthly magazine about visual culture and design that documents and critiques commercial, social and environmental design from every angle.

Target Marketing: www.targetmarketingmag.com

The authoritative source for hands-on, how-to information concerning all direct response media, including direct mail, e-mail and the Web. Readers gain insight into topics such as using databases and lists effectively, acquiring new customers, upselling and cross-selling existing customers, fulfillment strategies and more.

WEB SITES & BLOGS

The Alternative Pick: www.altpick.com

"The best source for creatives on the Web." Allows artists to display samples of their work that can be searched by art buyers and directors. Offers industry news, classifieds, job postings and more.

Animation World Network: www.awn.com

Comprehensive and targeted coverage of the international animation community has made AWN the leading source of animation industry news in the world. It provides an industry database, job postings, education resources, discussion forums, newsletters and a host of other resources covering everything related to animation.

Art Deadlines List: www.artdeadlineslist.com

Great source for calls for entries, competitions, scholarships, festivals and plenty of other resources. Subscription is free, or you can purchase a premium edition for $24/year.

The Art List: www.theartlist.com

Offers an extensive listing of art contests, competitions and juried art shows, as well as other resources for visual artists looking for income opportunities or to gain exposure for their work. An annual subscription to The Art List's monthly e-mail newsletters is only $15. Each newsletter includes a link to a searchable database of art contests, competitions, residencies, fellowships, calls for public art, and juried exhibition announcements.

Art Schools: www.artschools.com

Free online directory with a searchable database of art schools all over the world. Also offers information on financial aid, majors and lots more.

Artbusiness.com: www.artbusiness.com

Provides art appraisals, art price data, news, articles and market information for art collectors, artists and fine arts professionals. Also consults on marketing, promotion, public relations, Web site construction, Internet selling, and career development for artists at all stages.

Artdeadline.com: www.artdeadline.com

"The Professional Artist's Resource," offering thousands of income and exhibition opportunities and resources for artists of all disciplines. Subscriptions start at $24/year, or you can get a 20-day trial for $14.

Artist Career Training: www.artistcareertraining.com

Offers valuable information to help you market your art and build your career. Sign up for a monthly newsletter and weekly tips.

Artist Help Network: www.artisthelpnetwork.com

Designed to help artists take control of their careers, the network assists artists in locating information, resources, guidance and advice on a comprehensive range of career-related topics.

Artists Network: http://forum.artistsnetwork.com

Interactive artists' community and forum for discussions of art-related topics including business tips and inspiration. Connect to *The Artist's Magazine*, *Watercolor Artist* (formerly *Watercolor Magic*) and *Pastel Journal*, as well as fine art book clubs and lots of other helpful resources.

Artleby: www.artleby.biz

Online arts exhibition space, run by artists for artists. A one-year subscription, payable in monthly installments of $5, provides you with a Web site to display up to 50 images as well as résumé, biography, artist's statement, etc. The ability to create multiple portfolio categories according to media, themes, etc., allows you to direct your work to a specific audience/market.

Artlex Art Dictionary: www.artlex.com

Online dictionary that provides definitions, examples and cross-references for more than 3,600 art terms.

Artline: www.artline.com

Offers news and events from 7 reputable art dealer associations: Art Dealers Association of America, Art Dealers Association of Greater Washington, Association of International Photography Art Dealers, Chicago Art Dealers Association, International Fine Print Dealers Association, San Francisco Art Dealers Association, and The Society of London Art Dealers.

Children's Illustrators: www.childrensillustrators.com

Online networking community for children's illustrators, agents, publishing houses, advertising agencies and design groups from around the world.

The Comics Reporter: www.comicsreporter.com

Offers an overview of the history of comics, as well as resources and information about publishing comic books and syndicating comic strips.

Creative Talent Network: www.creativetalentnetwork.com
Online networking community of experienced animators, illustrators, designers, Web creators, production artists and other creatives.

The Drawing Board for Illustrators: www.members.aol.com/thedrawing
Information and resources for illustrators, including pricing guidelines, marketing tips, and links to publications, organizations and associations.

EBSQ: Self-Representing Artists: www.ebsqart.com
Online art association whose members represent their own work to the public. Membership is open to artists at all stages of their careers, and all media and styles are welcome.

Illustration Friday: www.illustrationfriday.com
Online forum for illustrators that offers a weekly challenge: a new topic is posted every Friday, and then participants have a week to submit an illustration of their own interpretation.

Theispot.com: www.theispot.com
Widely recognized as "the world's premier illustration site," allowing illustrators from all over the world to showcase and market their work.

The Medical Illustrators' Home Page: www.medartist.com
A site where medical illustrators can display and market their work.

The Nose: www.the-nose.com
A place for caricature artists to showcase their work.

Portfolios.com: www.portfolios.com
The first searchable creative directory on the Web. Through the Portfolios.com Partner Network, you can set up and manage one portfolio, but have it appear on multiple Web sites for one low price.

Starving Artists Law: www.starvingartistslaw.com
Start here for answers to your questions about copyright registration, trademark protection and other legal issues.

TalkAboutComics.com: www.talkaboutcomics.com
Provides a comprehensive list of all things comics related on the Web, as well as audio interviews with online comics creators.

Talkabout Design: www.talkaboutdesign.com
Online forum and blog for the design community.

UnderConsideration: www.underconsideration.com
A network of blogs (Speak Up, Brand New, Quipsologies, The Design Encyclopedia) dedicated to the progress of the graphic design profession and its practitioners, students and enthusiasts.

Volunteer Lawyers for the Arts: www.vlany.org
Provides education and other services relating to legal and business issues for artists and arts organizations in every discipline.

WetCanvas!: www.wetcanvas.com
Largest online community of visual artists, offering forums, critiques, art lessons and projects, marketing tools, a reference image library and more—all for FREE!

Glossary

Acceptance (payment on). An artist is paid for his/her work as soon as a buyer decides to use it.

Adobe Illustrator®. Drawing and painting computer software.

Adobe InDesign®. Revised, retooled version of Adobe PageMaker.

Adobe PageMaker®. Page-layout design software. Product relaunched as InDesign.

Adobe Photoshop®. Photo manipulation computer program.

Advance. Amount paid to an artist before beginning work on an assigned project. Often paid to cover preliminary expenses.

Airbrush. Small pencil-shaped pressure gun used to spray ink, paint or dye to obtain gradated tonal effects.

Anime. Japanese word for animation.

Art director. In commercial markets, the person responsible for choosing and purchasing artwork and supervising the design process.

Artist's Statement. A short essay, no more than a paragraph or two, describing an artist's mission and creative process.

Biannual. Occurring twice a year. See also semiannual.

Biennial. Occurring once every two years.

Bimonthly. Occurring once every two months.

Biweekly. Occurring once every two weeks.

Book. Another term for a portfolio.

Buyout. The sale of all reproduction rights (and sometimes the original work) by the artist; also subcontracted portions of a job resold at a cost or profit to the end client by the artist.

Calligraphy. The art of fine handwriting.

Camera-ready. Art that is completely prepared for copy camera platemaking.

Capabilities brochure. A brochure, similar to an annual report, outlining for prospective clients the nature of a company's business and the range of products or services it provides.

Caption. See gagline.

Carriage trade. Wealthy clients or customers of a business.

CD-ROM. Compact disc read-only memory; nonerasable electronic medium used for digitized image and document storage and retrieval on computers.

Collateral. Accompanying or auxiliary pieces, such as brochures, especially used in advertising.

Color separation. Photographic process of separating any multi-color image into its primary component parts (cyan, magenta, yellow and black) for printing.

Commission. 1) Percentage of retail price taken by a sponsor/salesman on artwork sold. 2) Assignment given to an artist.

Comprehensive. Complete sketch of layout showing how a finished illustration will look when printed; also called a comp.

Copyright. The exclusive legal right to reproduce, publish and sell the matter and form of a literary or artistic work.

Consignment. Arrangement by which items are sent by an artist to a sales agent (gallery, shop, sales rep, etc.) for sale with the understanding that the artist will not receive payment until work is sold. A commission is almost always charged for this service.

Direct mail package. Sales or promotional material that is distributed by mail. Usually consists of an outer envelope, a cover letter, brochure or flier, SASE, and postpaid reply card, or order form with business reply envelope.

DPI or dpi. Dots per inch. The unit of measure used to describe the scanning resolution of an image or the quality of an output device. See also resolution.

Dummy. A rough model of a book or multi-page piece, created as a preliminary step in determining page layout and length. Also, a rough model of a card with an unusual fold or die cut.

Edition. A set of identical prints published of one piece of art.

Engraving. A print made by cutting into the printing surface with a point. See also etching.

Environmental graphic design (EGD). The planning, designing and specifying of graphic elements in the built and natural environment; signage.

EPS. Encapsulated PostScript—a computer format used for saving or creating graphics.

Estimate. A ballpark figure given to a client by a designer anticipating the final cost of a project.

Etching. A print made by the intaglio process, creating a design in the surface of a metal or other plate with a needle and using a mordant to bite out the design.

Exclusive area representation. Requirement that an artist's work appear in only one outlet within a defined geographical area.

Finished art. A completed illustration, mechanical, photo or combination of the three that is ready to go to the printer. Also called camera-ready art.

Gagline. The words printed with a cartoon (usually directly beneath); also called a caption.

Giclée. Method of creating limited and unlimited edition prints using computer technology in place of traditional methods of reproducing artwork. Original artwork or transparency is digitally scanned, and the stored information is manipulated on screen using computer software (usually Photoshop). Once the image is refined on screen, it is printed on an Iris printer, a specialized ink-jet printer designed for making giclée prints.

GIF. Graphics Interchange Format—a computer format used for saving or creating graphics.

Gouache. Opaque watercolor with definite, appreciable film thickness and an actual paint layer.

Halftone. Reproduction of a continuous tone illustration with the image formed by dots produced by a camera lens screen.

Honorarium. Token payment—small amount of money and/or a credit line and copies of the publication in which an artist's work appears.

Informational graphics. Information, especially numerical data, visually represented with illustration and text; charts/graphs.

IRC. International Reply Coupon; purchased at the post office to enclose with artwork sent to a foreign buyer to cover his/her postage cost when replying.

Iris print. Limited and unlimited edition print or giclée output on an Iris or ink-jet printer (named after Iris Graphics of Bedford, Massachusetts, a leading supplier of ink-jet printers).

JPEG. Joint Photographic Experts Group—a computer format used for saving or creating graphics.

Keyline. An outline drawing on completed art for the purpose of indicating its shape, position and size.

Kill fee. Portion of an agreed-upon payment an artist receives for a job that was assigned, started, but then canceled.

Layout. Arrangement of photographs, illustrations, text and headlines for printed material.

Licensing. The process whereby an artist who owns the rights to his or her artwork permits (through a written contract) another party to use the artwork for a specific purpose for a specified time in return for a fee and/or royalty.

Linocut. A relief print made from linoleum fastened to a wooden block. See also relief.

Lithograph. A print made by drawing on fine-grained porous limestone or on a zinc plate with greasy material, then wetting the stone or plate and applying greasy ink, which will adhere only to the drawn lines. Dampened paper is applied to the stone and is rubbed over with a special press to make the final print.

Logo. Name or design of a company or product used as a trademark on letterhead, direct mail packages, in advertising, etc., to establish visual identity.

Mechanicals. Preparation of work for printing.

Mezzotint. A method of engraving in which the artist works from dark to light. The entire painting surface is first covered with a regular fine scratching made by using a rocking tool called a cradle. This takes the ink and appears as a black background. The design is burnished onto it, does not take the ink and therefore appears in white.

Multimedia. A generic term used by advertising, public relations and audiovisual firms to describe productions involving a combination of media such as animation, video, Web graphics or other visual effects. Also, a term used to reflect the varied in-house capabilities of an agency.

Offset. Printing process in which a flat printing plate is treated to be ink-receptive in image areas and ink-repellent in nonimage areas. Ink is transferred from the printing plate to a rubber plate, and then to the paper.

On spec. Abbreviation for "on speculation." See also speculation.

Overlay. Transparent cover over copy, on which instruction, corrections or color location directions are given.

Panel. In cartooning, the boxed-in illustration; can be single panel, double panel or multiple panel.

PDF. Portable Document Format—Adobe® file format for representing documents in a manner that is independent of the original application software, hardware and operating system used to create those documents.

P-O-P. Point-of-purchase; in-store marketing display that promotes a product.

Print. An impression pulled from an original plate, stone, block screen or negative; also a positive made from a photographic negative.

Production artist. In the final phases of the design process, the artist responsible for mechanicals and sometimes the overseeing of printing.

Publication (payment on). An artist is not paid for his/her work until it is actually published, as opposed to payment on acceptance.

QuarkXPress. Page layout computer program.

Query. Letter to an art director or buyer eliciting interest in a work an artist wants to illustrate or sell.

Quote. Set fee proposed to a client prior to commencing work on a project.

Relief. 1) A composition or design made so that all or part projects from a flat surface. 2) The impression or illusion of three dimensions given by a painting.

Rendering. A drawn representation of a building, interior, etc., in perspective.

Resolution. The pixel density of an image, or the number of dots per inch a device is capable of recognizing or reproducing.

Retail. The sale of goods in small quantities directly to the consumer.

Roughs. Preliminary sketches or drawings.

Royalty. An agreed percentage paid by a publisher to an artist for each copy of a work sold.

SASE. Self-addressed, stamped envelope.

Self-publishing. In this arrangement, an artist coordinates and pays for printing, distribution and marketing of his/her own artwork and in turn keeps all ensuing profits.

Semiannual. Occurring twice a year. See also biannual.

Semimonthly. Occurring twice a month.

Semiweekly. Occurring twice a week.

Serigraph. Silkscreen; method of printing in which a stencil is adhered to a fine mesh cloth stretched over a wooden frame. Paint is forced through the area not blocked by the stencil.

Simultaneous submission. Sending the same artwork to more than one potential buyer at the same time.

Speculation. Creating artwork with no assurance that a potential buyer will purchase it or reimburse expenses in any way; referred to as work "on spec."

Spot illustration. Small illustration used to decorate a page of type or to serve as a column ending.

Storyboard. Series of panels that illustrate a progressive sequence or graphics and story copy of a TV commercial, film or filmstrip. Serves as a guide for the eventual finished product.

Tabloid. Publication whose format is an ordinary newspaper page turned sideways.

Tearsheet. Page containing an artist's published illustration, cartoon, design or photograph.

Thumbnail. A rough layout in miniature.

TIFF. Tagged Image File Format—a computer format used for saving or creating graphics.

Transparency. A photographic positive film such as a color slide.

Type spec. Type specification; determination of the size and style of type to be used in a layout.

Unsolicited submission. Sample(s) of artwork sent to a buyer without being requested.

Velox. Photoprint of a continuous tone subject that has been transformed into line art by means of a halftone screen.

Wash. Thin application of transparent color or watercolor black for a pastel or gray tonal effect.

Wholesale. The sale of commodities in large quantities usually for resale (as by a retail merchant).

Woodcut. A print made by cutting a design in side-grain of a block of wood, also called a woodblock print. The ink is transferred from the raised surfaces to paper.

Geographic Index

NORTH CAROLINA

NORTH DAKOTA

Niche Marketing Index

The following index can help you find the most apropriate listings for the kind of artwork you create. Check the individual listings for specific information about submission requirements.

Children's Publications/Products

Collectibles

Fashion

Horror

Humorous Illustration

Informational Graphics

Licensing

Multimedia

Religious/Spiritual

General Index